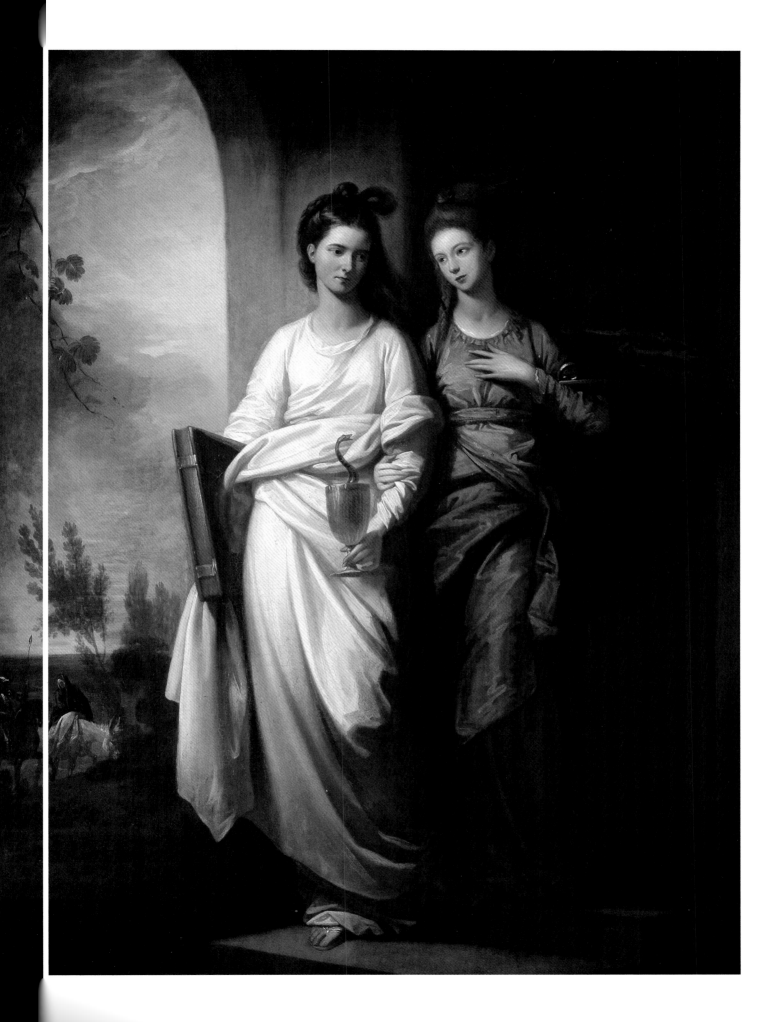

BEHOLD,
America!

Edited by Amy Galpin

With essays and
contributions by

Deborah Butterfield
Derrick R. Cartwright
Amy Galpin
James Grebl
Michael Hatt
Patricia Kelly
Patrick McCaughey
Alexander Nemerov
Rubén Ortiz-Torres
Robert Pincus
Frances K. Pohl
Lorna Simpson
and Brian Ulrich

ART OF THE UNITED STATES FROM THREE SAN DIEGO MUSEUMS

Museum of Contemporary Art San Diego | The San Diego Museum of Art | Timken Museum of Art

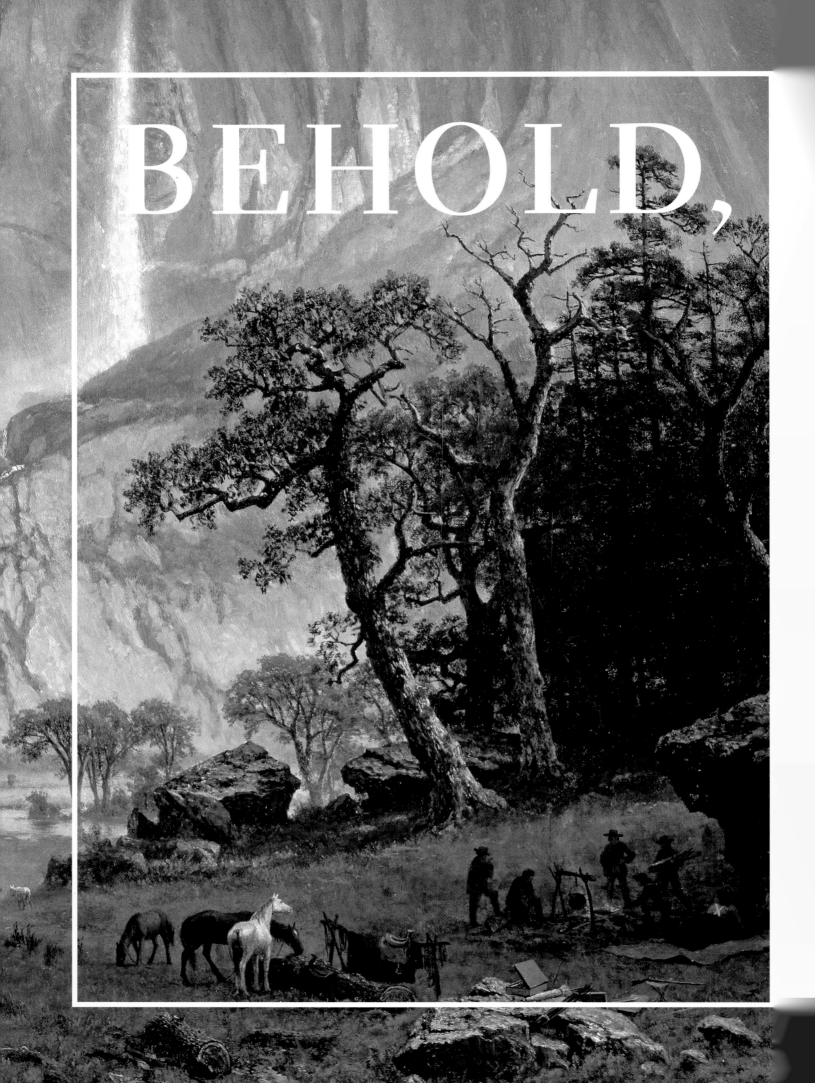

BEHOLD,

Contents

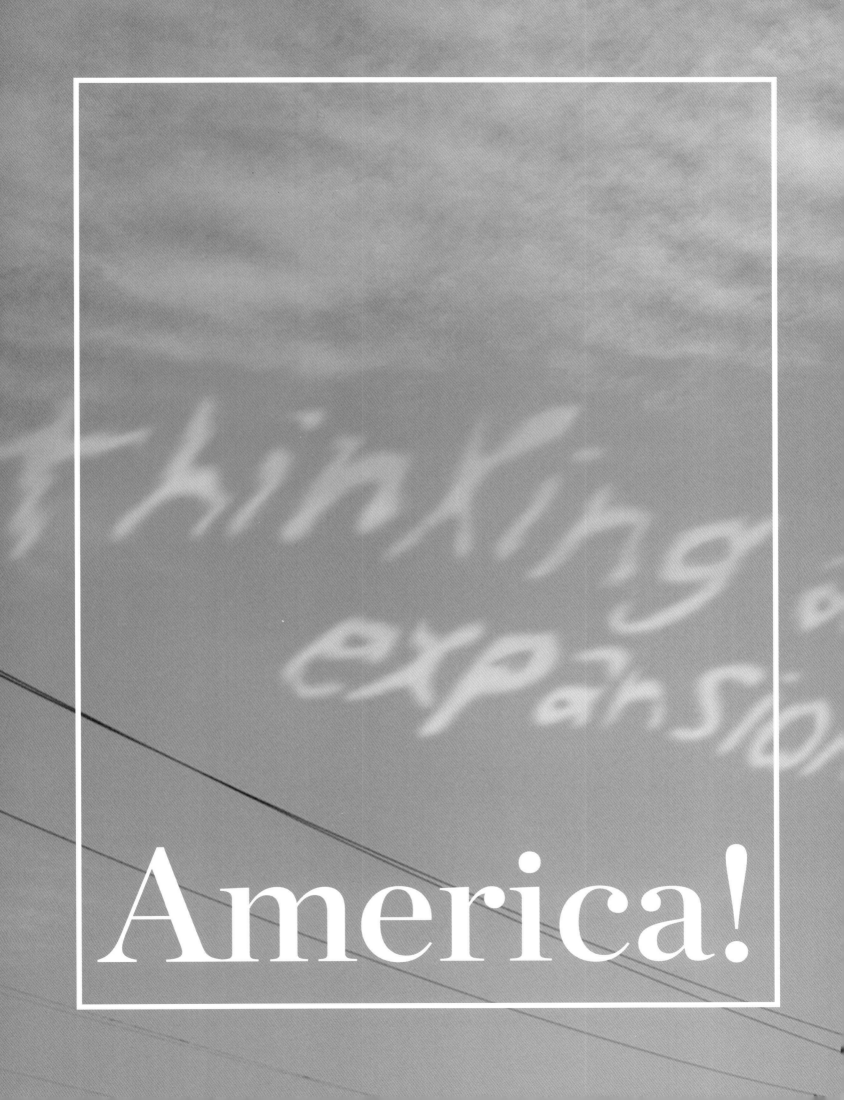

America!

In memory of John Petersen

Sponsor's Foreword

The exhibition *Behold, America! Art of the United States from Three San Diego Museums* celebrates more than two hundred years of United States history and the rich array of art our country has produced. The title of the exhibition, taken from the words of one of America's greatest literary artists, Walt Whitman, evokes the passion and spirit these visual artists and their works represent as they express a vision of America's evolution and cultural progression. Through a truly unique approach, this exhibition showcases the innovative history of American art through a blending of three expansive collections. The works range from colonial to contemporary art and include landscapes, portraiture, still lifes, and abstractions.

While separated into the distinct categories of forms, figures, and frontiers, the exhibition represents artists throughout American history who share a common pursuit of fresh and inventive approaches to their work. Examples of this pioneering spirit include Thomas Eakins and his quest for a newly vigorous realism based in observation and anatomical knowledge; Christo and his conception of a monumental art that would exist temporarily in the landscape; and Jenny Holzer and her novel uses of words and new technological media in art.

Qualcomm and Qualcomm Foundation are themselves the product of this same spirit, powered by people who have a passion for creating, for challenging established ideas of what is possible, and for working to make a difference. I am proud that the Qualcomm Foundation has the opportunity to be the lead patron for an exhibition that tells the powerful story of the history of art in our country by combining exceptional works from the Museum of Contemporary Art San Diego, The San Diego Museum of Art, and the Timken Museum of Art. This approach to collection sharing among local museums is both inspired and unprecedented. It is impressive to see San Diego's three leading art museums come together in a model of collaboration to present this outstanding exhibition in our community. I hope you enjoy *Behold, America!*

DR. PAUL JACOBS
Qualcomm Foundation Chair
Qualcomm Incorporated CEO and Chairman

QUALCOMM FOUNDATION

Directors' Foreword

No one believed in the idea of America as fervently as Walt Whitman, arguably the greatest and most influential poet the United States has yet produced. So it seems appropriate that the title of this large-scale exhibition of American art, *Behold, America!*, should be an exclamatory pair of words from one of his poems, "Song of the Exposition" (1871). And in an uncanny fashion, a line from that poem, "Mark the spirit of invention everywhere," speaks to an essential quality of this project, with its procession of American art from the colonial to the current.

This spirit has pervaded American life itself, even before independence was declared in 1776, whether in the field of technological invention or self-invention. It is also a hallmark of American art across the centuries, from John Singleton Copley's freshly naturalistic portraits of colonial New Englanders to the austerely geometric sculptures of Donald Judd and Martin Puryear, from the densely atmospheric landscapes of George Inness to the epic conceptual works of Christo.

New waves of immigrants have brought with them renewals of this spirit, both celebratory and critical. So many of the artists we think of as pivotal to the nation's art are first-generation arrivals, Albert Bierstadt and Christo among them. Central to the Southern California region is the influence of Latin Americans. Consider some of the important contemporaries in *Behold, America!* who were born elsewhere: Alfredo Jaar came to the United States from Chile, Iñigo Manglano-Ovalle from Spain, and Rubén Ortiz-Torres and Salomón Huerta from Mexico. Others, such as the early twentieth-century painter Alfredo Ramos Martínez and the contemporary duo brothers Jamex and Einar de la Torre, have straddled the border between Mexico and the United States throughout their careers.

Assembling such a rich array of works—175 selections by 144 artists—would not have been possible without an unprecedented collaboration between the Museum of Contemporary Art San Diego, The San Diego Museum of Art, and the Timken Museum of Art. The idea of a three-institution exhibition first took shape in 2005 as an effort to assemble a picture of American art that would take advantage of each museum's strengths in this area and create a grander composite portrait than any one institution

could. The thought was to create a new view of each collection, given that works from all three museums would be on view at each venue and organized around one of three themes: forms, figures, and frontiers. These thematic installations, by displaying works side by side that would not otherwise be seen this way, are sure to yield new insights and connections about the art in these permanent collections. Creating such an opportunity for the museum-going public has been one of the inspirations for this project.

Two former directors need to be mentioned for their pivotal roles in its inception and early planning: the late John Petersen of the Timken Museum of Art and Derrick R. Cartwright of The San Diego Museum of Art, who contributed an essay to this companion book for the exhibition. Their collegial efforts were instrumental in launching this ambitious project. Also unprecedented is the appointment of a single curator, Amy Galpin, who would represent the three museums and select work from all of the collections for the one show. Of course, the exhibition would not be possible without the tireless efforts of Kathryn Kanjo, Chief Curator at the Museum of Contemporary Art San Diego and Julia Marciari-Alexander, Deputy Director for Curatorial Affairs of The San Diego Museum of Art. The dedication of the collaborating institutions' staffs has assured the success of this project. We are especially grateful to the following staff members from the Museum of Contemporary Art San Diego, Charles E. Castle, Allison DeFrancesco, Rebecca Handelsman, Cris Scorza, Jenna Siman, Cameron Yahr, and Jeanna Yoo; from The San Diego Museum of Art, Sandra Benito, Amy Briere, Patrick Coleman, John Digesare, Devon Foster, James A. Gielow, James Grebl, Joey Herring, Scot Jaffe, Alexander Jarman, Katy McDonald, Joyce Penn, Reed Vickerman, Stephanie Ward, Cory Woodall, and Angela Yang; and from the Timken Museum of Art, Carrie Cottriall, Isabella Guajardo, Laurie Hawkins, Denise Lamas, James Petersen, and Kristina Rosenberg. While the current staff at each institution played an enormous role in the success of *Behold, America!*, this project would not be possible without all of the contributions of committed staff members who have furthered the missions of the three institutions since their inception. Additionally three talented volunteers, Daniela Kelly, Beth Solomon Marino, and Deanne Stratton Kamath provided noteworthy assistance at various stages of the project.

The cultural contributions of our professional leadership are fostered by enlightened patronage. Our three institutions are most grateful to the Qualcomm Foundation for its generous leadership grant. Through its sponsorship of *Behold, America!*, Qualcomm Foundation has meaningfully invested in the civic enrichment and cultural vibrancy of San Diego, the headquarters for Qualcomm, even as it has expanded the understanding of American art through the centuries. The Henry Luce Foundation's funding of the initial

curatorial appointment for *Behold, America!* was a prestigious acknowledgment of the project's contribution to American art scholarship. Additional major funding also came through the enlightened vision of Jake and Todd Figi, whose early and enthusiastic support of MCASD's participation in this venture is greatly appreciated. We are grateful, too, for the contributions of San Diego Gas & Electric®, US Bank, Mandell Weiss Charitable Trust, RBC Wealth Management, ResMed Foundation, the Wells Fargo Foundation, as well as the institutional funding supplied by the City of San Diego Commission for Arts and Culture. We also thank our community liaisons, Nancy and Matt Browar, Sarah B. Marsh-Rebelo and John Rebelo, and Joye Blount and Jesse J. Knight, Jr.

The timing of the exhibition is serendipitous, too, since election years always bring with them an abundance of rhetoric about the true nature of America and which political candidates or party embodies it more fully. If the eventful history of American art reveals anything, it is that there is no one true America but many Americas, many American stories. Whitman knew that. He was beholding an idea as much as a place. The works in this exhibition underscore the notion that this is an insistently dynamic culture, perennially in flux. It is a culture in which artists critique set notions of identity, as in James Luna's semiautobiographical conceptual trio of photographs *Half Indian/Half Mexican* (1991; cat. 93), and depict subjects from a panorama of economic strata, from the laborer (Robert Gwathmey, *Share Croppers* [ca. 1940; cat. 80]) to the seemingly middle-class person at leisure (Eastman Johnson, *Woman Reading* [ca. 1874; cat. 87]). It is also a place where artists have been innovators in the way they question everything from the nature of identity (Cindy Sherman's photographs) to the nature of art forms like painting itself (John Baldessari, *Composing on a Canvas* [1966–68; cat. 4]). Fittingly, there is a democracy of visions and views in *Behold, America!*, enriched by the fusion of three collections that presents American art through the centuries. Each of us will bring our vision and view to the work and see a different version of America in this art, and that is something to celebrate in a nation and culture that remains devoted to democratic ideals and the ever-changing ways of realizing them.

DR. HUGH M. DAVIES
The David C. Copley Director and CEO
Museum of Contemporary Art San Diego

ROXANA VELÁSQUEZ
The Maruja Baldwin Director
The San Diego Museum of Art

DR. JOHN WILSON
Director
Timken Museum of Art

What is this you bring my America?

FROM "BY BLUE ONTARIO'S SHORE" BY WALT WHITMAN

Introduction

AMY GALPIN

For the great Idea,
That, O my brethren, that is the mission of poets.
—Walt Whitman, "By Blue Ontario's Shore"

ehold, America! Art of the United States from Three San Diego Museums is a dynamic collaboration. By bringing together myriad works—many of which have never been shown side by side before— from the American art collections of the Museum of Contemporary Art San Diego (MCASD), The San Diego Museum of Art, and the Timken Museum of Art, this publication and the accompanying exhibition challenge readers and viewers to think about American art in new ways. Furthermore, *Behold, America!* offers both San Diego residents and art enthusiasts far and wide an opportunity to appreciate the notable holdings of this city by the ocean. Nicknamed "America's Finest City," San Diego has long been recognized for its picturesque vistas and plethora of palm trees, but beyond its natural beauty, San Diego is home to world-class art, and this is evident through-out the permanent collections of the three museums that have formed this groundbreaking partnership.

At the end of the "American Century" and in the midst of the worldwide struggles that erupt each day, *Behold, America!* takes a bold look across three centuries of visual art created in the United States. W. J. T Mitchell eloquently writes, "Empires have a way of coming to an end, leaving behind their landscape as relics and ruins."[1] Just as the British and Spanish empires succumbed to change, the United States is embarking on its own profound, systemic evolution. Specifically, this collaborative project examines how artists have addressed colonialism, environmentalism, and racial inequality and sought new ways to present forms, figures, and frontiers through their art. By bringing together a diverse group of objects, *Behold, America!* exam-ines how perceptions of self and nationhood have changed over time and, in dividing the exhibition into three specific but fluid themes—forms, fig-ures, and frontiers—reveals new relationships between works of art in three distinct but connected collections.

The title of the project, *Behold, America!* is drawn from a poem included in later versions of Walt Whitman's seminal work *Leaves of Grass*.[2] Literature

Fig. 1. Thomas Moran (1837–1926). *Below the Towers of Tower Falls, Yellowstone Park*, 1909. Oil on canvas; 30 × 25⅛ inches. The San Diego Museum of Art; Gift of Lydia and Etta Schwieder, 1968.48. Cat. 156.

and American visual art have long had a close relationship, perhaps most markedly during the nineteenth century, when landscape painters shared a kinship with writers Henry David Thoreau and Ralph Waldo Emerson. Furthermore, Mark Twain, F. Scott Fitzgerald, Zora Neale Hurston, and Upton Sinclair all produced novels that make us think differently about the American state of being. Similarly, poets such as e.e. cummings, Robert Frost, and William Carlos Williams have written texts that reverberate within the weave of the American cultural fabric. The title *Behold, America!* aims to evoke the natural landscape of the United States and imperialism and, perhaps ironically, also suggests the more infamous—as opposed to celebrated—aspects of American culture, thus moving beyond Whitman's original intentions. For example, Thomas Moran's *Below the Towers of Tower Falls, Yellowstone Park* (1909) relates to certain Whitman passages in its reinforcement of awe for the natural beauty of the American landscape (fig. 1). Furthermore, Eastman Johnson's *Wounded Drummer Boy* (1865–69) addresses the Civil War (1861–65), a conflict that deeply affected many Americans, including Whitman (fig. 2). Johnson and Whitman shared a deeply personal connection to the Civil War, as both men spent time with soldiers. This painting embodies the national spirit in the years following the conflict that pitted the country's southern region against the northern states. Proudly hoisted on the shoulder of a Union soldier, Johnson's young drummer boy, with his injured

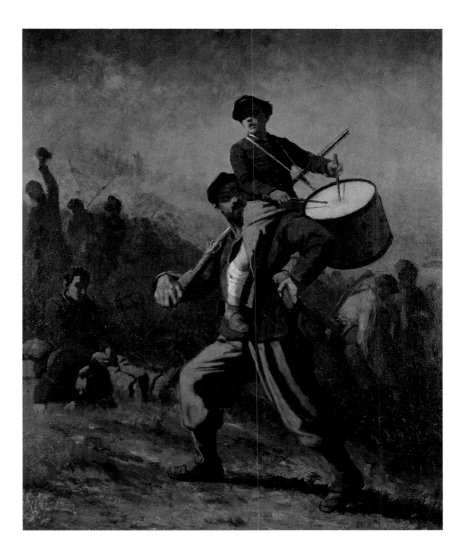

Fig. 2. Eastman Johnson (1824–1906). *Wounded Drummer Boy*, 1865–69. Oil on board; 26¼ × 21⅝ inches. The San Diego Museum of Art; Gift of Mrs. Herbert S. Darlington, 1940.79. Cat. 88.

knee, symbolizes the American national spirit, deeply wounded by the internal war. Drummer boys accompanied specific regiments during the war and boosted the spirits of the enlisted men. Johnson traveled with Union troops on several campaigns, documenting the soldiers' experiences. As in this work, his paintings often use scenes of daily life to symbolize larger concepts of national spirit and pride. Other works in the show inspire viewers to think about what it means to behold America in the twenty-first century. Most dramatically, Hugo Crosthwaite's *Bartolomé* (2004), inspired by the abuses at the Abu Ghraib prison, addresses the harsh realities of war in Iraq.

While artists' personal identities are often factored into evaluations of their art, this project emphasizes identity at a communal, national level. *Behold, America!* expresses the history of the United States. Whether the country was emerging from colonialism or civil war, visual artists working in the United States have contributed to a national identity that was continuously reformed and negotiated. At the dawn of the twentieth century, many American artists played prominent roles in the development of an international art scene in New York and further established the United States as a country capable of producing significant avant-garde art. In more recent years, artists have called into question how the United States views itself and how American artists contributed to its complex visual and cultural history. David Hammons, Cindy Sherman, and Lorna Simpson have all made work

Fig. 3. Bill Viola (b. 1951). *Heaven and Earth*, 1992. Two-channel video installation, edition 1/2; Dimensions variable. Museum of Contemporary Art San Diego; Museum purchase, Contemporary Collectors Fund, 1993.1. © Bill Viola 1992. Cat. 115.

that addresses the complications of contemporary identity surrounding American culture.

As stated previously, to organize this sweeping survey, objects have been grouped into three categories: forms, figures, and frontiers. These three sections are elastic in the sense that certain works located in figures could just as easily exist in forms, for example, Bill Viola's *Heaven and Earth* (1992; fig. 3) and Fred Tomaselli's *Head with Flowers* (1996; fig. 4). While *Heaven and Earth* might appear to be composed of abstract columns, in actuality it includes a two-channel video portrait of a mother and child. In Tomaselli's work, the profile of a man is hidden among swirling, flower-accentuated forms. Additionally, *Portrait of Tudl-Tur (Sun Elk)* (ca. 1910) by Bert Geer Phillips, while located in the frontiers section, could also be included in the figures group (cat. 163). These ambiguities are intentional and are meant to inspire those who view this show or read this book to think about how these works are different and how they are interconnected.

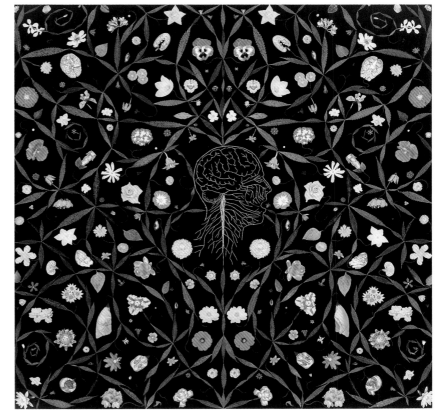

Fig. 4. Fred Tomaselli (b. 1956). *Head with Flowers,* 1996. Paper collage, datura, ephedra, hemp, and resin on wood; 60 × 60 inches. Museum of Contemporary Art San Diego; Museum purchase, Contemporary Collectors Fund, 1997.14. Cat. 114.

The forms section includes traditional still lifes by Raphaelle Peale, William Harnett, and Martin Johnson Heade. Peale's still lifes present an austerity, and Harnett's paintings demonstrate trompe l'oeil; both artists provide information on nineteenth-century domestic life. Heade's flowers often recount his travels and express an interest in unfamiliar subject matter (fig. 5). Later explorations of form by modern artists Arthur Dove, Stuart Davis, and Georgia O'Keeffe bring this portion of the exhibition into the twentieth century. Leading contemporary artists Claes Oldenburg and Ed Ruscha offer excellent examples of recent works that consider text as form and a vital part of creative processes. The grouping of works within the concept of forms reveals the strengths of the Museum of Contemporary Art San Diego's permanent collection as related to minimalism and the light and space movement that emerged in California. Furthermore, some of the forms works that have been placed at the Timken, such as those by Jo Baer and Andrea Zittel, have great resonance with the Timken building, a prominent, minimal box that stands out from much of the architecture in Balboa Park.[3]

The figures section features early portraits by artists of the British colonies such as Joseph Blackburn, John Singleton Copley, and Benjamin West. American artists embracing impressionism are well represented in portraits by Mary Cassatt and William Merritt Chase. Powerful portraits by Thomas Eakins and Robert Henri celebrate artists at the forefront of modernist

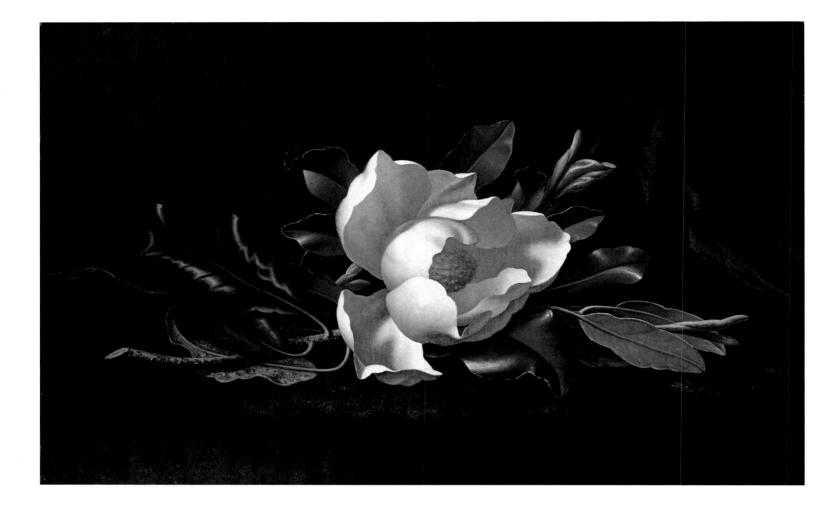

movements in New York and Philadelphia. These important historical paintings are in dialogue with contemporary photographs by Daniel Martínez and Luis Gispert, among others. Each portrait featured in the exhibition plays a role in understanding historical, political, and cultural developments in the United States. These works demonstrate that representations of individuals can symbolize the collective body of the people and express the drastic changes identity can undergo over time. Furthermore, each section, but particularly figures, uncovers new information regarding the history of collecting and attitudes toward American art in San Diego. Each institution has strong portraits. The San Diego Museum of Art's figures section offers an opportunity to view these portraits by American artists in concert with other outstanding portraits in its permanent collection by artists such as Giorgione, Francisco de Goya, Anthony van Dyck, Joaquín Sorolla y Bastida, and Diego Rivera.

The frontiers section pushes the boundaries of the organizing thematic concept both literally and figuratively. Works by Maynard Dixon and Moran address the United States' westward expansion. While the subject of the American West resonates in many of the works included in this section, here, the concept of frontiers evokes the idea of any territory or location that is used in new ways or a place where ideas and realities are pushed beyond the status quo. For example, the inclusion of John Sloan's *Italian Procession, New York* (1913–25; cat. 168) implies that as communities of immigrants embarked on new journeys in the United States, they crossed frontiers. Moreover, Sergio

de la Torre's poignant photograph *Thinking about Expansion* (2003; cat. 132) addresses colonialism in a contemporary context. While many of the works in the frontiers portion of the exhibition are painted landscapes, large-scale installations by Paul Kos, Ann Hamilton, and Alfredo Jaar add dimension to the project and demonstrate another strength of the MCASD collection. Furthermore, the presentation of frontiers at the Museum of Contemporary Art San Diego offers symmetry with institution's dynamic location overlooking the Pacific Ocean.

The nine essays and four artist interviews included in this publication augment the exhibition. Academics, critics, and museum professionals take various approaches to discussing this project as a whole while also addressing select works. The group of essayists includes both well-known American specialists and names that will surprise and delight readers. Patrick McCaughey's "From Spectacle to Environment: Albert Bierstadt to Andy Warhol" offers a sweeping look at the works in the exhibition and positions the project as its own distinctive look at American art. With his essay "Aggregate Nation: The Evolution of American Art in Three San Diego Museums," Robert L. Pincus, longtime *San Diego Union-Tribune* art critic and now an MCASD staff member, looks at the history of collecting American art at each participating institution. Frances K. Pohl's contribution is particularly salient in this study, as she is the author of the most inclusive survey text on American art. Her essay, "American Art, Museum Exhibitions, and National Identity: Problems and Promises," examines some of the problems and challenges inherent in survey exhibitions and looks at the highly discussed exhibitions *The West as America: Reinterpreting Images of the Frontier, 1820–1920* (1991) and *American Stories: Paintings of Everyday Life, 1765–1915* (2010). One of the most recognized and widely respected authorities on American art, Alexander Nemerov moves away from the specific works of *Behold, America!* and instead focuses on the important issue of tonal contrasts in nineteenth-century American paintings in his essay "The Forest of the Old Masters: The Chiaroscuro of American Places." James Grebl, an antiquities expert and manager of the archives and library at The San Diego Museum of Art, goes outside of his specialty with "The New World Discovers Italy," in which he tackles a topic of great interest to him and pertinent to this study, the story of American painters in Italy, with specific attention to artists included in the exhibition. Michael Hatt, who is based at the University of Warwick, looks at the development of modernism through the lens of *Behold, America!* using the organizing categories of rocks, skin, and walking. He posits that the three sections of the show, and the objects included in them, allow one to behold America as Whitmanesque litany because the forms, figures, and frontiers constitute the nation, or, as Whitman puts it, "not merely a nation, but a teeming nation of nations."[4] Derrick R. Cartwright, former director of The San Diego Museum of Art and one of the initiators of this project, discusses a topic that has fascinated him for a number of years, the presence of Robert Henri in San Diego in 1914 and Henri's role in the development of an American art exhibition for the 1915 Panama-California Exposition in Balboa Park (fig. 6). This was the first time that an American art exhibition with artists of national stature was held in San Diego. Patricia Kelly, who has recently published on artists ranging from Washington

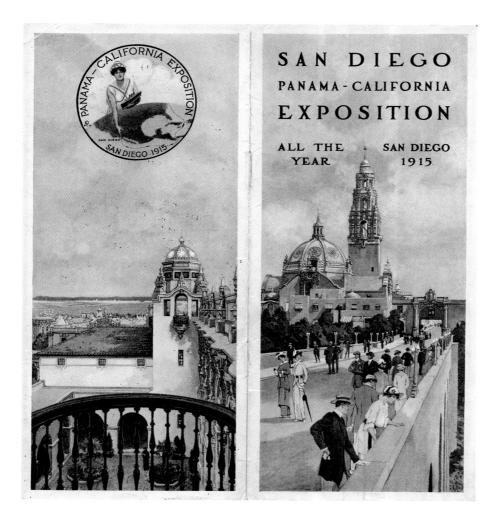

Fig. 6. Panama-California Exposition brochure (back and front), 1915. San Diego History Center.

Allston to Jo Baer, contextualizes works by Robert Smithson and Sol LeWitt, among others, in "Mapping as Practice, or Finding the Subject in American Art circa 1970." My own essay, "An American Art for San Diego: Rethinking Cultural Boundaries in Southern California," addresses how visual culture permeates the physical borders between the United States and Mexico, with specific attention to the muralist Alfredo Ramos Martínez and contemporary artists Rubén Ortiz-Torres and Hugo Crosthwaite.

To differentiate the book from other survey texts on American art, we have made a concerted effort to incorporate the artist's voice. Most markedly, four interviews with leading American artists are dispersed throughout the body of the book. Brian Ulrich, Lorna Simpson, Deborah Butterfield, and Rubén Ortiz-Torres were chosen in part for the strength of the works included in the exhibition and also for the different narratives of contemporary art that their work represents. Each interview was conducted at the artist's studio. Although Ulrich relocated to Virginia last year, he was interviewed at his studio in the Ravenswood neighborhood of Chicago. Simpson's interview occurred at her studio in Fort Greene, Brooklyn, and Ortiz-Torres was interviewed in his studio in the Echo Park neighborhood of Los Angeles. The conversation with Butterfield took place on her ranch in Bozeman, Montana. The mere locations of these interviews serve as reminders that artists are active in diverse parts of the country, and that the places where they work can greatly inform their art. Throughout the book, quotes from

artists and Whitman enhance the text and further give agency to the artist's voice. Specifically, in the entries in the back of the book, excerpts from some of the artists' writings and passages from Whitman's poems appear sporadically, to augment analysis and offer readers a new approach to the study of these works.

As a collaborative endeavor, *Behold, America!* seeks to engage audiences and readers of this book with an opportunity to conceptualize the American art collections of these three institutions as parts of a united entity that tells the history of American art and demonstrates in visual form the shifting identities of American culture across three centuries. This multifaceted exhibition will emphasize the way in which people, ideas, and topography have given the United States its cultural makeup and shaped its identity. People, ideas, and landscape were also cherished repeatedly in Whitman's poems. He thought about the cadence of American speech, the popularity of slang, and the ways in which he could use a democratic approach in his words, one that he hoped mirrored the country itself. He read his "Song of the Exposition" publicly at the National Industrial Exposition of the American Institute in 1871, and, like that event, the Panama-California Exposition celebrated the ingenuity of the American people. As we approach the centennial of the Panama-California Exposition in San Diego, it seems appropriate to reflect on the multitude of citizens who collaborated to make the 1915 event culturally rich and how, today, as we move toward that anniversary, we might think about honoring the historic fair.

For many who call San Diego home, topophilia is a major affliction. This passion is present in perhaps the most well-known American art movement to occur in San Diego, plein air painting. Two paintings, Nicolai Fechin's *Torrey Pines* (ca. 1925; fig. 7) and Alfred Mitchell's *La Jolla Cove* (ca. 1950; fig. 8), included in the exhibition, underscore the love of place among San Diego

Fig. 7. Nicolai Fechin (1881–1955). *Torrey Pines*, ca. 1925. Oil on canvas; 30 × 36 inches. The San Diego Museum of Art; Gift of Wilda B. Dunnicliffe, by exchange, 1998.87. Cat. 138.

residents and among plein air painters. Born in Russia, Fechin spent considerable time in New Mexico and in Santa Monica, California, during the latter part of his career. Mitchell was the first prominent American artist to spend the majority of his career in San Diego. Since the early twentieth century, artists have come to San Diego County to be inspired by its topography. These stunning locations are within minutes of the Museum of Contemporary Art San Diego, while the paintings themselves reside in the permanent collection of The San Diego Museum of Art. These particular places are counted among the favorite spots of both locals and visitors. The La Jolla Historical Society, located adjacent to the Museum of Contemporary Art San Diego, has numerous photographs taken of these spots over the years, though the three reprinted here closely match the paintings and were taken around the time that the paintings were completed (figs. 9–11).[5] The power of these locales in images is plainly seen in the number of photographs taken by residents, whether it is a snapshot of seals frolicking in the Cove or an iPhone picture taken on a hike through Torrey Pines.

Collections are autobiographical. For instance, the art in a certain private collection might reflect major moments in the owner's life—marriage, divorce, the birth of a child, or a move across the country. In the same way that private collections reveal information about the patrons who began and preserved them, public collections, like those of the Museum of Contemporary Art San Diego, The San Diego Museum of Art, and the Timken Museum of Art, divulge information about our shared community of San Diego. After all, the majority of the works in these collections were given to the museums by local collectors or purchased by local supporters of these institutions and

thus often reveal to us new information about the community identity and local history of San Diego. San Diego, known for its ocean views and agreeable climate, also possesses first-rate cultural institutions and art collections. Many dedicated residents have given their support over several decades to enhance the cultural legacy of this city, and this exhibition is a testament to their generosity.

Fig. 9. Torrey Pines area, La Jolla, California. La Jolla Historical Society.

Fig. 10. Guy Fleming (1884–1960). *Untitled*, 1921. Torrey Pines, La Jolla, California. La Jolla Historical Society.

Fig. 11. La Jolla Cove, La Jolla, California. La Jolla Historical Society.

1. W. J. T. Mitchell, "Imperial Landscape," in *Landscape and Power*, ed. W. J. T. Mitchell (Chicago: University of Chicago Press, 1994), 19.

2. Whitman's poems, compiled for the anthology *Leaves of Grass*, marked a watershed in the development of American poetry when they were first published in book form in 1855. In the nine subsequent editions of *Leaves of Grass*, the poet changed the titles of poems, altered the text here and there, played with punctuation marks, and in some cases removed poems. The last version, popularly known as the "deathbed version," was published in 1891 and announced in the *New York Herald* just two months before Whitman's death in 1892. His poem "The Song of the Exposition" originally appeared under the title "After All, Not to Create Only" in 1871. Later, in 1876, it was published under the title by which we know it today and was finally included in the 1881 edition of *Leaves of Grass*. Whitman was commissioned to write the poem in honor of the fortieth National Industrial Exposition of the American Institute, where he shared it with the public for the first time, reading it aloud on September 7, 1871. The poem was used again in connection with the Centennial Exposition in Philadelphia in 1876.

3. A San Diego architect, John Mock, designed the modern building for the firm of Frank Hope and Associates. It opened to the public in 1965.

4. Walt Whitman, "By Blue Ontario's Shore," *Leaves of Grass* (1855; New York: Doubleday, 1940 [1855]), 185.

5. My thanks to Russell Petty, Beth Solomon Marino, and to Michael Mishler of the La Jolla Historical Society for their help finding and identifying these photographs.

This is the city and I am one of the citizens,
Whatever interests the rest interests me, politics,
 wars, markets,
 newspapers, schools,
The mayors and councils, banks, tariffs,
 steamships, factories, stocks,
 stores, real estate and personal estate.

FROM "SONG OF MYSELF" BY WALT WHITMAN

From Spectacle to Environment: Albert Bierstadt to Andy Warhol

PATRICK MCCAUGHEY

T here is much to be learned from a survey of American painting and sculpture such as *Behold, America! Art of the United States from Three San Diego Museums*. Removed from their customary institutional setting, works of art suggest surprising connections, unsuspected links, and, sometimes, useful simplifications of the broad narrative of American art. The vividness of so many of the objects and their insight into the American experience openly invite the viewer to seek relationships between them. Even the obvious lacunae such as Winslow Homer or Edward Hopper accentuate the usefulness of the survey by throwing more weight on the less familiar.

In this essay, I examine the proposition that the great shift in the pictorial imagining of America from the mid-nineteenth century to the mid-twentieth century is the move from seeing America as spectacle to seeing America as environment. The fulcrum point lies in the last decades of the nineteenth century —here, splendidly represented by Eastman Johnson and William Merritt Chase— when the trope of the figure in the landscape took hold as the true representation of the American condition.

I

Albert Bierstadt's *Cho-looke, the Yosemite Falls* (1864; cat. 124) could hardly be bettered as a commanding image of America as spectacle. Even if some of his contemporaries doubted the absolute veracity of Bierstadt's account of western splendors,[1] the artist was famous for his forays into the western landscape. His vision sprang from experience. His visit to Yosemite in the summer of 1863 was documented by that voluble wastrel Fitz Hugh Ludlow. Bierstadt asserted the true-to-experience nature of the work by including the charming vignette of the travelers' fireside encampment at the lower right. Even if they are confined to the shadows so as not to distract the viewer, their presence asserts that they were there; they saw and experienced the spectacle. The falls—the light-attracting central motif—must, however, be the be-all and the end-all of the work. It is the explorers' reward for the arduousness of the journey, to find grandeur

in American nature that validates and substantiates the nation's Manifest Destiny. No other country is endowed with such natural glory as the United States. The sense of revelation is essential to the painting. The mists and clouds of Cho-looke part for a moment and reveal the white thread of the tumultuous water, the baptism of the landscape. That Bierstadt makes us see the waterfall *around* the foreground tree, not quite *en face*, and that the falls themselves are broken into two sections, all contribute to the idea that no single viewpoint can encompass such a mighty phenomenon. It reveals its full splendor only in multiple views. By composing his landscape in a vertical format, Bierstadt breaks with the neoclassical landscape of the first generation of Hudson River School painters. Nature now dictates the forms of art, not vice versa: the vertical falls means the vertical painting. It underscores the American character of the work. No European model can suffice to tell the story of American nature at its grandest.

Although sixteen years separate Bierstadt's *Cho-looke, the Yosemite Fall* (cat. 124) from Asher B. Durand's beautiful and evocative *Landscape Composition in the Catskills* (1848; cat. 137), there is a marked shift in sensibility and attitude to the American landscape. The Claudean landscape is exactly the effect Durand wants to elicit for his idealized image of upstate New York. American nature offers the promise of the same calm and ordered world as the old world of classical memory. The brilliant patch of light in the background beckons the travelers onward with the suggestion of grandeur in the distant mountain range and fecundity in the sun-swept plain. A path has been found in the wild. The deliberate contrast between the blasted tree in the foreground and the tree on the right with its knotty, life-giving roots— the Claudean framing device—marks the passage from decay to new life.

Durand may not be as spectacular as Bierstadt in Yosemite—save for Frederic Church, who could be?—but his Catskill landscape is still couched in the spectacle of American scenery and the promise it contains. It is not yet a landscape of settlement and work; that is its future. But the American painter can enjoy and share with his viewers a contemporary world that evokes the spectacle of the wild *and* the classical. The world's great age begins anew in the American landscape.

Falling chronologically between the Durand and the Bierstadt is the marvelous Fitz Henry Lane painting *Castine Harbor and Town* (1851; cat. 151). By painting directly into the light, looking westward toward the close of day with the immense sky and broken clouds, Lane wanted his viewers to see the commerce of the ships and the settlement straddling the low hills as part of the larger whole of sea and sky—the spectacle of American nature. What makes Lane the most original marine painter of the mid-nineteenth century in America is that the facts of this world—the ships, the buoy, the town—are set down so clearly and unemphatically yet are bathed in a light-filled atmosphere that spreads an immense and beneficent calm: America, the blessed. We are invited to contemplate the world as a place of optimism and potentiality, one like the western world of Bierstadt or the upstate New York of Durand. Although there is evidence of human activity or presence in the works of all three artists—the travelers and explorers in Bierstadt, the horseback travelers in Durand, marine life in Lane—the world as a whole underpins the vision of "confident, glad morning."

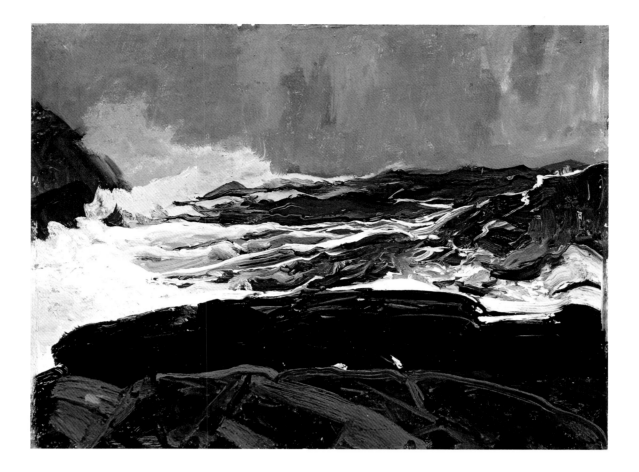

The idea of America as spectacle persisted well into the twentieth century. Nicolai Fechin's dry and heat-filled *Torrey Pines* (ca. 1925; cat. 138) certainly maintains the thrust, as does George Bellows's surging *Lobster Cove, Monhegan, Maine* (1913; fig. 12). Both are shorn of nineteenth-century optimism. Fechin strikes no note beyond the well-observed and well-realized landscape: the world is what it is. But Bellows's angry, foam-lashed ocean is another matter. *Lobster Cove* comes from what has been called "the most productive of periods of Bellows' career."[2] He spent July to October 1913 on the tiny island and produced more than a hundred paintings. The San Diego panel comes from the end of this Monhegan stint. The dark sky and the turbulent sea anticipate the onset of winter. The spectacle of wind and water and the crash of sea on rocky shore is one of unleashed power and violence, of elemental forces at odds and blind to human need. Pictorially, it owes quite a lot to the other master of the tempestuous Maine shore, Winslow Homer, but Bellows's own mood seems engaged in this ominous work. Only the wall of dark rock stands between the artist and annihilation. The fluency and fertility of Bellows in Monhegan in 1913 points to how inward he became with his motif, mirroring his own changeable nature. The violent world of *Lobster Cove* is a long way from the art of the summer retreat. American nature now strikes a note of threat as it enters a new century.

II

The theme of America as spectacle obviously persisted deep into the twentieth century. Ansel Adams became the Bierstadt of modernism. What did change slowly if decisively in the last three decades of the nineteenth century

Fig. 12. George Bellows (1882–1925). *Lobster Cove, Monhegan, Maine,* 1913. Oil on board; 15 × 19½ inches. The San Diego Museum of Art; Gift of Mrs. Henry A. Everett, 1930.52. Cat. 121.

was the buoyant and beneficent view of American nature. The bitter mood of the country after the trauma of the Civil War is often associated with the end of American optimism and the triumphalism of the doctrine of Manifest Destiny. Maybe. But Bierstadt's *Cho-looke, the Yosemite Fall* was painted and shown to great acclaim during the Civil War, and the artist continued to enjoy critical and commercial success through the 1870s. What superannuated the Hudson River School and the American landscape as spectacle was the sea change in the world of art. From the mid-1870s onward, the new turning in French art, principally impressionism and the doctrine of plein air painting, held sway over American practice. Expatriate American painters of superior talent such as James McNeill Whistler, John Singer Sargent, and Mary Cassatt were active participants in the radical turn of western painting. The impact of Paris came in many different forms, from large exhibitions of French impressionism in the United States and an increasing volume of traffic of American painters going to Paris and later homing in on Giverny. The complexities of the American-French dialogue in the last quarter of the nineteenth century have been explored in many studies and are tangential to this essay.[3] Two big truths translated across the Atlantic and became integral to American art: the need to paint modern subjects and the need to paint outside the studio as part of a basic routine. Stéphane Mallarmé remarked that "the open air influences all modern artistic thought."[4]

In American art, the subject that took hold in the changed atmosphere was the figure in the landscape, not as the diminutive staffage of a Bierstadt epic but as sentient beings, with the figure embodying or dramatizing the landscape and the landscape, in turn, resonating the mood and moment of the figure. American landscape had shifted decisively from spectacle to a lived-in world, an environment. There were other forces pushing American artists out of their studios and into the real world. American genre painting became increasingly sophisticated from the 1860s onward. Inevitably, that led the artist to outdoor subjects. Eastman Johnson, in his masterpiece *The Cranberry Harvest, Island of Nantucket* (1880), might be cited as the chief beneficiary of this impetus (cat. 148). The eminent Americanist Jules David Prown once sharply observed that "Eastman Johnson seems . . . to break like a false dawn in mid-19th-century painting, holding the promise of combining that grasp of the essence of American life in the popular genre paintings of Mount and Bingham with a high degree of technical training and skill."[5] *The Cranberry Harvest* may be an exceptional work within his oeuvre, and he may never have attained the heights of Winslow Homer, but few paintings embody so strongly the turn in American landscape from spectacle to environment. The sprawling figures of the children are literally embedded in the earth, prising out the cranberries. The tall standing woman in the middle of the picture looking toward the boy carrying an infant seems rooted to the spot. The embodiment of female strength, she is the sole figure to turn toward the light. The painting as a whole has the strong charge of labor rather than leisure to it. Here, all stages of life, from the children through the young to middle-aged couple in the center to the old man seated in the middle ground with the black top hat and jacket, are engaged in harvesting nature's bounty. Eastman Johnson delights in and emphasizes the rough spiky grasses of the bog, dried out at the end of summer. The random grouping of the figures and

the second wave of harvesters in the deeper middle ground combine the feeling of the casual and the well observed. It is above all a collective enterprise in which the harvesters are engaged, a human environment amid the otherwise minimalist landscape. The plot of the figure in the landscape but not overwhelmed by it was afoot, and the American impressionists would make good its claim, none better than William Merritt Chase at Shinnecock on Long Island during the summers of the 1890s.

The spare and sparse sand dunes surrounding Chase's summer home (designed by no less a figure than Stanford White, the gift of his patron Mrs. William Hoyt) stand at the opposite end of the spectrum of landscape as spectacle. A contemporary noted that "the whole of Shinnecock can hardly boast one tree," and this is borne out by the bushes in *An Afternoon Stroll* and their absence in the view of the Chase homestead (fig. 13). What makes these Shinnecock landscapes so vivid and appealing is the combination of a minimal landscape and the exclusive presence of women and children. Despite the bare, windswept quality of the landscape—note the racing clouds behind the Chase homestead—it is an entirely safe and secure environment. Instead of looking vulnerable to the elements, the child fossicking along the path and the single woman strolling by a pond in the afternoon are entirely at home in the landscape. Chase's marvelous tonal sense absorbs the child into the landscape. In *An Afternoon Stroll*, an overtly feminized landscape, the woman is the precise meeting point of the interchange of light and shade. The parasol

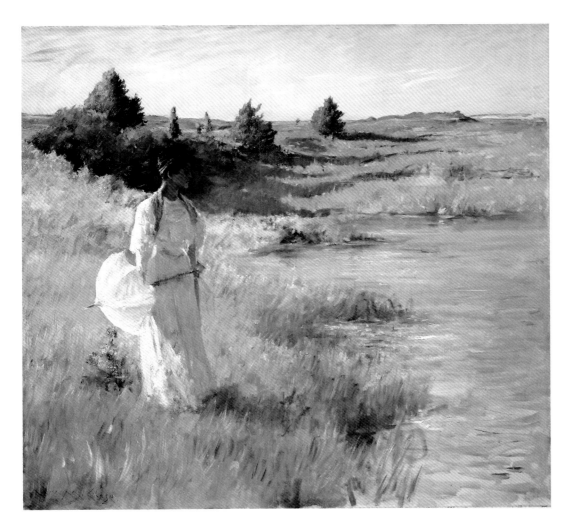

Fig. 13. William Merritt Chase (1849–1916). *An Afternoon Stroll,* ca. 1895. Oil on canvas; 47⅛ × 50¼ inches. The San Diego Museum of Art; Museum purchase with funds provided by the Gerald and Inez Grant Parker Foundation and Earle W. Grant Acquisition Funds, 1976.1. Cat. 71.

catches and reflects the light, leaving her body and face shaded. The woman embodies the environment, its simplicity and summertime leisure, its sparkling sunshine and residual warmth.

If Chase's Shinnecock landscapes represent a high-water mark in the turn of American landscape from spectacle to environment, they are not an isolated phenomenon. When the artistic fortunes of American impressionism declined sharply with the onset of the twentieth century, the succeeding wave of realist painters, most notably the Ashcan School and its fellow travelers, turned to the urban environment and produced the most robust cityscapes to date in American art. Again, the figure embodying and animating the environment was the key to their success, a tendency brilliantly represented by John Sloan's *Italian Procession, New York* (1913–25; cat. 168). The city as object is certainly present in Sloan's work, with the oppressive effect of the El, the narrow street, and the tenement. But the procession of old and young, men and women, ensures the experience of an inhabited environment in which the human activity forms the spectacle as much as the built forms of the city. The grit and griminess of the scene are clearly at play with the virginal white dresses of the women and girls. The interaction between figure and setting forges the distinctively American environment.

III

The abrupt turn to modernism after the Armory Show in 1913 meant a dramatic shift in the pictorial account of the American scene. At a stroke, the figure-in-the-landscape trope was dealt a fatal blow. The rhythmic composition of Morgan Russell's *Synchromy with Nude in Yellow* (1913) makes the customary practice of impressionist and realist painter alike look hopelessly old-fashioned (cat. 49). Yet the American environment, city and landscape, still held the best early modernists in thrall. It was not just the American-scene painters who wanted a distinctively American art. The post-Armory

Fig. 14. Georgia O'Keeffe (1887–1986). *Purple Hills near Abiquiu,* 1935. Oil on canvas; 16⅛ × 30⅛ inches. The San Diego Museum of Art; Gift and Mr. and Mrs. Norton S. Walbridge, 1976.216. Cat. 159.

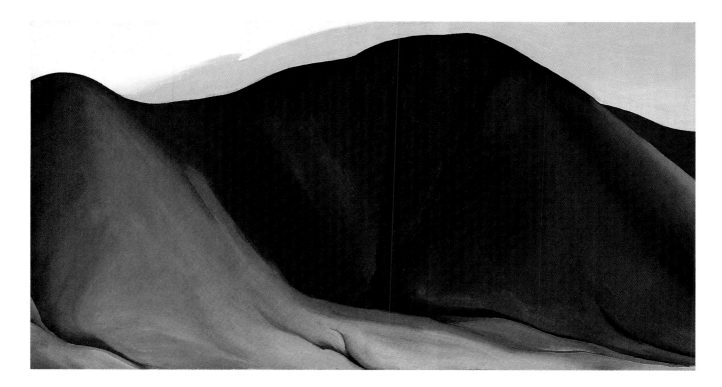

avant-garde wanted an American art to grow out of the stimulus of European modernism. Such diverse and exceptional practitioners as Georgia O'Keeffe, Arthur Dove, Stuart Davis, and Marsden Hartley felt the pull of the modern and the desire for the distinctively American in equal measure. Painter Max Weber spoke for them: "What we need today is an American art that will express the Whitmanesque spirit and concept of democracy, an art as heroic and prophetic as the undying *Leaves of Grass*."[6]

The anecdotalism of the American-scene painters was as remote to their modernist sensibilities as the figure-in-the-landscape routine. How could they use the tools of modernism to fashion a distinctive vision of America? In diverse modes, they fixed their attention on the complex and contradictory nature of the American environment, by turns raw and lively, uningratiating and primal. Stuart Davis forged a remarkable path, staying close to American realities yet mastering an individual, descriptive mode of Cubism. The cubist grid enabled him to join and link disparate elements and motifs as in the

lively and characteristic *Composition with Boats* (1932; cat. 9). Playfulness mixes here with taut, industrial structure, creating an environment of both labor and leisure. Davis's America comprises the man-made environment, the built, the industrial, but without individual human presence. It would set the pattern for his fellow pioneering modernists.

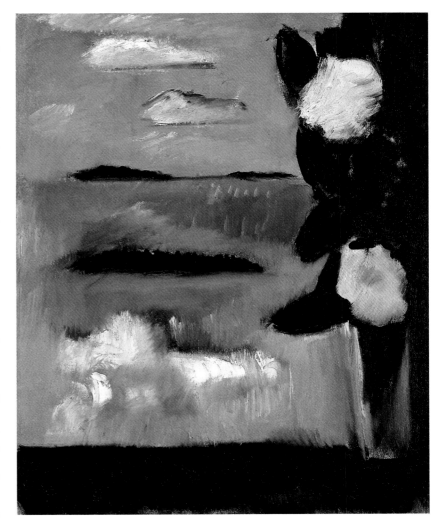

This holds true for both O'Keeffe and Hartley even when they are painting in more conventional landscape modes. The fine group of O'Keeffe paintings, particularly *Barn with Snow* (1933; cat. 34), *Purple Hills near Abiquiu* (1935; cat. 159), and *In the Patio* (1946; cat. 158), offer a severe, even desolate view of the American environment. The shuttered barn and the mazelike patio turn a blind, impersonal face to the viewer. *Purple Hills near Abiquiu* offers an equally estranging vision of America. The hills' blank folds fall well short of spectacle, and the landscape provides no path or entrance point to this anonymous, self-contained world. The American environment is purged of affect. The impersonality of modernism, stripping away the inessential, trumps all other considerations. Even the more overtly expressive and volatile Hartley matches O'Keeffe in impersonality in his fine, somber *Winter Wind—Maine Coast* (1941; fig. 15). The compositional device of looking at the winter world from within the confines and comfort of the studio, with its still life as antithesis to the extensive world beyond, is

Fig. 15. Marsden Hartley (1877–1943). *Winter Wind—Maine Coast,* 1941. Oil on canvas; 20 × 15 inches. The San Diego Museum of Art; Museum purchase with funds provided by the Gerald and Inez Grant Parker Foundation, 1973.134. Cat. 140.

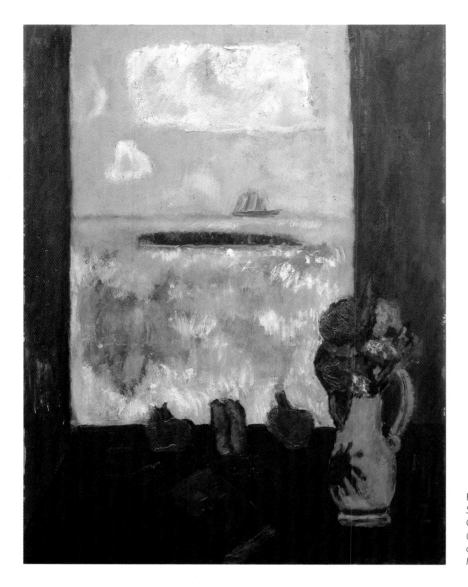

Fig. 16. Marsden Hartley (1877–1943).
Summer, Sea, Window, Red Curtain, 1942.
Oil on Masonite; 40⅛ × 30⅜ inches
(101.9 × 77.3 cm). Addison Gallery
of American Art, Phillips Academy;
Museum purchase, 1944.81.

one Hartley used quite frequently, most notably in the mate to the San Diego work, *Summer, Sea, Window, Red Curtains* (1942; Addison Gallery of American Art, Phillips Academy, Andover; fig. 16). In the winter version, the still life and the vestigial suggestions of an interior bring little comfort; indeed they seem to add to the gloominess and oppressiveness of the picture. The American environment is again all but purged of human presence, and the world beyond the window is quite alien to the human. For Hartley, that is the nature of the American environment: the grimmer, the more truthful.

Barely twenty years separate Hartley's dour seascape from Andy Warhol's *Liz Taylor Diptych* (1963), yet in that short space of time, American painting underwent as radical and dramatic a change as at any time in its history (fig. 17).[7] For Warhol, the figure or at least a famous face had a strong pull on his imagination. It is the face altered and simplified by reproduction, made vivid by mechanical means, from the electric blue eye shade to the raspberry red lips, framed by the jet black hair but always recognizable because of the fame, the celebrity of the sitter. Although Elizabeth Taylor fixes us with a provocative stare, we are hardly invited into the picture beyond reflecting on her Teflon, manufactured beauty. It is the impersonal portrait par excellence, standing on its head the traditional portrait of evocative insight.

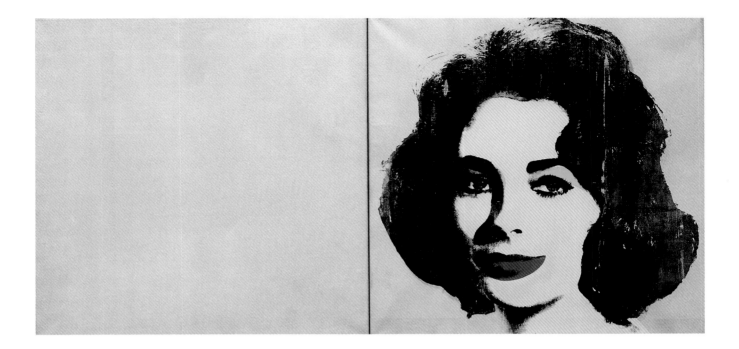

The scale of the head almost filling the forty-inch-square field furthers the feeling of un-intimate estrangement. It is public-poster size. The blank silver panel plays its part in the overall impersonal effect. It provides an anti-context, a non-environment in which the image of fame alone can survive, brilliantly and luminously as it does here. As much as O'Keeffe and Hartley, early Warhol proposes bleakness and blankness as the true conditions of the American environment—an antidote and riposte to the sentimentality and shysterism of the "American dream."

Fig. 17. Andy Warhol (1928–1987). *Liz Taylor Diptych,* 1963. Silkscreen ink, acrylic and spray paint on linen; 40 × 80 inches. Promised gift to the Museum of Contemporary Art San Diego.

NOTES

1. James Jackson Jarves complained that "they idealize in composition . . . so that, though the details of the scenery are substantially correct, the scene as a whole is often false." Quoted in G. Hendricks, *Albert Bierstadt Painter of the American West* (New York: Harry N. Abrams, 1988), 144.

2. Marianne Doezma, "Bellows on Monhegan," *Colby Quarterly* 39, no. 4 (2003): 393.

3. See Kathleen Adler, Erica E. Hirschler, H. Barbara Weinberg, *Americans in Paris, 1860–1900,* exh. cat. (New York: Metropolitan Museum of Art, 2006).

4. Quoted in D. Scott Atkinson, *William Merritt Chase: Summers at Shinnecock, 1891–1902,* exh. cat. (Washington, D.C.: National Gallery of Art, 1987), 20.

5. Jules David Prown, *American Painting from the Beginning to the Armory Show* (Geneva: Skira, 1969), 84.

6. Quoted in David Rosand, *The Invention of American Painting* (New York: Columbia University Press, 2004), 114.

7. This painting by Warhol is not represented in the exhibition, but represents a promised gift to the Museum of Contemporary Art San Diego.

Aggregate Nation:
The Evolution of
American Art in Three
San Diego Museums

ROBERT L. PINCUS

The history of any museum collection is a history of evolving taste, which emerges through conflict and consensus about what is of value, what endures. Bring together the American art holdings of three museums, as is the case with *Behold, America! Art of the United States from Three San Diego Museums* and you have a trio of discrete histories that represent this form of evolution or, to frame the discussion in visual terms, a triptych of histories that embody it. And since American art is the focus, there is, above all, an overarching story of the changing views of art made in the United States; this larger tale underpins the individual histories of the collections of the Museum of Contemporary Art San Diego, The San Diego Museum of Art, and the Timken Museum of Art.

You cannot delve into the story of these collections without discussing the evolving perceptions of American art and American culture that have pervaded the twentieth century and edged into the current one. Taken together, the history of collecting at these three institutions corresponds to the rising reputation of American art and burgeoning scholarship about it during this same era. The oldest of the three, The San Diego Museum of Art, opened in 1926, as the Fine Arts Gallery of San Diego, at a time when the American inferiority complex about its own art history was beginning to wane. The views of the German-trained, California-based art historian and painter Eugen Neuhaus and his once prominent book are typical and typically contradictory of his day. "With the last few decades American art has come into its own and has received merited attention not only abroad but also at home," he asserted in his well-received *The History and Ideals of American Art* (1931), "where many Americans are experiencing a new pride in the study of the history and achievements of the art of their own countrymen."[1] And true to that view, works by leading American artists were among those given to mark the inaugural year of the new venue: John Sloan's *Italian Procession, New York* (1913–25; cat. 168) and Robert Henri's *Bernadita* (1922; cat. 83). But Neuhaus's enthusiasm for American art, as it existed, was qualified; a truly original American art was a thing of the future, in his view. Or, as he put it,

"American art will develop its finest flower only if it looks forward and learns to follow, its own impulses . . . its own vision."[2]

Behold, America! reflects the different view that the history of American art, from the colonial era to the present, is an unquestionably important subject. And the increased appreciation of this history, during the course of the past ninety to one hundred years, is exemplified by the evolution of the collecting of American art at these three museums.

Chronologically speaking, the exhibition embraces the entire history of art in the United States. This cuts against the prevailing paradigm in museum display, which favors grouping American art, post-1945, with other recent work from everywhere else. In a literal sense, of course, all art made in the United States or made by American artists can be categorized as American art, but the time frame of this work, as museums have long presented it and scholarship has developed it, is not terribly straightforward. There is an underlying assumption that American art from the second half of the twentieth century and thereafter is primarily international, integrated into global trends, and only secondarily American.

This concept of categorization manifests itself within the display of collections at encyclopedic-style institutions like The San Diego Museum of Art. It does so as well in a selective small collection like that of the Timken Museum of Art, at least implicitly, since its holdings do not extend beyond 1900. The very concept of a contemporary art museum, of which the Museum of Contemporary Art San Diego is a seminal example, embodies this chronology, too, at least implicitly; its collection begins with art of the 1950s and does not generally place emphasis on American work as a category. However, mixing and reassembling the collections of these three institutions thematically in *Behold, America!* implies a continuum, from the eighteenth to the twenty-first century, and because it does, the exhibition and this catalogue let us see the works in each collection anew. Both the art and this publication encourage us to look for bonds between artists we might not, under different circumstances, expect them to share, to ask, for example, what a mid-nineteenth-century landscape and flower painter like Martin Johnson Heade might have in common with an iconic twentieth-century figure such as Georgia O'Keeffe, who is equally enamored with capturing the formal drama of a flower and a sense of place in her landscapes. Or what an eighteenth-century portraitist like John Singleton Copley could share with Salomón Huerta, a contemporary one.

When the Fine Arts Gallery of San Diego opened—it did not become The San Diego Museum of Art until 1978—varieties of American culture were already being looked at anew in a concerted way. Influential literary critic and cultural historian Van Wyck Brooks signaled that an era of reevaluation was beginning when he famously declared, in 1916, "Discover, invent a usable past we certainly can, and that is what a vital criticism always does."[3] Rediscovering American art was part of this effort to construct a path, to find a pattern within it that identified qualities from older work that could be useful in making things new, and to locate the living dimensions of an American tradition. It was an era in which the value of folk art and vernacular design gained serious appreciation and the astute cultural critic Constance Rourke found affinities between folk forms like the tall tale and literary works by

Henry James, Henry David Thoreau, and Walt Whitman in her groundbreaking study *American Humor: A Study of the National Character* (1931).[4]

The commitment to displaying American art in museums, however, grew through a slow and uneven process. One large barometer of the rising recognition of homegrown work was the founding of the Whitney Museum of American Art in 1930. (It opened a year later.) But museum support could still be grudging, and one indication was the Metropolitan Museum of Art's decision to decline Gertrude Vanderbilt Whitney's collection, which became the foundation of the Whitney Museum's collection.[5] It seems logical to speculate that there might never have been such a museum if the Metropolitan had accepted her generous offer.

The mind-set was not all that different in California and even lagged behind chronologically. It would be misleading to think, just because it received donations of American art to mark its opening, that such work was going to get a high profile in the Fine Arts Gallery. It was viewed as a "stepchild" until the 1940s, observes Martin Petersen, who served at The San Diego Museum of Art from 1957 to 1996 and for many of those years was its curator of American art. And when it began to be valued, that did not mean even prominent works would be on view. Knowing that the museum had Thomas Eakins's *Portrait of James Carroll Beckwith* (1904; fig. 18), Petersen wanted to hang it in the American art display. The painting ultimately surfaced in an obscure corner of the museum's storage area—and this was in the early 1960s.[6]

It is also worth noting that this painting came to the museum in 1937 through the efforts of a painter who is represented in the collection and in this exhibition, Alfred Mitchell. He was prominent in San Diego, particularly in the 1920s and 1930s. Mitchell was from Pennsylvania and trained at the Pennsylvania Academy of Fine Arts, where Eakins had long taught. He carried on a correspondence with Eakins's widow, Susan, and their rapport was the impetus for the gift of this portrait.[7] It is also useful to remember that artists often do not select and extol art for the same reasons that curators, museum directors, and arts historians do. Just where *Portrait of James Carroll Beckwith* fit into the history of Western art, of painting, of portraiture, or of realism, was surely less of a concern for Mitchell than the power with which Eakins practiced his craft as a portraitist. Fortunately, Mitchell's passion for this artist dovetailed with Eakins's place in history.

Nowadays, conventional curatorial wisdom is that Eakins is one of the most vital American painters of the nineteenth century: he is, in short, a canonized artist. But it is clear that his importance was not reflected in the storage room exile of his Beckwith portrait. And one of the most tantalizing aspects of *Behold, America!* is to see how each of the museums has come

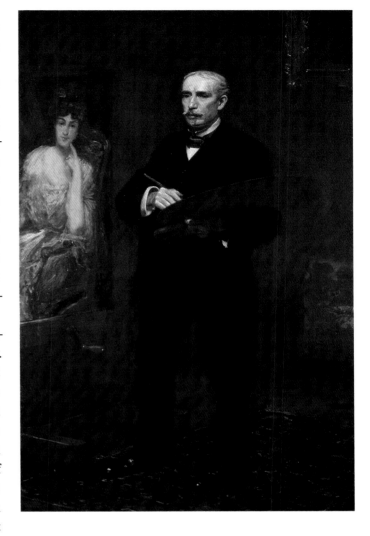

Fig. 18. Thomas Eakins (1844–1916). *Portrait of James Carroll Beckwith*, 1904. Oil on canvas; 83⅜ × 48⅛ inches. The San Diego Museum of Art; Gift of Mrs. Thomas Eakins, 1937.30. Cat. 76.

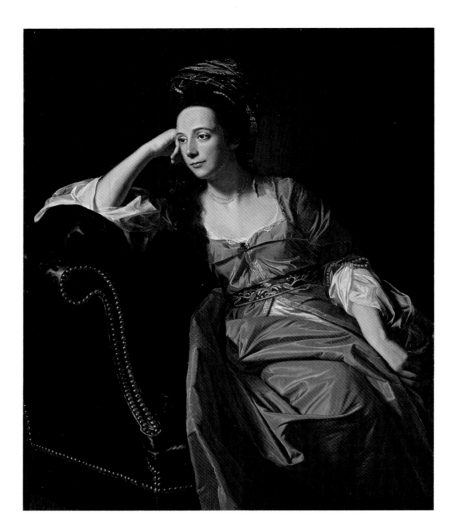

Fig. 19. John Singleton Copley (1738–1815). *Mrs. Thomas Gage*, 1771. Oil on canvas; 50 × 40 inches. Putnam Foundation Collection; Timken Museum of Art, 1984:001. Cat. 72.

to embrace and represent in different ways the broad contours of what we can call the American canon even as each has departed from it in an effort to embody regional as well as broader national history.

"All strong literary originality becomes canonical," wrote critic and literary theorist Harold Bloom. This statement is equally applicable to the visual arts. But at the same time, there is no reason to think that Eakins, though he was amply recognized in his lifetime, would have been valued as highly as he is now. Seeming strange in one's own time is a quality that often goes along with originality, Bloom adds.[8]

American art, as a whole, existed at a distinct disadvantage until the early twentieth century. Even as the American Revolution and the creation of a democratic republic inspired progressive political thinkers and leaders in Europe, South America, and elsewhere, the standard for art was far more conservative for a long time. Old World culture, particularly historical works, was most highly valued by collectors and connoisseurs alike, American ones as much as any others, throughout the nineteenth and at least the first half of the twentieth century; such works were the touchstones for American as well as European artists. In other words, political independence did not translate into cultural independence for American artists, collectors, or cultural institutions.

When greatness becomes recognized in an artist, as is true with numerous figures in *Behold, America!*, it is hard to return to the views of an era

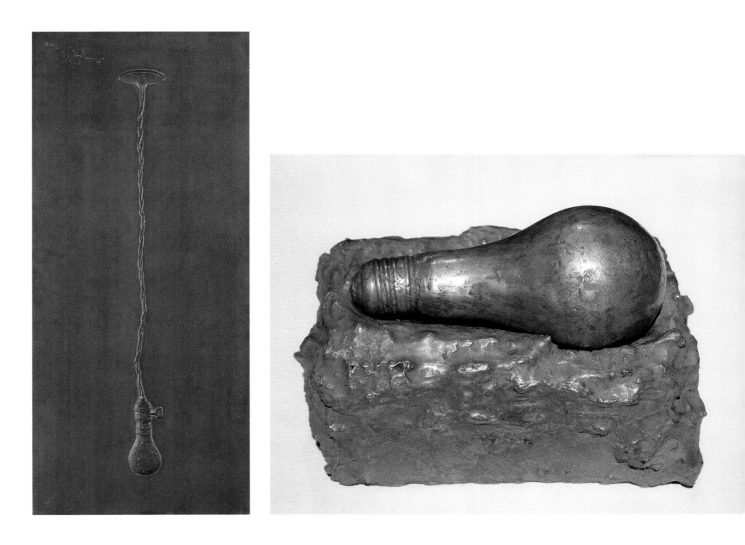

when this was not the case. Consider John Singleton Copley's portrait in the Timken's collection, *Mrs. Thomas Gage* (1771; fig. 19), arguably one of his stellar pictures from his colonial years. (Copley moved to England in 1774, to gain further training and transcend his "provincial" roots.) Oliver Larkin, in his widely read art historical text *Art and Life in America*, first published in 1949, writes, "The full measure of Copley's talent was in the first London portraits."[9] And yet critical consensus is now the opposite: Copley's American works are seen as far more original. Barbara Novak's influential book *American Painting of the Nineteenth Century*, first published in 1980, had a lot to do with that shift. In Copley's Boston years, he painted more crisply defined figures and objects as well as seamless surfaces that eliminated traces of the brushstroke. This style is valued over the more painterly work he did in England. In his earlier American phase, Copley exhibited, as Novak observed, "a rare ability to apprehend the hidden core of object reality."[10] Larkin had a keen eye for some nineteenth-century artists, but he saw Copley through the prism of British academic standards.

The conceptual realism that binds Copley to later artists such as Eakins creates a strong thread in American art. These and other artists of the nineteenth century strongly anticipate the intense focus on objects and symbols in Jasper Johns, evident in an important early sculpture such as *Light Bulb I* (1958; fig. 21) and a related wall relief made a decade later, *Light Bulb* (1969; fig. 20).[11] This is not a strain of heightened reality unique to American art;

Fig. 20. Jasper Johns (b. 1930). *Light Bulb*, 1969. Lead relief; 38¾ × 16⅞ inches. The San Diego Museum of Art; Gift of Mr. and Mrs. Norton S. Walbridge, 1991.14. Art © Jasper Johns/ Licensed by VAGA, New York, NY. Cat. 23.

Fig. 21. Jasper Johns (b. 1930). *Light Bulb I*, 1958. Sculp-metal; 4½ × 6¾ × 4½ inches. Museum of Contemporary Art San Diego; Gift of Mrs. Jack M. Farris, 2005.81.1–2. Art © Jasper Johns/ Licensed by VAGA, New York, NY. Cat. 22.

Fig. 22. Thomas Eakins (1844–1916). *Elizabeth with a Dog*, ca. 1871. Oil on canvas; 13¾ × 17 inches. The San Diego Museum of Art; Museum purchase and a gift from Mr. and Mrs. Edwin S. Larsen, 1969.76. Cat. 75.

Dutch masters such as Jan van Eyck worked in this way, as did the German artist Albrecht Dürer. However, this approach is pronounced in some American painters. Eakins's *Portrait of James Carroll Beckwith* is characteristic of the artist's method of making a portrait seem as if it contains only the essence of its subject. You feel as if you are viewing Beckwith thinking, locked inside the canvas as much as represented on it, parallel to the effect Copley achieves with Mrs. Gage. It is Eakins's version of representing the hidden core of reality. His realism heightens our sense of the real, making the physical appear imbued with a dimension of something larger, something so physically present that it appears virtually metaphysical. Even in the quasi-narrative domestic picture *Elizabeth with a Dog* (ca. 1871; fig. 22), this becomes true. The precision of the rendering gives the charm of the communication between girl and small dog a stately quality, all the more convincing for not being overly sentimental. And the structuring of areas of color—the brilliant red of Elizabeth's blouse offsetting the black of her skirt and of the dog, the elegant use of white in her hat—turns this painting into a thing of beauty, as much a figure study as a domestic genre scene.

Novak's major argument was that if we are to recognize the core virtues in particular American art, we have to see that it succeeded on its own terms, not by standards created in Italian, German, or British art. It has to be recognized for its own particular strain of strangeness. That did not mean being

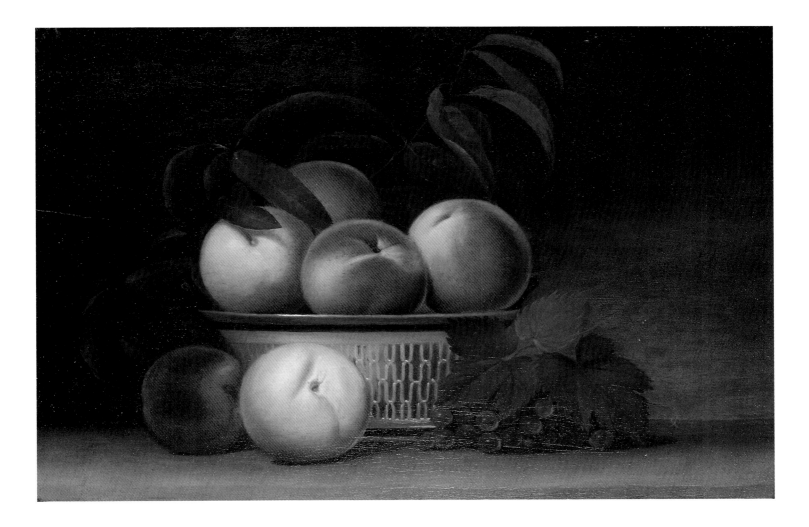

Fig. 23. Raphaelle Peale (1774–1825). *Still life with Peaches*, ca. 1816. Oil on panel; 13¼ × 20⅛ inches. The San Diego Museum of Art; Museum purchase through the Earle W. Grant Acquisition Fund, 1981.38.3. Cat. 42.

parochial or nationalistic but seeing how it took inspiration from history while departing from it. Clearly, Eakins's work was still strange by contemporaneous standards, even if it had its champions. One bit of concrete proof: only three museums owned his work when he died in 1916.[12]

Petersen's story of the Beckwith portrait is emblematic of the struggle to decide what place American art should occupy in The San Diego Museum of Art, a scenario that was true of American museums as a whole in the mid-twentieth century. To his credit, Reginald Poland, director of the museum from the time it opened its doors in 1926 until 1950, presided during a period of impressive gifts of American works. Those represented in *Behold, America!* make up a significant list; they include Eastman Johnson's noted genre painting *In the Hayloft* (ca. 1878; cat. 24), Eakins's Beckwith portrait, and Robert Gwathmey's striking, angular watercolor *Share Croppers* (ca. 1940; cat. 80). But the museum did not really have a robust acquisition program for American works until the early 1970s, when it gained the Earle W. Grant Acquisition Fund, allowing it to purchase a lovely Raphaelle Peale picture, *Still life with Peaches* (ca. 1816; fig. 23), for example, and when it received funds from the Gerald and Inez Grant Parker Foundation that it devoted to major pictures such as Asher B. Durand's *Landscape—Composition: In the Catskills* (1848; cat. 137). Acquisitions along these lines spanned the tenures of three directors—Warren Beach, Henry Gardiner,

and Steven Brezzo—especially those of the first two. It was an era when they could still take advantage of relatively modest prices for many American pictures.

The history of the Timken Museum of Art is intimately connected to that of The San Diego Museum of Art and to two of its vital patrons: Amy and Anne Putnam, sisters who shared a passion for the Old Masters and Russian icons. When they became disenchanted with Reginald Poland in the late 1940s and, by extension, The San Diego Museum of Art, they formed the Putnam Foundation in 1951, with the assistance of prominent local attorney Walter Ames, as an entity for works not gifted to the museum and others they wished to acquire. That collection, which the Putnam Foundation still owns, became the core holdings of the Timken Museum of Art, which opened in 1965 in Balboa Park. (Amy died in 1958, and Anne passed away in 1962.) The Putnams had no penchant for American art, and, at the outset, neither did Ames. But while overseeing the creation of the foundation and the opening of the museum, that interest emerged—along with Ames's decision to add American works to the collection—in a fairly organic way.

Ames, who guided the Timken from its opening until his death in 1980, was not any more interested in American pictures in the Foundation's early years than the Putnam sisters were. But he appeared to have a change of heart, at least partially, around the time that the Timken opened. The museum acquired Martin Johnson Heade's *The Magnolia Blossom* (1888; cat. 20) nine months before it opened to the public in October of 1965 and Albert Bierstadt's *Cho-looke, the Yosemite Fall* (1864; cat. 124) in 1966. He also borrowed additional paintings, Hudson River School landscapes, from artist and conservator Morton C. Bradley, who consulted briefly with both the Timken and The San Diego Museum of Art. The Putnam Foundation bought a pair of paintings from Bradley, Jasper F. Cropsey's *Apple Blossoms* (1887; fig. 24) and his *Fall Landscape: Autumn Lake* (1895), but only *Apple*

Fig. 24. Jasper Cropsey (1823–1900). *Apple Blossoms,* 1887. Oil on canvas laid on panel; 12⅛ × 21⅛ inches. Timken Museum of Art; Putnam Foundation Collection, 1978:002.

Blossoms remains in the collection. (Most of Bradley's holdings were given to the Indiana University Art Museum.)[13]

Being the kind of museum it is, a small one devoted to choice works by selected artists, the American works are few but exemplary. All represent artists who became part of the American canon as scholarship in the field has defined it. In the case of Copley's portrait, Fitz Henry Lane's *Castine Harbor and Town* (1851; cat. 151), and Eastman Johnson's *The Cranberry Harvest, Island of Nantucket* (1880; cat. 148), the examples are among each artist's luminous works. One can argue that the purchase of *The Cranberry Harvest* in 1972, for the then large sum of $400,000, marked a turning point for the Timken in its commitment to American art. The museum would then pay more for the Copley ($1.4 million) in 1984 and the Lane ($1.2 million) in 1986.[14]

Joining the collections of the Timken and The San Diego Museum of Art for this exhibition also provides a richer view of canonized artists than either museum could present on its own. Seeing Raphaelle Peale's *Still life with Peaches* (ca. 1816; cat. 42), from The San Diego Museum of Art, along with the Timken's Peale, *Cutlet and Vegetables* (1816; cat. 41) offers revealing context. Peale's perfect peaches are a much more pleasing subject, of course, but both paintings demonstrate his way of creating an elegant interplay between pronounced forms and background, illuminating the central objects in a way that makes them seem like archetypes of actual food—Platonic versions of everyday things. He, too, exhibits the American tendency to make the real appear conceptual. Having Johnson's *Woman Reading* (ca. 1874; fig. 25) in the same exhibition as his *The Cranberry Harvest, Island of Nantucket* underscores Johnson's way of strengthening the narrative dimension of a picture by imbuing the scene with a soft kind of light that makes the frozen moment seem as if it exists out of time, beyond the quotidian moment it depicts.

Fig. 25. Eastman Johnson (1824–1906). *Woman Reading,* ca. 1874. Oil on board; 25⅛ × 18⅝ inches. The San Diego Museum of Art; Gift of Gerald and Inez Grant Parker Foundation, 1977.9. Cat. 87.

An institution with encyclopedic ambitions for its collection, like The San Diego Museum of Art, inevitably has different criteria than the Timken, even within the scope of American art. An obvious point of departure is to represent post-1900 works, in which some artists are already canonized. Georgia O'Keeffe is one; Arthur Dove is another. But some artists are included in the collection because they represent regionalism in painting. Alfred Mitchell's *La Jolla Cove* (ca. 1950; cat. 154) displays obvious command of color and structure, but it is engaging more for its lovely evocation of place than for its place in the larger development of painterly realism. It deserves a place in the collection, but that is not enough to say it is part of an American canon. By 1950, when it was likely painted, Mitchell was a conservative

stylist, an artist of estimable skills with roots in early twentieth-century post-impressionism.

In the support and display of American art, the Museum of Contemporary Art San Diego plays a paradoxical role, quite different from those of institutions like The San Diego Museum of Art or the Timken. American art may not be exhibited as such in its galleries, and yet a large portion of its significant collection consists of works by American artists. The underlying assumption is that global trends trump national ones. This is not always true, but it is a bedrock concept in museums devoted to contemporary work. Solo exhibitions and thematic shows are more plentiful; so, too, are presentations devoted to a particular category of work such as street art, installations, or new video works.

The Museum of Contemporary Art San Diego opened its doors in 1941, as the La Jolla Art Center, and came of age as a collecting institution when it redefined its mission in 1964, was renamed the La Jolla Museum of Art, and, following the decision of its board, focused on art made since 1950. (It would change its name three more times, to the La Jolla Museum of Contemporary Art in 1971, the San Diego Museum of Contemporary Art in 1990, and the Museum of Contemporary Art San Diego in 1992.) Still, it had an earlier history as a broad showcase for art, a La Jolla counterpart to The San Diego Museum of Art. In that role, it never quite created an identity for its collection, but it did present some significant exhibitions. In the 1940s, a Thomas Eakins show from the Philadelphia Museum of Art marking the centennial of his birth appeared there. A decade or so later, the La Jolla Art Center hosted Edward Steichen's landmark showcase of photography *The Family of Man*, which the famed photographer assembled in his role as photography curator for the Museum of Modern Art. The La Jolla Art Center also co-organized (with the Los Angeles County Museum of Art) *Irving Gill Projects, 1895–1935*, devoted to the architect who designed the original structure, the home of Ellen Browning Scripps, on the museum's La Jolla site, as well as other innovative buildings in San Diego and beyond. In addition, the Art Center established a dynamic art school at which artists who would later gain much greater prominence, such as John Baldessari, Richard Allen Morris, and Guy Williams, taught courses. The La Jolla School of Arts and Crafts was short-lived, however; it opened in 1960 and closed in 1964.[15]

The collection of the Museum of Contemporary Art reflects its post-1964 identity; this differentiates it from the Timken Museum, which, as previously mentioned, collects no art newer than 1900, and separates it, too, from The San Diego Museum of Art, which acquires contemporary art as part of its encyclopedic sweep. Narrowing the panorama, it is safe to say that the museum has assembled a good number of works that have already become part of the history of American art. Just as *Mrs. Thomas Gage* (cat. 72) embodies the essence of what makes Copley a great portraitist for his time, *Red Blue Green* (1963; fig. 26) captures the essence of Ellsworth Kelly's significance as a painter. Kelly has the ability to make simple forms do complex things as they interact within a canvas and as they affect the viewer. And just as Copley's portraits looked strange by British standards of the late eighteenth century, Kelly's early paintings were a departure from the abstract

expressionist canvases being produced during his emerging years in the late 1950s.

It would be stretching the truth to call Kelly a conceptual artist, but his bedrock desire to take forms from the world and distill them is a conceptual approach, too. At its core, it is an effort to heighten our awareness of forms and objects, whether in paintings, sculptures, or drawings. His work evokes poet William Carlos Williams's famous line "No ideas but in things."[16]

You could say that conceptual art turns this notion on its head by turning ideas into things. No one did this more brilliantly than John Baldessari, as in *Composing on a Canvas* (1966–68; fig. 27). The text of the painting is composed of simple instructions on how to look at a "fairly uncomplicated picture." Of course the text on this subject has become the subject of this painting and is laid out in simple capital letters that were not painted by the artist; he paid a sign painter to make this and similar canvases for him. The artist gave this painting to the museum in 1970. Director Thomas Tibbs and curator Larry Urrutia were prescient enough to accept it, but no one could have known, four decades or so ago, that Baldessari's reputation would continue to rise until he is now seen as one of the most influential and important contemporary artists.

This points to the distinction between collecting at an institution that emphasizes current or recent art and at one that emphasizes historical work: the museum devoted to contemporary art is most often acquiring art by artists whose careers are unfolding and evolving. They might sustain their creativity and expand upon its promise, like Baldessari, or produce

Fig. 26. Ellsworth Kelly (b. 1923). *Red Blue Green*, 1963. Oil on canvas; 83⅝ × 135⅞ inches. Museum of Contemporary Art San Diego; Gift of Dr. and Mrs. Jack M. Farris, 1978.3. Cat. 26.

COMPOSING ON A CANVAS.

STUDY THE COMPOSITION OF PAINTINGS. ASK YOURSELF QUESTIONS WHEN STANDING IN FRONT OF A WELL COMPOSED PICTURE. WHAT FORMAT IS USED ? WHAT IS THE PROPORTION OF HEIGHT TO WIDTH ? WHAT IS THE CENTRAL OBJECT ? WHERE IS IT SITUATED ? HOW IS IT RELATED TO THE FORMAT ? WHAT ARE THE MAIN DIRECTIONAL FORCES ? THE MINOR ONES ? HOW ARE THE SHADES OF DARK AND LIGHT DISTRIBUTED ? WHERE ARE THE DARK SPOTS CONCENTRATED ? THE LIGHT SPOTS ? HOW ARE THE EDGES OF THE PICTURE DRAWN INTO THE PICTURE ITSELF ? ANSWER THESE QUESTIONS FOR YOURSELF WHILE LOOKING AT A FAIRLY UNCOM - PLICATED PICTURE.

Fig. 27. John Baldessari (b. 1931).
Composing on a Canvas, 1966–68.
Acrylic on canvas; 114 × 96 inches.
Museum of Contemporary Art San
Diego; Gift of the artist, 1970.11.
Cat. 4.

one significant body of work and fade. There is another dimension of the relationship between Baldessari, a native of the San Diego County town of National City, and the Museum of Contemporary Art San Diego that is worth stressing: his work spans the regional and the international. He did important work here, moved on to Los Angeles, and developed a significant reputation in Europe before Los Angeles and New York accepted him on a large scale. When the museum presented the exhibition *John Baldessari: National City* in 1996, it was to chronicle the breakthrough work that led to this larger recognition.

During the decades since 1969, when the museum defined its identity more clearly, the landscape for contemporary art has altered considerably—away from trends and movements to individuals, as the impetus for movements mostly faded away. Under Tibbs (1969–72) and Sebastian "Lefty" Adler (1973–83), the museum tended to acquire works that typified major trends such as pop, minimalism, and conceptual art. And many of the pivotal proponents of these currents were American. Many works by American artists acquired during that time have become touchstones of the collection. Andy Warhol's send-up of nature studies, *Flowers* (1967; cat. 60), and Claes Oldenburg's unnervingly fleshy sculpture, *Alphabet/Good Humor* (1975; cat. 37), are powerful pop works, and Sol LeWitt's complex grid-and-cube structure in painted wood, *Floorpiece #4* (1976; cat. 27), is, like Baldessari's word paintings, a pivotal conceptual work.

Dr. Hugh M. Davies, director of the Museum of Contemporary Art San Diego since 1983, has broadened the scope of the collection dramatically, even as he strengthened its holdings in major California artists. The museum has acquired a reputation as one of the major repositories of what has come to be called light and space art—a point highlighted in a major way by its recent landmark exhibition *Phenomenal: California Light, Space, Surface* (2011). Increasingly, these artists seem sure to have a larger place in the American canon: Robert Irwin, James Turrell, Maria Nordman, Helen Pashgian (fig. 28), Eric Orr, Mary Corse, and Doug Wheeler are major figures in this group and works by Irwin and Pashgian are in *Behold, America!* Irwin's major piece, *1°2°3°4°* (1997; cat. 145), is inseparable from its setting in the museum's La Jolla site, which connects nature with architecture, framing ocean and sky by setting up a vista in which apertures cut from a three-sided expanse of window and tinted glass frame these openings as changing views of the world. It is experiential in a sensory way that a painting cannot be, but there is a palpable link to earlier American pictures that evoke light as a metaphysical as well as a physical presence; in *Behold, America!*, there are extremely eloquent examples, with Lane's *Castine Harbor and Town* (cat. 151) and George Inness's

Fig. 28. Helen Pashgian (b. 1934). *untitled*, 1968. Cast polyester resin; 8 inches diameter, overall dimensions variable. Museum of Contemporary Art San Diego; Museum purchase, International Contemporary Collectors Fund, 2011.50. Cat. 40.

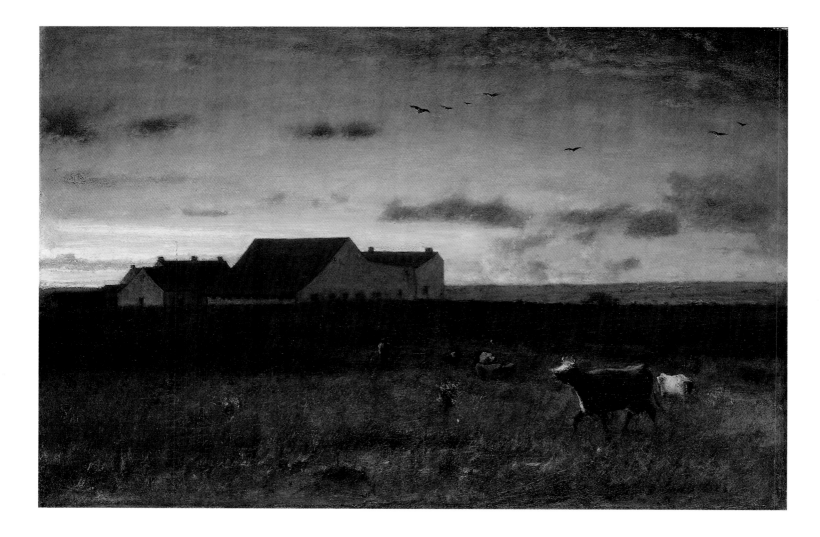

Fig. 29. George Inness (1825-1894). *Farm Landscape, Cattle in Pasture—Sunset Nantucket*, ca. 1883. Oil on panel; 20 × 30 inches. The San Diego Museum of Art; Bequest of Mrs. Henry A. Everett, 1938.31. Cat. 144.

Farm Landscape, Cattle in Pasture—Sunset Nantucket (ca. 1883; fig. 29) prime among them.

Another accomplishment of the Museum of Contemporary Art San Diego, since the early 1980s, has been to collect large-scale installations and sculptures as well as to represent the binational character of the region. Considered as a whole, the collection demonstrates the rich multiplicity of passions in American art, from the formal to the psychological to the social. Its heterogeneity allows the viewer to discover numerous threads that connect recent art to older work. In portraiture, for example, the theatricality of *Mrs. Thomas Gage*—the Turkish robe she wore for her sitting was a costume, after all—finds echoes in a pair of untitled images by Cindy Sherman: a 1984 black-and-white photograph in which she wears a brittle smile and a quietly malevolent expression and a second color image, dating from 2000, in which she sports a hideous running jacket, artificial-looking tan, and a blonde wig (figs. 30–31). These images, like Copley's portraits, are likely to endure because they do seem persistently mysterious.

Among paintings with a single figure, there are studies in contrast. The woman in Johnson's *Woman Reading* (cat. 87) may be turned away from us, but that is because he is presenting the illusion that she is unaware of the painter or the viewer, strolling or standing by the shore, lost in her book. The man in Salomón Huerta's *Untitled Figure* (2000; cat. 86), presumably but not necessarily the artist, lets you know he is aware of the viewer. He is seated

56

and deliberately has his back to us, as if to say he knows that portraits or self-portraits imply a presentation of character, even as the artist chooses to resist this idea. He rejects self-revelation, and yet his antirevelatory stance is revelatory in its way, because it slyly suggests that some viewers would be prone to categorizing him instead of seeing him as an individual.

Walt Whitman spoke about the one and the many as part of his vision of a democratic American culture, of the virtues of "a great aggregate Nation," a kind of democratic mosaic. But as he was also to write in "A Backward Glance O'er Travel'd Roads," a kind of summing-up of his career as both poet and champion of democratic culture, it was just as important for the United States to produce "myriads of fully develop'd and enclosing individuals."[17] The difficulty in America, he realized, was to have a balance between the many and the one. Huerta's portrait speaks to that problem and paradox, with its "no" to being categorized. So, too, does James Luna's trio of black-and-white photographs taken by Richard A. Lou, *Half Indian/Half Mexican* (1991; cat. 93), in which he looks neither and both.

Taking in the full sweep of American art, it is not hard to detect a scaling back of the grand hopes that Emerson and Whitman expressed for the United States and that landscape painters like Lane and Durand captured. The prevailing mood of the landscape painter in the nineteenth century was buoyant. People are small and the scene picturesque and inviting in a painting like Durand's *Landscape—Composition: In the Catskills* (cat. 137). The

Fig. 30. Cindy Sherman (b. 1954). *Untitled,* 1975. Gelatin silver print, edition 43/125; 17 × 14 inches. Museum of Contemporary Art San Diego; Museum purchase, 1984.5. Cat. 105.

Fig. 31. Cindy Sherman (b. 1954). *Untitled,* 2000. Color photograph, edition 2/6; 36 × 24 inches. Museum of Contemporary Art San Diego; Museum Purchase, International and Contemporary Collectors Fund, 2001.12. Cat. 106.

Fig. 32. Mark Dion (b. 1961). *Landfill*, 1999–2000. Mixed media; 71½ × 147½ × 64 inches. Museum of Contemporary Art San Diego; Museum purchase, Contemporary Collectors Fund, 2000.4. Cat. 133.

vista is wide, stretching into the distance and bathed in light. This mood could be sustained into the early twentieth century, in Romantic paintings along the lines of *Apache Land* (1915; cat. 134) by Maynard Dixon, but in depictions of the physical landscape, realities of greater population and crowded terrain intervene. Mark Dion's three-dimensional diorama *Landfill* (1999–2000; fig. 32), made during the artist's residency at the museum, presents a scene crammed with all manner of garbage. Only rats and seagulls seem to thrive. This work, which owes much to the displays in natural history museums, is not meant to be an end point in the dialogue about the American landscape but is instead cautionary realism about how individual freedom can create unwanted consequences for everyone. Even if the recent works in the exhibition are more sobering, the notion that current American artists are producing works as persuasive as historical figures is uplifting. Even in a highly mechanized and regulated society, far more so than Whitman could have ever imagined, his hope for an America of fulfilled individuals still resonates in contemporary art. This is one big thing that an exhibition that takes in the full sweep of American art can reveal in all its multiplicity.

1. Eugen Neuhaus, *The History and Ideals of American Art* (Stanford, CA: Stanford University Press, 1931), vii.

2. Ibid., 425.

3. Claire Sprague, ed., *Van Wyck Brooks: The Early Years* (New York: Harper & Row, 1968), 223. The essay in which Brooks introduces his famous statement, "On Creating a Usable Past," was first published in *Dial* in April 1918.

4. Constance Rourke, *American Humor: A Study of the National Character* (1931; New York: New York Review of Books, 2004).

5. Maxwell Anderson, "The Artists' Museum," *American Visionaries: Selections from the Whitney Museum of American Art*, exh. cat. (New York: Harry N. Abrams, 2001), 6–23.

6. Martin Petersen, telephone interview with the author, January 2, 2012.

7. Martin Petersen, *Catalog of American Painting* (San Diego: San Diego Museum of Art, 1981), 12–13.

8. Harold Bloom, *The Western Canon: The Books and School of the Ages* (New York: Harcourt, Brace & Company, 1994), 25–26.

9. Oliver W. Larkin, *Art and Life in America*, rev. ed. (New York: Holt, Rinehart and Winston, 1960), 66.

10. Barbara Novak, *American Painting of the 19th Century: Realism, Idealism and the American Experience* (Oxford: Oxford University Press, 2007), 14.

11. See Hugh M. Davies, Stephanie Hanor, and Mark Lancaster, *Jasper Johns: Light Bulb*, exh. cat. (La Jolla, CA: Museum of Contemporary Art San Diego, 2008).

12. See Larkin, *Art and Life in America*, 277.

13. Nancy Petersen, telephone interview with the author, January 5, 2012.

14. Robert L. Pincus, "Collecting Gems: Nothing but the Finest for Timken Art Gallery," *San Diego Union*, April 29, 1990, E-8.

15. See Ronald J. Onorato, *San Diego Museum of Contemporary Art: Selections from the Permanent Collection*, exh. cat. (La Jolla, CA: San Diego Museum of Contemporary Art, 1990), 10–11. See also Hugh M. Davies and Anne Farrell, *Learning from La Jolla: Robert Venturi Remakes a Museum in the Precinct of Irving Gill*, exh. cat. (La Jolla, CA: Museum of Contemporary Art San Diego, 1996).

16. William Carlos Williams, *Paterson* (New York: New Directions Books, 1963), 9.

17. Justin Kaplan, ed., *Walt Whitman: Poetry and Prose* (New York: The Library of America, 1996), 668.

American Art, Museum Exhibitions, and National Identity: Problems and Promises

FRANCES K. POHL

Organizing a survey exhibition of American art like *Behold, America! Art of the United States from Three San Diego Museums* is much like writing a textbook on the same subject.[1] Selections must be made from a vast array of objects, themes must be determined in order to make sense of these objects, and cost factors must be taken into consideration. New ideas must be merged with standard narratives in order to make the end product both challenging and legible, and political minefields must be navigated within a field that is often claimed by the American public at large, from local schoolteachers and construction workers to religious leaders and congressional representatives, as its own.

Survey exhibitions or textbooks treating American art inevitably prompt questions regarding citizenship and national identity, or what it means to be "American." This is particularly true if the exhibition or book has received funding from state or federal governments and/or appears at a time of political or economic crisis. Political discourse—in the twentieth century ranging from the Red Scare of the post–World War I era and the New Deal of the 1930s to the Cold War of the post–World War II era and the more recent War on Terror—has inevitably left its mark on cultural production of all sorts, just as cultural production has contributed to the shape of this discourse.[2]

The success or failure of survey exhibitions of American art depends, therefore, on both curatorial decisions and the political, economic, and social climate. While public responses can never be predicted with certainty, they can be anticipated by looking back to earlier instances when such exhibitions have raised the ire—or drawn the praise—of art critics, professional and amateur alike. This essay will examine two such earlier survey exhibitions of American art. The first, *The West as America: Reinterpreting Images of the Frontier, 1820–1920,* opened in the summer of 1991 at the National Museum of American Art in Washington, D.C. (now the Smithsonian American Art Museum), while the second, *American Stories: Paintings of Everyday Life, 1765–1915,* opened in the fall of 2009 at the Metropolitan Museum of Art in New York and in February 2010 at the Los Angeles County

Museum of Art. The first created considerable controversy; the second did not. Yet each provides valuable insight into what happens when cultural institutions attempt to reconfigure traditional narratives of national identity.

American Art at the Beginning of the Twenty-First Century
American art is particularly well poised today to contribute to the formation of a new discourse on citizenship and nationhood, for the past decade has seen increased attention to such art by many of our major cultural institutions. In a 2009 article in the *Los Angeles Times* entitled "U.S. Museums Look Homeward," art critic Suzanne Muchnic comments on the growing number of art institutions in the United States spotlighting the work of American artists before 1945.[3] Post-1945 American art has occupied a prominent place in both American and international museums for several decades (primarily as "modern" or "contemporary" art rather than "American" art), but not so the art produced in an earlier era. "Long the stepchild of a Eurocentric art world," writes Muchnic, "American art is finding new favor at home as a growing number of institutions showcase work from Colonial times to World War II."[4] This new favor is evidenced in the opening of the newly renovated Smithsonian American Art Museum, as well as new or refurbished American art wings at the Huntington Library, Art Collections, and Botanical Gardens in San Marino, California; the Metropolitan Museum of Art in New York; the Nelson-Atkins Museum of Art in Kansas City; the Cleveland Museum of Art; the Detroit Institute of Arts; the Virginia Museum of Fine Arts in Richmond; and the Museum of Fine Arts, Boston. In addition, Walmart heiress Alice Walton's new museum of American art, Crystal Bridges, in Bentonville, Arkansas, highlights iconic pre-1945 works such as Asher B. Durand's *Kindred Spirits* (1849). Publications and conferences on pre-1945 American art have also seen a considerable increase in the past few decades, as have challenges to the pre-/post-1945 divide itself.[5]

Muchnic suggests that this new interest in American art in the first decade of the twenty-first century can be attributed to at least three factors: "a national coming of age, a thirst for new artistic territory and a critical mass of American material that has made its way from private home to public museums."[6] The market for early American art has also escalated, with Walton paying $35 million for Durand's *Kindred Spirits*.[7] And while many of the building expansions were planned in the 1990s, the heightened sense of patriotism after the destruction of the World Trade Center towers and attack on the Pentagon on September 11, 2001, by radical Islamists certainly contributed to the urge to celebrate American cultural accomplishments.[8]

Andrew Walker, director of the Amon Carter Museum in Fort Worth, Texas, and former curator of American art at the Saint Louis Art Museum points to another possible reason for the dramatic increase in new and renovated American art museums or wings: the "Bilbao effect." "The opening of Frank Gehry's Guggenheim Museum Bilbao in 1997," writes Walker, "seemed to transform that city's cultural status overnight, luring tourists and opening doors to sustainable economic development. Could this be the fix to what ailed so many cities?"[9]

Such building projects, however, were not solely the result of their potential economic ramifications. Rather, notes Walker, they grew out of a

reevaluation of the field of American art that has been taking place over the past thirty years. Such a reevaluation led to the emergence of "a more diverse story . . . of how works of art were created for and circulated through social networks."[10] Much of this new scholarship was produced by art historians working within museums as curators and directors, and so it is no surprise that they began to reenvision their galleries in order to accommodate the more diverse stories this scholarship produced. For example, many installations of American art are presenting a more self-conscious examination of the connections between art and nationalism. Sylvia Yount, curator of American art at the Virginia Museum of Fine Arts (VMFA), notes in a discussion of the museum's McGlothlin Galleries of American Art:

> Unsurprisingly, the backstory to American art's heightened profile at VMFA is rooted in acts of individual philanthropy and cultural nationalism, twin engines that have propelled its standing since the museum's founding seventy-four years ago. Yet this has been checked at times by a wariness of provincialism, perhaps resulting from the commonwealth's and Richmond's complex legacy—that is, its colonial and Confederate pasts (reflected in the museum's Georgian revival façade situated on the grounds of a Civil War soldier's home).[11]

Another example of a more complex story can be found at both the Museum of Fine Arts, Boston, and the Los Angeles County Museum of Art, where newly installed collections of art made in the United States have been reconfigured within new Art of the Americas wings. Elliot Bostwick Davis of the Museum of Fine Arts, Boston, writes: "The museum's historic strengths—seventeenth-century decorative arts and paintings created in the Anglo-American colonies of North America and the art of the United States produced after the American Revolution and through the later nineteenth century—will appear within a far broader context that embraces the art of the indigenous ancient and Native Americans as well as Spanish colonial and Latin American art."[12] At the same time, The Art Institute of Chicago has taken a continental approach, combining twentieth-century U.S., Mexican, and Canadian art.

This continental or hemispheric vision of an art of the Americas has been encouraged by an inevitable mix of academic, political, and economic concerns. Since the signing of the North American Free Trade Agreement (NAFTA) in 1994, the economies of Canada, the United States, and Mexico have been more closely aligned, causing many scholars to speculate on the impact this economic alignment has had, and will have, on cultural developments in all three countries.[13] This alignment is not unprecedented, however, and has its origins in a shared colonial past and in long-standing tensions over political borders and natural resources. As Caroline Levander and Robert Levine write in the introduction to their 2008 anthology *Hemispheric American Studies*, "moving beyond the nation does not mean abandoning the idea of nation but rather recognizing its dynamic elements and fluid, ever-changing, essentially contingent nature."[14]

Increased attention has also been paid in the past few decades to attracting a broader audience to museums. In the case of American collections, this

effort has inevitably felt the impact of debates about the nature and value of education. What came to be known as the "culture wars" of the 1980s and 1990s were informed by the political upheavals of the 1960s and 1970s—the civil rights, women's rights, and antiwar movements—which led scholars to rethink and rewrite the American history curriculum for elementary and high schools so that it would include the voices and experiences of previously marginalized groups.[15] Despite resistance from defenders of the status quo, the curriculum did change, and museums played an active role in these changes, reconfiguring their collections and educational programming and engaging in concerted efforts to make their institutions more accessible to a broader audience (more will be said about this later). As Walker writes: "The specific achievements of Saint Louis's first phase are not as important as the implication: by making the permanent collection an institutional priority, art museums are able to extend their programs to reach broader and new audiences. . . . In fact, the trend to present American art with a rigorous approach and accessibility to broader audiences is characteristic of the larger museum expansion movement to reinvigorate art museum relevance in the twenty-first century."[16]

Yet attracting broader audiences often results in controversy, as the new stories museums try to tell meet with criticism from audiences, both old and new, as unnecessary, distorted, or insufficient.[17] Controversies, however, are not necessarily bad. In fact, one might argue, as does art historian and curator Jonathan D. Katz, that controversies are what often fuel the educational process itself. Speaking on a public panel on April 26, 2011, entitled "Flashpoints and Fault Lines: Museum Curation and Controversy," Katz noted: "Museums are places where controversies can be intelligently examined by informed scholars and, indeed, that's what museums should be. . . . They are also sites of teaching and of learning, where we can begin to engage a process of social change, where instead of punditry, we have history, scholarship and thought, and in our national museums that should happen most of all."[18]

The West as America

The literature on the exhibition *The West as America* and the controversy it generated is extensive.[19] A helpful summary and commentary can be found in "The Battle over 'The West as America,'" a 1994 essay by art historian Allan Wallach.[20] Wallach notes that it is more difficult to challenge the myths of nationhood in a museum than in an academic classroom because such challenges "[strike] at the very heart of the museum's traditional function, its capacity, in Walter Benjamin's words, to produce 'an eternal image of the past.'"[21] Any straying from this function, any attempt to burst the bubble of this eternal image, is bound to meet with resistance, from both funders and the public at large.

The West as America, which opened on March 15, 1991, set out to challenge the ideology of Manifest Destiny (the God-given right of white Europeans to conquer and colonize the Americas in the name of Christianity), which European settlers used to celebrate and justify westward expansion. It argued that the visual arts played a crucial role, along with military might, in the conquering of the West. The opening room of the exhibition, titled "Prelude to Expansion: Repainting the Past," contained monumental, melodramatic

canvases, such as *The Storming of the Teocalli* (1848) by Emanuel Leutze (fig. 33), that "set the rhetorical stage for westward expansion."[22] In order to bring home this message of the West as a cultural construction, the final room, "'Doing the Old America': The Image of the American West, 1880–1920," contained an enlargement of a 1903 photograph of the painter Charles Schreyvogel on the roof of his apartment in Hoboken, New Jersey, painting a kneeling male figure dressed in a cowboy costume.

The organizers of the exhibition, while certainly anticipating controversy, were not prepared for the intensity of the criticism because, according to Wallach, they failed to fully understand the problems inherent in issuing such a critique in a museum context, and in particular in a federally funded museum. Despite the fact that the exhibition's subtitle, *Reinterpreting Images of the Frontier*, pointed to its critical intent, visitors were still shocked by the bold challenges contained in the wall labels accompanying the 164 paintings, prints, sculpture, watercolors, and photographs. A columnist for the *Wall Street Journal* captured the sentiments of many: "Only in the land of the free, of course, is it possible to mount an entirely hostile ideological assault on the nation's founding and history, to recast that history in the most distorted terms—and have the taxpayers foot the bill."[23] National museums are particularly invested, in the minds of their government funders if not their directors and curators, in the creation of a celebratory image of

Fig. 33. Emanuel Gottlieb Leutze (1816–68). *The Storming of Teocalli by Cortez and His Troops*, 1848. Oil on canvas; 84¾ × 98¾ inches. Wadsworth Atheneum Museum of Art; The Ella Gallup Sumner and Mary Catlin Sumner Collection Fund, 1985.7.

the past. They are key cultural organizations in the creation of the values and truths upon which citizenship and patriotism are based.[24] Thus, their interpretations of the past must not dwell on the contradictions of founding a democratic and freedom-loving nation through violence, slavery, and genocide. In addition, while historical documents might contain such facts, works of art, still seen to this day as somehow invested with special insight, if not universal moral value, should not.

What created the most controversy were not the images themselves or their arrangement but the wall labels that accompanied them. As the art historian Bryan Wolf points out in a review of the exhibition: "The settling of the West blurs with the selling of the West; the conquest of native cultures merges with the conquering power of culture itself; and an exhibition of paintings, in themselves uncontroversial, translates into a wordy array of wall labels. There is something here to offend everyone...."[25]

These labels were described variously at the time as talking down to the audience, inaccurate, and destructive. They troubled not only those who wanted to maintain the myth of Manifest Destiny but also those who wanted to call it into question and who looked to works of art as factual records of what had happened in the past. Many of the labels argued that the content of the paintings, prints, and sculptures on display—such as battles between settlers and Native Americans—were symbolic statements of broader socioeconomic or political battles rather than literal accounts.[26]

Political battles did, in fact, inform the reception of *The West as America*. In February 1991, the United States claimed its first major military victory since its defeat in Vietnam in the mid-1970s by forcing the troops of Iraqi president Saddam Hussein to withdraw from Kuwait. "In an atmosphere of super-charged patriotism," writes Wallach, "the exhibition's critical assessment of Manifest Destiny and related expansionist myths seemed downright subversive to those celebrating the demise of the 'Vietnam syndrome.'"[27]

The victory in the Middle East also occurred the same year as the collapse of the Soviet Union. This collapse was seen by many politicians and members of the general public as a much broader victory—that of capitalism over Communism. Such a victory created even more reason to celebrate America's distinctive history. Capitalism's ascendency also served to further strengthen attacks on government funding for the arts, in particular those arts that raised critical questions about the U.S. government's actions at home or abroad, or about sexual or religious norms.[28] The National Endowment for the Arts (NEA) was founded in 1965 during the Cold War as part of an effort to prove how much more freedom of thought and imagination was available to artists in the United States as opposed to those in the Soviet Union. With the fall of the latter nation, many argued that artists should now "sink or swim" in the marketplace, rather than rely on "government handouts."[29]

In addition, the early 1990s witnessed the intensification of the culture wars, in battles over the content and interpretation not only of museum exhibitions but of school curricula from kindergarten through postsecondary education. In the months immediately before the opening of *The West as America*, articles appeared in national magazines and newspapers with titles such as "The Storm over the University," "Opening Academia without

Closing It Down," and "Taking Offense—Is This the New Enlightenment on Campus or the New McCarthyism?"[30] Such articles appeared with even greater frequency throughout 1991—"Multiculturalism and Its Discontents: The New Word Order," "Western Values Are Central," "Fear of the M Word" (the M word was "multiculturalism"), and "Politically Correct Is Politically Suspect."[31] Political conservatives claimed that political correctness and multiculturalism were stifling the free exchange of ideas, while political liberals argued the opposite.

These debates were even further exacerbated by national preparations for the celebration of the quincentenary of the arrival of Christopher Columbus in the Americas. In the article "Goodbye, Columbus?" published in *ARTnews* in October 1991, Robin Cembalest articulates this connection between the revisionary unrest in museums and schoolrooms and the "discovery" of America, noting that "textbooks are being rewritten and the story has gotten more complicated. The word 'discovery' is gone, and so is the idea that Native Americans were 'primitive.' . . . Just how 'multicultural' textbooks should become is a matter of debate, but there is a growing consensus that they should reflect the cultural diversity of their readers."[32]

And these readers were increasingly nonwhite. In 1990 Los Angeles, one of the most racially and ethnically diverse cities in the country, 38 percent of the population was white, 36 percent Latino/a, 15 percent African American, and 12 percent Asian American.[33] Cembalest writes that while textbook authors were attempting to accommodate these new demographics, the same could not be said of those in charge of the city's museums. According to a recent study by the Los Angeles Chamber of Commerce, 93 percent of local museum visitors were Anglo.

Various efforts were under way in the early 1990s, however, to rectify this situation. Public and private museums across the country were planning numerous exhibitions of contemporary art by African Americans, Asian Americans, Latino/as, and Native Americans. The Mexican artist Guillermo Gómez-Peña, who split his time between Mexico and the United States, summarized the goals of many artists and curators: "We're creating a new chronicle of the discovery—a chronicle that is less euphemistic and less triumphant."[34] The Smithsonian Institution, however, was treading more carefully. The exhibition *Circa 1492: Art in the Age of Exploration*, which opened at the National Gallery of Art in the same month as the publication of Cembalest's article, was divided into three sections: Europe and the Mediterranean world, the Americas, and eastern Asia. Each section, explained Jay Levenson, the exhibition's managing curator, would "stand on its own legs, avoiding at all costs looking at it as Europeans did in the 15th century."[35] Such an arrangement would also avoid the need to confront the problem of interpreting what happened when these three worlds came together on the North American continent.

The National Museum of American Art waded into this stream of controversy with its *The West as America* exhibition. Its organizers tackled the question of diversity at its most sensitive point—in this country's founding narratives. As Wolf writes of the exhibition: "It seeks out ghosts of intention never meant to meet the public gaze. It peers beneath the surface, into the depths, under the stairways and around the corner. It approaches history

from the servants' quarters rather than the grand entrance way, not because the exhibition concerns itself with the social history of everyday people, but because it mistrusts the master's language."[36]

The museum could not have foreseen the Gulf War and its influence on the public's willingness to engage in a critical reconsideration of the history of the American West and of the role of the visual arts in that history. Yet the Gulf War was not the sole cause of the exhibition's problems. It failed, according to Wallach, in its attempt to create a productive critical dialogue largely because, while it took on the master narratives of nineteenth-century American history, it was unable to challenge effectively the "traditional, hegemonic voice" of the museum itself.[37] The general public had been taught "to approach the museum with a sense of reverence, to anticipate that at the museum they will encounter once again The Vindication of Art" through the presentation of "timelessness and universality."[38] The curator of *The West as America*, William H. Truettner, and those who helped write the wall text "tried to adapt to [their] own purposes the museum's traditional hegemonic voice" rather than engaging the public in a more complex dialogue about the present and the past. What was it that convinced so many nineteenth-century Americans that Native Americans were lesser beings? What gave the political and religious tracts and images that present this argument such weight in people's lives? Why were they able to naturalize such an argument, to discredit those voices who argued differently? Where did those oppositional voices appear? The inclusion of evidence of such voices, whether through newspaper accounts or political cartoons, would have helped the exhibition's viewers gain "a greater sense of an interplay of rhetorics, or the clash of antagonistic discourses"[39] that inevitably make up any historical moment and that heighten the relevance of such moments to our lives in the present. Diverse voices would also have helped reveal the exhibition audience's political, emotional, and economic stakes in maintaining or challenging the central narrative conveyed so insistently in the wall labels.

Diverse voices did, in fact, appear within the museum, but not in its artworks, wall labels, or supplementary materials. They appeared, instead, in the comment books provided by the museum. According to art historian Andrew Gulliford,

> "The West As America" struck its audience viscerally. Visitors stood single file for up to twenty minutes to record their comments, which filled four comment books and ranged from ecstatic praise to outraged condemnation. Not only did visitors engage in personal dialogues with the exhibit curators and the Smithsonian Institution, but through dynamic, impromptu discourse, they also argued or agreed with other visitors who had written previous entries in the comment books. . . . The books served as forums for lively debates on ethnicity, Native Americans, politics, museum funding, censorship, and political opportunism in both the nineteenth and twentieth centuries. . . .[40]

This diversity of voices was enhanced in part through public condemnations of the exhibition that circulated in the national press. As is so often the case, controversy creates curiosity, and the national publicity garnered by

the exhibition, particularly after Republican senators Ted Stevens (Alaska) and Slade Gorton (Washington) threatened to investigate the Smithsonian in the Senate appropriations committee, brought people flocking to the museum. According to Gulliford, "because the controversial exhibit generated national publicity, visitors went in record numbers. In April and May 1991, attendance at the National Museum of American Art almost doubled from 98,000 to 173,000 visitors, and by the last week of the exhibit all 2,500 softcover copies of the exhibit catalog had been sold or distributed."[41] While the controversy was at least partly responsible for the decision to abandon plans to send the exhibition to Denver and Saint Louis,[42] without this controversy, and the critical wall text that spawned it, the works in *The West as America* may well have been viewed by fewer individuals and primarily within the triumphalist rhetoric of military victory.

American Stories: Paintings of Everyday Life, 1765–1913

At the end of his review of *The West as America*, Bryan Wolf noted "the pay-off, both historical and art historical, awaiting curators and museums intrepid enough to venture beyond aesthetics alone."[43] Many museums have, indeed, followed in the footsteps of the National Museum of American Art over the past twenty years, organizing exhibitions that both complicate and clarify this country's history and the visual methods used to portray it. Many have also learned from the controversy surrounding the exhibition's wall text and have either moderated the tone or minimized the amount of information accompanying the works of art, often leaving the more trenchant critiques for exhibition catalogues.[44]

Visitor responses to exhibitions of American art have also continued to be influenced by the legacy of the culture wars, and the exhibitions most vulnerable to attack continue to be those receiving federal funding. For example, *Hide/Seek: Difference and Desire in American Portraiture*, cocurated by Jonathan D. Katz and David Ward, opened in October 2010 at the Smithsonian's National Portrait Gallery and soon created a storm of controversy. The focus of the controversy was not the works dealing with homosexuality and lesbianism or the wall text but a short segment in David Wojnarowicz's video *A Fire in My Belly* portraying ants crawling on a crucifix. The video was the focus of an article, "Smithsonian Christmas-Season Exhibit Features Ant-Covered Jesus, Naked Brothers Kissing, Genitalia, and Ellen DeGeneres Grabbing Her Breasts," which appeared on the website of the conservative CNS News. This article prompted the Catholic League's president Bill Donohue to call the video anti-Christian "hate speech" and Speaker of the House John Boehner and Majority Leader Eric Cantor, both Republicans, to threaten to cut the Smithsonian's budget and shut down the exhibition. The secretary of the Smithsonian, G. Wayne Clough, bowed to pressure and removed the offending work.[45]

Katz and Ward were expecting some questioning of the exhibition's sexual content by its more conservative viewers, yet they had not anticipated the response to Wojnarowicz's video, even though the American artist Andres Serrano's photograph of a plastic crucifix submerged in a jar of urine (*Piss Christ* [1987]) had created similar outrage two decades earlier.[46] Ward commented in retrospect: "I think that people were kind of overly

sanguine about it. The feeling was: 'Well, Obama's president. The culture wars are over.'"[47]

While the election of the country's first African American president, Barack Obama, in 2008 did not signal the end of the culture wars, it did mark a significant moment in the evolution of the American public's understanding of diversity and questions of race in this country's history.[48] At least three decades of K–12 education informed by the culture wars has, to a certain extent, "normalized" diversity and multiculturalism, as have the television shows, movies, webcasts, and other forms of mass media that increasingly show the diverse faces and cultures that make up the United States of America. At least two generations have grown up accustomed to seeing blacks, whites, Asian Americans, Latino/as, and Native Americans in various combinations both in the classrooms and in the neighborhoods they occupy, as well as in the stories they read and see and hear in a variety of media. Such familiarity was certainly a factor in Obama's election. But it has not done away with the economic and social inequalities that continue to limit the future prospects of many people of color, or with what social psychologist Claude M. Steele describes as the less visible but equally potent "stereotype threats" that define us as individuals and impact our relationships with others.[49]

Perhaps a better indication of the state of the culture wars and their impact on education and museum exhibitions can be found in the content and audience response to *American Stories: Paintings of Everyday Life, 1765–1915*, a major survey exhibition of American art organized by the Metropolitan Museum of Art and the Los Angeles County Museum of Art. The exhibition opened at the Metropolitan Museum of Art in October 2009 (marking the completion of the new American wing) and in February 2010 at the Los Angeles County Museum of Art. It focused on genre paintings, or scenes of everyday life, and used these small-scale dramas to narrate a century and a half of American history marked by the colonization and conquest of a large swath of territory, the emergence of an independent nation based in large part on slavery and genocide, the near breakup of that nation in the Civil War, and the development of an urban, industrial powerhouse of both national and international significance.

The organizers of the exhibition, Carrie Rebora Barratt, H. Barbara Weinberg, Bruce Robertson, and Margaret C. Conrads, write in the catalogue's preface: "Our study is limited to depictions of ordinary events or events witnessed by average Americans. . . . We have excluded accounts derived from history, myth, and literature, emphasizing instead those based on artists' firsthand observation, documentation, and interaction with clients. One could say that our chosen narratives are analogous to original—not adapted—screenplays."[50] This is quite different from *The West as America*, in which the symbolic dimensions of the works of art were privileged over their literal narratives. The audiences that filled the galleries of the Metropolitan Museum of Art and the Los Angeles County Museum of Art reveled in these literal narratives and seemed to breathe sighs of relief that here was an art that was recognizable, that was, indeed, similar to their own lives, even if the fashions had changed somewhat. The organizers go on to explain their intentions and the main themes of the exhibition:

We also explore how contemporaneous viewers might have understood these painted stories—and what they might signify when we read them through the prism of our own time. Because we know that meanings of paintings, like those of written texts, shift with the reader's time, methodology, or viewpoint, we concede that our interpretations are only provisional, not definitive.

Although we organized our study chronologically, we realize that archetypal themes recur throughout our four sections, serving as long linear warps to our chronological wefts, thematic longitudes to our historical latitudes. For example, all of these painters of everyday life were consistently interested in gender roles, courtship, marriage, raising children, and growing old; how families functioned and were maintained against society's pressures; and how individuals related to the family, the community, and the wider environment. Time and again our painters addressed the attainment and reinforcement of citizenship; attitudes toward race; the frontier as reality and myth; and the process and meaning of art making.[51]

The exhibition was generally well received on both the east and west coasts, although the critical response was rather muted. No controversy ensued over wall labels or image content, but at the same time the praise was often qualified. Roberta Smith of the *New York Times* described the exhibition as "trundl[ing] through 150 crucial years of American life and art," providing, along the way, "prominent landmarks of American painting" and "unfamiliar gems of genre painting," as well as "less gemlike genre paintings, full of plots and props and stilted emotions."[52] Sanford Schwartz of the *New York Review of Books* found the point of the exhibition "more social history than art" and felt that "treating artists as illustrators of attitudes held by society in various bygone eras has a way of taking the pleasure out of looking at pictures."[53] Christopher Knight of the *Los Angeles Times* noted that "Lots of first-rate paintings keep company with dreadful Victorian morality plays."[54]

While many critics remarked upon the uneven quality of the works on display, they also recognized the contemporary political relevance of the exhibition. Smith writes: "In a sense this exhibition is a pitched battle about how painting should tell stories in a country whose history was unfolding at high speed and whose narrative was not quite like anything the world had ever seen." She concludes: "[The exhibition] invites repeated visits, providing insights into the national consciousness and lack of same. It explores the art and ambition of painting with incredible richness. It keeps slavery—the most irreducible fact of American history—before us in ways that illuminate both past and present. Its strength lies in its openness and synthesis of different points of view."[55]

Knight also ruminated on national identity in his review, opening with: "What is an American? Today, as the 20th century—the so-called 'American Century'—recedes in memory, the question can seem immodest or even grandiose. If we don't know now, after decades wielding almost unimaginable superpower status around the globe, will we ever?"[56] He continues by noting that there is another way to look at this question in light of "the conflicted place in which the United States finds itself today. With the national nervous

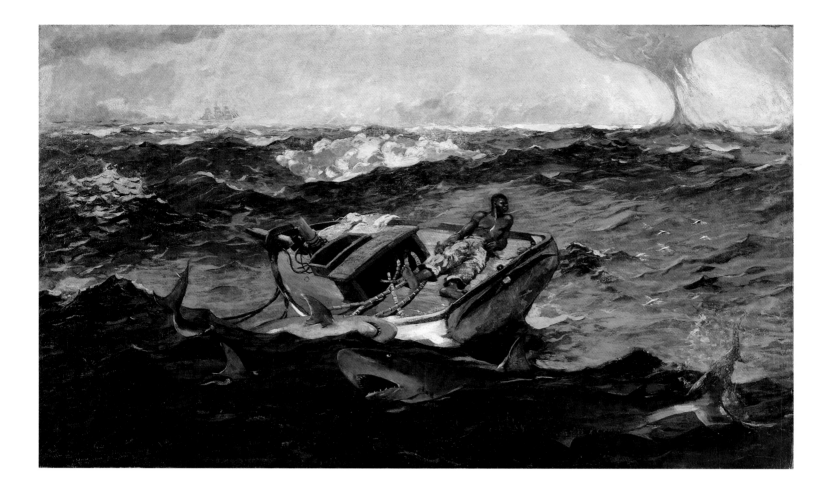

breakdown unleashed by the 9/11 terrorist attacks—trauma Americans have collectively been unable to resolve—our identity remains a shambles. The uncertainty had been building for at least 30 years. In the aftermath of Abu Ghraib and AIG, once-settled matters of morality now appear unrecognizable."[57] Knight suggests that *American Stories* was "prompted by this deep unease. The show turns to history—to the era when the question of what an American might be was still brand new and very much up for grabs."[58] This history is conveyed through the familiar narratives of genre painting— working, looking for work, shopping, voting, viewing paintings, eating—and through figurative, easy-to-read styles. If my experience of the show was any indication, such recognizable images encouraged a more prolonged viewing of individual works and engendered more animated conversations with fellow museumgoers. Smith appears to have had a similar experience. "In many instances," she writes, "you may be pulled into the intricacies of a genre painting's worldview purely for its anthropological richness and psychological confusion."[59]

 American Stories, unlike *The West as America*, did not insist on a single, correct "story" for each work of art. The wall text provided historical and biographical information, pointing out the significance of race, class, and gender in the development of this nation, but limited the interpretive material, leaving more lengthy interpretations to the catalogue. The results of this approach can be seen in the responses of some of my students to the initial room of the Los Angeles installation, which contained approximately twenty-five fewer works than the New York installation. This room housed

two groupings of paintings on the walls to the left and right as one entered. To the right were three canvases: William Sidney Mount's *Eel Spearing at Setauket* (1845), depicting a powerful black woman standing in a shallow boat, spear in hand, while a young white boy, seated in the rear of the boat, concentrates on holding it steady with an oar; John Singleton Copley's *Watson and the Shark* (1778), which portrays the tale of the young Brook Watson being attacked by a shark in Havana harbor while a boat full of men, including a standing black man, attempt to rescue him; and Winslow Homer's *Gulf Stream* (1899; fig. 34), with its small boat, mast broken, adrift on a sea full of sharks, and a reclining black male figure seemingly oblivious not only to the sharks but to the twister and large sailing ship in the background. To

the left of the entrance were several paintings, including John Singleton Copley's *Paul Revere* (1768), in which a seated Revere contemplates a silver teapot; Mary Cassatt's *The Cup of Tea* (ca. 1880–81; fig. 35), with a single female figure; William Merritt Chase's *Open Air Breakfast* (ca. 1887), which portrays two women and two children in a fenced-in yard; William McGregor Paxton's *The Breakfast* (1911), depicting a bored housewife, a departing maid, and a husband absorbed in his newspaper; and John Sloan's *Chinese Restaurant* (1909), in which a young woman plays with a cat while three men look on. All contain teapots and/or teacups.[60]

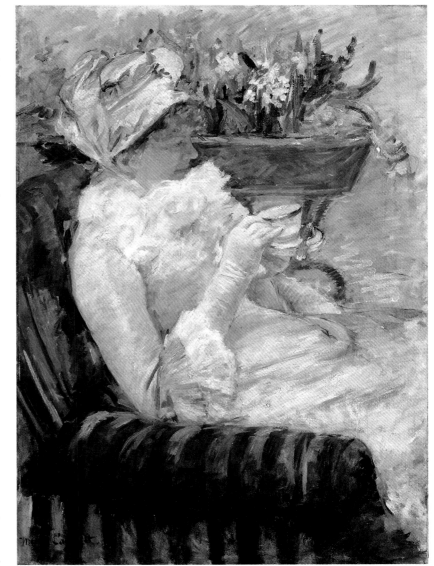

My students quickly discerned that these two groups represented two interlocking forces at work in the early years of the nation—trade and slavery, or commercial products (tea in particular) and the labor that made them possible. The social rituals and economic relations captured in the paintings on both walls were built on this material base.[61] The organizers of the exhibition presented a different interpretation of the paintings by Cassatt and Copley in the preface to the exhibition catalogue: "the stories implied by Copley's 1768 portrait of Paul Revere incising a teapot . . . and Cassatt's image of a young woman taking tea of about 1880–81 . . . may be read, respectively, as painted counterparts of Benjamin Franklin's pointed aphorisms and of Henry James's reflections on the inner life of the individual."[62] Yet they also acknowledged that "[o]ur viewers and readers will surely tease out other themes, issues, and parallels embedded in the works we have gathered."[63] This multiplicity of

Fig. 35. Mary Cassatt (1844–1926). *The Cup of Tea*, ca. 1880–81. Oil on canvas; 36⅜ × 25¾ inches. The Metropolitan Museum of Art; From the Collection of James Stillman, Gift of Dr. Ernest G. Stillman, 1922, 22.16.17.

viewing potentials accounted for much of the success of the show. The labels provided information but not direction. Viewers were able to insert themselves into the narratives contained in the paintings, narratives that were still relevant to modern-day Americans. Smith approaches this openness from another direction, turning a potential limitation into a strength: "The show has too many outstanding works ranging across too much history and art history to be orderly, which empowers viewers and gives them plenty to work with."[64]

Yet were all viewers able to insert themselves into the stories told by the paintings in the exhibition? Would the Latino/a, African American, Asian American, and Native American communities recognize their lives in these stories? Would they walk away feeling empowered as members of a nation whose history had been so fully recorded on canvas and paper?

African Americans appear in a significant number of paintings. They are peripheral figures in Mount's *Power of Music* (1847), Richard Catton Woodville's *War News from Mexico* (1848) and *Old '76 and Young '48* (1849), and John Lewis Krimmel's *The Quilting Frolic* (1813) as well as more central characters in Mount's *Eel Spearing at Setauket*, Copley's *Watson and the Shark*, Eastman Johnson's *Negro Life at the South* (1859), Christian Friedrich Mayr's *Kitchen Ball at White Sulphur Springs, Virginia* (1838), Homer's *Dressing for the Carnival* (1877), *Gulf Stream*, and *The Cotton Pickers* (1876), Theodor Kaufmann's *On to Liberty* (1867), and John George Brown's *The Card Trick* (1880–89).

Native Americans are not as fully represented and appear in the guise of the "savage" or "noble" Indian, as in George Caleb Bingham's *Fur Traders Descending the Missouri* (1845) (originally *French Trader—Half-Breed Son*), Charles Deas's *The Death Struggle* (1845), John Mix Stanley's *Gambling for the Buck* (1867), George de Forest Brush's *The Picture Writer's Story* (ca. 1884), and Frederic Remington's *Fight for the Water Hole* (1903).[65] Asian Americans are even less visible, suggested only indirectly in the title and setting of Sloan's *Chinese Restaurant* (1909), the Japanese screens in William McGregor Paxton's *Tea Leaves* (1909) and William Merritt Chase's *The Open Air Breakfast* (ca. 1887), and the Asian porcelains in Chase's painting and John Singer Sargent's *The Daughters of Edward Darley Boit* (1882). The inclusion of paintings depicting Americans of Mexican descent was, in Knight's words, "an afterthought," with ten paintings treating California added to the Los Angeles installation.[66]

Knight situates this absence within a larger problem with the exhibition: "its old-fashioned 'Westward Ho!' framework." He continues: "Although not strictly chronological, it generally considers American identity as something that blossomed in the East and unfolded as it moved West. The Spanish province of California is pretty much an afterthought, in 10 added paintings (at the Met it was virtually omitted), as are artists from vast swaths of America."[67]

Including the stories of people from all segments of this vast country would certainly be a difficult, but not necessarily impossible, task. And as more diverse communities are drawn to museums through the concerted efforts of museum educational programs and other forms of outreach, such

audiences are going to want to see their lives and their stories presented on museum walls.

Behold, America!

In 1998, Chicana feminist historian Antonia Castañeda questioned the legitimacy of the myth of "the West" as "a classless, casteless society where equality and justice for all reign supreme, where merit and hard work are rewarded, and where education—which is free and available to all children—is the key to success."[68] Her questioning emerged out of a study of the role of young Chicano/a children as translators for their non-English-speaking parents. "What," she asks, "do children of color, children of farmworker families, and other working-class children, whose daily experiences belie the national myths, understand and know about these myths?"[69] She continues:

> What is the relationship between those myths and the politics of translating cultures? What rites of passage are these that require children to conceive the significance of, construe, and interpret entire cultural universes for adults, universes that include every possible human experience: from a nation's mythology and ideology, a sibling's arrest, pregnancy and pre- and post-natal care, an argument with a boss who refuses to pay the wages he agreed to pay? What rites are these in which childhood's boundaries are transgressed each time a child is required to translate—and thus mediate, negotiate, and broker adult realities across cultures?[70]

Many of these children will be among the audience for *Behold, America!* A mere 160 years ago, Southern California was part of Mexico, and this legacy is apparent not only in the architecture and place-names of the region but also in its demographics. Southern California is home to one of the largest concentrations of individuals of Mexican heritage, both descendants of those who lived in the region before the end of the Mexican-U.S. War of 1846–48 and more recent immigrants, along with immigrants from other Latin American countries. Museums in the region have recognized this reality and made efforts to attract members of these communities into their exhibitions and educational programming, including those young cultural translators of whom Castañeda writes. What will they make of the *Behold, America!* exhibition? What political and economic events will inform their reading of the works that it contains?

At the time of the writing of this essay, the most pressing political debates in the United States concern economics. A combined debt and unemployment crisis is facing all levels of government—local, state, and federal. These U.S. economic woes are part of a larger series of interlocking international economic crises that are threatening to come together in one global financial disaster. The European Union has been forced to provide Greece with a financial bailout in order to save it from economic collapse and is faced with providing similar bailouts to Spain, Ireland, and Italy in the near future. China is experiencing a housing boom that could turn into the same kind of catastrophic bust that initiated the current three-year recession in the United States and led to a massive U.S. government bailout of banks and other

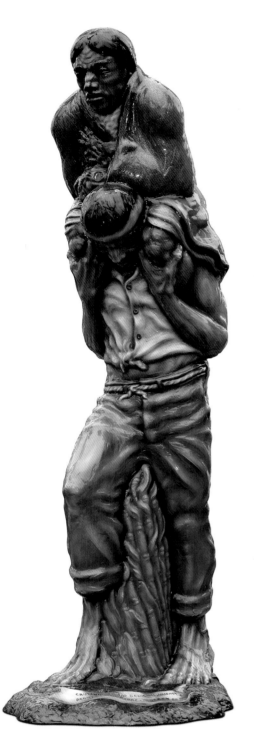

Fig. 36. Luis Jiménez (1940–2006). *Border Crossing/Cruzando el Río Bravo*, 1989. Fiberglass with acrylic urethane finish, edition 4/5, 2 A.P; 127 × 34 × 54 inches. Joint purchase, Museum of Contemporary Art San Diego and The San Diego Museum of Art in honor of Jackie and Rea Axline, MCASD 2002.46/SDMA 2002.226. Cat. 147.

financial institutions and industries deemed "too big to fail."[71] At the same time, the unemployment rate in the United States has steadily risen, putting pressure on the spending habits of a broad sector of the American population. Thus, what cultural critic Mike Davis describes as the "three pillars" of the global economy—American consumption, European stability, and Chinese growth—are on shaky ground.[72]

Immigration policy has also drawn the attention of political commentators and party spokespeople, many of whom continue the long-standing practice of scapegoating undocumented workers, particularly those from Mexico and Central America, as the source of the country's economic woes, despite evidence to the contrary.[73] One of the most contentious issues within these immigration debates has been access to both K–12 and postsecondary education for the children of undocumented workers not born in the United States. On July 25, 2011, California governor Jerry Brown signed into law a bill making it easier for such undocumented college students to access privately funded financial aid. He also indicated that he was willing to consider increasing access to state-funded financial aid.[74] These were welcome developments for those disappointed by the failure of the federal DREAM (Development, Relief and Education of Alien Minors) Act to muster enough votes to pass. This act would have created a way for illegal immigrants brought to the United States before the age of sixteen to gain citizenship if they attended college or served in the military.

Education is clearly an important factor in enabling immigrants and nonimmigrants alike to improve the quality of their lives, and museums are increasingly becoming important players in providing such an education. If we want to use American art as an aid in the teaching of American history, what kind of stories will we want to tell? Whose voices will enter into our narratives? How do we make the art more than illustrations for an already predetermined text? How do we make the viewing experience an active, questioning one? Politicians, religious leaders, teachers, and many others commonly call on historical events and texts as foundational and thus build their own belief systems on their understanding of these events and texts. We need informed citizens who recognize the multiplicity of beliefs that have guided this country's history and who will make reasoned arguments in support of their own. All residents of this country need access to information and opportunities to engage in intelligent public discourse about the crucial issues of our day. *Behold, America!* includes images that have traditionally supported Manifest Destiny interpretations of the West, such as the majestic landscapes of Albert Bierstadt (*Cho-looke, the Yosemite Fall* [1864]; cat. 124) and Asher B. Durand (*Landscape—Composition: In the*

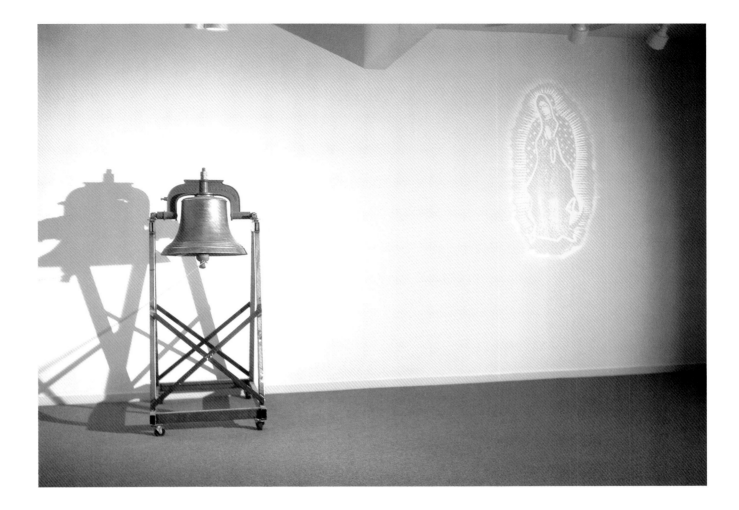

Catskills [1848]; cat. 137), yet it also contains works that complicate that interpretation, including the fiberglass sculpture of Mexican immigrants by Luis Jiménez (*Border Crossing/Cruzando el Rio Bravo* [1989]; fig. 36) and the mission bell and Virgin of Guadalupe by Paul Kos (*Guadalupe Bell* [1989]; fig. 37). The bringing together of these two stories about borders and their crossings in American history will provide one of many opportunities during the run of *Behold, America!* to delve once again into the complicated histories that have made this equally complicated moment in time and place possible.

Fig. 37. Paul Kos (b. 1942). *Guadalupe Bell,* 1989. Bronze bell, steel, phosphorescent pigment, strobe light; bell 25¾ inches diameter, overall dimensions vary. Museum of Contemporary Art San Diego; Museum purchase with contributions from the Awards in the Visual Arts Program, 1989.10. Cat. 150.

1. I was reminded of how closely these two enterprises are connected by an early review of my textbook *Framing America: A Social History of American Art* (New York and London: Thames and Hudson, 2012 [2008 and 2002]). Daniel A. Siedell, curator of the Sheldon Memorial Art Gallery at the University of Nebraska, wrote: "As a curator of a university art museum that focuses on the history and development of American art from the nineteenth century to the present, I understand some of Pohl's challenges, most particularly the need to communicate to multiple and even mutually exclusive audiences, as well as having to fight the continual temptation to play it safe and follow paths of the least possible resistance" (*CAAReviews*, 29 July 2003, www.caareviews.org).

2. The death in 2011 of Al Qaeda leader Osama bin Laden may shift the terrorism-patriotism discourse somewhat, but it will continue to have a significant impact on cultural production and its reception, as well as on political and economic decision making. For example, Duke University professor Ariel Dorfman recently wrote of the impact of concerns regarding U.S. citizenship and Bin Laden's death on a popular form of visual culture, the Superman comic book. "Can it be a mere coincidence," writes Dorfman, somewhat tongue-in-cheek, "that the world heard that Superman would renounce his U.S. citizenship just days before Al Qaeda's sinister and lugubrious leader was killed in his Pakistani compound?" In an earlier edition of *Action Comics*, Superman had been chastised by the U.S. national security adviser "for going to Tehran to show solidarity with Iran's Green Revolution and its protest against President Mahmoud Ahmadinejad and his cronies." Superman's presence was interpreted by the Iranian government as an act of war by the United States. "Superman decided that in an increasingly global world, it was counterproductive for him to be branded as an instrument of U.S. policy. He came from another planet, after all, which gave him a 'larger picture.'" The response of comic book readers was immediate and intense, with bloggers proposing to deport Superman to the planet Krypton and petitions circulating to boycott Time Warner, the parent company of DC Comics, if Superman does not reaffirm his U.S citizenship.

3. Suzanne Muchnic, "U.S. Museums Look Homeward," *Los Angeles Times*, 30 May 2009, A1, A8.

4. Ibid., A1.

5. One of the first such challenges appeared at Stanford University on 16–17 April 2004 at the "Minding the Gap: On the Modernist Divide in American Art/History" conference organized by art historian Richard Meyer for Stanford's Department of Art and Art History. See also the discussion of this divide in Katy Siegel, *Since '45: America and the Making of Contemporary Art* (London: Reaktion Books, 2011). A different reevaluation of the 1945 divide occurred at The Art Institute of Chicago. Before the completion of its new wing by Renzo Piano in 2009, the American art collection ended at 1900; it now ends at 1945.

6. Muchnic, "U.S. Museums," A1.

7. See Carol Vogel, "New York Public Library's Durand Painting Sold to Wal-Mart Heiress," *New York Times*, 13 May 2005, http://www.nytimes.com/2005/05/13/nyregion/13painting.html. For a discussion of the controversy created by the sale of a painting that many thought should remain in New York in the care of the New-York Historical Society, and for a critical view of the escalation of museum building in the early twenty-first century, see Michael J. Lewis, "Art for Sale," *Commentary* 191, no. 3 (March 2006): 32–38.

8. One of the downsides to such celebrations was the increasing restrictions on visas for foreign artists that accompanied the new War on Terror.

9. Andrew Walker, "Coming of Age: American Art Installations in the Twenty-First Century," *American Art* 24, no. 2 (Summer 2010): 4.

10. Ibid., 2.

11. Sylvia Yount, "'Provincial' No More: The Virginia Museum of Fine Arts," *American Art* 24, no. 2 (Summer 2010): 24.

12. Elliot Bostwick Davis, "The Art of the Americas Wing, Museum of Fine Arts, Boston," *American Art* 24, no. 2 (Summer 2010): 9.

My own textbook, while focusing on the United States, treats the colonial art of New France and New Spain, in the first chapter, and includes Mexican art produced in the territory that is now the American Southwest before its incorporation into the United States in 1848. It also looks at work produced by Mexican artists in the United States and

by U.S. artists in both Mexico and Canada, see Pohl, *Framing America.*

13. See, for example, Ronald Inglehart et al., *The North American Trajectory* (New York: Aldine de Gruyter, 1996).

14. Caroline F. Levander and Robert S. Levine, "Introduction: Essays beyond the Nation," in *Hemispheric American Studies*, ed. Caroline F. Levander and Robert S. Levine (New Brunswick, NJ: Rutgers University Press, 2008), 9.

15. On July 14, 2011, California governor Jerry Brown continued this trend of making education more inclusive by signing into law a bill that would require gay, lesbian, bisexual, and transgender history in social studies curricula in California public schools. See Wayne Buchanan, "New State Law Requires LGBT History in Textbooks," *San Francisco Chronicle*, 15 July 2011, http://articles.sfgate.com/2011-07-15/news/29776245_1_textbooks-gay-rights-safer-schools.

16. Walker, "Coming of Age," 7–8.

17. For an early discussion of some of the problems faced by those who attempt to include a broader array of voices or cultures in their art exhibitions, see Georgia Collins and Renee Sandell, "The Politics of Multicultural Art Education," *Art Education* 45, no. 6 (November 1992): 8–13.

For a more recent treatment of the attempts of museums to expand their audiences, see Center for the Future of Museums, *Demographic Transformation and the Future of Museums* (Washington, D.C.: American Association of Museums Press, 2010).

18. Jonathan D. Katz, participant in a panel, "Flashpoints and Fault Lines: Curation and Controversy," sponsored by the Smithsonian Institution on April 26, 2011. The panel was one of several public responses to a controversy that erupted over an exhibition Katz had cocurated with David Ward, *Hide/Seek: Difference and Desire in American Portraiture*, which had opened in October 2010 at the National Portrait Gallery. The website that posted a video of the panel discussion explained its origins as follows: "The Smithsonian is hosting a public forum to discuss the complex roles, responsibilities, and constraints of curating exhibitions in public institutions. This forum will be an opportunity to discuss the work of the Smithsonian and how the institution and others approach sensitive topics, and to provide the public with the opportunity to comment on the recent controversy surrounding the National Portrait Gallery's *Hide/Seek: Difference and Desire in American Portraiture* exhibition." http://si.edu/flashpoints.

19. The exhibition catalogue is *The West as America: Reinterpreting Images of the Frontier, 1820–1920*, ed. William H. Truettner (Washington, D.C.: Smithsonian Institution Press, 1991). Articles dealing with the exhibition include William G. Robbins, "Laying Siege to Western History: The Emergence of New Paradigms," *Reviews in American History* 19, no. 3 (September 1991): 313–31; Michael J. Watts, "Space for Everything (a Commentary)," *Cultural Anthropology* 7 (1992): 115–29; Andrew Gulliford, "The West as America: Reinterpreting Images of the Frontier, 1820–1920," *Journal of American History* 79, no. 1 (June 1992): 199–208; Thomas Woods, "Museums and the Public: Doing History Together," *Journal of American History* 82, no. 3 (December 1995): 1111–15; Kay Larson, "How the West Was Done," *New York Magazine*, 17 June 1991, 79; Miriam Horn, "How the West Was Really Won," *U.S. News and World Report*, 21 May 1990, 56–65; Kim Masters, "Two Senators Charge Smithsonian with Leaning Left," *Houston Chronicle*, 16 May 1991, A17; Robert Hughes, "How the West Was Spun," *Time*, 13 May 1991, 79–80; Eric Foner and Jon Wiener, "Fighting for the West," *Nation*, 29 July 1991, 163–66; Richard Bernstein, "Unsettling the Old West," *New York Times Magazine*, 18 March 1990, 34, 57–59; Antonia I. Castañeda, "Women of Color and the Rewriting of Western History: The Politics, Discourse, and Decolonization of History," *Pacific Historical Review* 61 (November 1992): 501–53; Brian W. Dippie, "The Winning of the West Reconsidered," *Wilson Quarterly Review* 14 (Summer 1990): 70; David Gutierrez, "Significant to Whom? Mexican Americans and the History of the American West," *Western History Quarterly* 24 (November 1993): 519–39; and Susan Lee Johnson, "'A Memory Sweet to Soldiers': The Significance of Gender in the History of the 'American West,'" *Western History Quarterly* 24 (November 1993): 495–517.

20. Allan Wallach, "The Battle over 'The West as America,'" in *Exhibiting Contradiction: Essays on the Art Museum in the United States* (Amherst: University of Massachusetts Press, 1998), 105–17. The essay was previously published in Marcia Pointon, ed., *Art Apart: Art*

Institutions and Ideology across England and North America (Manchester and New York: Manchester University Press, 1994), 89–101.

21. Walter Benjamin, "Eduard Fuchs, Collector and Historian," in *One Way Street and Other Writings*, trans. Edmund Jephcott and Kingsley Shorter (London: Verso, 1985), 352.

22. Bryan J. Wolf, "How the West Was Hung, Or, *When I Hear the Word 'Culture' I Take Out My Checkbook*," *American Quarterly* 44, no. 3 (September 1992): 421.

23. "Pilgrims and Other Imperialists," *Wall Street Journal*, 17 May 1991, quoted in Wallach, "The Battle," 100 n. 8. While, according to Wallach, the exhibition was financed with private funds, its organization by a federally funded institution (the Smithsonian) trumped the private funding.

24. On museums and citizenship, see Carol Duncan, "The Art Museum as Ritual," in *The Art of Art History: A Critical Anthology*, ed. Donald Preziosi (Oxford and New York: Oxford University Press, 1998), 473–85, 560–62.

25. Wolf, "How the West Was Hung," 423.

26. The label that accompanied Frederic Remington's *Fight for the Water Hole* (1903) drew particularly harsh criticism for its argument that the "last stand" depicted on the canvas was a reference to clashes between immigrant laborers (who had been referred to as "savages" and "redskins" in newspapers) and capitalists. In response to such vocal criticism of the exhibition, and in particular to threats from members of Congress about cutting the museum's funding, many of the wall labels were rewritten and the Smithsonian's secretary Robert Adams apologized in the *Washington Times* (Alan McConagha, "Smithsonian Chief Admits Exhibit Error," *Washington Times*, 6 June 1991).

27. Wallach, "The Battle," 110–11.

28. The first major attacks on exhibitions presenting challenges to sexual norms occurred in 1989 and involved the photographs of the recently deceased American photographer Robert Mapplethorpe, while religious controversy swirled around Andres Serrano's photograph *Piss Christ* (1987). See Graham Beal, "'But Is It Art?': The Mapplethorpe/Serrano Controversy," *Apollo* 132 (November 1990): 317–21.

29. See Brian Wallis et al., eds., *Art Matters: How the Culture Wars Changed America* (New York and London: New York University Press, 1999).

30. John Searle, "The Storm over the University," *New York Review*, 6 December 1990, 34–42; "A Campus Forum on Multiculturalism: Opening Academia without Closing It Down," *New York Times*, 9 December 1990, E5; Jerry Adler et al., "Taking Offense: Is This the New Enlightenment on Campus or the New McCarthyism?" *Newsweek*, 24 December 1990, 48–54.

31. Eleanor Heartney, "Multiculturalism and Its Discontents: The New Word Order," *New Art Examiner*, April 1991, 23–25; Donald Kagan, "Western Values Are Central," *New York Times*, 4 May 1991, 23; Jan Breslauer, "Fear of the M Word," *Los Angeles Times Calendar*, 2 June 1991, 7, 80–81; and Miles Harvey, "Politically Correct Is Politically Suspect," *In These Times*, 25 December 1991–4 January 1992, 24, 22.

32. Robin Cembalest, "Goodbye, Columbus?" *ARTnews* 90 (October 1991): 104.

33. By 2008, the figures were 47.7 percent Hispanic, 28.7 percent white non-Hispanic, 13 percent Asian–Pacific Islander, 8.5 percent black, and 2.1 percent other races (Los Angeles County Economic Development Corporation and The Kyser Center for Economic Research, *L.A. Stats*, March 2010, 3).

34. Quoted in Cembalest, "Goodbye, Columbus?," 106.

35. Quoted in ibid., 107.

36. Wolf, "How the West Was Hung," 249.

37. Wallach, "The Battle," 98.

38. Ibid.

39. Ibid., 99.

40. Andrew Gulliford, "Visitors Respond: Selections from 'The West as America' Comment Books," *Montana: The Magazine of Western History* 42, no. 3 (Summer 1992): 77.

41. Ibid.

42. Gulliford argues that "the exhibit was cancelled not because of curatorial controversy but because of the $100,000 participation fee and other costs" (Gulliford, "Visitors Respond," 77).

43. Wolf, "How the West Was Hung," 437.

44. This was the case with *Albert Bierstadt: Art and Enterprise*, an exhibition that appeared in the same year as *The West as America* at the Brooklyn Museum of Art. See Wolf, "How the West Was Hung," 431–38. Extensive labels have often been criticized as interfering with the "experience" of the work of art. Peter S. Samis of the San Francisco

Museum of Modern Art wrote in 2001 of resistance to the inclusion of new educational technologies within museum galleries rather than in separate study rooms: "It is a vestige of hard distinctions drawn between curating and educating, between the white cube of the gallery space (equated with unmediated experience) and purposeful contextualizations, between connoisseurship aimed at a pre-educated visitorship and fear of pandering to the populace" (Peter S. Samis, "Points of Departure: Curators and Educators Collaborate to Prototype a 'Museum of the Future,'" *Proceedings of International Cultural Heritage and Informatics Meeting*, 2001, 623–32, http://archimuse.com). In a 2003 article, "Dialogic Looking: Beyond the Mediated Experience," Sara Wilson McKay and Susana R. Monteverde argue for "dialogic looking—exploring works of art through multiple dialogues—as an integral component, and perhaps alternative, to mediated museum experiences . . . [such as] written wall text or guided tours" ("Dialogic Looking: Beyond the Mediated Experience," *Art Education* 56, no. 1 [January 2003]: 40).

45. See Sheryl Gay Stolberg and Kate Taylor, "Wounded in Crossfire of a Capital Culture War," *New York Times*, 3 April 2011, AR1; People for Blog, "At Smithsonian Forum, Hide/Seek Curators Fiercely Defend Controversial Exhibit," http://blog.pfaw.org/content/smithsonian-forum-hideseek-curator; and note 17 above.

46. See Beal, "But Is It Art?"

47. Stolberg and Taylor, "Wounded in Crossfire," AR1.

48. While the conservative Tea Party movement has called into question Obama's citizenship, claiming that he was not born in Hawaii, even after he produced his birth certificate, most Americans accept his U.S. citizenship. This questioning was prompted, in large part, by Obama's Kenyan father and the fact that, after his parents' divorce, his Kansas-born mother married an Indonesian man and moved to Jakarta, where she, her husband, and Obama lived for four years. See Barack Obama, *Dreams from My Father: A Story of Race and Inheritance* (New York: Three Rivers Press, 2004).

49. Claude M. Steele, *Whistling Vivaldi: How Stereotypes Affect Us and What We Can Do* (New York and London: W. W. Norton, 2010).

50. "Preface and Acknowledgements," in *American Stories: Paintings of Everyday Life, 1765–1915*, ed. H. Barbara Weinberg and Carrie Rebora Barratt (New York: The Metropolitan Museum of Art; New Haven, CT: Yale University Press, 2009), xi.

51. Ibid., p. xii.

52. Roberta Smith, "One Nation, in Broad Strokes," *New York Times*, 15 October 2009, http://www.nytimes.com/2009/10/16/arts/design/16stories.html?ref=marycassatt. A version of this article was also published in the *New York Times*, 16 October 2009, C23.

53. Sanford Schwartz, "American Scene," *New York Review of Books*, 14 January 2010, http://www.nybooks.com/articles/archives/2010/jan/14/corners-of-the-american-scene/.

54. Christopher Knight, "Art Review: 'American Stories: Paintings of Everyday Life, 1765–1915' @ LACMA," Culture Monster, *Los Angeles Times*, 28 February 2010, http://latimesblogs.latimes.com/culturemonster/2010/02/american-stories-lacma.html.

55. Smith, "One Nation in Broad Strokes."

56. Knight, "Art Review."

57. Ibid.

58. Ibid.

59. Smith, "One Nation in Broad Strokes."

60. The opening room in the Metropolitan Museum installation included six water-related paintings: Copley's *Watson and the Shark*, Mount's *Eel Spearing at Setauket*, Homer's *Gulf Stream*, Homer's *Breezing Up (A Fair Wind)*, George Caleb Bingham's *Fur Traders Descending the Missouri*, and Thomas Eakins's *The Champion Single Sculls (Max Schmitt in a Single Scull)*.

61. Knight also noted the significance of the teapot in the Copley portrait of Paul Revere, writing that it "of course nods toward the critical role of tea in the New World's economy" (Knight, "Art Review").

62. Weinberg and Barratt, *American Stories*, xii.

63. Ibid.

64. Smith, "One Nation in Broad Strokes." The public was also able to access the images and information about the exhibition after it had closed through a detailed website constructed by the Metropolitan Museum of Art. See http://www.metmuseum.org/special/americanstories/.

65. The exhibition catalogue acknowledges Alex Nemerov's interpretation of this painting from *The West as America* catalogue as one of many and observes that, in fact,

"Remington's art invites multiple narrative and symbolic interpretations—that its meaning is, in short, elastic" (Emily Ballew Neff, quoted in H. Barbara Weinberg, "Cosmopolitan and Candid Stories, 1877–1915," in Weinberg and Barratt, *American Stories*, 164).

66. Knight, "Art Review."

67. Ibid.

68. Antonia Castañeda, "Language and Other Lethal Weapons: Cultural Politics and the Rites of Children as Translators of Culture," *Chicano-Latino Law Review* (1998): 232.

69. Ibid.

70. Ibid, 233.

71. See Andrew Ross Sorkin, *Too Big to Fail: The Inside Story of How Wall Street and Washington Fought to Save the Financial System—and Themselves* (New York: Viking, 2009).

72. Mike Davis, "Racing Toward Chaos," *Los Angeles Times*, 26 July 2011, A13.

73. For a history of anti-Mexican sentiment in Southern California and the impact of Mexican labor on the region's economy, see Matt Garcia, *A World of Its Own: Race, Labor, and Citrus in the Making of Greater Los Angeles, 1900–1970* (Chapel Hill and London: University of North Carolina Press, 2001). For a more humorous treatment of the central role of Mexican labor in the California economy, see the 2004 film *A Day without a Mexican*, directed by Sergio Arau (DVD, Xenon, 2004).

74. Maeve Reston, "California Dream Act Signed into Law," *Los Angeles Times*, 26 July 2011, AA1–2.

Interview with Brian Ulrich

How do you find the Chicago art scene?

Chicago is really kind of wonderful.[1] I was just telling this story the other day to a friend, but when I came to Chicago I was lucky, because, right away—I've always been a person who is interested in the idea of community and interested in a kind of group or network or having that degree of support—with coming to Chicago, right off the bat, I met some really great people in graduate school. And we decided that we were going to collaborate in terms of the betterment of our own work and our careers. Chicago is a great place to do that. I always felt that in New York you could get a little bit—there is kind of almost too much at stake. And the other thing for a young artist, there are a tremendous amount of venues here that are accessible and are super supportive—like the Museum of Contemporary Photography, the Museum of Contemporary Art, which has a wonderful 12 × 12 program that I did early on, even the Art Institute, all of these people are accessible and easy to reach out to—as well as world-class galleries make for a great amount of opportunities for a young graduate student who is just like, well, "What do I do next?" The fact that people are very invested in each other's work is amazing.

I realize that not all of your photographs are set in the Midwest, but particularly in the *Copia* series,[2] there are images of Illinois, Indiana, and Wisconsin. Does the Midwest shape your work at all, or is that just happenstance for that particular body of work?

It does and it doesn't. There has been a concerted effort for it not to just be Midwest, but part of that is the fact that I am here and it is accessible to me. But there is a lot of New York, there is a lot of East Coast, there are some West Coast things. But I would say that when I first came to the Midwest, when I was eighteen or nineteen years old, I went to Akron, Ohio, and I was just completely blown away. That was the first time that I ever experienced a big-box store. Having grown up in the suburbs of Long Island, there really wasn't that supersized stuff. I couldn't believe how big these shopping carts were. I was so kind of confounded by what I was looking at and how big these spaces were. Here is the whole landscape of the Midwest and the economy of it. All of those things are right there and to me are very indicative of the American experience in broad, sweeping ways and in my opinion has not really been looked at enough until recently. It seems we are finally paying quite a bit more attention in a critical way.

Speaking of the big-box stores, for me, the photographs of the big-box stores are really haunting, and I think that there is something stark in the lighting. They're also dramatic and very hypnotic. Could you talk more about the influence of the big-box stores and what has drawn you to photograph them?

In the most basic sense, what is completely amazing about the space is that you are meant to be transformed once you move inside it, which is just bizarre. You are walking into this big temple or arena space, and then you are supposed to forget that there are even walls there. It places this great dramatic emphasis on the stuff, because what else is there to look at? In

Fig. 38. Brian Ulrich (b. 1971). *Kenosha, WI, 2003 (Spilled Milk)*, 2003. LightJet C-print; 40 × 52 inches. Museum of Contemporary Art San Diego; Museum purchase, 2006.82. Cat. 58.

the back or your mind you know somewhere along down that way there is a wall. From an architectural standpoint, it is very smart to create a dramatic emphasis on product, and that idea is totally fascinating because it reeks of a strategy that happens more often in the big-box store than in the mall, where—certainly the thrift store or any retail environment—is completely totalitarian. It is all about designing the space and the things in it to make these dramatic attempts to affect the consumer in very specific ways, and of course that capitalizes the idea.

As people navigate through the space where items are placed—the idea of Walmart selling pickles, eighteen gallons of pickles for five bucks, so you would buy those things and they would of course lose money, but then hopefully you would buy a jar of peanut butter for six dollars when it is really three—it is so subtle in that space, but so sophisticated and layered. To me that is the real opportunity to deconstruct it as best as I can. The lighting is awful, and when you really slow down and think about it, it is hard to make those spaces dramatic because they are so bland. I would go for hours and walk the entire store and try and find a place where light is reflecting off the floor, where it would create just that little bit of something else because it is hard, and you are looking at things that you look at all the time and [want] to revisit in a critical way.

Do you have to get permission?

Originally I tried to get permission to photograph a supermarket in Chicago that has a sign on its door that basically said 'no photographs or audio recording for any reason whatsoever', but if you want to contact us about this, here is a phone number for you to contact, (really they are telling you absolutely no, but just in case!) So I called them one time, and I said, "I am a graduate student at Columbia College and I am really interested in taking photographs in the space," and they were like, no, they didn't want to hear it. I realized I am never going to get anywhere, and if I do, it is always going to have to be on their approval. In the beginning, I was not 100 percent sure of what I wanted to do there, and so it was just a lot easier to go in and take the pictures candidly and kind of let my curiosity put me in the direction of what I was interested in photographing and talking about. You do not have to get permission. The only thing that could really happen is that someone could come along and tell you that you can't take photographs, which sometimes would never happen, and sometimes someone would say that in the first minute, and other times it would happen after an hour.

I remember making this Home Depot picture way back in 2002, I remember sitting there for forty-five minutes photographing people walk through that space, in a chair, a security guard chair, and then finally someone came over and said, "I think I heard the shutter on your camera going," and I explained, "Oh, it is a new camera, and I am trying to figure it out." It's not to dupe anyone. I would just rather have that conversation about the image, not what I am trying to do, because it is too easy for the conversation to get confounded into something else. I know what I am doing looks suspicious and weird and I am okay with that. If they ask me to not photograph I'll just move on to the next place. There is one just like it next door.

One of your photographs included in the show depicts a floor with spilled milk taken in Kenosha. Do you have any particular memories of taking that photograph?

Some pictures are very elaborately set up or, to a certain extent, decided about before I even get to a space, and that happens more in the recent work. But there is also something really wonderful about saying to myself, "I have this loose idea in my head and I wonder if I can find examples out there in the world," and not just necessarily looking for it but letting myself find it. That picture was one of those ideas. I didn't necessarily realize it until [I was] getting the film processed and looking at it. People had been telling me to go to this giant store in Kenosha for a very long time, I finally made the time to go up there and spent a whole day photographing in the space. There was this milk, and no one was coming, and it had obviously been there for a long time, and it was just so organic and beautiful and simple, like an action painting on the floor. I remember I used the shopping cart to act as a tripod so I could be steady and get things a little bit more described focus wise, and that was it.

The funny story about that picture is that, I think in 2007, I was in that area again, and I was photographing with a 4 × 5 camera, which is a lot slower of a process and a lot more elaborate, and I thought maybe I should just call up these people and see if I can take some 4 × 5 images. I have done that

candidly, but it is really hard to do, and it is just that much nicer, and since I didn't care so much if they said no, I just called them up, and they simply replied "Oh, yeah, fine." And I recall thinking, "You are not going to ask me anything? Who I am, what I am doing?"

"No, no, no, just come in." It was a Saturday, totally busy, and I went in and checked in with the people, and they were really nice, and I spent six, maybe eight hours photographing in the store, and at the end of the day this woman walks up and says, "Are we going to see any of these pictures?" And I said, "Well, if there is anything good, I will be happy to send you some prints or some copies or whatever." And she said, "Yeah, 'cause one time there was this picture in the back over in the corner of milk on the floor that someone took, and it was in the *Chicago Tribune Magazine*, and it was totally amazing, and ever since then, photographers can come anytime." I just loved the fact this type of surreptitious picture . . . and very smart of them on their part to welcome it rather than [forbid it]. So now whenever I hear "Cleanup in aisle 7," I try and get there before they mop.

In thinking about your photographs, I think there is a local/global dynamic going on where these stories really mean something and can completely change the local community in terms of where they go to shop, and then in a way they are so corporate, like Target or certainly Walmart, in the way that they go into a community and replicate the same store throughout the country. Do you see this dichotomy of local community versus global movement in your work?

Yeah, completely, often, and sometimes it is kind of troubling. The first week we started bombing Iraq, I was angry. I was really upset about it. I spent the entire week driving around the Midwest—Indiana, Illinois, Ohio, up into Michigan —to just try and make pictures of what was happening here. That is when I took that photograph in the Target. And even though that picture is what it is and you wouldn't really know that unless I gave you that information, what is so profound and unsettling about that, is that at the same time these people are strolling through thirty-four checkout aisles, we are blowing people up in order to have that thing, and that the weight of our actions influences these global conflicts. You know, this is a huge part of the work. *Thrift* talks a lot about that, too, and it indicts the idea that most of that plastic stuff, which has lost its glamour, is probably going to

Fig. 39. Brian Ulrich (b. 1971). *Toys and Gifts*, 2009–10. Refurbished neon sign. Courtesy of the artist.

be recycled back to China to produce new consumer goods. This is the weird circle between things that we buy and the global economy. That's why when I make portraits of people, it is easy not to be cynical, because even if it is this guy standing there with his fishing pole or a woman standing in the back of a

thrift store, they are so important. They are not necessarily the protagonists, but the victims themselves.

And, yes, I think we have choice about where we go and what we participate in, but we also have been severely limited in that choice by our environment, and that has been a specific agenda from these large corporations.

Here is this guy sleeping outside a dead mall in Florida, and that is what is there for him, the twenty-first century, and this is how far we have come, and it is totally amazing.

I was thinking about the ideas that you are talking about as I was looking at the images of the people, and there is a photograph of a child sitting on one of those awkward chairs, and everything is ill-fitting, and whether it is a child or an adult, there is this uncomfortable relationship with the things around you in a consumer environment. You sort of started to talk about the last time I was here, and this work [*points to an old toy sign*] was out, and you had just brought it in, and I was wondering, is this a new direction you are going in?

It comes out of photographing all these closed retail places and the abandoned malls and things and with an 8 × 10 camera. I started to come up to an interesting dilemma, which was, an obvious one, but I think it is kind of fascinating that I got to this place. Which is, I can take a photograph that is sitting on the outside of this dead building that has been there for forty years, but I don't know if I could ever make a picture that is of the actual thing. It seems logical to me to change the context of the thing rather than try and make a photograph that had the aura and the history of this simple object. I have ideas like this often, and I am just going to try and see what happens. A friend and I removed the sign, and we took it back to my studio and cleaned it up. It was all broken, and I worked with a local neon artist, and we relit it. I was totally fascinated with that idea, which is the idea of trying to turn the lights on in these places, which eventually or intentionally bring it back to life, which is kind of funny to me and kind of silly. At the time, everyone was talking about this idea of the bailouts, which is the same idea—we just turn the lights on, and all these places will come alive again and kick-start the whole economic region. Yeah, there is this weird reverence for these things, which in terms of American history are meant to be disposable. They are meant to disappear and be disposable. I like that idea of trying to make them permanent. It is not in a way that I feel that they are necessarily special. I feel that they are in a way reminding people of that futility in investment, and luckily I have found others, and I've been digging around, and they are not easy to find, the correct ones and the correct shape, and to necessarily obtain them. It is just kind of wonderful.

There are still times, and maybe it is just dumb, but having this year to work on the Guggenheim Fellowship, I basically allowed myself to indulge in something that dumb and just see what happens and realize it and maybe put it up and then decide. That is a real luxury. Of course there is the precedent with other people who have worked that way. I think the biggest compliment that someone said to me, a friend and local artist-photographer, Terry Evans, after I showed her some of the first neon signs, said, "I never realized why Walker Evans did that at the end of his life until now." I was reading in

these books about how Evans would go back to all these sites that he photo-
graphed in the '30s and '40s and in the '70s and '60s and removed the signs
from them. He actually did an exhibit at Yale of the signs, and [they are] their
own objects, and it is this wonderful, weird, interesting idea.

You know, I am not necessarily interested in nostalgia, which is why I try
to avoid a brand. The first one said "City Life," but the "f" was missing. This
one says "Toys and Gifts," and it is so generic. And I have another one that
says "Fast Food," and it is just a big, red, dumb, broken fast-food sign in italic.

Speaking of historical perspectives, since it is a broad show, a survey show, are
there any artists or movements, in particular, contemporary artists, that you
are interested in or that you find to be influential?

There's a lot. I have always been interested in history. When I first started
really diving into photography as an undergrad student, I got a job at a library.
It was the best place for a young artist to work, as it is a place for research,
and you can see, how did other people explore these ideas? I remember early
on being particularly interested in Warhol and his ideas about building this
strange community, and also his ideas about history and commodity. It is
the weird things about Warhol that I totally love, his collections of objects
that are being sorted through for infinity in that small room [at the Warhol
Museum]. A Polaroid, a postcard, a pack of gum, some weird note and a tape
recording of a telephone conversation. He also said that the best museum
exhibit would be to lock up a grocery store or shopping center for ten or
fifteen years and then reopen it as a museum.

And then of course there are so many. When I first started doing *Retail*,
I was so fascinated by the idea that dawned on me that what I was looking
at wasn't much different than [what] the early impressionists, specifically
Manet and Caillebotte, were thinking about in terms of documenting or
making art about the transition from the eighteenth and nineteenth centu-
ries and all those changes happening specifically in urban centers. Paris was
becoming extremely commercialized, and a lot of their works talk about that
alienation. As well as with *Thrift*, I started doing portraits of the people who
had to sort all the stuff rather than the shoppers. To me, those were much
better characters. It seemed a futile thing to do, but I was trying to make por-
traits that functioned like a Duane Hanson sculpture—this working-class
person, placed in the wrong place. So I remember my experiences coming
across Duane Hanson's pieces in museums. I will never forget it; it is just so
amazing to have that kind of knee-buckling response to your reality. And of
course it is this very simplistic sculpture of a guy holding a broom or a secu-
rity guard, and you are allowed to stare and study, and to me, that work is so
much about photography, I keep going back to those.

With *Dark Stores*, I was thinking a lot about Brueghel [Pieter Bruegel the
Elder] and certainly Edward Hopper, but Brueghel with the seasons. I had
never really worked as a landscape photographer before, and there were
often times I would come to spaces and I realized, this is going to look so
much better in January when there is a foot of snow on the ground. It wasn't
easier, and, again, it was a luxury to be able to have that thought in June and
decide that I am going to have to come back in six months and then finally

being able to do that. But there are so many—not to mention the work of all of my friends, which is probably the biggest influence.

When did you start taking photographs?

I think it was 1994.

Can you walk me through what kind of cameras you have used, and what kind of cameras you are using now, and what you have used in the past?

When I learned photography, it was still very much based on the tradition of mostly black and white and hand processing and dealing with chemistry and fixer and spending many, many hours in darkrooms to make prints. So I started out, and for a very long time, just using a 35 millimeter camera, a Nikon with wide lenses, and the earlier work was very experimental, autobiographical stuff. I used that method for years until I moved back to New York when I began to explore color photography. I started giving myself assignments based on photographing with color slide film and gave myself a couple of years to try and understand how the world is rendered in color. When I came to Chicago, I learned to shoot with color negative film and make color prints. I was pretty surprised how quickly it came.

When I first started working on the *Copia* and the retail pictures, that project demanded a better fidelity. It is interesting to think about people looking in a mirror, and in order to be in a mirror, they had to look good and seductive, so I started using a medium-format camera that I borrowed from a friend, a 645. I used that format, and I still do, for a long time. But the fascination with fidelity led me to start experimenting with a 4 × 5 camera, and I was also just a little curious as to what will happen if I lug a 4 × 5 camera into an Ikea? Surprisingly, people left me alone more because I looked authoritative with it. When I started working on *Thrift*, that camera seemed to make even more sense because what I was photographing was so unglamorous that it really gave it a kind of presence.

The *Dark Stores*, grew out of using an 8 × 10 camera, which just seemed to be, on one hand, the quintessential architectural camera. The 8 × 10, has an optical fidelity that is just so over the top for the subject. Also I thought it was funny and stupid on my wallet's part to take pictures of things that really talked about the economy with a really expensive camera. Therefore I was thinking about economy with every click of the shutter. I really had to give it a lot of investment.

I have worked on and off with digital cameras, and recently I got a digital DSLR that does video, too. But still, for me, the camera comes out of the idea. It is like trying to figure out what a specific instrument is good for. I know it will work really well for a particular idea or project that I haven't figured that out at all yet.

That actually relates to my next question—about the changing field of photography—particularly with the advent of digital photography.

It is like people have this misguided notion that the thing that has changed is the camera, the fact that we are not using film. But really, the big thing that has changed is our relationship to and the understanding of the photograph.

Those things are important, but really what is much more interesting and has had that effect is that we have twenty-four-hour access to photography. That photography has been, as it has become digitized, it has become subsumed into the language of the Internet, and as it has become subsumed, it changes a lot of its rules and changes the way it functions in the culture, and it changes our fundamental way of understanding it. I have been thinking about that tremendously, and it is always funny when people are, like, "You still shoot film? You are, like, old school!" No, that is not what it is really about. It is really about the image not what makes the image. Those things are important, but the bigger things are a lot more fascinating.

In terms of social media and the Internet and artists having websites and blogs, is that all positive for you, or do you see it as a major distraction?

Yeah, there are tons and tons of distractions. I am way too distracted by what's going on in web-land, but it is also a tremendous tool, and I wouldn't have been able to do half or even a third of the *Dark Stores* pictures without the Internet. That is simply because when I started doing that project in 2005 I had a hard time finding the spaces to photograph. Because of the Internet—now, it wasn't easy, but it was possible to use this resource and information and to have access to that on the computer and everything else. What is kind of interesting about photography in this new form is, to me, photography is better than ever at existing as propaganda, and what I mean by that is that photography has less ability to be ambiguous. You could perhaps get away with putting a really odd, ambiguous photograph on the wall, and it would bring about a series of questions, but once a photo is on a web page, all of a sudden, the way that I start to solve those questions is through Wikipedia or forums. Once you start to move outside the picture, the power of that ambiguity has changed dramatically, but the propaganda thing has become amplified. Because what happens is, if one of my photographs ends up on a forum or political blog, and it is slightly ambiguous, and they look outside the picture to find out how, where, or what, it comes back to me and my website, it goes back to the other blogs and interviews where my works exist on the web, and it retains the context, which is, to me, a critique, which, this is dangerous to say, but it almost makes it harder to co-opt it into something else.

In the show, there will be three sections—forms, figures, and frontiers—and when I saw your work, I began thinking about forms, and I thought your work was a great fit. Could you speak about the influence of shape? And I see a lot of attention, when you take away the cultural context, to color, form, line in your photographs in a traditional way, and there are some really interesting geometric forms.

I think a bigger idea is that the forms reference the architecture. You just start to notice certain things that work, the ceilings of the stores, and when you photograph the stores, there is this big emptiness, and depending on where you are standing, to use that ceiling and the lights and the things that are happening and the shapes to try and direct the viewer around the frame to some degree of content that is happening. When I was in grad school,

during my first semester one of my teachers, Bob Thall, really harped on me to think about background, almost more about what was happening far in the space of the picture than what was happening in the foreground. That was a really great lesson because it was, like, all of a sudden, why would I leave half a word? Because text is really powerful in those environments.

What do you like seeing at museums?

I like to be surprised at an artist's retrospective and to see a certain degree of work that shows the working process. I remember going with my father to see a Mondrian show at MoMA some years back, this huge retrospective, and one of the best parts of the show for me—which maybe it is a cliché for museums to do this too much, but it really worked for me—was the recreation of the studio. My father pointed out, as my great-grandfather was a painter, "It is really interesting that he mostly used landscape brushes." You would never think that Mondrian, the captain of form and grid, would be painting with these—why landscape brushes?—but it makes a lot of sense. That kind of subtle thing completely transformed my way of thinking about him as an artist and the context of his work.

Anything you don't like seeing at a museum? Any qualms? Curators, curatorial practice . . .

Fig. 40. Brian Ulrich (b. 1971). Black River Falls, WI, 2006. LightJet C-print, 40 × 53 inches. Museum of Contemporary Art San Diego, Gift of Joyce and Ted Strauss, 2010.29. Cat. 173.

That is so tough. . . .

I have a kind of complete—this is going to sound almost—I really cannot stand the photography work that is based on the fairytale fantasy thing. The kind where privileged people are being curious about their own identity and having weird ambiguous cinematic questions about what is under the bed, which really represents a much bigger idea that I am not really sure the artists themselves knows. It is that kind of work that just drives me kind of nuts. It seems easy, it is art, and it is narrative, almost like Nancy Drew novels, but, and that is not to say that it cannot be done well, but that is one kind of photography that I find self-indulgent. I wonder why, and I would never go so far as to say that people shouldn't do anything, but for my own tastes, it just really. . . .

I also hate when artists who make political work just don't come out and say they are making political work because they don't think they will be accepted. I have had people say to me, you know, you shouldn't really talk about politics. The whole history of art is about politics and I don't know how you can separate and escape it. I recently saw a lecture by a photographer, a quite well-known photographer, where they just spent the whole time trying to excuse and remain ambiguous about the political nature of their work, and I think that is really irresponsible.

That's not how the work functions. If everyone is responding to those forms, then those forms just can't be abstract. I honestly believe that because of the language of visual culture and how sophisticated it is, the ultimate way that we as a race communicate is through visual communication, now more than ever, especially with the use of the Internet, images have even more power to change things. I am not one of those people who think visual culture doesn't change anything, if that were the case, then advertising wouldn't change anything—we wouldn't feel hungry when we saw the Big Mac on the billboard. It still works, and that is what is so powerful about it. People are having this conversation that photography is dead—I saw you watching the Super Bowl ads—so of course it is not dead. . . . it is all working still.

NOTES

1. The interview was conducted by Amy Galpin in the artist's studio in the Ravenswood neighborhood of Chicago, May 17, 2010. Since this interview, the artist has relocated to Richmond, Virginia where he is Assistant Professor of Photography at Virginia Commonwealth University.

2. During the interview, that artist discusses several different bodies of photographs, *Copia, Retail, Dark Stores,* and *Thrift* that he has worked on during the last decade, among others, that focus on consumer culture in the United States.

The Forest of the Old Masters: The Chiaroscuro of American Places

ALEXANDER NEMEROV

Why is it that certain American places have the emotional intensity of Old Master paintings? The American places I have in mind do not literally look like paintings by Rembrandt, but they sometimes have the gravity and pathos, the infinite depth and unaccountable lightness, of profound pictures. If one could fall through the darkness of a Rembrandt painting forever, descending through level upon level without reaching an end, one might do so walking down Stratton Street in Gettysburg, Pennsylvania, for example—the street down which Sergeant Amos Humiston of the 154th New York ran before being shot on the first day of the battle there.[1] In the vicinity where Humiston died holding an ambrotype of his three young children, as I walk that place now, the darkness seems to travel directly through objects, the cricket hum of dusk to penetrate metal mailboxes. The evening sweeps across the road, lit by fireflies and scented with fertilizer, passing through my body as if it is not there.

By contrast, where is the pathos of nineteenth-century American painting? Too often I look for it in vain. The windswept cloud, the deer drinking, and the boy dipping his paddle in the river—such scenes are only charming. The ruffled surface of the lake, the moss-covered boulder, and the leafy glade lack the scudding chaos of a more devastating view of the world. The manacled slave and dead soldier in other American paintings allude to calamities, yes, but too often without the permeating quiet of real sorrow. Even when these paintings depict specific places, and even when they do so according to Old Master prototypes, the effect is pleasant only, even when one discovers the compelling historical motivations for the mildness.[2] Asher B. Durand's *Landscape—Composition: In the Catskills* (1848; cat. 137) is an idyll, a delight, but where are the pockets of darkness and the startling blasts of light in such paintings that might make them answer to the pathos of American experience, to enslavement, war, and a thousand other horrors, not to mention the most thrilling pleasures—buoyant laughter, for example—people felt then? To put it another way, why do I feel that the depths and exhilarations of nineteenth-century American life are now to be felt, not in the art, but in the actual *places*

Fig. 41. Samuel Finley Breese Morse (1791–1872). *Gallery of the Louvre,* 1831–33. Oil on canvas; 73¾ × 108 inches. Terra Foundation for American Art; Daniel J. Terra Collection, 1992.51.

where events occurred, at the specific spots where people (real or imagined) smiled, suffered, or loved?

Samuel F. B. Morse's *Gallery of the Louvre* (1831–33; fig. 41), one of the most ambitious American paintings of the nineteenth century, offers a way to consider this question. Morse's painting portrays some thirty-eight works of the Old Masters and should therefore deliver a concentrated pathos of a kind that few American pictures could match. The Old Masters, after all, were never wrong about suffering, as the poet W. H. Auden would later put it.[3] But *The Gallery of the Louvre* does not achieve this emotional intensity, and the reasons it fails to do so offer a case history of the failure of American art to portray—to internalize and make its own—the pathos-filled light and shade of the Old Masters.

Morse did not succeed with *The Gallery of the Louvre*—that is well known. Living in Paris in fall 1831, he had conceived the idea of making a grand picture portraying Old Master paintings at the Louvre, a picture that he could then display back in the United States for the edification of his fellow citizens and at a profit for himself. Working "at a grueling pace," as the art historian Paul Staiti writes, Morse painted miniature versions of pictures by Leonardo, Raphael, Rembrandt, and others, arranging them in an imagined hanging in the Louvre's Salon Carré (no such display of works likely ever existed).[4] Undaunted by a cholera epidemic sweeping through the city, Morse kept at the task and completed his monumental canvas (measuring some six by nine feet) in August 1833. When he displayed it on Broadway in New York that October, however, the painting was a critical and commercial failure: few came to see it. The following August, a bitterly disappointed Morse sold *The Gallery of the Louvre* to a private collector, and soon he abandoned painting altogether, taking up experiments in electromagnetism. His invention of the telegraph in 1844 made him famous.

The failure of *The Gallery of the Louvre* can be accounted for in two ways: one accurate and familiar to historians of American art; the second less familiar and even strange but perhaps equally accurate. Both concern the relation of the Old Masters to American experience. The first explanation, the correct and familiar one, goes as follows. Showing genteel figures politely discussing and copying the fine European pictures around them, Morse's painting depicts a society of erudition and discernment at a moment when the United States had become increasingly intolerant of such elitism. The Second Great Awakening, the industrial and market revolutions, and other momentous social transformations of the years around 1830 were making the United States a very different place than it had been.

Morse, front and center in his own painting, where he comments on a young woman's picture (fig. 42), was out of touch with a newly populist America.[5] In contrast to his social and religious conservatism—the artist was "raised on Calvinist doctrines of the elect and believ[ed] in Federalist notions of social order and elite rule," writes Staiti—the ex-soldier Andrew Jackson, president from 1829 to 1837, oversaw an increasing shift to the common man in American politics.[6] Amid such clamor, Morse's graceful calm was bound to fall on deaf ears. Against the moving spectacle of a barge of flour traveling smoothly down the Erie Canal, Guido Reni stood no chance.[7] The telegraph would be Morse's great address to the democratic multitude. Claude and Murillo, by contrast, did not speak to Americans.

But here is the second explanation. Claude and Murillo—or any of the Old Masters—*could* have talked to Americans of the 1830s if only their work had not been rendered of so little consequence by Morse himself. At first this does not make any sense. Was not Morse the champion of the Old Masters—the one who braved the cholera epidemic and who for nearly two

Fig. 42. Detail of fig. 41.

years broke off from his grand painting only to eat and sleep in order to bring the wonders of their art to his fellow Americans? Moreover, was he not the *only* person with such an ambitious aim? How then could he be the one who thought their work mattered so little?

The reason is this. Morse made the Old Masters into a sign of refinement when they might as easily have been made into a sign of broad American experience as it was then—the hardscrabble life of the docks, the gloom of the forests, the mercurial fortunes of the silk-clad, and the slaughter rags of the poor. Instead of quarantining the Old Masters as emblems of decorous behavior and cultural literacy, *The Gallery of the Louvre* might have made the emotional range of the great old pictures answer to the light and dark of lived experience in the 1830s. Would not the wisdom of these paintings— with their miracles and lamentations, their blessed births and their cruelties brought down on the heads of the helpless—be every bit the stuff to portray the squalor and beauty of Morse's era?

The failure is all the more striking because Morse had started his painting career some twenty years earlier with the attitude that the Old Masters *could* be a way of showing the lived experience of his time. His *Dying Hercules* (fig. 43), which he painted in 1812–13 while in London as a twenty-

Fig. 43. Samuel Finley Breese Morse (1791–1872). *Dying Hercules,* 1812–13. Oil on canvas; 96¼ × 78⅛ inches. Yale University Art Gallery; Gift of the artist, 1866.3.

one-year-old student of Washington Allston, is a crude but ambitious adaptation of Michelangelo and the central figure of the famous Hellenistic statue group, *Laocoön.* More than that, the vast eight-by-six-and-a-half-foot painting strives to connect Old Master art to contemporary experience. It does so partly by allegory: Hercules, struggling with the poisoned cloak of Nessus, may be an emblem of the United States during the War of 1812, according to Staiti.[8] But more fundamentally, the lurid color, violent foreshortening, and strange diagrammatic segmentation of the hero's body—the trilobite musculature of the abdomen, the X-ray of the left shinbone and toes—conspire to make the work into something more than allegory, something we could call *sensuous immediacy,* or at least a very good attempt at it. Hercules's agony is neither the shrill torture of an actual living soul nor an entirely persuasive emotional rendering of such pain but an exploitation of the young artist's awkwardness for all that it is worth, so that the power of the painting arises from the student crudity of each gesticulation, which somehow makes a slow and darkened map of suffering. The young Morse ends up persuading us of the hero's pain by portraying, mark for mark, the pains he took as an artist.

All that is gone, or almost gone, in the suavity of *The Gallery of the Louvre.* There, twenty years later, on a canvas basically the same size (imagine *The Dying Hercules* turned on its side, and you would have a canvas of nearly the same dimensions as *The Gallery of the Louvre*), the flaming anguish of

the larger-than-life hero has become the untroubled light of the Salon Carré. Almost all that remains of *The Dying Hercules* is the small copy at upper right of Guido Reni's great painting *Deianeira Abducted by the Centaur Nessus* (fig. 44), showing Hercules's wife and the centaur who has taken her away. Big has become small; passion and struggle have become the mildness of a mere cultural literacy: the Old Masters have been belittled. Morse's reduction of the Old Masters, no matter how it relates to the sheer practical considerations of his project (how to fit as many of these paintings as possible into one grand picture) and to the pictorial conventions of the *Kunstkammer* tradition he emulated, says a lot about his attempt to diminish, to scale down, the potential thunder and energy of their art and, by implication, its relation to American life.

Maybe that is why the painting has the quality of a parlor game. Perhaps because of the separate small copy he made for a friend of Titian's *Francis I* (one of the paintings shown in *The Gallery of the Louvre*), all of the small pictures in Morse's grand painting have the quality of playing cards. As the monarch of France looks like a king drawn from the deck (fig. 45), so the other pictures in Morse's painting take on the quality of chits, counters, colorful playthings. Smallness and seriousness sometimes go together, but here they do not. The paintings have become markers in a game of cultural pretense. Instead of the flexing prehistoric chest and stomach of Hercules, we have only the segmentation of neat little frames, spread across the picture one by one, the torsion of muscular effort having become the play pieces of a refined relaxation. The anguished contraction of muscles, in their "hot red coloration,"[9] becomes the mellow glow of the Grande Galerie receding in perspective, promising more cultural enjoyment.

Fig. 44. Guido Reni (1575–1642). *Deianeira Abducted by the Centaur Nessus*, 1617–21. Oil on canvas; 94.1 × 75.98 cm. Musée du Louvre; Collection of Louis XIV, inv. 537.

Fig. 45. Samuel Finley Breese Morse (1791–1872). *Francis I, Study for "The Gallery of the Louvre,"* 1831–33. Oil on panel; 8 × 10 inches. Terra Foundation for American Art, Chicago; Gift of Berry-Hill Galleries in honor of Daniel J. Terra, C1984.5.

Even the depicted figures within their frames are at ease. If one looks at them closely, Morse's rendition of Leonardo's *Mona Lisa*, Rubens's *Isabella Fourment*, and Raphael's Madonna in *La Belle Jardinière* do not have the same expressions they have in the original paintings. Morse's versions are cheery and benevolent, as if they succumb—happily, even—to the wan atmosphere of an enchanted land that has banished all struggle and strain. Leonardo's and Rubens's young women peer from their frames with kindly looks, as if with beneficent approval of the mild cultural enjoyment for which their paintings have become an occasion. Likewise, Raphael's Virgin looks down from her position higher on the wall as if to sanction the modesty and chastity of the cultural attainments she sees below her. There are no longer any herculean efforts in this picture that records the great achievements of the great painters, not even the herculean effort of Morse himself in making the picture. And when his grand attraction came to New York, it did not present an awe-inspiring spectacle the likes of which no one had ever seen, as another colossus (King Kong) was to do before a crowd of thousands in that city exactly one hundred years later. Instead, by the artist's own design, *The Gallery of the Louvre* sat sedately in the most untroubled calm, and it did so, consequently, before an average daily audience of about a dozen people.[10]

The Old Masters themselves were not then at fault. There was nothing innate in their art that made it out of touch with Jacksonian America. It was instead Morse's decision to present their work so narrowly that caused the public's lack of interest. At first this seems unfair. Few Americans then could have called for a wise public art that would answer to lived experience, and Morse was not inclined to be such a person, for reasons of temperament and social background.[11] Only Ralph Waldo Emerson could see the "frescoes of Angelo" and "a squirrel leaping from bough to bough" as sights equally "beautiful" and "self-sufficing," each vision helping us to see the "immensity of the world" and "the opulence of human nature, which can run out to infinitude in any direction."[12] And even then, Emerson regarded these two visions only in parallel and not blended together, as he would have needed to do in order to claim that the Old Masters were a medium for apprehending American experience. But it is still possible to be disappointed with Morse for missing his chance with *The Gallery of the Louvre*. He, too, could have made the art of the past resonate with contemporary American experience. Arguably, he could have done so better than anyone, since his picture was the most extensive effort any American made in those years to imagine the old European paintings in relation to the United States of the 1830s.

It is even possible to think that the public indifference to *The Gallery of the Louvre* was a form of ringing praise for the Old Masters, manifest as resentment that pictures of such feeling should be used in such a small-minded fashion. Even if he knew only remotely or hardly at all of such pictures before seeing versions of them in *The Gallery of the Louvre*, a viewer could sense, examining his disenchantment in front of the picture (is that all there is?), that something more must be out there, even *is* out there—that these playing cards are a deceitful trick, that they are a full deck, yes, but of frauds, that something has been worked on a spectator regarded as all too gullible, as a rube or rustic, whom Morse's painting is counting on to be beguiled by this show of dexterity. In fact, the real world—and the capacity of certain

works of art to portray it, forever, immediately, with power—did exist else-where, or so *The Gallery of the Louvre* might have inadvertently announced. The big mistake Morse's painting makes is to give the viewer a clue that this more urgent world of art and life does exist—perhaps everywhere except in Morse's painting itself. The hall of facsimiles, meant to forestall further inquiry and to be a summation of all the Old Masters can and should be to Americans, prompts the earnest and even urgent question: if this be passion in small, fitted to such a narrow purpose, what must passion be like in an art that speaks largely to American life?

Despite its limitations, *The Gallery of the Louvre* hints at an answer, in the form of Morse's friend James Fenimore Cooper. The novelist, newly famous for novels such as *The Last of the Mohicans* (1826), appears in the painting standing next to his wife Susan Delancey Cooper as they comment on the copying work of their daughter Susan, seated at her easel before them (fig. 46).[13] Cooper, it is true, appears at first as only another mild and genteel connoisseur. We can imagine him holding forth with complacent erudition (note his pointing hand) as he speaks about the Old Master pic-tures he loved to search for and collect with Morse. The two had known each other since 1823, had met up while abroad in 1830 in Florence and again the following year in Paris, and we could suppose the artistic tastes of the two politically conservative friends to be similar.[14] But in his own work, Cooper did not belittle the Old Masters as Morse did, and his relation to their art is more dynamic.

Look again at Cooper in the painting. His gesture is about more than polite instruction; it is also about the relation between Old Master painting and his fiction, specifically between the light-dark schemes of these paint-ings and the "chiaroscuro" of his writing, as it has been termed by the literary

Fig. 46. Detail of fig. 41.

historian Donald Ringe.[15] This chiaroscuro is an element of what D. H. Lawrence praised in 1925 as Cooper's pictorial imagination, namely, his capacity to make "Pictures! Some of the loveliest, most glamorous pictures in all literature."[16] And it is part of what Honoré de Balzac meant, in 1840, when he commended Cooper's "series of marvelous pictures" that afford "a school where the literary landscape painter should study."[17] Ringe, identifying the "arrangement of light and shadow" as an "important painterly technique" in Cooper's work,[18] invites us to think of *The Leatherstocking Tales* and the Old Masters as somehow rhymed together, as if around the chattering stream and lightning-shattered pine there gathered the thick and throaty and all but volumetric darkness of Rembrandt.

Consider one of the most famous sequences in Cooper's fiction—the one that takes place in the cave at Glens Falls in *The Last of the Mohicans.* The cave is the hiding place of Hawk-eye, Uncas, Chingachgook, Major Heyward, the preacher David Gamut, and the two daughters of Colonel Munro, Cora and Alice, as they make their perilous way to Fort William Henry. In vividly pictorial terms, Cooper describes the party's journey via canoe to the cave at night, giving their views of the darkened forest: "All beneath the fantastic limbs and ragged treetops, which were, here and there, dimly painted against the starry zenith, lay alike in shadowed obscurity. Behind them, the curvature of the banks soon bounded the view, by the same dark and wooded outline."[19] The scene is "painted," "bounded," and "outline[d]," all in accord with what Ringe calls Cooper's penchant for describing a view "as if it were literally a painting."[20]

Moreover, it is not any painting but specifically a Rembrandt-type darkness that is most striking in the Glens Falls scene. Again, Cooper's role in *The Gallery of the Louvre* provides a clue. He stands close to Rembrandt's *Angel Leaving Tobias and His Family*, the painting just to the side of Susan Cooper's easel, between that easel and the woman wearing the tall pointed hat

Fig. 47. Rembrandt Harmensz. van Rijn (1606–1669). *The Angel Leaving Tobias and His Family,* 1637. Oil on canvas; 66 × 52 cm. Musée du Louvre, Paris.

(fig. 47). Cooper admired this painting by Rembrandt and commissioned a copy of it from Morse. He also owned a Rembrandt print, *The Tribute Money*, that he had purchased from Morse and would offer to sell back to him in 1849 (fig. 48). Morse, in the fourth and last of his Lectures on the Affinity of Painting with the Other Fine Arts, delivered on April 12, 1826—lectures he had been preparing at least since November 1825, when Cooper was still at work on *The Last of the Mohicans*—discussed three engravings copied after Rembrandt, including *The Holy Family* and *The Presentation in the Temple* (fig. 49).[21] Still earlier, ever since they first met in New York in 1823, the year before Cooper got the idea for his novel, the two men likely had talked about art and probably pored over Morse's collection of prints that he would use in his lectures, including the Rembrandts.

In *The Deerslayer*, published in 1841, Cooper describes the "dark Rembrandt-looking hemlocks" of a forest,[22] and perhaps the chiaroscuro in *Last of the Mohicans* is

the same. In the night at Glens Falls, Hawk-eye disappears into the "impenetrable darkness." That same night, Hawk-eye, Uncas, and Chingachgook "disappeared in succession, seeming to vanish against the dark face of a perpendicular rock." Slightly earlier that evening, as the canoe moves down the river, in "the thickening gloom which now lay like a dark barrier along the margins of the stream," Heyward notices "a cluster of black objects, collected at a spot where the high bank threw a deeper shadow than usual on the dark waters." This dark is so dark, Hawk-eye says, that "an owl's eyes would be blinded by the darkness of such a hole," which turns out to be a cave. Intermittent dazzles of light, as in *The Angel Leaving Tobias and His Family* and *The Tribute Money*, are equally Rembrandtesque in the Glens Falls sequence—as when Hawk-eye holds "a blazing knot of pine" at "the further extremity of [the] narrow, deep cavern."[23]

The angel in Rembrandt's *Angel Leaving Tobias and His Family* suggests another Old Master effect in Cooper's Glens Falls—severely foreshortened figures that dangle, hang, and peer from above. Heyward and Hawk-eye, looking upward from the cave (situated at midlevel between the upper and lower cascades of the falls), see a Huron brave "floating over the green edge of the [water]fall" above them in the dawn light. The warrior tries to gain a point of safety by grasping onto a stump of vegetation at the crest of the fall and from that point to attack them, but he is whirled away at the last moment by the current. At that moment, he "appeared to rise into the air, with uplifted arms and starting eyeballs, and fell, with a sullen plunge, into that deep and yawning abyss over which he hovered." Slightly later in the fight, another Huron warrior, shot in the upmost branches of the tree in which he had been hiding, "was seen swinging in the wind . . . grasp[ing] a ragged and naked branch

Fig. 48. Rembrandt Harmensz. van Rijn (1606–1669). *The Tribute Money*, 1629. Oil on oak; 16½ × 12⅞ inches. National Gallery of Canada, Ottawa; Purchased 1967, 15231.

Fig. 49. Rembrandt Harmensz. van Rijn (1606–1669). *The Presentation in the Temple in the Dark Manner*, ca. 1654. Etching and drypoint; 8¼ × 6⅜ inches. The Metropolitan Museum of Art; Gift of Felix M. Warburg and his family, 1941, 41.1.16.

of the tree, dangling between heaven and earth."[24] Rembrandt's angel alike hangs in the air, as if to affirm the effects Cooper had already begun creating the previous decade.

Maybe he had a source for doing so, not pictures by the Old Masters but a painting meaningfully derived from their art. Morse's *Dying Hercules* also evokes these pained figures at the falls. Morse had taken the painting back with him to the United States when he returned in 1815 and exhibited it in Boston that year and in Philadelphia in 1816 but had never found a buyer for it.[25] It remained in his possession during his lifetime, and Cooper would have seen it in New York in the early 1820s. Consider the fate of Cooper's Huron flowing over the falls. He "struggled powerfully to gain a point of safety" and was "already stretching forth an arm to meet the grasp of a companion" but then "appeared to rise into the air, with uplifted arms and starting eyeballs," as "a single, wild despairing shriek rose from the cavern."[26]

Or consider the second Huron, the one hanging mortally wounded from the bough of the tree in those "few moments of vain struggling . . . hands clenched in desperation." Eyeing the sufferer, the humanitarian Heyward "turn[ed] away his eyes in horror from the spectacle of a fellow creature in such awful jeopardy."[27] Although the match between these passages and Morse's *Dying Hercules* is far from exact—and though indeed one would not expect it to be exact, for it is not plausible to think of Cooper deliberately basing scenes on a painting, stroke for stroke, sentence for sentence—the resemblance is near enough to indicate that Morse's first Old Masterly painting, or something like it, might be a basis for Cooper's strenuous wilderness chiaroscuro.

The key word here is *invention. The Gallery of the Louvre* shows Cooper's inventiveness, his way of adapting the Old Masters to American scenes. It does so, however, not in the literal figure of Cooper himself, prim in his educational role, but in the painter at lower left, in the vicinity of the novelist and his family (fig. 50). Shown along the same axis as Cooper—the base of the wall connects them—this young man in a red turban may be Richard West Habersham, whom the art historian David Tatham identifies as "a painter from Georgia who shared rooms with Morse in Paris in 1832" and "an intimate of the Coopers."[28] But we can also regard him, there in proximity to Cooper, as a surrogate depiction of the word-painter himself, now removed from his persona as polite cultural instructor and given a much more heroic and solitary guise as an individual creator.

This young man is at work on a landscape (on his canvas, a waterfall flows from a smooth mountain lake just below his right hand). The picture corresponds to none of the paintings we can see in the Salon Carré. He is making an original picture, drawn from the wall of sources before him. Accordingly, the painter exhibits an active, engaged relation to the dark picture on his easel. His weight resting on the right leg, just the right knee really, so that the sole of the right shoe appears, he assumes the unconsciously awkward stance of a person absorbed in making his work. For such a solitary creator, the array of pictures before him—not just landscapes, but all of them—amounts to a range of inspiration rather than a source to copy. Cooper's chiaroscuro is likewise an invention drawn from a gallery of sources.

Fig. 50. Detail of fig. 41.

Even so, the invention takes place in an atmosphere of copying. This is because copying artifacts from Europe and turning them into American inventions was a method of the times. Cooper is alleged to have begun his writing career by deciding to emulate Sir Walter Scott's extremely successful Waverley novels, as though such emulation were easy. "Madly reasoning" that he could match Scott, Cooper "launched his own career in the expectation that it would solve all his financial ills," according to his biographer.[29] His forest chiaroscuro may have been a similarly brash borrowing. His inventive copying likewise calls to mind the American businessman Francis Cabot Lowell, who, in Manchester, England, just before the War of 1812, memorized the technology of the power looms he saw there. When he returned, he and his master mechanic, Paul Moody, were able to fashion their own operational water-powered loom in Waltham, Massachusetts, in 1814, inaugurating the large-scale cotton textile industry in the United States.[30] Yankee ingenuity was one and the same with the perfect copy; the perfect copy, to put it another way, became an original when inventively adapted to a new situation. Susan Delancey Cooper referred to Rembrandt's *Angel Leaving Tobias and His Family* as "the steamboat," alluding to Robert Fulton's invention of the commercial steamboat in the first years of the nineteenth century. (Rembrandt's angel's wings reminded her of a steamboat's churning side wheels.)[31] If Rembrandt was a pictorial inventor, so was the American novelist who copied from Rembrandt in painting his scenes.

There was an urgent cultural need for such invention. This need had to do not with the paucity of American arts and letters in the 1820s—the relative deficiency in cultural attainment that Morse, Cooper, and other culturally minded Americans felt at the time—nor with the emptiness of American

places but rather with some combination of the two. It was a need to make the American arts answer to locations that already in the 1820s seemed to be not only empty spots, discouragingly overgrown and inelegant, but also the location of swarming historical associations both real and imaginary. Such places needed descriptions that would match their emotional power, stroke for darkened stroke. At Glens Falls, on an upstate New York trip in 1824 in company with several English travelers, Cooper got the idea to write a novel with a key scene set at the cave there.[32] Surveying this impressive yet blank place, crossed by a footbridge directly above it, and with the mills and other businesses of burgeoning Glens Falls all around it, Cooper probably felt acutely the problem of how to give it mysterious life.

The Old Masters, accordingly, might have supplied him with a machinery for making light and dark, a factory that could stream out chiaroscuro of the highest quality by the yard. In that place of industry, Cooper had his own mechanical invention near at hand, his own source of commercial prosperity. So from a warehouse of splendor, for a sensibility so attuned, there would be a limitless supply of that profundity in such sharp demand when all there was in the American scene were some trees, some rocks, and a few holes in the ground. With their dark and tragic pictures of significant human actions and compelling human fates, the Old Masters offered to a nascent literary and artistic culture a vivid example of what profound emotion might look like. Their works were a starter kit of gravitas, pathos in a can, as if sprinkling some of that heroic darkness and those flecks of light would transform even the most inchoate and disappointingly blobby American scene from just patches of trees and shrubs, with here and there a human association, into a rich, time-smoked black on black, a patina of shadows lit with crepuscular

Fig. 51. John Ferguson Weir (1841–1926). *The Gun Foundry,* 1864–66. Oil on canvas; 46½ × 62 inches. Putnam County Historical Society.

or blazing glows, that consequently would have, made to order, the infinite depth of real art.

Is such gravity always absent in American nineteenth-century painting? Not necessarily. Consider John Ferguson Weir's *The Gun Foundry* (fig. 51), a picture that revises *The Gallery of the Louvre*, acknowledging the earlier painting's failure to make proper use of the Old Masters. Painted between 1864 and 1866, *The Gun Foundry* shows the great munitions factory in Cold Spring, New York, across the Hudson from West Point, where Weir, born in 1841, grew up as the son of the accomplished artist and West Point art professor Robert Walter Weir (1803–1889). The younger Weir's large work—a multifigure composition measuring roughly four by five feet—shows a team of workers casting a Parrott gun, a high-performance cannon invented by Cold Spring resident Robert Parker Parrott. The foundry at Cold Spring produced some three thousand during the war.

The action in Weir's painting can be made out in detail. "A huge crucible of molten metal has been swung into place, held by a heavy chain supported by a timber crane," writes the art historian Betsy Fahlman. "Four men at a windlass struggle to lower it, while another helps steady it with a guide chain. Six more work to tip the heavy cauldron to pour the spluttering and hissing thick molten iron in the mold," lighting up the darkened interior of the foundry.[33] To the far right, solemnly watching the event, are Parrott and his wife, Mary Kemble Parrott (the leftmost couple in the group), a Union officer and a woman in a red dress (possibly the Cold Spring native General Gouverneur Kemble Warren and his wife, Emily Chase Warren), and, seated next to them, an older man, Warren's namesake, Gouverneur Kemble, who started the foundry back in 1818.

Fig. 52. John Ferguson Weir (1841–1926). *An Artist's Studio,* 1864. Oil on canvas; 25½ × 30½ inches. Los Angeles County Museum of Art; Gift of Jo Ann and Julian Ganz, Jr., M.86.307.

Weir's painting, despite its markedly different subject, bears an oblique but powerful relation to *The Gallery of the Louvre*. The young artist's most ambitious painting before *The Gun Foundry* had been *An Artist's Studio*, completed in January 1864, a depiction of his father, Robert, at work in the family's West Point home (fig. 52). *An Artist's Studio* shows the elder Weir seated at a desk to one side of a large easel displaying his painting *Taking the Veil* and also includes several paintings on the walls, notably at right, as well as a painted sketch at left identified by Fahlman as a copy after Rembrandt's *Christ Preaching*. Calling *An Artist's Studio* "a personal and native version of Samuel Morse's *Gallery of the Louvre*," Fahlman perhaps goes too far, but the link between Morse and the Weir family is difficult to miss. Robert Weir had been a young faculty member at the National Academy of Design founded by Morse in 1826, and in 1833, West Point had considered hiring Morse as a drawing instructor before eventually settling the following year on Weir.[34]

Moreover, the young John Ferguson Weir would have known about Morse not only from his father's experience but because of Morse's summer home, Locust Grove, designed by Alexander Jackson Davis in 1847 and located twenty-six miles up the Hudson in Poughkeepsie.[35] When Weir himself became an art professor and the first dean of Yale's new School of Art in 1869, it made sense that Morse's reputation followed him there as well. Morse, a member of the Yale class of 1810, had sought to promote the arts even back then, and as the young Weir started his professorship, according to Fahlman, he "was carrying on the ambitious cultural work exemplified by Morse's *Gallery of the Louvre*."[36] Morse's painting had been hidden away since 1834 as part of the collection of George Hyde Clarke (on Otsego Lake, not far from Cooperstown), but its legacy remained as perhaps the most ambitious picture yet attempted by an American—the one that dared to offer a definition of artistic cultivation in the United States. Younger artists such as Weir were bound to know of it, by hearsay or legend at the least.

How he responded to it in *The Gun Foundry* is another question. In the painting's depiction of a large interior space with a very high ceiling, roughly equivalent to the interior of Morse's Salon Carré, there are of course no pictures. But that is just the point. The paintings, being nowhere present, have not exactly gone away; instead, they have been dispersed as the very atmosphere of the foundry, its furnace gloom of lights and darks, what a critic in the *American Art Journal* of May 1866 called "the grand intermingling of fire-light from the molten metal with the light from the roof and the floating fumes of the furnaces . . . amid the fumy obscurity."[37] Without quoting Old Master paintings, Weir created a visceral effect made with Old Masterly means.

Think of the relation between *The Gallery of the Louvre* and *The Gun Foundry* in another way. The fiery sunsets visible in the paintings within Morse's picture, those of the two Claude Lorraine pictures on either side of the entryway, for example, have in Weir's picture jumped their frames and become instead, no longer just art, but the liquid glow of the boiling iron in the cauldron. Likewise, the tenebrous dresses and murky lands of many another Old Master painting in Morse's picture, those of the Cornelis Huysmans and Salvator Rosa landscapes at upper right, for example, have become the spreading shadow of the foundry's cavernous interior. The viewer is

consequently held "spell-bound and breathless," to use the terms of the *American Art Journal* critic, who called the painting the greatest picture on display at the 1866 National Academy of Design exhibition.[38] The point is not that *The Gun Foundry* achieves a power equivalent to that of a great Old Master painting—I believe it does not—but rather that it makes an impressive attempt to imagine how such a power might be let loose in American art. In Weir's painting, the Old Masters no longer need sit idle, static, and rather vainglorious on the walls as the objects of a merely respectful attention. Instead, they have become one and the same with the chiaroscuro of American experience that is the artist's subject. This is not a museum without walls but walls without a museum.

To put it this way, however, is to describe Weir's process too mildly. The Old Masters in his painting must suffer a flaming death and a pulverizing dissolution in order to be so born again as the stuff of an American scene. No matter how much we might say *The Gun Foundry* resembles the lighting scheme of a Rembrandt—for example, the *Christ Preaching* Weir had depicted in his father's studio—the point is not that he modeled *The Gun Foundry* on an Old Master template. He did not make the molten iron into a religious radiance, substituting an industrial epiphany for the glowing body of Jesus. Even though Gouverneur Kemble's own collection of Old Master paintings might have furnished him with a basis for *The Gun Foundry*,[39] and even though some of his father's prints and copies after seventeenth- and eighteenth-century European painting might have been sources, Weir aimed for no one-to-one correspondence between those pictures and his. To do so would have left the Old Masters intact—would have implied that "firelight" and "fumy obscurity" need be a matter only of switching a biblical or religious subject for a modern industrial one—when the point was to destroy these vaunted painters in order to let them live: to let their light and dark rain down across the whole scene rather than sit discretely enframed. Then the chiaroscuro could powder the atmosphere with the granular dust of these exploded pictures, allowing an ordinary American situation to acquire the emotional majesty of Old Master paintings even as those paintings themselves would, literally speaking, disappear from the scene. Here are the labors of Hercules portrayed by the light of Hercules's immolation. The hero is destroyed so that his atmosphere lives.[40]

For Weir, this was a matter of invention and hard work. In addition to Parrott, the designer of the cannon, *The Gun Foundry* emphasizes the heroic ingenuity of the laborers in their act of creation. The white-shirted foreman front and center, with his leather apron, expertly handles the guide chain that will help allow the boiling iron to be poured smoothly into the mold. Just to the left of the foreman, another laborer turns a stake in the earth, playing his part in the process. Both these men—perhaps especially the latter one—evoke the front-and-center figure of Morse bending to the left in *The Gallery of the Louvre*. But whereas Morse is the calm figure of discernment, commenting on the young woman's copy, the comparable men in *The Gun Foundry* define creation as hard work and careful calculation. Their relation to Morse is not exact. They correspond to him much as the phrase *Gun Foundry* does to *Gallery of the Louvre*: the matching "ou" and penultimate "r" of *Foundry* and *Louvre*, the matching "G" of the first word *Gun* and *Gallery*.

But that relation is tantalizing nonetheless. It is as though Morse would have made a better painting had he chosen to depict his own indefatigable labors while the cholera epidemic raged through Paris, or if he had chosen to portray the sheer effort required to paint so many copies of the Old Masters in such a relatively short period of time and in such stressful circumstances—rather than the placid composure concealing all that effort and stress. *The Gun Foundry*, showing intensive labor, may even be said to depict Morse's own hard work—his boiling of the light, his grinding of the shadows—as if it were Weir's respectful wish that, as the older man aged (Morse would die in 1872), his grand efforts to make his most ambitious picture should not be forgotten.

Weir's inventiveness, like Cooper's some forty years before, served an urgent cultural purpose. During the Civil War, what was more needed amid the brutality than the production of Old Master pathos? Better Rembrandt than the feckless representational bromides and timid allegories meant to address the horror in so many other contemporaneous works, even if those representations did achieve a widespread and superficial praise in that era. Walt Whitman wrote that the war's "interior history will not only never be written, its practicality, minutia of deeds and passions, will never be even suggested," and so much Civil War painting likewise never found that interior history.[41] Yet *The Gun Foundry* sets out on a much more ambitious project, akin to Whitman's poetry: namely, to depict not just the production of artillery for the Union but the making of a language of light and dark capable of portraying the emotion of the times. Heroically laboring, the men embody Weir's own purpose, "the honest, intelligent industry which the artist has bestowed on his subject," as the *New York Times* put it on May 1, 1866.[42] He took the raw materials of the Old Masters and manufactured an endless supply of molten pictorial emotion, putting it into streaming production, so that no artist from that time, faced with a death or joy to paint, need ever again be without blasts of radiance and deep darkness to draw upon. The men in Weir's painting work so hard because the times depended on it. *The Gun Foundry* shows the making of chiaroscuro.

It matters that all this happens in a particular place. For an American painting to achieve the depth of an Old Master picture, it needed to be set in a specific location, *The Gun Foundry* implies. This was perhaps because in ways imprecise and, one feels, impossible to describe either for the artist or for a historian, the places themselves came, as it were, ready-made with a certain amount of this shadowy atmosphere. To match a manner of painting with those places, as Weir did in *The Gun Foundry*, was to combine like with like, spreading the diffused dust of a thousand destroyed Old Master paintings across a space whose own atmosphere only *seemed* blank beforehand. In fact, these empty places already contained a light and shade that saturates the rare pictures whose chiaroscuro matches their own.

1. For the story of Amos Humiston, see Mark H. Dunkelman, *Gettysburg's Unknown Soldiers: The Life, Death, and Celebrity of Amos Humiston* (Westport, CT: Praeger, 1999).

2. See, for example, Bryan Jay Wolf, "All the World's a Code: Art and Ideology in Nineteenth-Century American Painting," *Art Journal* 44 (Winter 1984): 328–37, and Angela Miller, *The Empire of the Eye: Landscape Representation and American Cultural Politics, 1825–1875* (Ithaca, NY: Cornell University Press, 1993).

3. W. H. Auden, "Musée des Beaux Arts," in *The English Auden: Poems, Essays and Dramatic Writings, 1927–1939*, ed. Edward Mendelson (London: Faber and Faber, 1977), 237.

4. Paul Staiti, *Samuel F. B. Morse* (Cambridge: Cambridge University Press, 1989), 191.

5. For the identification of Morse and the other figures in the picture, see David Tatham, "Samuel F. B. Morse's 'Gallery of the Louvre': The Figures in the Foreground," *American Art Journal* 13 (Autumn 1981): 38–48.

6. Staiti, *Samuel F. B. Morse*, 209; for the Jacksonian era, see Christine Stansell and Sean Wilentz, "Cole's America," in *Thomas Cole: Landscape into History* (New Haven, CT: Yale University Press, 1994), 3–21; Paul E. Johnson and Sean Wilentz, *The Kingdom of Matthias* (New York: Oxford University Press, 1994); Wilentz, *Andrew Jackson* (New York: Times Books, 2005); and Wilentz, *The Rise of American Democracy: Jefferson to Lincoln* (New York: Norton, 2005).

7. For the barge of flour moving down the Erie Canal, see Paul E. Johnson, *Shopkeeper's Millennium: Society and Revivals in Rochester, New York, 1815–1837* (New York: Hill and Wang, 1978).

8. Staiti, *Samuel F. B. Morse*, 22.

9. Ibid., 23.

10. Ibid., 199.

11. For Morse's temperament in relation to two other pictures, his *House of Representatives* (1822–23; Corcoran Gallery of Art) and *Allegorical Landscape of New York University* (1836; New-York Historical Society), see Elisa Tamarkin, *Anglophilia: Deference, Devotion, and Antebellum America* (Chicago: University of Chicago Press, 2008), xv–xxii, 320–22.

12. Ralph Waldo Emerson, "Art," in *Ralph Waldo Emerson: Essays and Lectures* (repr., New York: Library of America, 1983), 433. Published as *Essays: First Series* in 1841.

13. For the identification of this figure as Cooper, see Tatham, "Samuel F. B. Morse's 'Gallery of the Louvre,'" 40.

14. For Cooper's conservatism, see Staiti, *Samuel F. B. Morse*, 143–48, and Alan Taylor, *William Cooper's Town: Power and Persuasion on the Frontier of the Early American Republic* (New York: Vintage, 1995).

15. Donald A. Ringe, "Chiaroscuro as an Artistic Device in Cooper's Fiction," *PMLA* 78 (September 1963): 349–57.

16. D. H. Lawrence, *Studies in Classic American Literature* (New York: Viking Press, 1973), 55.

17. Honoré de Balzac, *Knickerbocker Review* 17 (January 1841): 75.

18. Ringe, "Chiaroscuro," 349.

19. James Fenimore Cooper, *The Last of the Mohicans* (New York: Signet, 1962), 56.

20. Ringe, "Chiaroscuro," 350.

21. Tatham, "Samuel F. B. Morse's 'Gallery of the Louvre,'" 40, 48; Samuel F. B. Morse, *Lectures on the Affinity of Painting with the Other Fine Arts*, ed. Nicolai Cikovsky, Jr. (Columbia: University of Missouri Press, 1983), 93.

22. Cooper, *The Deerslayer* (New York: 1841), quoted in Ringe, "Chiaroscuro," 350.

23. *The Last of the Mohicans*, 57, 60, 55, 56, 60.

24. Ibid., 81, 87.

25. Staiti, *Samuel F. B. Morse*, 39.

26. *The Last of the Mohicans*, 81.

27. Ibid., 87.

28. Tatham, "Samuel F. B. Morse's 'Gallery of the Louvre,'" 44, 44 n. 24.

29. Wayne Franklin, *James Fenimore Cooper: The Early Years* (New Haven, CT: Yale University Press, 2007), xx.

30. Daniel Walker Howe, *What Hath God Wrought: The Transformation of America, 1815–1848* (New York: Oxford University Press, 2007), 132.

31. Tatham, "Samuel F. B. Morse's 'Gallery of the Louvre,'" 40.

32. Franklin, *James Fenimore Cooper*, 434–36.

33. Betsy Fahlman, *John Ferguson Weir: The Labor of Art* (Newark: University of Delaware Press, 1997), 80.

34. Ibid., 49; Staiti, *Samuel F. B. Morse*, 154, 157; Fahlman, *John Ferguson Weir*, 17–18.

35. Fahlman, *John Ferguson Weir*, 21.

36. Ibid., 133.

37. "Art Criticism," *The American Art Journal* 5 (May 2, 1866): 20.

38. Ibid., 20.

39. William Truettner, "Prelude to Expansion: Repainting the Past," in *The West as America: Reinterpreting Images of the Frontier, 1820–1920* (Washington, D.C.: Smithsonian Institution Press, 1991), 65.

40. Perhaps only during Weir's first trip to Europe, in December 1868, did he assume a properly respectful relation to the Old Master paintings he then saw in force for the first time. This would mean that *not* having seen these pictures was an advantage for him when he made *The Gun Foundry*, since he could more imaginatively conceive them as raw material to work with rather than venerable and untouchable masters worthy only of an emulation that was bound to be inadequate. For Weir's European trip, see Fahlman, *John Ferguson Weir*, 111–23.

41. Walt Whitman, *Memoranda during the War*, ed. Peter Coviello (New York: Oxford University Press, 2004), 7.

42. "Fine Arts: Carpenter's First Reading of the Emancipation Proclamation," *New York Times*, May 1, 1866, 5.

The New World
Discovers Italy

JAMES GREBL

After all, not to create only, or found only,
But to bring, perhaps from afar, what is already founded,
To give it our own identity, average, limitless, free . . .
Not to repel or destroy, so much as accept, fuse, rehabilitate . . .
These also are the lessons of our New World. . . .
—Walt Whitman, *After All, Not to Create Only*, 1871

As expressed in these verses, Whitman's vision of America in 1871 was of a country that was not an entirely new invention or a mere replica but a fusion of the Old World with the New.[1] Among the notions brought "from afar" during the colonial era by the predominantly English settlers was a reverence for the classical past and for its homeland, Italy. This attitude was manifested in the prime position that Italy held in the Grand Tour itineraries of well-to-do young gentlemen as well as in the desire of artists to travel and study there.

Between 1760, when Benjamin West embarked on the first artistic pilgrimage from the New World to Italy, and the 1880s, when the practice began to wane, hundreds of American painters and sculptors made the trek. For many, Italy was but one destination on an artistic Grand Tour, which often included London and Paris and, in later years, perhaps also Geneva, Düsseldorf, Munich, or Holland. Some artists stayed in Italy only a month or two, while many remained several years. A number of artists made multiple visits, often years apart, while a few even chose to make Italy their permanent home.

Over time, the nature and aims of these Italian sojourns changed substantially. The first two generations of artists, which include West, John Singleton Copley, and Washington Allston,[2] were interested primarily in studying the art of antiquity and the Renaissance, meeting and exchanging ideas with other artists, and obtaining commissions. Their chief destinations were Rome and Florence, where they visited galleries and copied works by Old Masters (Michelangelo and Raphael were favored), toured ancient ruins, churches, and palaces, and mingled

in the studios and salons of fellow artists. Though most of them completed paintings while abroad (sometimes for sale to English or American tourists and expatriates), perhaps the most valuable products of their stays were the numerous studies that they recorded in their sketchbooks for use in future compositions once they returned home.

In keeping with the interests of their time, history painting and portraiture were the dominant genres for the early visitors. West, for example, created his first great neoclassical work, *Agrippina Landing at Brundisium with the Ashes of Germanicus* (fig. 53), in 1768, five years after settling permanently in England, using sketches he had made in Italy of an antique Roman relief.[3] Similarly, his painting *Fidelia and Speranza* (cat. 117), painted in London in 1776 and now in the Timken Museum of Art,[4] incorporates the gesture of the Medici Venus, a Hellenistic statue that he no doubt saw at the Uffizi Gallery in Florence.[5] Copley's skill as a portrait painter, in contrast, earned him the commission in 1775 for what is arguably his best Italian work, *Mr. and Mrs. Ralph Izard* (fig. 54). This double portrait, which depicts a wealthy couple from South Carolina whom Copley had met in Florence, differs from those done before his stay in Italy primarily in the inclusion of classical details that the artist had seen firsthand, such as the Colosseum in the distant background as well as the ornate furniture, the antique vase, and the sculpture group.[6]

Fig. 54. John Singleton Copley
(1738–1815). *Mr. and Mrs. Ralph Izard
(Alice Delancey)*, 1775. Oil on canvas;
68¾ × 88 inches. Museum of Fine Arts,
Boston; Edward Ingersoll Brown Fund,
03.1033.

Toward the end of the eighteenth century, American painters, follow-ing the lead of their British counterparts, began to expand their interests beyond the portrait and history genres to include landscape painting. This trend quickly found its way into the repertoire of those making the artistic pilgrimage to Italy. The earliest type of landscapes painted by Americans in Italy do not record the actual appearance of specific locales but are idealized compositions in the tradition of Nicolas Poussin and Claude Lorrain that often feature classical architecture and pastoral figures. Allston, an early American romantic painter and student of Benjamin West's, was among the first American painters to turn his attention to the Italian landscape as more than a tourist, painting picturesque sites in the Roman Campagna, such as Tivoli, Lake Nemi, Albano, and Olevano, that were already popular with British and European artists. His *Italian Landscape* (1805; fig. 55) is char-acteristic of this type of picture, which he produced both during his time in Italy and after his return home.

Landscape became the dominant focus for subsequent generations of American artists in Italy.[7] Imaginary neoclassical landscapes like Allston's were succeeded, with few exceptions, by scenes that are topographically accurate but also overtly romantic, often featuring highly evocative ruins and dramatic effects of weather and light. Thomas Cole, founder of the Hud-son River School and already an established landscape painter before his

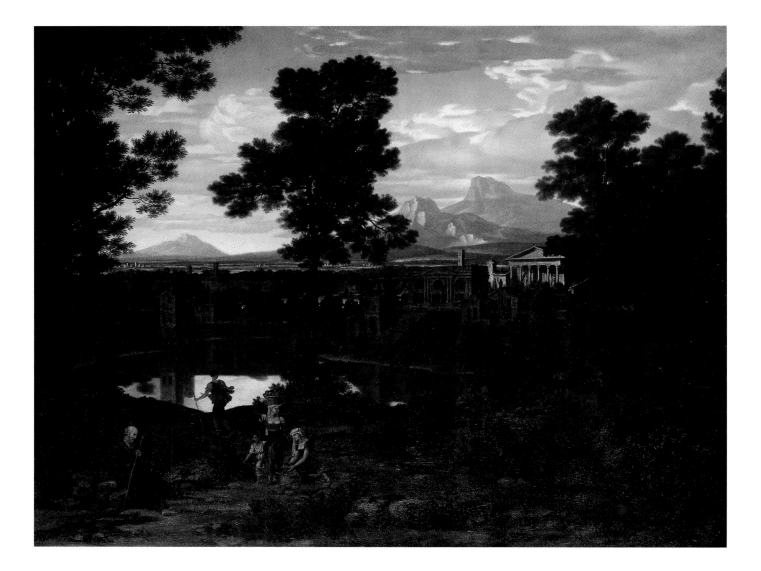

first visit to Italy in 1831–32, exemplifies this transition.[8] While several of his Italian subjects look back to the idealized tradition of Claude, the majority depict real places in considerable detail, though they are often infused with a romantic or moralizing tone.[9] *The Arch of Nero* (fig. 56), painted in 1846 in New York from sketches made during his first Italian visit, exemplifies this type of work. Although it contains pastoral figures in the tradition of neoclassical painters like Claude, it does not depict an idealized or imaginary place. Instead, it accurately depicts the ruins of an historic Roman aqueduct while using clouds and effects of light to transform the scene into an elegiac statement on the transitory nature of civilization. A generation later, another painter associated with the Hudson River School, Jasper Francis Cropsey, produced similarly romantic paintings of Italy but with even more meticulous attention to detail. Many of Cropsey's Italian scenes were painted in his New York studio based on sketches made during his visit to Italy of 1847–49. *Evening at Paestum,* painted eight years after he viewed the ruins of the ancient Greek city in southern Campania, romantically emphasizes the isolated setting and brooding quietude of the ancient temple through the dramatic treatment of the twilit sky and barren, malarial marshland.[10]

120

Fig. 56. Thomas Cole (1801–1848). *The Arch of Nero*, 1846. Oil on canvas; 60 × 40 inches. Newark Museum; Collection of The Newark Museum, 57.24.

Some American painters displayed great diversity in their responses to the Italian landscape. George Inness, for example, during his visits to Italy in 1851–52 and 1870–74, painted a variety of landscapes ranging from pastoral works in the tradition of Claude to fairly objective topographic records of particular sites and finally to works imbued with mystical, spiritual qualities derived from the Swedenborgian theology he adopted in 1868.[11] Characteristic of Inness's topographic type is the Timken Museum's *L'Ariccia, Italy* (cat. 143), painted in 1874,[12] while his 1871 work *Lake Trasimeno* (fig. 57), with its hazy light and haunting solitude, demonstrates his mystical side.

Another painter whose interests in the Italian landscape shifted over time is Thomas Moran, who made three visits to Italy. During his first stay, from 1866–67, Moran visited most of the usual sites frequented by British and American artists before him, and after returning to Philadelphia, he produced a number of canvases depicting the Campagna and other familiar locales. Among these is *Opus 24: Rome, from the Campagna, Sunset*, painted in 1867 and today in the Timken Museum of Art (cat. 155).[13] In its bold brushstrokes and dramatic color, this picture reflects Moran's study of the works of J. M. W. Turner, which he accomplished during his visit to London in 1861. But it is the multitude of works Moran painted on the basis of his two stays

Fig. 57. George Inness (1825–1894). *Landscape*, 1871. Oil on canvas; 17¼ × 25⅜ inches. Addison Gallery of American Art, Philips Academy, Andover, Massachusetts, gift of Mary D. and Arthur L. Williston, 1948.31.

in Venice, in 1886 and 1890 that reveals the full influence of Turner as well as the stimulus provided by Venice's radiant skies, shimmering water, and shining stones. *Venice* (fig. 58), painted in 1894, is characteristic of this body of work, which is larger than that of any other subject he painted.[14]

Moran's fascination with Venice was part of a growing appreciation of the city by American tourists and artists alike in the last third of the nineteenth century.[15] American painters working there around the turn of the twentieth century included such diverse talents as James McNeill Whistler, John Henry Twachtman, Maurice Prendergast, and John Singer Sargent, each of whom pursued a highly personal approach in portraying the city. Sargent, the cosmopolitan expatriate, is a good example, having visited Venice many times between 1880 and the start of World War I, including several extended stays. His early Venetian works of the 1880s depart from the traditional glowing views of the Lagoon and other famous landmarks, featuring instead intimate, dark studies of obscure streets and interiors. After an absence of more than a decade, Sargent returned to Venice in 1898 and produced *An Interior in Venice* (fig. 59), the remarkable portrait of his cousins the Curtises posing informally in the parlor of their elegant Palazzo Barbaro, where Sargent frequently stayed while visiting the city.[16] Only after 1900, when he turned primarily to the medium of watercolor, did Sargent begin to paint luminous images of the canals, churches, and palaces that were more conventional subjects for Venice.

With the advent of the twentieth century and the modern art movements it ushered in, the long-held fascination with Italy virtually disappeared as Paris became the new magnet for artists. Over the century and a half when

Fig. 58. Thomas Moran (1837–1926). *Venice*, 1894. Oil on canvas; 5 × 8½ inches. Fine Arts Museums of San Francisco; Memorial gift from Dr. T. Edward and Tullah Hanley, 69.30.144.

the lure of Italy was strong, American artists who visited the peninsula were affected in a variety of ways. Most collected sketches and memories that they were able to turn into commercially successful artworks for years or even decades afterward, some even experienced a creative epiphany that transformed their art for the rest of their lives, but very few came back from their Italian sojourns unaffected. New World artists, unconsciously fulfilling Whitman's words, were able to "accept, fuse, rehabilitate" the lessons of the Old World.

Fig. 59. John Singer Sargent (1856–1925). *An Interior in Venice,* 1898. Oil on canvas; 25 × 31 inches. Royal Academy of Arts, London.

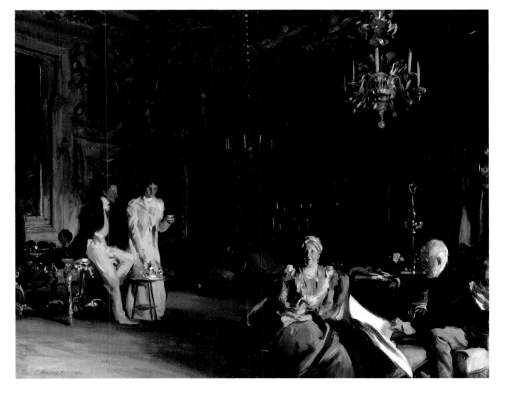

1. These lines as well as the title of the current exhibition, *Behold, America!*, come from a poem written by Whitman to be recited at the fortieth National Industrial Exposition of the American Institute in New York in July 1871. Later revised and retitled *Song of the Exposition* the work was republished in 1876 in connection with the Centennial Exhibition at Philadelphia. The poem is a celebration of America whose industry and progress have supplanted the culture and arts of the Old World.

2. West was in Italy from 1760 to 1763; Copley from 1774 to 1775; Allston from 1804 to 1808. For the history of American artists' travels in Italy and further bibliography, see Theodore E. Stebbins, Jr. et al, *The Lure of Italy: American Artists and the Italian Experience, 1760–1914*, exh. cat. (Boston: Museum of Fine Arts, Boston, 1992).

3. The relief was later identified as part of the frieze of the Ara Pacis Augustae. This and other sources used by West in *Agrippina* are discussed in Jules David Prown, "Benjamin West and the Use of Antiquity," *American Art* 10, no. 2 (1996): 38–40.

4. Acquired by the Putnam Foundation in 1969.

5. The pose is reversed in the painting, a common practice for artists quoting from others' works.

6. Discussion of the significance of the objects in the painting can be found in Roger B. Stein, "Transformations: Copley in Italy," in *The Italian Presence in American Art, 1760–1860*, ed. Irma B. Jaffe (New York: Fordham University Press, 1989), 53–55.

7. Many prominent nineteenth-century American landscape painters visited Italy in addition to those discussed in this essay, including Asher B. Durand, George Loring Brown, John F. Kensett, Worthington Whittredge, Albert Bierstadt, Thomas Hiram Hotchkiss, and Frederick Edwin Church.

8. Cole returned to Italy in 1841–42. After both of his visits, he continued to paint pictures derived from the sketches and studies he made while in Italy.

9. This aspect links the painting with *Desolation*, the final canvas of his epic allegorical series *Course of Empire*, painted in 1836, and with similar individual works.

10. A second, closely similar version of the scene was painted in 1859 and is now in a private collection.

11. Inness's Italian work was the subject of an exhibition mounted by the Philadelphia Museum of Art in 2011, which also appeared at San Diego's Timken Museum of Art June 10–September 18, 2011. See Mark D. Mitchell, *George Inness in Italy*, exh. cat. (Philadelphia: Philadelphia Museum of Art, 2011).

12. Acquired by the Putnam Foundation in 1972.

13. Acquired by the Putnam Foundation in 2005.

14. Erica E. Hirschler, "Thomas Moran," ed. Theodore E. Stebbins, Jr., *The Lure of Italy*, exh. cat. (Boston: Museum of Fine Arts, Boston, 1992), 419.

15. Although many early American artists from West and Copley to Samuel F. B. Morse visited Venice, they came to study the works of Titian and other Renaissance masters, not to paint views of the city, a practice that remained rare until the 1860s.

16. Daniel Sargent Curtis (1825–1908) and his wife, Ariana Wormely Curtis (1833–1922), were wealthy American expatriates who entertained many distinguished visitors, including Robert Browning, Henry James, and Isabella Stewart Gardner, at their palazzo. Their son, Ralph Curtis (1854–1922), was a close friend of Sargent's and had studied painting with him in Paris in 1874–76.

FORMS

RAPHAELLE PEALE
1774–1825

Cutlet and Vegetables

Oil on panel, 1816
18¼ × 24¼ inches
Timken Museum of Art, Putnam
Foundation Collection
2000:002
Timken Museum of Art
Catalogue 41

128

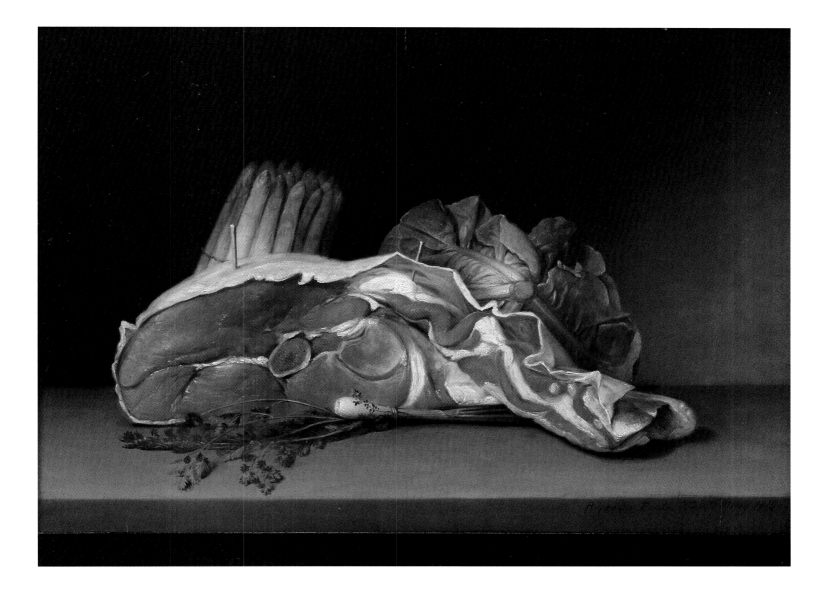

MARTIN JOHNSON HEADE
1819–1904

The Magnolia Blossom

Oil on canvas, 1888
15⅛ × 24⅛ inches
Timken Museum of Art, Putnam
Foundation Collection
1965:001
Timken Museum of Art
Catalogue 20

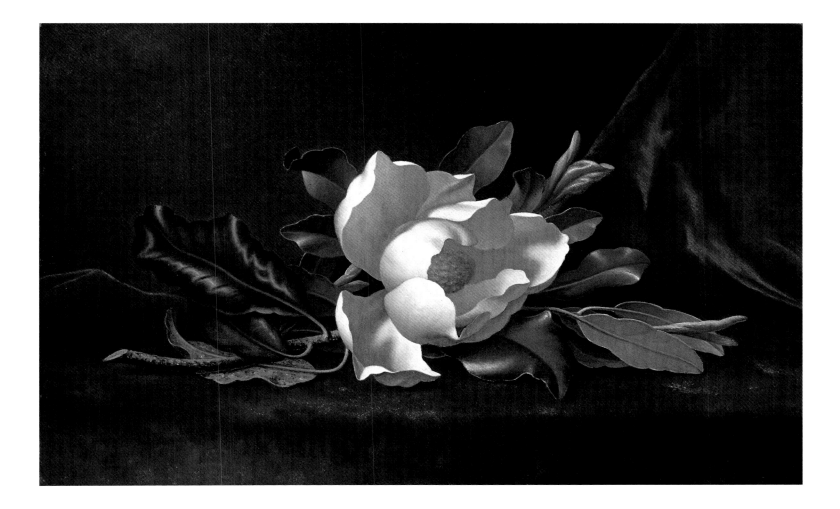

JOHN F. PETO
1854–1907

In the Library

Oil on canvas, 1900
30 × 40 inches
Timken Museum of Art, Putnam
Foundation Collection
2000:001
Timken Museum of Art
Catalogue 44

MORGAN RUSSELL
1886–1953

Synchromy with Nude in Yellow

Oil on canvas, 1913
39¼ × 31½ inches
Museum purchase through the Earle W.
Grant Endowment Fund
1973.22
The San Diego Museum of Art
Catalogue 49

GEORGIA O'KEEFFE *The White Flower*
1887–1986

Oil on canvas, 1932
29¾ × 39¾ inches
Gift of Mrs. Inez Grant Parker in memory
of Earle W. Grant
1971.12
The San Diego Museum of Art
Catalogue 35

EDWARD RUSCHA *Ace*
b. 1937

Oil on canvas, 1962
71⅜ × 66 inches
Museum purchase in memory of
Lois Person Osborn
1986.28
Museum of Contemporary Art San Diego
Catalogue 48

ELLSWORTH KELLY
b. 1923

Red Blue Green

Oil on canvas, 1963
83⅝ × 135⅞ inches
Gift of Dr. and Mrs. Jack M. Farris
1978.3
Museum of Contemporary Art San Diego
Catalogue 26

FRANK STELLA *Sinjerli I*
b. 1936

Fluorescent acrylic on canvas, 1967
Diameter 120 inches
Gift of Mrs. Jack M. Farris
1991.28
Museum of Contemporary Art San Diego
Catalogue 53

AGNES MARTIN *Untitled*
1912–2004

Acrylic priming, graphite, and brass nails
on canvas, 1962
12 × 12 inches
Museum purchase
1976.18
Museum of Contemporary Art San Diego
Catalogue 32

144

ANDY WARHOL *Flowers*
1928–1987

Silkscreen ink and synthetic polymer paint on canvas, 1967
115½ × 115½ inches
Museum purchase with contributions from the Museum
Art Council Fund
1981.2
Museum of Contemporary Art San Diego
Catalogue 60

ROY LICHTENSTEIN
1923–1997

Mirror

Oil and magna on canvas, 1971
96 × 108 inches
Gift of Irving Blum and Museum purchase
1978.1
Museum of Contemporary Art San Diego
Catalogue 28

MARTIN PURYEAR *Vault*
b. 1941

Wood, wire mesh, and tar, 1984
66 × 85 × 48 inches
Museum purchase
1984.25
Museum of Contemporary Art San Diego
Catalogue 45

FIGURES

JOHN SINGLETON COPLEY
1738–1815

Mrs. Thomas Gage

Oil on canvas, 1771
50 × 40 inches
Timken Museum of Art, Putnam
Foundation Collection,
1984:001
Timken Museum of Art
Catalogue 72

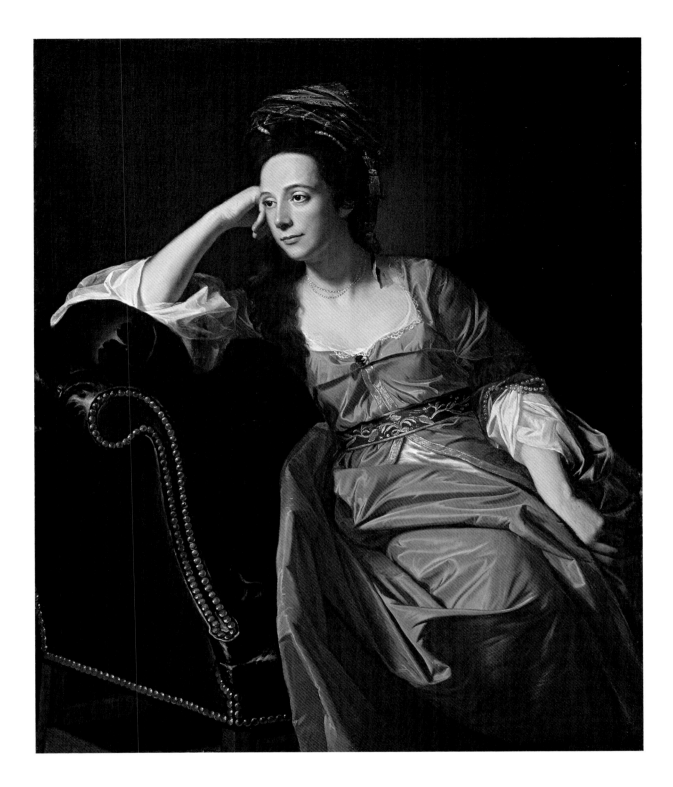

BENJAMIN WEST
1738–1820

Fidelia and Speranza

Oil on canvas, 1776
53¾ × 42⅝ inches
Timken Museum of Art, Putnam
Foundation Collection
1969:001
Timken Museum of Art
Catalogue 117

THOMAS SULLY
1783–1872

Portrait of Esther Fortune Warren and Her Daughter Hester

Oil on canvas, 1811
25⅜ × 21⅜ inches
Gift of Anna D. and John R. Reilly, through
their children
1973.115
The San Diego Museum of Art
Catalogue 113

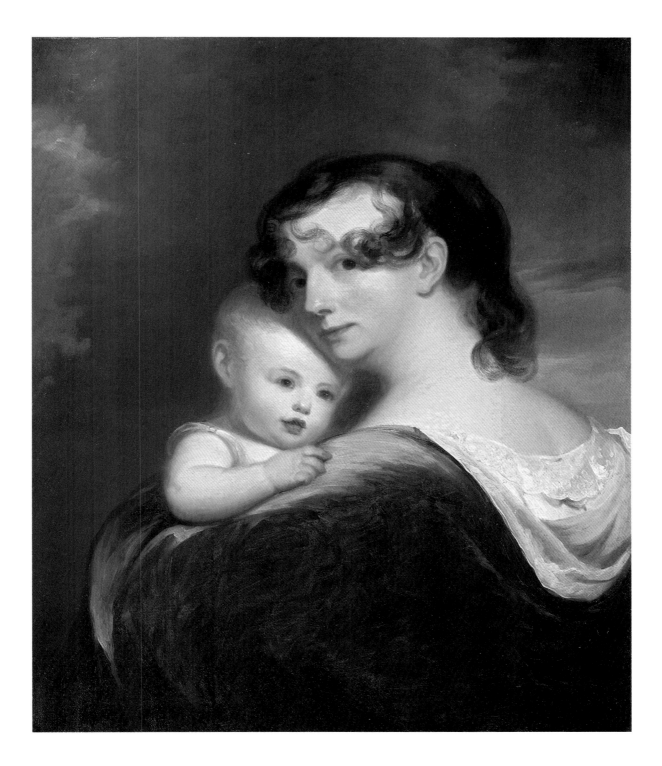

EASTMAN JOHNSON
1824–1906

Wounded Drummer Boy

Oil on board, 1865–69
26¼ × 21⅝ inches
Gift of Mrs. Herbert S. Darlington
1940.79
The San Diego Museum of Art
Catalogue 88

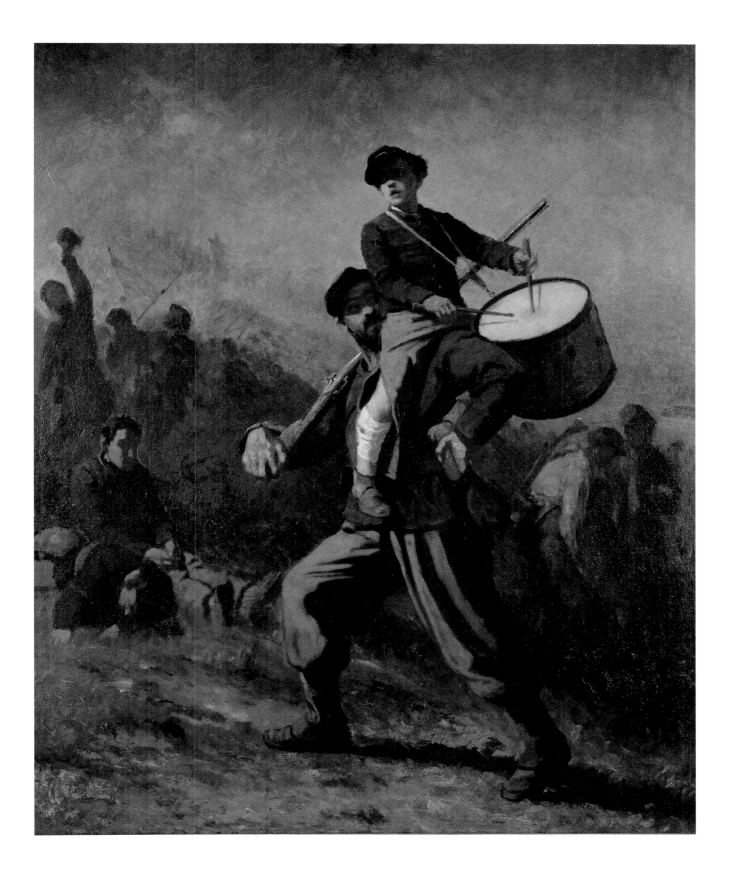

THOMAS EAKINS
1844–1916

Elizabeth with a Dog

Oil on canvas, ca. 1871
13¾ × 17 inches
Museum purchase and a gift from
Mr. and Mrs. Edwin S. Larsen
1969.76
The San Diego Museum of Art
Catalogue 75

162

EDWARD STEICHEN
1879–1973

Portrait in Grey and Black

Oil on canvas, 1902
31⅞ × 39⅛ inches
Museum purchase through the Earle W.
Grant Acquisition Fund
1975.1
The San Diego Museum of Art
Catalogue 111

ROBERT HENRI
1865–1929

Portrait of Mrs. Robert Henri

Oil on canvas, 1914
24 × 20 inches
Gift of Mrs. George Heyneman
1959.7
The San Diego Museum of Art
Catalogue 84

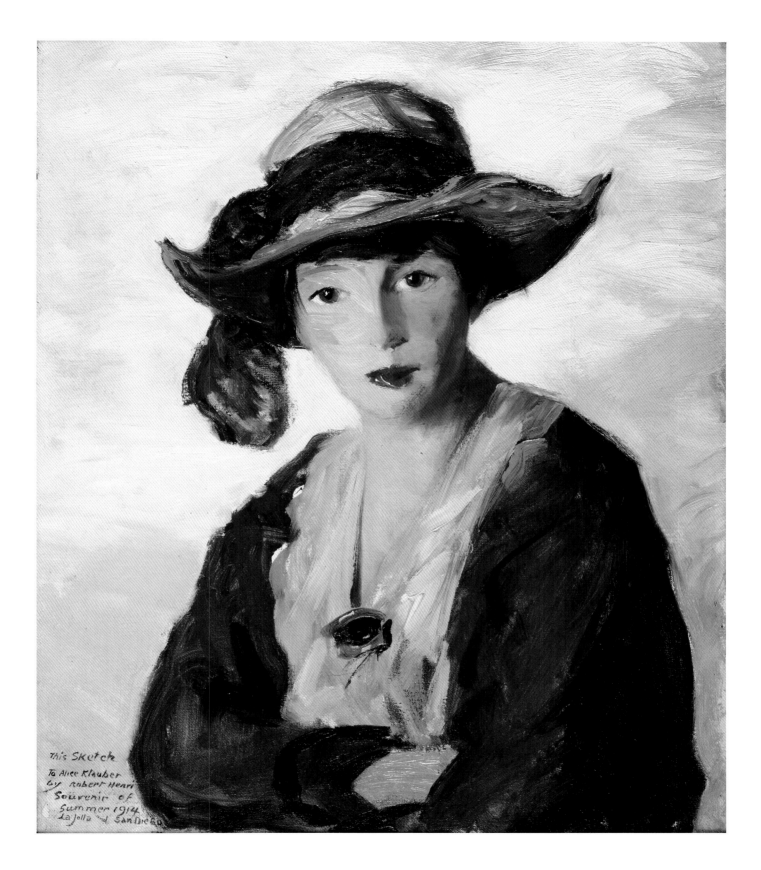

This Sketch
To Alice Klauber
by Robert Henri
Souvenir of
Summer 1914
La Jolla and San Diego

ALICE NEEL *Portrait of Mildred Myers Oldden*
1900–1984

Oil on canvas, 1937
36¾ × 21¾ inches
Bequest of Stanley K. Oldden
1991.98
The San Diego Museum of Art
Catalogue 98

DAVID HAMMONS *Champ*
b. 1943

Rubber inner tube, boxing gloves, 1989
66 × 19 × 27 inches
Museum purchase with funds from the
Awards in the Visual Arts Program
1989.3
Museum of Contemporary Art San Diego
Catalogue 82

JOHN CURRIN *The Hobo*
b. 1962

Oil on canvas, 1999
40 × 32 inches
Museum purchase, Contemporary
Collectors Fund
2000.3
Museum of Contemporary Art San Diego
Catalogue 74

FRONTIERS

THOMAS BIRCH
1779–1851

An American Ship in Distress

Oil on canvas, 1841
36 × 53¾ inches
Timken Museum of Art, Putnam
Foundation Collection
1973:001
Timken Museum of Art
Catalogue 125

ASHER B. DURAND
1796–1886

Landscape — Composition: In the Catskills

Oil on canvas, 1848
30 × 42¼ inches
Museum purchase with funds provided by
the Gerald and Inez Grant Parker Foundation
1974.72
The San Diego Museum of Art
Catalogue 137

FITZ HENRY LANE
1804–1865

Castine Harbor and Town

Oil on canvas, 1851
20 × 33¼ inches
Timken Museum of Art, Putnam
Foundation Collection
1986:001
Timken Museum of Art
Catalogue 151

ALBERT BIERSTADT
1830–1902

Cho-looke, the Yosemite Fall

Oil on canvas, 1864
34¼ × 27⅛ inches
Timken Museum of Art, Putnam
Foundation Collection
1966:001
Timken Museum of Art,
Catalogue 124

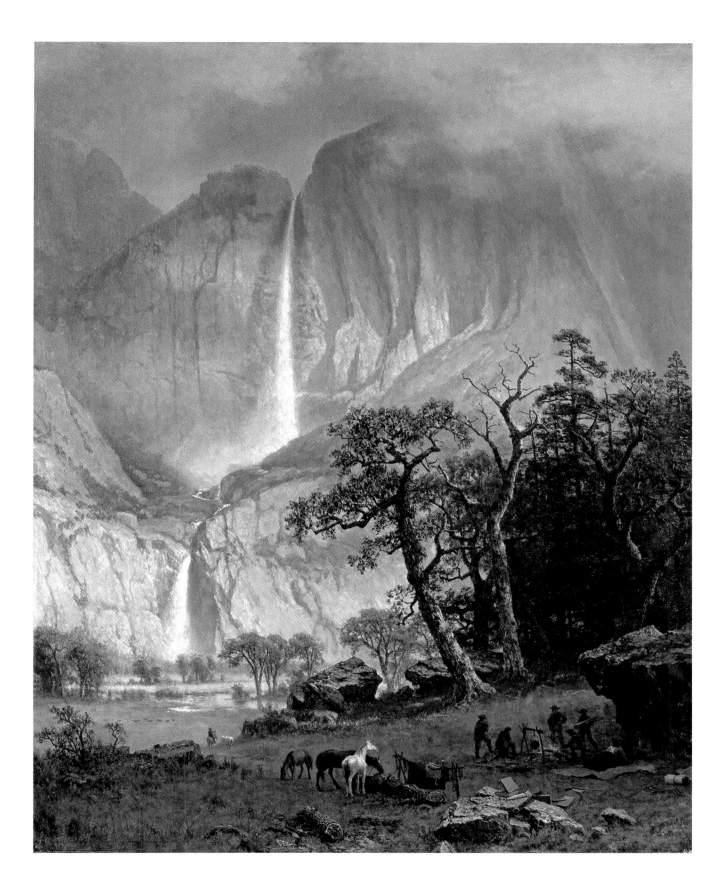

GEORGE INNESS *L'Ariccia*
1825–1894

Oil on canvas, 1874
26½ × 56⅞ inches
Timken Museum of Art, Putnam
Foundation Collection
1972:001
Timken Museum of Art
Catalogue 143

THOMAS MORAN
1837–1926

Below the Towers of Tower Falls, Yellowstone Park

Oil on canvas, 1909
30 × 25¹⁄₁₆ inches
Gift of Lydia and Etta Schwieder
1968.48
The San Diego Museum of Art
Catalogue 156

EASTMAN JOHNSON
1824–1906

The Cranberry Harvest, Island of Nantucket

Oil on canvas, 1880
27⅜ × 54½ inches
Timken Museum of Art, Putnam
Foundation Collection
1972:002
Timken Museum of Art
Catalogue 148

MILTON AVERY
1893–1965

Pool in the Mountains

Oil on canvas, 1950
30³⁄₁₆ × 40⅛ inches
Gift of Mr. and Mrs. Norton S. Walbridge
1991.9
The San Diego Museum of Art
Catalogue 120

ROBERT IRWIN
b. 1928

$1° 2 ° 3° 4°$

Apertures cut into existing windows, 1997
Museum purchase in honor of Ruth Gribbin
with funds from Ruth and Murray Gribin and
Ansley I. Graham Trust, Los Angeles
1997.18.1-5
Museum of Contemporary Art San Diego
Catalogue 145

ANN HAMILTON *linings*
b. 1956

Felt boot liners, woolen blankets, grass, glass, ink on paper, monitor with
video loop, 1990
Four-sided structure, 120 × 150 × 294 inches; overall dimensions may vary
Museum purchase with funds from the Elizabeth W. Russell Foundation
1990.23
Museum of Contemporary Art San Diego
Catalogue 139

Interview with Lorna Simpson

The show begins in San Diego with these three San Diego collections. Could you talk about your experience in San Diego in graduate school?[1]

As a New Yorker, and having lived a little bit in Europe, I had not lived in California, which was a bit of a culture shock. Going to UCSD [University of California, San Diego] was quite wonderful, because during the first year of living in La Jolla, it's like, "It's five o'clock, grab some stuff, grab a bottle of wine, get some food, let's go to the beach." I would go down to Mexico, I would be in L.A., or also San Francisco. It was an interesting time to be in California in the late '80s because it really was about performance, and certainly at UCSD there was a lot of performance art, which was really contrary to what I did as an artist. Everyone went to Sushi [Founded in 1980, Sushi Contemporary Performance and Visual Arts was a trailblazing San Diego-based nonprofit that closed in 2011].

Are there any memories of the city? Balboa Park?

Of course! Of course, I even went to SeaWorld, a different kind of thing. I went everywhere. Yes, I went to Balboa Park, The San Diego Museum of Art, and also the Museum of Contemporary Art. It's a kind of different view than the New York view of California painting and art in that respect. As a younger artist, I really kind of got a sense of the whole other field of the country. So it was great. It was really an eye-opener and much different than being in New York.

So many artists move to New York, but you were born in New York and have spent much of your life here. How has this city influenced your work?

Oh, I love New York. I mean, California was good, but I had to come back home to New York. What I love about New York is that it is crowded, it is cramped, and it is diverse. Neighborhoods change every couple of blocks. It is a very cosmopolitan city but also very foot oriented. In California, you are driving in isolation in your car. Growing up as an artist in New York in the '70s was amazing—going to clubs, going to theater. My parents were very interested in the arts, and so they would take me to see plays, dance, and to exhibitions. By becoming an artist, I grew to appreciate it even more.

In regards to your work in the exhibition *Guarded Conditions* (fig. 60), I know it is difficult to rewind time, but if you could share anything specific about the process that led you to create that work, that would be great.

Gestures/Re-enactments was completed around the time I got out of graduate school. I went to Washington, D.C., for a few months because of an internship at the NEA [National Endowment for the Arts], and then I returned to New York. I came back to New York with the work that I made in graduate school, and the works that I made upon returning to New York—that body of work set the tone of what I was going to do next with regard to the figure, with the back turned to the viewer, and text either in poetic form, lists or alliteration. *Guarded Conditions*, contains this switching back and forth between the words sex and skin—I think, with this work, its format is more listing of

GUARDED CONDITIONS

SEX ATTACKS | SKIN ATTACKS | SEX ATTACKS | SKIN ATTACKS | SEX ATTACKS | SKIN ATTACKS | SEX ATTACKS | SKIN ATTACKS | SEX ATTACKS | SKIN ATTACKS
SEX ATTACKS | SKIN ATTACKS | SEX ATTACKS | SKIN ATTACKS | SEX ATTACKS | SKIN ATTACKS | SEX ATTACKS
SKIN ATTACKS | SEX ATTACKS | SKIN ATTACKS | SEX ATTACKS

Fig. 60. Lorna Simpson (b. 1960). *Guarded Conditions*, 1989. Eighteen color Polaroid prints, twenty-one engraved plastic plaques, and plastic letters; overall dimensions 91 × 131 inches. Museum of Contemporary Art San Diego; Museum purchase, Contemporary Collectors Fund, 1990.12.1–28. Cat. 109.

things and items to build a phrase out of a list. I also wanted to work with Polaroids, and to work with a figure in the form of a composite. In *Guarded Conditions* the figure is in three different segments, and repeated six times. At the time I was thinking about violence with regard to women and men, and also violence with regard to sexual orientation. The figures do not represent victims; they are sentinels.

Could you talk a little about how you create the text or when you apply the text to the work? Does the text come first?

I really did not have a methodology around beginning with text or image. I would say at that time there would be a constant back and forth between considering fragments of patterns of speech or lists and seeing where that would lead. I have a love for language and the colloquial use of language, and how perceptions and description work in terms of patterns of speech. The image would come into play as this other cypher for the subject that I could also play with sequencing, repetition, and seriality.

The exhibition *Behold, America!* is divided into three sections, of forms, figures, and frontiers. Could you spesak a little bit about how the figure has been influential to you?

The role of the figure in my work created an opportunity to think about the role of the subject. So the assumption of the figure is that it has its own narrative. Using the figure allowed me to think about "who" that figure is, how the viewer superimposes their own idea of who that individual or person is or what that figure represents.

And your *Guarded Conditions* will be in the figures section of the exhibition, alongside works by John Singleton Copley and more contemporary artists like Cindy Sherman. Are there particular movements or artists who have inspired you?

I have to say Adrian Piper, whose work is much different than mine, was really a big inspiration when I was younger, in terms of looking at her work and seeing it in New York in the '80s and '90s here and there at different exhibition spaces. I think of her work often, and I wish there were more opportunities to see her work since she has been so influential to so many artists. She and David Hammons and how they work as conceptual artists I find really interesting. So those are the first two people that come to mind.

Because this exhibition offers a historic overview, I wondered if there are major historical events that have affected the process of your work.

I think it is a combination of two tracks of things. I think I am definitely affected by large political events from the '60s through the '70s and '80s that I think were really part of forming me as a person, as part of the experience of being an American. On the other hand, you know, small day-to-day things as well, that it's not always the kind of large political events or things that happen in history but how things kind of occur on a day-to-day level. So, I think, growing up in Queens, New York, and being bused to different schools in more suburban white neighborhoods, from elementary school through junior high in the '60s, was something! Running for the bus and hoping that it would arrive in time because of an angry mob that was just a few blocks away was heading our way. I remember there was an overpass over a highway and a mob was on the other side of the highway, but so was the bus that I needed to catch. So there are small instances of growing up in the '60s and '70s that I think also formed me in terms of language and the way people spoke and the kind of reactions to certain events that did have an effect on me being an artist.

Thinking about your process in terms of a work schedule, do you have a regular schedule? Do you come here five days a week?

Right now I am working, but I took the summer off because last year was really intensely busy and crazy. So, now I am just working on shows, not really lecturing or teaching, just working on my work which is nice. I do not have the kind of practice that I am in the studio 365 days a year. I need time away from making things to just think about things and the process of ideas, and not just producing things.

Do you think there are still challenges for women artists?

I think there are challenges for women as curators, directors, politicians, parents, etc. in the work place and their private lives to define their lives as

they see fit. There has always been and still is the assumption that women should make an effort to fulfill the expectations of others or operate within set boundaries meant to confine the scope of the lives of women. Many have chosen to live outside those norms.

You have reached amazing heights in your career and achieved a lot of success. Do you remember a time when you were sort of struggling?

Of course—last week!

Well, it is interesting. Do you always feel like you are struggling in a way?

I do remember when I came back from California, and I worked as a secretary or receptionist in a couple of different corporate offices on Fifth Avenue. It was a much different time than now because one could find temp jobs and work in cycles of making enough money for a place to live and take time between jobs to make work. When I look back at my experience, it was easy to find those kinds of jobs. Things are much different now. So for many young artists in terms of have a place to live and work and having the time to make art is much more difficult now.

Can you talk a little bit about your teaching experience?

Wonderful! I have taught a lot at The Cooper Union School of Art, and that has been amazing. Teaching gets you out of your own head, and forces you to take a longer look at the work of someone else. It creates the opportunity for a conversation.

NOTE

1. The interview was conducted by Amy Galpin and took place at the artist's studio in the Fort Greene neighborhood of Brooklyn, September 20, 2010.

Beholding Modern American Art

MICHAEL HATT

Do I contradict myself?
Very well, then, I contradict myself.
—Walt Whitman, *Leaves of Grass*, 1855

In asking us to behold America, Walt Whitman lays out a nation that is made up of seemingly endless peoples, places, and customs. His long, endlessly rocking poems revel in the multifariousness and infinite experience that constitute America from sea to shining sea. Indeed, Whitman makes it clear that an account of America is various even to the point of contradiction; a nation as wide as America will simply contradict itself, just as the poet himself does in *Leaves of Grass*. Whitman's untidiness, his insistence on asserting that there is something American uniting these different elements while continually introducing rupture and paradox, provides a useful lesson for the historian. Categorizing and defining are essential activities for any historian worth her salt, but there must be limits to how far we can go. The story of art as an unfolding of representation, always in line with other kinds of history, always parallel to other kinds of culture, might also benefit from some Whitmanesque paradox. This essay explores modern American art, its emergence in the first decades of the twentieth century, and how a turn toward Whitman's leaning and loafing might provide a means of coming to grips with the very idea of modern American art.

The appearance and development of modern art in the United States are often explained through a well-known story. The story begins with a nation that has had rather poor taste and struggled with art, a nation that looks across the Atlantic to Europe with feelings of inadequacy and a drive to bring art westward to the New World. In 1908, the exhibition of The Eight—more commonly known now as the Ashcan School—led by Robert Henri, made a bid to introduce some of the more recent French developments into the United States and got as far as importing the styles of the later nineteenth century and bringing them to truly American subject matter. Alongside them in New York was the real hero of American modernism, Alfred Stieglitz, who, through his gallery, his patronage, and his

publications, created the milieu in which modernist art could flourish in the United States, a milieu, moreover, that was fully avant-garde in its taste and practice. The Armory Show of 1913, as well as the Forum Exhibition of 1916, brought modernism to a wider public, intensified by the subsequent to-and-fro between New York and Europe. Modernist artists from Paris, led by Marcel Duchamp and Francis Picabia, saw New York as the epitome of the modern world, and Europeans increasingly identified the United States as the home and source of modernism. Eventually, we witness the triumph of American painting: Jackson Pollock and the abstract expressionists became the most celebrated painters, and New York took its position as the center of the art world. Anxieties about the inadequacy of American culture, its second-rate status in comparison to Europe, were dispelled as America produced a form of painting that was deemed the most valuable, the most beautiful, and the most significant. Abstract expressionism was long considered the apotheosis of modern painting, not least because, for a writer such as Clement Greenberg, it was where art truly achieved an understanding of itself. From mimetic beginnings, the conception of a painting as a window onto the world, transcribing reality, painting now demonstrated an awareness that it consisted of no more than color placed on a flat surface; art came to understand its own nature, to realize itself. The triumph of American modernism was the triumph of painting itself. From there, the move to post-painterly abstraction, minimalism, post-minimalism, and an array of competing schools took art further and further into itself.

This story has, of course, been much challenged by scholars and critics in recent years, and we have a much richer account of art in twentieth-century America than hitherto.[1] Nonetheless, one should also perhaps point out that the orthodox account is not wholly fictional, at least in historical terms rather than its metaphysics. However, the real problem with this story is the assumption that modernist art is what fully expressed modern America. Art of a non-modernist nature is seen to be backward, out of step with history; it is judged to be either a nostalgic fantasy or a willful and pathetic refusal to be modern. It is the kitsch foil to avant-garde genius. There is an unsatisfactory neatness in this assumption: namely, a belief that modernity and modernism just do fit together, and that the modern world just is adequately represented by modernist painting. Here, I want to suggest that non-modernist painting, or outdated forms of modernism, often expressed the modern nation in a more telling manner; moreover, figurative painting may have a stronger connection with much of the most recent politically engaged art. Painting in a nineteenth-century idiom was not the detritus left behind by modernism but its complement, and it is central to a historical, as opposed to a critical, understanding of modern American art.

An American in Paris

Let us begin with high modernism: Morgan Russell's painting *Synchromy with Nude in Yellow*, a perfect example of early American modernism, not only in terms of the object itself, but its history, its making, and the world it inhabited (fig. 61). In 1906, the young Morgan Russell traveled to France to become an artist and quickly became part of Gertrude Stein's circle. Stein was the most important American patron of avant-garde art in Paris and a

Fig. 61. Morgan Russell (1886–1953). *Synchromy with Nude in Yellow,* 1913. Oil on canvas; 39¼ × 31½ inches. The San Diego Museum of Art; Museum purchase through the Earle W. Grant Endowment Fund, 1973.22. Cat. 49.

significant avant-garde writer. Russell took up painting and created, along with fellow American Stanton MacDonald-Wright, synchromism, a style that drew together ideas from a range of Parisian experiments, and forged a way of painting that attempted to mimic musical harmony in the placing of color and the dissolution of form into chromatic pattern. The importance of creating an "ism" cannot be underestimated. A signature style was the most powerful aspiration for a budding modernist.[2]

The painting's modernist credentials are clear. This is a painting about painting in a number of respects. Formally, it is concerned with flatness, color, and pattern; using music as an analogue for painting rather than literature was a significant modernist move in eschewing mimesis. The nude model and the objects in the still life retain their forms but are flattened and become surfaces on which color harmonies can be projected. The composition, which is rather traditional in the arrangement of the objects, is fractured by the prismatic color effects, the stable format dissolved into light. *Synchromy with Nude in Yellow* also addresses painting as an object. The way that Russell paints a frame, in a shape that owes much to Pablo Picasso, emphasizes the fictive nature of painting, and this is further developed by the

decoration of this frame. Here, Seurat might be cited as the referent, since he, too, painted and decorated frames around his works. This is also a painting about painting in its allusion to art's history. Like Duchamp, with his famous *Nude Descending a Staircase*, the painting that shocked New Yorkers at the Armory Show in 1913, Russell uses the nude, the aesthetic epitome, in order to show his distance from the great tradition; it demonstrates his rejection of conventional representation. In the same way, the use of such a traditional genre as still life measures out the distance between past and present as well as allows him to show his allegiance to Paul Cézanne and Picasso, whose still lifes are sources for the painting.[3]

Although this painting was made in Paris and alludes to a range of French vanguard artists, synchromism emerged as an American modernist style.[4] The most pressing question for the American art world was, did America really have its own art or was it simply imitating the cultural achievements of Europe? And if, as many believed or hoped, Europe were worn out and the great culture of the future were to be American, then how would this shift from one side of the Atlantic to the other take place? Russell was self-consciously learning from French vanguard painting in order to escape the provincialism (as he saw it) of American culture and thereby create modern American painting. He followed the injunction to "go [east], young man," and returned to the United States in 1916 with a full-fledged modern signature style. The return home was as important as the trip to Paris, for, as has been widely discussed, modernist traffic was not one-way. As our familiar narrative reveals, many European artists headed west to the United States, and particularly New York, since they, too, saw this new world as the antidote to an exhausted European culture, particularly in the wake of the First World War.

So do we behold modern America here in Russell's painting? Up to a point. But this attempt to create, to use Clement Greenberg's famous phrase, "American-type painting" required a turning away from the America that Whitman sought to survey and capture.[5] The anti-literalism and radical aesthetic of Synchromism opened up new ways of making art and of viewing objects, but the style was blind to the themes of Whitman's adumbration of America. This raises the question: What might it mean to make American art? How is American painting to be recognized? There is no straightforward answer. It can be conceived geographically, simply as work made in the United States or by artists who are American themselves, a school of art in the nineteenth-century conception of that term, like the Florentine School or the British School. However, this apparently commonsense idea is based on questionable assumptions. The idea of national or regional schools is underpinned by the idea that geography produces a particular kind of art that expresses that place and that people. This goes back to the earliest years of the discipline of art history and was forged both by German philosophers like Johann Gottfried von Herder and Georg Wilhelm Friedrich Hegel and by connoisseurs like Giovanni Morelli.[6] It was just as strong in the early twentieth century, and much of the historiography of American art has been driven by a search to find its distinctive essence, to identify the American spirit, as if art expressed what was distinctive about Americans and their history, something that persisted through time and space. The philosopher

George Santayana famously posited a bifurcation in the American histori-cal road, between what he called the genteel tradition, a worn-out imitation of European culture, and the true American spirit, full of vigor and "aggres-sive enterprise."[7] These are the general terms in which art of the period was, and often still is, discussed. The painter Arthur Dove, a figure in Stieglitz's circle, described American art as something that was not really about sub-ject matter but about the qualities of the work and the artist, in terms very similar to Santayana's: "inventiveness, restlessness, speed, change."[8] This is an example of the ways in which the mythical structure of American history, a history of pioneering and innovation, is used to define a coherent national essence expressed by individual endeavor.

Dove's insistence on American art as characterized by individuality is significant. In the early decades of the twentieth century, modernism fre-quently tended toward the autobiographical and personal. Artists used avant-gardism as a way of asserting individualism, and this is built into con-ceptions of the avant-garde artist. Writing to Stieglitz in August 1921, Dove described his art as "almost self-portraits in spite of their having been done from outside things," and one can see this concern for painting as an autobio-graphical act in a work like *George Gershwin: I'll Build a Stairway to Paradise* (1929), a painting he made while listening to that music and responding on the canvas, just as his landscapes record his personal responses to the natu-ral world.[9] Marsden Hartley's landscapes are equally concerned with his own responses and memories.[10] Similarly, Georgia O'Keeffe famously remarked that New York could not be painted as it was but only as it was felt; again, she insisted on the personal experience of the artist as the core of the work. This personal approach is evident, too, in Russell's *Synchromy with Nude in Yellow*. Color is wholly dependent on the viewer, or specific conditions of viewing, rather than being the quality of an object. Building a method on light and color immediately draws it into the realm of the subjective, and one can see this in the way the nude disappears under the action of the painter, how his strokes and marks dissolve the objects before him. While individual style is, inevitably, crucial for any painter, one can find in non-modernist approaches attempts to bring individual vision to collective understanding and experience and to find an America that is less about spirit and more about social reality.

Painting and Walking

John Sloan's *Italian Procession, New York* reveals a very different relation-ship between Europe and the United States and a different conception of experience, one that is about collective life rather than the individual (fig. 62). Sloan is best known as a member of the so-called Ashcan School, whose famous (or infamous) exhibition of 1908 in New York introduced a grittier kind of painting, depicting the seamier side of urban life in the rap-idly expanding metropolis, its commerce and everyday life. The Ashcan artists have been absorbed into the history of modernism, and, certainly, many of them are indebted to nineteenth-century French painting: Everett Shinn's work looks to Edgar Degas, for instance (fig. 63). The Ashcan artists' concern for the new urban environment and the use of technical processes involving looser handling and particular kinds of brushstrokes were largely,

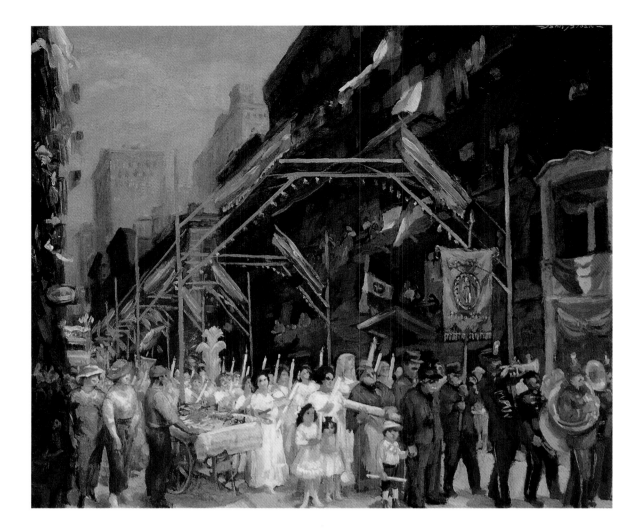

Fig. 62. John Sloan (1871–1951). *Italian Procession, New York*, 1913–25. Oil on canvas; 24 × 28 inches. The San Diego Museum of Art; Museum purchase with funds provided by Mr. and Mrs. Appleton S. Bridges, 1926.127. Cat. 168.

though not exclusively, derived from French painting as it developed after the rebuilding of Paris in the 1850s. There is much excellent literature on this, but the concern to assert the modernist credentials of the Ashcan painters and their pivotal role in the story with which we began has led to a rather partial view of their careers. It is their early work that has received the most attention, and we have, perhaps, overlooked the works they were making twenty years after their pioneering exhibition.[11] This work could no longer count as modernist by the 1920s and so has slipped from view, as if it were no longer pertinent to a modern American culture. Indeed, by 1925, when *Italian Procession* was completed, this was a distinctly *retardataire* way of painting, yet it was this mid-nineteenth-century Francophile style that made it possible for Sloan to capture the modernity of this scene.[12]

Italian Procession reveals the vibrancy and bustle of New York, down in Little Italy, away from the mansions and splendid buildings of Fifth Avenue. It shows a procession of Italian immigrants. Four million Italians had moved to the United States, mostly between the turn of the twentieth century and the Second World War, and, like so many newly arrived communities, retained customs and religious rituals from their homeland.[13] Here, the ritual in question is a *festa*, a procession in honor of a saint or the Virgin Mary. The *festa* was a crucial part of the Italian American Catholic calendar. The streets would be transformed using tinsel, lights, and Italian flags, as well as homelier things like sheets and drapes. Little Italy was reconceived as an Italian

Fig. 63. Everett Shinn (1876–1953). *Stage Costume*, 1910. Pastel and gouache; 7⅝ × 9⅝ inches. The San Diego Museum of Art; Bequest of Mrs. Inez Grant Parker, 1973.91. Cat. 107.

village. As Joseph Costa has pointed out, since most of these immigrants came from villages rather than cities, the intense localism of the village remained a feature of communal behavior, although this became a broader loyalty to southern Italian ethnicity as Italian Americans found their feet in the city.[14] Sloan revels in this transformation of the streets, a transformation that is partial, in that the fabric of the city is still wholly visible. We see two worlds superposed.

Sloan uses this double vision to structure the painting. Across the canvas, a set of pairings emerges, each resonant with the Italian and the American, the Catholic ritual and the everyday life of the city. The flags and banners of the procession compete with the wash hanging from the tenements; the white dresses of the women in the parade are set against the fashionable garb of the women watching on the pavement; the wares of the street seller and the central banner are both purple and gold, with the rich colors of religious ritual also the colors of goods on display in a barrow. These visual rhymes serve to integrate the procession into this new devotional context while pointing to divisions.

Indeed, the very composition of the painting is structured around the relationship between the modern form of the American city and the tradition of the Italian ritual: on the one hand, there is the verticality of New York, evident particularly on the left-hand side, where people lean out of high buildings, emphasized by the narrowness of the detail; on the other hand,

there is the horizontality of the action at ground level. At every point, then, the painting portrays the coherence of the scene and its many fissures.

The Italian *festa* had already attracted attention at the level of both social study and picturesque sight. The reformer and photographer Jacob Riis had been interested in the subject and the community performing it and wrote a series of articles called "Feast-Days in Little Italy," illustrated with his photographs, for *Century Magazine* in 1899.[15] Sloan's painting is not the kind of sociological study that interested Riis. Sloan famously remarked that he saw printmaking as the arena for political work and his painting as a separate kind of practice. Such a clear-cut division is misleading, and however Sloan might have described his thinking, this work does behold America as more than an aesthetic spectacle. Although this was not painted in order to protest distributive injustice, or to signal the artist's Socialist beliefs, a political perspective does emerge from the canvas.[16]

Like so many of Sloan's paintings, it is about walking, ways of moving through the modern city. Sloan is frequently described as a flaneur, the New York equivalent of the mythical French figure who strolls the city streets, observing, noting, casting his forensic gaze on the pageant of modern life.[17] This assumes that Sloan's paintings are, first and foremost, concerned with his own experience of looking at the city, but this is not the case. Sloan is concerned with the experience of others, with the internal lives and social rituals of the working class, immigrants, shopgirls, and others. His often brilliant and oblique views explore ways in which those experiences can be glimpsed, the limits of what can and cannot be seen. The walking portrayed in *Italian Procession* is, in fact, a very different kind of walking from that of the flaneur. Unlike that mythical figure, who remains invisible, at home in the crowd, able to indulge his curiosity and excitement, this is walking as collective and culturally bound, an act of making a home, as if treading the streets were a gesture of ownership. Moreover, Sloan does something rather tender here, quite at odds with the flaneur's cool distance: he addresses how one makes a life in a new city, how one crafts a life in this space, even as this space both enables and constrains the form of the ritual. Unlike, say, the woman in William Merritt Chase's *An Afternoon Stroll* (ca. 1895; cat. 71), a woman who simply belongs in her space and whose movement is about pleasure and ease, the members of the procession are using walking as a means of inhabiting the city. Sloan often recorded the processions he watched in his journal. In May 1912, he went to Union Square to watch a large Socialist parade, and earlier that year, his wife, Dolly, had helped organize a march of the children of striking workers from the mills of Lawrence down Fifth Avenue.[18] Most important of all, Sloan was involved with the Paterson Strike Pageant in 1913. Striking silk workers from New Jersey, supported by the International Workers of the World and an array of Greenwich Village bohemians, told the story of their struggle in a play staged in Madison Square Garden, for which Sloan designed and painted the scenery. The pageant began with a march through the streets of the city, and, as with the other examples, this was not only about being visible but about taking control of the space.[19]

The brilliance of *Italian Procession*, then, is the way in which it figures America as both home and abroad, past and present, modern and traditional, at the same moment—the ways in which these are resolved or unresolved.

Walking, like painting, is a way of inhabiting and representing the city and, in this case, is a collective enterprise. This history continues. Walking can still be freighted with the burden of displacement or exile, with the collision of old and new, leading in different directions. The working-class Italians parading through Little Italy are the predecessors of the figures in Luis Jiménez's *Border Crossing* (cat. 147). This is a much more politically loaded work, and one with a greater sense of desperation. Immigration and walking take different turns here. Rather than people trying to walk their way into an American urban life, this family wades the river simply in order to get to the United States, just as Jiménez's own father did.

The size and scale of the sculpture, along with its totemlike composition with the family piled up, emphasize the sheer effort required. The father is weighed down with more than the weight of his family. Although this work does have a relationship to the artist's own family history, this is no personal anecdote. Again, the size of the sculpture transforms one Mexican family into a gigantic symbol of hope, of despair, and of not belonging. Similarly, the finish, with its modern colored surface, removes it from the standard iconography of picturesque Mexicans. What is so striking is that Jiménez uses a tradition of large-scale figurative sculpture rather than minimalism and its descendants. The impact of the work is derived not only from the directness of figuration but also from the irony of its status as public sculpture, the long tradition of monumental works raised to commemorate nation and the famous rather than the exiled and the unnamed. With this family, as with Sloan's immigrants, walking measures the distance between a home and the absence of home, between the inside and the outside of America.

Skin

In a characteristically brilliant essay, "Personality and the Making of Twentieth-Century Culture," the historian Warren Susman describes a cultural shift that took place in the United States at the turn of the twentieth century, a shift from a concern with character to the newer category of personality.[20] In a range of sources, Susman identified a change in the ways in which people conceived of themselves and, crucially, what they understood as the most desirable and successful personal qualities. While nineteenth-century society had concentrated on the internal moral core of a person, replete with duty, responsibility, and ethical heft, the twentieth century heralded a greater interest in physical appearance, in qualities like charisma and glamour; advice literature, for instance, no longer instructs the reader how to be a better person but explains how to be physically and socially appealing. This, Susman explained, was a way of asserting one's individuality in a mass culture and a world in which aesthetic appearance was becoming more powerful than moral action.

One might think, perhaps rather glibly, about the move from realism to modernism in similar terms: from painting that aims, above all, to find the inner moral core of the world and to adumbrate ethical questions, to painting that wants a personality, the style that distinguishes itself, that attracts in an increasingly hectic visual landscape. Moreover, modernism was often aligned with shifts toward escape from the more restrictive aspects of a

culture of character. One might think of Gertrude Stein as a lesbian and Morgan Russell as a homosexual man, for instance. This is not to suggest that their aesthetic interests can be reduced to their sexuality, that this is a case of homosexual taste or of work that is simply coded. Rather, they sought a visual world that eschewed the moral straitjacket of character, with its Christian heritage, one that would not be at odds with homosexual desire. Of course, the division is not absolute, and one can think of many figures, particularly in the early part of the twentieth century, who were feted for their character, their sense of honor, duty, or citizenship, as well as for their personality. President Theodore Roosevelt is a case in point; as a public figure, he was a charismatic big-game hunter and man of action as well as an earnest and morally engaged historian and politician.[21] Robert Henri's paintings might be seen to occupy a similar position, aiming to combine the realism of Thomas Eakins, Henri's teacher, whom Henri believed to be the greatest of American artists, and the lessons of nineteenth-century Parisian modernism.[22] If modernism is the painting that wants a good complexion, to gain notice through its individual style and charm, to stand out in a crowd, approaches to painting that draw on nineteenth-century realism and an adherence to figuration are the ones that more often reveal, implicitly or explicitly, what is at stake in this cultural shift.

Henri's portrait *Bernadita* (1922; cat. 83) presents a young woman of Mexican or other Hispanic origins. It was painted in Santa Fe, where Henri often spent the summer in the later 1910s and early 1920s. Before visiting Santa Fe, he had met Edgar Hewett, the director of the American School of Archaeology in the town, from whom he received the invitation to help organize the exhibition of art at the Panama-California Exposition in San Diego in 1915; interestingly, the artists chosen for the exhibition were largely members of The Eight, which formed the original Ashcan group. Henri selected none of the post-impressionist art that hung on the walls of the Panama-Pacific International Exposition in San Francisco in the same year.[23] (The first exhibition of truly modern art in California is often deemed to be the 1922 show at the Los Angeles County Museum of Art curated by none other than Morgan Russell and Stanton MacDonald Wright.[24]) By 1915, he was already out of step with modernism.

The portrait is typical of Henri's concerns with the working class, African Americans, Indians, and other marginalized people. Rebecca Zurier, the leading scholar of Ashcan painting, has argued that these portraits rehash familiar types from Old Master painting and other stereotypical formats; while they use a portrait format, they retain the structure of power, hierarchy, and the sitter as an object of interest. She suggests that Henri cannot cross the barriers of class and culture, and so he finds the type rather than the person.[25] It is easy to see why Zurier and other scholars have seen the work, or portraits like it, as a typological approach to portraiture, in which the sitter is shown as an interesting exemplar or specimen. In *Bernadita*, this sense of type is evident in the sultry and seductive beauty, long, luxuriant hair shining in the light, its glossiness suggesting tactility, and the large dark eyes that flash, just as they always do in cheap novels and popular songs. And yet there is also a strong sense of interior life; there is also inquiry on her side

of the canvas, represented through the skeptical look, the pose, half turning away from the viewer, and the way her eyes survey her surroundings.

This interiority is also achieved through the representation of skin. Skin is a significant element of both character and personality. The film star, that epitome of personality, has flawless skin, a blank canvas on which fans can project their dreams and desires. Eakins's portraits offer equivalent use of skin as a sign of character, for these represent skin as the record of a life lived, its creases and marks and folds suggesting an internal world of struggle and emotion. Skin is the greatest element of most portraits, yet it is largely unremarked. Other features, eyes and ears and mouths, are routinely described in detail, but the skin itself is often ignored, unless its color is used to categorize the sitter racially, or a particular distinguishing feature, like a scar or a blush, has a narrative function. Henri poses skin as something changeable, never a straightforward background for the features or the ground of a formal arrangement as is so often the case in modernist portraiture, but something to be read, something that shows us the internal world of the sitter and her distance from us. Look, for example, at the area around Bernadita's left eye. There is white scumbling on her forehead, where the light is strongest. Beneath this, we see the dark line of her eyebrow, and beneath the eyebrow a passage of almost red paint around the eye. This is not like the thin, careful red lines that outline eyes and suggest melancholy or wistful reflection in so many of Eakins's female portraits; Henri paints broader blocks of color and shadow, which emphasize skin as the barrier between inside and outside, a barrier both literal and metaphorical. As Bernadita's head turns in the light against the darkness, her skin changes tone. The very strong color contrasts suggest more than just emergence from dark to light or vice versa. They are instrumental in representing what lies beneath and are crucial to the sense of something withheld; Bernadita is not a transparent type who can be read unproblematically by a trained viewer. The portrait is an exchange rather than an examination. Modern America is about the hidden as well as the visible.

Through the early decades of the twentieth century, the discussion of character and personality often aligned the two modes of selfhood with the European and the American. Character, what it meant, and how it was recognized, was, after all, largely derived from painted portraiture, such as Rembrandt's. Similarly, personality was exemplified by modern cultural forms, like film, which flourished in the New World. One can see this geography of the self in Al Jolson's famous film *The Jazz Singer.* Jolson plays a Jewish man from the Lower East Side who is torn between the old and new worlds: he has to choose whether to sing as cantor in the synagogue as Jakie Rabinowitz or to perform on the Broadway stage as Jack Robin. The ethical dilemma is whether he stays true to his history or becomes a full-fledged American and takes the path of popular entertainer. It is a choice between character and personality, between the inside—the film's text has Jakie say "the songs of Israel are tearing at my heart"— and the outside, exemplified by the blackface Jolson wears when he performs as a jazz singer.[26] While *Bernadita* is not concerned with such a moral conundrum, it, too, balances the outward appearance of popular culture and the inward world of an outsider:

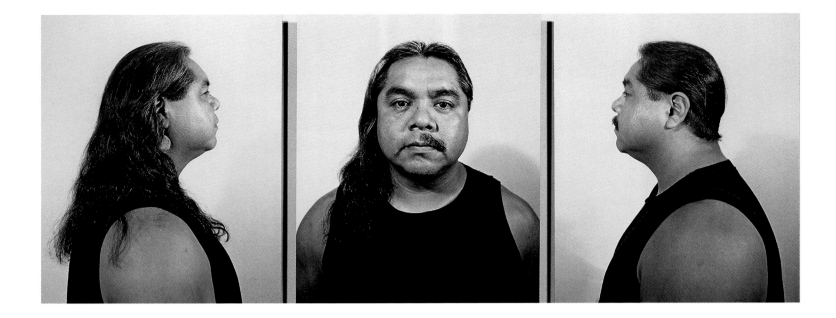

Fig. 64. James Luna (b. 1950). *Half Indian/Half Mexican*, 1991. Three black-and-white photographs; each 30 × 24 inches. Photographer: Richard A. Lou. Museum of Contemporary Art San Diego; Gift of the Peter Norton Family, 1992.6.1–3.

the stereotypical Hispanic beauty and the inwardness of a portrait tradition derived from Edouard Manet and Diego Velázquez.

Like his friend Sloan, Henri is not using art for sociological or political comment. In his book *The Art Spirit*, he writes, "I am not interested in these people to sentimentalize over them, to mourn over the fact that we have destroyed the Indian, that we are changing the shy Chinese girl into a soubrette, that our progress through Mexico leaves a demoralized race like the peons. I am looking at each individual with the eager hope of finding there something of the dignity of life, the humor, the humanity, the kindness, something of the order that will rescue the race and the nation."[27]

But, also like Sloan, there is nevertheless a politics at work here, expressed in a rather high-minded and impractical way in that quotation: too overt a political use denies people their selfhood, their sense of an interior life. What is so striking about Sloan's images of working-class people is that, as with the Italian immigrants, they have a life, a culture, subjectivity. When Sloan paints scrubwomen laughing or Catholics in a procession, this is not to turn them into picturesque genre scenes but to present them as people with minds and lives and cultures. Though *Bernadita* may be perilously poised on the edge of stereotype, Henri manages to show a young woman whose relationship to character and personality is complicated and, most of all through the attention to skin, is not fully knowable to the artist or viewer. Just as Sloan's painting resonates with Jiménez's sculpture, so Henri's portrait resonates with more recent politically committed art in a way that high modernist works do not.

James Luna's *Half Mexican/Half Indian* also raises questions of skin, the known and the unknown, the type and the person (fig. 64). Luna had a Mexican father and an Indian mother, and the work shows him represented as a Mexican, as an Indian, and, in the center, as those two halves joined together into an incoherent whole, as troubling as it is absurd. The work is a witty undermining of certain pictorial traditions that also have their roots in the nineteenth century. The obvious allusion is to the mug shot, the photographic form used to taxonomize criminals and ethnic groups in a bid

to identify the appearance of the perverse and dangerous. Luna's work makes it clear what a foolish enterprise this was: his visibility as a Mexican and as an Indian is no more than a matter of hair and mustache and the predetermined preconceptions of the viewer when a mug shot is labeled with an ethnic term. Furthermore, the set of photographs suggests that, as a non-white American, he has had to conform to the categories of Mexican and Indian, replete with assumptions and stereotypes, and that his actual ethnic background is one that conventional and institutional taxonomies cannot contain.

The representation of race and ethnicity in Luna's work presents the flip side of Henri's attempts at exchange and shared humanity. It hardly needs to be said that skin is unthinkable apart from ideas about racial classifications, racial prejudice, and the place of race in American culture and politics. So often, larger, nobler ideals of liberty and freedom, those that Walt Whitman beholds in his America, are undermined by skin politics. The cleverness of *Half Mexican/Half Indian* is that it not only makes this point in a striking visual manner but also suggests that the very taxonomy of people along racial and ethnic lines is not something that can be judged visually. While photography enables the fantasy of people being wholly knowable, their appearance serving as a transparent index of their selves, Luna debunks this through the very medium of photography, turning the camera against itself. Sloan's painting examines the implied hyphen in the term *Italian American*. Luna reveals another form of hyphenation, one that seems to be outside America, with "Mexican Indian" signaling internal and external threats. It is in rejecting modernism and its traditions that Luna is able to make an art with a radical political core.

If, for Stieglitz's circle, art was fundamentally a form of self-portraiture, as Dove declared, Luna's literal self-portrait undoes the assumptions behind that. Here, he photographs himself and yet reveals nothing, only the assumptions and categories that work to objectify him. In much of his work, he examines the ways in which photography, museum display, tourism, and other cultural forms deny the Indian any subjectivity, even as they claim to reveal the truth of the people and their worlds. Luna shows himself as an American who is regarded as devoid of character and ineligible for personality.

The Modern West

I want to end with one other portrait: Bert Geer Phillips's *Sun Elk* (fig. 65). This kind of Western art is frequently characterized as a worn-out aesthetic and a symptom of a colonizing and aggressive politics. This is not a wholly unfounded judgment, and we cannot view *Sun Elk* without considering westward expansion, the treatment of Native peoples, and the dream of Manifest Destiny.[28] Phillips trained in Paris at the Académie Julien in the mid-1890s and so encountered the Parisian world of academic art rather than the modernism of the Steins' home. On returning to the United States, he learned of New Mexico and traveled there in 1898 with fellow painter Ernest Blumenshein. Together, they set up an art colony in Taos—which still exists today—and the town became extremely popular with artists and audiences, offering a blend of ancient and modern, the American and the exotic, reality and fantasy.[29] Indeed, in the summer of 1915, more than one hundred

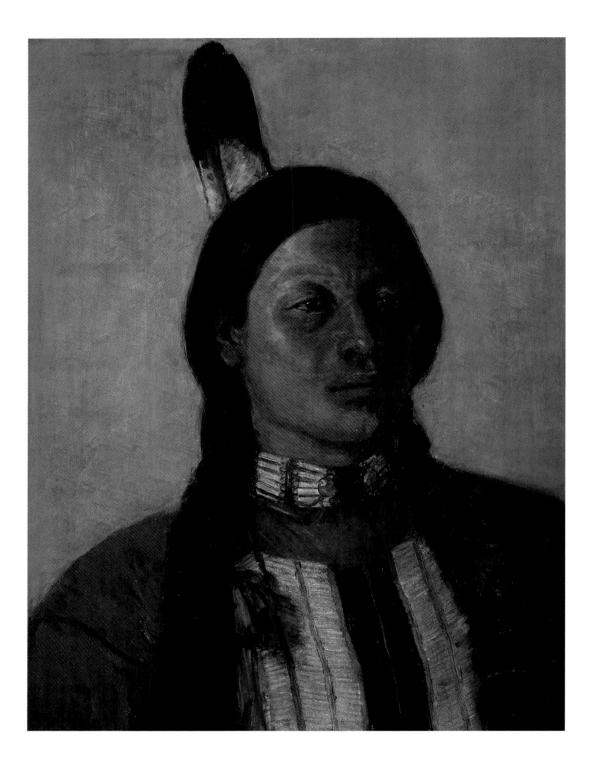

Fig. 65. Bert Geer Phillips (1868–1956). *Portrait of Tudl-Tur (Sun Elk)*, ca. 1910. Oil on board; 12 × 9¼ inches. The San Diego Museum of Art; Gift of Frank P. Phillips, 1979.39. Cat. 163.

artists visited Taos.[30] This number reveals that Taos was not an outpost but quickly became a highly developed and orthodox location for painting; Phillips retained his links with institutions such as the Art Students League of New York and the American Bureau of Ethnology in Washington, D.C. Taos was removed from the art market of major cities but soon developed its own forms of displaying and selling. So the town both allowed a sense of pioneering, of escape from the urban art world into a purer and more authentic American locale, and ensured that careers were not constrained.

Many artists headed west and established themselves in Santa Fe, Taos, and other towns where similar art worlds were set up. Henri traveled there to work from the mid-1910s, and Sloan followed him in 1919. The region also

216

became a magnet for committed modernists, luring artists from the Stieglitz circle such as Hartley, who first visited in 1918, and O'Keeffe, who traveled there at the end of the 1920s, as well as such major figures as Frank Lloyd Wright and Mabel Dodge Luhan, whose salon was at the heart of Greenwich Village bohemianism before World War I.[31] For many, if not most, of the modernist painters, the topography of New Mexico formed the basis of their work in the West. O'Keeffe's *Purple Hills near Abiquiu* (cat. 158) is a case in point, exploiting the abstractness of the landscape, the way it lends itself to a formal pattern. The color of the desert was also important for modernism, for this American landscape has a palette that might be derived from analytical Cubism, with its subtle contrasts of sand and stone. The light, too, was ideal for painters, and this is also apparent in O'Keeffe's canvas. This landscape enables forms of modernist painting because it already conforms to certain pictorial principles; it can be seen easily through modernist eyes. In most of these cases, the modernist landscape in the Southwest is uninhabited. For O'Keeffe, as for other modernists, it is an empty space to be entered by viewer or artist. Here is an instance of what is sometimes called the "soil and spirit" ethos, central to Stieglitz's thinking, which sought an organic or metaphysical link between artist and earth.[32] O'Keeffe's forms, almost bodily in their curves and folds, suggest an erotic closeness between the artist and her landscape, so very different from a painting like Nicolai Fechin's *Torrey Pines* (cat. 138). In Fechin's work, the paint is used to represent the surface of the landscape, the brushstrokes like the facets of rock or the rough wiry plants (indeed, there is a kind of unintended pun related to the dense bushes of the desert brush in the painting and the brush of the artist).

Here, modernists are moving in the opposite direction, away from Paris and into America. As the examples of Fechin and Phillips show, they were preceded by artists who did not share their modernist styles and values, although all these painters were seeking something distinctively American, an alternative to European subject matter. It is the non-modernist artists who more often painted a peopled landscape, dealing with inhabitation rather than isolation, social encounter rather than subjective epiphany. *Sun Elk* is the record of such an encounter between a French-trained, urban artist and a Native American. But this is an encounter that cannot help but bear the difficult baggage of relations between Indians and white America. Supporting the politics of westward expansion, the claiming of land, and removal of the Indians, there were three important cultural modes: romanticism, missionary zeal, and commerce. A long-standing romantic representation of Indians presented these peoples as something from the past, something irrelevant to the modern world. This was to be found not only in painting and literature but in such arenas as scientific exploration. The photographs taken to accompany the great geological surveys of the trans–Mississippi West often included Indians asleep on the ground or merging into rock formations as if they were one with the landscape.[33] Such images helped to justify the removal of Native peoples to reservations and the practice of forced assimilation; they presented Native American life as a primitive culture that had no place in the modern nation. Such images also provided apparent evidence supporting the thesis of the vanishing race, the notion

that Indians were doomed to extinction by fate or by nature (never by the white man) and could be saved only if they assimilated. This, in turn, motivated the missionary zeal of groups like the Friends of the Indian, who were sincere in their concern for Native Americans but whose civilizing mission aimed to destroy Indian cultures, replacing tepees with shacks, blankets with suits and dresses, hunting with farming. Richard Henry Pratt, a leader in Indian industrial education and important advocate of forced assimilation, famously declared that America must "kill the Indian to save the man," following the Christian rhetoric of hating the sin and loving the sinner.[34] Indians were also a commercial source and staple of popular culture, as evinced by Wild West shows, Western art, the rise of the Western as literary, pictorial, and film genres, and spectacles such as the defeated chief Geronimo on display at the 1904 World's Fair in Saint Louis. Dream, relic, sinner, commodity: modernity transformed the Indian into a set of representations, images with no inner life.

All this provides the hinterland of the portrait *Sun Elk*, and, as a consequence, here, even more than in *Bernadita* (cat. 83), we see the tension inherent in so much portraiture between the depiction of a person and a depiction of a type. One might ask whether, in early twentieth-century America, was there any way around this problem in Indian portraits? What would have to be done to ensure that the sitter was always presented fully as an individual person? And what would this mean for his or her Indian identity, given that he or she was persecuted as a member of a tribe? Was there a way out of the double bind of romantic fetish and marketable image, of vanishing nobility and debased savage? It is not just the encounter in the studio but the very encounter between viewer and image that is problematic, as if, in this matrix of white representations, there was no place for the Indian himself. Phillips tried his hardest. Sun Elk is named; he is not an exemplar of a whole tribe or a whole ethnic type but a single person. In Indian portraits, though, this may exacerbate the problem. The romance of Indian names, the ways in which they are used for belittling humor or for dreams of the noble savage and his apparent oneness with nature, means that naming the Indian does not save him from typecasting. The same double bind emerges with dress and adornment. Phillips, in trying to represent the culture and status of Sun Elk, very carefully painted the beads, the feather in the hair, and the hair itself, but these are all items long since locked into a popular iconography, drained of their original significance.

Perhaps this struggle is what makes the portrait so moving. Indeed, the very form of the portrait means that Sun Elk not only has status in his own terms, evident in his dress and adornment, but is being granted status in Phillips's terms, as a man meriting this form of representation. Moreover, the pose, the cool demeanor, and the serious gaze of the sitter work to suggest character rather than personality; the Native American as a moral person rather than a picturesque or national symbol. The messy political history within which this is located also alerts us to the fact that Phillips is dealing with history on a human scale. Unlike the geological timescale, the sublime sense of something beyond our life span that O'Keeffe's rocks present, Phillips engages the consequences of human history: not the timeless rocks outside, but the flesh-and-blood bearer of history sitting in the studio.

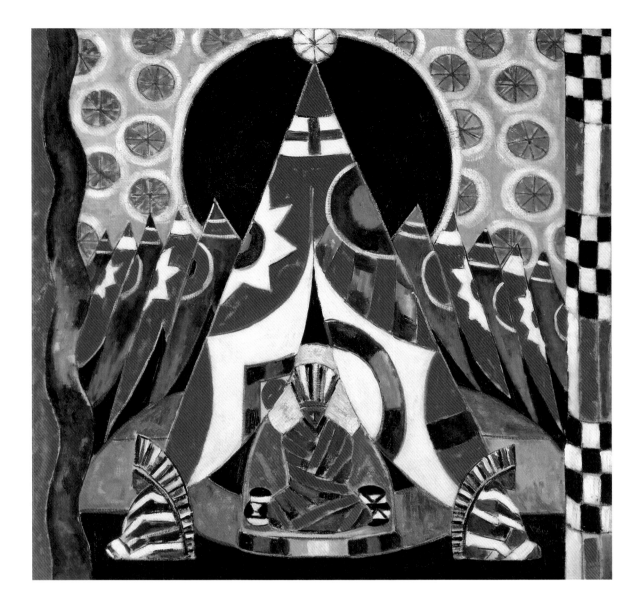

This is not an absolute comparison of modernism and non-modernism. After all, Hartley used Indian motifs in some of his more abstract works, such as *American Indian Symbols* (1914; fig. 66). For Hartley, Native culture offered a spiritual alternative to industrial modernity, a potential antidote to the ills of the contemporary world. Here, the beads and patterns and tepees could perhaps be used to counter orthodox white iconographies, given their reconfiguration in his modernist style, but it is telling that his interest is in objects and symbols rather than figures and their experiences. It is still a question of timelessness, of an alternative to contemporary history. Hartley's paintings do not meet the matter head-on in the way that more traditional forms of painting do. This is meant not as a value judgment but rather as an illustration of the ways in which the complicated history of modern America might be more visible in art that, apparently, is mired in the previous century than in the most adventurous abstraction. In Hartley's work, there is a kinship between the modern painter and Native American culture; in *Sun Elk*, we see the bitter irony of a man who is the very symbol of a nation that has rejected him.

Fig. 66. Marsden Hartley (1877–1943). *American Indian Symbols,* 1914. Oil on canvas; 39¼ × 39¼ inches. Amon Carter Museum, 1999.8.

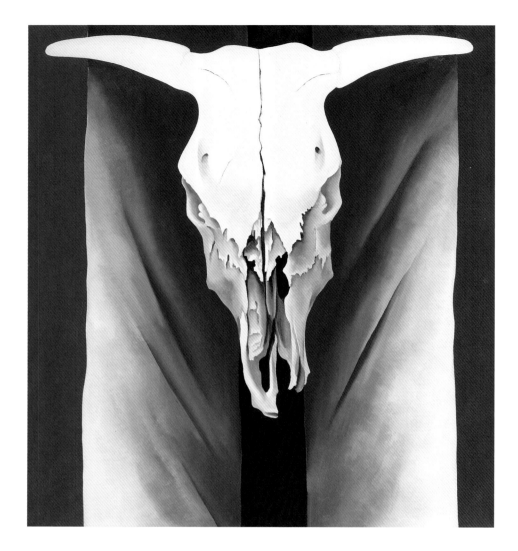

Fig. 67. Georgia O'Keeffe (1887–1986). *Cow's Skull: Red, White, and Blue,* 1931. Oil on canvas; 39⅞ × 35⅞ inches. The Metropolitan Museum of Art; Alfred Stieglitz Collection, 1952, 52.203.

While modernist artists tended to paint uninhabited, personalized land-scapes, artists continuing in figurative and non-modernist traditions showed the tensions and complications of this paradox, some intentionally, some unintentionally. Sloan's images of tourist culture in the Southwest are popu-lated with Indians performing their rituals for visitors from the city; Joseph Henry Sharp shows Indians with cigarettes and ethnographic images.[36] Modernism, of course, can have its own irony. O'Keeffe famously painted *Cow's Skull, Red, White, and Blue* (1931; fig. 67), a whitened skull against the colors of the flag, as a parody of the nationalist ambitions of regionalist painting in the 1930s, but this is an attenuated politics and, again, a gesture that is largely internal to art, unlike the ironies in Sloan, Luna, and Jiménez. Phillips does not share a sense of irony with these artists, and, for twenty-first-century sensibilities, the irony arises from his social situation: that his wish to record and capture what he finds noble and positive about the Taos Indians may look today like no more than romantic primitivism. But *Sun Elk* is a serious work of art, an attempt to engage with another culture, even if this well-intentioned bid to portray an Indian man as heroic slides into a fetishizing form of racist iconography.

Contradiction

In order to behold modern American art, we need to attend both to modernism and to its alternatives, for it is in the meeting of the two that the nature of American art fully emerges. As Whitman surmised, it is only such unfathomable variety that can describe or express a nation so complicated in its historical, social, and ethnic dimensions. No single painting can do the job of Whitman's rambling verse; such range could not be compressed into a single image, but when paintings are arrayed, as in this exhibition, side by side, room by room, the untidy history of American art becomes visible. There is no spirit, no individuality, no restlessness, that can serve as an essence for our understanding of the field. Indeed, what is more striking is the way in which any attempt to find American-style painting is undermined by itself, by other painting, or by its social and historical location. This is not simply to say that modern American art is a collection of different styles; rather, modern American art is a category that will never cohere, in which the very terms "modern" and "American" resist straightforward definition. Do I contradict myself? Very well then, I contradict myself, for these contradictions, these ironies, are the points at which we most clearly behold modern American painting.

NOTES

1. Two excellent modern surveys that offer valuable alternatives to the modernist story are: Frances Pohl, *Framing America: A Social History of American Art* (London and New York: Thames & Hudson, 2002); Angela Miller et al, *American Encounters: Art, History, and Cultural Identity* (New York: Prentice Hall, 2007).

2. Henry Adams, *Tom and Jack: the intertwined lives of Thomas Hart Benton and Jackson Pollock* (New York: Bloomsbury Press, 2009); Wanda M. Corn and Tirza True Latimer, *Seeing Gertrude Stein: Five Stories* (Berkeley, CA, and London: University of California Press, 2011); Janet Bishop, Cecile Debray, and Rebecca Rainbow, *The Steins Collect: Matisse, Picasso and the Parisian Avant-Garde* (New Haven and London: Yale University Press, 2011).

3. For the Armory Show, see: Milton Brown, *The Story of the Armory Show* (Greenwich, CT: New York Graphic Society, 1963); Martin Green, *New York 1913: The Armory Show and the Paterson Strike Pageant* (New York: Scribner, 1988); *Documents of the 1913 Armory Show: The Electrifying Moment of Modern Art's American Debut* (New York: Hol Art Books, 2009); and still of great value is Meyer Schapiro's 1952 essay, "The Introduction of Modern Art in America: The Armory Show" reprinted in Meyer Schapiro, *Modern Art: 19th and 20th Centuries* (London: Chatto & Windus, 1978), 135–78. For helpful accounts of the emergence of American modernism and its relationship to Europe, see: Sarah Greenhough, ed., *Modern Art and America: Alfred Stieglitz and his New York Galleries* (Washington D.C.: National Gallery of Art, 2000); Debra Bricker Balken et al, *Debating American Modernism: Stieglitz, Duchamp, and the New York Avant-garde* (New York: American Federation of Arts, 2003).

4. Gail Levin, *Synchromism and American Color Abstraction, 1910–1925* (New York: G. Brazilier, 1978).

5. Clement Greenberg, "American-Type Painting (1955)," in John O'Brian, ed., *Clement Greenberg: The Collected Essays and Criticism*, vol. 3 (Chicago: University of Chicago Press, 1986), 217–35.

6. See Michael Hatt and Charlotte Klonk, *Art History: A Critical Introduction to its Methods* (Manchester: Manchester University Press, 2005).

7. George Santayana, "The Genteel Tradition in American Philosophy," in Douglas L. Wilson, ed., *The Genteel Tradition: Nine Essays by George Santayana* (Cambridge, MA: Harvard University Press, 1967), 40.

8. Ann Lee Morgan, *Arthur Dove: Life and Work, with a Catalogue Raisoneé* (Newark:

University of Delaware Press, 1984); Debra Bricker Balken, *Arthur Dove: A Retrospective*, exh. cat. (Andover, MA: Addison Gallery of American Art, 1997); Ann Lee Morgan, ed., *Dear Stieglitz, Dear Dove* (Newark: University of Delaware Press, 1988).

9. William C. Agee, "Arthur Dove: A Place to Find Things," in Greenhough, ed., *Modern Art and America*, 426. See also: Will South, *Color, Myth and Music: Stanton MacDonald Wright and Synchromism* (Raleigh, NC: North Carolina Museum of Art, 2001). John Gage remarks that Morgan Russell sometimes worked with a Beethoven score in front of him: John Gage, *Colour and Culture: Practice and Meaning from Antiquity to Abstraction* (London and New York: Thames and Hudson, 1993), 193.

10. Heather Hole, *Marsden Hartley and the West: The Search for an American Modernism* (New Haven and London: Yale University Press, 2007), 28. For a nuanced account of Hartley's self-representation, see: Bruce Robertson, "Marsden Hartley and Self-Portraiture," in Elizabeth Mankin Kornhauser, ed., *Marsden Hartley* (New Haven and London: Yale University Press, 2003), 153–74.

11. Elizabeth Milroy, *Painters of a New Century: the Eight and American Art*, exh. cat. (Milwaukee WI: Milwaukee Art Museum, 1991); Rebecca Zurier, Robert W. Snyder, Virginia M. Mecklenburg, *Metropolitan Lives: the Ashcan Artists and their New York*, exh. cat. (New York: National Museum of American Art in association with W. W. Norton, 1995).

12. Rowland Elzea, *John Sloan's Oil Paintings: A Catalogue Raisoneé* (Newark: University of Delaware Press, 1991), 128.

13. Joseph P. Cosco, *Imagining Italians: The Clash of Romance and Race in American Perceptions, 1880–1910* (Albany: SUNY Press, 2003).

14. Cosco, *Imagining Italians*, 47.

15. Jacob Riis, "Feast Days in Little Italy," *Century*, 58 (August 1899), 491–99.

16. For Sloan's politics, see: Rebecca Zurier, *Picturing the City: Urban Vision and the Ashcan School* (Berkeley and Los Angeles, CA: University of California Press, 2006); Rebecca Zurier, *Art for the Masses: A Radical Magazine and Its Graphics, 1911–1917* (Philadelphia: Temple University Press, 1988); Rachel Schreiber, *Gender and Activism in a Little Magazine: The Modern Figures of the Masses* (Ashgate: Farnham, Surrey, and Burlington VT, 2011).

17. For an interesting discussion of Sloan as a flaneur see: Molly S. Hutton, "Walking in the City at the Turn of the Century: John Sloan's Pedestrian Aesthetics," in Heather Campbell Coyle and Joyce K. Schiller, *John Sloan's New York*, exh. cat. (Wilmington: Delaware Art Museum, 2007), 82–115.

18. Bruce St. John, ed., *John Sloan's New York Scene* (New York: Harper & Row, 1965), 620; 602.

19. For the Paterson Strike Pageant, see: Brooks MacNamara, ed., 'Paterson Strike Pageant,' *The Drama Review: TDR*, 15: 3 (Summer 1971), 60–71; Martin Green, *New York 1913*. For Greenwich Village Bohemianism, see: Gerald MacFarland, *Inside Greenwich Village: A New York City Neighborhood, 1898–1918* (Amherst MA: University of Massachusetts Press, 2001); Rick Beard and Leslie Cohen Berkovitz, *Greenwich Village: Culture and Counterculture* (New Brunswick, NJ: Rutgers University Press, 1997); Leslie E. Fishbein, *Rebels in Bohemia: The Radicals of the Masses, 1911–1917* (Chapel Hill, NC: University of North Carolina Press, 1982).

20. Warren I. Susman, 'Personality and the Making of Twentieth-Century Culture,' in *Culture as History: The Transformation of American Society in the Twentieth Century* (New York: Pantheon Books, 1973), 271–85.

21. The starting point for all work on Roosevelt must now be Edmund Morris's trilogy: *The Rise of Theodore Roosevelt* (London: Collins, 1979); *Theodore Rex* (New York: Random House, 2001); and *Colonel Roosevelt* (New York: Random House, 2010). See also: James G. Barber, *Theodore Roosevelt: Icon of the American Century*, exh. cat. (Seattle and London: National Portrait Gallery, Smithsonian Institution, and University of Washington Press, 1998).

22. Robert Henri, *The Art Spirit* (New York: J. B. Lippincott Co., 1923), 89–91.

23. Bernard B. Perlman, *Robert Henri: His Life and Art* (New York: Dover Publications, 1991), 115–6.

24. Peter Plagens, *Sunshine Muse: Art on the West Coast, 1954–1970* (Los Angeles: University of California Press, 1974), 16. Nancy Mowll Matthews suggests that there is an even earlier exhibition of 'bona fide' modernist art organized by MacDonald-Wright at the Los Angeles Museum of Science, History and Art in 1920: Nancy Mowll Matthews, *American Dreams: American Art to 1950 in*

the *Williams College Museum of Art* (New York: Hudson Hills Press, 2001), 141.

25. Zurier's excellent account of Henri can be found in: Rebecca Zurier, *Picturing the City*, 107–34.

26. Michael Rogin, *Blackface, White Noise: Jewish Immigrants in the Hollywood Melting Pot* (Berkeley and Los Angeles: University of California Press, 1998) offers an influential and important analysis of the film and its use of blackface.

27. Henri, *The Art Spirit*, 147.

28. The politics of Western art has been a fraught topic since the controversial exhibition at the National Museum of American Art in 1991: William H. Truettner, ed., *The West as America: Reinterpreting Images of the Frontier, 1820–1920* (Washington D.C.; National Museum of American Art, 1991). For two classic accounts of the West in culture and politics, see: Brian W. Dippie, *The Vanishing American: White Attitudes and U.S. Indian Policy* (Lawrence, KS: University Press of Kansas, 1982); Richard Slotkin, *Gunfighter Nation: The Myth of the Frontier in Twentieth-Century America* (New York: Athenaeum, 1992).

29. Suzan Campbell, *Taos Artists and Their Patrons, 1898–1950*, exh. cat. (Notre Dame, IN and Albuquerque, NM: Snite Museum of Art, University of Notre Dame and University of New Mexico Press, 1999); Mary Carroll Nelson, *The Legendary Artist of Taos* (New York, Watson-Guptill Publications, 198; Peter H. Hassrick and Elizabeth J. Cunningham, *In Contemporary Rhythm: The Art of Ernest L. Blumenschein* (Norman: University of Oklahoma Press, 2008); Julie Schimmel, *Bert Geer Phillips and the Taos Art Colony* (Albuquerque: University of New Mexico, 1994); Charles C. Eldredge, Julie Schimmel, and Wiliam H Truettner, *Art in New Mexico, 1900–1945: Paths to Taos and Santa Fe*, exh. cat. (Washington D.C.: National Museum of American Art, 1986).

30. Tom Holm, *The Great Confusion in Indian Affairs: Native Americans and Whites in the Progressive Era* (Austin, TX: University of Texas Press, 2005), 125.

31. Sascha T. Scott, *Paintings of Pueblo Indians and the Politics of Preservation in the American Southwest* (Ann Arbor, MI: UMI, 2008); Lois Palken Rudnick, *Mabel Dodge Luhan: New Woman, New Worlds* (University of New Mexico Press, 1984), 143–190; Mabel Dodge Luhan, *Taos and its Artists* (New York: Duell, Sloan and Pearce, 1947);

Barbara Buhler Lynes, ed., *Georgia O'Keeffe and New Mexico: A Sense of Place* (Princeton, NJ: Princeton University Press, 2004); Heather Hole, *Marsden Hartley and the West: The Search for an American Modernism* (New Haven and London: Yale University Press, 2007); Wanda M. Corn, "Marsden Hartley's Native Amerika" in Elizabeth Mankin Kornhauser, ed., *Marsden Hartley* (New Haven and London: Yale University Press, 2003), 69–94.

32. The phrase 'soil-and-spirit nationalism' was coined by Wanda Corn: Wanda M. Corn, *The Great American Thing: Modern Art and National Identity, 1915–1935* (Berkeley and Los Angeles: University of California Press, 2001). The term is, however, grounded in the discourse of the Stieglitz Circle: see, for example, Paul Rosenfeld, *By Way of Art: Criticisms of Music, Literature, Painting, Sculpture and the Dance* (New York: Coward-McCann, 1928); *America & Alfred Stieglitz: A Collective Portrait*, edited by Waldo Frank, Lewis Mumford, Dorothy Norman, Paul Rosenfeld, and Harold Rugg (Garden City, NY: Doubleday, Doran & Co., 1934).

33. See François Brunet et Bronwen Griffiths, eds., *Visions de l'ouest: photographies de l'exploration americaine 1860–1880* (Giverny: Terra Foundation for American Art, 2007).

34. Richard Henry Pratt, *Official Report of the Nineteenth Annual Conference of Charities and Correction* (1892), reprinted as Richard H. Pratt, "The Advantages of Mingling Indians with Whites," *Americanizing the American Indians: Writings by the "Friends of the Indian" 1880–1900* (Cambridge, Mass.: Harvard University Press, 1973), 260. See also: Richard Henry Pratt, *Battlefield and Classroom: Four Decades with the American Indian, 1867–1904*, ed. Robert M. Utley (University of Oklahoma Press, 2003).

35. See, for example, Sharp's *Three Taos Indians* (oil on canvas, 1920–40, Anschutz Collection, Denver). Sharp sometimes paid his models in cigarettes as well as cash: Joan Carpenter Troccoli, ed., *Painters and the American West: the Anschutz Collection* (Denver: Denver Art Museum, 2000), 34.

36. O'Keeffe described the painting as 'my joke on the American scene': Lisa Mintz Messinger, "Georgia O'Keeffe," *The Metropolitan Museum of Art Bulletin*, 42: 2 (Autumn 1984), 49.

Robert Henri's
San Diego

DERRICK R. CARTWRIGHT

California's role in modernist art history is unsettled, and San Diego's place within that larger narrative is more uncertain still. A few historians in recent years have challenged the reigning East Coast biases when rehearsing the story of modern art's progress,[1] but mainstream accounts still emphasize vanguard activities in New York City above "regional" (read: provincial) contributions. For instance, scholars regard Alfred Stieglitz's venues—the Little Galleries of the Photo Secession, 291, An American Place—as crucial to awakening public tastes for new imagery and conclude that the Armory Show of 1913 (officially, the International Exposition of Modern Art) delivered the coup de grâce to safe academicism in this country. There is no point to disputing the significance of impresarios like Stieglitz or exhibitions like the Armory Show here. However, a myopic concentration on established activities in the metropolitan east has served to narrow appreciation of modern art's initial breadth and diverse themes. Surely other specific, local, and competing circumstances tempered innovative art practices throughout the United States. Exploring San Diego as a potential site of complex changes during the first decades of the twentieth century suggests fresh perspectives on modernist practice and offers new insights into complex expressions elsewhere.

As this essay's title suggests, Robert Henri is a protagonist in a larger, more inclusive story of Southern California as modernist elsewhere. Although he was born in Ohio, spent his youth in Nebraska, and trained first as an artist in Philadelphia and then Paris, scholars have tended to treat Henri as a quintessentially New York realist. His mature career was, in fact, peripatetic, and the representational priorities for his realism changed several times. In addition to France, his frequent destinations abroad included Spain, Holland, and Ireland, and more often than not he opted to summer on Monhegan Island, Maine or in Santa Fe, New Mexico during his later career. It is not well known that he spent time in California and celebrated his forty-ninth birthday in La Jolla. The change in orientation that Henri's work underwent while he was in San Diego has been underappreciated by his biographers, just as this place remains under-recognized within the

broader narrative of twentieth-century American painting. The year 1914 was a definitional one for Henri.

Before turning to the reasons this celebrated artist chose to devote an extended period to painting in California, let us acknowledge that Henri would be well known to us had he never done so. Since the 1890s, as both an exhibiting artist and, later, as an influential teacher, Henri's name was closely associated with progressive painting in both Philadelphia and New York. Indeed, he led an important group of self-identified realists—John Sloan, Everett Shinn, William Glackens, George Luks, and George Bellows, as well as others—who emerged from the nineteenth-century tradition of newspaper illustration, using Daumier-like scrutiny of class incongruities and biting satire as their guideposts. Their dark easel paintings eschewed impressionistic color and grand manner portraiture, celebrating instead the urgent, unglamorous sides of urban living.

The works of the so-called "Ashcan School" were rightly interpreted as an aesthetic rebuke to prevailing tastes.[2] While Henri and his peers were not always shown the door by conservative art juries who looked askance at their gruff images, they were likely to be shown poorly in the turn-of-the-century installations organized by leading New York art institutions, such as the annual displays at the National Academy of Design.[3] Given this treatment, Henri's cohort soon opted for an alternative path, one already laid out by Gustave Courbet and Edouard Manet: they initiated their own Salon des Refusés, a show of eight independents at The Macbeth Gallery in 1908, which ultimately gave them a name of their own choosing, The Eight. Henri was their acknowledged leader.[4] Similarly, in their unanimous decision to exhibit their works in the Armory Show five years later, members of The Eight were making an effort to align their new approach to painting with the latest European innovations. Older artists, such as Childe Hassam, politely refused the invitation to affiliate with the Associated American Painters and Sculptors, the organizers of the Armory Show, while members of The Eight were among the first to join the fledgling group.[5]

By showing deliberately American scenes alongside the most abstract painting and sculpture from abroad, artists of the younger generation aimed to direct favorable comparisons between their current work and that of the most advanced Europeans, in so doing further underscoring their difference from established art circles in New York. Henri predicted that the show would "make a great stir—and do a great deal of good in a great variety of directions."[6] To be sure, Henri underestimated the character of the stir and the vehemence with which critics received this exhibition. Still, the ridicule and scorn that was generally heaped on the Armory Show did not detract from the fact that Henri emerged confident and sold at least one work from the exhibition: *The Red Top* fetched $925.00 for the artist, less a 10 percent commission.[7]

The wider cultural skepticism toward foreign-born, modern artists, such as Constantin Brancusi, Henri Matisse, and Marcel Duchamp, forced Henri and his compatriots to reevaluate their claims as modern artists. Mainstream New York critics deepened their hostility to the aims of the Ashcan School, and the gambit of forging a new allegiance with European practice seemed a failure. In this context, perhaps, it makes sense now to interpret

Henri's wanderlust as an effort to discover creative solutions elsewhere. He once wrote to Sloan, who was at that time considering relocating to New York from Philadelphia, that "I always find a move productive of an awakening of some sort."[8] After the negative reception of the Armory Show, and with dwindling patience for the New York art world, Henri immediately set off for Ireland, in 1913. The next year, after passing the winter in his Gramercy Park studio, he set off in the opposite direction: California.

Henri's curiosity about San Diego can be traced to 1912 and owes much to a former student, Alice Klauber, who had traveled with him in Spain (fig. 68).[9] Klauber was San Diego–born and probably issued an invitation to her teacher to visit her while on that summer trip. Henri wrote her in November that he "should like much to see San Diego sometime" but waited two years to act on the invitation. He wrote again in early March 1914: "Westward ho! We intend to come to California this summer . . . sometime early in May we shall start. I am now quite convinced that San Diego is one of the most interesting and beautiful places in the world and we shall head that way and will not be convinced otherwise until we have seen the place and have been turned away."[10] This exuberant letter to Klauber provides an index of the older artist's enthusiasm for new adventures, but Henri was careful to set clear expectations. In his next letter, he was quick to inform Klauber that he had "'retired' as a teacher" but that he was looking forward to California "as a place where the sun will warm me up to the right heat of production, where I can luxuriate in work and sunshine, fruit, flowers, good food, no dutys [sic], not have to dress, not entertain or be entertained."[11] Furthermore, in addition to Klauber, Henri had numerous former students in Southern California, including Henrietta Shore, Rex Slinkard, and Alson Skinner Clark, all of whom were then living near or in Los Angeles.[12] His April letter explained that he would visit with some of these other students and tour the coastline at least as far north as Santa Barbara during this trip. He cautioned Klauber, lest she take any offense later, that in the end he and his wife Marjorie might not decide to spend much time in San Diego at all. The exchange demonstrates just how motivated the New Yorker was to take in the coastal landscape on this journey.

Most of all, these preliminary letters make clear that what was attracting him to California was its reputation for "interesting people." Henri needed to be assured explicitly that he would find them in San Diego:

> I am told you have them [i.e., interesting people] all the way from [the] up to date class to the half-breed gipsy [sic]. Is that so? and is it likely that any or a significant number of them would be willing to pose as models for a reasonable model's wage? Of course, this does not apply to the up to date class. I will paint their portraits at my usual rate, provided they don't want to tell me how to do the portraits. I don't know enough about San Diego and the chances of getting models to do more, of course, than imagine what I want. I

Fig. 68. Portrait of Alice Klauber. San Diego History Center, #85:15336.

want the sun. I want to be where I can see the beauty of a surrounding. I don't care whether it is in town or out of town, just so the models are available.[13]

Klauber went to great lengths to ensure that the Henris would have access to what they wanted in San Diego that summer, and more. She did this by promising her former teacher that only she was well positioned enough in her community to supply him with an abundance of the requisite "interesting" subjects to paint. Evidently, that promise was enough to convince the Henris to at least begin their tour of the West with her in San Diego and to put off their explorations of the rest of the state until after they had checked in with Klauber.

While some of Henri's biographers mention the 1914 trip to California, no comprehensive discussion of what actually took place in La Jolla exists.[14] Robert and Marjorie Henri arrived in San Diego in mid-June. After spending a night downtown in the U.S. Grant Hotel, they were taken by Klauber to the beach cottage that she had arranged for them to rent while in town. While San Diego itself had a population of close to one hundred thousand in these years, La Jolla was a smaller subcommunity of the city. Located more than ten miles from Klauber's home in Mission Hills, La Jolla was then accessible by electric train. The small guest house at 300 Coast Boulevard was owned by Mary Richmond and had been designed by soon-to-be-renowned California architect Irving Gill. Although the cottage no longer stands, snapshots from the period show its sun-struck, pure geometries, as well as its proximity to the water, features that must have appealed to the vacationing New Yorkers (fig. 69).

After just a few days, Henri seems to have dropped the idea of exploring California from his base in La Jolla, announcing to Klauber that he was "keyed to the place," "content," and ready to begin a summer's work of painting. We might expect Henri to have been drawn to the water, since he clearly

Fig. 69. Robert Henri at the Richmond Beach Cottage. The San Diego Museum of Art Archives; The Alice Klauber Collection.

was fond of seascapes, judging from the many small sketches he had painted in Maine, Ireland, and France. Even though the coast and La Jolla Cove were just steps away from his front door, there is scant evidence that he took a deep interest in the California shore. This is surprising, given the attraction of this landscape for so many other artists in the region. In fact, it appears that Henri chose to create only one or two small images of California's famed beaches during his visit, and these seem to have been his only plein air efforts in California.[15] What, then, did Henri do while in La Jolla?

There are three answers to this question: he painted portraits, he organized exhibitions, and he wrote articles. Furthermore, he did these prolifically. By looking at this busy time, I hope to underscore the importance of Henri's 1914 sojourn in La Jolla in reckonings of his larger career, as well as alternative accounts of modernism in American art history. In La Jolla, Henri achieved a breakthrough that merits special attention from scholars. Before clinching any argument about the status of this admittedly brief interlude in Henri's overall contribution, we should turn to the quantity and nature of the portraits he produced.

Henri thrived outside of the New York art scene and clearly enjoyed painting away from the city. He often painted subjects multiple times, and one of his favorite subjects to depict while traveling was Marjorie Organ Henri, his wife. He painted her on at least two occasions in San Diego. The first portrait was presented as a gift to his host, Alice Klauber, and today belongs to The San Diego Museum of Art (cat. 84). As the inscription to Klauber at lower left suggests, the painting was a "souvenir" of the summer of 1914. As a personal remembrance, the artist's representation of Marjorie, who had been with Klauber two years before in Spain, stands as a strong demonstration of the artist's unadorned pictorial style. Marjorie sits with her arms crossed confidently before her. The bust-length portrait on a commercially prepared canvas is typical of Henri, with its slashing brushwork and economical means of describing the figure. The only evidence of this portrait's California manufacture might be the bright colors and large-brimmed straw hat that barely shades Marjorie's pale features. A second, larger portrait of her from this period, *The Beach Hat*, shows the sitter in an identical outfit, but leaning forward and with somewhat greater intensity of expression.[16] These works, while rooted in interpersonal relationships, end up being exceptional within the larger group of portraits made in the summer of 1914.

The vast majority of works that Henri painted in La Jolla represent racial minorities of the region. The artist had alluded to seeking "interesting people" in his correspondence with Klauber, and her response to this request seems to have been to arrange a remarkably diverse group of sitters for her former teacher. The portraits of Chinese American, Mexican American, African American, and Native American individuals whom Henri chose to paint while living on the beach are remarkable for their concentration on these varied people as well as the Mediterranean palette with which he created his portraits of Southern California citizens.

Henri was interested in ethnic and racial diversity before coming west and created multiple representations of Irish immigrants as well as African American subjects on numerous occasions. Images such as *Willie Gee* (1904; Newark Art Museum) and *Eva Green* (1907; Wichita Art Museum) suggest

Fig. 70. Robert Henri (1865–1929). *The Failure of Sylvester,* ca. 1914. Oil on canvas; 41 × 33 inches. Collection of Cheekwood Botanical Garden and Museum of Art; Museum purchase through the bequest of Anita Bevill McMichael Stallworth, 1993.6.

the personal interest and warmth that Henri applied in depicting individuals who had previously been treated with caricature by American artists. La Jolla had a small population of African Americans in 1914, many of them service workers, and Henri painted a young boy, Sylvester, three different times during his stay in San Diego. Henri described his sittings with Sylvester in a letter to his mother:

> I have a good portrait of a negro boy laughing. His name is Sylvester and he is a great youngster. Sells papers in the depot of our La Jolla train in San Diego. The Victrola kept him awake and kept his feet patting the floor the last time he posed. Before that, when he posed he could not keep awake—I had him sitting like the prince of Africa in one of Mrs. Richmond's beautiful high backed chairs, but he could not keep up the state of the prince. Fell into a deep sleep after yawns that showed that behind his black face there was a vast wealth of color—namely the inner rim of his lips, his red gums, and his ivory yellow teeth. Such width of yawns were never seen! He went to sleep and I painted him so the picture might be called "the failure of Sylvester."[17]

The chiding identification "the failure of Sylvester" stuck with the portrait (fig. 70), but the sustained sense of devotion with which Henri attended to this particular subject and his enthusiasm for the "great youngster," as evidenced by the multiple sittings, have been mostly lost. Henri's care for his La Jolla subjects was clearly important.

Alice Klauber dutifully introduced the Henris to her social circle. Another portrait of a child, an unfinished work titled *Mukie,* suggests that

Fig. 71. Robert Henri (1865–1929). *Mukie,* 1914. Oil on canvas; 25 × 20 inches. The San Diego Museum of Art; Gift of Alice Klauber, 1942.72.

Henri performed at least one artist demonstration for Klauber's friends in the Wednesday Club (fig. 71). Still, her most appreciated task as host was to help supply models. Jim Lee was another such subject. Lee has been identified as a local vegetable salesman. Like Sylvester, he was asked to pose on several occasions by Henri and also permitted the artist to paint other members of his family. In fact, the multiple paintings of Chinese Americans done in 1914 stand out within the artist's broader career. While Jim Lee appears as a working man, with battered hat and a cigarette hanging from his mouth, the paintings of a matriarch (fig. 72) and at least three young Chinese girls stand out among the most gripping portraits from this time. Each features a highly sensitive portrayal of the sitter, in traditional dress, enlivened by a bright palette of citrus colors. *Tam Gan, Chow Choy,* and *Girl with a Fan* were often chosen as reproductions for publications by and about Henri in the years that followed the La Jolla visit.[18] These works maintained a lasting personal significance for their maker, who saw them as emblematic of new subjects for progressive painting.

The treatment of Chinese American communities in California ought to be historicized here. Although Chinese immigrants were initially tolerated as railroad labor, hostility to permanent Chinese residency was evident from the earliest years of statehood and culminated in federal legislation such as the Asian Exclusion Act of 1882. Nineteenth-century Chinese immigrants encountered formal and informal legal resistance to their efforts to gain citizenship rights, especially on the West Coast. In the early 1900s, antipathy for individuals of Asian origin escalated to violent levels in California

and took the form of public protests. In 1908, the Asiatic Exclusion League bemoaned the "fact that today we have nearly as many Chinese in California as we had twenty years ago" (i.e., the time of the Asian Exclusion Act), and in spite of its efforts to prevent all new immigration of Chinese laborers. That group's leaders "prayed . . . California be saved from the threatening inundation of Chinese coolies." Washington's policy toward the Chinese was unmistakably hostile. On May 3, 1912, President Woodrow Wilson communicated his position: "In the matter of Chinese and Japanese coolie immigration I stand for the national policy of exclusion. We cannot make a homogenous population out of a people who do not blend with the Caucasian race."

Fig. 72. Robert Henri (1865–1929). *Chinese Lady,* 1914. Oil on canvas; 41¼ × 33¼ inches. Milwaukee Art Museum; Gift of Mr. and Mrs. Donald B. Abert, M1965.61.

Between mid-June and late October 1914, the months of Henri's California residence, no fewer than twenty-six articles in San Diego's largest-circulation newspapers addressed matters directly related to the city's sizable Chinese community. The headlines of these articles, many of them running in large type on the front pages of the *San Diego Union,* conveyed a disheartening picture: opium use, gambling, slave trafficking, smuggling, illegal immigration, gang activity, reckless mayhem, and labor law violations were reported with regularity and most with the high rhetorical venom of the period. Henri must have been aware of these vicious attacks on ethnic groups like the Chinese and was driven by his compassionate politics to paint their portraits. In any case, his portraits of Chinese Americans go far toward constructing a counterimage to the overtly racist distortions in the popular press.[19] His personal empathy for these California sitters made them numerically the largest single group of sitters he painted while in California and amounted to more than just an opportunity to explore new pictorial effects. This choice was a reflection of deeply held political beliefs. The consistency with which Henri looked to San Diego's diverse communities for his subjects is noteworthy. Two portraits of Ramón, a young Mexican American, may have represented a more assimilated subject for most Southern California viewers.

In terms of both scale and persistent interests, his most important portraits from 1914 were of Native American sitters. Because a large population of indigenous people lived in the region, it is hardly surprising that he would paint them in significant numbers in Southern California. Shortly after arriving, he wrote to his mother about his encounter with one of these subjects: "Last week I painted two Indian pictures—portraits of an Indian

girl. She is young, perhaps 19, a powerful Indian type, deep copper color, wide cheek bones, straight nose—and a look of the sphinx. I think I got the Indian in the portraits—and am greatly satisfied by them,—and people who have seen them are all quite enthusiastic.... She is reticent 'as an Indian'—its [*sic*] mighty hard to get any words out of her but she seems a 'friend'."[20]

From the description and the July dating of the letter, it is possible to identify this sitter as Yen Tsidi, or Ground Sparrow. Henri took special care to record his impressions of most of the San Diego residents he painted, but it is interesting that he gravitated mostly toward the tribal representatives who came to San Diego to prepare for the Panama-California Exposition, which opened on the last day of 1914 and attracted roughly two million visitors over the next year (see for example fig. 73).[21] Henri played a critical role among the exposition's organizers and was evidently repaid for this service with access to several of the key exhibitors in the Painted Desert section. Among these were members of the famed Martinez family of potters from the San Ildefonso Pueblo in New Mexico, including Florentino, Maria, and Julian Martinez and their cousin Ramoncita Gonzales, who helped produce "authentic" designs for that section of the fairgrounds.[22] Black-and-white photographs of the Martinez family in San Diego confirm the identification of Henri's contemporaneous portrait of Ramoncita (Tom Po Qui), which uses the same brightly keyed color scheme as his other La Jolla portraits.

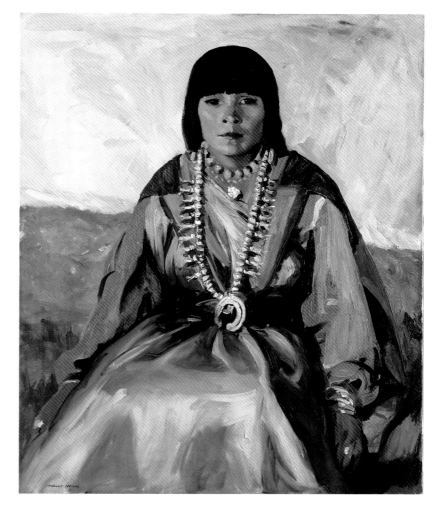

Fig. 73. Robert Henri (1865–1929). *Tom Po Qui*, 1914. Oil on canvas; 40½ × 32½ inches. Denver Art Museum Collection; William Sr. and Dorothy Harmsen Collection, 2001.461.

Henri's contact with Native American laborers at the Panama-California Exposition was fated both as a result of his curiosity about ethnic types and because of Klauber's connections. In her role as the chair of the exposition's fine arts department, Klauber had recommended her visiting painter friend to the director, Edgar L. Hewett (fig. 74). Hewett was a Swiss-trained archaeologist who specialized in ancient Native American culture. He played a prominent role in anthropology circles in the Southwest during the decade before he accepted the role of exposition director in 1911.[23] Hewett sought to combine historical displays of Native American work with the most contemporary work then being done and believed Henri could help him assemble a progressive display. Letters of invitation to a list of artists dictated to Hewett by Henri went out in October 1914.[24]

The exhibition of modern American art that took place at the Panama–California Exposition reflected Henri's own vision for the future of painting

in the United States. Henri asked his friends Sloan, Bellows, Lawson, Luks, Prendergast, and Glackens to join him in establishing the aesthetic tone for the display, which included six of his own recent portraits, two of them from his time in San Diego. In addition to those colleagues from The Eight, he invited Guy Pène du Bois, Childe Hassam, Joseph Henry Sharp, and Carl Sprinchorn to participate. The original exhibition plan was to include six works by each of the painters, but several artists sent fewer canvases, and in the end the public presentation included forty-nine works.[25]

Fig. 74. Photograph of Edgar Lee Hewitt. Courtesy Palace of the Governors Photo Archives (NMHM/DCA), 7324.

The exhibition took place in a handsome, if narrow, gallery within the part of the California Quadrangle designated for the fine arts, opposite Bertram Grosvenor Goodhue's landmark California Building and tower. This placement might well have served to guarantee the project's visibility, but few critics in 1915 bothered to notice the exhibition, and those that did tended to review the show skeptically. Christian Brinton, for instance, admired Hewett's concept of bringing Native American culture into public view and also wrote glowingly about the overall architectural surroundings, but the New Yorker was fundamentally unimpressed by the quality of paintings on view: "You can hardly expect perfection even in such an exposition as that at San Diego and it is in the choice of paintings for this same Fine Arts Building that one may point to a certain lapses from an otherwise consistently maintained standard. It is not that Mr. Henri and his coterie are not admirable artists. It is simply that they do not fit into what appears to be and in other respects manifestly is a worked out programme."[26]

Brinton's remarks beg to be read in relation to the Panama-Pacific International Exposition in San Francisco, which he was also reviewing for the *International Studio*'s readers at this time. The two fairs competed with each other for attention, but San Francisco's ambition was primarily international, a true "world's" fair. In keeping with that ambition, it presented a more historical sweep of American paintings as well as European art to West Coast audiences. Still, the journal-reading public might have sensed that there was something problematic, if not provincial about the American art on view in San Diego, especially by comparison to what was available in Northern California at the same time.[27]

Correspondence between Henri and Klauber in late 1914 suggests that he already felt sheepish about being closely identified with the forthcoming exhibition in Balboa Park. If he was worried about the significance of works

that he was able to bring to Southern California, he was unhesitant about promoting the quality of the paintings he produced in 1914. He showed these works often in the months that followed and received critical praise each time.[28] An anonymous critic, perhaps Helen Appleton Read, writing for the *Brooklyn Eagle*, expressed enthusiasm for thirteen of the La Jolla works that Henri showed at Macbeth's in New York that winter: "The pictures by Robert Henri at the Macbeth Gallery are calculated to stir latent pride, when we consider how much America has in interesting individual types for artists to paint: the Mexican, the Indian and the Chinese-in-America which seems to be a special type of its own. The really charming Chinese girls of California, the fine faces of the Indian, and the Mexican type 'sui generis,' Robert Henri has painted them all graphically and sincerely.[29]"

The critic's identification of Henri's sincerity in approaching his sitters is telling. He might have been initially drawn to these ethnic minorities as representatives of the different kinds of people that Southern California offered in the early twentieth century, but ultimately he was drawn to show individuals and felt committed to representing the diversity of San Diego, not what he derisively called "the up to date class," during his four-month visit. The progressive viewpoint that supervised Henri's project was "calculated to stir latent pride" and is worth underscoring as more than just a passing observation. We know from the artist's other activity in San Diego, writing, that he was drawn to paint these subjects because of a proud, even political engagement with "others" that stood out as unique among leading painters of this time.

Today, Henri is known to many as the author of a pithy book about artistic values, *The Art Spirit*, which was first published in 1923 and remains in print.[30] In fact, that collection of aphoristic writings was assembled for Henri by Margery Ryerson, who worked alongside the artist for many years to complete it.[31] Interestingly, Klauber had proposed creating a similar volume, but Henri asked her not to pursue this, knowing that he had already assigned the task to another student in New York.[32] By all accounts, Henri was a charismatic teacher, and many of his students were drawn to his bold proclamations about creative practice. He only occasionally wrote for a public audience, however, and it is noteworthy that he used his time in La Jolla to craft two separate essays.[33] These two texts epitomize the new ideas that he formulated while in California, and we turn to them next in order to locate them firmly within that 1914 experience.

Art historians have retrospectively taken what Henri wrote while in La Jolla as a summary of his general approach to portraiture. His writing from this time is frequently quoted by scholars and has been used as a titling device for exhibitions devoted to portraiture by this artist.[34] Still, it is rarely noted that, in addition to his choice of illustrating only works from San Diego in the published version of "My People," the narrative itself is directly tethered to his Southern California experience. Indeed, the published text is introduced by an editorial note explaining that "Henri's paintings of the people of France, Holland, and Spain are famous the world over. During the past summer he painted the people of most vital interest to him in Southern California and the Southwest."[35]

In "My People," Henri lays out the representational stakes of painting people in different locales, all the while focusing on his San Diego subjects as the best illustrations of his newfound principles. He writes that, since being in the Southwest,

> I saw many great things in a variety of human forms—the little Chinese-American girl who found coquetry in new freedom; the peon, a symbol of destroyed civilization in Mexico, and the Indian, who works as one in slavery and dreams as a man in still places—I have been reproached with not adding to my study of these people the background of their lives. This has astonished me because all their lives are in their expressions, in their eyes, and their movements, or they are not worth translating into art. I was not interested in these people to sentimentalize over them, to mourn the fact that we have destroyed the Indian, that we are changing the shy Chinese girl into a soubrette, that our progress through Mexico leaves a demoralized race like the peons. This is not what I am on the outlook for. I am looking at each individual with the eager hope of finding there something of the dignity of life, the humor, the humanity, the kindness, something of the order that will rescue the race and the nation. . . . I do not wish to preach through them. I only want to find whatever of the *great spirit* there is in the Southwest.[36]

While a distinctly Whitmanesque tone dominates "My People," this voice barely conceals a deep contempt. By illustrating the essay exclusively with four San Diego subjects, Henri directly associates the place and these actors with social injustices. Indeed, we are informed that the Native American Yen Tsidi works in "slavery," that Ramón is the Mexican who has been systematically "demoralized," and that Tam Gan has been assigned a deprecating role as a "soubrette." Henri further indicates in this passage that he has been criticized for not recording the circumstances of his sitters' lives in his presentation of their portraits. While he rejects this as unnecessary—it is already there "in their expressions, in their eyes,"—he does view this work as ideologically motivated. It aims to do nothing less than rescue the race and the nation. This radical ambition can be connected to Henri's own political identity, but first we should briefly review the other text he conceived during or shortly after his return from San Diego.

"An Ideal Exhibition Scheme" was published in *Arts and Decoration* in December 1914, less than two months after Henri returned to New York from California. Documentary evidence suggests that he was working on page proofs for this publication while in La Jolla.[37] As he did in *The Craftsman* essay, for the *Arts and Decoration* text Henri used as illustrations San Diego subjects. The cover of the magazine was graced with his portrait of "Minnie" (*Chinese Girl with Fan;* fig 75), and the essay was punctuated by the five other faces, including Romancita (*Tom Po Qui*) and Marjorie (*The Beach Hat*). If "My People" records Henri's thoughts about portraiture and the diverse people who composed the United States in 1914, then "An Ideal Exhibition Scheme" declared his deepest convictions for displaying new art in the modern era.

The essay stands as a manifesto for the artist. In "An Ideal Exhibition Scheme," Henri pronounced the official exhibition practice "a failure." He argued vociferously for an "ideal," artist-led alternative to the jury's remote

decision making. Indeed, his ideal resembled closely the very approach that he had conceived for the Panama–California Exposition's display of modern American art.[38] From a selection process guided by artists, to the description of more intimate viewing space, to the prescription to hang the works "on the line" with plenty of space between them, as opposed to stacked Salon-style, the ideal he sought was mostly realized in the actual installation of the Modern American Painting gallery in San Diego (fig. 76).

Critical reading of this seldom-cited text quickly reveals the deep revolutionary intent that subtends Henri's ideas of this moment. "This form of exhibition can only be arrived at successfully on a large scale. It is a principle of hands-off. Its tendency is to do away with big organizations, to destroy the power that big organizations have and have had over art advancement. The institution [i.e., Henri's new ideal] does not propose to judge art, but offers its galleries to groups formed of the various tendencies, groups so small that they in no way monopolize the field."[39]

Henri concludes "An Ideal Exhibition Scheme" with a burst of exclamations: "Let us clear the way for an open field. Respect to the new schools and to the old schools alike! Respect to the public!"[40] The passionate rhetoric that Henri uses throughout this essay is intriguing, not because its target was new— Henri had been arguing for jury-less exhibitions since before the Armory Show—but because of its consistently radical tone. Henri wants to "destroy" the status quo, to do away with "big organizations" and in their place empower minority groups. Rarely was he more explicit about his abiding wish to "clear the field" for drastic change. By way of a conclusion, I want finally to connect this language to Henri's larger attachments. In so doing, I argue that the San Diego experience further consolidated the artist's radical thinking, as represented in both his realist portraits and writing.

Henri's La Jolla sojourn coincided with his deepest political and intellectual engagement with anarchism. Two years before he traveled to California, he helped found an art program at the Ferrer Center in New York. The Ferrer Center had become a hub for the most radical educators in Manhattan of the early twentieth century. In 1911, Henri announced that he would stop teaching courses at his eponymously named "school" and would relocate those classes to the Upper East Side brownstone named in tribute to a martyred Spanish anarchist.[41] That decision was noteworthy enough to attract the notice of the New York Times and was further celebrated by a temporary exhibition of Henri's work at the Ferrer Center. Bayard Boeysen commemorated the occasion with a public lecture, "Artists' Hope in Anarchic Ideals."[42]

Fig. 75. Cover of Arts and Decoration 5, no. 2 (December), featuring Robert Henri's Chinese Girl with Fan.

Fig. 76. Art exhibition, Fine Arts Building, 1915 Panama–California Exhibition. San Diego History Center, #2419.

Henri attended lectures by and ultimately painted several portraits of the American anarchist spokesperson Emma Goldman. One of those portraits was painted in 1915, shortly after he returned to New York from San Diego and has since been destroyed. In fact, Goldman had gone to San Diego before Henri and may have played an unacknowledged role in encouraging his visit.[43] Even the choice of *The Craftsman* as a vehicle for his writings of this period reflects his left-leaning political mind-set.[44] There is not space enough here to make the full claim that Henri was committed to anarchism before and after his La Jolla visit, but his multiple affiliations in the years surrounding that summer sojourn are an undeniable, too often elided part of his biography.

Robert Henri is best known to us as an unflinching painter of urban life. The more than twenty portraits that he painted, the group exhibition he curated, and the several texts that he crafted in San Diego in 1914 stand out as different from that reputation, however. Taken together, these experiences in the west inaugurated a phase of restless activity, one that drew the artist back to the West repeatedly, though not to California again until the very end of his career. In La Jolla, Henri reimagined his realist project, articulated that new focus in his writings, and tied race to his heartfelt political beliefs. In many ways, the La Jolla experience prefigured his deepening commitment to these subjects, specifically in his fascination with Native Americans, which he explored over the next several years in Santa Fe. Paintings like *Bernadita*, also in The San Diego Museum of Art's permanent collection, embody that lasting interest (fig. 76). Taken together, these works

238

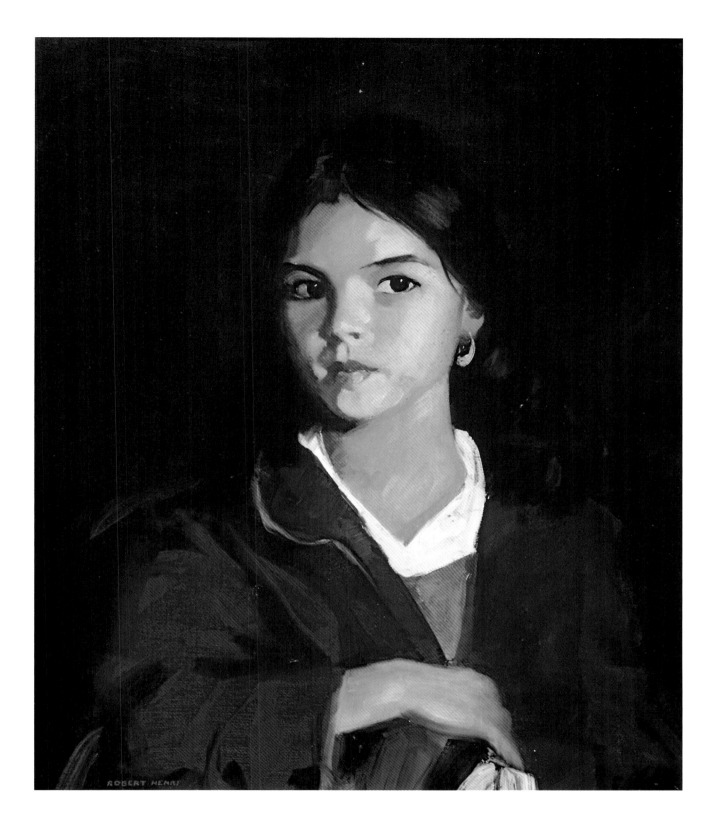

demonstrate the artist's large compassion for underrepresented subjects in American culture and his belief that the modern artist had a responsibility toward them. Among Henri's many people, we should count the San Diegans he encountered in 1914 as among his proudest depictions of democratic culture and radical representational work.

Fig. 76. Robert Henri (1865–1929). *Bernadita*, 1922. Oil on canvas; 24⅛ × 20⅛ inches. The San Diego Museum of Art; Gift of the San Diego Wednesday Club, 1926.138. Cat. 83.

1. For example, see P. J. Karlstrom, ed., *On the Edge of America: California Modernist Art, 1900–1950* (Berkeley and Los Angeles, CA: University of California Press, 1996); S. Barron et al., *Reading California: Art, Image, Identity, 1900–2000* (Berkeley: University of California Press, 2001); or R. Cándida Smith, *The Modern Moves West: California Artists and Democratic Culture* (Philadelphia: University of Pennsylvania Press, 2009).

2. The derisive name "Ashcan School" did not appear until 1915 or so and probably was given to the group surrounding Henri by Art Young, in response to an illustration by George Bellows titled "Disappointments of the Ash Can." See J. W. Tottis, *Life's Pleasures: The Ashcan Artist's Brush with Leisure* (London: Merrell, 2007), 18–20.

3. A January 1901 letter from John Sloan to Henri comments on their mistreatment at the hands of the academies: "I heard from [Edward] Redfield that you had sorry treatment from N.A.D. I was thrown out entirely. [H]e says he is hung up above the line. I understand him to say that only one of yours gets in here at the P[ennsylvania] A[cademy of the] F[ine] A[rts]." See B. B. Perlman, ed., *Revolutionaries of Realism: The Letters of John Sloan and Robert Henri* (Princeton, NJ: Princeton University Press, 1997), 43.

4. The exhibition, held at The Macbeth Gallery in February 1908, included Henri, Sloan, Glackens, Shinn, and Luks, in addition to Arthur B. Davies, Ernest Lawson, and Maurice Prendergast. Newspaper reports characterized the act of these "independents" as a "rebellion," and the legend of The Eight was formed.

5. Arthur B. Davies, Walt Kuhn, and Walter Pach all played critical roles in organizing the Armory Show. Henri was among the first to respond to their invitation to become involved. He wrote enthusiastically in late December 1911: "Success to the young society. May its youth have a long life! Will be there with pleasure, Jan. 2, at 8 pm." Henri, letter to Walt Kuhn, dated 26 December 1911, box 3 (folder 3), Walt Kuhn Family Papers and Armory Show Records, Archives of American Art, Smithsonian Institution.

6. Henri, letter to Walter Pach, 3 January 1913, Walter Pach Papers, microfilm reel #4217 (frame 109), Archives of American Art, Smithsonian Institution.

7. See letter to Henri dated 25 March 1913, box 1 (folder 70), Walt Kuhn Family Papers and Armory Show Records, Archives of American Art, Smithsonian Institution. *The Red Top* (1910), a laconic portrait of a red-haired child, is in a private collection today.

8. Henri letter to Sloan, 14 October 1898, in Perlman, ed., *Revolutionaries of Realism*, 32–33.

9. Martin E. Petersen's path breaking scholarship on Alice Klauber has proved to be a major resource for this essay. I recommend his handsomely illustrated, digitally published biography *Alice Ellen Klauber* (2007) to all readers with a curiosity about her critical place in early San Diego arts and letters. See www.aliceklauber.museumartists foundation.org.

10. Henri to Alice Klauber, 11 March 1914, Alice Klauber Papers, roll 583, frames 626–29, Archives of American Art, Smithsonian Institution.

11. Robert Henri to Alice Klauber, 4 April 1914, Alice Klauber Papers, roll 583, frames 626–29, Archives of American Art, Smithsonian Institution.

12. Henri's reputation as a teacher was legendary even during his own lifetime. It was estimated that he had taught "thousands." See W. Yarrow and L. Bouché, *Robert Henri: His Life and Works* (New York: Boni and Liveright, 1921). For a thorough examination of Henri's impact as a progressive teacher of women painters, also see M. Wardle, ed., *American Women Modernists: The Legacy of Robert Henri*, exh. cat. (Provo, UT: Brigham Young University Museum of Art, 2005).

13. Ibid.

14. Typically, the San Diego sojourn receives a page or two at best in major monographs on this artist. For example, W. I. Homer, *Robert Henri and His Circle* (Ithaca, NY: Cornell University Press, 1969), 254; B. Perlman, *Robert Henri, Painter*, exh. cat. (Wilmington, DE: The Delaware Art Museum, 1984), 123–25; B. Perlman, *Robert Henri: His Life and Art* (Minneola, NY: Dover Publications, 1991), 116; and V. A. Leeds, *My People: The Portraits of Robert Henri* (Orlando, FL: Orlando Museum of Art, 1994), 33–34. The most developed discussion of this moment can be found in two little-known, relatively short articles: M. E. Petersen, "Henri's California Visit," *Fine Art Source Material* 1 (Feb. 1971): 27–34; and J. Stern, "Robert Henri and

the 1915 San Diego Exposition," *American Art Review* 2 (Sept.–Oct. 1975): 108–17.

15. That painting, *The La Jolla Beach* (1914) was shown at an exhibition held in Los Angeles at the Museum of History, Science and Art in September 1914 and might be the small sketch that recently appeared in the art market again. That work is titled *On the Beach, La Jolla* and is inscribed "To Mrs. James M. Dean, Robert Henri, La Jolla, Cal Sept. 11, 1914," in which case, it dates from just before the hanging of the exhibition in Los Angeles and very near the end of the Henris' La Jolla trip. That work bears the Henri record book number 197-1.

16. A third portrait seems to be related to this pair: *Viv in Blue Stripe* shows Marjorie's sister, Violet Organ, seated in beach fashion, in the same bright-hued palette and dates to 1914. See V. A. Leeds, "The Portraits of Robert Henri: Context and Influences," *American Art Review* 7 (April–May 1995): 92–97.

17. Henri, letter to his mother, Theresa Cozad, 27 July 1914, Robert Henri Papers, Yale Collection of American Literature, Beinecke Rare Book and Manuscript Library.

18. Martin Petersen and Bernard Perlman have both suggested that the six Chinese subjects painted by Henri while in La Jolla are members of the same family. This seems plausible, and Henri chose to exhibit them as a group on several occasions. Indeed, a pamphlet in the San Diego Museum of Art's library commemorates a late 1914 exhibition that includes pencil inscriptions in what might be Henri's own hand. In any case, this document seems to record Americanized first names for all of these figures: Jim Lee, Ma Chu (Nellie), Chow Choy (Grace), Tam Gan (Mary), and Chinese Girl with Fan (Minnie). Further research into the sizable, relatively well-documented Chinese American community in San Diego at the turn of the last century should help confirm this assertion. See "Recent Paintings by Robert Henri," November 17–December 7, 1914, The Macbeth Gallery, New York, in the Robert Henri Artist File at The San Diego Museum of Art.

19. On the representation of Chinese communities in California, see A. W. Lee, *Picturing Chinatown: Art and Orientalism in San Francisco* (Berkeley and Los Angeles, CA: University of California Press, 2001). For general background on the legal actions taken toward citizens of Chinese ancestry, see E. C. Sandmeyer, *The Anti-Chinese Movement in California* (Urbana: University of Illinois Press, 1991); and E. Lee, *At America's Gates: Chinese Immigration during the Exclusion Era, 1882–1943* (Chapel Hill: University of North Carolina Press, 2003). For the particular circumstances surrounding Chinese and Japanese laborers in San Diego in 1914, see L. T. Saito, *The Politics of Exclusion: The Failure of Race Neutral Policies in Urban America* (Palo Alto, CA: Stanford University Press, 2009). A compelling account of Chinese experience in Southern California can be found in S. Zesch, *The Chinatown War: Chinese Los Angeles and the Massacre of 1871* (New York: Oxford University Press, 2012).

20. Henri letter to his mother, 27 July 1914, Robert Henri Papers, Beinecke Library Rare Books and Manuscripts, Yale University; quoted in V. Leeds, *Robert Henri in Santa Fe: His Work and His Influence* (Santa Fe, NM: Gerald Peters Gallery, 1998).

21. San Diego's Panama–California Exposition was less well publicized and attended than San Francisco's Panama–Pacific International Exposition with which it competed directly for attention. On the importance of the San Diego exposition for cultural issues in the Southwest, see E. Neuhaus, *The San Diego Garden Fair* (San Francisco: Paul Elder and Company, 1916); and M. F. Bokovoy, *The San Diego Fairs and Southwestern Memory, 1880–1940* (Albuquerque: University of New Mexico Press, 2005).

22. For a brief account of the Martinez clan's labor in San Diego, see T. Perdue, *Sifters: Native American Women's Lives* (New York: Oxford University Press, 2001), 168–69.

23. For an overview of Hewett's long career and his work in San Diego, see B. Chauvenet, *Hewett and Friends: A Biography of Santa Fe's Vibrant Era* (Santa Fe: Museum of New Mexico Press, 1982).

24. See Petersen, "Henri's California Visit," 33.

25. There is evidence that both Hewett and Henri had wished for a larger display that would have represented all of The Eight, but Arthur B. Davies refused to send his work to San Diego. See Stern, "Robert Henri and the 1915 Exposition"; M. E. Petersen, "Modern Art Goes to California," *Southwest Art Gallery Magazine* (Sept. 1972): 45–50; and M. E. Petersen, "Modern American Painting, 1915," *The Fine Arts Gallery of San Diego Bulletin* 1

(Dec. 1962–Jan. 1963): 1–23. A letter from Henri to Sloan explains both his intentions for the San Diego display and a summary of works then being shown at the Corcoran's 5th Biennial Exhibition of Oil Paintings by Contemporary American Artists:

> Dear Sloan,
> AS I remember there was possible question about whether you w[oul]d send 5 or 6 to San Diego on acc[ount] of space. Send 6.
> I suppose you have heard from Dr. Hewett (San Diego) and from A[rtist] P[acking] & S[hipping Co.] who collect on the 10th. Your picture is well hung in Wash. And looks fine. All our fellows have excellent places and prizes went to Wier, Woodbury, Beal, and Farley. The Weir was O.K. Many fine pictures were exempt.
> Henri
> Letter dated December 8, 1914; quoted in Perlman, *Revolutionaries of Realism*, 225.

26. C. Brinton, "The San Francisco and San Diego Expositions," *International Studio* 55 (June 1915): cx.

27. San Francisco's effort dwarfs San Diego's in all respects, except for the scale of the grounds. The acreage devoted to the exposition in San Diego was roughly twice that in San Francisco, which compensated for the lack with its sheer density of presentation. In addition to its abundant architecture and sculptural and mural ornamentation, the Panama–Pacific International Exposition featured vast displays of art from Europe and hundreds of American works, including several by Henri and his peers. See J. E. Trask and N. Laurvik, eds., *Catalogue Deluxe of the Fine Arts Department of the Panama Pacific International Exposition*, 2 vols. (San Francisco: Paul Elder and Company, 1915); and E. Neuhaus, *The Art of the Exposition* (San Francisco: Paul Elder and Company, 1915).

28. A first exhibition, *Paintings of Robert Henri*, was held in Los Angeles at the Museum of History, Science and Art, I Exposition Park, September 14–30, 1914. That project featured fourteen works, all from the La Jolla sojourn. Henri next showed these works with his dealer, Macbeth Gallery, in New York, November 17–December 7, 1914. He also showed several works at the Panama–Pacific International Exposition in San Francisco in 1915, and a much larger traveling show, *Exhibition of Paintings by Robert Henri of New York*, which included at least seven of the portraits completed in San Diego, went to The Art Institute of Chicago, August 18–September 26, 1915.

29. "Henri 'Types' Creative," *Brooklyn Eagle*, November 18, 1914, 8. Read wrote art criticism for the *Brooklyn Eagle* throughout the 1910s and 1920s and in 1931 authored one of the first book-length studies of Henri's career as part of a series on American artists published by the Whitney Museum.

30. Robert Henri, *The Art Spirit* (Philadelphia: J. B. Lippincott, 1923).

31. Throughout her long life, Ryerson remained closely identified with her teacher and lived near him in Gramercy Park. See her obituary, "Margery A. Ryerson, Painter, Dead at 102," *New York Times*, April 8, 1989.

32. Klauber compiled the notes she had taken from Henri's talks during her Spanish trip into an essay, "Robert Henri: Notes on Painting Taken from Talks to His Students," 1913. Evidently, during Henri's visit in 1914, Klauber brought up the idea of publishing them, but he demurred, suggesting that Ryerson's work was already under way. Klauber acceded to Henri's wishes, and her text was published posthumously. See Petersen, *Alice Ellen Klauber*, 12. For a printed version of Klauber's notes, see Perlman, *Robert Henri*, 139–48.

33. Henri did not typically make time to craft essays. Indeed, the few works he chose to publish tended to be doctrinal statements and were chronologically linked to breakthroughs: first, his organization of "independent exhibitions" in 1908–10 and also the La Jolla trip of 1914. See his "Progress in Our National Art Must Spring from Individuality of Ideas and Freedom of Expression: A Suggestion for a New Art School," *The Craftsman* 15 (Jan. 1909): 387–402; and "The New York Exhibition of Independent Artists," *The Craftsman* 18 (May 1910): 161–73.

34. See, for example, V. A. Leeds, *My People: The Portraits of Robert Henri*, exh. cat. (Orlando, FL: Orlando Museum of Art; Seattle: University of Washington Press, 1994).

35. R. Henri, "My People," *The Craftsman* 27 (Feb. 1915): 459.

36. Ibid., 462–67.

37. Henri asked his friend George Bellows to review his text before publication, for example. A holograph of the essay including Bellows's corrections can be found in the Robert Henri Papers, box 24, folder 564, Yale

Collection of American Literature, Beinecke Rare Book and Manuscript Library.

38. See R. Henri, "An Ideal Exhibition Scheme," *Arts and Decoration* 5 (Dec. 1914): 49–52, 76.

39. Ibid., 51.

40. Ibid., 76.

41. For a rigorous account of the Ferrer Center and Henri's place within it, see A. Antliff, *Anarchist Modernism: Art, Politics, and the First American Avant-Garde* (Chicago: University of Chicago Press, 2001), esp. 11–30.

42. Ibid., 27.

43. Goldman first traveled to San Diego to deliver a controversial lecture there in 1910 and may have incited a revolutionary riot in Tijuana when she returned in May 1911. Her next visit took place almost exactly a year later, in early May 1912, at which time her hotel was instantly surrounded by a mob, a fact that may have led to her being arrested on arrival in the city when she returned next in May 1913. She did not travel to San Diego in 1914. Her last visit to San Diego took place in June 1915, however. For a chronology of Goldman's activities in San Diego, see "Light and Shadows: Emma Goldman, 1910–16," www.metadata.berkeley.edu/emma/.

44. On the anarchist dimension within the Arts and Crafts movement in the United States, see E. Boris, *Art and Labor: Ruskin, Morris, and the Craftsman Ideal in America* (Philadelphia: Temple University Press, 1986).

Interview with Deborah Butterfield

Do you miss teaching or the university environment, or are you happy to be able to focus on your own work?[1]

I am really happy to be out of it. I think Kissinger said it, or someone probably said it before him, that academic politics are so brutal because there is so little at stake. It is true. The sculpture budget for the year was $500, and if the furnace for the metal casting went out once, then that was your whole budget. We [referring to herself and her husband, artist John Buck] were always buying tools like pliers and other supplies. We were making only $25,000 a year. All it did, because we would sell that much in art, was put us in a higher tax bracket. It was a lot of hours. I sometimes miss the students, but we have stayed in touch with the university, and we have done a few teaching things here and there and visited students, but I don't miss the politics and all of the paperwork.

It is kind of nice here [at the ranch] because being an artist and working in your studio can be isolating, and with teaching you have a lot of interaction with others, including students, but here you have so much interaction with the people that work with the horses.

Yeah, right, we've kind of had to create our own campus. That is a good observation. The faculty are usually somewhat boring, compared to the graduate students; they are always coming and going with new ideas. That was very stimulating. We both had our art careers and the teaching, and I was doing horses, and then we had kids. That is like four careers and something had to give, and the only thing that we were willing to give up was the teaching. I think the kids and the teaching took the same kind of energy. So for three years, I think from 1984 to 1987, we just taught one quarter a year to grad students, and that was lovely because we could keep in touch. But then we ended up having the good fortune of traveling so much that we were always gone, and so we felt that we weren't giving them a fair shake, and then we just remained—I don't know if we were adjunct—or kind of informally we would be invited to critiques and stuff and that was the best.

Thinking about your own graduate career, I thought since you worked with Wayne Thiebaud and Manuel Neri, and both have works in the permanent collection of The San Diego Museum of Art, that you might elaborate more on your experience with them.

My main experience at Davis [University of California, Davis] was with Bob Aronson, Roy DeForest, and William Wiley.

I was Manuel's TA [teaching assistant] in a drawing class, and Manuel wasn't your typical teacher. He was the strong, silent type, but he taught by doing; if you had a drawing class and a model, he was there, drawing the model. What was so spectacular was that Wiley taught so much by words and Aronson by example and words, and Roy was crazy, he would give you riddles almost, and Manuel—it was like we had the perfect balance of every way to learn, because Manuel was so nonverbal but so sensual in his response to the materials and the model. I felt like he completed a circle for me, and when

Mapping as Practice, or Finding the Subject in American Art circa 1970

PATRICIA KELLY

Mapping, plotting relative coordinates and determining causal relations, has become an idiom of sorts in contemporary cultural and critical theory, used to describe physical, conceptual, and even virtual space.[1] Informed, no doubt, by an increased reliance on advanced spatial technologies, such as MapQuest, Google Earth, and the Global Positioning System (GPS) (interestingly, developed in the early 1970s), mapping is more concerned with process than product. As opposed to a map, a document that normalizes in visual terms a real or imagined environment, mapping is always in a state of becoming, inhabiting uncertain and mutable forms.[2] If maps are evidence of conquest, a central tool of colonialism, mapping is a creative means of evaluating real-world power relations. As a practice, it renders complex networks of influence and antagonism visible, in potentially productive, and compelling, ways.

Using notions of mapping (broadly defined) as a point of departure, this essay considers how artists of the late 1960s and early 1970s developed visual and conceptual strategies for measuring distance, bodies, subjectivity, and even social relations. The point was to evaluate the political dimensions of space as both a material and an ideological construct, at an emergent postmodern moment marked by war-related anxieties and a pervasive climate of dissent. To map at this time was a form of political and social commitment, a strategy for making sense of a changing world order evidenced by increasing violence, hyperconsumerism, and the pervasiveness of mass media.

For some artists, this meant physically measuring or otherwise appropriating geographic space. Consider, for example, Sol LeWitt's *Six-Part Modular Cube* (1976), a large-scale, outdoor sculpture based on the arbitrary repetition of an open-faced cube (fig. 78). Committed to simple materials and serial form, LeWitt explored proportion, scale, and arrangement in order to test the conceptual possibilities of sculpture and reconsider the role of the artist as the hegemony of modernist painting began to break down. For other artists practicing at this time, however, mapping must be understood as a symbolic process, a way of highlighting relations between the individual, established institutional hierarchies, and

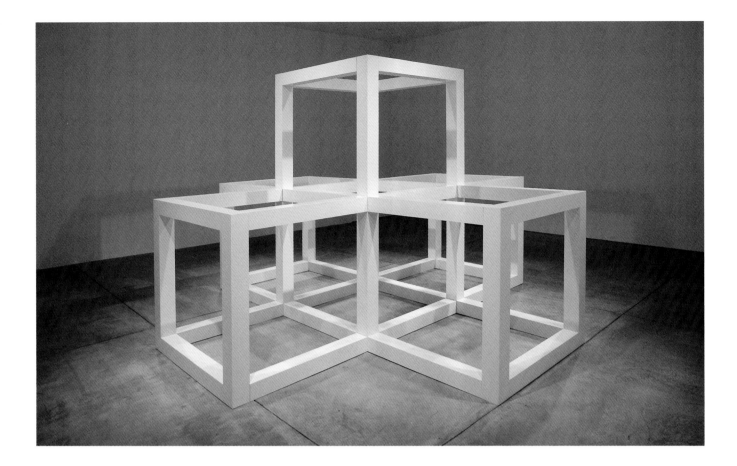

Fig. 78. Sol LeWitt (b. 1928). *Six-Part Modular Cube*, 1976. Polyurethane on aluminum; 120 × 180 × 180 inches. Museum of Contemporary Art San Diego; Museum purchase, Museum Art Council Fund, 1982.6.

larger environmental interests. A case in point is Robert Smithson's *Mono Lake Non-Site (Cinders Near Black Point)* (1968), which uses artifacts from a natural site to expose the supposed neutrality of the museum setting (fig. 79), and Ana Mendieta's *Silueta* series, in which the artist's body instigates a dialogue between cultural difference, the feminine subject, and the land itself (fig. 80). Regardless of approach, common to all is the realization that situating the subject within a broader spatial context is crucial to navigating the historical realities of this period and to clarifying how power is oriented through physical and discursive ground. Toward this end, mapping is a method for connecting real-world visible criteria, including people, cities, and landscapes, with the intangible phenomena of social networks and interpersonal relations. As such, it is a vital activity, both circa 1970 and for understanding and potentially dismantling power dynamics today.

Working the Land

Obviously, a preoccupation with mapping is not new to American art circa 1970. Physical space, the land, and rights to ownership have been time-tested subject matter, connected to larger themes of national identity and political power.[3] In nineteenth-century American culture, this was particularly evident in the landscape painting of Thomas Cole and the Hudson River School, and the writings of American Transcendentalists, such as Ralph Waldo Emerson and Henry David Thoreau (fig. 81).[4] Within the framework set, the wilderness, evoked through a rhetoric of Manifest Destiny, was what made the United States distinct from its European rivals, a uniqueness subsequently used to justify governmental policies of westward expansion and limitations

256

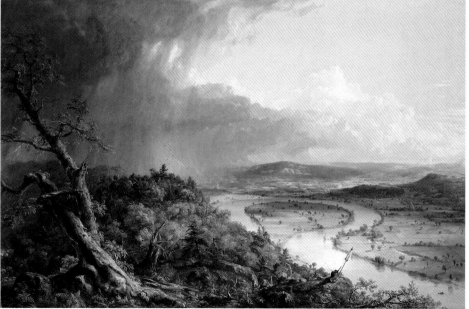

Fig. 79. Robert Smithson (1938-1973). *Mono Lake Non-Site (Cinders Near Black Point)*, 1968. Painted steel container, cinders, map photostat; site map 40¼ × 40 inches; container 7 × 39¾ × 39¾ inches. Museum of Contemporary Art San Diego; Museum purchase, 1981.10.1–2. Art © Estate of Robert Smithson/Licensed by VAGA, New York, NY. Cat. 169.

Fig. 80. Ana Mendieta (1948-1985). *Untitled (from the Silueta Series)*, 1976/2001. Cibachrome prints, suite of nine, edition 8/10; each of 5: 8 × 10 inches, each of 4: 10 × 8 inches. Museum of Contemporary Art San Diego; Museum purchase, International and Contemporary Collectors Funds. 2002.7.1–9. Cat. 96.

Fig. 81. Thomas Cole (1801–1848). *View from Mount Holyoke, Northampton, Massachusetts, after a Thunderstorm—The Oxbow*, 1836. Oil on canvas; 51½ × 76 inches. The Metropolitan Museum of Art; Gift of Mrs. Russell Sage, 1908, 08.228.

on indigenous land rights. Such romanticization of nature, pervasive in cultural production at this time, was based as much in desire and memory as in any sort of physical reality.[5] The natural environment was a malleable site for processing and working through pressing social and political contradictions, a zone of symbolic possibilities inherited by postmodern artists.

By fall of 1968, when the *Earthworks* exhibition opened at the Virginia Dwan Gallery in New York, the land provided a different subject matter for U.S. artists, though one no less ideologically fraught (fig. 82). As the Vietnam War, the draft, and organized protest brought questions regarding subject formation to the fore, space as an abstract concept and the land more concretely defined became increasingly tied to here-and-now social relations. Everyday life, the mundane "other" of spectacle culture, became an important site of philosophical inquiry, a politicized ground for the expansion of self-conscious social critique.[6] Issues opened up for consideration included the personal implications of late capitalism, the possibilities for subversion or political resistance, and the articulation of authentic, participatory engagement.[7] Within this shifting worldview, it was the impulse to map, to situate the subject within a broader and inherently contradictory social milieu, that is of interest. Here, Fredric Jameson's model of cognitive mapping is of use: "the cognitive map is called upon . . . to enable a situational representation on the part of the individual subject to that vaster and properly unrepresentable totality which is the ensemble of society's structures as a whole."[8] In other words, artists now began to map more than just the natural landscape, increasingly interested in understanding intersubjective relations and institutional power.

Robert Smithson's interest in mapping, at least as traditionally defined, began in 1966 with his short-lived involvement with the design of the Dallas–Fort Worth Airport.[9] Collaborating with the engineering and architectural

RUNWAY LAYOUT
ULTIMATE PLAN

WANDERING EARTH MOUNDS
AND GRAVEL PATHS

DALLAS FORT WORTH REGIONAL AIRPORT LAYOUT PLAN
TIPPETTS · ABBETT · McCARTHY · STRATTON

R. Smithson

firm of Tibbetts-Abbett-McCarthy-Stratton, Smithson was inspired by aerial photographs and topographic maps to produce an environmental art, large in scale and concerned with the relationship between fringe and center, linking the airport's auxiliary spaces to the terminal building (fig. 83).[10] This interest was manifest in a series of earthworks to be placed on taxiways, runways, or approach "clear zones" and construed as an "aerial art that could be seen from aircraft on takeoff and landing, or not seen at all."[11] For example, in his *Proposal for Earthworks and Landmarks to be Built on the Fringes of the Fort Worth–Dallas Regional Air Terminal Site* (1966–67), Smithson planned four works: two would be executed on the surface of the site, an earth mound by Robert Morris and a progression of triangular concrete pavements by Smithson; the other two, Carl Andre's crater formed by an explosion and Sol LeWitt's buried cube, would be sited below grade. As has been noted, such emphasis on substratum brings forth a political dimension, a reference to the violence and casualties caused by the Vietnam War.[12] Smithson further explored his interest in cartography through a series of collages produced in 1967, some of which examine geographic areas familiar to the artist, while others are more metaphorically conceived (figs. 84, 85). That same year, he published a travelogue of sorts, "The Monuments of Passaic," documenting what he saw and thought on a walk through his hometown.[13]

Smithson then moved to investigating the correlation between nature and the constructed environment in 1968 through his non-sites, by bringing rocks, salt, and dirt—elements of raw, physical matter—into the exhibition space.[14] If the site was the natural, outdoor environment, the non-site was both the three-dimensional structure Smithson inserted in the gallery, its shape based on the artist's physical and temporal experience of the site, and the literal exhibition space, envisioned as an artificial container with its own historical and contextual referents.[15] Like many of his contemporaries,

Fig. 83. Robert Smithson (1938–1973). *Dallas-Fort Worth Regional Airport Layout Plan: Wandering Earthmounds and Gravel Paths,* 1966. Pencil and crayon on map; 11 × 14 inches. Image courtesy James Cohan Gallery, New York/Shanghai. Art © Estate of Robert Smithson/ Licensed by VAGA, New York, NY.

Fig. 84. Robert Smithson (1938–1973). *Untitled [Map on Mirror—Passaic, New Jersey]*, 1967. Cut map on seven mirrors; 14 × 14 × 1½ inches. Image courtesy James Cohan Gallery, New York/Shanghai. Art © Estate of Robert Smithson/Licensed by VAGA, New York, NY.

Fig. 85. Robert Smithson (1938–1973). *Untitled [Antarktis Circular Map]*, 1967. Circular cut map; 19⅝ inches diameter. Image courtesy James Cohan Gallery, New York/Shanghai. Art © Estate of Robert Smithson/Licensed by VAGA, New York, NY.

Smithson was critical of the teleological view of modernism supported by the formalist theories of Clement Greenberg and predicated on art's autonomy from the social realm. Instead, highly influenced by structuralism and the work of French anthropologist Claude Lévi-Strauss, Smithson was concerned with patterns of usage and relational frameworks, arguing: "Late modernist art criticism has for some time placed all its emphasis on art as an order of particular *things*, objects that exist by themselves removed from what surrounds them. . . . Dialectical language offers no such esthetic meanings, nothing is isolated from the whole."[16] Here, Smithson adopts a dialectical model for the purpose of counteracting what he believes are the ossifying effects of contemporary art criticism, reworking the terms of aesthetic experience through his site/non-site practice.

In *Mono Lake Non-Site (Cinders Near Black Point)*, Smithson examines the link between the exterior environment and art institutions by bringing cinders and pumice, which he collected from Mono Lake, California, a saline basin between the Sierra Nevada and the desert, into a museum context.[17] The natural materials were inserted in a thin channel running along the perimeter of a square, shallow steel container, the center of which is hollowed out. On the wall above, a geographic map, its interior voided, mimics the shape of the structure. With few topographic referents visible, the empty space of the map combined with the cut-out of the square below signals an absence or limit. What is missing from the non-site is a sense of the artist physically exploring the landscape and the knowledge created by a body moving through and psychically registering space. Philosopher Edward S. Casey refers to this process as "scanning," a type of mapping enacted by phenomenological rather than just visual engagement.[18] By highlighting this distinction between different forms of experience—that of the artist versus that of the museum visitor—Smithson signals the constructed nature of the art context. Describing his non-sites as "maps that pointed to sites in the world outside of the gallery," he debunked what had long been established as the perceived neutrality of the exhibition space.[19]

In this way, Smithson prioritized site specificity, demonstrating the intrinsic association between the physical location in which a work is situated and the existence and meaning of the work itself.[20] The art object was no longer autonomous or universal but conceived as contingent on both its setting and a phenomenological experience in time and space. Recent art historical scholarship has worked to sort out distinctions of site and its political possibilities both then and now. Consider James Meyer's comparison of a literal site, locatable in time and space, and a functional site, unhinged from a physical place. Here, the functional site "is a process, an operation occurring between sites, a mapping of institutional and textual filiations and the bodies that move between them (the artist's above all)."[21] This complicated, even contradictory, conception of site calls for a very different kind of mapping, not necessarily based on aerial projections or topography. The issue for artists working circa 1970 was how to understand what was increasingly recognized under the influence of post-structuralism as a nebulous field of social relations and practices that politicize and ground the art object.

Positioning the Subject

Thus, for Smithson and his contemporaries intent on challenging art's commodity status and initiating an early form of institutional critique, processes of mapping involved more than just graphic representations and orthographic viewpoints. While its traditional problems—scale, selection of geographic features, legibility, and iconography—were still relevant and explored, mapping was now equally a conceptual procedure, less tied to standardized tropes of visual representation. For postmodern artists, more important than its pictorial form, mapping was concerned with a politics of position, an examination of how the subject is spatially located. The goal was to assess the bond between the subject and her environment, with mapping as a tool for comprehending and visualizing one's place in the world.[22] Thus, this analysis utilizes an inherently imaginative model of mapmaking, receptive to numerous artistic styles, alternative media, and practices. Yet, common to all the work considered here is an examination of the political function of mapping. If historically used to support exploration and conquest and to normalize specific equations of power, mapping now interrogates social and cultural relations and probes how ideologies operate.[23] Able to clarify the postmodern condition both spatially and globally, it provides one strategy for artists to rethink a politics of representation and the creative possibilities of contemporary art.

However, this interest in charting the relationship between the subject and its context was not specific to art production but dovetailed with a broader social inquiry into power relations during the Vietnam era. The writings of the French cultural theorist Louis Althusser, which first appeared in the United States in the late 1960s, addressed this problem, maintaining that the real subjects of history were situated in terms of the structural relations between productive and ideological forces.[24] Ideology interpolates or hails the individual, thereby creating the subject. It is not just the site of class struggle but a phenomenon embedded in a range of institutions—family, church, school, and state—and a means through which a society perpetuates itself. For many political activists associated with the emergent New Left, the issue was how to deconstruct the effects of power and authority on the production of modern subjectivities. Such focus on the subject was fundamental to reconceptualizing political agency and the connections between self and state. Moreover, it was the constitutive nature of ideology that resonated with a disenfranchised body politic interested in participatory engagement and the subversion of power. This is not to say that an interest in the constitution of subjectivity was exclusive to this period. To cite but one example, the work of André Breton and the surrealists in 1920s and 1930s France was preoccupied with similar issues, using the writings of Sigmund Freud as a vehicle with which to explore both the unconscious and the possibility of revolutionary change. What is unique to the late 1960s, however, is the grounding of experience in the physical body of the subject. This is perhaps not surprising considering that the body was centrally placed within contested public battles, including draft evasion, political activism, and reproductive rights.

Simultaneously, artists began to challenge the cohesiveness of the Cartesian subject, interested instead in the instability of postmodern identity

and the possibilities this raised for political agency. As is evidenced by Black Power, the emergence of Second-Wave Feminism, and the Gay Liberation Movement, the personal was increasingly political, as the realization that politics is inherent in social relations and practices and ultimately connected to identity formation became more commonplace.[25] Using this as a point of departure, artists began to explore subjectivity as a thematic preoccupation. If, as feminist scholar Teresa de Laurentis has argued, "subjectivity is an ongoing construction, not a fixed point of departure or arrival from which one interacts with the world," then the individual could participate in the construction of meaning through committed engagement in social practices and discourses.[26] Here, strategies of mapping, establishing rules of correspondence or association, made normative equations of power perceptible to a newly skeptical body politic interested in drastic personal and political change.

Projecting/Displacing/Unearthing the Body

Born in Cuba but arriving in the United States without her parents at age twelve, Mendieta began her *Silueta* series in 1973. In this extensive collection of images, enacted through Super 8 film, slides, and photographs, the artist's naked body (or its absence) is situated in various natural environments: sand, water, dirt, and grass.[27] Sometimes the body is clearly visible to the viewer, while at other times its physical trace is fleeting, suggested only by an impression in the landscape or a composition of organic materials. Throughout, permanence and authority are undermined as the transitory nature of each *Silueta* is emphasized. Waves erode an impression of the figure, gunpowder is ignited and burned off, natural elements are displaced through atmospheric conditions. The rituals of purification, healing, and transcendence called up provide a means of synthesizing aspects of the artist's individual identity, more specifically exploring her sexuality, Cuban heritage, and feelings of exile in the United States.[28] Interpreted at least initially as a series of self-portraits, the *Siluetas* demonstrate Mendieta's commitment to critical self-exploration, for her an essential artistic condition, and reinforce her understanding of the subject as grounded both materially and socially in the physical world.[29]

In creating what she described as "earth-body" sculptures, performative actions resulting in anthropomorphic shapes, Mendieta was influenced by ancient mythologies, matriarchal imagery, and various ritualistic traditions.[30] Her *Siluetas* often evoke a goddess pose, a female figure with hands gesturing upward and arms outstretched (fig. 86).[31] In her travels to Cuba and Mexico, Mendieta researched such imagery, as well as indigenous symbolic practices and Afro-Cuban traditions. Through this process, she developed a cultural identity consisting of more than just the sum of her immediate or inherited experiences. Instead, she was amalgamating cultural references and demonstrating their continued political resonance. For this reason, Mendieta's work has been theoretically linked to feminist and postcolonial theory and related to both the earth art movement and an emerging body-art practice.[32] The dialectic set up between the female body and nature, and its reification through hundreds of images, has generated a multiplicity of

263

Fig. 86. Ana Mendieta (1948–1985). *Untitled (from the Silueta Series)*, 1976/2001. Cibachrome prints, suite of nine, edition 8/10; each of 5: 8 × 10 inches, each of 4: 10 × 8 inches. Museum of Contemporary Art San Diego; Museum purchase, International and Contemporary Collectors Funds. 2002.7.1–9. Cat. 96.

readings concerning the postmodern subject, feminine identity, and the relationship between the individual and the earth.[33]

Characterized by Mendieta as "a search to find my place, my context in nature," the *Silueta* series can be construed, in some ways, as the antithesis of Smithson's site/non-site practice.[34] Male land artists of this period, reinforcing established modernist paradigms, created large-scale, permanent installations intended to examine the implications of an art context and extend formalist concerns. This interest in culture over nature, or what Suzaan Boettger describes as "going to nature, but relating to it as dirt," reflected a broader social ambivalence at this time to ecological awareness and the vulnerability of the earth and its resources.[35] In contrast, Mendieta's project, by traversing multiple media and an exhaustive reiteration of action, demonstrates a heightened sensitivity to the environment. Her work does not control or dominate the landscape but instead engages in a version of eco-feminism, drawing parallels between the oppression of women and the control of nature in a Western cultural tradition.[36] By producing transitory interventions on beaches and riverbeds, and utilizing organic materials such as blood, fire, flowers, and sticks, Mendieta avoided the monumental or authoritative gesture. She was less concerned with mapping physical space or the limitations of the institution than with mapping subjectivity, enacting the instability of the postmodern subject through the continuous replaying of her silhouette in time and place. In part, she achieved this through emplacement in the landscape, a mutually reinforcing process whereby the living body influences and helps to form the place around it, just as the place inhabited contributes to subject formation.[37]

The reiteration of identity in Mendieta's work, particularly the *Silueta* series, has been read extensively in relation to Judith Butler's theory of performativity, the notion that the individual acts out and produces her identity through the repetition of symbolic social signs, including language and gesture.[38] In this way, the subject creates the illusion of social and cultural identity through the continuous performance of gender acts in everyday activities, a method that, for Butler, is crucial to the continuation of heteronormative standards. Interpreting Mendieta's images through a performative lens has connected it to broader postmodern objectives regarding the deconstruction and even dismantling of identity and to questions regarding personal agency and political commitment in the early 1970s.

Such reliance on performance and interest in examining gender standards was evident earlier in Mendieta's oeuvre, including in *Untitled (Facial Hair Transplants)* (1972; figs. 87, 88). In this action, performed twice and documented in 35mm slides, Mendieta transferred the facial hair of her friend Morty Sklar onto her own face, first the beard and then the mustache. The resulting images became the basis for a series of silkscreens submitted for completion of her master's thesis in painting at the University of Iowa.[39] Mendieta was not alone at this time in using a multimedia approach to interrogating identity, particularly the connections between the body, subject formation, and the social sphere. Vito Acconci, for example, was considering normative male subjectivity through performance, video, and conceptual projects, as the privilege of white patriarchy was increasingly challenged during the Vietnam years. Additionally, Mendieta's exposure to Willoughby Sharp, art critic in residence and cofounder of *Avalanche* magazine, and to other University of Iowa faculty ensured her awareness of the alternative art community in New York and new material and theoretical developments.[40]

Fig. 87. Ana Mendieta (1948–1985). *Untitled (Facial Hair Transplants)*, 1972. 35 mm color slide.

Fig. 88. Ana Mendieta (1948–1985). *Untitled (Facial Hair Transplants)*, 1972. 35 mm color slide.

The underlying subtext to such aesthetic experimentation was the obvious impact of the protest movements and counterculture on the political landscape in the United States, making lived political engagement (however defined) central to shifting ideas of art activism.

Mendieta's practice, and its insistence on exploring the interstices and connections between body, identity, nature, and culture, can be related back to a notion of mapping as a meandering process, an attempt to comprehend that which can only ever be partially located in time and space, in this case, the subject itself. In fact, Mendieta's continual reiteration of identity through her entire field of production implies the subject's inherent instability. No one *Silueta* or series is ever enough to explicate fully its disparate parts. Subjectivity may be rooted in the body, but it is "composed of and by a 'federation' of different discourses/persona, united and orchestrated to a greater or lesser extent by narrative, and as registered through a whole series of senses,"[41] and as such is never whole or complete. Thus, Mendieta's strategies for mapping the body, ethnicity, and gender, as well as specific discourses and sites, demonstrate a postcolonial impulse to unhinge from Universalist concepts or Eurocentric images. Her practice was part of a broader interest among artists to rethink the terms of art activism on a personal, local level and in potentially radical and politically effective ways.

Back to Square One

Both Smithson's and Mendieta's conceptions of mapping, however disparate in form or intent, owe a debt to minimal and conceptual artists working in the mid- to late 1960s. Sol LeWitt, for one, was an important predecessor, articulating through both his writings and his visual production varied methods and procedures for theorizing space.[42] In 1966, LeWitt participated in *Primary Structures: Younger American and British Sculptors*, an exhibition at the Jewish Museum that established minimalism on the New York art scene. However, throughout his career, he was careful to emphasize the conceptual rather than the formal nature of his practice.[43] As part of a group of artists engaged in a "serial attitude" or approach, LeWitt downplayed emotive affect and artistic agency, hallmarks of advanced modernism of the 1940s and 1950s, in favor of strict intellectual rigor executed through simple materials and forms.[44] The goal was not mental acumen per se but a new form of aesthetic experience responsive to the skepticism of postmodern society and the look of the information age.[45] In one of the first historical overviews of conceptualism, art historian Benjamin Buchloh demonstrates a teleological progression of conceptual art from a self-referential aesthetics of administration (cataloguing, systems analysis, communication) to the more politically engaged practices of institutional critique. He locates LeWitt's practice, and the questions it raises regarding the condition and intent of art, as central to instigating this shift.[46]

LeWitt's open, modular structures based on the cube demonstrate an insistence on fixed conceptual models, exploring systems theory through various configurations and scales.[47] In his *Six-Part Modular Cube* and *Floor Piece #4* (both 1976), the size and arrangement of structures vary, but the overall ratio of 1:8.5 inherent in each cube, between the wood or metal framework and the spaces in between, is consistent (figs. 78, 89). Arbitrary decisions become

the rules that articulate the work's final arrangement. With 122 objects in total, this series proves LeWitt's adage: "The idea becomes the machine that makes the work of art."[48] In other words, the concept is more important than the finished object in defining an artistic condition. Well aware of the communicative limits of both verbal and visual languages, LeWitt insisted that a system be set out in advance that would define the terms of the art object, a conceptual map of sorts, allowing the work to be executed by either the artist or an assistant. This abandonment of control on the part of the artist raises questions about what constitutes aesthetic value and directly challenges traditional markers of artistic quality, such as originality, commodity status, and handcraft.

It is perhaps LeWitt's wall drawings, first executed in 1968 and which stressed the idea over the execution, that most decisively challenge the function of the artist. Existing as written specifications and diagrams, and only secondarily as temporary manifestations on the wall, these works are situated in text that is open to interpretation. For instance, in *Wall Drawing #146, All two-part combinations of blue arcs from corners and sides and blue straight, not straight and broken lines* (September 1972), the apparent simplicity of the textual referent belies the work's visual complexity, as well as the endless permutations possible (fig. 90). Often executed by someone other than LeWitt, each wall drawing is specific to the terms of its installation. Above all else, process is emphasized, or as art historian Alex Alberro stated: "The implication was that the procedure of making—not just the process of realization, but also the process of conception itself (precisely

Fig. 89. Sol LeWitt (1928–2007). *Floor Piece #4,* 1976. Painted wood; 43¼ × 43¼ × 43¼ inches. Museum of Contemporary Art San Diego; Museum purchase, dedicated in 2011 in honor of Sebastian "Lefty" Adler (1932–2010), Director of the San Diego Museum of Contemporary Art from 1973 to 1983, 1978:4. Cat. 27.

Fig. 90. Sol LeWitt (1928–2007). *Wall Drawing #146. All two-part combinations of blue arcs from corners and sides and blue straight, not straight and broken lines,* September 1972. Blue crayon. Dimensions variable. Solomon R. Guggenheim Museum, New York; Panza Collection, Gift, 92.4160. Installation view: Villa Menafoglio Litta Panza, Biumo Superiore, Varese, September 16, 1981. Photo © Giorgio Colombo, Milano.

267

SITE SCULPTURE PROJECT 42° PARALLEL PIECE
14 LOCATIONS ('A'THROUGH'N') ARE TOWNS EXISTING EITHER EXACTLY
OR APPROXIMATELY ON THE 42° PARALLEL IN THE UNITED STATES.
LOCATIONS HAVE BEEN MARKED BY THE EXCHANGE OF CERTIFIED
POSTAL RECEIPTS SENT FROM AND RETURNED TO "A" -TRURO,
MASSACHUSETTS. AUGUST-SEPTEMBER 1968

Fig. 91. Douglas Huebler (1924–1997). *Site Sculpture Project: 42° Parallel Piece,* (detail), 1968. 14 locations (A through N) are towns exactly or approximately on the 42° parallel in the United States. Locations were marked by the exchange of certified postal receipts sent from and returned to site "A" in Truro, Massachusetts. 3 typewritten documents, map with ink and hand lettered statement mounted on illustration board, assorted mailing receipts and correspondence; documents, overall: 17¾ × 38 inches; documents, each: 8½ × 11 inches; map and statement: 9 × 17 inches. Courtesy Paula Cooper Gallery, New York.

because conception takes place over time)—is the most literal and material aspect of an artwork."[49] Within LeWitt's proposition, art does not exist in an instance, nor does it inhabit a state of timelessness. Rather, it is revealed temporally through a self-reflexive practice, which starts with artistic conception and continues through interpretation. In this way, LeWitt's wall paintings are reminiscent of French literary critic and semiotician Roland Barthes's "Death of the Author," published in English in 1967.[50] Both criticize the idea that a creative work, whether art object or literary text, solely relies on the artist/author's biography or intention, highlighting instead the viewer/reader's participation in the construction of meaning.

There are other conceptual artists who work more explicitly with cartography. Douglas Huebler, for instance, used maps to similarly question the nature of art. His *Site Sculpture Project: 42° Parallel Piece* (1968) denotes fourteen locations labeled "A" through "N" on a map, towns at latitude 42° north, singled out by the artist for the exchange of certified mail receipts, sent from and to point A (Truro, Massachusetts) on the map (fig. 91). The full piece, defined by the artist's statement, the map, postal receipts, and supporting documents, expands conventional ideas of sculptural production to include gross approximations of geographic locations and abstract space.[51] But what sets LeWitt's wall paintings apart is their reliance on plotting and production as an interactive and inclusive process.

According to the philosophers Deleuze and Guattari, the map is defined as "open and connectable in all of its dimensions; it is detachable, reversible, susceptible to constant modification. It can be torn, reversed, adapted to any kind of mounting, reworked by an individual group or social formation. It can be drawn on a wall, conceived of as a work of art, constructed as a political action or as a meditation."[52] That is, the map is malleable and, above all else, open to analysis. In this way, LeWitt's textual "directions" for his wall drawings can be read as maps, diagrammatic representations of symbolic

and material relations. While the aim of Deleuze and Guattari is to chart the spatiality of contemporary power dynamics and disciplinary regimes in late capitalist society, LeWitt's work functions similarly to underscore the possibilities or limitations of established artistic conventions. He was initiating an analysis of the parameters of creative practice, codified and supported by art institutions, and in the process expanding the nature of what constitutes art.

Conclusion

The conceptual strategies developed by artists in the late 1960s and early 1970s, however visually varied, must be contextualized within the broader social changes of this period and their political implications. The Vietnam War, protest movements, and the birth of identity politics set the stage for intense critical debate in all areas of the public sphere, leaving artists in no way separated, despite claims to autonomy, from the crisis. As part and parcel of this turmoil, the relationship between politics and art was hotly debated and in a sense provides a measure for comprehending the importance of spatializing in visual terms a whole host of individual and collective data.[53] For some artists, this meant using the art object to further ideological concerns through direct social activism; for others, the ambition was to deconstruct and rework institutional constructs and expectations. The site specificity prioritized by Smithson, Mendieta's investigations of subjectivity and body-based practice, and LeWitt's commitment to questioning the very procedures of art fit within this changing political climate and were by extension transformative, not just for visual production of the day, but for subsequent generations of artists.

Consider, for example, Rubén Ortiz-Torres's *Malcolm Mex Cap* (1991; cat. 38) or Jenny Holzer's *With All the Holes in You Already There's No Reason to Define the Outside Environment as Alien* (1983; fig. 92), both of which confront issues of postcolonial identity and racial and gender inequities through language. Contemporary artists working in multiple media and alternative contexts similarly participate in a form of social mapping, spatializing not just geographic coordinates but socioeconomic realities, historical data, and personal experience as well. Postmodernism is in some ways predicated on the recognition that society is the spatial distribution and arrangement of individuals.[54] Fully comprehending its composition requires intense topographical investigation, not only from an elevated viewpoint, but at the most local of levels. Today, because of digital media and new technologies, a variety of names and descriptions are used for these sorts of

Fig. 92. Jenny Holzer (b. 1950). *With All the Holes in You Already There's No Reason to Define the Outside Environment as Alien*, 1983. Enamel on aluminum sign on metal, edition 1 of 3. 24 × 24 inches Museum of Contemporary Art San Diego, Gift of Margo H. Leavin, 1986.39. Cat. 141.

WITH ALL THE HOLES IN YOU ALREADY THERE'S NO REASON TO DEFINE THE OUTSIDE ENVIRONMENT AS ALIEN

investigations: collaborative mapping, dependent on the open-access flow of information between various users and locations; deep mapping, which interweaves autobiography, archaeology, folklore, interviews, science, natural history, and intuition; and, most recently, the spatial humanities, the use of software to analyze and display information related to specific physical locations in innovative ways.[55]

Further, the strategies initiated in early postmodern art practices for examining space, bodies, institutions, subjectivity, social relations, language, and consciousness were fundamental in radicalizing viewership as well, leading to what Jacques Rancière has described as the "emancipated spectator," a viewer who has a dynamic role in the process of observation, an active interpreter appropriating and transforming the original narrative.[56] This new model of looking at and interpreting the work is grounded within a larger, relational and intersubjective context. Perhaps this is the legacy of artists such as Smithson, Mendieta, and LeWitt and their specific mapping strategies, to ensure the critical consciousness of the viewer and reveal the broader social implications of art. In this way, their work effectively politicized the art establishment, changing the stakes of contemporary art.

NOTES

1. See, for example, Manuel Lima, *Visual Complexity: Mapping Patterns of Information* (Princeton, NJ: Princeton Architectural Press, 2011); Dennis Cosgrove, ed., *Mappings* (London: Reaktion Books, 1999); and Janet Abrams and Peter Hull, eds., *Else/Where: Mapping New Cartographies of Networks and Territories* (Minneapolis: University of Minnesota Press, 2003).

2. On the difference between map and mapping, see Janet Abrams and Peter Hull, "Where/Abouts," in Abrams and Hull, *Else/Where*, 12.

3. See, for example, Barbara Novak, *Nature and Culture: American Landscape and Painting, 1825–1875* (Oxford: Oxford University Press, 2007); Angela Miller, *The Empire of the Eye: Landscape Representation and American Cultural Politics, 1825–1875* (Ithaca, NY, and London: Cornell University Press, 1993); and Albert Boime, *The Magisterial Gaze: Manifest Destiny and American Landscape Painting, c. 1830–1865* (Washington, D.C.: Smithsonian Institution Press, 1991).

4. Consider, for example, Thomas Cole's "Essay on American Scenery" (1836), Ralph Waldo Emerson's "Nature" (1836), and Henry David Thoreau's *Walden* (1854).

5. Miller, *Empire of the Eye*, 18.

6. For a discussion of everyday life as a site of critical inquiry, see Henri Lefebvre, *Critique of Everyday Life*, trans. John Moore (1947; repr., London and New York: Verso, 1991); and Michel de Certeau, *The Practice of Everyday Life*, trans. Steven Rendall (Berkeley: University of California Press, 1984).

7. See Herbert Marcuse, *One-Dimensional Man* (Boston: Beacon Press, 1964); Marcuse, *Essay on Liberation* (Boston: Beacon Press, 1969); C. Wright Mills, *The Power Elite* (1956; repr., Oxford and New York: Oxford University Press, 1970); and Mills, *Power, Politics & People: The Collected Essays of C. Wright Mills* (1963; repr., Oxford and New York: Oxford University Press, 1967).

8. Fredric Jameson, *Postmodernism, or, The Cultural Logic of Late Capitalism* (Durham, NC: Duke University Press, 1991), 51. For an interesting analysis of Jameson's project, see Robert T. Tally, Jr., "Jameson's Project of Cognitive Mapping: A Critical Engagement," in *Social Cartography: Mapping Ways of Seeing Educational and Social Change*, ed. Rolland G. Paulston (New York: Garland, 1996), 399–416.

9. For a comprehensive account of Smithson's involvement with this project, and its implications for his subsequent practice, see Janna Eggebeen, "'Between Two Worlds': Robert Smithson and Aerial Art," *Public Art Dialogue* 1, no. 1 (March 2011): 87–111.

10. Here, Smithson was influenced by Donald Judd's seminal article "Specific Objects," in which Judd describes two forms of new sculptural production, work based on the single object or environmental in scale. Donald Judd, "Specific Objects," *Arts Yearbook* 8 (1965): 78.

11. "Aerial Art," in Robert Smithson, *Robert Smithson: The Collected Writings*, ed. Jack Flam (Berkeley: University of California Press, 1996), 116.

12. Eggebeen, "'Between Two Worlds,'" 95.

13. Robert Smithson, "The Monuments of Passaic," *Artforum* 6, no. 4 (December 1967): 48–51.

14. For the distinction between site and non-site, see "Earth," in Smithson, *Robert Smithson*, 178.

15. According to Smithson, the shape of the non-site "is based on the map that I devise in terms of my experience of the site"; quoted from "Four Conversations between Dennis Wheeler and Robert Smithson," in Smithson, *Robert Smithson*, 198.

16. "Art and Dialectics (1971)," in Smithson, *Robert Smithson*, 370–71.

17. For more on the critical emergence of earth art, see Suzaan Boettger, *Earthworks: Art and the Landscape of the Sixties* (Berkeley: University of California Press, 2002), 126–53.

18. See Edward S. Casey, *Earth-Mapping: Artists Reshaping Landscape* (Minneapolis: University of Minnesota Press, 205), 12–14.

19. Moira Roth, "An Interview with Robert Smithson (1973)," in *Robert Smithson*, by Eugenie Tsai with Cornelia Butler (Berkeley: University of California Press, 2004), 84.

20. For an in-depth analysis of site specificity and its various manifestations vis-à-vis contemporary art, see Miwon Kwon, "One Place after Another: Notes on Site Specificity," *October* 80 (Spring 1997): 85–110.

21. James Meyer, "The Functional Site; or, The Transformation of Site Specificity," in *Space, Site, Intervention: Situating Installation Art*, ed. Erika Suderburg (Minneapolis: University of Minnesota Press, 2000), 25.

22. For a discussion of how processes of map-making and the discipline of cartography are currently being transformed, see Robert W. Karrow, Jr., introduction to *Maps: Finding Our Place in the World*, ed. James Ackerman and Robert W. Karrow, Jr. (Chicago: University of Chicago Press, 2007), 1–17.

23. For a brief history of mapping practices in Europe, see Hannah Higgins, "Map," in *The Grid Book* (Cambridge, MA: The MIT Press, 2009), 79–97.

24. See, for example, the following by Louis Althusser: "Contradiction and Overdetermination," in *The New Left Reader*, ed. Carl Oglesby (New York: Grove Press, 1969), 57–83; and *Lenin and Philosophy and Other Essays*, trans. Ben Brewster (London: New Books, 1971), esp. "Ideology and Ideological State Apparatuses," 123–73; and *For Marx*, trans. Ben Brewster (London: Allen Lane, 1969).

25. Carol Hanisch coined this phrase in her essay of the same name, originally published in *Note's from the Second Year: Women's Liberation*, ed. Shulamith Firestone and Ann Koedt (New York: Radical Feminism, 1970). For an artist's interpretation of the phrase, see Martha Rosler, "Well, *Is* the Personal Political?" in *Feminism—Art—Theory: An Anthology, 1968–2000*, ed. Hilary Robinson (Oxford: Blackwell, 2001), 95–96.

26. Teresa de Laurentis, *Alice Doesn't: Feminism, Semiotics, Cinema* (Bloomington: Indiana University Press, 1984), 159.

27. There is some scholarly debate regarding both the scope of this series and its start date. See Susan Best, "The Serial Spaces of Ana Mendieta," *Art History* 30 (February 2007): 58–64.

28. Mary Sabbatino, "Ana Mendieta: Identity and the *Silueta* Series," in *Ana Mendieta*, ed. Gloria Moure (Barcelona: Ediciones Polígrafa, 1996), 135–36.

29. Mendieta spoke extensively about this process during a discussion on art and politics at the New Museum of Contemporary Art in New York in February 1982: "It is only with a real and long enough awakening that a person becomes present to himself, and it is only with this presence that a person begins to live like a human being. To know oneself is to know the world, and it is paradoxically a form of exile from the world. I know that it is this presence of myself, this self-knowledge which causes me to dialogue with the world around me by making art." Reprinted in Moure, *Ana Mendieta*, 167–68.

30. Mary Jane Jacob, *Ana Mendieta: The "Silueta" Series, 1973–1980*, exh. cat. (New York: Galerie Lelong, 1991), 3.

31. For a discussion of this pose and its connection to cultural archetypes, see Best, "The Serial Spaces of Ana Mendieta," 68–69.

32. Mendieta's interest in performance was grounded in her studies at the University of Iowa, where, over a ten-year period, she completed an undergraduate degree and two master's degrees. Particularly influential was her relationship with Hans Breder and her experiments in the Intermedia Program. See Julia A. Herzberg, "Ana Mendieta's Iowa Years, 1970–1980," in *Ana Mendieta Earth Body: Sculpture and Performance, 1972–1985*, ed. Olga M. Viso, exh. cat. (Washington, D.C.: Hirshhorn Museum and Sculpture Garden, in collaboration with Hatje Cantz Publishers, 2004), 137–78.

33. For a consideration of Mendieta's work in relation to charges of essentialism, specifically that the *Silueta* series equates the female body with nature, see Best, "The Serial Spaces of Ana Mendieta," 67–79.

34. Ana Mendieta, "A Selection of Statements and Notes," *Sulfur* 22 (Spring 1988): 70.

35. Boettger, *Earthworks*, 225.

36. Best, "The Serial Spaces of Ana Mendieta," 67.

37. Here, I am drawing on philosopher Edward S. Casey's theory of emplacement, a phenomenological understanding of being in place, and his insistence that perception is always grounded in spatial relations. See the following by Casey: "How to Get from Space to Place in a Fairly Short Stretch of Time: Phenomenological Prolegomena," in *Senses of Place*, ed. Steven Feld and Keith Basso (Santa Fe, NM: School of American Research Press, 1997), 13–52; *Representing Place: Landscape Painting and Maps* (Minneapolis: University of Minnesota Press, 2002); and *Earth-Mapping: Artists Reshaping Landscape* (Minneapolis: University of Minnesota Press, 2005).

38. Judith Butler, "Performative Acts and Gender Constitution: An Essay on Phenomenology and Feminist Theory," in *Performing Feminisms: Feminist Critical Theory and Theatre*, ed. Sue-Ellen Case (Baltimore, MD: Johns Hopkins University Press, 1990), 270. See, for example, Jane Blocker, W*here Is Ana Mendieta?: Identity, Performativity, and Exile* (Durham, NC: Duke University Press, 1999), and Amelia Jones, *Body Art: Performing the Subject* (Minneapolis: University of Minnesota Press, 1998).

39. Herzberg, "Ana Mendieta's Iowa Years," 147.

40. For an analysis of the influence of *Avalanche*, see Gwen Allen, "An Artists' Magazine: *Avalanche*, 1970–1976," in *Artists' Magazines: An Alternative Space for Art* (Cambridge, MA: The MIT Press, 2011), 91–119.

41. Steve Pile and Nigel Thrift, introduction to *Mapping the Subject: Geographies of Cultural Transformation* (London and New York: Routledge, 1995), 11.

42. See, for example, Sol LeWitt, "Paragraphs on Conceptual Art," *Artforum* 5, no. 10 (June 1967): 79–83; and LeWitt, "Sentences on Conceptual Art," *Art-Language* 1, no. 1 (May 1969): 11–13.

43. LeWitt, "Paragraphs on Conceptual Art," 80. More specifically, LeWitt argued against minimalism as a critical construction: "much has been written about minimal art, but I have not discovered anyone who admits to doing this kind of thing." He instead concluded that the minimal was "part of a secret language that art critics use," exclusionary in nature and irrelevant to the artists whose work it describes. Here, LeWitt was not alone, as other artists associated with minimalism, including Carl Andre, Donald Judd, and Robert Morris, also dismissed the term and its critical implications.

44. This interest in seriality, rules of logic, and systems theory is acknowledged contemporaneously in Mel Bochner, "The Serial Attitude," *Artforum* 6, no. 4 (December 1967): 28–33; and Jack Burnham, "Systems Esthetics," *Artforum* 7, no. 1 (September 1968): 30–35.

45. In his second text on conceptual art, LeWitt argued that rationality alone was not the point. The first of his "Sentences on Conceptual Art" states: "Conceptual artists are mystics rather than rationalists. They leap to conclusions that logic cannot reach."

46. Benjamin Buchloh, "Conceptual Art, 1962–1969: From the Aesthetics of Administration to the Critique of Institutions," *October* 55 (Winter 1990): 105–43.

47. See Nicholas Baume, ed., *Incomplete Open Cubes* (Cambridge, MA: The MIT Press, 2001).

48. LeWitt, "Paragraphs on Conceptual Art," 79.

49. Alexander Alberro, *Conceptual Art and the Politics of Publicity* (Cambridge, MA: The MIT Press, 2003), 38.

50. Roland Barthes, "Death of the Author," *Aspen*, no. 5–6 (Fall–Winter 1967): n.p.

51. For an interesting analysis of both situationists' maps and those of conceptual

artists, see Peter Wollen, "Mappings: Situationists and/or Conceptualists," in *Rewriting Conceptual Art*, ed. Michael Newman and Jon Bird (London: Reaktion Books, 1999), 27–46.

52. Gilles Deleuze and Félix Guattari, *A Thousand Plateaus: Capitalism and Schizophrenia* (Minneapolis: University of Minnesota Press, 1987), 13–14.

53. See, for example, "The Artist and Politics: A Symposium," *Artforum* (September 1970): 35–39; Dore Ashton, "Response to Crisis in American Art," *Art in America* 57 (January 1969): 24–35; Barbara Rose, "Problems of Criticism 4: The Politics of Art, Part 1," *Artforum* 6, no. 6 (February 1968): 31–32; and Therese Schwartz, "The Politicization of the Avant-Garde," part 1, *Art in America* 59, no. 6 (November–December 1971): 97–105; part 2, *Art in America* 60, no. 2 (March–April 1972): 70–79; part 3, *Art in America* 61, no. 2 (March–April 1973): 67–71; and part 4, *Art in America* 62, no. 1 (January–February 1974), 80–84.

54. The work of the French philosopher Michel Foucault was of great import here, particularly his archaeological and genealogical works. See, for example, *The Archaeology of Knowledge* (New York: Pantheon, 1972), *Discipline and Punish: The Birth of the Prison* (New York: Vintage Books, 1979), and *The Birth of the Clinic: An Archeology of Medical Perception* (New York: Pantheon, 1973).

55. For an early example of deep mapping, see William Least Heat-Moon, *PrairyErth (A Deep Map): An Epic History of the Tallgrass Prairie Country* (Boston: Mariner Books, 1999); and on the implications of the spatial humanities see David J. Bodenhamer, John Corrigan, and Trevor M. Harris, eds., *The Spatial Humanities: GIS and the Future of Humanities Scholarship* (Bloomington: Indiana University Press, 2010).

56. Jacques Rancière, *The Emancipated Spectator* (London: Verso, 2009).

An American Art for San Diego: Rethinking Cultural Boundaries in Southern California

AMY GALPIN

W ho are Americans? What exactly constitutes America? Behold, *America*? It is a historically significant name and a rather complex one, too. We sing "America, the beautiful" and "home of the brave." But what does it mean to say "American art"? Experts and enthusiasts of Latin American art typically bristle at the idea that the often-cited term "American art" is meant to apply only to work created within the geographic boundaries of the United States. Furthermore, those who disapprove of American art prefer to speak of the art of Latin America and the art of the United States. Words have weight and sensitivities cannot be ignored.

Southern California is a dynamic region with several strong art collections, in particular the permanent collections of the Museum of Contemporary Art San Diego (MCASD), The San Diego Museum of Art, and the Timken Museum of Art. Each institution holds work by artists who have been active in the United States ranging from the colonial period to the present, but the definition of American art in this geographic space proves to be inherently multifaceted. In fact, MCASD, The San Diego Museum of Art, and the Timken have each led important initiatives, from educational programming to exhibitions, that have linked the arts of Mexico and the arts of the United States. Each museum has exhibition space within fifteen miles of the U.S.-Mexico border. Specifically, MCASD has a track record of collecting, exhibiting, and producing important books on artists from both sides of the border.[1] The San Diego Museum of Art has also made a commitment to the art of Mexico and the U.S. through select acquisitions and the organization of both small and large exhibitions that celebrate artistic ingenuity in the United States and Mexico.[2] The Timken Museum remains dedicated to serving the Spanish-speaking population on both sides of the border. Through its Outreach Español Program, the Timken offers Spanish-language gallery tours, talks, lectures, and other special events. Since 1996, more than twenty-three thousand students from Baja California have toured the Timken collection with Spanish-speaking docents.[3]

In addition to recognizing the presence of many contemporary artists of Mexican descent such as Hugo Crosthwaite, Raúl Guerrero, Rubén Ortiz-Torres, and Iana Quesnell, *Behold, America!* makes less of a distinction between a solely American artist and an international artist living and working in the United States. For example, there are many artists in cities like Los Angeles and New York who may be from other countries but have contributed to the visual cultural environment by living and working in the United States for many years. Works by artists such as Chilean native Alfredo Jaar and Cuban-born Ana Mendieta are included in this exhibition because they produced important work in the United States. The presence of international artists in the United States and the work they make enrich the culture of the United States. Artists born in other countries are represented in this exhibition with particular attention paid to artists of Mexican heritage.

In the city of San Diego, the Spanish language is frequently spoken, and the beach attitude and popular lunch choice of fish tacos have more in common with Ensenada, Mexico, than with any other city in the United States. Southern California and Baja California are inextricably linked by geography and cultural identity. Mission architecture, desert mountains, and rock music recorded in both countries have a presence in these regions. This dynamic reality has been in existence for hundreds of years, long before colonization, war, and a second colonization decided the physical boundaries of these two countries.[4] Rather poignantly, historian Matthew A. Redinger writes, "Geography brought them together, but history drove them apart. This is the fundamental reality in relations between the United States and Mexico."[5] While history and certain government policies and economic practices continue to drive the two countries apart, art brings them together. From colonial times to the present, artists and art have crossed the boundaries of these nations and affected the cultural milieu in foreign territories. The first half of the twentieth century saw a rush of artists, writers, and scholars moving to Mexico City to engage in the post-Revolutionary politics of the country. In Southern California, plein air painters were inspired both by the beauty of San Diego County and by the coastline of Tijuana and farther south.

After settling in California, Alson Skinner Clark first traveled to Mexico in 1922.[6] He made subsequent trips and found great inspiration in the natural beauty of the land, as well as in the decaying colonial architecture of Taxco and Cuernavaca. This type of scenery and a more traditional approach informed by plein air tradition can also be found in the early work of Everett Gee Jackson, who made many impressionism-infused canvases of Mexico, specifically Chapala, before turning to a more modern style, indicative of the influence of the Mexican muralists. The mural movement stirred many to travel to Mexico City, while, locally, artists like Jackson and Alfredo Ramos Martínez were able to make use of their proximity to Mexico.[7] At a time when American interest in Mexico was strong, Ramos Martínez made the journey in reverse, and Southern California became his home from 1929 to 1946.

Born in Monterrey, Ramos Martínez spent time in Europe and then returned to Mexico, where he became an important figure in Mexico City's art scene just as the Mexican Revolution (1910–17) was erupting. In 1929, he relocated his family to Los Angeles. Shortly after arriving, he returned to Mexico and created a mural cycle for the Hotel Riviera, a casino resort

that catered to Americans during Prohibition. Ramos Martínez completed a mural cycle in Ensenada in 1930, his first opportunity to create a large-scale project after moving to Los Angeles. Although the project was located in his birth country, it was a mural cycle funded by Americans in a space that welcomed wealthy American visitors, a new hotel and casino, known formally as the Hotel Riviera del Pacífico, less than two hours from the U.S.-Mexico border.[8] The mural cycle for the Hotel Riviera signaled a major turning point in the artist's career. The murals he painted in Ensenada led to commissions in the United States and marked the last time he painted large-scale works that were purely decorative and without social implications. The confluence of cultural exchanges involved in the creation of the casino is indicative of its geographic context, the border region.

Southern California and Baja California are intrinsically intertwined politically, socially, and economically. During the 1920s, an influx of Americans, who spent time in Tijuana and Ensenada, viewed Baja California as a playground. As a result of Prohibition, which had passed in 1920 in the United States, Americans were eager to cross the border and take advantage of Mexico's more liberal liquor policies.[9] Moreover, gambling was a major source of revenue in the small but burgeoning city of Tijuana. Due to the successful Agua Caliente Hotel, which had opened in June 1928, both American and Mexican businessmen increasingly recognized the potential of the coast of California as a tourist destination.[10] The Tivoli, the San Francisco, and the Foreign Club were all casinos in Tijuana, but the Agua Caliente was the most renowned of the local casino-resorts. The designers of the Agua Caliente paid attention to details and created a luxurious space that attracted many guests. Grand chandeliers decorated the ceilings, an elaborate tile arch stood in the area near the spa, beautiful bronze handles adorned the doors in the guest rooms, and the Salón de Oro (Golden Room), its walls accentuated with brocade, welcomed visitors.

In Ensenada, on the coast of Baja California, the counterpart to the Agua Caliente Hotel was the Hotel Riviera. The small city of Ensenada, founded in 1882, is located about seventy miles from San Diego and less than a five-hour drive from Los Angeles. Its proximity to Southern California allowed the wealthy and fabulous to venture to the hotel and casino via yacht cruises and long drives down the coast. Hollywood luminaries such as Myrna Loy, Rita Hayworth, Dolores del Río, Johnny Weissmuller, and Bing Crosby flocked to Ensenada in the 1930s for weekend getaways. Other significant names listed on the register include Marion Davies, William Randolph Hearst, Lupe Vélez, and Frank Morgan. Vélez and del Río were Mexican actresses who found success in the Hollywood film industry, and both were often called upon to play characters that ultimately promoted stereotypes about Mexican identity.[11]

After completing the project in Ensenada, Ramos Martínez found steady work in Los Angeles, where he also created works for private residences; for example, in 1933, he agreed to paint a mural titled *Guelaguetza* in the home of Jo Swerling, a well-known Hollywood screenwriter.[12] From the 1920s through the 1950s, Swerling participated in writing some of the most legendary American films, such as *Gone with the Wind* (1939), *It's a Wonderful Life* (1946), and *Guys and Dolls* (1955). Ramos Martínez was taken with popular art and indigenous customs, and this aesthetic appealed to Swerling

and several prominent collectors in Los Angeles. Guelaguetza is an indigenous celebration that is held annually in late July in the city of Oaxaca and surrounding communities in southern Mexico. The celebration involves traditional music, costume, and food, and allows for different groups within the community to demonstrate their practices. Beyond the Swerling commission, Ramos Martínez completed other murals in Southern California, including projects for the Santa Barbara Cemetery Chapel in 1934; the Chapel of Mary, Star of the Sea Catholic Church, in La Jolla during 1937 (the mural was destroyed a number of years ago, and there is now a mosaic mural in its place); the Avenida Café in Coronado in 1938 (the mural is now displayed in the Coronado Public Library); and Scripps College in 1946 (the unfinished mural remains on view on campus).

Reginald Poland, first director of the Fine Arts Gallery San Diego (now The San Diego Museum of Art), developed a strong relationship with Ramos Martínez. Following the artist's 1931 exhibition at the Fine Arts Gallery, the two Ramos Martínez paintings acquired in 1932 marked the first works by a Latin American artist in the Museum's collection. Eight years later, Ramos Martínez was invited to teach a fresco class at the Fine Arts Gallery. Students included the noted San Diego art promoter, collector, and artist Alice Klauber.[13] Klauber was a great champion of both the American and Asian art collections in the Museum.[14] Her notes from Ramos Martínez's lecture at the Museum are the only formal documentation of the class and provide further testimony to her varied involvement and commitment to art in San Diego. Though Ramos Martínez emphasized his knowledge of fresco, his students made use of a variety of media. At the end of the six-week class, Ramos Martínez held an exhibition of his students' work.[15]

In the San Diego region, Ramos Martínez created two murals. The first was for the facade of Mary, Star of the Sea Catholic Church.[16] A devout Catholic, Ramos Martínez was able to meld his own spiritual practice with a mural commission. The year after the La Jolla mural was complete, he began an extensive project for Albert Bram of Coronado, California, the proprietor of La Avenida Café, a local restaurant across the street from the elegant Hotel del Coronado. Bram visited Ramos Martínez's apartment in Los Angeles and convinced him to take the commission, paying the artist $1,000 for five separate murals for the Avenida Café.[17] Two of the murals did not survive; one is in a private collection in Palm Springs, California; and the other two are on view at the Coronado Public Library. Ramos Martínez chose some of his favorite subjects, women carrying flowers, for the mural titled *Market Day* (1938). The subject matter might seem trivial, but in reality these women are engaged in labor as they prepare and carry their goods to be sold in the market. By presenting them as workers, Ramos Martínez aligns himself with the people. This view reflects the leftist politics prevalent in Los Angeles and the Socialist inclination common among many artists; however, Ramos Martínez's portrayal of the people was bound by his faith and current trends that held sway among Mexican modernists working in the United States.

As mentioned previously, Ramos Martínez left his final mural project unfinished, with three of the nine panels still in progress. The mural cycle *The Flower Vendors* (1945–46) was made at the Margaret Fowler Garden, a walled space adorned with wisteria arbors on the east side of the Scripps

Fig. 93. Alfredo Ramos Martínez at work on his mural *The Flower Vendors*, 1945–46. Black and white archival photograph, 9⅞ × 7⅞ inches; Schenck Photography, Courtesy of Scripps College.

College campus in Claremont, California (fig. 93). In the years preceding Ramos Martínez's preparations for this final commission, he completed *Los charros del pueblo*, which is in the collection of The San Diego Museum of Art (fig. 94). In this particular work, rural dwellers wearing sombreros ride horses into the vast Mexican landscape. This type of imagery romanticizes Mexico, but it was also evoked often as a symbol of the new Mexico in the years following the Mexican Revolution by other Mexican muralists, such as Diego Rivera and David Alfaro Siqueiros, in works created in both the United States and Mexico.

Understanding the relationship to the border region and specifically Ramos Martínez's California legacy remains a complex challenge, and more research will illuminate the way in which the community of artists in Los Angeles affected him and how his distinctive artistic vision affected others. Margarita Nieto, a leading Ramos Martínez scholar, contends that the artist was inspired by sculpture in Los Angeles, particularly the work of George Stanley that represents the figural form as abstract experimentations with volume.[18] Stanley was well connected in the Los Angeles area, as he studied at Otis Institute of Art and Design, participated in the Federal Art Project, and later taught at the Chouinard Art Institute. The vibrant color palette of blue, red, and orange hues in Ramos Martínez's *Los charros del pueblo* is typical of his later work. It is also representative of the exploration of volume and perspective, begun in California, which differs from his earlier works.[19] The round horses, sombreros, and hills that delineate the countryside are

Fig. 94. Alfredo Ramos Martínez (1871–1946). *Los charros del pueblo*, ca. 1941. Oil on binder board; 30 × 24 inches. The San Diego Museum of Art; Museum purchase, 1946.9. © The Alfredo Ramos Martínez Research Project, Reproduced by permission. Cat. 165.

different from the earlier representations of friars and monks at the Santa Barbara Cemetery. Angular, flat forms have been replaced by rounded figural ones. This change might reflect the influence of Stanley, as Nieto hypothesizes, or it might have been inspired by the rounded forms of Rivera, whose work was popular in the United States in the 1930s and 1940s. As a Mexican painter living in Los Angeles, Ramos Martínez had access to stylistic trends among both American and Mexican modernists. He responded to these diverse influences and negotiated his own identity and the identity of the Mexico he portrayed through the lens of both Mexican and American inspiration.

In the decades following Ramos Martínez's death in 1946, many artists of Mexican heritage created works in Southern California that reference Mexican tradition. Art historian Anna Indych-López suggests that Ramos Martínez's more political work might be viewed as "proto-Chicano."[20] During the height of Chicano activism, The San Diego Museum of Art hosted an exhibition of works by Ramos Martínez in 1968. Although lacking the political content of Chicano art, the Ramos Martínez show with its imagery of Mexico related to its time. The Chicano mural movement of the 1960s produced prominent murals in East Los Angeles and beyond and inspired murals in San Diego at Chicano Park and El Centro Cultural de la Raza. While many local artists and community members were responsible for the murals at these sites, Salvador Torres and Victor Ochoa led the way in supporting murals at Chicano Park. The murals under Coronado Bridge (the area known as Chicano Park) were conceived in 1969 and painting commenced in 1973. El Centro Cultural de la Raza was founded in 1970 and has both exterior and interior murals. Additionally, El Centro has been a site for cultural engagement, dance performances, lectures, and art exhibitions since its founding. Chicano muralists continue to work in Southern California to this day, and the barriers they broke in the region paved the way for the success of many contemporary artists born in Mexico but actively working in the United States. Furthermore, Asco, a collective of artists from East Los Angeles focused on performance and conceptual art, active from 1972 to 1987, provided a link between the murals and a more contemporary approach.[21]

"Who were they? What did they do? How did they sound or what did they look like? If they were anarchists, I was one of them."[22]

In the past two decades, contemporary artists of Mexican descent have garnered international attention. Mexico City has become an international art powerhouse, and as artists have moved abroad, this fact has become better known. While contemporary Mexican art derives from diverse influences, some of its ingenuity belongs to the punk movement. Artists Rubén Ortiz-Torres, Daniela Rossell, and Carlos Amorales experimented with punk culture as they navigated their identities as artists. Each found his or her

place in the ever complex contemporary art scene following formative experiences with the punk movement in the early 1980s in Mexico City. Indeed, punk culture provided the catalyst for many of the most creative minds working today, either within or tangentially to the Mexican art scene. While the punk scenes of London, New York, and Southern California are well known, few recognize the truly international impact of punk culture in places such as Mexico City. Bands like the Clash, the Ramones, and Social Distortion are heralded for their loyal punk followings, but their reach extended far beyond their own countries as people in various locales embraced their music. In Mexico City, international punk bands were influential, but so was a homegrown punk scene. Punk music was ignored by radio stations, and concerts were forbidden, but punk music enriched the cultural scene in Mexico during the 1980s.

Through his friendship with the people he portrays in *Mexi-punx* (1982–86), a body of work documenting the punk scene, Ortiz-Torres was able to create a personal response to an important moment in the development of the arts in Mexico (fig. 95). Several of these photographs were first displayed in Mexico City after the earthquake of 1985, as a part of an effort to raise funds for the victims. This exhibition was titled *Jesús y los Mutantes*, in honor of the band of one of the artist's friends. These early punk influences led to the later work he created in California: first, in the form of paintings that continue the theme of self-exploration through looking at friends and loved ones; second, through his continued interest in pop culture as manifested in a series of refashioned baseball caps (cats. 38, 39, 160).

Ortiz-Torres was born in Mexico City and studied art at Universidad Nacional Autónoma de México (UNAM). He came to Los Angeles in 1990 and received an MFA degree from the California Institute of the Arts in 1992.

Fig. 95. Rubén Ortiz-Torres (b. 1942). *Catrín con Peñafiel (Dandy with Peñafiel)*, Gelatin silver print, 2011 (negative, ca. 1986), 15⅞ × 19⅞ inches. Courtesy of the artist.

Through frequent travel and strong roots, Ortiz-Torres has continued to be a part of the art scene in both Mexico City and Los Angeles. Music has always been a significant part of his life, from his father's folk music band, which wrote protest songs, to Frank Zappa, whose ability to play jazz, rock and roll, and classical music without making a distinction between high and low continues to inspire the artist.

During this formative period, Ortiz-Torres produced many self-portraits that convey a sense of immediacy using pencil, gouache, and watercolor, but one particular self-portrait in oil on wood reveals the traditionally trained artist. His *Retrato de pasaporte* (1991) is far from the immediacy of his sketches. This skillfully painted self-portrait, based on his passport photo, was created shortly after he arrived in Los Angeles (fig. 96). The other people in the self-portrait, depicted through rigid vertical bands, represent individuals he met at CalArts and the influence of the community there. Away from his friends in Mexico City, whom he honors in photographs and sketches, he finds a new community of artists in Los Angeles. While the subject might be viewed as a statement on multiculturalism, Ortiz-Torres points out that the presence of multiple cultures was essential to many artists working in the 1920s and 1930s in Mexico. Moreover, the painting reveals how the artist saw himself in other people and how his adopted city of Los Angeles sparked a reconsideration of both the self and others.

Also in 1991, shortly after he arrived in the United States, Ortiz-Torres painted a portrait of Mexican artist Daniela Rossell (fig. 97). Ortiz-Torres was thinking of Rossell as he adapted to Los Angeles and the environment at

Fig. 96. Rubén Ortiz-Torres (b. 1964). *Retrato de pasaporte,* 1991. Oil and tempera on wood; 35⅞ × 23⅞ inches. Patrick Charpenel Collection.

Fig. 97. Rubén Ortiz-Torres (b. 1964). *Sin título (Retrato de Daniela Rossell),* 1990. Oil on wood; 36 × 24 inches. Courtesy of the artist and OMR Gallery, Mexico City.

Fig. 98. Workshop of Hieronymus Bosch (ca. 1450–1516). *The Arrest of Christ,* ca. 1515. Oil and tempera on panel; 19⅞ × 31⅞ inches. The San Diego Museum of Art; Gift of Anne R. and Amy Putnam, 1938.241.

CalArts. The scar on Rossell's arm was the result of an injury she received as Ortiz-Torres prepared to depart for California. For Ortiz-Torres, the mark became a metaphor for his feelings about the United States. The border is a type of scar, and once you cross it, you can never be healed.[23] Today both Ortiz-Torres and Rossell are highly regarded international artists. Rossell is perhaps best known in the United States for *The Rich and the Famous* (1998–2002), for which she photographed wealthy Mexican women in their homes.

Like Ortiz-Torres, Hugo Crosthwaite is informed by popular culture. Born in Tijuana in 1971, Crosthwaite spent his childhood in nearby Rosarito and often helped his parents at their curio shop. At a young age, he taught himself to draw after studying the black-and-white reproductions in his father's books, such as *The Divine Comedy* by Dante Alighieri and *Don Quixote* by Miguel de Cervantes. This formative experience led to a fascination with black-and-white compositions. During his childhood, his parents often took him to Balboa Park to visit The San Diego Museum of Art. Crosthwaite recalls being fascinated by the knife in a work created by an artist associated with the workshop of Hieronymus Bosch, *Arrest of Christ* (ca. 1515; fig. 98). The juxtaposition of figures, a general sense of chaos, and the exaggerated facial features in this Bosch painting are highly visible in Crosthwaite's work.

Crosthwaite received a BA degree in 1997 from San Diego State University. Though he currently lives in Brooklyn, New York, the influence of the Tijuana–San Diego border region lingers in his art. Filled with diverse and hybrid cultures, his work represents a synthesis of the art historical canon and contemporary human experience. He explores the immediacy of drawing and simultaneously demonstrates a keen eye for detail. While Crosthwaite has been inspired by experiences in Atlanta and New York, *Behold, America!*

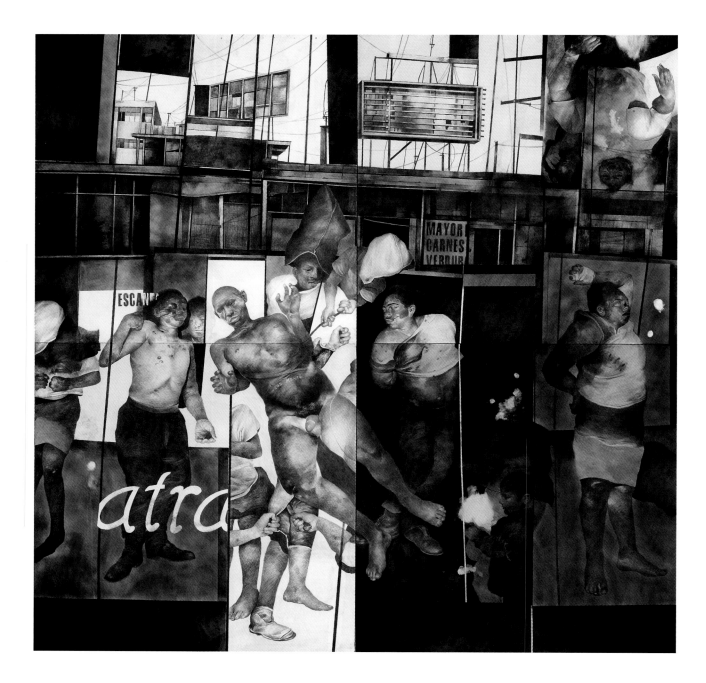

Fig. 99. Hugo Crosthwaite (b. 1971). *Bartolomé*, 2004. Graphite and charcoal; 96 × 96 inches. The San Diego Museum of Art; Museum purchase with funds provided by Ken and Jacki Widder and by Kevin and Tamara Kinsella, 2005.95.a–d. Cat. 73.

includes his *Bartolomé* (2004), one of many works in which he presents the cityscape of Tijuana as a backdrop with an emphasis on figural form (fig. 99).

Working primarily with charcoal and graphite, Crosthwaite melds the fragility of humanity with references to popular culture, daily life, and recent history, such as the events of September 11 and prisoner abuse at Abu Ghraib. His figures exude a brutal beauty: they are as awe-inspiring for their physical forms as for dramatic sensibilities that suggest baroque, surreal, and film noir influences. *Bartolomé* was created in response to an invitation to produce a religious-inspired work for an exhibition at Self-Help Graphics in Los Angeles. The artist immediately knew that he wanted to create something unexpected and avoid the Virgin of Guadalupe, a popular subject.[24] Crosthwaite quickly chose Bartolomé because of his interest in martyrdom. As he began the piece, the subject matter took on new direction. Crosthwaite tends to listen to National Public Radio while working, and the abuse of

prisoners at Abu Ghraib became international news as he began work on *Bartolomé*.

Crosthwaite describes the change in the direction of the work, saying, "The news, the stories about Abu Ghraib affected me in a way that I knew I could not just do this martyrdom scene. I felt undignified, I felt hurt, and I felt angry at American soldiers—I felt angry about the war—at humanity—at everybody."[25] In the composition, the central figure is attacked by disembodied hands. For Crosthwaite, the hands are a way in which the viewer enters the drawing and is ultimately implicated in the torture. In this scene loosely inspired by martyrdom, redemption depicted through the presence of an angel or other religious being is absent. In *Bartolomé*, the flaying of the saint's skin is a metaphor not only for the abuses at Abu Ghraib but also for the atrocities humanity has enacted in the name of religion.

Ramos Martínez, Ortiz-Torres, and Crosthwaite arrived in the United States as outsiders, but their work, although incredibly disparate, has contributed to a varied American visual culture. In creating work in the United States, these artists have forced us to think about American culture in new ways. The popularity of Ramos Martínez's work in Southern California suggests a type of imagery of Mexico that was widely embraced in the 1930s and 1940s. In Ortiz-Torres's paintings, the artist offers a device with which to experience the process of migration. His baseball caps (cats. 38, 39, 160) provide a fascinating comment on American popular culture because he reminds us that, as an international icon, the cap functions differently in particular cultural spaces and that the seemingly trivial words and images found on the popular caps can evoke deeper emotions. For his part, Crosthwaite melds Old Master visions with contemporary Tijuana life in works that serve as commentary on life in the United States and reinforce the United States' impact on the world. This approach is powerfully realized in his haunting work *Bartolomé*.

The geographer Yi-Fu Tuan writes, "The word 'nurture' says two things about us: that we 'feed' on places and art works, and that, so fed, we grow. The self, in other words, is not fixed."[26] For these artists, place—whether Mexico or the United States—has proved to be a catalyst for their artistic process. The presence of their work in *Behold, America!* allows for a fuller and ultimately more accurate representation of the art of the United States.

1. An abbreviated list of exhibitions includes *La Frontera/The Border: Art about the Mexico–United States Border Experience* (March 5–May, 22 1993); *Ultrabaroque: Aspects of Post–Latin American Art* (September 23, 2000–January 7, 2001); *Baja to Vancouver: The West Coast and Contemporary Art* (January 23–May 16, 2004); *TRANSactions: Contemporary Latin American and Latino Art* (September 17, 2006–May 13, 2007); *Viva la Revolución: A Dialogue with the Urban Landscape* (July 18, 2010–January 2, 2011); and *Mexico Expected/Unexpected* (February 5–May 15, 2011).

2. *Axis Mexico: Common Objects and Cosmopolitan Actions* (September 14, 2002–March 9, 2003); *Everett Gee Jackson/San Diego Modern, 1920–1955* (July 19–September 28, 2008); *Brutal Beauty: Drawings by Hugo Crosthwaite* (February 25–July 18, 2010); *Global Journey/Local Response: Works by Jean Charlot* (March 5–July 10, 2011); *Rubén Ortiz-Torres: Portrait of an Artist as a Young Man* (July 30–November 6, 2011); and *Marianela de la Hoz: Heaven on Earth, the Determined Freedom of an Undetermined Life* (October 13, 2012–February 24, 2013).

3. Kristina Rosenberg, Director of Education at the Timken Museum, e-mail correspondence with the author, March 20, 2012.

4. Following Spanish colonization, the United States colonized Mexico in the twentieth century through its distribution of American culture and its economic practices.

5. Matthew A. Redinger, *American Catholics and the Mexican Revolution, 1924–1936* (South Bend, Indiana: University of Notre Dame Press, 2005), ix.

6. Deborah Epstein Solon, *An American Impressionist: The Art and Life of Alson Skinner Clark*, exh. cat. (Pasadena, CA: Pasadena Museum of California Art; Manchester, VT: Hudson Hills Press, 2005), 108.

7. Jackson is represented in the permanent collection of The San Diego Museum of Art by nine works. The publication accompanying the show, *Everett Gee Jackson: San Diego Modern* by D. Scott Atkinson, brought much needed attention to the artist. Ramos Martínez is represented in the permanent collection of The San Diego Museum of Art by seven works.

8. The hotel and casino were first promoted as the Club Internationale of Ensenada and later the Ensenada Beach Club.

9. During Prohibition, Americans were not allowed to sell, distribute, or make alcohol.

10. María Eugenia Bonifaz de Novelo, "The Hotel Riviera del Pacífico: Social, Civic and Cultural Center of Ensenada," *The Journal of San Diego History, San Diego Historical Society Quarterly* 29, no. 2 (Spring 1983): 76–85; José Gabriel Rivera Delgado, "El Edificio del ex Hotel Playa, hoy Centro Social, Cívico y Cultural Riviera: Símbolo de la Historia de Ensenada," in *Del Hotel Playa Ensenada al Centro Cultural Riviera, 75 años de historia gráfica* (Mexicali, Mexico: Archivo Histórico del Estado de Baja California in association with the Museo de Historia de Ensenada, 2005), 9–17.

11. Joanne Hershfield, *Inventing Dolores del Río* (Minneapolis: University of Minnesota Press, 2000), 3–4.

12. Swerling's home in Los Angeles was eventually destroyed, but art dealer Bryce Bannatyne intervened and saved the mural from destruction in 1991.

13. Alice Klauber's notes from Alfredo Ramos Martínez's fresco class at The San Diego Museum of Art, July 13, 1940. The San Diego Museum of Art Archives.

14. Klauber organized the groundbreaking exhibition of American art in San Diego for the 1915 Panama-California Exposition held at Balboa Park. This exhibition was co-organized by Robert Henri and marked the first official showing of leading American artists like George Bellows and John Sloan in San Diego. See D. Cartwright's essay in this volume.

15. María Sodi de Ramos Martínez, *Alfredo Ramos Martínez*, trans. Berta de Lecuona (Los Angeles: Martínez Foundation, 1949), 36.

16. A few years after completion of the Ramos Martínez mural, the 1940 La Jolla census stated that the population was 5,438. "Diamond Anniversary, 1906–1981, Mary, Star of the Sea, La Jolla, California" (La Jolla, CA, 1982), unpaginated. Folder for Mary, Star of the Sea, La Jolla Historical Society.

17. Unsigned, undated statement written by the grandchildren of Albert Bram, "Historical Appreciation of Location, Romaine Salad and Ramos Martínez Murals," Coronado Historical Society.

18. Margarita Nieto, "Alfredo Ramos Martínez en Los Angeles: El azar y el recuerdo,"

in *Alfredo Ramos Martínez (1871–1946): Una visión retrospectiva*, exh. cat. (Mexico City: Museo del Arte Nacional, 1992), 91–92.

19. One of the more interesting aspects of this particular work is the remnants of another *charro* on horseback that has been painted over by the artist. Ramos Martínez likely changed his mind about the composition but chose not to abandon completely the work and start over, instead leaving a hint of the figure as a mysterious presence in the painting.

20. Anna Indych-Lóopez, "Alfredo Ramos Martínez: Indians, Hollywood, and the *Los Angeles Times*," in *MEX/L.A.: "Mexican" Modernism(s) in Los Angeles, 1930–1985*, ed. Rubén Ortiz-Torres and Jesse Lerner, exh. cat. (Long Beach, CA: Museum of Latin American Art, 2011), 47.

21. For more information, see the groundbreaking publication *Asco: Elite of the Obscure, a Retrospective, 1972–1987*, ed. C. Ondine Chavoya and Rita Gonzalez, exh. cat. (Ostfildern, Germany: Hatje Cantz Verlag in association with the Williams College of Art and the Los Angeles County Museum of Art, 2011).

22. Rubén Ortiz-Torres, "Mexi-Punx," in *Punkacademics*, ed. Zack Furness (Wivenhoe: Minor Compositions, 2012), 187.

23. Rubén Ortiz-Torres, interview by the author, June 2011, The San Diego Museum of Art.

24. Hugo Crosthwaite, interview by the author, December 2011, The San Diego Museum of Art.

25. Ibid.

26. Yi-Fu Tuan, *Place, Art, and Self* (Chicago: Center for American Places and Columbia College, 2004), 4.

Interview with Rubén Ortiz-Torres

How long have you lived here in Echo Park?

Wow. Since 1990.

How much time do you spend here versus your time spent in San Diego?

I spend most of the time here. I would say a couple of days in San Diego during class time. Either once or twice a week in San Diego, the rest I spend it here.

Do you feel as much a part of the art scene in San Diego? Or do you really just consider yourself as working here in Los Angeles?

Well, yes and no. I mean it's very strange, but I think that one of the things that happens with globalization is that we don't belong to a place anymore; you sort of create these networks and these accesses. I'm here, but I do think of myself as part of Mexico City. I live in Los Angeles and I feel I'm part of the Los Angeles art scene, although I still feel like an outsider. You know, I'm going to be showing at MOCA [The Museum of Contemporary Art, Los Angeles] as part of Los Angeles artists [*The Artist's Museum*, October 31, 2010–January 31, 2011]. And yet, it's very strange because I still think that in Los Angeles, I see myself as an outsider in a way, as an outsider of a certain art scene. But at the same time, I think I understand more a certain part of Los Angeles than the artist that is supposedly from Los Angeles, and that's something that, in a weird way, has happened since I arrived in Los Angeles. I mean, I had access to certain parts of Los Angeles that most people didn't. And yet I can spend a lot of time here, and it is difficult to be part of a certain scene.

In the same way, I think the same sort of thing happens in San Diego because, I mean, I teach at UCSD [University of California, San Diego]. I have a certain affinity with the region and a certain group of students in ways that the rest of the faculty doesn't, even faculty that live there. So perhaps my relationship, for example, with the border or Tijuana is particular. The border seems to be like a magnet that, as much as I try to get far from it, it keeps pulling. I can't escape for some reason. I'm still trapped there. So I think it's a place where I constantly try to go back and forth, and this is regardless of my job.

I was wondering if you could speak a little bit about what it was like moving here and beginning at CalArts [California Institute of the Arts]. Or about the environment of CalArts. How do you think it affected your work?

When I went to CalArts—it is a very complicated story, and it is a very personal story. Like a lot of people, I have relatives in California; I have cousins in San Diego. And I came to Los Angeles more for personal reasons. I had a friend, this woman, who, actually, right now, [is] a film director, Catherine Hardwicke, and she wanted me to come to Los Angeles. She suggested that I go to CalArts, and I went there and I liked it, the school, and I applied, thinking that it was a long shot, and I was not exactly thinking that I would be accepted, and then I was accepted. But I did not have the money to go, I didn't

have the funding. So then the possibility of going there became serious. I started applying for grants, and I got the Fulbright grant. Then my options to stay in the United States expanded because I was not necessarily bound to just go to CalArts. I could go to New York. So then, for me, it became a real serious decision. Between going to New York or coming to the West Coast and going to CalArts, which is this very complicated decision that, up to this day, I still think about it. Whether it was the right decision I will never know. I think in New York I probably could have done some things that would have been very difficult to do. But I would also say the same—here, I could do things that in New York I couldn't do. As a school, CalArts was more interesting than the schools in New York. And I thought, at some point perhaps, if it were necessary, I could go to New York after going to CalArts. But at the end, this didn't happen; I stayed in California. I had too many things to do here. I was attached to the region in different ways.

It's certainly true that since I arrived to—I mean, CalArts is a very particular place, where I found a certain kind of familiarity. Because it was very open, the school somehow reminded me of the education I had as a kid. I went to these anarchist schools, where the programs were also very open. I also think that the geography of the place—open space, mountains, palm trees, and a swimming pool—kind of reminded me of Cuernavaca. Or one of these places close to Mexico City. Here, I thought that I could produce more, and it was more comfortable. And if the whole plan failed, I could always go to Tijuana. I always thought there was something familiar relatively close. Even though—perhaps I romanticized that, more than the reality of it—I understand that Tijuana is not that familiar, but in my mind it was. It would bring a certain kind of comfort to be close to it. And I thought that Los Angeles could have some of that familiarity.

And how do you find that teaching affects, distracts, informs your work? How do you see teaching as having an effect on your own practice?

It works both ways. It distracts you to the extent that you have to commit time to teach and to prepare classes and to do faculty service and all these things. I definitely give some time to that, even the commuting—what can I say? On another level, I think it also helps me because one of the problems of California is that, geographically, the region is very decentralized. I remember reading an interview, a European composer was saying that for culture to develop you have to have these tight networks, this density of artists, this group of smart people together so that they interact and exchange ideas. This is the way cities in Europe would produce avant-garde music. California doesn't work like that. I mean, it is spread out; it doesn't have these clusters of people together. And yet, information travels in different ways. We get to see what other people do, even though we don't necessarily socialize or are together with each other. It seems to me that the university is a place where I can socialize to that extent. It is a place where I do see a concentration of people and discussions. Even the work of the students reflects what is happening outside in the art world. To that extent, I think the school helps me. Otherwise, personally, like other American artists, I have . . . in California, you have the possibility of becoming isolated and just doing things on your own.

But I definitely think that the way I think about art has changed as I have spent time here in California and the U.S. I remember when I was in Mexico, there was a certain thirst for information and a need to participate as part of a scene. And not just me but most artists. Most artists were eager to consume and be aware of what was happening elsewhere. We would share art magazines, and we would look at them and consume them. I remember, for example, my relationship with *Artforum*. *Artforum* would arrive sporadically; you couldn't find it on a regular basis at the magazine store. But when you could find it, we would read it. I remember all of the advertisements, also certain issues that I compulsively read. When I came to California and I went to CalArts, I remember I had this class where you would talk about your influences. I was very excited, thinking of all the influences that I had, all of the artists that interested me. For me, it was a very complicated question, because I had many. How was I going to organize them? And who would be my real favorites? Because I pretty much liked everybody, everything. For my peers, in fact, it was the opposite. There was an obsession to not have any influence. I guess the coolest guy was the guy who disliked more artists. To be really independent, to not be paying attention. To really make work on your own. Now it's kind of weird, because every month I receive *Artforum*. And I don't open it. It stays there in my garden. When I open it, I just see advertisements. That for the most part doesn't interest me anymore. Now the problem has been reversed. Instead of being associated with whatever is happening, I try to think that what I'm doing is actually different and operating on its own and does not necessarily depend on that.

As you know, the exhibition is divided into three sections: forms, figures, and frontiers. Your work that is in the permanent collection of the MCASD [Museum of Contemporary Art San Diego], some will be in the frontiers and some in the forms section. When we first met, you told me the story of how you came to work with a baseball hat and the influence of baseball. And I was wondering if you could tell me one more time, for posterity this time.

The influence of baseball is something we could talk a lot about. It works in many ways. I used to play in little league in Mexico. I played for a long time, and we would go to the stadium to see the games there. And I think it was perhaps one of the first sophisticated encounters with aesthetics. The game for me had a lot to do with aesthetics. The uniforms, the logos, why certain teams would play with certain colors, and other teams with other colors. Why certain teams would have certain logos and other teams other ones, and how you would identify with a team and not another one. Why certain people would identify themselves with the Yankees as opposed to the Red Sox, or the Dodgers, or the Oakland A's, or the San Diego Padres. Being in Mexico City, I did not have a forced geographical allegiance to a particular major league team. So I would choose teams of my own. I used to like the Oakland Athletics. They had long hair and they were, like, these rebels, and somehow, they were more counterculture than the other ones. This was the early 1970s. I remember the World Series of 1973. Also, they were a successful team. I think in art those decisions have to be made. Sometimes you like certain art because of its formal qualities. Or otherwise, because of what it stands for. I used to like the Cincinnati Reds because I like red. But also, red was a color

Fig. 100. Rubén Ortiz-Torres (b. 1964). *Malcolm Mex Cap (La X en la frente)*, 1991. Ironed lettering on baseball cap; 7½ × 11 × 5 inches. Museum of Contemporary Art San Diego; Gift of Mr. and Mrs. Scott Youmans by exchange, 2001.6. Cat. 38.

that had this ideological connotation, I suppose, as opposed to other colors. I liked the Mexico City Red Devils. The Devils were my team. Or the Raiders. It's not necessarily baseball. These are teams that stand for something. So in a way, I think that kind of logic, when I started studying art and identifying with some art, liking some art and disliking some other one, I remember some of the decisions that would make me like a team, as opposed to another. How a team plays as opposed to another, that's a very immediate thing.

Of course there are a lot of things we could discuss about baseball. As I came to the United States, it seems to me that baseball represents a side of the United States that I am very fond of. Baseball is a very unique sport. It's very different from most sports. Baseball is a sport that by its own nature requires diversity. Basketball, for example, basketball players have to be very tall. Football players have to be very heavy. Soccer players have to have a lot of stamina to be athletes in a way. In baseball, it depends on the position. Each position requires a certain physical characteristic. If you are very tall, you play first base. If you are very strong, you play catcher. If you are very fast, you play shortstop. If you are more of a thinker, you can be a catcher. Also, it is very democratic in the sense that all the players in the team . . . have the same offensive opportunities. And also you have the same defensive opportunities. Both of the teams have the same chances in the offensive and on the defensive. You have ninety minutes, and you are going to bat and you are going to defend. So it is very democratic. It requires diversity and therefore it requires individuality, but it is a team sport. It is more of a team sport than most team sports. Even though it is so individual, you cannot play without a single player, as opposed to soccer, where you can expel players and the game still continues. I've played soccer, and you can be in situations where you don't do anything and the game still happens, right? Here, without a player in a position, you can't have the game, the game can't just go. And imagine, what would the game be without a catcher? Without a pitcher? That would be fantastic! It just couldn't happen. The point here is that it is an individual game, but it is a team game.

Could you tell me a little bit about one of the hats? I will let you pick whether it's the "Rodney King," or the "Malcolm X," or the "1492." What led you to create one of those hats?

The first hat I did was actually the "Malcolm X" hat. It was not thought to be an art piece. I mean, I collected hats, and I have a lot of hats. Well, first of all, hats became trendy because they were associated with hip-hop culture and street culture, even though I have been wearing them like Charlie Brown since the '70s. Yeah, for me, I will be honest with you, the hat had to do more with Charlie Brown than with Easy-E or with Ice Cube. However, baseball caps became very fashionable in relation to street culture and hip-hop culture. And also, in New York and Los Angeles, they function differently. But in Los Angeles, the colors of the hats were associated with particular gangs and particular streets and neighborhoods. So red hats were associated with some gang, and blue hats with some other one.

I used to wear caps of mostly Latino teams and personal things. And I had a teacher whose name was Joe Lewis, who at some point, I suppose in the early '80s, he used to run this gallery in the Bronx, called Fashion Moda. This was very important for graffiti artists and these artists from the Bronx. Joe Lewis gave me this baseball hat as a joke. When the Malcolm X movie appeared, Spike Lee made all these hats with the X to promote the movie. I liked the cap, but for me it stood for something else, because there is this very famous essay on Mexican identity written by this philosopher called Samuel Ramos, that influences Octavio Paz to write *The Labyrinth of Solitude,* and the name of the essay is "The X on the Forehead." So according to Samuel Ramos, every Mexican works with an X on their forehead—this, sort of, "la 'x' en la frente," this burden of being Mexican. And so, look at all these caps— you have the X in the front, so it has to do with Mexico. But, of course, that's the thing about connotative meaning. It's like symbolic meaning—when you have a symbol, everyone can interpret it however they want. The meaning of a symbol is defined by conventions, and therefore it is open to different

Fig. 101. Rubén Ortiz-Torres (b. 1964). *L.A. Rodney Kings (2nd version),* 1993. Stitched lettering and design on baseball cap. 7½ × 11 × 5 inches. Museum of Contemporary Art San Diego; Gift of Mr. and Mrs. Scott Youmans by exchange, 2001.8. Cat. 39.

Fig. 102. Rubén Ortiz-Torres (b. 1964). *1492 Indians vs. Dukes,* 1993. Stitched lettering and airbrushed inks on baseball caps; each 7½ × 11 × 5 inches. Museum of Contemporary Art San Diego; Gift of Mr. and Mrs. Scott Youmans by exchange, 2001.7. Cat. 160.

interpretations. We could think of a swastika meaning something, but for other groups of people, it can mean something else. And the same with this X. So as a joke, I called it the "Malcolm X cap" in my mind, having to do with this history and then realizing that here it meant something else. Because Joe Lewis told me, he said: "I'm giving you these caps so that you don't wear those ethnic ones that you wear." And I thought, well, I would wear these ones, but I would customize [them] and adapt [them] to certain particular circumstances. And it became like a joke. But after the Rodney King riots in Los Angeles, Joe wanted to include this cap in a show. I showed it in Baltimore, and all of a sudden they invited me to participate in different shows that have to do with African American art. And I really liked that, because once again, for me, these symbols are often associated with nationalism, or with separatism, an ethnocentric point of view, when, in reality, often there is this need to cross boundaries that have to do with an international empathy that has to do with issues of class. So in a way, this cap was an internationalist cap—that was, for me, empathizing with the Rodney King incident. It had to do more with sharing a situation and certain class affinity. Which interestingly enough, as I have seen recently, in a lot of the journals of the Black Panthers—which have often been presented as this separatist ethnocentric group—there is constant support for the farmworkers or the Native American cause, which they found an affinity with. So I thought with my cap—in a way, this was an issue that was affecting the barrio, the ghettos, in the poor neighborhoods in Los Angeles.

I could tell you many stories [about] all the other caps. Other caps have interesting stories, too. Because all the caps have to do with the logos and how these logos portray different ethnic groups, mostly Native Americans. There are a lot of baseball teams that have names that are associated with Native Americans. Often the logos are very controversial because they seem to be cartoons. And for me, it is interesting because my little league was called the Mayan League. Most of the leagues actually have names of older civilizations, pre-Columbian civilizations—the Olmec League, the Toltec League, and the Mayan League. I don't think that, in the case of Mexico, it was ever seen pejoratively. The thing that obviously operates differently in the U.S. is that whoever decides to call the team the Cleveland Indians is really not

an Indian, whereas in Mexico, somehow if you decide to call your team the Aztecs, somehow you would claim to be the inheritor of the Aztecs. To be the owner of the copyright. Here, somehow, it seems to be an infringement. These logos have been appropriated. I don't know to what point I was aware of the whole politics of this, but I definitely was aware of the kinds of representations that I have seen of Native cultures, Native civilizations. They were very different from Chief Wahoa from the Cleveland Indians. Chief Wahoa definitely did not look like the Aztec calendar. I was interested in those stylistic differences and how these aesthetics could have a different context or mean something different. So how Native American representations could be different from these logos, and if you juxtapose them, you could see this conflict and perhaps have this more postmodern sort of dialogue, or deconstruction. So in a lot of these baseball caps, I collaborated in the embroidery with different indigenous artisans who would embroider the caps and create their own logos or responses to the logos or regional Native designs.

You work in a lot of different media. Did you start as a painter and then morph into photography, these sculptural pieces, etc.?

You know, that is my usual spiel . . . that I started as a painter, but now that you say that, I'm just thinking, Why do I say that? I say that to the extent that that is what I learned in art school. When I went to art school, I learned how to paint. So up to this date, often I solve problems with painting or with photography because those are mediums I learned how to use. And in a way, perhaps, they are not very original. I immediately start to think in terms of painting. I almost have to spend time forgetting how to paint to start getting other kinds of ideas.

Now, having said that, I'm just starting to rethink when do you really start to express yourself. Because, if I think about it, when I was in grammar school, I went to this anarchist grammar school where we had a lot of freedom to express ourselves by any means necessary. And I had a lot of fun, in school, and I think I have a lot of fun today. Because I do the same as I did when I was in grammar school. When I was in grammar school, we did a Super 8 film, a theater play; I did a lot of cartoons. I wanted to paint. The most difficult thing for me was to paint because I was not good at it. There were a couple of kids in school who were better painters than me, and I admired them. I thought that doing cartoons, or drawings, or theater plays, or Super 8 movies was something that I could do, and I felt very comfortable . . . using forms of expression that had to do more with public culture. Also, I used to consume a lot of comics. I used to read comic books. So I felt that was more familiar. I thought that I wanted to learn art because I thought that that was more difficult. That it was better. So I spent a lot of time in high school learning how to draw, and when I was in the university, I paid a lot of attention to learning how to paint. I think there are certain mediums that perhaps are more suited to the way I think, in terms of complex narratives and associations and things, than perhaps painting. Recently, for example, I made an opera, and I didn't study how to make operas but I really enjoyed it. I had a lot of fun. It was like being in grammar school inventing something. Opera in particular seemed fantastic to me. Because it is this idea of total art. So I guess if art school is where we define the beginning, then yes . . .

When did you first begin thinking of yourself as an artist?

I don't know if I can answer that because I would say either always or never. I don't know if I consider myself an artist.

I see SpongeBob behind me and you mentioned being interested in comics. Can you talk about the role of popular culture in your work?

My father was an architect interested in music. He played in a band called Los Folkloristas, so he played folk music, but he loved classical music. His real passion was actually classical music. He took folk music very seriously, too. There was always this duality of these two things coexisting with each other and operating in different ways because they are not exactly the same. Listening to Latin American music, or *corridos*, had a very important role, but it was different. These things coexisted. And I think they were also part of a political discussion. My father's band was part of Latin American folk music that was very political. There were protest songs trying to somehow contest popular commercial music.

In terms of visual arts, in my house, even though there were books on art and my father was an architect, there were a few paintings but not from major painters. There were things that we inherited. I certainly played baseball and took it very seriously, read comic books, and at some point, when I grew up and became a teenager who paid a lot of attention to rock and roll, [listened to] mostly punk music. So all those things existed in my mind somehow and were competing and negotiating space. Some of my favorite artists—perhaps one of my favorite being Frank Zappa, [who] does everything. He does jazz, rock and roll, classical music—there isn't a distinction between high and low. He is just trying to create this new space for him to be independent and finance his projects and do what he wants to do.

You anticipated one of my other questions, thinking about Frank Zappa. Are there artists and movements that influence you?

I look at the world and often like it and find it to be an interesting aesthetic experience. Obviously there are a lot of things that I like, and I pay attention to everything. And there are all sorts of artists that I like, from Russian art, Caravaggio, to Turner. I mean, you name it. Now, personally, there are two or three things that I pay attention to—Spanish art and American art. I think it is a kind of strange because they are absolute opposites. They function very differently. But I like them precisely in their differences and how they complement each other. Spanish art, I like it because of its level of emotional intensity and drama and the gravitas of it and the depth of it. Definitely, perhaps in the history of art I would not find anything as intense that grabs my attention as much as Goya and Velázquez and El Greco, some Picassos, not all Picassos. The American art operates in the opposite side. What I like about American art is precisely its freshness. Its freshness and immediacy. Perhaps right now I don't pay as much attention as I used to because I have it more close. It's not something that stands out as much because I am surrounded by it. But certainly, when I grew up as a teenager, that kind of energy grabbed my attention. Andy Warhol, Jasper Johns, de Kooning, Rauschenberg, these were artists that I paid a lot of attention to, that I felt naturally related to, as

well as certain photographers. Mexican art, I was very familiar with. And in a way it sort of relates to these two things. So I don't even mention it because it gravitates to each of these things. It is somewhere in between these two things. But if I have to say, I particularly like José Guadalupe Posada, if you ask me, or [José Clemente] Orozco.

What do you like to see when you go to museums? Are there any particular things you dislike when you go to museums?

When I go to museums, I like to discover things. I sometimes get a little exhausted when I go to museums. The more museums try to validate themselves, they repeat themselves. There is certain art that has become established and a standard and, to a certain degree, expected to be seen in that museum. So it becomes very boring to me when I go to a museum and I see the same things over and over in other museums. For me, museums have become almost like going to a food court in a mall. You are supposed to have diversity, and then at the end I have McDonalds, Burger King, and Shakey's Pizza. There are certain things that are expected to be there that are supposed to be important things in the history of art. Therefore, everybody shows them. And it's so funny how museums repeat certain discourses. For example, I don't know how many museums I have gone and seen they are very excited to show minimalism because minimalism is underrepresented, and yet everyone shows it. They still tell you that minimalism does not appear in the history of art. Then we go and see the same thing over and over again. Obviously, for me right now, it is more interesting to go to a museum and see something else, something different.

Another conflict that I see with museums, for example, this sort of insecurity that forces a museum to present itself as an important place, showing something that is international. I will be honest with you, I am interested in particularity. Maybe it is a defect. I mean, I am not going to tell you that this is something good. Maybe it is really bad. Why do I have this obsession? I don't know. But I love particularity. I immediately pay attention. Subculture attracts my attention. If I go to a play and they tell me there is a new subculture that pays attention to surfers and bikers and gypsies, that attracts my attention. Why does someone express themselves differently? The other day I was looking at these posters from the seventies. Why is the typography different? If I go to San Francisco to see a show of Keith Haring, it frustrates me. Why do I go to San Francisco to see a show of Keith Haring that I can see in New York? I would like to go to San Francisco and see what is happening there, even if I don't like it. If I go to San Francisco to see the same thing they show in New York, and if I go to China and see the same thing that's in New York, and if I go to Mexico and see the same thing. If I go to Mexico City and they are showing Keith Haring, would I really go there?

NOTE

1. The interview was conducted by Amy Galpin in the artist's studio in the Echo Park neighborhood of Los Angeles, August 7, 2010.

CATALOGUE

FORMS

1. Josef Albers (1888–1976), *Homage to the Square: On Dry Ground*, 1963

Oil on board, 40¼ × 40 inches. Gift of Mr. and Mrs. Norton S. Walbridge, 1991.8, The San Diego Museum of Art

Josef Albers worked on his *Homage to the Square* series for twenty-six years, from age sixty-two until his death. This particular painting falls at the midpoint of his engagement with this formal subject matter. Across many of Albers's compositions, the boldness and gradation of color and the emphasis on basic geometric form make his work highly recognizable. The artist arranges his color tones within box shapes. In the words of Frederick A. Horowitz and Brenda Danilowitz, "In Albers' universe, color seduced, beguiled, *schwindled*, and these characteristics made color the most fascinating of art's formal elements. Albers' passion for color prompted his decision to launch what was possibly the first full-blown course in color ever given anywhere, and certainly the first based exclusively on direct observation of color's behavior."[1]

Albers came to the United States from Germany in 1933 and brought with him design ideas associated with the Bauhaus, where he had been both a student and a teacher. He taught at Black Mountain College from 1933 to 1949 and was head of the design department at the Yale University School of Art from 1950 to 1958. Like several artists included in this exhibition, in particular, Robert Henri (1865–1929) and Hans Hofmann (1880–1966), Albers's influence as a painter was rivaled by his influence as a teacher. At Black Mountain, where he had a significant impact, Albers taught with his wife, Anni (1899–1994), a textile artist, designer, and writer. During his time at Black Mountain, he interacted with many important artists, including Jean Charlot (1898–1979), a printmaker, muralist, and author, with whom he maintained a friendship that spanned many decades. Charlot wrote of Albers's work, "The coolness of Albers' craftsmanship, his obvious love of the law, make one feel that in the midst of such geometric fantasmagories and pulsating images, the artist longs for rest, for a superior state in which incidentals, without being annulled, may be allowed to register correctly within the frame of a stable absolute."[2] Albers's approach to abstraction and his use of color won the respect of his students and fellow artists.

2. George Ault (1891–1948), *Untitled*, 1931

Oil on canvas, 26⅛ × 20¹⁄₁₆ inches. Gift of Mr. Louis Musgrove, 1960.4, The San Diego Museum of Art

George Ault was born in Cleveland, Ohio and moved with his family to London when he was eight years old. He developed his artistic inclinations in Europe, studying Old Master paintings in Paris and London and eventually enrolling for formal study at University College School, the Slade School of the University of London, and St. John's Wood School. During the 1920s and 1930s, Ault created several urban scenes not unlike this painting, in which he stressed the formal qualities of the buildings as well as the presence of geometric forms. A comparable urban scene painting, *Hudson Street* (1932), is held in the collection of the Whitney Museum of American Art. Ault was most often associated with precisionism, a style derived from cubism and characterized by reduction in detail, an emphasis on form, and the absence of painterly brushstrokes and atmospheric effects. Furthermore, many precisionist paintings, like this one, present scenes that feature architecture but are devoid of figures.

During much of the 1930s, Ault lived in Greenwich Village, and he participated in the formation of the American Artists' Congress in 1935. A few years later, he decided to leave the city and relocated to Woodstock, New York. While Ault's paintings have suffered critical neglect, Alexander Nemerov's recent exhibition and associated publication *To Make a World: George*

Ault and 1940s America drew considerable attention to the artist's work, which was presented in concert with the paintings of contemporaries Rockwell Kent (1882–1971) and Edward Hopper (1882–1967).[3]

3. Jo Baer (b. 1929), *Untitled*, 1966

Oil on canvas, 48 × 60 inches. Museum purchase, International and Contemporary Collectors Fund, 2005.10, Museum of Contemporary Art San Diego

It might not seem that viewers would participate in such a sparse canvas, but the simplicity of Jo Baer's works inspires strong responses and draws out the complex process of visual perception. Are the center portions of her works empty or full? Baer responded to the prevailing practice of abstraction during the 1960s by decentralizing her compositions. In New York, she met Donald Judd (1928–1994) and Dan Flavin (1933–1996), both of whom were influential to her work. From 1963 to 1975, she limited her painted representations to bands of black and another color (here, green) at the edges of her canvases, although she did use other colors, such as red, as a way of emphasizing the essential object-like qualities of painting. In 1966, the same year that she painted this work, she had her first solo exhibition at the Fischbach Gallery. This was also the year of the groundbreaking exhibition *Systemic Painting* at the Solomon R. Guggenheim Museum in New York.

In assessing Baer's contribution to abstract painting, art historian Patricia Kelly writes, "On the one hand, Baer aligned herself with Clement Greenberg's modernist legacy through her preoccupation with the formal elements of painting. On the other, by prioritizing the visual encounter with the spectator, an experience based in real time and space, Baer cut herself off from established institutional backing. Such oppositional push-and-pull—between modern art and minimalism, painting and sculpture, stillness and movement, and even canvas and edge—was central in Baer's efforts to radicalize contemporary painting."[4]

Baer's enclosed compositions of white with distinct hard edges became emblematic of minimalism. Furthermore, political undertones exist in the artist's paintings, as in the works of many minimalist painters, and she exhibited her paintings in a number of exhibitions with leftist motivations. Baer became disillusioned with the U.S. government, in particular, President Nixon's administration, and in 1975, she relocated to Europe, eventually settling in Amsterdam. Also in 1975, she was celebrated with a major exhibition at the Whitney Museum of American Art. It was around this time that she chose to reject her previous interest in abstraction and returned to figurative painting.

4. John Baldessari (b. 1931), *Composing on a Canvas*, 1966–68

Acrylic on canvas, 114 × 96 inches. Gift of the artist, 1970.11, Museum of Contemporary Art San Diego

John Baldessari is a pioneer in conceptual art practices. He was born in National City, California and has spent the majority of his life in Southern California. Baldessari received undergraduate and graduate degrees from San Diego State College (now San Diego State University) and later taught at several institutions, most notably the University of California, San Diego, California Institute of the Arts, and the University of California, Los Angeles.

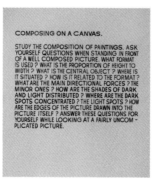

The Museum of Contemporary Art San Diego has a special relationship with Baldessari. In 1960, when it was known as the La Jolla Art Center, it gave the artist his first exhibition. Furthermore, the museum owns several important works by Baldessari and has mounted a number of shows that prominently featured his work, including the 2012 exhibition *John Baldessari: A Print Retrospective from the Collections of Jordan D. Schnitzer and His*

Family Foundation.[5]

Composing on a Canvas is from a series of works in which text becomes the image. The basic questions listed here break down the art-making process into simple methods. Specifically, the text takes a humorous approach to traditional ways of conceiving and interpreting a painting. Baldessari's ability to embrace humor in his work is a common thread across much of his artistic production. He thinks carefully about syntax and puns when using text. Moreover, his delin-

eation of the process of thinking through essential ways of creating a canvas makes the work an excellent contribution to the forms section of *Behold, America!* Although text is the dominant visual component in *Composing on a Canvas,* the artist has often managed to meld figural and narrative art with a conceptual approach. The Museum of Contemporary Art San Diego has a closely related painting by Baldessari in its permanent collection, *Terms Most Useful in Describing Creative Works of Art* (1966–68).

5. Thomas Hart Benton (1889–1975), *After Many Days*, 1940

Tempera and oil on canvas board, 31⅛ × 21⅛ inches. Museum purchase through the Earle W. Grant Acquisition Fund, 1975.3, The San Diego Museum of Art

Thomas Hart Benton hailed from Missouri and found the heartland of the United States to be his greatest source of inspiration. He studied in Europe and worked in New York, but he grew tired of the New York art scene's increasing interest in abstraction and rejection of his figural work. Benton became a leading voice advocating regionalism, in which artists focused on figural representations that documented daily experience. Other prominent artists associated with regionalism include Grant Wood (1891–1942) and John Steuart Curry (1897–1946). The style was popular in the United States during the 1930s and 1940s, and Benton was successful as a muralist both in New York and across the Midwest.

Benton often created images of the American landscape that reinforce the notion of land as a source of fertility, but *After Many Days* expresses age and even death—the leaves are wilted and a skull figures prominently in the composition. He created a similar composition, *After Many Springs* (ca. 1940; Collection of the Thomas Hart Benton Estate), before he attempted *After Many Days*. Benton wrote, "They were executed, one after the other in the same year, winter of 1940–41. The second is an enrichment of

the first. Compositionally they are almost identical."[6] He explained the inspiration for the paintings: "On a 1939 fishing float on the Whale River in the Ozarks one of the guides told this story. A farmer cutting brush out of the edge of his field found a human skeleton near the head of which was a rusted pistol (revolver of early vintage). The skeleton was never identified. As its discovery was made in the spring I called the imaginative picture of the story *After Many Springs*."[7]

After Many Days was shown at the 1940–41 Annual Exhibition of Contemporary American Painting at the Whitney Museum of American Art. The painting's autumn setting made it different from its predecessor *After Many Springs,* although both works imply the passage of time through the seasons mentioned in their titles and the presence of a skull. In describing the choices he made for *After Many Days,* Benton wrote, "There is no particular story about [the] painting. Perhaps it was affected by some unconscious memory of the story I told about the other picture. Anyhow it is a skull in a setting of autumn weeds which were growing on the edge of our garden here. I suppose I put the horses in it to give it a larger and more animate setting."[8]

6. Hans Burkhardt (1904–1994), *Signs of Our Times*, 1966

Oil on canvas, 50 × 60 inches. Gift of Dr. and Mrs. Alan Leslie, 1969.77, The San Diego Museum of Art

Hans Burkhardt was born in Basel, Switzerland and came to New York in 1924. He shared a studio with Arshile Gorky (1904–1948) from 1928 to 1937 and knew Willem de Kooning (1904–1997) well. Burkhardt's

works from this period share an aesthetic vision with those of Gorky and the Chilean painter Roberto Matta (1911–2002), who was also in New York around this time. During these years, Burkhardt began to develop

his own distinctive approach to abstraction through his rigorous use of paint.

Burkhardt moved to Los Angeles in 1937 and found early success. He had a solo exhibition at the Stendahl Gallery in 1939 and at the Los Angeles County Museum of Art in 1945. Beyond making his own work in Los Angeles, Burkhardt inspired several generations of students. He taught at a number of institutions and became a full professor at California State University, Northridge, from which he retired in 1972. He was the primary representative of abstract expressionism on the West Coast.

Burkhardt's 1968 solo exhibition at The San Diego Museum of Art marked a historic moment, as the show presented paintings the artist had created in protest of the Vietnam War. His longtime friend and art dealer Jack Rutberg wrote, "In contrast to the artists of L.A.'s 'cool school,' Burkhardt's work was passionate and painterly, reflecting the '60s with the same range of emotion and fervor that marked that remarkable decade."[9] Burkhardt later recounted how amazing it was to attend the opening reception in San Diego, a military town, with both hippies and military personnel in the galleries during the height of the Vietnam War.[10]

Signs of Our Times is from a series of works that reference the Vietnam War. From the 1930s, when he painted work in response to the Spanish Civil War (1936–39), to his final painting of the American flag with an extra stripe, staunch objection to war and strong political sentiments were typical of his work. For Burkhardt, in his last completed work, the extra stripe symbolized hope.

7. Alexander Calder (1898–1976), *Beastly Beestinger*, 1968

Steel and wire, 5 × 27⅞ × 18 inches (mobile), 15 × 13¼ × 14¼ inches (base). Gift of Mr. and Mrs. Norton S. Walbridge, 1991.10, The San Diego Museum of Art

Alexander Calder's work is widely recognized, and his large-scale sculptures are currently on view in a number of public locations. At the time he created *Beastly Beestinger*, a smaller, more intimate construction, Calder took a strong stance against the Vietnam War.[11] Moreover, two of his large-scale works were installed in prominent locations. The artist changed the name of his *Object in Five Planes* (1965) to *Peace* and donated it to the U.S. delegation at the United Nations Headquarters in New York. Furthermore, at the University of California, Berkeley, his *Hawk for Peace* (1968) was installed at the Berkeley Art Museum.

Beastly Beestinger references the artist's widely popular mobiles, as the top of the piece is movable and reflects the artist's interest in kinetic art. The base of the work takes a whimsical shape, with its one wide, curved piece and two more angular, narrow legs. Calder's reverence for simplicity in form and his preference for basic colors—here, red, white, and black—are evident in the work.

While most known for his sculptures, Calder was also a printmaker, painter, and jewelry designer. He studied early on with John Sloan (1871–1951) at the Art Students League, but time in Europe under the influence of Joán Miró (1893–1983) and exposure to the work of artists such as Paul Klee (1879–1940) and Piet Mondrian (1872–1944) defined his interests in abstraction. More broadly, Calder's work includes influences of surrealism and constructivism. Calder divided his time between the United States and Europe. Rather poignantly, he once stated, "I don't have much patriotism. . . . There's nothing to be patriotic about. Trying to get your country to do what you think is right, that's what I would consider patriotism."[12]

8. Emil Carlsen (1853–1932), *Thanksgiving Still life*, 1891

Oil on canvas, 46 × 42 inches. Gift of Mr. Melville Klauber in memory of his wife, Amy Salz Klauber, 1928.80, The San Diego Museum of Art

Melville Klauber donated this painting to The San Diego Museum of Art in honor of his wife, Amy, who had studied with Emil Carlsen. After looking around the country for an excellent example of Carlsen's work for San Diego, Klauber settled on a picture in the collection of William L. Carrigan, a longtime friend of the artist's. Carrigan had the work in his possession for thirty-four years, nearly its entire life span, before he agreed to sell it to Klauber.

Reginald Poland, director of the Fine Arts Gallery of San Diego (now The San Diego Museum of Art) when the painting was acquired, described the painting in the local paper: "This canvas represents a couple of turkeys, a ruddy pottery water-jug, a little copper pitcher, a much smoked kettle, a handful of onions, and a fisherman's net. It sounds like an unusual combination; in the hand of the great master, however it assumes proportions of greatness and rare beauty. The artist, to our way of thinking, is the leading still-life painter in this country today."[13] Just one day after his article was published, Poland wrote to Klauber, reiterating that "this picture is as important as any we have in the American department, that it is a highly representative, important and beautiful example of this great painter's work and that, to my way of thinking, Emil Carlsen is the greatest painter of still-life in the country in the permanent collection of The San Diego Museum of Art."[14]

The reference to the American holiday in the painting's title makes Carlsen's work an important contribution to *Behold, America!* When *Thanksgiving Still life* entered the collection, it was greeted with fanfare, and this appreciation was not quickly forgotten. The painting was exhibited in the important California-Pacific International Exposition at the Palace of Fine Arts, San Diego, from May to November of 1935.

9. Stuart Davis (1892–1964), *Composition with Boats*, 1932

Oil on canvas, 20 × 22 inches. Gift of Mrs. Edith B. Halpert, 1941.82, The San Diego Museum of Art

Stuart Davis developed his own interpretation of modernism and translated cubism and abstraction into distinct canvases. He grew up in Philadelphia and, through his father, the art director of the *Philadelphia Press,* became aware of artists such as Robert Henri (1865–1929) and John Sloan (1871–1951). Davis studied at Henri's school in New York from 1909 to 1912 and developed a friendship with Sloan, who was his teacher. New York became an important site for his creative advancement. He exhibited five works in the Armory Show in 1913 and participated in the first biennial at the Whitney Museum of American Art in 1932. Davis finally traveled to Paris in 1928, much later than many of his contemporaries, and was greatly influenced by Pablo Picasso's minimal line drawings of studio space (1927–29).

The outlined and overlapping forms in *Composition with Boats* share formal qualities with Davis's *Landscape* (1932–35; Brooklyn Museum of Art). Both works have a sense of flatness in terms of dimension, but in terms of movement, there appears to be kinetic activity in the looping lines that delineate the shoreline of Gloucester, Massachusetts, which the artist depicted in skeletal sketches in 1932. During the summer months, Gloucester was a site of interest for a number of painters, including William Glackens (1870–1938) and Edward Hopper (1882–1967). Davis's *Composition with Boats* was derived from an ink drawing of similar size and is a rare case of the artist copying a drawing onto a canvas, with color appearing only in the realized painting.[15]

10. Manierre Dawson (1887–1969), *Observation*, 1913

Oil on panel, 18 × 22 inches. Museum purchase with funds provided by the Leona G. Landberge Bequest, 2001.7, The San Diego Museum of Art

Manierre Dawson's abstract works are unusual for American artists of the early twentieth century. For example, in the same year that Dawson created *Observation,* Morgan Russell (1886–1953), who was living in Paris and working closely with Stanton MacDonald Wright (1890–1973), completed his work, *Synchromy with Nude in Yellow,* which is also included in this exhibition. Dawson's abstraction was different from that of his American contemporaries because it was not developed in Europe, and the artist did not train in New York. Instead, his interest in abstraction was a product of his education in Chicago, a city in the Midwest considered to be distant from avant-garde trends in the opening decades of the twentieth century. While the ingenuity of artists working in Chicago during the first half of the twentieth century has not received adequate recognition, Dawson's works stand out from those of his contemporaries in the Midwest and across the United States.[16]

Dawson studied engineering at the Armour Institute of Technology (later the Illinois Institute of Technology) and, upon graduation, found work at the architectural firm of Holabird and Roche. His technical background led to his experiments in abstraction. Dawson first traveled to Europe in 1910. There, he met Gertrude Stein, who purchased one of his paintings, marking the artist's first official sale.[17] Although he was unable to accept an invitation from Arthur B. Davies (1863–1928) to participate in the Armory Show, he did present one work at the Chicago version.[18]

A year after Dawson painted *Observation,* he made a major life change and moved to Ludington, Michigan, to pursue farming. Although he still found time for his art while meeting the demands of this new profession and fulfilling his responsibility to support his family, he had less time to paint, and his artistic output was much reduced.[19]

11. Tara Donovan (b. 1969), *Untitled (pins)*, 2004

Nickel-plated steel pins held together by gravity and friction, 46 × 46 × 46 inches. Museum purchase, International and Contemporary Collectors Funds, in honor of Dr. Mary Bear (1916–2005), 2005.11, Museum of Contemporary Art San Diego

In 2009, the Museum of Contemporary Art San Diego held an enormously popular exhibition of the work of Tara Donovan, organized by the Institute of Contemporary Art/Boston. It included many works composed of nontraditional materials such as drinking straws, Styrofoam cups, and Scotch tape. Donovan began experimenting with nontraditional materials in the mid-1990s, when she was inspired to think about the potential of mundane materials after dropping toothpicks on the floor.[20] By repurposing fixtures of domestic life, Donovan appeals to viewers' familiarity with the objects and simultaneously stirs their imaginations.

Donovan's works express a sense of density through their multitude of individual components. Moreover, *Untitled (pins)* presents a controlled mess, as the pins appear unruly save for the rigid and geometric form in which they are held by gravity and friction. While many of the artist's sculptures express biomorphic forms, this work presents the defined geometric space of a cube. It is evocative of minimalist works by Sol LeWitt, such as *Floor Piece #4* (1976; cat. 27), and emblematic pieces by John McCracken, such as *Blue Block in Three Parts* (1966; cat. 33), both of which are in the permanent collection of the Museum of Contemporary Art San Diego and included in *Behold, America!*

12. Arthur Dove (1880–1946), *Formation I*, 1943

Oil and wax emulsion on canvas, 25 × 35 inches. Purchased with Helen M. Towle Bequest Fund, 1972.189, The San Diego Museum of Art

After graduating from Cornell University, Arthur Dove moved to New York City in 1903. A trip to Europe and meeting Alfred Stieglitz (1864–1946) in New York were formative experiences in the development of his career. In 1910, he decided to abandon representational art and pursue abstraction, a daring move for an American or, really, any Western artist at that time. Dove married another important American abstract painter, Helen Torr (1886–1967), whom he affectionately called "Reds." His first retrospective took place at the Phillips Collection in Washington, D.C. in 1937.

Dove's *Formation I* was preceded by a small study, in oil and gouache on cream woven paper, dated July 16, 1942, *Abstraction* (Wichita Art Museum), in which the artist figured out the arrangement of the shapes and other aspects of the final piece. Leading up to the creation of *Formation I,* Dove experimented quite readily with the possibilities of watercolor in his abstract compositions. As Debra Bricker Balken observes, "The fluidity of the watercolor process anticipated the immediacy and formal reduction of natural elements in his later paintings, such as *Formation I* and *High Noon*."[21] He worked on this painting and others while recovering from illness.

From 1942 to 1944, Dove played with different materials, including wax emulsion, and a number of institutions such as the Phillips Collection and the Philadelphia Museum of Art possess works from this productive and experimental period. Charles C. Eldredge wrote of these works, "During the productive summer of 1942, however, these hard-edged abstractions were balanced by persistent use of the organic motifs of his early years."[22] The presence of both strong lines and organic shapes in *Formation I* contributes to its intensity and its significance in the artist's oeuvre. This painting demonstrates Dove's distinctive signature in the middle of the lower edge of the painting as opposed to the lower right or left corner. The purchase of this painting by The San Diego Museum of Art was considered a newsworthy event.[23]

13. Dan Flavin (1933–1996), *Untitled (to Marianne)*, 1970

Fluorescent lights and fixture, edition 2 of 5, 25 × 35 inches. Gift of Leo Castelli Gallery, New York, 1979.8, Museum of Contemporary Art San Diego

Dan Flavin activates spaces with his signature fluorescent tube sculptures. The artist began using the commercial material in 1963. Flavin created many singular sculptures, like *Untitled (to Marianne),* but he also created installations, such as the large-scale project for the Menil Collection in an old grocery store, which he was in the process of completing at the time of his death. The name in the title refers to Marianne Barcelona, who worked at Leo Castelli Gallery when Flavin's works were shown there in 1970.[24] He drew a design for another Marianne sculpture that consisted of an eight-foot square situated in a corner using the same color order as this work, but the piece was never realized. The artist sketched his ideas in his studio, which functioned more like an office space than the traditionally conceived artist's studio, and he typically fabricated his work on-site.

In many ways, Flavin's sculptures were a product of the time in which they were created, both from a political and an art historical context. As Tiffany Bell explains:

In a related way, the work could be said to engender a political statement that paralleled the challenges to authority and social structures so prevalent in the student demonstrations and protest marches of the 1960s and as a commercial product available in only standard sizes and colors, fluorescent lights offered a preset system of form

and color that was infinitely variable and adaptable. The system defied the tenets of Abstract Expressionism endorsed by much of the preceding generation of artists; although Flavin's art is easily identifiable as *by* Flavin, it rejects the individualized hand-marked character of gestural painting and sculpture.[25]

At a time when artists were developing their own abstract mediations, distinctly different from the strategies implemented by the previous generation of abstract expressionists, Flavin developed a body of work that was sensitive not only to form but also to environment, meaning the space in which his forms could exist. Furthermore, his version of abstraction elicits an ethereal response through the light that emanates from the tubes.

Flavin created many works in honor of individuals—as a way of cataloging his sculptures—but the forms themselves were often related to those to whom they were dedicated. He dedicated other works to artists Ken Price (1935–2012), DeWain Valentine (b. 1936), and gallery owner Leo Castelli and also dedicated a number of works to the Russian artist Vladimir Tatlin (1885–1953). Flavin moved minimalism in a new direction with his fluorescent light tubes. Perhaps no other artist has created more work with repurposed fluorescent lights. More recently, Robert Irwin (b. 1928) has experimented with the medium as did Bruce Nauman (b. 1941).

14. Helen Frankenthaler (1928–2011), *Five Color Space*, 1966

Acrylic on canvas, 112¾ × 73⅝ inches. Gift of Mrs. Jack M. Farris, 1999.30, Museum of Contemporary Art San Diego

Early on, Helen Frankenthaler was exposed to the work and teaching of artists of great significance. She learned from Rufino Tamayo (1899–1991) at the Dalton School in New York, and later she studied under Hans Hofmann (1880–1966) briefly at his school in Provincetown, Massachusetts. In New York she knew the critic Clement Greenberg, and he proved to be an influential supporter of her work. She received her first solo show in 1951, and she became a leading figure in the large-scale abstraction practiced readily by abstract expressionists and color-field painters in the 1950s and 1960s.

Frankenthaler tended to thin paint and then pour it on to unprimed canvas to establish a soak-stain approach as evidenced here by *Five Color Space* (1966).

Frankenthaler's method was in opposition to the use of a paintbrush to apply the paint directly to the canvas, a practice that was also embraced by other abstract painters including Morris Louis (1912–1962) and Kenneth Noland (1924–2010). Frankenthaler was a second-generation abstract-expressionist painter. She developed her particular approach to abstraction in the years following the trailblazing path set forth by Jackson Pollock (1912–1956) and Willem de Kooning (1904–1997). Coincidently, the second-generation of abstract painters active in New York included several important women painters such as Mary Abbott (b. 1921), Elaine de Kooning (1920–1989), Grace Hartigan (1922–2008), Joan Mitchell (1925–1992), and Janet Sobel (1894–1968).

15–17. Sam Gilliam (b. 1933), *Dance Me, Dance You 1*, 2009; *Dance Me, Dance You 2*, 2009; *Dance Me, Dance You 3*, 2009

Acrylic on polyester, each 52 × 42 × 35 inches. Museum purchases, International Contemporary Collectors Fund, funds provided by Joan and Irwin Jacobs and a partial donation by Sam Gilliam and Carl Solway, 2011.49, 2011.64, 2011.65, Museum of Contemporary Art San Diego

Sam Gilliam's paintings *Dance Me, Dance You 1; Dance Me, Dance You 2;* and *Dance Me, Dance You 3* are separate works, but when shown together, they create a lyrical and dynamic installation. Gilliam began making three-dimensional paintings in 1965. He explains, "It is constructed painting, in that it crosses the void between object and viewer, to be part of the space in front of the picture plane. It represents an act of pure passage. The surface is no longer the final plane of the work. It is instead the beginning of an advance into the theater of life."[26]

These three brightly painted works look like they have been dipped in paint cans. Suspended from the ceiling, they convey a light, ethereal feeling. If compared to the painting *Five Color Space* (1966; cat. 14) by Helen Frankenthaler (1928–2011), also in *Behold, America!,* Gilliam's works appear to be color-field paintings in three dimensions. Acquired by the Museum of Contemporary Art San Diego in 2011, these paintings are the most recent work in *Behold, America!* As such, they are a testament to the museum's rigorous collecting of new work by artists of significance.

18. Philip Guston (1913–1980), *Bottles*, 1977

Oil on canvas, 67 × 79½ inches. Gift from the estate of Mrs. Musa Guston, 1992.20, Museum of Contemporary Art San Diego

Born Philip Goldstein in Montreal, Philip Guston arrived in Los Angeles in 1919 and had his first solo show at Stanley Rose Gallery in 1931. In Los Angeles, Guston met many artists who would prove influential, including Jackson Pollock (1912–1956), Lorser Feitelson (1898–1978), and Reuben Kadish (1913–1992). Guston demonstrated an interest in Mexican muralism, traveling to Mexico and visiting murals created by José Clemente Orozco (1883–1949) and David Alfaro Siqueiros (1896–1974) in Los Angeles. He worked with the Works Progress Administration's mural division. In 1935, Guston and Kadish created a mural, *The Struggle against War and Fascism,* for the Museo Regional Michoacano, Morelia.[27] Also in that year, they painted the mural *Progress of Life* for the City of Hope Foundation (now City of Hope Medical Center), in Duarte, California. The two artists demonstrated their response to Mexican muralism on both sides of the border.

In his early development as an artist, Guston pursued figural work but later turned to abstraction. During the 1950s and 1960s, he was widely hailed for his completely abstract compositions; the painterly appearance of his works aligned him with the style of the abstract expressionists and his former high school classmate Pollock. *Bottles* is emblematic of the artist's late work in which he returned to more representational compositions but retained his interest in abstraction. In the latter part of his career, Guston produced figural works, landscapes, and still lifes, such as the oil painting *The Street* (1977; Metropolitan Museum of Art), in which bottles also appear. Guston's ability to devote himself to figurative work, then to abstraction, and back to representational art, all the while creating extremely engaging and skillful paintings, makes him rare in the history of art.

19. William Harnett (1848–1892), *Merganser*, 1883

Oil on canvas, 34⅛ × 20½ inches. Gift of Gerald and Inez Grant Parker Foundation, 1972.185, The San Diego Museum of Art

After studying in Philadelphia and New York, William Harnett lived in Europe from 1880 to 1886, spending four of those years in Munich, where he was exposed to seventeenth-century still-life paintings by Dutch artists. While abroad, he produced a number of canvases depicting suspended game and hunting accoutrements, a type of work that became increasingly popular with local patrons. Harnett's move toward hunting imagery was a change from his earlier work, which portrayed still lifes and emphasized writing and smoking utensils. These paintings were precursors to his best-known work, *After the Hunt,* a series of four paintings in which he furthered the illusion of suspended game and other objects.

Merganser was commissioned as one of a pair of paintings for a dining room in the home of a Mr. Hastings of Munich.[28] The feathers on the duck's wings and one leg draw the viewer's eyes to the right-hand side of the canvas. The bird is lifeless, but its angled right foot gives it a sense of life. The companion piece to *Merganser* is *Mallard Drake Hanging* (1883; National Gallery of Canada, Ottawa).

The academies and critics favored paintings of historical events and scenes from literature, followed by portraiture and landscape images. Despite being historically undervalued, still lifes such as Harnett's paintings demonstrate great technical skill while also revealing domestic life through the depiction of popular foods. His canvases belong to the tradition of trompe l'oeil and appeared so real and natural that they often fooled the viewer.

20. Martin Johnson Heade (1819–1904), *The Magnolia Blossom*, 1888

Oil on canvas, 15⅛ × 24⅛ inches. Timken Museum of Art, Putnam Foundation Collection, 1965:001

Martin Johnson Heade was interested more in aesthetic appearance than in scientific documentation in his highly regarded still lifes. From 1866 to 1881, he traveled to many places with varied cultures and natural environments such as Brazil, British Columbia, Colombia, Jamaica, Nicaragua, and Panama as well as California and Florida. In Brazil, orchids and hummingbirds proved particularly inspiring. Despite his extensive travels, his main working space was located in the Tenth Street building in New York, where Frederic Edwin Church (1826–1900) and William Merritt Chase (1849–1916) also kept studios. After 1883, Heade lived in Saint Augustine, Florida, the oldest city in the United States, founded by Spanish colonists in 1565. The magnolia flower, as depicted here, appears in many of the still lifes he painted in Florida. Heade made a total of seventeen paintings and approximately five oil sketches of the magnolia.[29]

The lush velvet background of *The Magnolia Blossom* adds to the sense of texture in the painting. Heade used velvet, both red and different shades of blue, as a visual device in several of his late still lifes. Other similar works that depict a white magnolia blossom on a red velvet cloth are *A Magnolia on Red Velvet* (ca. 1885–95; collection of the Heinz Family) and *Magnoliae Grandiflorae* (1888; collection of the Ganz family). In the Timken's *Magnolia Blossom,* however, the way the velvet draping falls and reveals a neutral brown background on the left side creates a much more interesting composition. The beauty of the white flower and the purity implied by the color contradict the slightly wilting green leaves, which are presented with a meticulous attention to detail that further attests to the artist's technical abilities.

Heade was not only a still life painter; he also produced portraits and landscapes, including some landscapes with dramatic thunderstorms approaching.[30] While relatively unknown in the 1860s and 1880s, his work enjoyed a revival of interest during the 1940s, which corresponded with renewed interest in American art.

21. Robert Irwin (b. 1928), *untitled*, 1967

Sprayed lacquer on curved aluminum, depth 4 inches, diameter 60 inches. Gift of Mrs. Jack M. Farris, 2005.80, Museum of Contemporary Art San Diego

Shortly after he stopped painting, Robert Irwin began to experiment with making disks out of aluminum; later, he began to use acrylic materials. Stephanie Hanor described the artist's work in a 2011 exhibition catalogue: "Irwin's discs and columns epitomize an interest in new materials so sheer that they border on immaterial."[31] The installation of these works requires particular precision. The disk must be mounted 24⅜ inches from the wall with the gallery lights positioned according to the artist's instructions so as to create a dynamic reflection of the disk.

This work is emblematic of the light and space movement, which was loosely formed in the Los Angeles area during the 1960s. Light and space artists frequently incorporated artificial or natural light into their work, often sculptures or installations, and experimented with industrial materials. Irwin is one of the central figures in the light and space movement and was active with the pioneering Ferus Gallery in Los Angeles. He also participated in the 1971 exhibition *Transparency, Reflection, Light, Space* at the University of California, Los Angeles.

Through the Getty Center's 2011–12 initiative *Pacific Standard Time: Art in L.A. 1945–1980*, museums, galleries, and other arts institutions in Southern California collaborated on exhibitions and programs related to the birth of the Los Angeles art scene. This initiative stressed the significance of light and space artists, and the Museum of Contemporary Art San Diego created one of the most important exhibitions, *Phenomenal: California Light, Space, Surface,* curated by Robin Clark.[32]

22. Jasper Johns (b. 1930), *Light Bulb I*, 1958

Sculp-metal, 4½ × 6¾ × 4½ inches. Gift of Mrs. Jack M. Farris, 2005.81.1-2, Museum of Contemporary Art San Diego

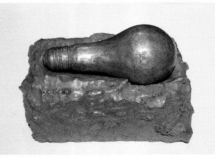

Jasper Johns, along with Ellsworth Kelly (b. 1923) and Frank Stella (b. 1936), is among the most important living artists whose dedication to paint defines an artistic generation and whose significance has been widely acknowledged by the art historical canon. Each of these artists, though known primarily as painters, has created sculpture. In fact, *Light Bulb I* is the first sculpture made by Johns.

In 2008, the Museum of Contemporary Art San Diego organized an exhibition focused on Johns's use of the lightbulb that included drawings, prints, other sculptures, and the lightbulb painting in the collection of The San Diego Museum of Art.[33] As the centerpiece of the exhibition, *Light Bulb I* makes for an interesting contradiction—an object that is inherently part of daily life portrayed with a faux metal, giving it a sense of permanence. In this and other works, the artist experimented with sculp-metal, a material that could be molded into a three-dimensional object or applied as a top layer onto an existing object. Johns was interested in lightbulbs as sculptures, but he also used sculp-metal to realize flashlights. Specifically, sculp-metal consists of aluminum powder mixed with vinyl and resin, and once it is applied and thoroughly dry, it can be polished to create a metallic sheen.

This seminal work was given to the museum, along with several other extraordinary pieces, by Carolyn Farris, a longtime La Jolla resident, whose tremendous generosity has given the Museum of Contemporary Art San Diego several encyclopedic works by the most significant artists of the twentieth century.

23. Jasper Johns (b. 1930), *Light Bulb*, 1969

Lead relief, 38¾ × 16⅞ inches. Gift of Mr. and Mrs. Norton S. Walbridge, 1991.14, The San Diego Museum of Art

Jasper Johns is noted for his dedicated exploration of iconic objects such as the American flag and targets. Color has often been a way in which the artist communicates, and, most noticeably, Johns has pursued the color gray with ardent dedication. Curator James Rondeau writes, "Gray exists in Johns' work not just as color, but also as idea, condition, and material—a thing in and of itself."[34] His first large gray painting is *Gray Alphabets* (1956), currently in the Menil Collection, Houston.[35] Despite his frequent use of gray, Johns avoids explaining this use implicitly. "I don't know, I don't really often think about gray. I mean, I work with it, and I guess that's a form of thought, but I don't have particular ideas about it that can be separated from the work."[36] Johns is certainly not alone in his interest in gray. Painters such as James Abbott McNeill Whistler (1834–1903) and Cy Twombly (1928–2011) made gray an essential part of their oeuvres.

In this work, Johns isolates the lightbulb, which hangs from a long electrical cord connected to a light fixture. The slight waviness to the cord conveys a sense of movement and adds to the painting's overall allure. One of the advantages of *Behold, America!* is the opportunity to bring together objects by the same artist that are in different collections. Considered together, these two Johns works, *Light Bulb* and the Museum of Contemporary Art San Diego's *Light Bulb I,* offer a rich viewing experience and a further understanding of the artist's development.

24. Eastman Johnson (1824–1906), *In the Hayloft*, ca. 1878

Oil on canvas, 26½ × 33 inches. Gift of Mrs. Herbert S. Darlington, 1935.54, The San Diego Museum of Art

Eastman Johnson was a successful painter, and his pictures garnered widespread praise during his lifetime. Early on, he painted the portraits of a number of well-known Americans such as Dolley Madison, John Quincy Adams, Henry Wadsworth Longfellow, and Ralph Waldo Emerson. Eventually, Johnson moved beyond portraits and turned his attention to genre paintings, at times taking a romantic approach in his attempts to capture the spirit of nineteenth-century America.

While *In the Hayloft* could easily have been included in the figures section, given the children who populate the scene, in particular, the central girl, whose striking profile draws attention as she stretches out an arm for balance, it has been placed in the forms section because the central element in the composition is a structural beam in the barn's hayloft. This beam serves a more diversionary role as a play space for a group of young children. Such scenes inspired several works by the artist. In the lower right corner of the painting, a younger child observes the more rambunctious and venturesome children. Brown and amber hues, like those represented here, are typical of Johnson's work.

Patricia Hills, an expert on Johnson's work, writes, "Children were greatly sentimentalized in nineteenth-century art and literature, whether saintly little Evas or naughty Tom Sawyer. The charms of childhood were especially praised by a self-conscious America, a country that defined its self-image in terms used typically to describe children: youthful energy, unconventional daring, unspoiled naiveté, and moral goodness. This sentimentality can also be understood as having a practical aspect: healthy children were one of America's prized national products to be nurtured carefully in order to swell the ranks of its future citizenry."[37] In line with these concepts, Holly Pyne Connor of the Newark Museum organized *Angels and Tomboys: Girlhood in 19th-Century American Art,* a traveling exhibition and accompanying publication that debuts in the fall of 2012. This will be the first exhibition to examine in depth how young girls were

represented by nineteenth-century artists such as Johnson, William Merritt Chase (1849–1916), and Thomas Eakins (1844–1916).

25. Donald Judd (1928–1994), *Untitled*, 1972

Anodized aluminum, galvanized iron, 6⅛ × 110¾ × 6 inches. Gift of Lynn and Danah Fayman and Dr. Vance E. Kondon, 1976.1, Museum of Contemporary Art San Diego

Through the process of creating his sculptures, Donald Judd thought carefully about proportions in terms of both the size of the components of a given work and the empty space between objects. Judd was a painter until the early 1960s, and his sculpture evolved from his experimentation with abstract painting. For his sculpture, he was drawn to industrially sourced materials.

In this work, the artist presents a long, narrow aluminum bar with five galvanized iron rectangular or cube forms below. The empty spaces between the galvanized iron shapes and the open ends of the aluminum bar at the top allow the viewer to ponder the weight of the object and inspire thoughts on the potential of volume. Judd conceived of his sculptures, but assistants fabricated the works.

In 1971, Judd traveled to Marfa, Texas, and in 1973, he bought land on the site of a former military base and began creating art with assistance from the Dia Art Foundation. After disputes with Dia, he founded and transferred his works to the Chinati Foundation. Through Chinati, Judd sponsored works by John Chamberlain (1927–2011) and Dan Flavin (1933–1996), building a legacy for art in Marfa, which remains one of the most unusual places in which to appreciate world-class American art. He also contributed to the arts through the criticism he wrote, largely from 1959 to 1965, for a number of art journals, extolling contemporaries such as Claes Oldenburg (b. 1929) and Frank Stella (b. 1936).

26. Ellsworth Kelly (b. 1923), *Red Blue Green*, 1963

Oil on canvas, 83⅝ × 135⅞ inches. Gift of Dr. and Mrs. Jack M. Farris, 1978.3, Museum of Contemporary Art San Diego

Ellsworth Kelly was stationed in France during World War II and witnessed historic events at Normandy and Brittany. He also had the opportunity to visit Paris for the first time. After the war was over, he returned to Paris, where he lived from 1948 to 1954, and enrolled at the École des Beaux-Arts under the G.I. Bill. Kelly familiarized himself with French painters and sculptors. Although this work relates to the minimalist forms common among American artists working in the 1960s, *Red Blue Green* is also informed by the work of French artists Jean Arp (1886–1966) and Henri Matisse (1869–1954).

Kelly reduced his works to basic components such as color, line, and shape. His paintings were frequently inspired by subjects from the natural world, yet his realized canvases demonstrate how formal abstract qualities can become the subject. Kelly created similar works during this same period, for example, *Green Blue Red* (1963; private collection) and *Blue Green Red* (1963; Metropolitan Museum of Art). In *Red Blue Green,* the composition is dominated by a red rectangle and a blue oval that appear to float on a green background. Both the red and blue shapes are only partially visible. While Kelly was experimenting with these three colors, he also created a number of works that represent a color spectrum. Although the artist paints his works, he leaves no trace of the brush. Kelly is associated with large-scale paintings and has also completed a number of public commissions, such as *Curve XXII (I Will)* (1981; Lincoln Park, Chicago) and *Totem* (1986; Parc de la Creueta del Col, Barcelona).

27. Sol LeWitt (1928–2007), *Floor Piece #4*, 1976

Painted wood, 43¼ × 43¼ × 43¼ inches. Museum purchase, dedicated in 2011 in honor of Sebastian "Lefty" Adler (1932–2010), Director of the San Diego Museum of Contemporary Art from 1973 to 1983, 1978.4, Museum of Contemporary Art San Diego

Sol LeWitt was born in New Haven, Connecticut and received his BFA degree from Syracuse University, New York. After working as a graphic designer for *Seventeen* magazine and in the studio of I. M. Pei (b. 1917), he went on to become one of the most important artists of the second half of the twentieth century. LeWitt's ruminations on minimalism and conceptualism expressed in small and large sculptures, wall drawings, and paintings became iconic representations of the age. His work led trends in art during the 1960s and 1970s in New York, and in 1978, he was honored with a retrospective at the Museum of Modern Art in New York.

Floor Piece #4 is a spare, ordered sculpture. With the interior of the cube exposed, LeWitt reveals a structured interior informed by mathematical precision, although the crisscrossing of the inner beams creates a dizzying effect of lines and smaller cube forms. Here, as in many of his other sculptures, the artist experiments with volume and sequence.

In addition to creating art, LeWitt also wrote a number of important texts, including *Sentences on Conceptual Art* (1969), in which he compared conceptual artists to mystics.[38] His method of exposing the cube alludes to how systems work, but he emphasizes the power of the idea in his work as opposed to artistic craftsmanship. The grid that appears inside *Floor Piece #4* is not necessary for the cube to exist, but it is one defined way of thinking about geometry.

28. Roy Lichtenstein (1923–1997), *Mirror*, 1971

Oil and magna on canvas, 96 × 108 inches. Gift of Irving Blum and Museum purchase, 1978.1, Museum of Contemporary Art San Diego

Between 1969 and 1972, Roy Lichtenstein worked on some fifty different interpretations of the mirror, studying glass and furniture company catalogues for inspiration for this body of work. In this painting, the artist suggests the properties of a mirror that creates shadows and changes lights. This work exemplifies Lichtenstein's signature use of stenciled benday dots (named for Benjamin Day, a newspaper printer who invented the process) and flat primary colors. The arrangement of the dots implies transparency. The mirror has been a device in many important paintings, such as *Las Meninas* (1656; Museo del Prado) by Diego Velázquez (1599–1660) and *Bar at Folies-Bergère* (1882; Courtauld Institute of Art Gallery) by Edouard Manet (1832–1883). Throughout his career, Lichtenstein demonstrated a deep understanding of the art historical canon.

While Lichtenstein produced some wholly abstract compositions, such as *Mirror,* he is more recognized for figurative works that recall comics in their composition and emphasize narrative representation. Instead of humorous scenes, he was drawn to dramatic and romantic images. By producing the type of imagery found in the Sunday newspaper comic pages on large-scale canvases, Lichtenstein blurred the boundary between popular culture and traditional notions of what constitutes art in the museum space, making something permanent with an image that would otherwise be recycled or thrown away.

Lichtenstein is one of the great figures in the development of pop art. The Art Institute of Chicago organized his largest retrospective in the summer of 2012, and the accompanying catalogue offers new scholarship on this significant artist.[39]

29. Robert Mangold (b. 1937), *Two Squares within a Square and Two Triangles*, 1976

Acrylic paint and brown pencil on canvas, 84 × 231 inches. Museum purchase, 1977.6.1–3, Museum of Contemporary Art San Diego

Robert Mangold pursued his studies at the Cleveland Institute of Art and Yale University. After earning an MFA degree at Yale, he moved to New York and became part of the art scene on the Lower East Side. Mangold worked first as a guard at the Museum of Modern Art and then in the museum library. He interacted with many artists, including Sol LeWitt (1928–2007), and maintained a studio near the workspace of Eva Hesse (1936–1970).

The industrial landscape of New York had a significant influence on Mangold, and he produced work that referenced architectural fragments. Although he originally viewed pop art as a welcome change from abstract expressionism, he had a deep respect for the transcendental abstraction of Barnett Newman (1905–1970) and Mark Rothko (1903–1970). Mangold recounted: "There was a silliness in a lot of Pop Art and Kinetic Art of this time—art that moved, blinked, made sounds, was gaglike. I was not interested in any of that stuff; I wanted to make paintings that extended the kind of serious dialogue I saw in the work of Newman and Rothko, but the only way seemingly to do this was through a door that Pop Art opened."[40] His first solo exhibition, *Walls and Areas,* at the Fischbach Gallery in 1965, demonstrated his interest in the mingling of architecture and abstract, geometric forms.

In 1968, Mangold began working with acrylic paint, the medium he used in *Two Squares within a Square and Two Triangles.* The muted colors and economy of gesture, line, and form make this a typical work by the artist. Mangold offered this explanation of his color palette: "I used ordinary colours, colours taken from things, things whose colour we take for granted: paper-bag brown, cement grey, brick-red, manila-envelope yellow, etc."[41]

In 1974, the Museum of Contemporary Art San Diego honored the artist with a solo exhibition. During the 1970s, Mangold left New York for the Catskills and later moved to Washingtonville, New York, where he continues to reside.

30. Christian Marclay (b. 1955), *Telephones*, 1995

Video, Running time: 7 minutes, 30 seconds. Gift of the Suzanne Figi Latin American and Contemporary Art Fund, 2003.90, The San Diego Museum of Art

Christian Marclay combines irreverent popular culture with a deep, probing examination of human nature and emotion. *Telephones* brings together various clips of phones ringing and being answered in a logical narrative in which at times certain characters from disparate clips appear to be communicating with one another. Marclay chooses scenes with highly regarded actors such as Katharine Hepburn, Cary Grant, Jimmy Stewart, and Humphrey Bogart. Moments from more recent films such as *Mr. Mom* (1983) and *Sleepless in Seattle* (1993) are represented as well. The still presented here is taken from *Mr. Mom,* a scene in which Michael Keaton's character, Jack Butler, leans over to answer the phone while sitting on the couch.

The phone itself becomes the major protagonist in this video. Marclay offers several seductive images of phones. In just over two minutes, he focuses on different phones: old phones, newer phones, and phones that match their environments. He explains, "Telephone scenes are ubiquitous in films. It's a simple shot, cheap, based on a jump-cut edit, with which we are familiar and which we accept. For the viewer it seems normal to jump cut from one actor in one space to another in a completely different space, or from one film to another."[42] The emotional core of the piece revolves around how the characters react to the phone—some appear anxious when the phone rings, others want privacy. In a clip

from the romantic comedy *Jersey Girl,* Jami Gertz's character Toby leaps onto her bed in an excited rush in hopes of answering the phone. Sean Connery, with his characteristic sex appeal, leans over in bed to answer the phone, while Geena Davis greets her caller with a hilarious "What?" The piece resonates strongly with lovers of American film and makes no distinction between highbrow and lowbrow performances.

Marclay studied art in Switzerland and later in the United States, in New York and Boston. He cites punk, Vito Acconci (b. 1940), Joseph Beuys (1921–1986), and Dan Graham (b. 1942) as early influences.[43] He was deeply involved with the club scene in the East Village during the 1980s and gained recognition as an avant-garde DJ.[44] Marclay has produced other highly recognized works that, like *Telephones,* meld popular culture imagery and audio experience. His 2010 video *The Clock,* which has a running time of twenty-four hours, pulls various clips from film and television in which people comment on or look at (via a clock or watch) a specific hour of time.

31. John Marin (1870–1953), *Still-life and the Sea,* 1942

Oil on canvas, 14 × 18 inches. Museum purchase with funds provided by the Gerald and Inez Grant Parker Foundation, 1973.133, The San Diego Museum of Art

Born in Weehawken, New Jersey, John Marin grew up across from the city where he would become a highly regarded painter, largely due to the early support of Alfred Stieglitz (1864–1946) and later praise from figures such as Clement Greenberg. The sea was a major inspiration for Marin; in both watercolor and oil paint, the artist revealed an approach to painting water in which his application of paint mimicked the rhythm of waves.[45] Although he is most often associated with his iconic renderings of the Brooklyn Bridge, water was his most consistent inspiration. During the 1930s, Marin became increasingly interested in the sea and painted it more frequently.

Marin's trajectory was typical of many accomplished artists of the period, and he knew many prominent artists. He studied at the Pennsylvania Academy of the Fine Arts from 1899 to 1901 and lived in Paris from 1905 to 1910, becoming a founding member of the New Society of American Artists led by Edward Steichen (1879–1973). Other notable members of the Parisian group include Patrick Henry Bruce (1881–1936), Max Weber (1881–1961), and Alfred Maurer (1868–1932). Upon returning to New York, Marin was given his first solo exhibition at Stieglitz's trailblazing 291 gallery. Marin was a bridge from the abstraction promoted by artists such as Stuart Davis (1892–1964), Arthur Dove (1880–1946), and Georgia O'Keeffe (1887–1986) to the abstract expressionists Jackson Pollock (1912–1956) and Willem de Kooning (1904–1997). He preferred to paint outdoors and achieved an expressive form of abstraction that anticipated the next developments in American art.

By placing the still life before the water landscape in this painting, Marin creates a distinctive composition. In fact, the juxtaposition of still life and seascape causes this painting to stand out from the artist's highly recognizable depictions of water.

32. Agnes Martin (1912–2004), *Untitled*, 1962

Acrylic priming, graphite, and brass nails on canvas, 12 × 12 inches. Museum purchase, 1976.18, Museum of Contemporary Art San Diego

Born in Macklin, Saskatchewan, Canada, Agnes Martin developed her own particular response to mini-malism. Her work is influenced by a variety of beliefs, including Taoism, Buddhism, and her own Presbyte-rian upbringing. Noted gallerist Betty Parsons offered Martin a show at her space in 1957 but said she would have to relocate from New Mexico to New York. Martin agreed. She exhibited with Parsons and "found herself catapulted into a vanguard gallery that had featured artists, notably Jackson Pollock, Mark Rothko, Ad Reinhardt, and Barnett Newman, whose thinking and practices she would soon deeply absorb."[46] In particular, Martin developed a close rela-tionship with Reinhardt (1913–1967). During her first year in New York, Martin moved into the same build-ing as Ellsworth Kelly (b. 1923) on Coenties Slip in Manhattan.

By 1960, two years before creating this work, Mar-tin had begun to use the grid in her work, a defining attribute of her paintings. Before turning to a more minimal form of art informed by the grid, she was drawn to biomorphic shapes, much like Arshile Gorky (1904–1948).

A case could be made that Martin's grid format closes the circle on the Cubist contribution first realized by Mondrian's application of the grid device to nature as the path to the "spiritual enlightenment" of total abstraction. Martin's grid paintings and Mon-drian's early grid compositions have similar roots in a highly personal asceticism and "moral tenacity," a common source in metaphors from nature, and striking parallels in an imminent, formal heuristic process and its purely abstract resolution through absolute balance or equilib-rium of horizontals and verticals.[47]

Martin's grids were often constructed in spare for-mats. She became known for her use of graphite on canvas. Donald Judd wrote in *Arts Magazine* in March 1964, "There is a good painting by Agnes Martin. It is quiet and looks like graph paper."[48] With *Untitled*, the artist also incorporated brass nails in her work, giv-ing the piece another dimension of texture. The grid pattern, square format, and nails give the painting a sense of functioning like an object as opposed to a two-dimensional canvas. "Martin baited critics and refused to grant the interpretation reward of intention—much less to expose the actual details of her life—choosing instead to construct the Martin of subsequential rev-erential biography out of the New Age effluvia of a Zen that eschewed the ego and a modernist formalism that deflected questions of agency apart from their articu-lation in and as lines traced on a support."[49] In 1967, Martin relocated to Cuba, New Mexico and did not make art again until 1971.

33. John McCracken (1934–2011), *Blue Block in Three Parts*, 1966

Lacquer, polyester resin, fiberglass, plywood, 33 × 40 × 33 inches. Museum purchase with funds from Ansley I. Graham Trust, Los Angeles, 1996.25.1-3, Museum of Contemporary Art San Diego

Primarily, John McCracken created three specific types of sculpture: cubes, planks, and pyramids. He was often drawn to both primary and pastel col-ors. McCracken recalled, "I did realize that I wanted things that worked right and that had color energy and so forth. I always tried to be careful to not have color that distracted from form, but rather that added

to it or was part of it. Sometimes a sculpture is painted or some-thing with color and it seems like the color is added, and I wanted it to be a part of it."[50]

McCracken's sculptures, like the one depicted here, were made by pouring polyester pigment resin onto fiberglass-resined wood. Typically, his sculptures demonstrate an interest in reflective qualities, and

therefore he focuses on the surfaces of his works. Furthermore, he was greatly influenced by custom cars and the surfboard culture. McCracken is associated with the finish fetish movement in Southern California, a version of minimalism that emphasized smooth surfaces with a refined sheen. Other finish fetish artists include Larry Bell (b. 1939) and DeWain Valentine (b. 1936).

34. Georgia O'Keeffe (1887–1986), *Barn with Snow*, 1933

Oil on canvas, 16¼ × 28¼ inches. Gift of Mr. and Mrs. Norton S. Walbridge, 1976.215, The San Diego Museum of Art

In her many landscape paintings, Georgia O'Keeffe demonstrates sensitivity to capturing the aesthetics of a locale, a sense of local mood and atmosphere that persisted even as she demonstrated an economy of detail and a propensity for flat geometric forms. In New York City, for example, where she struggled with the urban setting, she created a masterful abstract response to the growing presence of skyscrapers. In New Mexico, she gleaned inspiration from the desert terrain and adobe architecture. Barns, too, were a frequent motif in her work, and *Barn with Snow* was motivated by her time in Lake George and a 1932 trip to the Gaspé region of Canada. O'Keeffe wrote, "I have been to Canada three times—very good country for painting—quite as good as New Mexico—but I miss the sun—it is better in that one never meets anyone one knows and I can't talk with anyone because they all speak French."[51]

Born in Sun Prairie, Wisconsin, O'Keeffe spent her formative years in a modest rural environment in relative isolation. The barns in the Gaspé region connected her to her past, but it was their formal qualities, their history, and their connection to the land itself that inspired her. Her emphasis on geometric planes in *Barn with Snow* reoccurs later in her approach to architecture in New Mexico. For O'Keeffe, there was a simplicity to both the barns and the adobe homes of the Southwest that resonated with her rejection of ornate detail and her focus on economy of line. The most important sticker on the back of the painting is from An American Place, one of Alfred Stieglitz's galleries. In addition to this sticker, O'Keeffe's initials appear twice on the back of the work; most notably, she wrote "OK" inside a hand-drawn star.

35. Georgia O'Keeffe (1887–1986), *The White Flower*, 1932

Oil on canvas, 29¾ × 39¾ inches. Gift of Mrs. Inez Grant Parker in memory of Earle W. Grant, 1971.12, The San Diego Museum of Art

Georgia O'Keeffe received early training from a number of important American artists. She studied with John Henry Vanderpoel (1857–1911) at the Art Institute of Chicago, F. Luis Mora (1874–1940) and William Merritt Chase (1849–1916) at the Art Students League, and Arthur Wesley Dow (1857–1922) at the Columbia University Teachers College. All of these figures were influential, but it was Alfred Stieglitz (1864–1946) who, after viewing O'Keeffe's work in 1916, began showing her art in his gallery spaces and promoted her talents for the rest of his life.

Despite the influence of many established artists, O'Keeffe was able to develop her own distinctive response to modernism, separating herself from her contemporaries through her focused study of the natural world and, specifically, the copious canvases in which she presented flowers. She often enlarged flowers, making a single bloom dominate the entire pictorial space. In *The White Flower*, O'Keeffe explores the beauty of nature and emphasizes formal qualities such as shape, color, and line.

The independence O'Keeffe exuded in her paintings was reflected in her creative practice as she refined her artistic process and kept to a consistent regime. She stretched and primed her own canvases, kept cardboard squares of her favorite colors, which

she typically used to select her color palette before beginning a work, and often visualized a work completely before she began painting.[52] She wore all black with an apron over her clothes and sat in front of her easel as opposed to standing.[53]

36. Claes Oldenburg (b. 1929), *Wedding Souvenir*, 1966

Cast plaster, plain edition of approximately 200 slices, 6 × 6⅝ × 2¼ inches. Anonymous Gift, 1986.41.1-2, Museum of Contemporary Art San Diego

37. Claes Oldenburg (b. 1929), *Alphabet/Good Humor*, 1975

Painted fiberglass, bronze base, edition 4 of 12, 36 × 20 × 11 inches. Gift of Lynn and Daynah Fayman and Museum purchase with matching funds from the National Endowment of the Arts, 1975.1, Museum of Contemporary Art San Diego

Claes Oldenburg was born in Stockholm, the son of a diplomat. He lived in Chicago from 1936 to 1956, with the exception of the four years when he attended Yale University. He initially pursued painting, and in 1956, he moved to New York. Although he worked in different media, he is known primarily as a sculptor. Several of his large-scale public sculptures have become icons of the American cultural landscape, for example, *Spoonbridge and Cherry* (1985–88), at the Minneapolis Sculpture Garden, across from the Walker Art Center, and *Lipstick (Ascending) on Caterpillar Tracks* (1969–74), at Yale University. In 1977, he married Coosje van Bruggen (1942–2009), and she became his collaborator.

Both *Alphabet/Good Humor* and *Wedding Souvenir* are ruminations on themes that the artist had been exploring for some time. Oldenburg developed an interest in depicting food, and especially desserts. He began with large, soft sculptures of food and gradually turned to more durable materials that retain an appearance of softness. He was inspired to sketch food and various kinds of merchandise by the displays in shops on New York's Lower East Side.[54] Oldenburg experimented with the Good Humor ice cream bar in his Mouse Museum, a work he developed over many years, in which he addressed obsession with collecting and museology practices with wit and irony.[55] One of the displays in the Mouse Museum presented two untouched Good Humor bars made of plastic and two melted bars, also made of plastic. In *Alphabet/Good Humor*, the sheer volume of the letters and the way in which they meld together and seem to drip evoke the properties of ice cream. The humorous and ironic qualities of the work are amplified by the contradiction of what is represented (ice cream) and the material used to depict it (fiberglass).

Oldenburg's *Wedding Souvenir* was commissioned for the wedding of James Elliot and Judith Algar on April 23, 1966. At the time, Elliot was a curator at the Los Angeles County Museum of Art. The wedding took place in Topanga Canyon, California, and other noted guests included Dennis Hopper (1936–2010) and Robert Rauschenberg (1925–2008). As gifts for the couple's guests, Oldenburg designed slices of cakes. He displayed them as single slices on plates, although they could have been assembled into a complete cake. Oldenburg, however, preferred to present the cake as he had originally envisioned it, as slices.[56] Although the exact number of slices is unknown, it is believed that there were 250 and that 72 were tinted on top with silver spray enamel. Many of the slices were stamped, and Oldenburg signed a few during the reception. Elliot had an extensive career, but among the achievements mentioned in his obituary was the commissioning of the Oldenburg cake slices.[57]

38. Rubén Ortiz-Torres (b. 1964), *Malcolm Mex Cap (La X en la frente)*, 1991

Ironed lettering on baseball cap, 7½ × 11 × 5 inches. Gift of Mr. and Mrs. Scott Youmans by exchange, 2001.6, Museum of Contemporary Art San Diego

39. Rubén Ortiz-Torres (b. 1964), *L.A. Rodney Kings (2nd version)*, 1993

Stitched lettering and design on baseball cap, 7½ × 11 × 5 inches. Gift of Mr. and Mrs. Scott Youmans by exchange, 2001.8, Museum of Contemporary Art San Diego

Rubén Ortiz-Torres works with a variety of media, including photography, sculpture, video, altered objects, and paint. His studio is located in a detached space in front of his home in the Echo Park neighborhood of Los Angeles. Traditionally associated with the city's Mexican American population, Echo Park has increasingly become popular among artists.

Baseball has been a major part of Ortiz-Torres's oeuvre, and the baseball caps depicted here are among his most recognizable works. These refashioned everyday objects have been included in a number of important exhibitions such as *The Interventionists: Art in the Social Sphere*, in 2004, at the Massachusetts Museum of Contemporary Art. Victor Zamudio-Taylor writes of the artist's approach: "Ortiz-Torres's ongoing exploration of the borderlands contested and shared by Mexico and the United States may be read as emphasizing an intermeshing of symbols, histories, and complex vernacular expressions that . . . point to webs of meaning."[58] With these caps, Ortiz-Torres intermeshes symbols and relates shared meanings and contested histories.

L.A. Rodney Kings (2nd version) begins with a cap that represents the Los Angeles Kings, a National Hockey League team often associated with the legendary player Wayne Gretzky. This particular cap, however, has been changed so that it references political unrest and a notorious incident in L.A. history. The name *Rodney* has been stitched above the word *Kings*, evoking the name of Rodney King, a man who was arrested and brutally beaten by L.A. policemen, and a representation of a police car has been added on the side of the cap. King's arrest and the accompanying police abuse were videotaped by an onlooker. This incident sparked protests that eventually became violent and caused the entire country to think about racism and police brutality.

The *Malcolm Mex Cap (La X en la frente)* takes an iconic "X" cap that represents civil rights activist Malcolm X (1925–1965), a figure whose rhetoric was often found controversial. The artist transforms the cap so that it spells out the words *Mexico* on the front and *Malcolm Mex*. With these alterations, Ortiz-Torres suggests that the radical activism associated with the work of Malcolm X is also present and needed among Mexican Americans.[59]

40. Helen Pashgian (b. 1934), *untitled*, 1968–1969

Cast polyester resin, Diameter 8 inches. Museum purchase, International Contemporary Collectors Fund, 2011.50, Museum of Contemporary Art San Diego

Helen Pashgian began experimenting with resin sculptures in the early 1960s. She was born in Pasadena, California, received her undergraduate degree from Pomona College, California, and went to Boston University for graduate work. Subsequently, she settled in Los Angeles, and her work is closely associated with a group of artists working in the region who were informed by minimalism and interested in the potential of industrial materials and reflective surfaces.

Pashgian described her process in an interview with Robin Clark: "What is very tricky about these pieces, as opposed to a square or a

rectangle or some other geometric figure with hard edges, because we are working within a spherical shape, the colors within the material are very thin at one point and very thick at another. They can crack where they are thin—it is important to control humidity, it has to be dry and rather warm as this material only works within a certain temperature."[60] While many of her peers, such as DeWain Valentine (b. 1936), Larry Bell (b. 1939), and John McCracken (1934–2011), tend to create large-scale sculptures, in this piece, Pashgian demonstrates her ability to work on a more intimate scale. The temperamental materials require painstaking efforts, as Pashgian explained: "It can never become a liquid again, so if there is a crack or it is unpleasing to the artist or if there is a speck in it that you don't initially see, it is ruined and you have to start over."[61]

In *Behold, America!*, Pashgian's sphere is presented with light aimed at it from multiple points. The artist envisioned the work placed in front of a wall, as opposed to being presented completely in the round, with light hitting both the wall and object. In addition to spheres, Pashgian creates disks and wall-mounted panels.

41. Raphaelle Peale (1774–1825), *Cutlet and Vegetables*, 1816

Oil on panel, 18¼ × 24¼ inches. Timken Museum of Art, Putnam Foundation Collection, 2000:002

Raphaelle Peale's father, noted portrait artist Charles Willson Peale (1741–1827), encouraged his sons to be artists.[62] Moreover, by giving them such illustrious names—Raphaelle's brothers were Rembrandt (1778–1860), Rubens (1784–1865), and Titian (1799–1885)—he foretold their artistic futures. A number of women in the family also pursued painting, and a portrait by Raphaelle's cousin, Sarah Miriam Peale (1800–1885), is also included in *Behold, America!* Raphaelle Peale began making still lifes around 1810. Just after completing this painting, in 1817, he exhibited two still lifes at the Pennsylvania Academy of the Fine Arts. Though once considered an undistinguished artistic direction, still-life painting afforded artists an opportunity to expand preconceived notions about form.

Cutlet and Vegetables shares with *Still life with Peaches*, the other work by this artist included in *Behold, America!*, a horizontal structure and sedate background. The work differs in subject matter, however, and *Cutlet and Vegetables* has a simultaneously lush and raw feel through its presentation of sliced meat. Art historian Alexander Nemerov compared John Bell's anatomical drawing of an arm to the visceral flesh portrayed in Peale's *Cutlet and Vegetables*.[63] More broadly, he identified a growing interest in Philadelphia, beginning in 1812, in medical practices and the production of medical illustrations.[64] These relationships were likely influential for Peale. The vegetables in the painting are neatly arranged around the slab of meat. A sprig of parsley is delicately depicted in front of the meat, and behind the meat, light casts a glow on a head of lettuce. The asparagus that tilts to the left of the composition gives the work a sense of verticality despite the overall horizontal presentation.

42. Raphaelle Peale (1774–1825), *Still life with Peaches*, ca. 1816

Oil on panel, 13¼ × 20³⁄₁₆ inches. Museum purchase through the Earle W. Grant Acquisition Fund, 1981.38.3, The San Diego Museum of Art

Raphaelle Peale was born in Annapolis, Maryland but raised in Philadelphia. He preferred to paint still lifes even though he was an able portrait painter and portraits were more lucrative. In fact, Peale was one of the first American painters to make the still life the focus of his oeuvre. Over the course of many years, he returned intermittently to portraits, and his father, the well-known portrait painter Charles Willson Peale (1741–1827), maintained great hope for his economic success.

Around 1812, Peale began to turn to still lifes, as his ill health interfered with his ability to interact with sitters. By the early 1820s, he was devoted to still lifes. He rebelled against his father's artistic expectations and dealt with his physical impairments. There are fifty known still lifes by Peale, an estimated one-third of his total artistic production. Most portray fruit, particularly peaches, as in this work and two other paintings in the collection of The San Diego Museum of Art. The sense of anatomy in his still lifes augments his compositions. Here, the branches of the peach on the left might reference hungry fingers plucking a fruit from the display.[65] In his depiction of peaches, Peale often used vibrant orange and pink hues. Like this painting, his still lifes tend to emphasize the horizontal plane and exhibit an overall restraint. Peale was influenced by the works of sixteenth-century Dutch and Spanish still life painters, which were popular in Philadelphia, including those of Juan Sánchez-Cotán (1560–1627).

43. Agnes Pelton (1881–1961), *The Primal Wing*, 1933

Oil on canvas, 24 × 25 inches. Gift of the artist, 1934.12, The San Diego Museum of Art

Agnes Pelton was born in Stuttgart, Germany. Early in her career, she found success in the United States, on the East Coast, and her work was included in the Armory Show of 1913.[66] She came to California in the late 1920s and was inspired by the topography of the state. Pelton had two solo exhibitions at the Fine Arts Gallery, San Diego (now The San Diego Museum of Art), the first in 1934 and the second in 1943.

Over the years, she exchanged a number of letters with the painter Raymond Jonson (1891–1982), who appreciated her work. Both Pelton and Jonson were drawn to abstract renderings of light and its effects on landscape. Pelton preferred the twilight hours and often painted in the early morning or in the evenings after 6:00 p.m.[67] As a result of this time preference, cool blue hues often appear in her canvases, as in this work. Pelton was influenced by music and literature and often penned poems for her paintings. For *Primal Wing*, she wrote:

> In a dim world before its day
> Above the silent waters
> Self propelling, radiating

Behold the swift wing
Of Life awakening—
As the first blunt mountains rise.[68]

This painting was on view at the 1935 California-Pacific International Exposition in San Diego. On the stretcher bar, Pelton wrote "Cathedral City, California," the desert town where she was a long-time resident. In more recent decades, this work was included in significant exhibitions on twentieth-century art of California: *Ceci n'est pas le surrealism, California: Idioms of Surrealism* (Fisher Gallery at the University of Southern California, 1983) and *Turning the Tide: Early Los Angeles Modernists, 1928–1965* (Laguna Art Museum, 1998).[69] In 1995, Michael Zakian, then curator at the Palm Desert Museum, organized the most important retrospective of the artist's work, *Agnes Pelton: Poet of Nature*, and brought widespread attention to her extraordinary work.[70] Pelton has been considered in concert with her more well-known contemporary Georgia O'Keeffe. Recently, the Orange County Museum of Art mounted the 2009 exhibition *Illumination: The Paintings of Georgia O'Keeffe, Agnes Pelton, and Florence Pierce*, which placed the works of these highly regarded American artists side by side.[71]

44. John F. Peto (1854–1907), *In the Library*, 1900

Oil on canvas, 30 × 40 inches. Timken Museum of Art, Putnam Foundation Collection, 2000:001

John F. Peto was not well known during his lifetime. In fact, he spent much of his career unrecognized, although he consistently created work. Peto was born in Philadelphia and grew up in the care of his grandmother and her four unmarried sisters. He lived with the women until he was in his mid-twenties. In 1877, he enrolled at the Pennsylvania Academy of the Fine Arts, where Thomas Eakins (1844–1916) was a teacher. There, he met William Harnett (1848–1892), who was completing his studies just as Peto was beginning his own work at the renowned institution, and was greatly influenced by Harnett's trompe l'oeil compositions. Peto sold paintings to businessmen in Philadelphia who wanted to decorate their offices. After 1889, he lived primarily in Island Heights, New Jersey.

In the Library depicts the cluttered reality of a busy scholar. Many of Peto's compositions, like this painting, possess dark dramatic backgrounds and show careful attention to detail, with objects in the still lifes appearing dusty. The depiction of the piece of paper falling in front of the table is so naturalistic that viewers may feel that they could almost reach out and grab the page before it falls to the floor. By suggesting light movement, the casual folds of the tablecloth project realism more effectively than would sharp creases.

During the 1940s, there was increased interest in American art, as historians and collectors alike turned inward instead of toward Europe. Peto was among the American artists who benefited from this change in the direction of scholarship. Many of his unsigned works were thought to be paintings by Harnett until additional research in the mid-twentieth century revealed Peto's life and work. With strong examples of both artists' works in *Behold, America!*, readers and viewers alike will be able to understand the similarities and differences between these two talented American painters.

45. Martin Puryear (b. 1941), *Vault*, 1984

Wood, wire mesh, tar, 66 × 85 × 48 inches. Museum purchase, 1984.25, Museum of Contemporary Art San Diego

Martin Puryear's sculptures are placed directly on the floor rather than on a deck or a pedestal. As a result, his works, like *Vault*, activate the floor. Wood is a common medium for the artist, and it serves as a connection to the natural environment. The wire mesh sheath that covers the back of *Vault* augments its texture. This work does not have a recognizable shape; its strong forms represent an icon of sorts and conjure thoughts of various traditional types of carved sculpture. Unlike previous generations of minimalist artists, Puryear creates his sculptures with his own hands. His craftsmanship is so skilled that it forces the viewer to question whether or not the components of the piece are machine- or handmade.

Although he is formally trained, his early experiences with crafting furniture, guitars, and canoes inform his sculpture, and a year in Sierra Leone with the Peace Corps furthered his interest in African art. In 1977, a fire destroyed much of Puryear's work and possessions. He was able to overcome that tragedy and has channeled the event into his work, as the dark wood he uses in pieces like *Vault* suggests the effects of exposure to extreme heat and smoke.

46. Faith Ringgold (b. 1930), *Seven Passages to a Flight*, 1995

Hand-stitched quilt, 51 × 42¾ × ¾ inches. Museum purchase, 1995.73.b, The San Diego Museum of Art

47. Faith Ringgold (b. 1930), *Seven Passages to a Flight*, 1995

Etching, pochoir, 9½ × 7⅞ × ¾ inches. Museum purchase, 1995.73.a, The San Diego Museum of Art

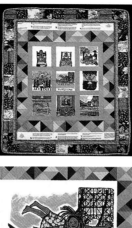

Seven Passages to a Flight

Faith Ringgold developed a distinctive art form by combining text and image to present personal and historical narratives that explore the African American experience. Ringgold learned about the African American tradition of quilts, which has been passed down through multiple generations of women, from her mother. This work consists of a quilt, with nine narrative squares that include imagery from earlier works, and a forty-two-page artist's book. The book is one of ten deluxe editions created in collaboration with the San Diego–based Brighton Press. Founded in 1985 by Bill Kelly, Brighton has worked with a number of significant artists on limited edition books.

Ringgold first made her story quilt, *Who's Afraid of Aunt Jemima?*, in 1985. Sometimes the stories told on her quilts are fictional; others are autobiographical; and occasionally they are a mixture of both. Ringgold commented about her work: "I was trying to say something, I was trying to use this, this African vision, but I was trying to tell an American story."[72] The central right square of *Seven Passages to a Flight* recalls *Tar Beach* (1988), the quilt that became the basis for Ringgold's first children's book. In *Tar Beach*, a young girl, Cassie Louise Lightfoot, escapes the summer heat in her apartment at an evening picnic with her family on the roof of their building. The central lower square of the quilt references Ringgold's *The French Collection* (1991–97), which presents the story of Willa Marie Simone, who leaves Harlem in the 1920s to seek artistic fulfillment in Paris.

Beyond the narrative, the amalgamation of colorful geometric shapes in Ringgold's *Seven Passages to a Flight* form a bold, almost dizzying pattern. The creation of a personal iconography is one of the quintessential aspects of American art in the later twentieth century, and in Ringgold's case, that iconography likewise examines a much broader cultural phenomenon.

48. Edward Ruscha (b. 1937), *Ace*, 1962

Oil on canvas, 71⅜ × 66 inches. Museum purchase in memory of Lois Person Osborn, 1986.28, Museum of Contemporary Art San Diego

A longtime resident of Los Angeles, Edward Ruscha has been a central figure in that city's art scene for many decades. He was born in Omaha, Nebraska and spent much of his formative years in Oklahoma City. In 1956, he moved to Los Angeles and attended the Chouinard Art Institute. While in art school, Ruscha painted in the style of the abstract expressionists, but he grew tired of this approach and found inspiration in graphic design, advertising, and commercial art. His early collages were influenced by popular culture and surrealism, and he began to combine texts from different sources with unexpected imagery. This approach led to his text-based paintings, enigmatic compositions that often elicit jarring responses.

In 1961, a year before creating this painting, Ruscha traveled extensively in Europe and completed a small oil sketch in Paris that appears to be a study for the later painting. In the sketch *Ace* (1961; private collection, formerly Robert Rauschenberg Foundation), the letters of the word "ace" are blue, but the background is a mustard yellow, instead of the painting's deep black, and the letters are lowercased and in the middle of the composition. The painting in the Museum of Contemporary Art San Diego has the uppercased word "ACE" at the top, where it suggests a newspaper headline; the placement also

results in a more enigmatic composition, as the sea of black below the letters resonates with mystery. Neal Benezra describes *Ace* and its closely related paintings as "brushy depictions of emphatic monosyllable words."[73] Certainly, this work has a painterly quality,

a method that the artist moved away from in later works. A year after he completed this painting, Ruscha had his first solo exhibition at the Ferus Gallery, the groundbreaking space founded by Walter Hopps (1932–2005) and Edward Kienholz (1927–1994).

49. Morgan Russell (1886–1953), *Synchromy with Nude in Yellow*, 1913

Oil on canvas, 39¼ × 31½ inches. Museum purchase through the Earle W. Grant Endowment Fund, 1973.22, The San Diego Museum of Art

Born in New York City in 1886, Morgan Russell studied at the Art Students League and the New York School of Art. After visiting Europe twice, he settled in Paris in 1909. In the French capital and art metropolis, he spent some time under the tutelage of Henri Matisse. He was also taken with the color palette of the fauvists. Russell and artist Stanton Macdonald-Wright (1890–1973) were friends and founded an artistic movement, Synchromism, while living in Paris. The word "synchromy" means "with color." Synchromism marked the first movement of abstraction founded by Americans. Both Russell and Macdonald-Wright pursued a bright and varied color palette and, in keeping with their movement, believed that variations in color hues implied shifts in volume. The first painting to be exhibited as a work of synchromism was Russell's *Synchromy in Green* (1912–13), which was shown at the Salon des Indépendants in Paris in 1913.[74]

Russell was deeply interested in sculpture, and many of his works reference those of Michelangelo

(1475–1564) and Auguste Rodin (1840–1917).[75] In fact, Russell was a sculptor before he was a painter. In *Synchromy with Nude in Yellow*, the artist portrays a still life within a lunette, demonstrating his ability to render work that blends the representational with pure abstraction. Behind the traditional fruits and books associated with still life representations, a partial sculpture of a man rests on a table.[76] Russell's early synchromist works, like this painting, maintain representational objects. The color palette here has much in common with that of his collaborator Macdonald-Wright but also shares the hues favored by French painters Robert Delaunay (1885–1941) and Sonia Delaunay (1885–1979).

Although Russell's paintings were rather avant-garde for their time, widespread analysis of his work did not come easily. The first retrospective of his work did not take place until 1990 at the Montclair Art Museum in New Jersey.[77]

50. Richard Serra (b. 1939), *Drawing for Documenta VI*, 1976

Oil paintstick on paper, 120 × 52⅛ inches. Museum purchase, 1977.1, Museum of Contemporary Art San Diego

Richard Serra's drawings and sculptures recall architectural forms. The title *Drawing for Documenta VI* refers to a respected and well-attended exhibition of modern and contemporary art, founded in 1955, that takes places every five years in Kassel, Germany. *Documenta VI* ran from June 24 to October 2, 1977.

In this large-scale minimal drawing, the angled lines at the top and right side of the shape make for an intoxicating composition. Serra's use of paintstick, an oil-based crayon, is typical of his work from

this period. The monumentality of the drawing alludes to the artist's propensity for enormous sculptures. He began making wall-sized abstractions in 1974.

In 1979, shortly after he completed *Drawing for Documenta VI*, Serra was commissioned by New York's General Services Administration to create what would become his most controversial project, *Titled Arc*, a sculpture intended for the city's Federal Plaza. The work was an awe-inspiring 120 feet long and was installed in 1981. After much community criticism,

public hearings, and lawsuits, the sculpture was removed in 1989.

Although Serra is known for his sculptures, new scholarship is developing about his significant drawings. The 2011 exhibition *Richard Serra Drawing: A Retrospective*, organized by the Menil Collection, in Houston, Texas, marked the first major survey of his drawings.[78]

51. Gary Simmons (b. 1964), *Gazebo*, 1997

Paint and chalk on panel, 120 × 240 × 2⅛ inches. Museum purchase, Contemporary Collectors Fund, 1997.2.1–1997.2.5, Museum of Contemporary Art San Diego

Gary Simmons was born in New York and studied at the School of the Visual Arts before moving to Los Angeles, where he attended graduate school at California Institute of the Arts. In Los Angeles, he achieved early success with his first gallery exhibition, at Roy Boyd Gallery, months before he received his MFA degree.[79] Simmons is known for his large-scale chalk drawings on surfaces that are similar to the traditional chalkboard found in school classrooms, although these materials are increasingly giving way to dry-erase boards. In this particular work, he references a type of architecture evocative of small towns throughout the United States, the gazebo.

Simmons's use of chalk and his evocation of the classroom chalkboard is similar to the broad, sweeping, democratic way in which Walt Whitman sought to engage the people. This piece was originally created live as an ephemeral work at the Museum of Contemporary Art's La Jolla space, and Simmons later created the piece depicted here for the Museum's collection.

Gazebo is a departure from earlier works in which Simmons replicated cartoon figures in order to make political commentary. In *Gazebo*, the architectural form appears fleeting in that it is drawn and then rubbed through, providing the viewer with an impression of the structure as opposed to a naturalistic rendering. The artist creates the chalk drawing and then partially destroys it through the use of big, athletic gestures. The buoyancy he applies is also expressed in Whitman poems such as "Song of the Exposition," which inspired the title of this book and the accompanying exhibition.

52. Tony Smith (1912–1981), *The Snake Is Out*, 1962

Bronze, edition 2 of 9, 17¾ × 25 × 14½ inches. Gift from the estate of George E. and Lois P. Osborn, 1990.17, Museum of Contemporary Art San Diego

Tony Smith was interested in painting, architecture, and sculpture, but he remains best known for his minimalist sculptures of the 1960s and early 1970s. His interest in architecture informed his other work. The designs of Le Corbusier (1887–1965) were a formative influence, and he studied at the New Bauhaus in Chicago with László Moholy-Nagy (1895–1946) and Alexander Archipenko (1887–1964). Robert Storr wrote of Smith: "For many people—including many artists—space is a void waiting to be filled. For Tony Smith this was only half true. Whether empty or occupied by form, space as Smith conceived it was always structured."[80] A larger version of *The Snake Is Out*, in painted steel, is located at the Nasher Sculpture Center, Dallas (1962, fabricated 1981).

Smith created sculptures based on two phrases from the short stories of John McNulty (1895–1956): "the snake is out" and "the elevens are up." McNulty was a reporter for the *New Yorker*. He spent a considerable amount of time at Costello's, a now defunct Irish pub on Third Avenue, which inspired the stories in *This Place on Third Avenue: The New York Stories*.[81] In his writing, the

phrase "the snake is out" refers to a vein that appears near a man's left temple when he has had too much to drink, and "the elevens are up" describes a more dire condition, indicated by two cords sticking out on the back of a man's neck, caused by years of heavy alcohol consumption.

53. Frank Stella (b. 1936), *Sinjerli I*, 1967

Fluorescent acrylic on canvas, diameter 120 inches. Gift of Mrs. Jack M. Farris, 1991.28, Museum of Contemporary Art San Diego

54. Frank Stella (b. 1936), *Flin Flon VIII*, 1970

Acrylic on canvas, 108 × 108 inches. Museum purchase, 1979.19, The San Diego Museum of Art

Frank Stella was born in Malden, Massachusetts, to first-generation Italian American parents. He was educated at Phillips Academy in Andover, Massachusetts, and Princeton University. Upon graduating from Princeton, Stella immersed himself in the New York City art scene. He arrived in New York at a time when abstract expressionism was on the decline and there was an opening for artists to make their art in a dramatic way. Stella met many fellow artists and hung out at the Cedar Tavern.[82] He has famously said of his art that "what you see is what you see," a statement so often repeated that it is both defining and limiting. Beyond what you see, Stella pioneered a distinctive form of abstraction that deftly weaves painting and sculpture and exhibits an architectural sensibility. He is one of the most significant living artists and the only living artist to have two retrospectives at the Museum of Modern Art in New York.

Stella makes the viewer aware of the vertical and horizontal edges of the canvas. Following a generation of abstract expressionist and color field painters, he and other abstract artists such as Donald Judd (1928–1994) set a new tone in American art by creating compositions that were not tied to spiritual meaning, a product of gestural painting, or oriented to pop culture. Stella encouraged viewers to look at the most basic elements in his work, such as color, line, and shape, as opposed to assigning esoteric and enigmatic meanings to it. His first paintings to gain widespread recognition used a primarily black color palette, but his large-scale compositions gradually became more colorful and he was drawn to irregularly shaped canvases.

Stella has often given his works titles that refer to specific geographic places. From the Middle East to Canada and small Polish villages, disparate places have become a part of his work. The local Del Mar Race Track was used in the artist's *Race Track Series*. Both paintings included in the exhibition, *Sinjerli I* and *Flin Flon VIII*, have specific place-names that relate to their actual forms. *Sinjerli I*, from the artist's *Protractor Series*, owes its title to an ancient Hittite city (the site is located in the south-central region of Turkey) with curved walls that form a circle. In creating *Sinjerli I*, Stella furthered his interest in nontraditional canvases. Just three years before completing this piece, his work was included in the important 1964 exhibition *The Shaped Canvas*, held at the Solomon R. Guggenheim Museum in New York. Art historian Frances Colpitt writes, "The shaped canvas, although frequently described as a hybrid of painting and sculpture, grew out of the issues of abstract painting and was evidence of the desire of painters to move into real space by rejecting behind-the-frame illusionism."[83] *Flin Flon VIII* relates to the artist's *Protractor Series*, as evidenced by the flurry of colorful angular shapes evocative of the small tool. The title of this painting comes from a small town located on the border of Saskatchewan and Manitoba, Canada. In this square canvas, Stella explored many of the ideas on the potential of form, color, and scale that he was experimenting with in his irregularly shaped canvases.

Stella continues to make work in his studio in upstate New York and to enjoy tremendous success. In 2011, he was feted with shows in London, Washington, D.C., and Berlin. A wide-ranging, startlingly innovative gallery show at Haunch of Venison in

London—encompassing large-scale sculpture, paintings, works on paper—included art that had never left his studio. In 2014, the Whitney Museum of American Art will host a retrospective of his work.

55. John Storrs (1885–1956), *Forms in Space*, 1923

Bronze, 21¼ × 12 × 3¾ inches. Gift of Mr. and Mrs. Norton S. Walbridge, 1977.147, The San Diego Museum of Art

Born and raised in Chicago, John Storrs studied briefly at the Art Institute of Chicago and continued his education at the School of the Museum of Fine Arts, Boston, and the Pennsylvania Academy of the Fine Arts. In Paris, he studied with Auguste Rodin (1840–1917) and met many important artists of the day, including his fellow American and sculptor Alexander Calder (1898–1976). Storrs's father, an architect and real estate developer, stipulated in his will that his son should remain in Chicago eight months out of the year, but Storrs was drawn to Europe and often resided in France, forgoing the majority of his inheritance. Although he was deeply infatuated with France, he continued to be influenced by two architects who made the biggest impact on the city of his birth, Louis Sullivan (1856–1924) and Frank Lloyd Wright (1867–1959).

Storrs's works, like the piece depicted here, are often minimal and possess strong geometric shapes. His sculptures of the 1920s and 1930s demonstrate the influence of skyscrapers and urban construction. Around the time he produced *Forms in Space*, Storrs began a series of sculptures with the same title produced in different media.[84] His work was an amalgamation of American and European influences, and he was interested in cubism, futurism, and constructivism. Moreover, many of his sculptures, including this one, anticipate the widespread impact of art deco among American architects and sculptors. Here, he demonstrates a dedication to formal abstraction but also exhibits the elegance that so defined art deco. While he is known for his sculptures and is considered to be the first American sculptor to devote himself to abstraction, he began pursuing painting more seriously in the early 1930s.

Although the beginning of his career afforded him many brilliant opportunities, the final years of his life were rather difficult. During World War II, he was detained and imprisoned for six months during 1941 and 1942 and was arrested again in 1944. Upon release, he favored more figural compositions, and his early notoriety and frequent commissions and exhibitions diminished. Moreover, the emotional impact of imprisonment affected his artistic production.

56. Donald Sultan (b. 1951), *Yellow Iris Smoke Stack*, 1981

Tar, plaster, and oil on vinyl-asbestos tile on Masonite, 97¾ × 49½ inches. Museum purchase, 1983.4.1-2, Museum of Contemporary Art San Diego

Donald Sultan received an MFA degree from the School of the Art Institute of Chicago and moved to New York in the mid-1970s. He gained considerable recognition through his participation in the 1979 Whitney Biennial. His mature work combines the influences of pop art and minimalism. Sultan created a number of highly recognizable paintings of flowers and also used imagery as diverse as lemons and steer in his works.

The smokestack portrayed here is also a reoccurring element in the artist's work. By isolating this familiar, multifaceted image that can symbolize the urban milieu, industry, the plight of laborers, and environmental hazard, Sultan's work takes on many meanings for the viewer. Lynne Warren remarks that "Sultan's Americanness is also reflected in his ability to capitalize on an image—the same talent that has proved so successful in advertising, with its billboards and logos and in television, has transformed American culture into a visually oriented ethos."[85]

Yellow Iris Smoke Stack, like many of the artist's pieces, consists of several

tiles attached to a Masonite background. On top of the tiles, the artist applied several layers of tar, creating a considerable thickness on the surface before finishing with paint. By using nontraditional materials, Sultan challenged artistic norms and expanded the potential for materials—such as tar, which is normally used to patch roads, and tiles that are more often used in houses—that are associated with functions other than making art.

57. Sarah Sze (b. 1969), *Drawn*, 2000 (detail)

Mixed media, dimensions variable, site-specific installation at La Jolla. Gift of The Alberta duPont Bonsal Foundation, 2001.20, Museum of Contemporary Art San Diego

Sarah Sze's *Drawn* is one of many site-specific works created for the La Jolla venue of the Museum of Contemporary Art San Diego.[86] The title of the piece is fitting, but it could also be appropriate for many of the artist's works, which often combine drawing and sculpture, an approach that frequently results in organic and dizzying patterns that appear to defy gravity. While a free-flowing rhythm enlivens *Drawn*, the angled lines of individual components give the work a strong sense of structure. Furthermore, the artist's keen understanding of architecture is revealed in the relationship between *Drawn* and the physical space that it occupies in La Jolla.

Sze often incorporates found objects and every-day household items in her installations. Christian Viveros-Faune wrote in the *Village Voice*: "Sze has long pointed the way to Whitmanesque freethinking through her interpretations of democratic consumerism. Cast from the bins at Target, Walgreens, and Home Depot, her sculptures convey both the epic and mundane integrity of *Leaves of Grass*."[87] From a formal point of view, Sze's objects exude a challenging complexity, a concept investigated in the artist's solo exhibition *Sarah Sze: Infinite Line*.[88]

Sze received a BFA degree from Yale University and an MFA from the School of the Visual Arts in New York. Among her numerous honors, she became a MacArthur Foundation Fellow in 2003 and has been selected to represent the United States at the Venice Biennale in 2013.[89]

58. Brian Ulrich (b. 1971), *Kenosha, WI, 2003 (Spilled Milk)*, 2003

LightJet C-print, 40 × 52 inches. Museum purchase, 2006.82, Museum of Contemporary Art San Diego

In *Kenosha, WI, 2003 (Spilled Milk)*, Brian Ulrich portrays an attention-grabbing scene related to daily life experience and emphasizes the distinctive geometric shapes found in a large food store. The boxes of Faygo soda, made by a Michigan-based soft drink company, and the rectangular tiles on the floor add a sense of formal composition to the work. The spilled milk contrasts with the rigid lines of the boxes and tiles as it takes a more organic shape. In the interview in this volume, Ulrich discusses the background of this photograph in depth. Although he did not intend this interpretation, his photograph makes for an interesting statement on twenty-first-century American consumer culture, economic recession, and the ironic ways in which we might behold America today.

Ulrich's recent solo exhibition at the Cleveland Museum of Art, *Is This Place Great or What*, featured work from three series: *Retail* (2001–06), *Thrift* (2005–08), and *Dark Stores* (2008–11). The works in *Retail* were created in response to President Bush's mandate that Americans should go shopping following the tragic events of September 11, 2001. Much of the series focuses on the banality of big-box stores. The photographs in the *Thrift* series depict people who work and shop at secondhand stores. *Dark Stores* was formed out of the economic recession and presents boarded-up storefronts. This work, *Kenosha, WI, 2003 (Spilled Milk)*, is part of the artist's *Retail* series.

Just as Ulrich's photographs portray popular culture, they have also become part of popular culture: two of his works accompanied an article in the December 20, 2010, issue of *Time* magazine.[90]

59. Kay WalkingStick (b. 1935), *Another Autumn Goodbye*, 1978

Encaustic wax ink and acrylic on double-layered canvas, 36 × 36 × 3 inches. Gift of Sara Scott and Dr. Nicholas Roberti, 1983.2, Museum of Contemporary Art San Diego

Kay WalkingStick was born in Syracuse, New York. She earned her BFA degree from Beaver College (now Arcadia University), in Glenside, Pennsylvania, and her MFA degree from the Pratt Institute, in Brooklyn, New York. In 1975, the same year she completed her graduate degree, she had her first major solo exhibition, at the New Jersey State Museum in Trenton.

Now retired, WalkingStick taught at Cornell University in Ithaca, New York, an area associated with vibrant fall weather. Her interest in the seasons is evident not only in this work, created more than thirty years ago, but in her 2010 exhibition at June Kelly Gallery, which highlighted a series of paintings inspired by autumn that are much more representational than *Another Autumn Goodbye*. Both landscapes and experiments in abstraction are at the core of WalkingStick's works. The dark color palette of *Another Autumn Goodbye* suggests the early evenings and cloudy skies of the approaching winter season, and the various lines contribute rhythmic and lyrical qualities. The long, scar-like forms reoccur in a number of her paintings produced in the late 1970s and through the 1980s.

While WalkingStick's work is often associated with her Native American heritage, she aims for universal meanings and connections in her art. Many people experience a relationship to landscape and, like WalkingStick, see themselves reflected in certain places. The topography of both the American Southwest and Italy have inspired this artist.

60. Andy Warhol (1928–1987), *Flowers*, 1967

Silkscreen ink and synthetic polymer paint on canvas, 115½ × 115½ inches. Museum purchase with contributions from the Museum Art Council Fund, 1981.2, Museum of Contemporary Art San Diego

Andy Warhol was a key figure among innovative artists active during the second half of the twentieth century. Perhaps most famously, he took Campbell Soup cans and made a body of work featuring this everyday object. Banal objects such as Brillo boxes and animals, specifically cows, were repeated readily in his art. He also made iconic representations of well-known figures such as Jacqueline Kennedy, Elizabeth Taylor, and Marilyn Monroe. Along with these favored types of imagery, Warhol created a number of flower compositions.

During the 1950s, Warhol finished a few still lifes. This work, however, relates to a major series of flowers that he began in 1964 after he saw a photograph of hibiscus blossoms by Patricia Caulfield in *Modern Photography*. While this large-scale painting is an important example of this Warhol series, The San Diego Museum of Art also has a lithograph by the artist, *Flowers* (1964), inspired by the Caulfield photograph. Warhol used Caulfield's photograph as the inspiration for this work and many others. Caulfield sued Warhol over his appropriation of her image, and the two artists reached a settlement. With *Flowers*, Warhol strips the image of its references to the natural world, save for the shape of the flower petals. The ominous black background and purple-gray flowers recontextualize the still life. The portrayal of flowers in the history of art occurs among diverse cultures. In *Behold, America!*, Warhol's still life is given historical context within American art by Georgia O'Keeffe's *The White Flower* (1932; cat. 35) and Martin Johnson Heade's *The Magnolia Blossom* (1888; cat. 20).

61. Pae White (b. 1963), *Hobo Woods/Tears of Vietnam*, 1999

Gouache, paper, thread, 72 × 72 × 72 inches. Gift of the Suzanne Figi Latin American and Contemporary Art Fund, 2001.5, The San Diego Museum of Art

Pae White's sculptural installation *Hobo Woods/Tears of Vietnam* is composed of ninety-six strands of thread and hundreds of small pieces of Color-aid paper. Color-aid paper, produced since 1948, has provided artists, including Josef Albers (1888–1976), who pioneered its artistic use, with a tool for creative innovation.[91] The pieces of paper, suspended from wires, seem to float in the air, giving the piece an ethereal feel. The scale of the work invites viewers to consider their physical selves in relation to the piece. While *Hobo Woods/Tears of Vietnam* does not represent the title in a literal way, it shares with another work in the exhibition, Burkhardt's *Sign of Our Times*, a more abstract and conceptual response to the Vietnam War. Hobo Woods was a base area for the Viet Cong during the Vietnam War.

An internationally recognized artist, White was included in the 2010 Whitney Biennial and had a solo show at The Power Plant in Toronto in 2011. The Gloucester Road tube station in London featured a sculpture by the artist during the 2012 Summer Olympics.[92]

White has strong roots in Southern California. She was born in Pasadena, studied at Scripps College, where she received her BA degree, and completed the MFA program at Art Center College of Design, Pasadena. She is currently working with a team of designers on a redevelopment plan for the North Embarcadero in San Diego. The plan repurposes the large public space and incorporates text from Richard Bach's 1970 novel *Jonathan Livingston Seagull*.

62. Andrea Zittel (b. 1965), *Paper Pulp Panels*, 2002

Molded paper pulp, 72 × 72½ × 1½ inches. Gift of Robert Conn and Anne Hoger, 2005.21, Museum of Contemporary Art San Diego

Andrea Zittel was born in Escondido, California. In 1988, she earned a BFA degree in painting and sculpture from San Diego State University and completed an MFA degree in sculpture from Rhode Island School of Design in 1990. Her early exposure to suburban life proved influential. Recounting the experience of living in Berlin during 1995, the artist wrote, "I also became more aware of the 'American-ness' of my work. My interests had always touched on issues of European modernism, but now I realized how much they also had to do with my suburban American upbringing."[93]

Zittel's artistic practice is completely intertwined with her daily existence. Largely as a result of living in the secluded desert area of Joshua Tree, California, she began to reconsider waste and explore how to incorporate paper waste into her work. She experimented with paper pulp, which is extremely durable, lightweight, and malleable, playing with the material

in her construction of shelters and also in the work depicted here.

Through her investigations into sustainable materials, she began various projects related to furniture, clothing, food, and other necessities under the umbrella of her A–Z enterprise. Her work in effect became very much about an exploration of how one lives. For example, in 1991, under the auspices of her A–Z enterprise, she began to make clothing that she described as a six-month uniform. Zittel would design a dress and then wear the same dress each day for six months. She recalled that the creativity and emotion involved in designing a new dress supplemented any need to be distracted by "the tyranny of constant variety."[94]

The economy of line and simple, elegant forms inherent to *Paper Pulp Panels* are typical of the artist's aesthetic but also place her among a generation of like-minded artists. Zittel's work was included in the important exhibition *Sense and Sensibility: Women*

Artists and Minimalism in the Nineties (1994), at the Museum of Modern Art, in New York, alongside that of Mona Hatoum (b. 1952), Rachel Lachowicz (b. 1964), and Rachel Whiteread (b. 1963). Beyond this exhibition, Zittel's work has been exhibited internationally and has been widely praised.

FIGURES

63. Edgar Arceneaux (b. 1972), *Spock, Tuvac, Tupac*, 1997

Graphite, gesso, marker on frosted vellum, 32 × 42 inches. Museum purchase, Elizabeth W. Russell Foundation Fund, 1997.27, Museum of Contemporary Art San Diego

In this sparse work, Edgar Arceneaux depicts three popular culture icons: Tupac Shakur (right), Tuvok (center), and Spock (left). Tupac Shakur (1971–1996), a musician whose life was cut short by violence, lives on in his rap music, the lore surrounding his death, and, specifically, his association with the East Coast– West Coast rivalry among rap musicians that escalated in the late 1980s and early 1990s. Shakur's image still generates enormous interest—as evidenced by the strong public reaction to the hologram representation of the rapper during the performance of fellow rapper Dr. Dre at the 2012 Coachella Valley Arts and Music Festival.[95] The figure in the middle represents Tuvok, a character in *Star Trek: Voyager* (1995–2001). He was a Vulcan, hence, the pointy ears. Tuvok's main job was as a security and tactical officer. The most recognizable face from *Star Trek* appears on the left, Spock, another Vulcan, who was made famous by the actor Leonard Nimoy (b. 1931). Arceneaux leaves the viewer to compare his renderings of the three individuals and to think about the ways in which they are similar: their names, their celebrity, and their relationship to mythic lore.

Arceneaux established Watts House Project in Los Angeles to serve the Watts community and specifically to engage artists in the redevelopment of the neighborhood. He recently stepped down as director of the organization, but the mission of the group speaks to his engagement with community service and his dedication to bridging the gap between fine arts and the community at large. Through his work and actions, Arceneaux has appealed to popular sentiment.

64. Alexander Archipenko (1887–1964), *Leda and the Swan*, ca. 1938

Bronze, 13 × 5⅝ × 4⅛ inches. Bequest of Margot W. Marsh, 1995.37, The San Diego Museum of Art

In Greek mythology, Zeus appeared to Leda in the form of the swan. Since the Renaissance, this myth has reoccurred in the work of many artists. *Leda and the Swan* demonstrates the long curvilinear shapes associated with Alexander Archipenko's sculpture. The slight twisting of the sinuous forms suggests Archipenko's *Turning Torso* (1921), also in the collection of The San Diego Museum of Art. Throughout his career, Archipenko moved back and forth between abstraction and more classical forms, and this sculpture combines both as it reveals an abstract but elegant and graceful pair.

Archipenko was born in the Ukraine. His grandfather was an icon painter, and his father was an engineer and engineering professor. Archipenko combined the creative and mathematical tendencies of his family to produce an important body of sculpture. As a young man, he studied and worked in Paris, where he settled in 1909 and, in 1914, opened an art school. In 1921, Archipenko moved to Berlin, where he would also open an art school. His time in the German city, however, was short. By 1923, he had moved to the United States.

Archipenko avoided labels in regard to his own heritage and its application to his art, insisting, "There is no nationality in my creations. In that respect, I am no more Ukrainian than I am Chinese. I am no one person."[96] Likewise, the artist preferred not to identify

his art as belonging in any particular category. He wrote, "It is difficult to classify an artist into periods. I never belonged to schools; I was expelled from schools."[97] This sculpture is typical of the artist's work in the 1930s and 1940s in its ode to more traditional sculpture through its subject matter and material. It was during this period that the artist focused more on bronze, marble, and various ceramic materials.

65. Matthew Barney (b. 1967), *T.L: ascending HACK descending HACK*, 1994

Chromogenic print, self-lubricating plastic frame, 39½ × 27½ inches. Museum purchase, Contemporary Collectors Fund, 1995.4, Museum of Contemporary Art San Diego

Matthew Barney's work is often characterized by athleticism and sexuality. His performance-driven art continues the type of work pioneered by Bruce Nauman (b. 1941) and Vito Acconci (b. 1940). Barney's five *Cremaster* films are his most recognized works. The word *cremate* refers to a thin muscle that surrounds and suspends the testicle. Barney is often the director, set designer, performer, and fabricator of various items in his films; he also produces stills, installations, and sculptures inspired by happenings on the set.

Barney took *T.L: ascending HACK descending HACK* during the filming of *Cremaster IV* (1994). The scene depicted was inspired by a motorcycle race, known as the Tourist Trophy, that takes place on the Isle of Man, off the coast of Scotland, an annual event that began in the early twentieth century. The artist was also inspired by the region's folklore. In the film and in this photograph, the two competing teams, the ascending and descending hacks, are assisted by faeries. Strong figures and forms dominate the picture, but the emphasis is on figures, not only the four people who embody the narrative and interject action into the scene but also the figures depicted on the backs of their suits and on the cars themselves.

66. Tina Barney (b. 1945), *Jill and Polly in the Bathroom*, 1987

Ektacolor Plus print, 45¼ × 58 inches. Museum purchase with funds from Lannan Foundation, 1988.33, Museum of Contemporary Art San Diego

Tina Barney was born in New York. She began collecting photographs at the age of twenty-six and started taking her own photographs in the mid-1970s. *Jill and Polly in the Bathroom* is typical of her mature work. The women in this scene are mother and daughter. Jill is the artist's sister, and Polly is the artist's niece. Barney often portrays the domestic lives of upper-middle-class families in New York and New England and frequently uses her own family members as subjects. Jill returns the gaze of the photographer/viewer as though she is surprised by the intrusion in such a private space, while Polly gazes downward with a slight smirk that adds to the enigmatic quality and psychological tension of the work. While the mother and daughter are physically close to each other, the work conveys a certain distance, common between a parent and a teenager.

Various details complicate and augment the scene. For example, the sink is filled with many objects, such as a porcelain dish, two hairbrushes, and a hair tie; all of these items make the space crowded and realistic-looking, as though the figures represented did not have time to clean up before the photographer invaded their space. The scene is both multifaceted and voyeuristic in the juxtaposition of the mirror and the window. On the one hand, the mirror shows a reflection of the mother and one of the daughter's arms. It also accentuates the pink flower pattern of the curtains, increasing the density of the scene. On the other hand, the window reveals the backyard and a small doghouse in the distance. The presence of detail in the near and far distance makes for a remarkable photograph.

67. George Caleb Bingham (1811–1879), *Portrait of Colonel James Hervey Birch, Jr., ca. 1878*

Oil on canvas, 27⅛ × 22¼ inches. Gift of Armistead B. Carter, Rear Admiral Grayson Birch and Ruth Carter Heuckendorf, in memory of Ruth Birch Carter, 1965.37, The San Diego Museum of Art

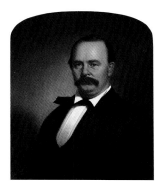

George Caleb Bingham's paintings of the Midwest, and particularly the Missouri River, are some of the most heralded pictures in the history of American art. In particular, his oil paintings *Fur Traders Descending the Missouri* (1845; The Metropolitan Museum of Art) and *The Jolly Flatboatmen* (1877–78; Terra Foundation for American Art) have become iconic representations of a nation nostalgic for a more rural past as sweeping advancements in the industrial sector affected both rural and urban populations. Bingham participated in the construction of an image of the United States as the country developed its sense of nationalism in the first one hundred years of its existence.

This particular work is a departure from Bingham's well-known genre scenes of the Midwest in that it portrays a single individual. Although Bingham was a talented portrait painter, this work relates to his more well-known narrative paintings in that it depicts an American rooted in the life of nineteenth-century Missouri. Little is known of the stocky, middle-aged man portrayed in this portrait, but much is known about his successful father. Birch was the son of Judge James Harvey and Sarah Catherine (Halstead) Birch. The family moved in 1826 from Virginia to Saint Louis, Missouri, where Harvey founded a newspaper, *Western Monitor*, and became active in the state senate. From 1849 to 1852, he held his most prestigious position as a member of the Missouri supreme court.[98] His successful political and legal careers seem to have eclipsed his son's military career.

68. Joseph Blackburn (ca. 1730–1778), *Portrait of Thomas Wentworth*, 1761

Oil on canvas, 50⅝ × 40⅝ inches. Gift of Mrs. John Sheafe Douglas, 1957.12, The San Diego Museum of Art

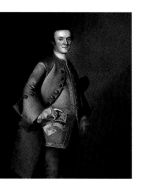

Colonial portrait painters were often commissioned to create a likeness as a way of promoting a subject's power and wealth. Joseph Blackburn trained in England before traveling in 1752 to Bermuda, where he painted portraits for two years. By 1755, he had settled in Boston and had become a prominent colonial portrait painter. Thomas Wentworth, depicted here in fashionable dress, was a graduate of Harvard College who found work as a merchant in Portsmouth, New Hampshire. He is not portrayed in a luxurious environment or in an overly ornate costume, but his gray suit is stylish and accented with prominent matching buttons and delicate lacework. The representation of his flushed cheeks draw attention to his face, and the position of his right arm on his hip expresses pride and regality. This painting is a poignant testament to Wentworth, who died prematurely at the age of twenty-eight, and is the earliest-dated work in *Behold, America!*

Wentworth came from a distinguished family, as he was the son of the Honorable Mark Hunking and Elizabeth (Rindge) Wentworth and the nephew of Benning Wentworth, New Hampshire's first royal governor. His brother, John Wentworth, would become royal governor of New Hampshire during the American Revolution.

69. Gutzon Borglum (1867–1941), *Awakening*, 1911

Marble, 34¼ × 15¼ × 15 inches. Gift of Mr. and Mrs. Archer M. Huntington, 1925.2, The San Diego Museum of Art

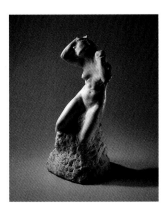

Gutzon Borglum once wrote, "I love America with an idolatry that consumes all other passions. The virgin west world is still to me the gift of heaven to humanity."[99] Although he is best known for the monumental carvings of four U.S. presidents at Mount Rushmore National Memorial in South Dakota and carvings of Confederate leaders of the Civil War in Stone Mountain, Georgia, Borglum created a number of small-scale works like *Awakening*, which reveals his technical skill and creative talents on a much more intimate level.

Born in Ovid, a town in Bear Lake County, Idaho, Borglum eventually traveled to Paris to further his art education at the Académie Julian. He was initially interested in painting, but his preferred medium soon changed. While in France, he was greatly influenced by the work of French sculptor Auguste Rodin (1840–1917), whose rough and evocatively unfinished style of marble carving Borglum emulated in works like *Awakening*, in which he emphasizes the medium itself while also dramatizing the figure's movement.[100] *Awakening* is one of three marble sculptures that Borglum created on the themes of grief, conception, and motherhood.[101] This particular work reveals the grief the artist and his second wife, whom he married in 1909, experienced after the loss of two infants. As the figure "awakens" from the marble base and twists her body, her hand raised to her head expresses her emotional pain.

70. Mary Cassatt (1844–1926), *Simone in a Blue Bonnet (No. 1)*, ca. 1903

Oil on canvas, 26 × 20 inches. Bequest of Mrs. Henry A. Everett, 1938.20, The San Diego Museum of Art

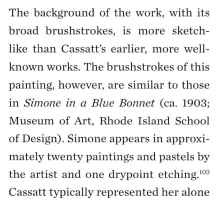

Mary Cassatt once stated, "I am an American, definitely and frankly American."[102] Despite this bold declaration, Cassatt's artistic transformation took place outside of the United States. Born to a wealthy family in Allegheny City, Pennsylvania, she demonstrated an interest in art from an early age. As a young woman, she studied at the Pennsylvania Academy of the Fine Arts, but she longed to study in Paris. After arriving in France, Cassatt transformed her life. She studied with the celebrated history painter Jean-Léon Gérôme (1824–1904) and first showed her work publicly at the Paris Salon in 1872. Cassatt was the American impressionist painter who was most accepted by her European counterparts. Edgar Degas (1834–1917) became a supporter and mentor.

In this portrait, the subject, Simone, wears a blue bonnet with a narrow pink ribbon tied under her chin. The background of the work, with its broad brushstrokes, is more sketch-like than Cassatt's earlier, more well-known works. The brushstrokes of this painting, however, are similar to those in *Simone in a Blue Bonnet* (ca. 1903; Museum of Art, Rhode Island School of Design). Simone appears in approximately twenty paintings and pastels by the artist and one drypoint etching.[103] Cassatt typically represented her alone and wearing a bonnet and dress.

Simone in a Blue Bonnet (No. 1) was first exhibited at The San Diego Museum of Art as part of a presentation of American paintings in 1930, eight years before it came into the permanent collection. The work was a gift of Josephine Everett, who gave a number of important American paintings to the museum. The collection includes another portrait of a young girl by Cassatt, the watercolor *Head of a Little Girl* (ca. 1908).

71. William Merritt Chase (1849–1916), *An Afternoon Stroll*, ca. 1895

Oil on canvas, 47⅛ × 50¼ inches. Museum purchase with funds provided by the Gerald and Inez Grant Parker Foundation and Earle W. Grant Acquisition Funds, 1976.1, The San Diego Museum of Art

The female figure in William Merritt Chase's *An Afternoon Stroll*, garbed in a white dress with coral accents, complements rather than competes with her natural surroundings. The soft yellows and greens that dominate the picture are typical of the artist's choices in his rendering of Shinnecock, Long Island and demonstrate his ability to convey the delicate interplay between light and shadow. In this painting, the late afternoon sun strikes the figure and the cedar trees in the background from behind, casting their shadows forward onto the grassy ground. The paintings Chase completed near the ocean contrast starkly with the darker, more decoratively dense paintings he finished at his Tenth Street studio.

When Chase died, *An Afternoon Stroll* was still in his studio, some twenty years after he had completed the picture.[104] His fondness for the painting might corroborate the hypothesis that the woman depicted in it is modeled after his wife, Alice Gerson. While much of his work around this time is focused on the terrain of Shinnecock, such as the area's open fields and beaches, he was deeply inspired by his wife, daughters, and other women visitors to his home and studio in Long Island and repeatedly created portraits of women in the same spirit expressed in the works of impressionist painters Berthe Morisot (1841–1895) and Mary Cassatt (1844–1926).

72. John Singleton Copley (1738–1815), *Mrs. Thomas Gage*, 1771

Oil on canvas, 50 × 40 inches. Timken Museum of Art, Putnam Foundation Collection, 1984:001

John Singleton Copley's parents, Mary Singleton and Richard Copley, emigrated to the United States from England. He was born in Boston, in the same year as the painter Benjamin West (1738–1820), and despite their beginnings in the colonies, both men would ultimately pursue their artistic careers in England. When Copley settled in London, he began to create paintings with looser brushstrokes in emulation of the chosen style of Thomas Gainsborough (1727–1788), whose works were popular at the time. Joshua Reynolds (1723–1792) was another influence, and Copley occasionally replicated in his paintings the poses enacted by Reynolds' sitters.

Copley refused to take sides in the American Revolutionary War (1775–83). Although his in-laws were Tories, he did not want to publicly align himself with either the Whigs or the Tories, a stance that certainly avoided limiting his commissions. His patrons included the Whig Samuel Adams and the Tory Thomas Gage. After Whigs threatened his family, he left for England in 1774 and made arrangements for his loved ones to join him later.

Copley was often commissioned to create a portrait to document an important occasion in the life of a sitter. Portraits undertaken in Colonial America were frequently related to the assertion of power. Sitters were presented in their best attire, and the portraits attested to the importance of the sitters and their families. Margaret Kemble Gage, the subject of this painting, was married to Thomas Gage, the commander in chief of the British Army in North America, on December 8, 1758. In 1768, Copley painted a portrait of Thomas Gage in Boston (Yale Center for British Art). Gage subsequently led the British forces in their defeat at the Battle of Bunker Hill, in 1775, a major accomplishment for the colonists, and this victory gave them the confidence and energy to continue their struggle for independence. Rumors have swirled for centuries that Margaret Kemble Gage's loyalties were divided between her husband and her native land (she was born in New Brunswick, New Jersey) and that she might have provided information that aided the colonies. True or not, this story certainly adds to the allure of Copley's painting.

Mrs. Thomas Gage is striking in many ways. Certainly the relaxed posture and natural beauty of the sitter come to the immediate attention of the viewer, and her uncorseted look makes the portrait even more remarkable. Paul Staiti describes the impression created by the portrait: "Moreover, along with the same Orientalizing line, he constructed a languid sexuality for his sitter, manifested in her dreamy eyes and in her glossy brown hair that escapes the loosely fitted scarf and cascades sensually over her shoulder and chest. It is a sexuality situated in the gesture of the left hand that holds the dress and presses up against her thigh in the sinuous curves of the camelback sofa, itself a furniture form from west Asia and in a lolling pose so relaxed and expressive of idleness and self-indulgence as to challenge contemporary codes of polite bodily conduct."[105]

The sitter's adornments are plentiful. The pearls in her hair and around her arm make for an interesting comparative aesthetic relationship with the brass tacks at the end of the lush navy sofa. The lace at her bodice, the central brooch, and the gold patterned sash accentuate her waist and overall appearance.

The loose Turkish caftan that she wears was fashionable among women of stature. Donning Turkish dress for portrait sittings was popular among women in England, and the practice was adopted by women in America; in a sense, it was a type of "thirdhand appropriation."[106] In many cases, Copley had props for his subjects to wear and interact with in their portraits. This particular dress, however, might have belonged to Gage, as her father was born in Smyma to a Greek mother. He spent the first sixteen years of his life there, and his childhood outside of England may have directly influenced his daughter's tastes and inventory of costumes.[107]

Shortly after the painting was completed, it was sent to England, where it would remain. This painting was exhibited in London in 1772 and served as a way of introducing both Copley and Gage to London society, an arena in which, in a few years, they would both become participants. Firle Place, the Gage Family estate located in East Sussex, not far from London, housed this Copley painting until it was purchased by the Putnam Foundation for the Timken Museum of Art.

73. Hugo Crosthwaite (b. 1971), *Bartolomé*, 2004

Graphite and charcoal on panel, 96 × 96 inches. Museum purchase with funds provided by Ken and Jacki Widder and by Kevin and Tamara Kinsella, 2005.95.a–d, The San Diego Museum of Art

In describing the inspiration for this work, Hugo Crosthwaite explains, "I always thought that being skinned alive was a horrible way to die, and when I started this piece, I wanted to make a very Baroque composition, sort of like Caravaggio's crucifixion of Peter, a very diagonal composition, and then as I was working through the piece, I was thinking about martyrdom."[108] Crosthwaite's *Bartolomé* uses the predicament of the saint to comment on contemporary society, and specifically to address the abuses at Abu Ghraib, which were made public as he began the work, when photographs taken by American soldiers were released to the media.

The figures and architecture of Tijuana dominate the four panels that the artist used to draw his powerful composition. Crosthwaite explains the work further, continuing,

> They look bloated, they look tortured and hit and cut and bruised and even drowned, and all of this

with the backdrop of Tijuana. These bodies are being impaired or closed in by the claustrophobic architecture of Tijuana, this very chaotic city, which is something I love and an aesthetic that I carry with me in all of my work. This notion of a very geometric, chaotic pattern that happened to the facade of Tijuana that encases these figures. Like everything in Tijuana, there is always signage, so I referenced a sign *carnes* [meats], referencing food—or a grocery store where you can buy meat. So representing these martyred bodies as tortured pieces of meat that are being sold, which, in a way, was what this war to me was sort of reflecting.[109]

As in many of his works, Crosthwaite includes partial words or text. The letters E-S-C-A behind one figure refer to the word *escándalo* (scandal) and represent another way in which the artist suggests the abuses at Abu Ghraib while simultaneously portraying a contemporary Saint Bartolomé.

74. John Currin (b. 1962), *The Hobo*, 1999

Oil on canvas, 40 × 32 inches. Museum purchase, Contemporary Collectors Fund, 2000.3, Museum of Contemporary Art San Diego

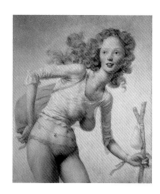

John Currin was born in Boulder, Colorado. He received his BFA degree from Carnegie Mellon University and an MFA degree from Yale University. In his paintings, Currin focuses on figural forms. His figures—men, couples, and mostly women—recall the work of European masters such as Lucas Cranach (1472–1553). Like Cranach, Currin often creates portraits of women with blondish red hair with gentle curls, and, although they are not the focus of his oeuvre, he has also created a number of provocative nudes. The figures in Currin's works often share some physical features with his wife, Rachel Feinstein, and himself. "I basically project myself onto everything rather than reveal a lot about other people. I'm not like Alice Neel—in her paintings you really get the feeling of a particular person. The people I paint don't exist."[110]

In this striking painting, Currin renders a rather traditional portrait, evocative of Renaissance paintings, with tender hair framing the woman's face.

Beyond that element, however, he created a nontraditional work. The artist writes of this painting, "For *Hobo* and *Sno-bo* (both 1999) I had this idea of a sexy hobo, like one in some low-budget TV show from the '80s like *Knight Rider* or *Baywatch*. It was set in a soup kitchen, with a hilarious line of basically good-looking, sexy homeless people. And I just love that image of a kind of sexy wanderer, I guess."[111] The flushed cheeks and windblown hair, the walking stick in one hand and the bag on her back, relate the image to the title of the painting. In a simultaneously bizarre and sexy representation, the woman's femininity is augmented by a belly chain, transparent blouse, and revealing underwear. Like many of Currin's representations of women, this figure is big-bosomed, which contrasts awkwardly with her slender arms and waist, and the unevenness of the proportions makes for a captivating composition.

75. Thomas Eakins (1844–1916), *Elizabeth with a Dog*, ca. 1871

Oil on canvas, 13¾ × 17 inches. Museum purchase and a gift from Mr. and Mrs. Edwin S. Larsen, 1969.76, The San Diego Museum of Art

76. Thomas Eakins (1844–1916), *Portrait of James Carroll Beckwith*, 1904

Oil on canvas, 83⅜ × 48⅛ inches. Gift of Mrs. Thomas Eakins, 1937.30, The San Diego Museum of Art

These two paintings exemplify Thomas Eakins's sensitive portrayal of people in his life and his penchant for dark, Victorian interiors in Philadelphia, the city where he spent most of his life.

The Crowell and Eakins families were intertwined. Eakins's sister, Frances, married William J. Crowell, the brother of the Elizabeth depicted in *Elizabeth with a Dog* . Eakins was engaged to another sister, Kathrin, whom he also portrayed, but she died before they could be married. Another painting by Eakins of Elizabeth, *Elizabeth at the Piano* (1875), is in the collection of the Addison Gallery of American Art in Andover, Massachusetts. In *Elizabeth*

with a Dog, the subject teaches a dog how to balance a cookie on its nose. She wears a white fur hat and her red blouse is accentuated by bands of black velvet. Claire Perry writes that Eakins gave Elizabeth "power and independence" in this painting. She surmises that "the keen intelligence of her gaze, however, sets her apart from the docile creature who obeys her, as well as from society's expectations for female passivity. The schoolbooks that lie on the floor beside her also introduce the idea that her authority is connected to a developing intellectual acuity."[112] The setting for the painting is the Eakins family home at 1729 Mount Vernon Street. Many of the

artist's genre paintings from the early 1870s feature the same carpet, piano, chair, and neutral walls.[113] The painting remained in Elizabeth Crowell's possession. She brought it with her to California in 1893, and The San Diego Museum of Art acquired it in 1969 from her daughter.

Born in Hannibal, Missouri, James Carroll Beckwith (1852–1917) became an accomplished portrait painter in New York, counting among his subjects William Merritt Chase and Theodore Roosevelt. Eakins portrays Beckwith in the act of painting, with a brush and palette in his hands, standing before a portrait of his wife, Bertha Beckwith, who was also an artist. On the back of the painting, Eakins wrote, "To Mrs. Carroll Beckwith from her friend Thomas Eakins, 1904." This painting was one of sixty works included in a memorial exhibition for Thomas Eakins held at the Metropolitan Museum of Art in November 1917.[114] Alfred Mitchell (1888–1972), a California-based plein air painter, corresponded with Susan Eakins, the painter's widow, about the possibility of bringing an Eakins painting to San Diego. After multiple letters, she wrote to Mitchell that Beckwith's widow could not care for the picture and that she had encouraged Eakins "to feel at liberty to follow my own inclinations regarding the final disposal of the portrait."[115] Eakins donated the painting to the museum in 1937.

Eakins was one of the most high-profile American artists to demonstrate reverence for Walt Whitman (1819–1892). He painted a portrait of the poet (1887; Pennsylvania Academy of the Fine Arts) and photographed him as well. Both men were lauded for their presentation of American society.

77. Nicolai Fechin (1881–1955), *Manuelita with Kachina*, ca. 1930

Oil on canvas, 20¼ × 16⅛ inches. Bequest of Mrs. Henry A. Everett, 1938.25, The San Diego Museum of Art

Nicolai Fechin was born in Russia and studied with Ilya Repin (1844–1930). After completing his studies at the Imperial Art Academy in Saint Petersburg, he took a position at the Kazan Art Academy, where he met Miss Sapojnikoff, a student. Fechin's *Portrait of Miss Sapojnikoff* (1908; The San Diego Museum of Art) and a portrait of his father were shown together in a 1910 competition hosted by the Carnegie Institute in Pittsburgh, Pennsylvania.[116] Some thirteen years later, seeking refuge from the violence and chaos that followed the Russian Revolution of 1917, Fechin and his family arrived in the United States, settling first in New York and then moving to Taos, New Mexico. The house and studio that the artist built there for himself and his family now houses the Taos Art Museum.

Fechin joined the Taos Society of Artists and became part of the growing movement of artists who moved to the Southwest and were inspired to portray Native American culture. These representations often embody romantic notions, as artists tended to present idealized images rather than reveal the daily realities for many Native Americans living in the region. In *Manuelita with Kachina*, Fechin portrays a young girl holding two kachina dolls. Typically associated with Pueblo communities and most frequently with the Hopi culture, the dolls are often carved from wood, painted, and adorned with feathers and are used to teach children about their culture. In the painting, Fechin correlates the young girl with her heritage through her physical attachment to a cultural artifact. Overall, the subject matter of this Fechin painting is quite traditional, but individual areas of the painting reveal an expressionistic brushstroke indicative of the work that was to come from American artists engaged increasingly in abstraction. Fechin created a number of similar paintings, including *Girl in Purple Dress* (ca. 1930; Fred Jones Jr. Museum of Art, The University of Oklahoma) and *Indian Girl with Pottery* (ca. 1930; Fred Jones Jr. Museum of Art, The University of Oklahoma).

78. Luis Gispert (b. 1972), *Wraseling Girls*, 2002

Fujiflex print mounted on acrylic, edition 2 of 5, 80 × 50 × 1 inches. Gift of Robert Shapiro, 2005.16, Museum of Contemporary Art San Diego

Luis Gispert was born in Jersey City, New Jersey and grew up in Miami. He earned a BFA degree in film from the School of the Art Institute of Chicago and an MFA degree in sculpture from Yale University. Gispert makes sculpture and video as well as photographs, which often demonstrate his background in the study of moving images and sculptural forms.

Wraseling Girls confronts viewers with an extreme juxtaposition, pairing popular culture—expressed by a combination of hoop earrings, tattoos, and cheerleading uniforms—with the young women's classical pose. The simultaneously related and contradictory facets of *Wraseling Girls* suggest Baroque visual strategies. Moreover, the work suggests themes of beauty and power. The poses of Gispert's subjects often reference specific historical works of art. Here, the young women's pose is similar to that seen in the painting *Hercules and Antaeus* (ca. 1475) by Antonio Pollaiuolo (1431/1432–1498), but Gispert has reinvented the work by reimagining the figures as women.

From 2000 to 2002, Gispert worked on a body of photographs in which cheerleaders often appear in front of a prominent green background. His videos, including *Can It Be That It Was All So Simple Then* (2001) and *Block Watching* (2003), present cheerleaders against the same green background and, like many other works by the artist, reference hip-hop culture.

79. Raúl Guerrero (b. 1945), *Peru: Francisco Pizarro, 1524–1533*, 1995

Oil on linen, 34⅛ × 48¼ inches. Museum purchase with funds from the Elizabeth W. Russell Foundation, 1997.24, Museum of Contemporary Art San Diego

Born and raised in Brawley, California, Raúl Guerrero possesses a distinctive and important perspective on the San Diego–Tijuana region. In talking about the region's inherent hybridity, Guerrero states, "In California much of my exposure to art came from the cacophony of images encountered when crossing the border, for example, velvet paintings of Elvis Presley, Pancho Villa and literary figures like Don Quixote and Sancho Panza."[117]

This painting is one in a series in which the artist evokes a nude figural form in order to portray the history of exploration. The dominant female nude is evocative of well-known nudes by Francisco de Goya (1746–1828) and Edouard Manet (1832–1883). The prominence of the figure and its relationship to the art historical canon make this painting an excellent addition to the figures section of *Behold, America!* In explaining the influence of the figure in his work, Guerrero states, "I think my interest in figurative art stems from the way I was raised. My parents always listened to tangos and boleros, narrative musical styles."[118] The journey of Francisco Pizarro is delineated alongside the figure. The connection between the female form and colonization has precedence in colonial representations of America as a woman. In the modern era, Mexican painter Antonio Ruiz (1897–1964) portrayed a sleeping woman with a colonial town rendered on the side of her body in his painting *The Dream of Malinche* (1939; Collection Mariana Pérez Amor).

Beyond the nude figure, in *Peru: Francisco Pizarro, 1524–1533*, Guerrero portrays a variety of objects associated with indigenous Peru. By way of explanation, he asserts that "encounters with the artifacts of culture influence the way we see the world."[119]

80. Robert Gwathmey (1903–1988), *Share Croppers*, ca. 1940

Watercolor, 17¾ × 12¾ inches. Museum purchase with funds provided by Mrs. Leon D. Bonnet, 1941.61, The San Diego Museum of Art

Robert Gwathmey was born in Richmond, Virginia and educated in Baltimore, Maryland, and Philadelphia, Pennsylvania. He was selected for a fellowship to study in Europe, and when he returned to the United States, he was increasingly dismayed by the poverty he encountered in the South and the overall situation of many African Americans. The African American experience became the focus of his work, and *Share Croppers* is typical of the artist's subject matter and style. Gwathmey pursued his art in New York and in Pennsylvania, where he held numerous teaching positions, including twenty-six years at the Cooper Union School of Art in New York.

Share Croppers presents two minimally rendered figures bent over by the weight of their work and their

social condition. It was one of 197 works selected out of 679 submissions for a major watercolor show at The San Diego Museum of Art in 1941 and received the exhibition's top award.[120] The exhibition attracted the attention of *Los Angeles Times* critic Arthur Millier. Noted artists Howard Cook (1901–1980), Doris Rosenthal (1889–1971), and Bernard Zakheim (1896–1985) were also included in the exhibition.[121]

In 1944, shortly after completing this watercolor, Gwathmey received a fellowship from the Julius Rosenwald Fund, which had been founded by a philanthropist who, after reading the writings of Booker T. Washington, had become interested in issues pertaining to African Americans.

81. Ann Hamilton (b. 1956), *Untitled*, from the *body/object* series, 1986

Gelatin silver print, Image 5 × 5 inches; 10 × 8 inches framed. Museum purchase, 1990.13, Museum of Contemporary Art San Diego

Ann Hamilton was born in Lima, Ohio, and taught at the University of California, Santa Barbara, from 1985 to 1991. She relocated to Columbus, Ohio, in 1992. Hamilton's photographs from the *body/object* series (1984–93), which frequently combines animate and inanimate objects, were taken at around the time she was teaching at the university. These

works were initially created as studies during the process of creating new installations and many portray the components of fully realized installations. Sarah J. Rogers writes, "To Hamilton, the body is the locus for empirical knowledge; it is through our bodily senses—tactual, aural, visual, olfactory, and cognitive—that we find experience and knowledge. The sensory abilities of the figures in both the body object photographs and the installations are often altered, denied or extended, at the very sites where information is

heard, seen, or tasted. And the figures themselves become both objects and living presences in a restructured reality, reminding us of the finite and ultimately artificial conditions of the tableaux."[122] In this photograph, Hamilton defies the human form with a bush that stifles the figure's individuality. Other photographs from this series depict a body engulfed by a door, a shoe injected into a head, and a basket placed over a head. Many of Hamilton's works deal with issues of protection and censorship. Her first project for a commercial gallery, *Malediction* (1991), included audio of a woman reading Walt Whitman's poems *Song of Myself* and *I Sing the Body Electric*.[123] The audio came from speakers located within the walls so that the source of the voice was hidden, as is the identity of the figure in this photograph.

82. David Hammons (b. 1943), *Champ*, 1989

Rubber inner tube, boxing gloves, 66 × 19 × 27 inches. Museum purchase with funds from the Awards in the Visual Arts Program, 1989.3, Museum of Contemporary Art San Diego

Born in Springfield, Illinois, David Hammons studied at the Otis Art Institute and the Chouinard Art Institute in Los Angeles before relocating to New York in 1974. Around this time, he began incorporating nontraditional materials in his work. Hammons often addresses issues pertaining to race in his work.

Many of Hammons's works have a sense of history, whether it is a reimagined representation of Jesse Jackson (b. 1941) or the American flag, and the artist acknowledges the power of memory and historical icons in the construction of racial attitudes. In *Champ*, Hammons addresses the practice of boxing in low-income neighborhoods as a mechanism that enables residents to escape their current circumstances and achieve athletic and financial success. Stephanie Hanor writes of this work, "The imagery of passive arms with gloved hands is at odds with the title of the work, and plays with the stereotype of African

American males as great athletes, while reminding the viewer of the false promises and unhappy endings. Notions of oppression and freedom, tawdriness and beauty, mix in the double-edged work."[124] The shape formed by the inner tube, the boxing gloves, and the duct tape that holds them together mimic the way in which boxing gloves can dangle from a nail on a wall, but there is also a sense of defeat, a physical deflation of the materials that elicits thoughts of failure as opposed to success. Ronald J. Onorato observes, "Hanging limply on the wall, *Champ* crosses locker-room artifact with evidence of martyrdom, St. Bartholomew's flayed skin from Michelangelo's *Last Judgment*."[125] In pursuit of a dream, the young men and women who devote themselves to boxing as a means of validation and redemption can become martyrs in the process as a result of both physical and emotional wounds.

83. Robert Henri (1865–1929), *Bernadita*, 1922

Oil on canvas, 24⅛ × 20⅛ inches. Gift of the San Diego Wednesday Club, 1926.138, The San Diego Museum of Art

Between 1916 and 1922, Robert Henri took three extended trips to Santa Fe, New Mexico. Like many American artists during the first half of the twentieth century, Henri was inspired by the culture of the region, which seemed so different from his own experiences. Berna "Bernadita" Escudero, a young girl of Mexican and Native American heritage, posed for a number of portraits in 1922. During his career, Henri was inspired to create several series of "types" of people. For example, he painted a series of portraits of Spanish women after traveling to Spain and completed many portraits of children on Achill, a small island off the northwest coast of Ireland.

Henri championed a straightforward approach to portraiture in which the subject often returns the gaze of the viewer. He encouraged his students, such as John Sloan, to do the same. Sloan and Henri both

shared a passion for collecting books and appreciated great literature. Henri admired Ralph Waldo Emerson, and Sloan admired Molière, but both shared a love for the work of Walt Whitman (who had passed away ten months before they met).[126] After chatting with Henri at a party in December 1892, Sloan went to Henri's studio at 806 Walnut, not far from his own, and gave Henri a new edition of *Leaves of Grass* (Henri owned a worn 1884 copy at that time).[127] Their love for the poetry of Whitman, who often took a popular approach and had a penchant for American vernacular, was in concert with their pursuit of realism in their art. Henri asserted, "Walt Whitman was such as I have proposed the real art student should be. His work is an autobiography—not of hap and mishaps, but of his deepest thought, his life indeed."[128]

84. Robert Henri (1865–1929), *Portrait of Mrs. Robert Henri*, 1914

Oil on canvas, 24 × 20 inches. Gift of Mrs. George Heyneman, 1959.7, The San Diego Museum of Art

Born Robert Henry Cozad, Henri grew up in towns that his father developed, such as Cozaddale, Ohio, and Cozad, Nebraska. In 1882, his father shot a man who worked for the family. The charges were dropped, but Henri stopped using Cozad as his last name and began to be known as Robert Henri (pronounced "Hen-rye"). The family spread out and moved to several places, including Atlantic City. Henri never revealed the truth about his family even to his closest friends. He and his brother moved to Philadelphia, where Henri studied under Thomas Pollock Anshutz (1851–1912) at the Pennsylvania Academy of the Fine Arts. Several trips to Europe were formative. Henri's first teaching position was at the Women's School of Design, and he would mentor many important painters, including John Sloan (1871–1951) and George Bellows (1882–1925).

This portrait of Henri's second wife, Marjorie Organ Henri (1886–1931), whom he affectionately called "O," was a gift to Alice Klauber, a former student who resided in San Diego. (See Derrick Cartwright's "Robert Henri's San Diego," in this publication, which elaborates on the relationship between Klauber and Henri.) Henri painted several portraits of Marjorie, who arrived in the United States from Ireland at age thirteen. *The Beach Hat* (1914), a work similar to this one, is likely from the same sitting and is in the collection of the Detroit Institute of Arts, and a highly regarded portrait of Marjorie, *The Masquerade Dress* (1911), is held in the permanent collection of the Metropolitan Museum of Art. Marjorie was also an artist. She studied with Henri and was employed as a cartoonist for the *New York Journal*.

85. Hans Hofmann (1880–1966), *Woman Seated*, 1938

Oil on Masonite, 43¹⁵⁄₁₆ × 36⅜ × ¼ inches. Gift of the Potiker Family Foundation in memory of Hughes and Sheila Potiker, 2012.39, The San Diego Museum of Art

Hans Hofmann is one of the great abstract painters who was active in New York during the twentieth century. A contemporary of Willem de Kooning (1904–1997) and Jackson Pollock (1912–1956), Hofmann was interested in using paint liberally and exuding strong, broad brushstrokes in his work. Clement Greenberg wrote, "Hofmann is perhaps the most difficult artist alive—difficult to grasp and to appreciate. But by the same token he is an immensely interesting, original, and rewarding one, whose troubles in clarifying his art stem in large part precisely from the fact that he has so much to say. And though he may belong to the same moment in the evolution of easel painting as Pollock, he is even less categorizable."[129]

Although Hofmann is known for his wholly abstract compositions, this work is dominated by a female figure. In the foreground, however, his interest in abstraction is evident. Created just six years after Hofmann arrived in the United States from Germany, *Woman Seated* demonstrates the influence of German

Expressionism on the artist. Hofmann wrote about his work, "My ideal is to form and to paint as Schubert sings his songs and as Beethoven creates a world in sounds. That is to say—the creation of one's own inner world through the same human and artistic discipline. An inner sensation can find external expression only through a spiritual motivation. This makes it necessary that the medium of expression be understood and mastered. A pictorial decorative arrangement is dictated only by taste. Pictorial homogeneity of the composition—plastic unity—is developed by lawfully governed inner necessities. From this derives the rhythm, the personal expression in the work."[130] Hofmann began an interior scene on the verso of this painting but abandoned it before completing the composition. In addition to creating his own work, Hofmann was an influential teacher in both Europe and the United States. Former students include Lee Krasner (1908–1984) and Larry Rivers (1923–2002), and many established artists visited his summer school in Provincetown, Massachusetts.

86. Salomón Huerta (b. 1965), *Untitled Figure*, 2000

Oil on canvas on panel, 68 × 48 inches. Museum purchase, International and Contemporary Collectors Funds, 2001.9, Museum of Contemporary Art San Diego

Salomón Huerta was born in Tijuana and grew up in East Los Angeles. He earned a BFA degree from the Art Center College of Design in Pasadena, California, and an MFA degree from the University of California, Los Angeles. Two years later, the same year he completed this painting, he was included in the Whitney Biennial. Although Huerta established himself as an artist with his nontraditional portraits, another important body of work uses a bright color palette to depict the exteriors of modest, unadorned Los Angeles homes.

While a typical portrait involves a frontal view of the subject with an emphasis on the sitter's facial features, in this work, Huerta presents the subject's back. This view denies access to the usual elements that build up a subject's individuality, but the artist's careful attention to details such as the backs of the ears and the scalp demonstrate a naturalistic rendering of the human form. In contrast, the subject's clothes function like geometric forms. Moreover, the pink of the shirt and the overall background color are saturated, creating a heightened effect. A sense of vulnerability pervades the painting, as a person who is approached from behind typically is at a disadvantage. Huerta's figure, however, refuses to be the "subject" of the viewer's gaze and rejects the conventions of art history by turning his chair around. With this bold, strong image, Huerta addresses prejudices based on race and gender.

87. Eastman Johnson (1824–1906), *Woman Reading*, ca. 1874

Oil on board, 25⅛ × 18⅝ inches. Museum purchase with funds provided by the Gerald and Inez Grant Parker Foundation, 1977.9, The San Diego Museum of Art

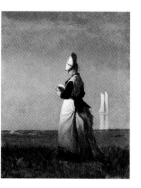

This type of representation—a woman alone amid an attractive landscape, in contemplative thought—appears in other works by the artist, notably *Woman on a Hill* (ca. 1875–80; Addison Gallery of American Art). Art historian Sarah Burns draws comparisons between the work of Winslow Homer (1836–1910) and Johnson's work from this period, identifying *Woman Reading* as Johnson's "most Homeric" work. The solitary figure reading as she walks toward the ocean evokes a sense of romanticism with this quiet moment free of urban chaos. Johnson, like other major artists of the period, avoided the industrialization that was becoming increasingly common in the United States and instead focused on individual and communal relationships with the serene potential of nature.

Burns further describes the scene in *Woman Reading:* "Shading her face is a steeply titled coal-scuttle straw hat edged in red. She appears to be holding a letter which absorbs her completely. On the ocean floats a two-masted sail boat, its reflections shimmering. Pink mist suffuses water and sky alike erasing the horizon. The paint handling is summary, describing figure and ground in sketchy swathes and stipplings."[131] In several ways, the style of the clothing worn by the woman is typical of American Victorian dress during the second half of the nineteenth century. The overskirt is draped at the front, similar in form to an apron, and the underskirt and a full petticoat are visible from the bottom. The overskirt usually was pulled up at the side to expose an underskirt, as depicted here.[132] Like many of Johnson's subjects, the woman in this painting is a member of the middle class, a status signified by her dress and her leisure.

88. Eastman Johnson (1824–1906), *Wounded Drummer Boy*, 1865–69

Oil on board, 26¼ × 21⅝ inches. Gift of Mrs. Herbert S. Darlington, 1940.79, The San Diego Museum of Art

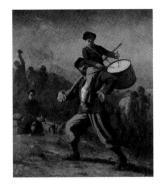

During the 1860s and 1870s, Eastman Johnson created many idealized narratives of American life. In these paintings, he represented different types of people, such as women, soldiers, children, and runaway slaves. *Wounded Drummer Boy* demonstrates one of many Civil War themes explored by the artist and is a study for a completed work in the collection of the Union League Club in New York. Several other studies for this subject matter were completed between 1864 and 1872. Another well-developed study resides in the collection of the Brooklyn Museum of Art (Study for *Wounded Drummer Boy*, ca. 1864–70). The model for the young boy might be Johnson's nephew, Philip J. Wilson. The subject matter itself was inspired by the Battle of Antietam (1862), the most violent engagement of the Civil War.

Drummer boys often traveled with soldiers and played music in order to raise the morale of the hardworking men. Patricia Hills writes, "The charming pathos of the subject disarms any genuine concern for the hardships of war or pitiful condition of this child-warrior."[133] Despite the pain of the injury to his right leg, the young boy is proudly hoisted on a man's shoulders and proceeds with his musical performance. His perseverance in the face of tragedy is a metaphor for Johnson's hope for the nation. Other artists, such as William Morris Hunt (1824–1879), recognized the symbolic power of young drummer boys. An example of Hunt's work, *The Wounded Drummer Boy* (1862), is in the collection of the Museum of Fine Arts, Boston.

Hills compares Johnson's drummer boy to a Christ figure, and the adult man who carries him can be viewed in her estimation as Saint Christopher.[134] By evoking religious imagery, Hills focuses on the drama and spiritual nature evident in this work. Another historian, Anne C. Rose, has made related observations, writing, "The tough little drummer, raised high, centers the composition. He is the moral exemplar, surrounded by touches of hopefulness: a wounded man being cared for and vegetation miraculously not tramped down. Completed six years after the war's end, the painting may have helped viewers frame sad memories in invigorating thoughts."[135]

Like Johnson, Walt Whitman was directly affected by the Civil War. Both men visited encampments and witnessed the ravages of war firsthand. Furthermore, in their respective art forms, Johnson and Whitman addressed a war that pitted one region of the country against another. In his poem "A Song for Occupations," Whitman writes:

> We thought our Union grand, and our Constitution grand,
> I do not say that they are not grand and good, for they are,
> I am this day just as much in love with them as you,
> Then I am in love with You, and with all my fellows upon the earth.[136]

The buoyancy of Whitman's lines and the sense of optimism they exude are also present in Johnson's *Wounded Drummer Boy*.

89. Joan Jonas (b. 1936), *Double Lunar Dogs*, 1984

Color videotape, 25 minutes. Museum purchase, v1987.6, Museum of Contemporary Art San Diego

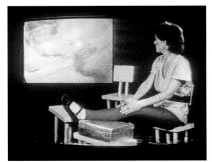

Joan Jonas initially pursued sculpture but turned to performance art in 1968. Her performances were captured on film, and she quickly became one of the most innovative artists working in the medium. Jonas recalls the beginnings of video art: "I wasn't trained in video art or performance. Nobody was, in the early 1960s. There was nothing to be trained in because there was no tradition of video or performance; it was totally new territory. There were artists working in dance and there were Happenings, but it wasn't a school. When contemporary American artists

first started going to Europe, I remember Philip Glass saying, 'the Europeans think we're primitives.' That was the advantage of being American; we were fresh and the language was fresh."[137]

In *Double Lunar Dogs*, Jonas incorporates elements of the short story "Universe" (1941), by Robert Heinlein (1907–1988),[138] such as the characters' struggle for survival and power as they try to remember their pasts. The characters in Jonas's video are on a spaceship, but they cannot recall their lives on Earth or remember the reasons for their journey. The artist has also inserted digital effects and NASA footage in her video. Confusing questions are posed, and disorienting visual effects occur frequently throughout the work. Viewers are left to ponder the plight of the characters and the negative effects of technology on their lives and in society. Jonas herself appears in the film along with other participants, including the actor Spalding Gray (1941–2004).

90. Barbara Kruger (b. 1945), *Untitled (Memory is Your Image of Perfection)*, 1982

Black-and-white photograph, 60¾ × 33¾ inches. Museum purchase with proceeds from Museum of Contemporary Art San Diego Art Auction 2002, International and Contemporary Collectors Funds, and funds from Nancy B. Tieken, 2003.13, Museum of Contemporary Art San Diego

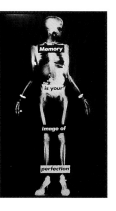

Barbara Kruger's aesthetic, composed predominantly of black-and-white images with the frequent addition of red bands with white text, stands out in the field of contemporary art. The texts tend to be both direct and thought-provoking. In her work, the artist has occasionally used X-ray effects, as in her *Untitled (Your Body is a Battleground)* (1989; The Broad Art Foundation), and evoked skeletons, as, for example, in her poster for Visual Aids (1992). While *Untitled (Memory is Your Image of Perfection)* bears some relationship to her other works, it is distinct from compositions that include photography of individuals and well-known people such as Eleanor Roosevelt and Marilyn Monroe.

This work suggests many of the major issues addressed across Kruger's oeuvre, in which the artist deals with gender, beauty, and other issues frequently associated with women. In *Untitled (Memory is Your Image of Perfection)*, the text suggests that perfection is obtainable only in one's mind. The figure in the image is stripped of commercially available ways in which to enhance one's physicality, save for shoes and bracelets, and is left in the hands of medical technique.

Kruger draws great inspiration from graphic design as well as advertisements of the 1940s and 1950s when creating many of her signature works. She has had direct experience with commercial design, as she worked as an art director for *Mademoiselle* magazine during the 1960s. She had her first gallery show in 1974 at the Artists Space in New York and began making large-scale installations in 1989, a practice that enabled her to use her long-standing interest in architecture. Her art has bridged the gap between the museum space and popular culture, with her work being shown in a number of important museums and the band Rage Against the Machine commissioning her to design backdrop art for one of its tours. Kruger, who was born in Newark, New Jersey, now splits her time between Los Angeles and New York.

91. Yasuo Kuniyoshi (1889–1953), *Girl in White Dress (Sara Mazo)*, 1934

Oil on canvas, 14¼ × 11¼ inches. Bequest of Earle W. Grant, 1972.53, The San Diego Museum of Art

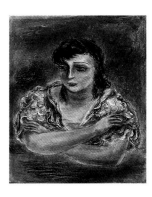

Yasuo Kuniyoshi was born in Okayama, Japan and came to the United States at the age of thirteen. He studied art first in Los Angeles and then in New York. During the late 1920s, he began spending extended periods in Woodstock, New York, and became an important member of the artists' colony there. Kuniyoshi returned to Japan twice during the 1930s, and his work was well received in his birth country. Despite his time away in Woodstock and abroad, he continued to be an important figure in the New York art scene, teaching at the Art Students League and the New School for Social Research, and he was the first president of the Artists' Equity Association, serving from 1947 and 1950.

This painting portrays Sara Mazo, soon to be Kuniyoshi's second wife, in a somber and reflective moment. They were married one year after the portrait was completed. *Girl in White Dress (Sara Mazo)* was given to The San Diego Museum of Art by Earle Grant, who purchased it from the Downtown Gallery in New York, an important space for modern American art. The back of the painting bears inscriptions from the couple. Kuniyoshi wrote "To Earl [*sic*] Grant with pleasant recollections of our meeting—more of them. April 19, 1935." Mazo's reads "With much appreciation of your choice—and to a new friend."

92. Jacob Lawrence (1917–2000), *The 1920's . . . The Migrants Arrive and Cast Their Ballots*, 1974

Screenprint, 31⅞ × 24¼ inches. Gift of Lorillard, a Division of Loews Theatres, Inc., 1976.193, The San Diego Museum of Art

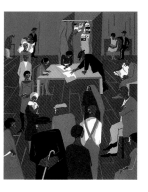

Born in Atlantic City, New Jersey, Jacob Lawrence spent the majority of his life in the Northeast. He studied with the painter Charles Alston (1907–1977), who had a significant influence on his career. To help support his early work, Lawrence received three consecutive fellowships from the Julius Rosenwald Fund in 1940, 1941, and 1942.[139]

An extraordinarily talented painter and printmaker, Lawrence is most known for his *Migration Series*, a collection of sixty paintings that address the movement of African Americans from the southern to the northern regions of the United States. Half of the original series is in the collection of the Museum of Modern Art in New York and the other half is in the Phillips Collection in Washington, D.C. Across his entire oeuvre, Lawrence was drawn to narrative art and often addressed the plight of workers and incidents in American history.

In this particular print, the artist references the themes of his *Migration Series*. The fifty-ninth work in the highly regarded collection of prints is accompanied by the following text: "In the North the Negro had freedom to vote." The process of African Americans gaining the right to vote inspired Lawrence in both *The 1920's . . . The Migrants Arrive and Cast Their Ballots*, 1974 and the *Migration Series*.

His parents were born in the South and migrated north, and the physical upheaval families went through so that they could obtain increased rights appealed to him as a subject. The angular depictions of the figures and the presence of sharp lines in *The 1920's . . . The Migrants Arrive and Cast Their Ballots* are characteristic of Lawrence's work.

93. James Luna (b. 1950), *Half Indian/Half Mexican*, 1991

Three black-and-white photographs, three prints, each 30 × 24 inches. Photographer: Richard A. Lou. Gift of the Peter Norton Family Foundation, 1992.6.1–3, Museum of Contemporary Art San Diego

James Luna is an internationally renowned performance artist of Native American heritage. He lives on the La Jolla reservation in north San Diego County and identifies as a member of the Puukitchum (Luiseño) and Ipi (Diegueño) tribes. Although Luna often performs alone, he has had high-profile performance partners, including Guillermo Gómez-Peña (b. 1955). Paul Chaat Smith wrote of Luna, "From his mountain outpost on the far edge of America, James Luna scans the horizon and sees everything. On clear days he can see the Pacific Ocean. On clear nights, ancient starlight washes over Palomar Mountain, and he can see forever. Luna watches and remembers."[140]

Luna often creates work that addresses stereotypes of Native American cultures and references the difficulties given communities face, such as political alienation and, in some families, alcoholism. In *Half Indian/Half Mexican*, the artist presents himself in a modest black tank top. In the first image, his hair is long and he wears an earring in his right ear, a hairstyle and item of jewelry typically associated with men of Native American descent. In the photograph on the right, he has short hair and a mustache; this haircut and facial hair are often associated with Mexican men, particularly twenty years ago, when the photograph was taken. In the middle photograph, the artist presents himself as in between, in a liminal space in which he is both Native American and Mexican. This liminal space is a reality across the United States but is particularly prominent in the southwestern region of the country. While Luna calls to mind similarities between the ways in which Native Americans and Mexicans are perceived and treated by the Anglo population, his work also reminds viewers that cultural identity is complex and cannot be reduced to one distinct label.

94. Iñigo Manglano-Ovalle (b. 1961), *Paternity Test (Museum of Contemporary Art San Diego)*, 2000

Chromogenic prints of DNA analysis, thirty prints, each 60 × 19½ inches. Museum purchase with partial funds from Cathy and Ron Busick, Diane and Christopher Calkins, Sue K. and Dr. Charles C. Edwards, Dr. Peter C. Farrell, and Murray A. Gribin, 2000.24.1–30, Museum of Contemporary Art San Diego

Iñigo Manglano-Ovalle's childhood informed his artistic development. With one parent from Spain, and the other from Colombia, he grew up on three continents and developed a certain internationalism that shaped his later work. Furthermore, his parents were medical researchers, and their work encouraged the artist's interest in science and technology. Manglano-Ovalle pursued his formal studies at Williams College and the School of the Art Institute of Chicago.

Paternity Test (Museum of Contemporary Art San Diego) is made up of large-scale panels that portray the digital DNA portraits of members of the Museum of Contemporary Art San Diego's board of trustees. Cell samples collected from trustees by buccal swabs were processed, and the results were enlarged, revealing lush, colorful, intoxicating patterns. The colors recall the abstract paintings of a previous generation, but the digital format of the work is more closely related to contemporary trends of the late twentieth and early twenty-first centuries. Furthermore, Manglano-Ovalle raises larger issues of categorizing people and using scientific analysis for determining identity.

DNA testing has increasingly entered the popular consciousness as a result of its use in paternity testing and in both identifying the guilty and exonerating the wrongfully accused and imprisoned. Manglano-Ovalle's use of this form of technology melds scientific study, art, and social commentary. Also, by creating abstract portraits, he limits the way in which viewers can read the subjects. Devoid of defining features such as personal possessions and physical appearance, the portraits simultaneously present scientifically accurate and creatively abstract representations of an important group of people.

95. Daniel Joseph Martínez (b. 1957), *Self-portrait #9B, Fifth attempt to clone mental disorder or How one philosophizes with a hammer, After Gustave Moreau, Prometheus, 1868; David Cronenberg, Videodrome, 1981*, 2001

Digital print, 48 × 60 inches. Museum purchase, 2004.19, Museum of Contemporary Art San Diego

Daniel J. Martínez developed a series of photographs in which he depicted himself in painful scenarios—eyelids stapled shut, intestines removed, and a cut across the neck. Both of the works referred to in the title, the painting by Moreau and the film directed by Cronenberg, address issues of bodily harm. The self-portrait, with the figure's hand inserted into a large vertical cut, conjures thoughts of self-mutilation but also serves as a metaphor for the role of violence in society and its effects on individuals and the population at large.

In addition to his photography, Martínez has created public interventions that address physical violence. In 1992, he produced a large-scale poster collage on the wall of a former store at the corner of Washington Boulevard and Main Street in Los Angeles in response to the acquittal of four police officers on trial for the brutal beating of Rodney King (1965–2012). Among the images and text on the poster were two blood-red graffiti-painted guns and the words "Time to Die."

Daniel J. Martínez was born in Los Angeles and completed his studies at the California Institute of the Arts in Valencia, California. In 1993, the artist burst onto the international art scene with his participation in the Whitney Biennial, Whitney Museum of American Art, New York, and the Venice Biennale, Italy. Martínez lives in Los Angeles and is a professor of art at the University of California, Irvine.

96. Ana Mendieta (1948–1985), *Untitled (from the Silueta Series)*, 1976/2001

Nine Cibachrome prints, edition 8 of 10, five prints, each 8 × 10 inches; four prints, each 10 × 8 inches. Museum purchase, International and Contemporary Collectors Funds, 2002.2.1-9, Museum of Contemporary Art San Diego

Ana Mendieta was born in Cuba and came to the United States while she was still a young girl with her sister, Raquel. They settled in Iowa, and Mendieta experienced a difficult cultural transition. The artist's personal experience as an exile has often been cited as a major impact on her work, but her art relates more closely to advancing trends in contemporary art and more specifically to issues of cultural history and gender. She studied video art and performance art at the University of Iowa during a period of tremendous artistic innovation. Her earlier works, created while she was still enrolled in graduate school, involved her physical self and often dealt with issues of gender identity and difficult topics such as sexual abuse.

Mendieta received her MFA degree from the Intermedia Program at the University of Iowa in 1976. Lucy Lippard's inclusion of Mendieta's work in an essay for *Art in America* brought Mendieta's work to national attention. She joined AIR gallery in New York, a space associated with powerful work by women artists, in 1978, but two years later, in 1980, she openly criticized "American Feminism" for serving solely the white middle class. The activist group the Guerrilla Girls often evokes Mendieta's name in its fight for greater representation of women at significant institutions.

Mendieta spent time in Mexico through a summer study program and created a number of important works in that country. In fact, several *Siluetas* were realized on the beach at La Ventosa "incorporating red tempera, red flower, and white cloth on driftwood, which washed out to sea."[141] La Ventosa is a fishing village on the peninsula of Salina Cruz on the Gulf of Tehuantepec. In this work, along with many others, Mendieta successfully combined body art and land art. Her experiences in Mexico gave the budding artist great inspiration. Some of the performances staged in Mexico dealt quite literally with traditional culture—referring to pre-Columbian, colonial, and folk art. Mendieta became interested in the female form. Her *siluetas* are modeled after an ancient goddess pose, a project that she turned her attention to in 1973.

Both Chris Burden (b. 1946) and Robert Smithson (1938–1973) created notable works in Mexico around this period. Mexico has long been a source of inspiration for foreign artists, but specifically for artists traveling from the United States. For Mendieta,

Mexico was an in-between space. She was not tied to her biographical experiences in Cuba and in the United States and was free to explore her lyrical and imaginative practice. Jane Blocker wrote about this particular body of work, "In yet another shadow, which she created in Mexico in 1976, we are brought to the water's edge and forced to confront the border, to see the trace of a body that is now no longer there. In this work, she inscribes her silhouette on the beach in Mexico, adds red paint to the shoal water, and photographs and films the successive stages in which the tide reclaims the figure and takes it out to sea. This shadow briefly inhabits the liminal space where land and water meet, where Mexico's national frontier begins and ends."[142]

The iconic nature of Mendieta's *Siluetas* and their ephemeral nature documented through film and photography have led to increased interest in her work and in these particular works in the collection of the Museum of Contemporary Art San Diego. Julia P. Herzberg observes,

Blood—actually bloodlike red tempera—was also the material used for another untitled *Silueta* work that, along with a Silueta of red flowers, was made at the shoreline of Salina Cruz on the Gulf of Tehuantepec so the rising tide would wash away from the figure, recalling Acconci's *Drifts* and her own *Ocean Bird Washup*. Mendieta's remarks in her sketchbook document her plan: "Make a Silueta at the end of the ocean. Leave the figure so the water flows into it and then empties out. Also fill the Silueta with blood or red tempera so that it empties in the ocean and disappears. Over time document the erosion of the figure."[143]

As a young artist in the midst of her creative development, Mendieta made work that was on a par with that of the established performance artist Vito Acconci. Moreover, her dedication to the goddess pose and to the use of natural materials established her stature as a contemporary artist of note.

97. Bruce Nauman (b. 1941), *Studies for Holograms*, 1970

Set of five silkscreens, edition 120 of 150, each 26 × 26 inches. Museum purchase, 1978.6.1-5, Museum of Contemporary Art San Diego

Bruce Nauman received an MFA degree from the University of California, Davis. He was a pioneering performance artist, and many of his early photographs feature his exploration of his own physical ability and potential. These formative photographs relate closely to the works depicted here. His photograph *Self-Portrait as a Fountain* (1966) was included in his inaugural show at the Leo Castelli Gallery. It depicts the artist spewing water from his mouth in a clean arc. On a panel adjacent to the photograph were the words "The Artist is an Amazing Luminous Fountain." In *Self-Portrait as a Fountain*, Nauman is placed slightly off center in the composition, and he clearly references Marcel Duchamp (1887–1968). For some of his first photographs, Nauman spun around in a dark room holding a flashlight. His body disappears in the resulting photographs, but he was physically present in their making. Nauman took up photography in a serious way after seeing a retrospective of the work of Man Ray (1890–1976) in the fall of 1966.

In the five images presented here, the artist continues his earlier photographic studies. By contorting his face, he manipulates the camera's control over its subject. He refuses to offer a natural pose and instead frames the images to focus on his lips, neck, nose, mouth, and cheeks. The viewer is not permitted to see his full face. Heather Diack offers a social context for these works: "Viewed within the context of political and social upheaval in America (such as the Kent State shootings and the Civil Rights movement) and internationally (namely, the war in Vietnam) they must be seen as more than childish insolence. For although not overtly political, their emphasis on discomfort and distorted information can be read as a reaction to and against their time, and a questioning of the possibility of protest, not just in art but in the public realm more broadly."[144] Some of Nauman's contemporaries also employed their physical selves as a primary artistic medium during this period. In 1972, two years after Nauman completed this work, Ana Mendieta (1948–1985) conducted a similarly motivated project, *Untitled (Facial Hair Transplants)*.[145]

Beyond photography, Nauman worked in different media. He was a key figure in the early experimental film and video movement of the late 1960s and early 1970s. He also created nontraditional sculpture inspired by minimalism.

98. Alice Neel (1900–1984), *Portrait of Mildred Myers Oldden*, 1937

Oil on canvas, 36¾ × 21¾ inches. Bequest of Stanley K. Oldden, 1991.98, The San Diego Museum of Art

Alice Neel is noted for her sensitive portraits of women. Neel found work through the Works Progress Administration during the economic depression of the 1930s.[146] She worked in relative obscurity during the 1940s and 1950s but did not garner major attention until the rise of feminism in the 1960s led to a reconsideration of previously overlooked artists. She continued to create portraits throughout her career and made a series of works by well-known artists and other figures, including Faith Ringgold (b. 1930).

In contrast to her later portraits, this is more finely painted and the subject, Mildred Myers Oldden, more naturalistic.[147] Neel demonstrates sensitivity in her portrayal of her sitter and also reveals a certain sense of psychological intensity. Mildred wears a rather fashion-forward hat, and her act of smoking exhibits the increasing popularity of the practice among women in the 1920s and 1930s. Both Mildred and her husband, Stanley, were friends of the artist's in New York. During the 1930s, when Neel painted this portrait, she lived in East Harlem. Her neighbors and friends often served as models. In this case, though, the subject and her husband lived, not in the same neighborhood as Neel, but first at 865 First Avenue and later at 160 E. Forty-Eighth Street. Mildred was Stanley's second wife, and she was nineteen years his junior. He was a successful businessman who owned a mercantile collection agency. They must have been fairly affluent, since they traveled to Europe numerous times on ocean cruise liners such as the *Mauretania* and the *Queen Mary*. Stanley gave the painting to the The San Diego Museum of Art after the couple relocated to La Jolla, California. Mildred died in 1989 and Stanley in 1991, which led to the bequest of this painting to the museum during the same year.

99. Dennis Oppenheim (b. 1938), *Attempt to Raise Hell*, 1974–85

Clothed figure with cast aluminum head and hands, cast iron bell, wood base, motor, 40 × 48 × 36 inches. Museum purchase with matching funds from the National Endowment for the Arts, 1989.5, Museum of Contemporary Art San Diego

Dennis Oppenheim received his BFA degree from the California College of Arts and Crafts (now California College of the Arts), in Oakland, California and an MFA degree from Stanford University; he has spent the majority of his career in New York. His work incorporates various mechanisms and involves action in both a literal and a conceptual way. He is known for his work related to the land art and body art movements. As he explains, "Body art as I practiced it from 1971 to 1973 was always complemented with other works, installations, things of this sort. In 1974 Body Art moved into installations. It was time to move on. Marionettes, I was familiar with because I made them as a child. They seemed to be an obvious way of continuing the performance-related self-referential autobiographical work without being physically part of the engagement."[148] Oppenheim refers to the marionettes as "surrogates," recognizing that the figures are self-portraits.

In *Attempt to Raise Hell*, the artist portrays a small figure dressed in a felt suit sitting in front of a bell. The figure is on a timer, and every sixty seconds, the figure lunges forward, knocking his head on the bell and creating a loud noise that lasts for about thirty seconds and resonates in the gallery. The audio component is an important part of the experience of this piece and other works by the artist. The act of the small figure is both stubborn and obsessively self-destructive.

100. Sarah Miriam Peale (1800–1885), *Portrait of Mrs. William Crane*, ca. 1840

Oil on canvas, 30 × 24⅞ inches. Gift of Mary Vivian Conway, 1958.31, The San Diego Museum of Art

The subject of this portrait is Jean Niven Crane (née Daniel). Her father, Dr. Moncure Daniel, was a surgeon. Her parents were married in 1793, and she was their second child. Her family included several distinguished members such as her uncle Peter Vivan Daniel, who was a member of the U.S. Supreme Court, and her maternal grandfather, Thomas Stone, one of the distinguished signers of the Declaration of Independence.[149] Although her birth date is unknown, we know that she died in 1881. The dress she wears dates to about 1845, and Sarah Miriam Peale was painting in Baltimore at that time.[150] The painting remained in the possession of ancestors until it was donated to the The San Diego Museum of Art. The donor's great-grandmother was the subject's sister.

Painting was not a hobby to Sarah Miriam Peale. It was her profession, and she was one of the earliest American women to pursue painting as a primary occupation. Peale was the youngest daughter of James Peale (1749–1831), an established painter of miniatures and still lifes. Her uncle was Charles Willson Peale (1741–1827), and Raphaelle Peale (1774–1825; see cats. 41, 42) and Rembrandt Peale (1778–1860) were her cousins. She grew up in Philadelphia, where she was immersed in the city's rich artistic scene and readily exposed to her own family's dedication to the arts. Peale trained by studying under her cousin Rembrandt Peale. During the early 1820s, she moved to Baltimore and was advertising her skills as a portrait painter in Baltimore newspapers as early as 1822; she moved to Saint Louis in 1847. Other accomplished women artists in the Peale family include this artist's sister, Margaretta Angelica Peale (1795–1882), and Harriet Cany Peale (1800–1869), who was married to Rembrandt Peale.

101. Guy Pène du Bois (1884–1958), *Chanticleer*, 1922

Oil on canvas, 24½ × 32 inches. Museum purchase with funds from the Helen M. Towle Bequest, 1936.15, The San Diego Museum of Art

Guy Pène du Bois was one of the many artists active in New York during the opening decades of the twentieth century who fell under the influence of Robert Henri (1865–1929). Pène du Bois responded affirmatively to Henri's charge to seek creative stimulation from life and found inspiration in cafés, restaurants, concerts, and clubs. While he remained busy painting, he also wrote art criticism and worked for two important publications, *New York American* and *Arts and Decoration*, where he was editor from 1913 to 1921.

Pène du Bois's work is often characterized by rounded and rather stylized figural forms. In certain compositions, like *Chanticleer*, distinctive features such as faces are less defined. While one rotund male is positioned in the corner, another man struts across the room and cuts quite a figure. With a mustache, top hat, and cane, the elegant man, the eponymous Chanticleer, appears to be in motion. His arms are held out from his body as he hits a full stride, and the tail of his coat hangs in the air. The bright red of the wall in the background adds a dramatic and somewhat startling feel to the composition.

Around the time that Pène du Bois painted *Chanticleer*, he also completed *Juliana Force at the Whitney Studio Club* (1921; Whitney Museum of American Art), which, like *Chanticleer*, presents two central but disconnected figures within a gallery space. Pène du Bois's paintings anticipate the interior scenes of psychological intensity set in New York by the painter Edward Hopper (1882–1967).

102. Ammi Phillips (1788–1865), *Portrait of George Greenwood Reynolds*, 1829

Oil on canvas, 30¾ × 25 inches. Gift of Mrs. John L. Guinther in memory of John Greenwood Reynolds, M.D., 1986.1, The San Diego Museum of Art

103. Ammi Phillips (1788–1865), *Portrait of Abigail Penoyer Reynolds*, 1829

Oil on canvas, 30⅞ × 24⅞ inches. Gift of Mrs. John L. Guinther in memory of John Greenwood Reynolds, M.D.,1986.2, The San Diego Museum of Art

An itinerant painter, Ammi Phillips worked in rural communities in Connecticut, Massachusetts, and New York for more than fifty years. He was a self-taught painter and created a highly recognizable portrait style. In this pair of subdued portraits, the somber background and rather reserved poses and dress worn by the sitters lack the romanticism practiced by Phillips's contemporary Thomas Sully (1783–1872) in his *Portrait of Esther Warren*, also included in this publication (cat. 112).

In New York, Phillips painted in communities like Hoosick, Troy, and Rhinebeck. He made these two portraits of George Greenwood Reynolds and Abigail Penoyer Reynolds in South Amenia, New York. George Greenwood Reynolds (1788–1873) was one of five children born to George Reynolds (1756–1808) and Abigail Peck (1759–1837).[151] Of Welsh heritage, Reynolds was born in Bristol, Rhode Island and later settled in South Amenia. Before he had a family, he participated in the War of 1812 with the Dutchess County Regiment. On May 26, 1819, he married Abigail Penoyer (1794–1863?). The couple had four children, George Greenwood, Caroline, Mary Elizabeth, and Justus Powers. Justus Powers (1833–1910), who was born in the house his father built, became a farmer and patented several items, including the first cream separator.[152] Both paintings were in the possession of the sitters' ancestors until they were given to the Museum.

In *Portrait of George Greenwood Reynolds*, the subject holds in his hand a copy of the *Intelligencer*. This issue of the newspaper, which was based in Washington, D.C. and was associated with the Whig Party, is dated June 24, 1829. Phillips used the paper as a prop in several works.

The artist did not always sign his paintings, making *Portrait of Abigail Penoyer Reynolds*, which has his signature and the date written in the upper left of the painting, distinctive among his works. The delicate rendering of the lace hat, an accoutrement that appears in other Phillips's works, and the gentle way in which the ribbons fall naturally, one over her shoulder and the other along her neckline, are standout features of this portrait.

104. Ben Shahn (1898–1969), *Helix and Crystal*, 1957

Tempera on board, 53 × 30 inches. Museum purchase through the Earle W. Grant Endowment Fund, 1973.21, The San Diego Museum of Art

Ben Shahn once said, "I tell you, I think I am the most American of all American painters. This is a novel thing to say. It is said without modesty. Maybe because I came to America and its culture and was sort of swallowing it by the cupful."[153] Shahn was born in Lithuania and came to the United States as a young boy with his family. His work frequently incorporated his concern with social issues. As a result of the violence of war and particularly the use of the atomic bomb, Shahn had become somewhat skeptical of science and technology. He maintained a friendship with Albert Einstein (1879–1955) and others in the scientific community but protested atomic energy in his art.

Shahn produced murals with the Works Progress Administration and worked on a series of photographs documenting the struggle of agricultural workers for the Farm Security Administration.

During World War II, he made posters for the Office of War Information. *Helix and Crystal* was made around the time that he was producing posters for the National Committee for a Sane Nuclear Policy. Most notably, in 1960, he completed a poster that declared "Stop H Bomb Tests." Shahn's concerns about nuclear research contextualize his rendering of a scientist in *Helix and Crystal*.

Shahn turned increasingly to an allegorical mode in the years following World War II, and, as in *Helix and Crystal*, he repeatedly juxtaposed scientists at work to molecular structures. Although he had found work through the Works Progress Administration and the Office of War Information, his government connections did not prevent visits from FBI agents who questioned his "subversive" activities.[154] Subject matter aside, Shahn's frequent use of tempera and the blurred edges of his forms in *Helix and Crystal* reveal a painterly style that had much in common with the development of abstract art occurring in the United States at this time.

105. Cindy Sherman (b. 1954), *Untitled*, 1975

Gelatin silver print, edition 43 of 125, 17 × 14 inches. Museum purchase, 1985.4, Museum of Contemporary Art San Diego

106. Cindy Sherman (b. 1954), *Untitled*, 2000

Color photograph, edition 2 of 6, 36 × 24 inches. Museum Purchase, International and Contemporary Collectors Fund, 2001.12, Museum of Contemporary Art San Diego

Cindy Sherman was born in Glen Ridge, New Jersey, and studied at Buffalo State College, New York. She received her degree in 1976, one year after she created *Untitled* (1975). The early date of this photograph makes it an important marker in the artist's career and a significant work in the permanent collection of the Museum of Contemporary Art San Diego.

After graduation, Sherman moved to New York and began *Untitled Film Stills* (1977–80), a series composed of black-and-white photographs. In these early works, she often represented scenarios and characters similar to those found in B movies. The artist presents herself in these photographs but not as a manifestation of her own identity; instead, there is an erasure of personal identity and an emphasis on identity as a social construct and cultural phenomenon. These early works formed Sherman's entire oeuvre. She has depicted herself in a variety of situations and as a multitude of characters with the assistance of makeup, costume, and prosthetics.

In *Untitled* (2000), Sherman portrays herself as a middle-aged woman, one in a series that the artist referred to as "California types." In this work, she assembles an identity related to the stereotypical idea of a woman from California, with a tan, makeup, bleached blond hair, a tiara, and a track suit. Does the track suit refer to a focus on fitness or the uniform of the middle-aged mom on her way to pick up her kids at school? The jacket looks older, as it evokes 1980s fashion. The overly bright color of the hair and the length and style also appear out of fashion. Has Sherman portrayed a former beauty queen or a middle-aged California Barbie? The mystery behind the motivations of the woman depicted is indicative of the artist's work and brings the photograph into a larger discussion of gender and the construction of identity.

107. Everett Shinn (1876–1953), *Stage Costume*, 1910

Pastel and gouache, 7⅝ × 9⅝ inches. Bequest of Mrs. Inez Grant Parker, 1973.91, The San Diego Museum of Art

Everett Shinn rendered theatrical performances in London and Paris, but most often New York was his muse. Early on, he was inspired by the works of Edgar Degas (1834–1917), which he viewed during the time he spent in Paris. Shinn shared with Degas an interest in dancers and the fleeting moments that occur both in front of crowds and backstage.

Although the crowd is not evident in this work, its presence is experienced through the subject's slight bow and glance toward the front rows of the audience. Furthermore, the viewer of this work has a perspective similar to that of a person seated in a balcony. Like many of his depictions of performers, this portrait does not specifically identify the subject. With the spotlight shining down on her from above, Shinn contrasts the abstract bold representation of the stage curtain with delicate details such as the ruffles of the dress and the long line of buttons that runs down the center of her costume.

Shinn often worked with pastels, although here, he chose to work on a black background, an uncommon characteristic across his oeuvre.[155] Much of the black evident in the picture is actually the paper on the board, not black pastel. The San Diego Museum of Art has another work by Shinn in its permanent collection, a portrait of an actor walking on the street.

108. Taryn Simon (b. 1975), *Frederick Daye, Alibi Location, American Legion Post 310, San Diego, CA Where 13 witnesses placed Daye at the time of the crime Served 10 years of a life sentence for Rape, Kidnapping and Vehicle Theft*, 2002

Chromogenic print, edition 1 of 5, 48 × 62 inches. Museum purchase, International and Contemporary Collectors Funds, 2004.7, Museum of Contemporary Art San Diego

Taryn Simon's photographic series often depict specific groups of people and societal trends. Her body of work *A Living Man Dead and Other Chapters I–XVIII* (2008–11) portrays groups of people such as a landless family in India and children living in an orphanage and maps their relationships to one another with short photographic and textual narratives. For her *Contraband* series (2009), Simon photographed confiscated objects at the U.S. Customs and Border Protection Federal Inspection Site and the U.S. Postal Service International Mail Facility at John F. Kennedy International Airport, New York.

In her series *The Innocents* (2003), Simon portrays wrongfully convicted individuals at various locations pertaining to their arrest: the sites where they were arrested, the sites where they allegedly committed crimes, and the sites where they were seen by witnesses while allegedly committing crimes. In these works, Simon addresses the central role photography played in the identification of the wrongly accused and the power of photography to meld truth and fiction.

Frederick Daye is an ex-marine from Iowa who was riding in a car with an open container of beer when the car was pulled over by San Diego police. This infraction led to his arrest for rape, kidnapping, and theft. Although the rape victim and a witness chose Kaye out of a lineup, thirteen other witnesses came forward to attest that Daye was drinking at the bar at the American Legion Post 310 at the time of the crimes. Nevertheless, Daye was convicted and spent ten years in jail. In 1994, he was exonerated as a result of new information, specifically, from DNA testing. Daye has struggled with alcoholism, unemployment, and emotional trauma since leaving prison. In Simon's powerful portrait, he sits at the bar with a beer in front of him and returns the viewer's gaze. Although dangling lights, framed pictures, and a poker machine crowd the scene, his honest stare is the focal point of the photograph.

109. Lorna Simpson (b. 1960), *Guarded Conditions*, 1989

Eighteen color Polaroid prints, twenty-one engraved plastic plaques, plastic letters, 91 × 131 inches overall. Museum purchase, Contemporary Collectors Fund, 1990.12.1-28, Museum of Contemporary Art San Diego

Lorna Simpson received a BFA degree in photography from the School of Visual Arts in New York in 1983 and an MFA degree in visual arts from the University of California, San Diego, in 1985. She had first solo exhibition, *Gestures/Reenactments*, at 5th Street Market Alternative Gallery in San Diego.

Simpson typically takes a conceptual approach to figurative photography, although she has produced landscapes and object studies. In *Guarded Conditions*, the assembled photographs compartmentalize six nearly identical photographs of the subject. The female figure seen from behind suggests vulnerability, which is further emphasized by the manner in which her hands are placed behind her back. The text, which reads "skin attacks" and "sex attacks," allows the viewer to consider race and gender, signature aspects of Simpson's oeuvre. Although the artist's works are frequently associated with these paramount and inherently complex concepts, her art must not be viewed solely through these lenses. In an interview, Simpson stated, "I just try to go about making the work and have it come to fruition. And in some ways it is interesting to try to build very complex characters that live outside of a stereotype of time, place, identity, sexuality, and race and are complicated by those things, and this implicates everyone. I find it fascinating and still unbelievable—or maybe not that unbelievable—that work can be viewed or perceived as if in a racial/cultural vacuum."[156]

Guarded Conditions is discussed along with other aspects of Simpson's art in the interview with the artist included in this volume.

110. Kiki Smith (b. 1954), *Untitled (Skin)*, 1990

Wax, gauze, shoe polish, pigment, 30 × 50 inches. Gift of the Peter Norton Family Foundation, 1992.9.1-2, Museum of Contemporary Art San Diego

Kiki Smith often makes work that addresses human anatomy and presents both the internal workings of the body and its exterior form. For *Untitled (Skin)*, the artist made a beeswax cast of a male model's body. She then took the cast and reinvented it as the small squares that appear here in grid form. The format of the piece references the statistic that the average body is covered by two thousand square inches of skin. While *Untitled (Skin)* demonstrates scientific inspiration and appears in an orderly form, the organic is also present in its reference to skin and through materials like the mesh, which droops below the lower edge of the beeswax. Toby Kemps writes of the work: "Evincing both the cool logic of a mathematical grid and the rolling fleshiness of a body in extremis, Smith's sculpture is a memento mori for the age of bioengineering."[157]

Smith completed her first life-size sculptures of human forms, a type of work for which she would become highly recognized, in 1990, the same year in which she completed *Untitled (Skin)*. Maura Reilly wrote of the artist: "In the twenty years that Kiki Smith has been exhibiting her multimedia work, she has explored the body from inside to outside, constantly conflating the borders between the two. A Virgin Mary with flayed skin, a disembodied stomach, a wax figure with exposed muscles, a porcelain pelvis on a pedestal, truncated hands and feet—all are part of her extensive repertoire."[158] Smith's father, the sculptor Tony Smith (1912–1981), is also represented in *Behold, America!* with his work *The Snake Is Out* (1962).

111. Edward Steichen (1879–1973), *Portrait in Grey and Black*, 1902

Oil on canvas, 31⅞ × 39⅛ inches. Museum purchase through the Earle W. Grant Acquisition Fund, 1975.1, The San Diego Museum of Art

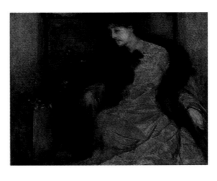

Most people think of Edward Steichen as a photographer. He developed a great passion for taking photographs when he was stationed in France with the U.S. Army. Indeed, he was an innovative photographer, partnering with the influential Alfred Stieglitz (1864–1946) on a number of projects, and several of his works were reproduced in Stieglitz's legendary journal *Camera Work*. Moreover, Steichen curated the groundbreaking photography exhibition *The Family of Man* (1955) at the Museum of Modern Art in New York.

Steichen was also a painter, but he destroyed many of his works in a fire in an attempt to focus only on photography. After burning copious canvases in France, he destroyed the rest when he returned to his New York studio. The paintings that remain were sold or given to friends before 1923.

Portrait in Grey and Black is a melancholy portrait with gentle infusions of color. The woman's lips and the flowers in a vase before her provide a small injection of color to the composition's overall muted palette. The painting's darker hues mimic the subject's facial expression. At the time that he painted this work, Steichen was influenced by tonalism, a style adopted in the late nineteenth century by American artists who were drawn to atmospheric effects and a darker color palette. Moreover, the color selections reference the work of painter James Abbott McNeill Whistler (1834–1903).

112. Thomas Sully (1783–1872), *Portrait of William Warren*, 1808

Oil on panel, 26 × 21¾ inches. Gift of Anna D. and John R. Reilly, through their children, 1973.114, The San Diego Museum of Art

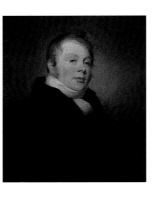

Thomas Sully was an influential figure in Philadelphia and eventually taught at the prestigious Pennsylvania Academy of the Fine Arts. In this portrait, he rendered the likeness of another important Philadelphia figure, William Warren (1767–1832), an accomplished actor. Sully was from a family of actors, and therefore it is not surprising that he painted portraits of individuals involved in theater.

In this three-quarter portrait, Warren wears a striking black coat and a sharp, high, white collar. Overall, this painting is a much more subdued representation than its companion piece, *Portrait of Esther Fortune Warren and Her Daughter Hester* (cat. 113), which has richer colors and a more dramatic background and is ultimately a more romantic portrait.

Warren was born in Bath, England. His father was a cabinetmaker, and he had seven brothers, one of whom was Henry Warren, a talented artist. Warren demonstrated an interest in acting from an early age. As his career progressed, he became known as a comedic actor. Thomas Wignell (1753–1803), a founder of the New Theater, which was located on Chestnut Street in Philadelphia, invited him to perform in a number of productions.[159] Philadelphia was one of the first cities to boast an American theater that could compare to the theater in England. Warren's first role in the United States was Friar Laurence in *Romeo and Juliet*. After Wignell's death, Warren took on a major role in the management of the theater, and he invited his brother, Henry, to come to the United States to paint scenery and design costumes for his productions in Philadelphia.[160]

113. Thomas Sully (1783–1872), *Portrait of Esther Fortune Warren and Her Daughter Hester*, 1811

Oil on canvas, 25 3/8 × 21 3/8 inches. Gift of Anna D. and John R. Reilly, through their children, 1973.115, The San Diego Museum of Art

Thomas Sully was born in Horncastle, Lincolnshire, England. A prolific painter, he was considered to be the most important portraitist in Philadelphia during the first half of the nineteenth century. Moreover, following the deaths of noted portrait painters Gilbert Stuart (1755–1828) and Charles Willson Peale (1741–1827), Sully's reputation and popularity grew. Over the course of his successful seventy-year career, he painted some two thousand portraits.

Sully arrived in the United States with his family in 1792, when he was just nine years old. In June 1809, he traveled to England, where he had the opportunity to meet with Benjamin West (1738–1820) and absorb his techniques. A comparison of *Portrait of Esther Fortune Warren and Her Daughter Hester* with its companion piece, *Portrait of William Warren* (1808, cat. 112), reveals how Sully's style evolved after he returned to the United States. His rendering of Esther Fortune Warren portrays a richer, more decoratively dressed figure. The subject wears a velvet robe, and lace on the garment beneath the robe shows across the top of her back. The background of the painting is more lush than those in Sully's earlier portraits.

Esther Fortune Warren was William Warren's third wife. They had six children together, and Hester was their eldest child. All of the children in the family entered the family business of theater. Hester Warren (1810–1841; see cat. 112) became an actress and married a musician.[161]

114. Fred Tomaselli (b. 1956), *Head with Flowers*, 1996

Paper collage, datura, ephedra, hemp, and resin on wood, 60 × 60 inches. Museum purchase, Contemporary Collectors Fund, 1997.14, Museum of Contemporary Art San Diego

Born in Santa Monica, California, Fred Tomaselli was influenced by the punk rock scene in Los Angeles during the late 1970s and early 1980s and the finish fetish artists who found inspiration in the colorful, smooth surfaces of surfboards and automobiles. He was also deeply interested in the effects of hallucinogenic drugs and how that experience could by expressed or incorporated into his art.

Tomaselli studied painting, but collages became the focus of his work. By combining a plethora of substances with precision, he brings a scientific sense of order and function to his materials, almost as if they were specimens. Some works in his oeuvre incorporate a variety of legal and contraband drugs, and *Head with Flowers* includes hemp and datura. Datura is found in the Americas and is particularly dense in the United States and Mexico. The leaves have hallucinogenic properties and have been used as a poison, as a way in which to facilitate a sacred rite, and as a recreational drug. The interlocking forms and the variety of flowers create a dizzying effect for the viewer.

At the middle of the composition is the profile of a man with his brain outlined. While this piece would have made an excellent contribution to the forms section of *Behold, America!*, it finds its home for this project here in this section, figures. It is one of several works that exemplify the fluidity of the *Behold, America!* sections. Tomaselli lives and works in Brooklyn, New York. In 2010, the Brooklyn Museum of Art honored him with a midcareer survey.

115. Bill Viola (b. 1951), *Heaven and Earth*, 1992

Two-channel video installation, edition 1 of 2, dimensions variable. Museum purchase, Contemporary Collectors Fund, 1993.1, Museum of Contemporary Art San Diego

Now considered one of the most important video artists in the United States, Bill Viola honed his interest in experimental video at Syracuse University, where he received a BFA degree in 1973. This piece dramatically combines light and form. Upon first viewing, the tall pillars—one hanging from the ceiling, and the other mounted to the floor—offer a striking sense of minimalism. On closer inspection, however, the work reveals itself to be a portrait of a woman and child, one of the most common images in the history of Western art. In this case, though, the woman is not the mother of the child but the mother of the artist, and the baby is the artist's newborn child. The two monitors are attached to the pillars and face each other as though the people depicted are in dialogue, with each face, one youthful and one elderly, reflected in the other. In explaining the piece,

Viola stated, "It's like the famous Michelangelo two fingers—God and man not actually touching in the Sistine Chapel. It's that kind of an idea—heaven and earth never quite meet."[162] The grandmother and the grandchild, who never had the opportunity to meet, are united in this work of art. *Heaven and Earth* relates to a much earlier work by Viola, *Silent Life,* in which he captures some of the earliest images of babies (from ten minutes to one day old) born in a New York hospital. Both works reinforce the steady power of the life cycle. Deidre Boyle notes that "Viola's art, like that of Robert Smithson or James Turrell, is situated within a contemporary art tradition that draws its authority and iconography from primitive art and mythology, reaching back in time to the origins of art in religion. It is not an echo of the past, although it resounds with the past."[163]

116. Carrie Mae Weems (b. 1951), *What Are Three Things You Can't Give a Black Person?*, 1987

Gelatin silver print with answer plaque, edition 1 of 5, Framed print 20¾ × 16¾ × 2 inches; Plaque 1⅝ × 8 inches. Museum purchase with funds from Joyce and Ted Strauss, 1996.16.1–4, Museum of Contemporary Art San Diego

Carrie Mae Weems began taking photographs in 1973. Her early influences include Dawoud Bey (b. 1953) and the work of Robert Frank (b. 1924), Walker Evans (1903–1975), and Garry Winogrand (1928–1984).[164] Weems was born in Portland, Oregon, and received a BFA degree from the California Institute of the Arts and an MFA degree from the University of California, San Diego, in 1984. Her work often addresses the way in which African Americans have been historically portrayed from the nineteenth century to the present. More broadly, her work questions the image and its role in creating accurate historical accounts. Weems frequently incorporates old photographs in her work and includes text that recontextualizes the image for viewers.

In this photograph, Weems presents a middle-aged man resting one arm on a ledge as he calmly returns the gaze of the photographer. The man's inaction is contrasted with the provocative question below

him: "What Are Three Things You Can't Give a Black Person?" Below the man, printed on a placard in white letters on a red background, is the word "Answer." Weems takes a conceptual approach to her explorations of stereotypes and the inequality of power. The use of red, black, and white in this work suggests an important later body of work, *From Here I Saw What Happened and I Cried* (1995–96). In this series, the artist takes historical photographs of African Americans and reprints them so that they appear to be covered with an infrared lens. The photos are emblazoned with the names of locations such as "kitchen," "yard," and "field," specific places for work often associated with subordination. While known primarily as a photographer, Weems has created important installations and video work, among other projects. From 2012 to 2014, the major traveling retrospective *Carrie Mae Weems: Three Decades of Photography and Video* will be on view at several venues in the United States.

117. Benjamin West (1738–1820), *Fidelia and Speranza*, 1776

Oil on canvas, 53¾ × 42⅝ inches. Timken Museum of Art, Putnam Foundation Collection, 1969:001

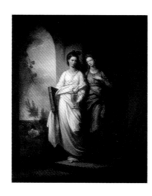

Benjamin West was among the first American-born artists to achieve an international reputation. He was reared by Quakers and self-taught until the age of twenty-two, when loyal patrons afforded him the opportunity to travel to Italy, where he engaged with the masterpieces of Italian Renaissance painters. He was also inspired by the artists he met in Italy, such as Anton Raphael Mengs (1728–1779) and Angelica Kauffman (1741–1807). Mengs encouraged West's interest in literature as a source for artistic inspiration. West never returned to the United States and found great success in England. In fact, by age thirty-four, he was appointed history painter to George III and became president of London's Royal Academy of the Arts in 1792. Both his historical narratives and his portraits were highly sought after.

West was influenced by diverse works of literature including the Old Testament and several plays by William Shakespeare (1564–1616). Shakespeare's writings were popular in late eighteenth-century Britain. West created four paintings that depict act 4, scene 7, of *King Lear,* the moment when King Lear is reunited with his youngest daughter, Cordelia. This painting, *Fidelia and Speranza,* is one among a series of pictures inspired by *The Faerie Queen,* by Edmund Spenser (ca. 1552–1599). *The Faerie Queen* was also an inspiration to Thomas Sully (1783–1872), and John Singleton Copley (1738–1815), who painted this same scene from Spenser's work. The prestige of both Spenser, under Elizabeth, and West, under George III, rose quickly in their respective royal courts.[165]

The name Fidelia signifies faith, while the name Speranza means hope. Derrick Cartwright wrote of West, "He looked to Spenser for an example of personally virtuous and historically validated English creativity—a model against which he might test his rising stature within the British court of the 1770s and his enduring allegiance to his North American heritage during the years of the American Revolution."[166] During the same year he worked on *Fidelia and Speranza,* West was also painting portraits of the king, the king and queen, their children, and the queen and her daughter.[167] Coincidentally, this was also the year that the American colonies declared their independence from England.

FRONTIERS

118. Vito Acconci (b. 1940), *Instant House*, 1980

Flags, wood, springs, ropes, pulleys, 96 × 252 × 252 inches (open). Museum purchase, 1984.6, Museum of Contemporary Art San Diego

Accomplished writer, sculptor, and performance and video artist Vito Acconci was born in New York. Many of his works involve a variety of provisional dwellings, such as shelters built from train cars and automobiles. In addition to large-scale sculptures such as *Instant House,* Acconci has created public works for diverse environments, including the University of Illinois campus in Chicago and the Arvada Center Sculpture Garden in Arvada, Colorado.

The exterior walls of *Instant House* display the flag of the Soviet Union, while the interior walls present the American flag. When a viewer approaches the work, the four walls of the house are on the ground, with the interior walls facing up, exposing the American flag. The work is activated when the viewer sits on the metal swing at the center of the four walls, and the weight on the swing causes the walls to be raised. Surrounded by four walls, the person sitting on the swing is framed by the house's doorway. Acconci describes this kind of work:

Once a viewer is in the middle of things, art becomes architecture. The artistic implication is that, ultimately, art isn't necessary anymore

as a field, a profession; art is no longer a noun, it becomes a verb. Art is an activity that you do while having some other career—you do art as a mathematician, as a physicist, as a biologist. Art is nothing but a general attitude of thickening the plot. Once a viewer is a participant, there's no receiver, no contemplator—hence, no viewer. The political implication is that the former viewer becomes an agent, a decision-maker; you're on your way to becoming a political activist, whether or not you choose to take that road to its destination.[168]

Although *Instant House* literally engages the viewer, the two flags, American and Soviet, conjure thoughts of the Cold War (1947–91) and domestic isolation as opposed to foreign cooperation. Acconci has used the American flag in other works, including his 1983 *Sculpture (usable architectural unit)* for Artpark in Lewiston, New York.

119. Eleanor Antin (b. 1935), *100 Boots* (detail), 1971–73

Fifty-one postcards, each 4½ × 7 inches. Museum purchase, 1996.2.1-5, Museum of Contemporary Art San Diego

In 1968, Eleanor Antin moved to San Diego, a relatively sleepy coastal city. Lacking a vibrant art scene in her new home, Antin returned to New York often to exhibit her work. During her earliest years in San Diego, she began to think about how to present her art in new ways. With the help of a photographer, she began a series composed of compelling, narrative-driven scenes, which were then realized on postcards. From March 15, 1971, to July 9, 1973, Antin mailed her postcards to selected recipients, thereby making her work accessible to many and challenging its permanency.

The narrative of Antin's postcards was structured around the adventures of one hundred boots, which she characterized as her male protagonist, that visited the beach, went to church, went to work, trespassed on another person's property, and eventually went to New York. Antin created these moments with fifty pairs of boots that she bought from an army surplus store and set up in various locations. The San Diego environs and their diverse topography became the most common setting for the boots.

On August 30, 1971, Antin mailed a postcard that showed one hundred boots trespassing, an act of civil disobedience that echoed the activist spirit of the times. In a more passive image, which she mailed on October 4, 1971, she positioned the boots in a field in Rancho Santa Fe, California, surrounded by cattle. The artist wrote of the boots: "He began to champ at the bit, and, ignoring a 'No Trespassing' sign, he climbed over the chain-link fence protecting a power transformer. He had committed his first crime and had to hit the road. . . . Later he reappeared in a meadow, hanging out with the cows. As Walt Whitman said 'Sometimes I think I could turn and live with cows, they are so placid and self-contained.' And 100 boots was on his way to his next adventure."[169]

There was no schedule for mailing the postcards; instead, Antin let her protagonist's narrative dictate when the next postcard should go out. Recipients included artists, critics, dancers, writers, universities, museums, and galleries. Some people asked to be removed from Antin's address list, but those who wished to be added simply had to make the request. With great ingenuity, Antin developed a popular art for the masses. Her boots ended their long journey with a trip to the Museum of Modern Art in New York, and the final postcard showed the boots on vacation, back in San Diego. The first and last postcards were actually taken on the same day, February 9, 1971.

Antin is a professor emeritus in the visual arts department at the University of California, San Diego. She continues to live and work in San Diego.

120. Milton Avery (1893–1965), *Pool in the Mountains*, 1950

Oil on canvas, 30³⁄₁₆ × 40⅛ inches. Gift of Mr. and Mrs. Norton S. Walbridge, 1991.9, The San Diego Museum of Art

Milton Avery chose unusual color combinations and was drawn to flat planes of color in his representations of both landscapes and figures. Art historian Barbara Haskell writes, "By broadly generalizing contours, and minimizing shapes and graphic details, he sought to transcend the particular factual accidents of his subjects and capture their universality—whether of individual form or of essential relationships between objects."[170] Avery's distinctive approach to painting defies identification with specific movements and creative trends. In *Pool in the Mountain,* the green, yellow, and blue hues that define the landscape work harmoniously together. The artist plays with perspective as the tiny trees that dot the landscape have a disproportionate relationship to the immensity of the pool, its surrounding territories, and the enormous mountains. In the year that Avery completed this painting, he spent the summer with his family in Woodstock, New York.

Avery was a longtime resident of New York and was influential to a subsequent generation of artists, in particular the painter Mark Rothko (1903–1970), who frequented Avery's studios in New York, as well as Barnett Newman (1905–1970) and Adolph Gottlieb (1903–1974). By his sixties, Avery was a nationally recognized figure. After Avery's death, Rothko wrote, "This conviction of greatness, the feeling that one was in the presence of great events, was immediate on encountering his work. It was true for many of us who were younger, questioning, and looking for an anchor. This conviction has never faltered. It has persisted, and has been reinforced through the passing decades and the passing fashions."[171]

Sally Michel Avery (1902–2003), Avery's wife, former student, and occasional model, painted alongside the artist. They both pursued a distinctive form of abstraction of figures and landscapes with interesting color choices, although she rendered the figure more regularly. For many years, Sally Michel worked as an illustrator so that her husband could focus on painting. Together, they championed a lyrical form of abstraction that rejects rigid classification.

121. George Bellows (1882–1925), *Lobster Cove, Monhegan, Maine*, 1913

Oil on board, 15 × 19½ inches. Gift of Mrs. Henry A. Everett, 1930.52, The San Diego Museum of Art

Monhegan, the subject of this painting, became popular among artists in the mid-nineteenth century, and in the twentieth century, artists such as Robert Henri (1865–1929) and Rockwell Kent (1882–1971) visited the island.[172] George Bellows studied at the New York Art School with Kent and was greatly influenced by Henri. As Monhegan developed into an artist colony, Bellows was one of those who found its sea views to be particularly inspiring. The lush and loose brushstrokes of his *Lobster Cove, Monhegan, Maine,* particularly in the foreground of the composition, make this work a thoroughly modern picture.

The San Diego Museum of Art is fortunate to have a number of works by Bellows in its permanent collection, notably three paintings and a series of lithographs, including perhaps Bellows's most recognizable print, *A Stag at Sharkey's* (1917). This particular work was given to the Fine Arts Gallery of San Diego (now The San Diego Museum of Art) by Josephine Everett, a philanthropist based in Pasadena, California, who was a benefactor to the Museum and made major contributions to its collection of the art of the United States. Everett's husband was a well-known developer of street railways,[173] and she supported several philanthropic objectives, including other art institutions around the country. From 1927 to 1938, Everett gave a number of important works to the Museum. Her bequest included 127 works and several notable pieces such as *Simone in a Blue Bonnet* by Mary Cassatt (1844–1926; cat. 70) and *Farm Landscape, Cattle in Pasture—Sunset Nantucket* by George Inness (1825–1894; cat. 144), both included in this book and the accompanying exhibition.

122. George Bellows (1882–1925), *Three Pigs and a Mountain*, ca. 1922

Oil on board, 16½ × 24 inches. Gift of Michael and Dru Hammer, The Armand Hammer Foundation, 2000.83, The San Diego Museum of Art

George Bellows was born in Columbus, Ohio and briefly attended the Ohio State University. After saving enough money from playing semiprofessional baseball, he moved to New York City to pursue his art career and study at the New York School of Art. He participated in a number of important exhibitions, including the Armory Show in 1913. Although his career was short, he was able to complete approximately six hundred paintings and thousands of prints and drawings.[174]

Bellows is most associated with the Ashcan School, a group of artists affiliated with painter Robert Henri (1865–1929) who practiced their own distinctive version of urban realism. In its presentation of a tranquil, rural environment, however, *Three Pigs and a Mountain* is a departure from Bellows's well-known exterior and interior scenes of New York. Its composition looks compressed, creating a dynamic perspective. The trees that frame the scene and the shrubbery in the middle appear to be in motion. While the pastoral quality of the animals and the shed gives the painting a traditional feel, the depiction of the trees conveys a modern impression. While other American artists were experimenting with abstract compositions at this time, Bellows clung to representational art, but this work demonstrates the forward-thinking practices of the artist and his Ashcan School counterparts.

123. Albert Bierstadt (1830–1902), *View of the Wetterhorn from the Valley of Grindelwald*, ca. 1856

Oil on canvas, 28⅛ × 19⅜ inches. Gift of Mr. and Mrs. Edmund T. Price, 1958.11, The San Diego Museum of Art

124. Albert Bierstadt (1830–1902), *Cho-looke, the Yosemite Fall*, 1864

Oil on canvas, 34¼ × 27⅛ inches. Timken Museum of Art, Putnam Foundation Collection, 1966.001

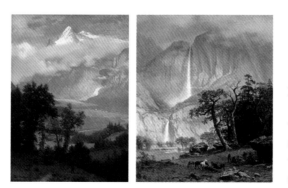

Albert Bierstadt created sweeping landscapes, and his canvases often feature the American West. He frequently presented the natural terrain as relatively untrammeled space. Bierstadt maintained a studio in New York, where he worked on his final product. Though he is best known for his paintings of the American landscape, *View of the Wetterhorn from the Valley of Grindelwald* is representative of one of the many trips he took to Europe. The Wetterhorn is a mountain (12,113 feet tall) located in the valley of Grindelwald in Switzerland. The ascent of the Wetterhorn in the mid-nineteenth century sparked interest in the Swiss Alps among the general public and inspired numerous leading European artists of the previous generation, foremost among them the British master of atmospheric landscape painting Joseph Mallord William Turner (1775–1851).

One year before completing *Cho-looke, the Yosemite Fall,* Bierstadt traveled to Yosemite for the second time. As per usual, the artist traveled with his sketchbook and created a number of studies on-site. Some things that Bierstadt took on his sketching trip to Yosemite, like a sketching umbrella and a color-box, are evident in the lower right of the canvas. Once he returned to his studio in New York, he completed the painting. The grandeur of Yosemite Falls and the tranquil beauty of the meadow below provide an inviting juxtaposition. Bierstadt emphasizes the magnificence of the scene by depicting the horses and a small group of people who appear minuscule in comparison to the immensity of the natural environment.

Yosemite Falls was discovered in 1851, and by 1890, Yosemite was declared a national park. During this second half of the nineteenth century, there was an influx of visitors, and Yosemite became one of the most frequented tourist sites. Casual visitors were joined by painters and photographers who wished to take part in the awe-inspiring scene. "Artists painting the valley felt they were promoting knowledge of and pride in their country, as well as helping to develop American landscape art."[175] Virgil Williams (1830–1886) and

Enoch Wood Perry (1831–1915), fellow artists, accompanied Bierstadt on this trip to Yosemite. Fitz Hugh Ludlow, in his *Heart of the Continent* (1870), shared with Bierstadt a stunning response to Yosemite. The two men traveled together on the 1863 trip, and in his writing, Ludlow described the place as otherworldly, as incomparable to any topography on the East Coast, and as a type of Garden of Eden.[176] Shortly after Bierstadt completed the painting, he welcomed visitors to his studio for a viewing.[177]

125. Thomas Birch (1779–1851), *An American Ship in Distress*, 1841

Oil on canvas, 36 × 53¾ inches. Timken Museum of Art, Putnam Foundation Collection, 1973:001

Thomas Birch was born in England in 1779 and moved to the United States with his artist father in 1794. Fellow painter Benjamin West (1738–1820), whose work is also represented in the Timken Collection, wrote Birch letters of introduction that he could give to other artists

and wealthy patrons in the city of Philadelphia, where father and son first settled. Birch started out with a focus on landscapes but turned to marine scenes in the second half of his career.

In *An American Ship in Distress,* Birch portrays a large ship in danger on a deep blue-green sea. The pale blue sky revealed through the gently parting clouds offers a sense of hope compared to the precarious scene depicted below. Walt Whitman's poems often

evoke the natural beauty of the sea, its movement, and its power:

"Sea of stretch'd ground-swells,
Sea breathing broad and convulsive breaths,
Sea of the brine of life and of unshovell'd yet always-ready graves,
Howler and scooper of storms, capricious and dainty sea,
I am integral with you, I too am of one phase and of all phases."[178]

These words, from Whitman's "Song of Myself," could apply as well to the sea Birch depicts in *An American Ship in Distress.*

126. Deborah Butterfield (b. 1949), *Aluminum Horse #3*, 1982

Steel and aluminum, 18 × 123 × 72 inches. Gift of the artist, 1998.89, The San Diego Museum of Art

127. Deborah Butterfield (b. 1949), *Aluminum Horse #5*, 1982

Steel and aluminum, 72 × 108 × 36 inches. Museum purchase, 1990.7, The San Diego Museum of Art

The horse in and of itself is an iconic representation in American art. Specifically, artists of the American West such as Charles M. Russell (1864–1926) and Frederic Remington (1861–1909) have made memorable works highlighting the animal's robust and powerful nature. Several horses appear in the frontiers section

of *Behold, America!,* in paintings by Frank Tenney Johnson (1874–1939; cat. 149), Maynard Dixon (1875–1946; cat. 134), Asher B. Durand (1796–1886; cat. 137), and Alfredo Ramos Martínez (1871–1946; cat. 165).

In an interview, Butterfield responded to the question "Why just horses?" by saying, "For

starters, of course, they're not just horses. From early on, the horses were—were me."[179] Indeed, for the artist, each representation of a horse is a self-portrait. Both *Aluminum Horse #3* and *Aluminum Horse #5* demonstrate the way in which Butterfield deftly weaves abstraction and a naturalistic approach in her portrayal of the horses.[180] Their physical bodies are composed of twisting and intricately woven strands of aluminum, resulting in abstract masses. In contrast, the outline of the horses and the gentle tilts of their heads so realistically capture the gestures of these revered animals.

Butterfield was born and raised in San Diego, and pony rides in her neighborhood make up her formative memories of horses. She began her college career at San Diego State College (now San Diego State University) and completed her BFA and MFA degrees at the University of California, Davis. Butterfield had her earliest solo exhibitions in 1976, after she completed her graduate degree, at Madison Art Center in Madison, Wisconsin and Zolla/Lieberman Gallery in Chicago. The San Diego Museum of Art honored this local artist who had won international acclaim with a solo exhibition in 1996. Butterfield maintains studios in Montana and Hawaii, where the natural environments, associated with stunning views, and the horses that live on the land inspire her greatly.

128. William Merritt Chase (1849–1916), *The Chase Homestead, Shinnecock, Long Island*, ca. 1893

Oil on panel, 14½ × 16⅛ inches. Gift of Mrs. Walter Harrison Fisher, 1933.120, The San Diego Museum of Art

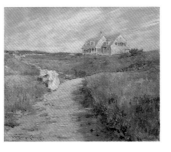

During much of his career, William Merritt Chase maintained an active studio in New York, where he made his living as a painter of highly regarded still lifes and was much sought after for his portraits of New York society. From 1891 to 1902, he spent the summers with his family in Shinnecock Hills, Long Island, not far from Southampton. With continued support from local patrons, Chase led a plein air art school at Shinnecock and created many enduring images of the local landscape. Although the ocean was close by, he was more interested in depicting the terrain.

The Chase Homestead, Shinnecock, Long Island celebrates the family's summer home and his artist's studio, designed by renowned architect Stanford White (1853–1906) of New York. Another painting of the house, *The Bayberry Bush* (or *Chase Homestead in Shinnecock Hills*) (1895; The Parrish Art Museum), features the Chases' three daughters playing in the fields. The Colonial Revival, Shingle Style home was quite fashionable for the period and had recently been remodeled. Lisa N. Peters writes: "The house had originally been built in 1888 for another client, but Chase personalized it largely by means of interior decorations and the addition of a window in the north wall where his studio was situated. Seen in *Chase Homestead, Shinnecock*, the house is situated prominently at the horizon, its lively gambrel roofs and dormer windows suggesting the animated life within the household, where Chase enjoyed the company of his eight children and worked in his studio."[181] Chase transformed Shinnecock into a site for inspiring artistic innovation in others through his teaching, a challenging space for his own creative development, and, finally, a summer home for his family.

129. Christo (Christo Vladimirov Javacheff) (b. 1935), *Running Fence, Project for Sonoma and Marin Counties*, 1975

Charcoal and pastel on paper, 42 × 96 inches. Museum purchase, 1976.5, Museum of Contemporary Art San Diego

130. Christo (Christo Vladimirov Javacheff) (b. 1935), *Running Fence Project for Sonoma County and Marin County, State of California*, 1976

Mixed media, Two parts, 15 × 96 inches and 42 × 96 inches. Museum purchase, 1998.99.a–b, The San Diego Museum of Art

Christo, along with his wife and artistic collaborator Jean-Claude (1935–2009), created the public art project *Running Fence, Project for Sonoma and Marin Counties,* which spanned twenty-four and a

half miles north of San Francisco. It consisted of 2,050 fabric panels installed on a system of steel spools and cables across properties belonging to approximately fifty-nine ranchers. The work ran from east to west and ended in the Pacific Ocean. Although it was on view for only fourteen days, the process of preparing the installation was much more laborious and extended over forty-two months. Local residents expressed concern

about many issues, such as whether the work could be identified as "art" and if there would be environmental consequences (a 450-page environmental impact report was prepared to appease critics). The public hearings, letters, and other primary evidence regarding the debate on the project's viability were recorded in a number of books and documentary films.[182]

The white cloth that created a physical divide across the land ultimately made for a lyrical and harmonious presentation. Likewise, the studies conducted after the work was disassembled revealed that no harm had been done to the land, and supplies used to erect the work were donated to the ranchers. Christo prefers not to accept sponsors and therefore finances these elaborate projects through his other work, often selling the preliminary drawings for a specified project. The drawings held in the collections of the Museum of Contemporary Art San Diego and The San Diego Museum of Art are powerful testaments to the breadth of the fully realized project and reminders of how Christo and Jean-Claude have transformed a number of landscapes. *The Gates* (2005), perhaps their most heralded project, took place in Central Park and covered twenty-three miles. Another project scheduled for the Arkansas River, in south-central Colorado, has generated considerable controversy, but Christo remains hopeful that the work will be on view for two weeks in August 2015.

131. Einar de la Torre (b. 1963) and Jamex de la Torre (b. 1960), *El Fix*, 1997

Blown glass, mixed media, 30 × 72 × 4 inches, Museum purchase with funds from an anonymous donor, 1999.27.a-b, Museum of Contemporary Art San Diego

Brothers Einar and Jamex de la Torre collaborate predominantly in the creation of glass sculpture. Born in Guadalajara, Mexico, they moved to San Diego during their teenage years. They both attended California State University Long Beach. Their lives and artistic practice con

tinue to straddle the U.S.-Mexico border, as they maintain studio space in both countries.

Miki García writes: "Using irony, over-the-top embellishment, and double entendres, the artists invite the spectator to reconsider their preconceptions of 'authentic' Mexican art and culture and to reexamine the increasingly blurred lines between the United States and Mexico."[183] The de la Torre brothers create work that is at once whimsical and evocative of history and cultural traditions. They are inspired by popular culture and the precolonial imagery of ancient Mexico. In their work, they make little distinction between high and low art.

In *El Fix*, the brothers construct what appear to be intestines within a map of Mexico. On the map, a needle in the shape of a crucifix has been inserted into Baja California. The international border that lies between Tijuana and San Diego is extremely busy, in fact it is one of the most active land crossings in the world. Many associate the border region between San Diego and Tijuana with drug trafficking, and the artists allude to this association with the needle. Moreover, the title of the sculpture relates directly to the needle and references a drug addict's uncontrollable desire. A religious icon evocative of both the Virgin Mary and religious trinkets appears in the middle of the work, but a closer look at the icon reveals a tiny baby Jesus enclosed by a vulva form. The de la Torre brothers' highly original sculptural forms combine religion, popular culture, and a contemporary baroque aesthetic.

132. Sergio de la Torre (b. 1967), *Thinking about Expansion*, 2003

Digital photograph on Lite paper, mounted on Plexi and metal, 16 × 22 inches. Museum purchase, Louise R. and Robert S. Harper Fund, 2005.47, Museum of Contemporary Art San Diego

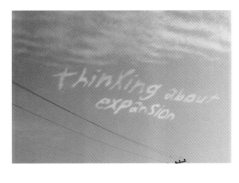

Sergio de la Torre is a photographer, filmmaker, and performance artist. He directed the film *Maquilapolis* (2006) and is a cofounder of the performance group Los Tricksters. De la Torre's work is directly informed by his experiences in the Tijuana–San Diego border region and often addresses issues pertaining to immigration, tourism, and identity. Furthermore, he examines how people transform themselves within their communities and how place functions as a tool that enables change.

Thinking about Expansion is an excellent counterpart to the nineteenth-century landscape paintings in the frontiers section of *Behold, America!* Works by artists such as Thomas Moran (1837–1926; cats. 155, 156)) and Albert Bierstadt (1830–1902; cats. 123, 124) were created at a moment in American history when there was intense interest in exploring unknown territories, ideas pertaining to Manifest Destiny were popular, and highly regarded writers such as Henry David Thoreau (1817–1862) and Ralph Waldo Emerson (1803–1882) were extolling the beauty of the American landscape and emphasizing a spiritual connection between humanity and the land. In de la Torre's photograph, the sky serves as a symbol for an imagined frontier, and the wires in the foreground are a reminder of the reality of everyday life. The letters have a dreamlike, whimsical connotation and conjure thoughts of colonization and landownership. Where will we expand? How will we expand? Does someone already live in the place where we want to expand? Is the expansion a mental or a physical manifestation? These questions are applicable to the history of landscape painting and to de la Torre's photograph. Indeed, physical geography can have myriad meanings in different contexts and to diverse populations. In regard to the notion of landscape and its many manifestations, Simon Schama writes: "For if, as we have seen, our entire landscape tradition is the product of shared culture, it is by the same token a tradition built from a rich deposit of myths, memories, and obsessions. The cults which we are told to seek in other native cultures—of the primitive forest, of the river of life, of the sacred mountain—are in fact alive and well and all about us if only we know where to look for them."[184]

A given place makes one reevaluate and view one's identity in the reflection of the particular geographic location. One can experience simultaneously a sense of both detachment from and connection to a given place. These ideas and more are inspired by de la Torre's powerful photograph, a profound example of the landscape tradition in the twenty-first century.

133. Mark Dion (b. 1961), *Landfill*, 1999–2000

Mixed media, 71½ × 147½ × 64 inches. Museum purchase, Contemporary Collectors Fund, 2000.4, Museum of Contemporary Art San Diego

Mark Dion's *Landfill,* with its contemporary take on environmental decay, offers another stark contrast with the nineteenth-century and early twentieth-century landscapes included in *Behold, America!* by artists such as Asher B. Durand (1796–1886; cat. 137) and Maynard Dixon (1875–1946; cat. 134). Patricia Hills, an expert on the work of Eastman Johnson, wrote regarding nineteenth-century visions of the United States: "Moreover, American nationalism emphasized the present and future greatness of this country rather than the mythic past and military glories. The future and the land to the West of the Mississippi were both uncharted, and both promised great riches for the white, male American of ambition."[185] Ralph Waldo Emerson (1803–1882) expressed this view when he

exulted, "America is a poem in our eyes; its ample geography dazzles the imagination."[186] In Dion's work, however, the American landscape is now charted, its geography seemingly less ample, and the promise of great riches has been denied. It is an American landscape that has suffered the consequences of poor environmental standards.

In his work, Dion deals with issues pertaining to extinction, environmental preservation, and scientific inquiry and incorporates diverse materials such as plants, dirt, wheelbarrows, stuffed animals, taxidermic specimens, butterflies, and trash. He has explored the work of important naturalists and the field of museology, specifically at natural history museums. As a contemporary manifestation of a diorama, *Landfill* expresses the artist's interests and concerns. Dion states: "I think I've been consistent in pursuing my interest in the history of the representations of nature and exploring how concepts like chains of being, evolution, the 'wilderness' and fantasies of growth and utopia have shaped our thinking about nature. These days, the dominant idea guiding what we thinking of as nature is influenced by environmentalism, especially in relation to conservation, so my work has tried to challenge its effects."[187]

134. Lafayette Maynard Dixon (1875–1946), *Apache Land*, 1915

Oil on canvas, 20 × 30 inches. 1967.8, The San Diego Museum of Art

From an early age, Lafayette Maynard Dixon, known as simply Maynard Dixon, was inspired by the topography and people of the American West. He was born on a ranch in Fresno, California and, while still a boy, developed a great interest in the sculptor and painter Frederic Remington (1861–1909), even sending the well-known artist his sketches. After 1893, when his family relocated to the San Francisco area, he briefly studied art at the Mark Hopkins Institute of Art and under the landscape painter Raymond Dabb Yelland (1848–1900).

From approximately 1912 to 1938, Dixon lived in Los Angeles and worked as an easel and mural painter. He won accolades for his work, including a bronze medal at the Panama-Pacific International Exposition in 1915. In 1920, he married the photographer Dorothea Lange (1895–1965). During his career, he made several murals and worked for the Mural Division of the Works Progress Administration from 1936 to 1937.

The artist spent the last nine years of his life in Tucson, Arizona, with his second wife, Edith Hamlin (1902–1992), whom he married in 1937. After his death, Hamlin continued to document and promote his work.[188]

Dixon was drawn to landscapes, but he also made frequent reference in his work to Native American cultures, including those of the Apache, Hopi, and Blackfoot Indians. *Apache Land* was created outdoors and quickly—there are no underdrawings evident, and just one layer of paint was applied over the ground layer.[189] The artist signed this painting "Maynard Dixon Ariz 1915." As is evident in this painting, Dixon created distinctive clouds in his works. His attention to atmosphere and, specifically, clouds is highly recognizable. For the most part, he rejected the abstraction popular in New York in the early twentieth century. He was drawn to a more traditional way of painting and continued to produce plein air landscapes depicting the diverse terrain of desert regions.

135. Thomas Doughty (1793–1856), *Shipwreck*, 1834

Oil on canvas, 36 × 53¾ inches. Bequest of Eleanor Louise Stanton, 1962.8, The San Diego Museum of Art

Born in Philadelphia, Thomas Doughty created idealized and romanticized landscapes of the United States. As early as 1820, he considered himself to be a landscape painter. Largely self-taught, he absorbed the arts when traveling in Europe, visiting England in 1837 and France in 1845. Thomas Cole (1801–1848), founder of the Hudson River School, and Hudson River School painter Asher B. Durand (1796–1886) were contemporaries, and Doughty himself was an early follower of the school. He was born in Philadelphia and spent

much of his life on the East Coast; he passed the final years of his life in New York City.

With his painting, *Shipwreck,* Doughty reveals the power and the perils of the sea. Roger B. Stein, writes, "Doughty's *Shipwreck* defines the sublime as an active force. Though he attempts to frame the violent action from the perspective of the land world, the trees to right and left twist and turn rhythmically, the storm cloud above hangs oppressively low, all squeezing and compressing, orchestrating space and focusing attention on the awesome power of nature. Dramatic action rather than the size of open space itself becomes the expressive vocabulary."[190]

In Doughty's composition, a single, minuscule figure stands on a rock and surveys the scene, while below another tiny figure washes into land for safety. "Nature in its violent moods or theatrical moments was not common in Doughty's oeuvre. Never do his landscapes of this genre boil with uncontrolled chaos or fury, but the artist was able to create an expressive sense of nature's power and destructive force."[191] Doughty signed and dated the work on a rock in the lower left center of the painting.

136. James Drake (b. 1946), *Knife Table,* 1984

Steel, 84 × 48 × 18 inches overall. Museum purchase with funds from the Lannan Foundation, 1988.3.1-7, Museum of Contemporary Art San Diego

James Drake's *Knife Table* evokes the violent relationship between animals and hunters. Furthermore, it conjures thoughts of the recreational sport of hunting as a means of securing nourishment and ensuring human survival. Knives and a set of bow and arrows accompany wall-mounted trophies in this distinctive sculptural installation. Within the elegant enclosed table, different sizes of knives are on display. The knives are in a controlled space, and the weapons are used to subdue animals. As in many of the artist's works, the themes of power and control are dominant. Drake used steel, a strong material associated with industry, but the finished forms give the appearance of

being light and lyrical. In particular, the horns of the trophy plaques are slender and sinuous. The animal skull also conveys a sense of fragility.

Drake was born in Lubbock, Texas and received his formal art education at the Art Center College of Design in Pasadena, California. Throughout his career, he has worked in myriad media, including photography, video, drawing, sculpture, and installation. The artist has often addressed issues pertaining to the U.S.-Mexico border, but a common theme in his work is the dynamic relationships between animals and humans, as exemplified by this work.

137. Asher B. Durand (1796–1886), *Landscape—Composition: In the Catskills,* 1848

Oil on canvas, 30 × 42¼ inches. Museum purchase with funds provided by the Gerald and Inez Grant Parker Foundation, 1974.72, The San Diego Museum of Art

Asher B. Durand is best known today for his enduring images of the American landscape, especially the Hudson River Valley, the Catskills, and the Adirondack Mountains in New York. *Landscape—Composition* is an excellent example of this important American painter's landscapes. A founding member of the National Academy of Design, Durand studied engraving before devoting himself to landscape painting and was one of the primary painters of the Hudson River School.

Durand's canvases reflect his great passion and unrelenting respect for the natural environment. In the detailed charcoal study (ca. 1848; New-York Historical Society Museum) for *Landscape—Composition: In the Catskills,* which he probably made on-site, he included the small figural forms in the foreground;

in this, the final painting of the subject, these tiny figures juxtaposed with the immensity of the mountains and the breadth of the land before them emphasize the awe-inspiring presence of the land itself. The framing trees and the distant views of the landscape are typical traits of Durand's paintings. The painting was exhibited at the National Academy of Design in 1848.[192]

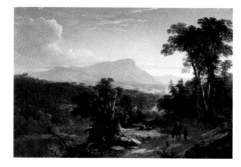

It is hard to look at this painting without thinking about the contemporaneous literature that also celebrated nature. Most often, writings by Henry David Thoreau (1817–1862) and Ralph Waldo Emerson (1803–1882) are considered in concert with Durand's landscapes, but passages from Walt Whitman's poem "Song of the Open Road" are also applicable. Whitman writes,

> Afoot and light-hearted I take to the open road,
> Healthy, free, the world before me,
> The long brown path before me leading wherever I choose.[193]

The traveler on Durand's road inspires thoughts of adventure and a lengthy journey. Whitman continues in the same poem,

> The earth is rude, silent, incomprehensible at first,
> Nature is rude and incomprehensible at first,
> Be not discouraged, keep on, there are divine things well envelop'd,
> I swear to you there are divine things more beautiful than words can tell.[194]

The meaningful and enduring power of the natural environment is celebrated by both Whitman and Durand. Whitman's words were clearly not written as a literal guide for Durand's painting, nor were they necessarily meant to be taken literally; however, when used in application to this particular work and others, they can cause viewers to "read" the paintings in new and introspective ways.

138. Nicolai Fechin (1881–1955), *Torrey Pines*, ca. 1925

Oil on canvas, 30 × 36 inches. Gift of Wilda B. Dunnicliffe, by exchange, 1998.87, The San Diego Museum of Art

Nicolai Fechin was already an established artist in his birth country of Russia before he arrived in the United States in 1923. After achieving success in New York, he moved west and spent most of his remaining years in Taos, New Mexico, and Santa Monica, California. In New Mexico, Fechin developed an interest

in Native American culture and painted numerous works that demonstrate a romanticized view of Native American people. In contrast, his painting *Torrey Pines,* which depicts the Torrey Pines State Reserve located along the Pacific coast between La Jolla and Del Mar, California, reflects his interest in the local topography. Torrey Pines offers sweeping views of the Pacific Ocean, but Fechin focused on the chaparral and sunstruck sandstone cliffs on a beautiful blue-sky day.

Although Fechin's technique is reminiscent of that of the California landscape painters who incorporated the loose brushstrokes of the Impressionists into their work, he pushes the boundaries of California plein air painting with his rigorous and strong application of paint. Fechin created multiple views of Torrey Pines and other areas around San Diego, such as Point Loma. Torrey Pines also interested other plein air painters, including Alfred Mitchell (1888–1972), who is represented in *Behold, America!* with his late oil painting *La Jolla Cove* (ca. 1950).

139. Ann Hamilton (b. 1956), *linings*, 1990

Felt boot liners, woolen blankets, grass, glass, ink on paper, monitor with video loop, four-sided structure, 120 × 150 × 294 inches; overall dimensions vary. Museum purchase with funds from the Elizabeth W. Russell Foundation, 1990.23, Museum of Contemporary Art San Diego

Ann Hamilton received a BFA degree in textile design from the University of Kansas in 1979 and an MFA degree in sculpture from Yale University in 1985. Her installation *linings* creates a vital and surprising space. Visitors encounter a stack of felt liners for boots at the entrance to a boxlike shelter. The liners are not meant to be worn, but they do symbolize many journeys and elicit thoughts of the inner layers, both literally and metaphorically, of walking and the human form. The softness of the boots is reflected in the exterior of the shelter. Inside the minimal shelter, glass covers the grass floor. On the walls of the space, glass covers the writings of John Muir (1838–1914). All of these components are accompanied by a video loop with no audio. Hamilton describes the piece,

> But I wanted to look at how we censor our own voices, how the inability to feel mutes our voice. I was focusing on internal censorship. The microscopic slide glass covers all of the text on the walls. The writing was all taken from published journals made in response to walking in the landscape, but it was sealed off, like the grass on the floor was sealed by a skin of glass. Outside there were felt bootlines [that suggest] an internal lining,

an internal muffling. All of the room becomes a frame for the video. The water. Again the water—the source of both creation and destruction—is coming in and out of this person's mouth. It's a kind of drowning. The video is silent. And for a long time I felt there needed to be a story in there, there needed to be a sound. Why make a piece that's about the absence of voice if you're trying to talk about that problem? Why don't you talk about how you find voice, what kind of voice to have? I only knew how to point to the absence of voice. I don't know if it's possible to make it present. It's something I continue to wrestle with.[195]

The artist was inspired to create this intricate work by the simple act of walking. While at the Headlands Center for the Arts in Sausalito, California, Hamilton routinely walked, and she endeavored to find an alternative method for recording the activity. Since she did not keep a journal, she turned to the writings of Muir, not because of his role as an important naturalist and early advocate for environmental protection, but because he recorded the physical act of walking at its most basic level. Hamilton is also represented in *Behold, America!* in the figures section, with a photograph from her *body/object* series (cat. 81).

140. Marsden Hartley (1877–1943), *Winter Wind—Maine Coast*, 1941

Oil on canvas, 20 × 15 inches. Museum purchase with funds provided by the Gerald and Inez Grant Parker Foundation, 1973.134, The San Diego Museum of Art

Maine figured prominently in Marsden Hartley's life. He was born in the town of Lewiston, spent summers and autumns in the final years of his life in the fishing village of Corea, and died in Ellsworth. Hartley was inspired by different aspects of Maine, and beach scenes, lobsters, churches, and lighthouses appear in his later work. Most conspicuously, the seascapes of Maine inspired many compositions, including *Winter Wind—Maine Coast.* During his last years, Hartley could rarely afford canvas, so he more often

painted on Masonite or composition board, making this one of his few works on canvas from this time.[196] The loose brushstrokes are typical of his work from this period but the pop of pink color adds something unexpected to the composition. Hartley's vision of the Maine coast makes for an interesting comparison with an earlier painting by George Bellows (1882–1925), *Lobster Cove, Monhegan, Maine* (1913), also included in this publication and the accompanying exhibition (cat. 121).

Alfred Stieglitz (1864–1946) was a strong supporter of Hartley's work and gave the artist his first solo exhibition at 291 Gallery in 1909, the same year in which the artist William Glackens (1870–1938) held an exhibition for Hartley in his studio. Before his late work of Maine, Hartley created an important body of abstract works in Germany that refer to the military and found inspiration in the landscapes of Mexico and New Mexico. In addition to his visual art, Hartley wrote many poems. His circle of artist friends and supporters was wide and included Milton Avery (1885–1965), who painted a portrait of Hartley in 1943 (Museum of Fine Arts, Boston), two years after *Winter Wind—Maine Coast* was completed.

141. Jenny Holzer (b. 1950), *With All the Holes in you Already There's No Reason to Define the Outside Environment as Alien*, 1983

Enamel on aluminum sign on metal, edition 1 of 3, 24 × 24 inches. Gift of Margo H. Leavin, 1986.39, Museum of Contemporary Art San Diego

Jenny Holzer studied at Duke University and the University of Chicago before receiving her BFA degree from Ohio University in 1972. After pursuing further formal training at Rhode Island School of Design, Holzer moved to New York in 1977 and began posting her text-based works around the city in poster form. Like artists Barbara Krueger (b. 1945) and Ed Ruscha (b. 1937), Holzer uses ambiguous texts that evoke provocative ideas. She has presented her texts through a variety of media, including T-shirts, marble benches, bronze plaques, and LED screens. Her most recognizable works have appeared in public environments such as Times Square and the Guggenheim Museum in New York.[197] In 1990, she became the first woman to represent the United States with a solo exhibition at the Venice Biennale.

Holzer's texts are written in series, and this particular piece comes from her *Survival* series. A related work *Duratrans,* from the same series, created with Dennis Adams, was installed on a bus shelter at Sixty-sixth and Broadway in New York in 1984. Its text read, "OUTER SPACE IS WHERE YOU DISCOVER WONDER, WHERE YOU FIGHT AND NEVER HURT EARTH. IF YOU STOP BELIEVING THIS, YOUR MOOD TURNS UGLY." The texts from both works reference environmental conservation, the unknown, and anxiety. In addition to this work by Holzer in *Behold, America!*, the Museum of Contemporary Art San Diego has her large-scale work *For MCASD* (2007) affixed to one of its buildings, located in downtown San Diego.[198]

142. Douglas Huebler (1924–1997), *Crocodile Tears II: Lloyd (Peaceable Kingdom I)*, 1985

Oil on canvas, text, gelatin silver print, 42 × 69 inches. Museum purchase, Contemporary Collectors Fund, 1987.13.1–3, Museum of Contemporary Art San Diego

The title and, specifically, the animals in the work by conceptual artist Douglas Huebler reference the series of paintings *Peaceable Kingdom,* created by Edward Hicks (1780–1849) from approximately 1820 until the time of his death. Huebler's composition's light and dramatic geography evoke the nineteenth-century paintings of Albert Bierstadt (1830–1902) and Frederic Edwin Church (1826–1900). In Huebler's hands, the influences combine to create a landscape that suggests the stunning setting for a science fiction novel.

Crocodile Tears II: Lloyd (Peaceable Kingdom I), like many of Huebler's works, combines text and image. Ronald J. Onorato writes, "His questioning of art as language, so central to his work since 1968, runs parallel to similar investigations by the early group of conceptualists, particularly Joseph Kosuth, whose comparative series of objects, photographs, and texts deconstruct the way we understand things in our everyday world. Like Huebler's suggestive storytelling schematics, John Baldessari's aphoristic phrases

and found photographs, often arrayed in narrative sequence, demand an active interchange between the viewer and the information provided before a tale can be fleshed out from such skeletal vocabularies."[199]

The text presented here includes an excerpt from a screenplay, *Crocodile Tears,* which Huebler completed in 1981.[200] The placement of the texts and found photograph next to the canvas evokes traditional museum presentation. In the excerpt, the characters Lloyd and Ellen are engaged in a debate. Lloyd dislikes the squirrels that are eating from their bird feeder, so he takes the rocks Ellen had collected for her Zen garden and throws them at the animals, to scare them. Ellen disapproves of Lloyd's behavior. The relationship between humans and the natural world is an underlying theme

in all three components of the work. In the caption for the found photograph, Huebler wrote, "Represented above is at least one person who believes that there is a place for everything and everything should be kept in its place." While the caption seems somewhat at odds with the content presented in the photograph, it connects Huebler's painting and screenplay. In the painting, the spectacle comes from the sky, while the animals and man on horseback appear at peace as they survey the expansive scene. In the screenplay, the characters search for the same serenity in nature but disagree when an object (bird feeder) and animals (squirrels) do not perform their prescribed roles as expected.

143. George Inness (1825–1894), *L'Ariccia, Italy,* 1874

Oil on canvas, 26½ × 56⅞ inches. Timken Museum of Art, Putnam Foundation Collection, 1972:001

144. George Inness (1825–1894), *Farm Landscape, Cattle in Pasture—Sunset Nantucket,* ca. 1883

Oil on panel, 20 × 30 inches. Bequest of Mrs. Henry A. Everett, 1938.31, The San Diego Museum of Art

George Inness was one of the great landscape painters working during the second half of the twentieth century. While the Hudson River School artists tended to focus on accurate depictions of nature, Inness moved toward more emotional paintings that convey the ambience of a place.[201] Inness evolved from the Hudson River School to express subjective feelings and ideas in his landscapes.

In different ways, Inness looked to Europe for inspiration. The landscape paintings of Claude Lorrain (1600–1682) were among his significant artistic influences, and he was affected by his direct encounter with the Barbizon School in France. He also spent time in Italy and was inspired by the topography of the country. Italy remained a subject for approximately thirty years, although his time in the country was much shorter. He took two trips to Italy, one from 1851 to 1852 and the other from 1870 to 1874. Mark D. Mitchell explains that "Italy—with its breathtaking vistas, unparalleled art, and long history—provided Inness with an array of subjects

and stylistic examples (some imported) to help him discover his future in a past more resonant and inspiring to the artist than the work of the emerging modernists of his own generation."[202] While Inness painted the Italian countryside, Italy itself was experiencing both urban and rural transformation through increased industrialization. His clear decision to emphasize the pastoral qualities of the Italian landscape as opposed to encroaching industry may represent his ambivalence toward this change.[203]

Ariccia is a small town in the Alban Hills, located southeast of Rome in central Italy. The town inspired a number of painters, including James Mallord William Turner (1775–1851) and Jean-Baptiste Camille Corot (1796–1875). Inness's *L'Ariccia* emphasizes the horizon, with the Mediterranean Sea in the distance and a long bridge resting parallel to the horizon. The distinctive domes belong to the Church of the Assumption, which was designed by Gian Lorenzo Bernini (1598–1680). All of the features in this painting would

not have been visible from the vantage point that Inness presents; therefore, he altered elements to make a more dynamic vista as opposed to creating a realistic vision.

Like Eastman Johnson, Inness found inspiration in the natural environs of Nantucket, and he increasingly painted the island after 1880. Around the time that he painted *Farm Landscape, Cattle in Pasture—Sunset Nantucket,* his letters regularly described the productivity and repeated inspiration he found in Sconset. On August 2, 1883, he wrote to his wife, "I saw a very fine sunset last evening from Mr. Burbank's house which with figures could be made interesting and striking, and I do not know but that I may send for two larger boards and paint two more extensive scenes which have impressed me."[204] Just two days later, he wrote again to his wife, "I have just been out to see the setting of the sun, strolling up the road and studying the solemn tones of the passing daylight. There is something peculiarly impressive in the effects of the far-stretching distance, the weather-worn gray of the buildings, and the general sense of solitariness which quite suits my present mood."[205]

As is evident in his landscapes of both Italy and Nantucket, a strong sense of place resonates within Inness's oeuvre, reflecting the inspiration he found in the writings of the philosopher Emanuel Swedenborg (1688–1772). In fact, it is difficult to talk about Inness's works without mentioning the Swedish philosopher's effect on the artist. Swedenborg argued that a paramount connection exists between the spiritual and natural worlds. Inness believed that the natural environs he painted possessed spiritual qualities. He stated, "A work of art does not appeal to the intellect. It does not appeal to the moral sense. Its aim is not to instruct, to edify, but to awaken an emotion."[206] Inness's emotional and spiritual responses to landscape occurred across many paintings, including *L'Ariccia* and *Landscape, Cattle in Pasture—Sunset Nantucket.*

145. Robert Irwin (b. 1928), *1°2°3°4°*, 1997

Apertures cut into existing windows, left: 24 × 30 inches; center: 24 × 26 inches; right: 24 × 30 inches; overall room dimensions: 115 ×320 × 221 inches. Museum purchase in honor of Ruth Gribbin with funds from Ruth and Murray Gribin and Ansley I. Graham Trust, Los Angeles, 1997.18.1-5, Museum of Contemporary Art San Diego

Robert Irwin was born in Long Beach, California, and is a longtime resident of San Diego, California. He began his career as a painter in the 1950s, but in 1970, he gave up the medium altogether. He is frequently associated with large-scale works that combine elements of light and references to the natural world, such as his *Two Running Violet V Forms* (1983), which is held in the internationally renowned Stuart Collection at the University of California, San Diego, and the monumental (134,000 square feet) Central Garden (1992–97) he designed at the Getty Center, Los Angeles.

The Museum of Contemporary Art San Diego, which has a long-standing relationship with Irwin, commissioned *1°2°3°4°* for its Krichman Gallery, which consists mostly of glass and overlooks the Pacific Ocean. The work is fitting for this museum, with its tradition of working with internationally renowned artists as well as its location in Southern California and its sweeping views of the ocean. The artist designed a plan in which square cuts through the existing windows allow visitors to incorporate the sea, air, and sounds of the outdoors into their experience and to appreciate how viewing the work during different times of the day, with bright sun, a sunset, or even total darkness, enhances its multifaceted nature. In effect, it gives museumgoers a new way of viewing San Diego's greatest frontier, the Pacific Ocean.

146. Alfredo Jaar (b. 1956), *Gold in the Morning (Oro en la mañana)*, 1986–89

Five light boxes with color transparencies, four metal boxes, nails, gilded frame, 120 × 264 × 264 inches; overall dimensions vary, Museum purchase with matching funds from the National Endowment for the Arts 1990.7.1-11, Museum of Contemporary Art San Diego

Alfredo Jaar's most recognized work, *A Logo for America* (1987), was a projection in Times Square in New York, in which the Jumbotron showed an outline map of the continental United States. Inside the map were the words "This is not America." Other New York–related pieces include a collaboration on a series of faux *New York Times* headlines that were featured in the 2011 exhibition *Being American* at the School of Visual Arts in New York. He is a truly international artist with roots in Chile and a rigorous artistic practice that has documented the plight of people in diverse places, including Latin American and Africa, and his work finds a place in *Behold, America!* because it is representative of the many international artists who live in New York. Through his powerful works, Jaar contributes to the multifaceted contemporary art created within the United States.

This piece sheds light on a mining region, Serra Pelada, now home to the largest open pit mine in Brazil. The influx of industry into the region, tucked away in the mountains, as the result of the discovery of its mining potential in the 1980s, has had a drastic effect on the people who live there and the environment itself. In a more literal way, documentary photographer, Sebastião Salgado (b. 1944), a native of Brazil, has produced images that relate the tremendous workforce in Serra Pelada to the energy exuded by the workers. Like Jaar, Salgado travels to remote areas of the world and creates work inspired by the people he meets and the cultures that are in transition and in many cases in peril as a result of war, poverty, the remnants of colonialism, and environmental disaster. Jaar, however, takes a more organic, conceptual, and multimedia approach, whereas Salgado's body of work consists of documentary photography.

This installation *Gold in the Morning (Oro en la mañana)*, consists of five light boxes that project photographic images of the Serra Pelada community. In the middle of the installation is a large bed of nails that supports an ornate, gilded frame. A gold box is situated below, above, or at a right angle to each light box. The gold boxes absorb and reflect the light from the boxes.

Another work by Jaar in the permanent collection of the Museum of Contemporary Art San Diego, *Six seconds/It is difficult*, includes text from a poem by William Carlos Williams (1883–1963) and imagery inspired by Jaar's time in Rwanda.

147. Luis Jiménez (1940–2006), *Border Crossing/Cruzando el Río Bravo*, 1989

Fiberglass with acrylic urethane finish, edition 4 of 5, 2 A.P., 127 × 34 × 54 inches. Joint purchase, Museum of Contemporary Art San Diego, 2002.46, and The San Diego Museum of Art in honor of Jackie and Rea Axline, 2002.226, Museum of Contemporary Art San Diego and The San Diego Museum of Art

Luis Jiménez is known for his large-scale fiberglass sculptures, such as *Mustang* (2008) at the Denver Airport and *Southwest Pietà* (1994, originally cast 1984) at Arizona State University. Jiménez's signature bright color palette reflects diverse influences, from his father's neon "spectaculars" to lowrider culture. The baroque qualities of neon signs and lowrider cars are often present in the artist's sculptures as they take on exaggerated form through their scale and color palette.

Jiménez was born in El Paso, Texas and pursued formal studies in Austin, Texas and Mexico City. In 1966, he moved to New York, where he worked as an assistant to the sculptor Seymour Lipton (1903–1986). Jiménez's works are rooted in the history of art and in daily life. He often used Native American, pre-Columbian, and popular cultural references in his work.

Border Crossing/Cruzando el Río Bravo, like many of the artist's sculptures, relates the Mexican American experience. It

demonstrates the emotional strength and sheer physical will it can take to cross the Mexico-U.S. border. In this strong, vertical work, a woman shields her baby as a man carries both of them on his shoulders. In the foreground, the artist alludes to cactus, which dot much of the landscape between the United States and Mexico. The Rio Grande, the river that separates the two countries, is known as the Río Bravo in Mexico.

The Museum of Contemporary Art San Diego and The San Diego Museum of Art purchased this work together in honor of Jackie and Rea Axline, who gave, among other gifts, a joint fund to both institutions for a shared lecture series, which would bring internationally renowned speakers to each museum. *Border Crossing/Cruzando el Río Bravo* is the only work in the exhibition that is owned by two of the collaborating institutions.

148. Eastman Johnson (1824–1906), *The Cranberry Harvest, Island of Nantucket*, 1880

Oil on canvas, 27⅜ × 54½ inches. Timken Museum of Art, Putnam Foundation Collection, 1972:002

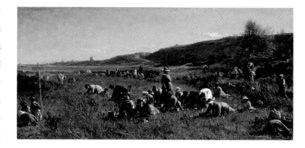

Literature was an important influence in Eastman Johnson's life. Patricia Hills writes, "Rather it was Emerson's and Longfellow's preoccupation with the notion of indigenously 'American' literature that would have struck a sympathetic chord in the artist."[207] In this painting, Johnson portrays a fleeting America, one that was becoming harder to find as modernization and increased industry threatened rural environments. The artist's studio on Nantucket was located on Cliff Road, and for some twenty years, he created work inspired by the local environment.

In *The Cranberry Harvest, Island of Nantucket*, a central woman stands upright and looks off into the distance. While a majority of the depicted figures are engaged in labor, a young boy enters the composition from the right with a baby in his arms. The town of Nantucket can be seen on the distant horizon. In depicting this American scene, Johnson also drew inspiration from the works of European artists, including Jules Breton's oil painting *The Gleaners* (1854; National

Gallery of Ireland, Dublin).[208] Johnson produced many works portraying cranberry picking, and the one closest to this finished work is an unfinished oil, *Cranberry Pickers* (ca. 1878–79; Yale University Art Gallery).

Johnson was painting in Nantucket at a time when residents were increasingly interested in promoting the island as a comfortable and relaxing locale for tourists in order to spur the local economy.[209] He tended to leave New York for Nantucket in late June, and his stays grew lengthier, extending until late November or early December. After 1880, around the time he completed this picture, portraiture again became his primary focus.

The Cranberry Harvest, Island of Nantucket has an impressive exhibition history.[210] It represented Johnson at the National Academy of Design's yearly spring exhibition in 1880. Following that, it was also exhibited at the Metropolitan Museum of Art and, in 1893, at the World's Columbian Exposition in Chicago.

149. Frank Tenney Johnson (1874–1939), *In Old Isleta*, 1935

Oil on canvas, 24 × 30 inches. Gift of Mrs. Alexander Bill, 1967.11, The San Diego Museum of Art

Born in Iowa, Frank Tenney Johnson spent time as a child on the Overland Trail and witnessed the migration of settlers to the West. As a young man, he went to New York, where he studied with the important American painters Robert Henri (1865–1929) and John Henry

Twachtman (1853–1902), also represented in this exhibition, and honed his technique.

Johnson traveled to Isleta, New Mexico, a town just south of Albuquerque, as early as 1904.[211] He was taken with the local architecture and people, some of whom he paid

a small fee to pose for him. Around the same time that he ventured to New Mexico, he also traveled to Colorado on assignment for *Field and Stream*. He later settled in Alhambra, California, and spent much time in Wyoming and Yellowstone Park during the 1930s.

Painted from memory toward the end of his life, *In Old Isleta* presents a serene scene of daily life at twilight. Johnson set many of his compositions in the evening hours.

In Old Isleta was worked over many times, with paint applied over paint, and not created in a single session.[212] Johnson remembered his experiences in Isleta fondly.

> The first thing I ran across when I got off the train at Isleta was a fine character of an old Indian and a white pony in front of his adobe. After "much talk" I persuaded him to let me take his picture for 2 bits (25 cents). . . . Then I went about the village getting some good photos. The old church (300 years old) was most interesting. The door was open and I went inside—all was silent as the grave, save for the swallows as they winged their way back and forth through the open doorway up to their nests on the great hand hewn logs that have supported the roof since it was built so long ago. The alter [*sic*] was adorned with ancient and crude draperies, and there were antique religious canvases that adorned wither wall. Gazing out through the doorway I could see Indian women passing to and fro with their large water jars balanced upon their heads. In the distance the mountains clothed in purple haze, with a crown of turquoise sky above them reposed in quiet dignity. I went up into the gallery of the old church and there found an old organ that was covered with dust of ages. The swallows sat on the edges of their nests almost within reach and flitted about near the ceiling, and in and out the door. All else was silence. Hundreds of years have passed since the Spanish era when the adobe walls were built. Generations upon generations of these people have been born and lived on to old age, and then mingled with the dust. If that old church could only have spoken to me, what a tale it could have told.[213]

This description makes clear the artist's love for the history of Isleta and the romantic nostalgia he experienced when there, which resulted in many works.

150. Paul Kos (b. 1942), *Guadalupe Bell*, 1989

Bronze bell, steel, phosphorescent pigment, strobe light; bell, diameter 25¾ inches; overall dimensions vary. Museum purchase, with contributions from the Awards in the Visual Arts Program, 1989.10, Museum of Contemporary Art San Diego

Paul Kos makes work that incorporates sounds and directly engages the viewer. His sculptural installations often address the relationship between humanity and certain social constructs such as religion. In *Guadalupe Bell*, the artist represents one of the most revered images in Catholicism, a rendering of the Virgin Mary as the Virgin of Guadalupe, whose veneration is a particularly popular phenomenon in both the United States and Mexico. The bell evokes the church bell located in a tall tower and frequently used to toll the time as well as call worshippers to Mass.

Guadalupe Bell is activated when a visitor pulls a string, which causes the large bell to ring, and an image of the Virgin of Guadalupe is projected onto the wall behind the work. The revered image appears via a strobe light effect that emphasizes the miraculous and awe-inducing qualities of the Virgin. As the sound of the bell dissipates, so does the image. In Kos's work, the act of witnessing the "miracle" of the Virgin can occur again and again.

Kos received an MFA degree from the San Francisco Art Institute in 1967, a time when there was increased interest in installation art and performance, and became a major figure in the Bay Area Conceptual Art movement. The Museum of Contemporary Art San Diego (then called the La Jolla Museum) expressed early support for his work, which it presented in a solo exhibition in 1973.

151. Fitz Henry Lane (1804–1865), *Castine Harbor and Town*, 1851

Oil on canvas, 20 × 33¼ inches. Timken Museum of Art, Putnam Foundation Collection, 1986:001

Fitz Henry Lane's paintings often juxtapose boats to the expansive sea. While several of his works depict choppy waters, in *Castine Harbor and Town*, the stillness of the sea dominates the scene, and the artist's presentation of light results in a dramatic sky filled with long, low-lying clouds and fog. Lane's use of light is often considered in concert with the landscapes of Martin Johnson Heade (1819–1904) and Jasper Cropsey (1823–1900), who are also represented in the permanent collection of the Timken Museum of Art.

Lane's paintings were frequently inspired by the harbors of Boston and Gloucester, Massachusetts, but this particular work portrays a more tranquil scene in Castine Harbor, Maine. Margaretta Lovell writes that Lane's images of boats on the sea portray the "inhabitable landscape" in the mid-nineteenth century.[214] It was a landscape in which many laborers worked long hours and many lost their lives to the dangers of the sea. Lovell further states that Lane's works provide a counterpoint to the open landscapes of artists such as Albert Bierstadt (1830–1902) and Frederic Edwin Church (1826–1900), who were inspired by the doctrine of Manifest Destiny.[215]

Lane struggled after his legs became partially paralyzed. He worked in the Boston area and managed to make a name for himself, but his work fell into obscurity following his death until the mid-twentieth century, when there was renewed interest in his approach to portraying the sea and in his rigorous attention to light and overall environment.

152. Hughie Lee-Smith (1915–1999), *Sunday Afternoon*, 1953

Acrylic on board, 24 × 36 inches. Gift of Mr. and Mrs. Norton S. Walbridge, 1996.5, The San Diego Museum of Art

Hughie Lee-Smith was born in the small town of Eustis, Florida and moved with his mother to Cleveland, Ohio, at a young age. In 1938, he graduated from the Cleveland Institute of Art. His given surname was Smith, but he changed his name to Lee-Smith after some of his friends decided that Smith was too ordinary of a name if he was going to be an important artist. A year after graduating from the Cleveland Institute of Art, Lee-Smith relocated to Detroit, where the urban environment and, in particular, its dilapidated housing inspired many works. These scenes, like that depicted in *Sunday Afternoon*, present desolate spaces and evoke a sense of loneliness, expressing the emotional distance between people.

During the period that Lee-Smith painted this work, abstract expressionism was at the height of its power, yet despite the artistic trends, he remained focused on representational and narrative art. Although *Sunday Afternoon* addresses urban alienation and decay, there is also a mysterious quality to the composition that is typical of the artist's work as he also engaged with surrealism. The National Academy of Design recognized Lee-Smith's talent in 1967. With this honor, he became the first African American artist in forty years to be elected to the National Academy of Design.[216]

Widespread recognition eluded Lee-Smith until 1988, when a national traveling exhibition attracted new viewers to his work. Lee-Smith was an active teacher, including twenty years at the Art Students League, and he inspired loyalty among his students. Norton and Barbara Walbridge were two of the great donors to the American art collection at The San Diego Museum of Art as well as to the La Jolla Museum of Contemporary Art (now the Museum of Contemporary Art San Diego). They bought this painting directly from the artist, with whom Barbara Walbridge had studied painting.

153. Maya Lin (b. 1959), *Atlas Landscape: Rand McNally The New International Atlas,* 1981

Recycled atlas, 1⅛ × 23¼ × 15 inches (open), 1¾ × 11⅜ × 15 inches (closed). Museum purchase, 2010.27, Museum of Contemporary Art San Diego

In her June 2000 Academy of Achievement honoree interview, Maya Lin recalled, "I probably spent the first twenty years of my life wanting to be as American as possible. Through my twenties and into my thirties, I became aware of how so much of my art, and architecture, has a decidedly Eastern character. I think it is only in the last decade that I have understood how much I am a balance and a mix."[217]

Lin is probably most known for her design for the Vietnam Veterans Memorial in Washington, D.C. (1981), one of the most recognized and, for a time, most controversial works of public art in the history of the United States. She was a senior at Yale University when she entered her winning design in a national competition held by the Vietnam Veterans Memorial Fund. Her masterful monument is an icon among American public sculptures. Its connection to the earth and the surrounding environment allows visitors to reflect and also to immerse themselves physically within the piece. The earth at the site was cut away for the minimal slabs that make up the monument.

This idea of cutting away the earth is also reflected in Lin's series of transformed atlases. Through her use of an everyday object, the artist recalls the ready-mades of Marcel Duchamp (1887–1968). In the process of cutting the atlas, she suggests the sliced canvases of Lucio Fontana (1899–1968). Lin makes her own marks on these reproductions of the earth's varied topographies and transforms them, at least in map form. *Atlas Landscape: Rand McNally The New International Atlas* belongs to this body of work. Here, the atlas is open to the map of South America. The cuts to the page over Brazil reveal an imaginary lake. Lin cut each page individually, and the altered pages add a new sense of dimension to the land. *Atlas Landscape: Rand McNally The New International Atlas* is rather timely, as references to maps and creative processes related to mapping have become increasingly popular among contemporary artists. Moreover, art historians have evaluated contemporary art through the lens of mapping, as does Patricia Kelly in this volume.

154. Alfred Mitchell (1888–1972), *La Jolla Cove,* ca. 1950

Oil on canvas, 24 × 36 inches. Gift of the artist, 1965.26, The San Diego Museum of Art

Alfred Mitchell spent much of his artistic career in San Diego and was a pivotal figure locally. In 1913, he began to study painting formally under the plein air painter Maurice Braun (1877–1941). The San Diego Museum of Art owns an early Mitchell painting that the artist signed, "Fred Mitchell after Maurice Braun."[218] After Mitchell won a Silver Medal at the 1915 Panama–California Exposition, Braun encouraged the budding artist to leave San Diego, if only temporarily, and study at the Pennsylvania Academy of the Fine Arts, where he could obtain the rigorous training not available in San Diego at that time.[219] While Braun was a very influential teacher for Mitchell, Mitchell developed his own, different style, as indicated by this late painting. His mature work lacked the pastel hues so associated with landscapes by Braun. Mitchell became a member of several important San Diego organizations such as the La Jolla Art Association and the San Diego Art Guild, and he was influential in the founding of the Fine Arts Gallery (now The San Diego Museum of Art) in 1926.

Indeed, by studying with Braun, Mitchell trained with one of the great California impressionists. He

also had access to the work of other important figures such as Charles Fries (1854–1940) and Charles Reiffel (1862–1942). Late works, like *La Jolla Cove*, with the large shadow cast across the expansive beach and the bulky cliff that forms a surprising barrier on the right side of the composition, demonstrate the artist's ability to create a more modern composition than many of his California impressionist predecessors. Despite the extraordinary interest in California Impressionism, which is one of the few art trends with deep roots in Southern California, this piece finds a welcome home in the frontiers section of *Behold, America!* due to its portrayal of a much cherished location in proximity to the Museum of Contemporary Art San Diego in La Jolla.[220]

155. Thomas Moran (1837–1926), *Opus 24: Rome, from the Campagna, Sunset*, 1867

Oil on canvas, 25 × 45⅛ inches. Timken Museum of Art, Putnam Foundation Collection, 2005.001

156. Thomas Moran (1837–1926), *Below the Towers of Tower Falls, Yellowstone Park*, 1909

Oil on canvas, 30 × 25¹⁄₁₆ inches. Gift of Lydia and Etta Schwieder, 1968.48, The San Diego Museum of Art

Although Thomas Moran was born in England, he is often credited as being one of the first American painters to portray the topography of the American West. His father, an artisan weaver, came to the United States in 1842 and established a place for his family near Philadelphia. The entire family was reunited in 1844. Moran was one of seven children, and several of his brothers pursued careers in the visual arts. Edward Moran became an established marine painter; John Moran photographed the outdoors; and Peter Moran frequently depicted animals. In 1871, after reworking sketches of Yellowstone for *Scribner's Monthly*, Moran was so inspired that he obtained funding to join Ferdinand Hayden's expedition to the Yellowstone region for the U.S. Geological Survey of the Territories. Moran's paintings and the photographs of William Henry Jackson (1843–1942) encouraged the U.S. Congress to make Yellowstone a national park.

Like many of his contemporaries, Moran found that the time he spent in Europe was influential, and the landscapes of Joseph Mallord William Turner (1775–1851) had an early effect on his art. His travels in Italy resulted in several powerful landscapes, including *Opus 24: Rome, from the Campagna, Sunset*. This expansive landscape includes ruins in the right and left foreground and the skyline of Rome on the horizon just left of center in the composition. The setting sun and its brilliant yellow and red hues bring drama to the cloudy sky. Beyond capturing the beauty of the natural environment and the grand sense of history evoked by the architecture, Moran added a quirky detail, depicting several lizards in the rocky left foreground. He completed this painting in June 1867, one month after he returned from his second trip to Italy.

While *Opus 24: Rome, from the Campagna, Sunset* is a tremendous display of Moran's talent at thirty years of age and foretells his experiences in the American West, the smaller painting at The San Diego Museum of Art, *Below the Towers of Tower Falls, Yellowstone Park*, demonstrates the type of scenery that fascinated the artist during the second half of his career. Martin E. Petersen, curator of Western art at The San Diego Museum of Art at the time the institution acquired this painting, wrote, "Despite lingering shadows of romanticism, Moran's works during his lifetime were acclaimed by his contemporaries for their color harmonies and grandeur and were admired by the leading English critic John Ruskin."[221]

The area Moran depicts in *Below the Towers of Tower Falls, Yellowstone Park* was one of his favorite spots. Photographer Jackson remembered the beauty of the place: "Around Tower Falls also the scenery is worth more than the casual look-over it generally gets. The weird and fantastic towers and pinnacles along the turbulent creek above the falls contrast strangely with the chaste beauty of the Hot Springs and caught

Moran's fancy."[222] Moran emphasizes the tall trees and shale warmed by the yellow hues of sunshine. Because he sketched and painted this area of Yellowstone several times, related works exist. His *Above Tower Falls, Yellowstone* (1872; Smithsonian American Art Museum) is another fine example of his interest in the rock formations at the site. Jackson further described the conditions that the men experienced when reaching the awe-inspiring area. "There was some rough traveling between Tower Falls and the canyon, passing Mt. Washburn on the way; some went around its eastern base, others over the top for the bird's eye view of the entire lake basin and the canyon, but the larger number went by the pass to the west and then followed a tortuous trail to make camp on a small creek near the canyon and falls."[223] Moran lived the final years of his life in California and died in Santa Barbara.

157. Arnold Newman (1918–2006), *Georgia O'Keeffe*, 1968

Gelatin silver print, 8¾ × 13 inches. Gift of Cam and Wanda Garner, 2010.98, The San Diego Museum of Art

Arnold Newman was one of the great American portrait photographers of the twentieth century. The San Diego Museum of Art has a number of Newman's portraits of American artists such as Frank Stella (b. 1936) and Milton Avery (1885–1965) in its collection. In addition to his well-known portraits of artists, Newman also photographed actors and politicians. His work often appeared in popular publications such as *Life* magazine.

This photograph of Georgia O'Keeffe is especially iconic because it positions her amid the natural terrain that she connected with and painted so often. The rich texture of the rock on which she rests her hand is indicative of the simultaneously raw and awe-inspiring landscape of New Mexico. Newman took several powerful photographs of O'Keeffe when he visited her in 1968, but this was not the first time he documented the artist. In 1944, he completed a portrait of O'Keeffe and her husband Alfred Stieglitz (1864–1946).

Several noted photographers saw inspiration in O'Keeffe. In addition to Stieglitz, other accomplished photographers such as Ansel Adams (1902–1984), Laura Gilpin (1891–1979), and Todd Webb (1905–2000) produced portraits of O'Keeffe. Although she was the subject in a number of striking photographs, O'Keeffe owned a Leica camera and used it both to document the landscape and formal studies indoors.[224] Four years before this photograph was taken, she came into the possession of a Polaroid camera, which, with its instant film development, delighted her immensely.[225]

158. Georgia O'Keeffe (1887–1986), *In the Patio I*, 1946

Oil on board, 29¾ × 23¾ inches. Gift of Mr. and Mrs. Norton S. Walbridge, 1986.35, The San Diego Museum of Art

159. Georgia O'Keeffe (1887–1986), *Purple Hills near Abiquiu*, 1935

Oil on canvas, 16⅛ × 30⅛ inches. Gift and Mr. and Mrs. Norton S. Walbridge, 1976.216, The San Diego Museum of Art

Needing a break from her surroundings in Lake George, New York, Georgia O'Keeffe stayed in Taos, New Mexico, from May to August of 1929, her first extended visit. The land and the intense sun inspired the artist, and these factors continued to influence her paintings until her death. After 1929, O'Keeffe spent her summers in New Mexico and moved there permanently in 1949. She often painted at Ghost Ranch, particularly during the summer months, and bought a small home and acres of land from Arthur Pack, the founder of *Nature* magazine. Four years before she began to live in the region full-time, in 1945, she purchased a second home in the town of Abiquiu, where she had an ample enough water supply to keep a garden. Abiquiu is located

approximately fifty miles north of Santa Fe, and its outlying areas served as the inspiration for the minimalist landscape *Purple Hills near Abiquiu*. In September 1942, O'Keeffe wrote to her good friend Arthur

covered mesa to the west—pink and purple hills in front and the scrubby fine dull green cedars—and a feeling of much space."[226] The architecture and light of O'Keeffe's courtyard in her Abiquiu home resulted in more than

Dove (1880–1946), "I wish you could see what I see out the window—the earth pink and yellow cliffs to the north—the full pale moon about to go down in an early morning lavender sky behind a very long beautiful tree twenty paintings, finished between 1946 and 1960. *In the Patio I* is the artist's earliest painting of this special space.

160. Rubén Ortiz-Torres (b. 1964), *1492 Indians vs. Dukes*, 1993

Stitched lettering and airbrushed inks on baseball caps, two baseball caps, each 7½ × 11 × 5 inches. Gift of Mr. and Mrs. Scott Youmans by exchange, 2001.7, Museum of Contemporary Art San Diego

Valerie Loupe Olsen writes of Rubén Ortiz-Torres's use of baseball caps: "The artist views baseball caps as a popular form of ageless expression. Caps are so prevalent that they have become almost invisible as everyday fashion. Seen

concepts over its use of the name Aztecs. While some believe that it honors an ancient civilization of Mexico, others view it as derogatory. Moreover, the Moctezuma figure that performed "ceremonial rituals" at football games caused contro-

at any type of sporting event, at shopping malls, at gyms, and at stores, they are worn for many reasons, and most of these have nothing to do with baseball."[227] With *1492 Indians vs. Dukes*, Ortiz-Torres addresses the remnants of colonialism. He playfully adds corn and the numbers 1 and 4 to a Cleveland Indians baseball cap. The other cap represents the Albuquerque Dukes, a popular minor league baseball team that became defunct in 2000. The artist augments the Dukes hat with the numbers 9 and 2 and a cross, implying the spiritual colonization of the Americas by Christians. The city of Albuquerque was named after Don Francisco Fernández de la Cueva y Enríquez de Cabrera, whose many titles included the Duke of Albuquerque.

Locally, San Diego State University became involved in the debate on the meaning of mascots and the appropriation of culturally significant names and versy. The Aztecs name remains at San Diego State, but the role of the Moctezuma figure has been reduced. While Ortiz-Torres's works are about more than the political correctness of mascots, the artist continually proves through his work his distinctive understanding of the artistic communities of Baja California, Los Angeles, Mexico City, and Southern California.

Tyler Stallings writes about Ortiz-Torres's work: "It is through this combination of art and artifact that Ortiz-Torres speaks in a discourse that denies dichotomous constructions—like Mexico versus the U.S., Aztlán versus North America, Tijuana versus San Diego, Los Angeles versus New York, nationalist versus internationalist, low art versus high art—in order to reveal the mistaken faith in transcendental ideas such as Truth, History, and Justice, which have been deceptively stabilized through simply being named and encoded in linguistic and cultural signs."[228]

161. Raymond Pettibon (b. 1957), *No Title (According to its)*, 2005

Pen and ink on paper, sheet, 15½ × 15¾ inches. Museum purchase with funds from prior donations by Susan and Frank Kockritz and Mr. and Mrs. Norton S. Walbridge, 2006.14, Museum of Contemporary Art San Diego

162. Raymond Pettibon (b. 1957), *No Title (Pardon me, but)*, 2005

Pen and ink on paper, sheet, 22½ × 30¼ inches. Museum purchase with funds from prior donations by Susan and Frank Kockritz and Mr. and Mrs. Norton S. Walbridge, 2006.15, Museum of Contemporary Art San Diego

Raymond Pettibon was born in Tucson, Arizona, and grew up in Hermosa Beach, California. His brother was a guitarist for the punk band Black Flag, which gave him the opportunity to design art for albums produced by SST Records. Pettibon was influenced by the punk scene in Los Angeles during the 1980s as well as by comic books, television, and literature. His works present both highly recognizable figures such as George W. Bush, Charles Manson, and Elvis Presley and unrecognizable figures, as in the two works in *Behold, America!*

Pettibon's pen-and-ink drawings frequently suggest a comic book aesthetic. The text in his works, often ambiguous and ironic, derives from different sources: Pettibon writes some of it himself, alters interesting passages that he has found, and quotes from works of literature, such as books by Henry James and John Ruskin, and the Bible. The artist does not shy away from difficult imagery and addresses religion, politics, and sexuality in his work. In *No Title (Pardon me, but)*, Pettibon presents a landscape with a small alien or gnomelike figure. This figure, identified as Vavoom, appears in many of Pettibon's works, typically, as here, shouting his speech to the sky. In *No Title (According to its)*, a vampy woman leads a man wearing a suit into a vortex that emanates target-like circles. These two titles are similar in structure to the titles of other works by the artist, with the words *No Title* followed by a descriptive phrase in parentheses. The works are colorful and playful and suggest new frontiers.

163. Bert Geer Phillips (1868–1956), *Portrait of Tudl-Tur (Sun Elk)*, ca. 1910

Oil on board, 12 × 9¼ inches. Gift of Frank P. Phillips, 1979.39, The San Diego Museum of Art

Like his fellow painters of the American West, Joseph Henry Sharp (1859–1953) and E. Irving Course (1866–1936), Bert Geer Phillips was drawn to portraying Native Americans and their cultural traditions in his work. In 1898, Phillips and artist Ernest Blumenschein (1874–1960) arrived to Taos, New Mexico. Phillips became one of the first modern American artists to settle in and create a body of work inspired by the scenery and culture of the American West. Phillips found the landscape and the Taos Pueblo Indians particularly captivating, and, like many of the other American artists who settled in the region, he created a body of work that reflects his curiosity about the place and its indigenous peoples and his interest in their historical documentation; the paintings that resulted from this fascination often impart an idealized view of their subjects.

Tudl-Tur (Sun Elk), also known as Manuel Mondragón, was Phillips's friend and a frequent subject of his portraits. Among other things, Tudl-Tur taught the artist how to use a bow and arrow.[229] On a more official level, he functioned as a guide for Phillips when the artist traveled to Native communities in the region and provided him with invitations to select religious

services.[230] Moreover, Phillips, Tudl-Tur, and a couple of others traveled six miles south of Taos to Ranchos de Taos and Río Chiquito to witness Holy Week traditions; Phillips was particularly engrossed with the Penitents and their customs of self-flagellation.[231]

In this portrait, Phillips immortalizes the man who granted him access to cultural traditions that he would not have otherwise been welcome to observe and who inspired him to create his most important paintings of the American Southwest.

164. Iana Quesnell (b. 1969), *Triptych: Migration Path*, 2007

Graphite on paper, three pieces, each 79 × 79 inches. Museum purchase, Louise R. and Robert S. Harper Fund, 2007.62.1-3, Museum of Contemporary Art San Diego

In many of her large-scale drawings, Iana Quesnell maps physical movement within a defined geographic space. These works often relate to the artist's life and therefore become a type of autobiography presented through landscape. Quesnell explains, "To me home is an ephemeral experience. Since I do not own property, I am curious about where I have a right to exist and what the rules and regulations are that govern my body."[232]

Quesnell creates highly detailed drawings as well as works that incorporate iconic imagery ranging from the American flag to sombreros. *Triptych: Migration Path* presents a sparse rendering, while some of her compositions appear more densely packed. In both the drawn space and the blank areas of the work, the artist expresses the immensity of the landscape.

This drawing represents Quesnell's journey on public transportation from her home in Tijuana to her former studio in La Jolla, California. Although the distance is only about twenty miles, her journey lasts many hours. Quesnell's work is very much informed by the region in which she lives, in and around the U.S.-Mexico border. Many artists who reside in this area are drawn to create work about the cultural connections and disconnections between San Diego and Tijuana. In this crowded field of talented artists, Quesnell stands out through her creation of a highly recognizable art form, characterized by the use of large panels of paper and simultaneously delicate and rigorous application of graphite.

Quesnell received her BFA degree from Tampa University and an MFA from the University of San Diego. Although she lives in Tijuana and has been honored with a solo exhibition at the Centro Cultural Tijuana, she has developed her work in San Diego as well. Several local spaces have exhibited her work, including La Voz Gallery, where she had a solo exhibition, and the Museum of Contemporary Art San Diego, which included her work in its Cerca Series.

165. Alfredo Ramos Martínez (1871–1946), *Los Charros del Pueblo*, ca. 1941

Oil on binder board, 30 × 24 inches. Museum purchase, 1946.9, The San Diego Museum of Art

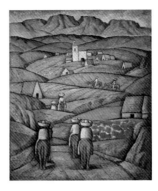

Alfredo Ramos Martínez was an important artist working in the opening decades of the twentieth century, but his impact on Mexican modernism was overshadowed by *los tres grandes*—Diego Rivera (1886–1957), David Alfaro Siqueiros (1896–1974), and José Clemente Orozco (1883–1949). One of Ramos Martínez's more important achievements was the founding of Open Air Schools in Mexico. Upon returning from an extensive sojourn in Europe, supported by the American philanthropist Phoebe Apperson Hearst, Ramos Martínez advocated for painting outdoors and taking pleasure in the routines of daily life, an enthusiasm that originated with his interest in Breton peasants in France. Despite various administrative posts and a number of portrait commissions, Ramos Martínez was not able to match the success of Rivera, Siqueiros, and Orozco in Mexico City. With his devoted wife and their ailing daughter, he moved to Los Angeles in 1929.

In Los Angeles, Ramos Martínez's work became increasingly about Mexico. He saw both his county and his culture from a new perspective and was able to satisfy the growing interest in Mexican art among California collectors. Albert Bender, a San Francisco–based collector of Mexican art, purchased some of Ramos Martínez's works, as did a number of people connected to the Hollywood film industry. Ramos Martínez arrived in Los Angeles just as the Great Depression was beginning, and several letters he wrote to Bender about a possible mural commission in San Francisco reveal that he struggled financially during his life.[233]

This painting is characteristic of the artist's subject matter after he settled in California. Ramos Martínez rendered an additional man on horseback, but he changed his mind and ultimately painted over it. Though difficult to detect in reproductions, the "phantom" rider is easily discernible when the painting is viewed in person.

166. Theodore Robinson (1852–1896), *The Edge of the Forest*, ca. 1890

Oil on canvas, 17⅛ × 22 inches. Gift of Mrs. Robert Smart, 1931.38, The San Diego Museum of Art

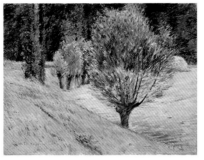

Theodore Robinson was born in Irasburg, Vermont, spent his formative years in Wisconsin, and moved to Chicago to pursue his studies. Later, in New York, he studied at the National Academy of Design and participated in the formation of the influential Art Students League. During the fall of 1875, Robinson left New York for Paris, where he continued his education at the École des Beaux-Arts. Robinson was well liked among the American artists living in Paris and befriended significant French painters, spending time in the studio of Jean-Léon Gérôme (1824–1904). He was one of the first American painters to engage with impressionism. Beyond his stay in Paris, Robinson lived for part of 1878 and 1879 in Venice. After returning to New York, he found work as an assistant to John LaFarge (1835–1910) and as a decorative painter at the Metropolitan Opera House.

Despite the stable income he was earning in New York, Robinson was drawn to return to France and pursue his career as an easel painter. In the spring of 1884, he settled in France, and for the next eight years, he split his time between Barbizon and Paris. In 1887, he visited Giverny, where he befriended Claude Monet (1840–1926) and occasionally painted alongside the artist. Their friendship and the stunning natural environment agreed with Robinson, and he returned to Giverny for the next five summers. *The Edge of the Forest* presents the lush and varied green hues of the French countryside that often served as a muse for Robinson.

In 1892, Robinson's time abroad came to an end, and he relocated permanently to New York, where he established his studio on Fourteenth Street. In 1895, Macbeth Galleries mounted a solo exhibition of his

work. His connection to Monet gave him prominence, and his French subjects tended to be more popular than his renderings of American scenes. He also wrote several essays on French painting.

After Robinson left France, landscapes continued to inspire him. In an interview with the writer Hamlin Garland (1860–1940), Robinson recalled that Garland had paraphrased the words of Walt Whitman in an earlier conversation. Garland recounted, "I tried to recall it in substance, at least, 'You go round the earth; you come back to find the things nearest at hand the sweetest and best after all.'" Pleased with his memory, Robinson responded, "That is what I mean. All I have done seems cold and formal to me now. What I am trying to do this year is to express the love I have for the scenes of my native town."[234] Toward the end of his life, he embraced the American landscape more passionately, but he is better known for his depictions of France. Whether in Europe or in the United States, a sense of place affected him profoundly.

167. Guy Rose (1867–1925), *Late Afternoon, Giverny*, ca. 1907–9

Oil on canvas, 23¾ × 28¾ inches. Museum purchase, 1926.161, The San Diego Museum of Art

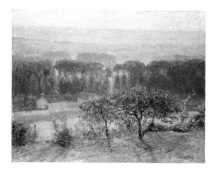

After graduating from high school in Los Angeles, Guy Rose moved to San Francisco, where he worked under the painter Emil Carlsen (1853–1932), who is also represented in this exhibition with his painting *Thanksgiving* (cat. 8). Rose went to Paris in 1888 and studied at the Académie Julian. In 1890, he traveled to the town of Giverny, made famous as the home of Claude Monet (1840–1926), who had arrived there in 1883, and spent much time in the burgeoning artists' colony. There, Rose interacted with a number of fellow American painters such as Alson Skinner Clark (1876–1949), Frederick Frieseke (1874–1939), and Richard Miller (1875–1943). In 1904, he purchased a small stone cottage and lived there until 1912.

The gentle gradations of green, blue, and purple hues in *Late Afternoon, Giverny* are typical of Rose's work. Ilene Susan Fort, longtime American art curator at the Los Angeles County Museum of Art, wrote about this work and others, "At Giverny, Rose was more intrigued by the light effects of a delicate haze or the nuances of early morning and twilight than by brilliant sunlight. Consequently, many of his French scenes, such as *Late Afternoon, Giverny*, are characterized by soft, almost wispy brushwork, gentle coloration, and a limited tonal range."[235] The small houses seen in the distance are also typical of Giverny and Rose's cottage. The lush trees of the landscape populate both the foreground and the middle ground of the composition; the foreground trees are likely fig trees. Rose is remembered not only as a superbly talented painter but also for encouraging artists to practice plein air painting after he returned to California. Several of his works were inspired by the views from La Jolla.

168. John Sloan (1871–1951), *Italian Procession, New York*, 1913–25

Oil on canvas, 24 × 28 inches. Museum purchase with funds provided by Mr. and Mrs. Appleton S. Bridges, 1926.127, The San Diego Museum of Art

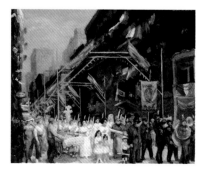

John Sloan is often associated with the Ashcan School, a group of urban realist painters who ushered in a new era of American art by seeking inspiration from their local environments instead of concentrating strictly on the lifestyles of the upper class. Before moving to New York, Sloan worked as an artist-reporter for several newspapers in Philadelphia. This exposure to daily realities informed his later work, which presents the streets, saloons, and tenements of lower Manhattan. In *Italian Procession, New York*, Sloan depicts a community celebration and stresses the prevalence of immigrant tradition in New York City. In his 1939 autobiography *The Gist of Art*, he wrote

about *Italian Procession, New York*: "These religious festivals in the Italian quarters of New York were and still are colorful invasions of very drab localities. . . . I remember the palette as a violet dominant."[236]

Sloan had a great appreciation for American literature. He referred to Walt Whitman several times in his diaries and noted the day, May 26, 1909, when he read Whitman's "Song of Myself."[237] He maintained a diverse library, something he had learned from his family, as he recounted that he grew up surrounded by books and that, from the time he was five, his family had a library in which he could seek inspiration. Moreover, as a child, Sloan spent many Saturdays at the public library, absorbed in the works of Charles Dickens and William Shakespeare.[238] Sloan and Whitman certainly shared a love for the urban milieu and specifically an affinity for New York City. On May 31, 1910, Sloan wrote, "I walked across the Brooklyn Bridge for the first time. I enjoyed it immensely. There were fine clouds over the sky with sun-ladders of silver, one of which struck the Statue of Liberty. This sounds like a romantic touch but it's true nonetheless. I walked a little in Brooklyn which was the town Whitman knew so well, and on the bridge I thought of Whitman's *Brooklyn Ferry*."[239]

With *Italian Procession*, Sloan focused on the immigrant experience and the popular traditions of a community. He worked on this painting for more than a decade—first painting the work, then leaving it alone for an extended period of time, and finally adding dramatic, violet paint to complete the work. While Sloan records a public procession, Whitman positioned himself as a participant in a variety of urban moments and spaces. In his poem "Song of Myself," Whitman writes,

> This is the city and I am one of the citizens,
> Whatever interests the rest interests me, politics, wars, markets,
> newspapers, schools,
> The mayors and councils, banks, tariffs, steamships, factories, stocks,
> stores, real estate and personal estate.[240]

Both Sloan and Whitman contributed to the formulation of a modern American identity in their respective works and chose to document the popular classes and everyday experience.

169. Robert Smithson (1938–1973), *Mono Lake Non-Site (Cinders near Black Point)*, 1968

Painted steel container, cinders, map photostat, site map, 40¼ × 40¼ inches, container, 7 × 39¾ × 39¾ inches. Museum purchase, 1981.10.1-2, Museum of Contemporary Art San Diego

Robert Smithson painted abstract canvases during the 1950s but turned to sculpture in 1964. He became known for earthworks, defined as monumental interventions in the landscape, and became closely associated with land art.[241] Influenced by minimalism, Smithson began the series *Non-Sites* in 1968. The title is not only a negative reference to conventional procedures for mapping and studying topography but also a play on the words *site* and *sight*, as the viewer cannot see the depicted site.

With *Mono Lake Non-Site (Cinders near Black Point)*, the artist presents two different but related components. On the floor, there is a painted steel

square with a gutter. Inside the gutter are cinders. On the wall, above the square on the floor, is a square of similar size with a blank white middle section and maps depicted along the edges, with only a few words, such as "Sulpher Pond" and "Warm Springs," clearly discernible.

Mono Lake, a large, shallow lake formed more than 760,000 years ago, is located in east-central California.[242] Given Smithson's interest in ancient architecture and the underlying structures of nature, it is a logical place for creative inspiration. Black Point, a low volcanic mountain of cinders and black ash, overlooks Mono Lake.

170. Larry Sultan (1946–2009), *Cabana*, 2000

Chromogenic print, edition 3/10, 40 × 49½ × 2 inches. Anonymous gift, 2005.28, Museum of Contemporary Art San Diego

Larry Sultan grew up in San Fernando Valley, California, and began photographing near his former high school during the 1990s. Known popularly as "the Valley," the area is a suburb adjacent to Los Angeles. In *Cabana*, which is from Sultan's series *The Valley*, the artist combines the image of the San Fernando Valley as the domain of cookie-cutter houses filled with middle- and upper-middle-class families and the region's reality as the site of a booming porn industry. During the day, many homes are rented out as sets for pornographic films. The couple engaging in a tryst in a makeshift blue-and-white-striped cabana is barely visible. The satellite on the second-floor balcony in the background gives a sense of the environment in which the photograph was taken. Although the couple will no doubt be presented in a simultaneously sensuous and dramatic moment on-screen, Sultan's camera provides the viewer with a wider perspective and a more realistic context for the scene.

Sultan received a BA degree in political science from the University of California, Santa Barbara, in 1968, and an MFA degree from the San Francisco Art Institute in 1973. From 1988 until his death, he taught at the California College of the Arts in San Francisco. During this time, he was an influential figure on campus and in the Bay Area.

171. Jules Tavernier (1844–1889), *Kilauea Caldera, Sandwich Islands*, 1886

Oil on canvas, 28 × 57 inches. Museum purchase with funds provided by Kevin and Tamara Kinsella, 2002.35, The San Diego Museum of Art

Jules Tavernier was born in Paris and began his formal art education at the Ecole des Beaux-Arts at age sixteen. He served as a war correspondent during the Franco-Prussian War (1870–1871) and, a year later, came to the United States, where he was soon employed as an illustrator for *Harper's Weekly*. While at *Harper's*, Tavernier was assigned to illustrate scenes of the American West, which took him across the United States and provided him with the opportunity to depict Native American cultures. Coincidentally, at the same time that Tavernier was exploring the American West, thousands of French immigrants, looking to improve their fortunes amid their country's political and economic problems, arrived in California in search of gold.[243]

After spending time in Cheyenne, Wyoming, and similar communities, Tavernier settled in San Francisco, where he was influential in the formation of the Palette Club in 1884. Later, he moved to Monterey, which inspired him with its stunning oceanfront vistas. Given his previous artistic achievements, his presence in Monterey raised the community's profile as a burgeoning artists' colony. Tavernier struggled with alcoholism and financial debt and often had to relocate because of problems caused by his behavior. From Monterey, the artist left for Hawaii.

In *Kilauea Caldera, Sandwich Islands*, Tavernier depicts an exploding volcano with great attention to color and his distinctive use of light. The dramatic fire and hot lava portrayed in brilliant orange, yellow, and red emerge from the volcano slowly and dissipate into softer pink and purple hues. The natural terrain in Hawaii fascinated the artist, but he was more captivated by volcanoes. During his time in Hawaii, he made one hundred paintings and pastels depicting volcanoes.

Dissecting the title of this Tavernier painting offers a way in which to further contextualize the work. The volcano depicted here, Kilauea, is located on the island of Hawaii, which was one of the artist's favorites. The term caldera refers to a depression at the summit of a volcano that typically is large in diameter.

Captain James Cook (1728–1779) named the islands the Sandwich Islands after John Montagu, fourth earl of Sandwich (1718–1792), a supporter of his voyages, when he happened upon them unexpectedly on January 18, 1778. The Sandwich Islands continued to be the standard English name for the islands until the mid-1890s. In 1810, less than eighty years before the artist completed this work, the islands were united for the first time under a single ruler, Kamehameha I, with the help of foreign weapons and advisers. Hawaii's diverse cultures and landscapes inspired foreign artists, politicians, and businessman, among others, to settle in the islands.

172. John Henry Twachtman (1853–1902), *The Shore*, ca. 1879

Oil on canvas, 14³⁄₁₆ × 24⅛ inches. Gift of Mrs. Henry A. Everett, 1927.83, The San Diego Museum of Art

As a young man, John Henry Twachtman studied with the painter Frank Duveneck (1848–1919) and traveled with him to Munich in 1875. He later followed Duveneck to Florence, where he taught at Duveneck's short-lived art school. Unlike his nineteenth-century contemporaries, Twachtman was drawn to painting landscapes on a smaller, more intimate scale. Later in his career, when he was back in the United States, he focused on landscapes near Greenwich, Connecticut and Gloucester, Massachusetts. *The Shore*, however, represents a view of Jersey City.

During the late nineteenth and early twentieth centuries, Jersey City was a hub of port activity and home to various manufacturing industries. At the time that Twachtman portrayed the scene, Jersey City was undergoing a major transformation, and the contradictory pairing of a quiet, but dense waterfront scene in a rapidly changing industrial center likely intrigued him. Furthermore, the city was home to many new immigrants, and its proximity to Manhattan resulted in a steady influx of residents. As Lisa N. Peters writes, "Painting with dark tones and free, gestural strokes, he captured the slapped-together, unplanned look of this crowded community. His awareness of the advance of modern life is suggested in his juxtaposition of a single empty rowboat in the work's foreground with the burgeoning development just beyond."[244]

In 1879, Twachtman relocated to New York and immortalized the harbors of both New York City and Jersey City. After completing her dissertation on Twachtman, Peters wrote to Martin E. Petersen at The San Diego Museum of Art, confirming the location of the painting: "It shows a view looking northwest from a point at the south of Jersey City's Green Street Boat Basin, a short walk from the Jersey City train station and parallel to the Morris Canal (landfilled in 1929)."[245]

173. Brian Ulrich (b. 1971), *Black River Falls, WI*, 2006

LightJet C-print, 40 × 53 inches. Gift of Joyce and Ted Strauss, 2010.29, Museum of Contemporary Art San Diego

Brian Ulrich's *Black River Falls, WI* reminds the viewer of the societal changes that have taken place since the terrorist attacks of September 11, 2001. Since those horrific events, words such as "homeland security" and the red, orange, and yellow threat levels have become a part of the American popular lexicon. Black River Falls is a small town located in west-central Wisconsin.[246] There is irony in this work because although violence can occur anywhere, Black River Falls is far from the areas targeted on September 11. The widespread effect of the violence is emphasized by the presence of the threat level updates sign.

In Ulrich's rendering, the bar where the threat level is posted is blank, and text

below encourages interested parties to ask the cashier for details. The disconnect in communication in the store could function as a metaphor for the post-9/11 age. From a formal point of view, the photograph possesses strong lines, for example, the roof of the gas station and the geometric forms of the trash cans.

Moreover, the windows of the shop at the gas station further complicate the formal composition and augment its visual power. Ulrich is represented in the forms section of *Behold, America!* with *Kenosha, WI, 2003 (Spilled Milk)* and his work is the subject of an interview also in this volume.

174. Mario Ybarra, Jr. (b. 1973), *Go Tell It #2*, 2001

Color LightJet print, 48 × 60 inches. Museum purchase with funds from Hilarie and Mark Moore and the Moore Family Trust, 2009.31, Museum of Contemporary Art San Diego

175. Mario Ybarra, Jr. (b. 1973), *Go Tell It (Microphone)*, 2006

Megaphone on stand; Stand, height 48 inches, diameter 12 inches; Megaphone, 13½ × 14 × 9 inches. Museum purchase with funds from Hilarie and Mark Moore and the Moore Family Trust, 2009.31.a-b, Museum of Contemporary Art San Diego

Mario Ybarra, Jr., was born in Los Angeles. He received formal training at Otis College of Art and Design, where he completed his BFA degree in 1993, and the University of California, Irvine, where he obtained an MFA degree in 2001. Ybarra had formative experiences working with two other artists whose works are included in *Behold, America!* A brief stint as a studio assistant for Rubén Ortiz-Torres (b. 1964) and work with Daniel Martínez (b. 1957) at the University of California, Irvine, were influential.

Ybarra combined his interests in education and art in 2002, when he cofounded the collective Slanguage with artists Karla Diaz and Juan Capistran. Slanguage members engage in a variety of activities, ranging from making art, organizing exhibitions, teaching workshops, and developing other types of art-related programs. He has participated in a number of important group and solo exhibitions, including the 2005 Whitney Biennial and, in 2008, *Phantom Sightings: Art after the Chicano Movement* at the Los Angeles County Museum of Art and *Take Me Out . . . No Man Is an Island* at the Art Institute of Chicago.

Go Tell It #2 and *Go Tell It (Microphone)* combine Ybarra's interests in the visual arts and social activism. These works are from a series that evokes the history of Chicano activism in California and more broadly questions who hears any given political protest and suggests the value of speaking one's mind, even if to no one in particular. The series began with a body of photographs in which the artist portrays himself alone, shouting into a megaphone in settings such as an open field, as in *Go Tell It #2*, the roof of a single-family home, and a cliff with a sweeping ocean view. In *Go Tell It (Microphone)*, the megaphone itself is transformed into a work of art. The megaphone is a practical device of protest and also a symbol of activism. Furthermore, in a museum context, *Go Tell It (Microphone)* questions the effectiveness of the object as a tool that simultaneously represents action, in its function of amplifying a voice, and inaction, when no one uses it or no one is present to respond to the noise it augments.

NOTES

1. Frederick A. Horowitz and Brenda Danilowitz, *Josef Albers: To Open Eyes, the Bauhaus, Black Mountain College, and Yale* (London: Phaidon, 2006), 195.

2. Jean Charlot, "Nature and the Art of Josef Albers," in *An Artist on Art: Collected Essays of Jean Charlot* (Honolulu: University of Hawaii Press, 1972), 1:204. The essay was published in a slightly different form in the spring 1956 edition of *College Art Journal*.

3. Alexander Nemerov, *To Make a World: George Ault and 1940s America*, exh. cat. (Washington, D.C.: Smithsonian American Art Museum in association with Yale University Press, 2011).

4. Patricia Kelly, "Jo Baer, Modernism and Painting on the Edge," *Art Journal* 68, no. 3 (2009): 53.

5. The exhibition was a collaboration between the Museum of Contemporary Art San Diego and the Palm Springs Art Museum.

6. Thomas Hart Benton, letter to Martin E. Petersen, 30 December 1974. The San Diego Museum of Art Archives.

7. Ibid.

8. Thomas Hart Benton, letter to Martin E. Petersen, 12 January 1975. The San Diego Museum of Art Archives.

9. Jack Rutberg, foreword to *Hans Burkhardt: Painting of the 1960s* (Los Angeles: Jack Rutberg Fine Arts, 2008), 4.

10. Jack Rutberg, conversation with author, December 3, 2011.

11. Alex J. Taylor, "Unstable Motives: Propaganda, Politics, and the Late Work of Alexander Calder," *American Art* 26, 1 (March 2012): 39.

12. Ibid., 39. Originally quoted in Michael Gibson, *Calder* (London: Art Data, 1988), 93.

13. Reginald Poland, "Most Important American Painting for San Diego: An Emil Carlsen Given by Melville Klauber for Art Gallery," *San Diego Union*, December 2, 1928.

14. Letter from Reginald Poland to Melville Klauber, 3 December 1928. The San Diego Museum of Art Archives.

15. John R. Lane, letter to Henry G. Gardiner, March 13, 1978. The San Diego Museum of Art Archives.

16. For an overview of Chicago modernism, see Elizabeth Kennedy et al., *Chicago Modern, 1893–1945: Pursuit of the New*, exh. cat. (Chicago: Terra Museum of American Art, 2004).

17. Randy J. Ploog, "The First American Abstractionist: Manierre Dawson and his Sources," in *Manierre Dawson: American Pioneer of Abstract Art* (New York: Hollis Taggart Galleries, 1999), 69.

18. Susan Weininger, "Modernism and Chicago Art: 1910–1940," in *The Old Guard and the Avant-Garde: Modernism in Chicago, 1910–1940*, ed. Sue Ann Prince (Chicago: University of Chicago Press, 1990), 61.

19. Ibid.

20. Suzanne Hudson, "Tara Donovan: Institute of Contemporary Art, Boston," *Artforum International* 47 (January 2009), 204.

21. Debra Bricker Balken, *Dove/O'Keeffe: Circles of Influence*, exh. cat. (Williamstown, MA: Sterling and Francine Clark Institute, 2009), 71.

22. Charles C. Eldredge, *Reflection on Nature: Small Paintings by Arthur Dove, 1942–1943*, exh. cat. (New York: The American Federation of Arts, 1997), 14.

23. "Fine Arts Gallery Buys First Abstract," *San Diego Union-Tribune*, April 15, 1973.

24. Michael Govan and Tiffany Bell, *Dan Flavin: The Complete Lights, 1961–1996*, exh. cat. (New York: Dia Art Foundation in association with Yale University Press, 2004), 293.

25. Tiffany Bell, "Fluorescent Light as Art," in ibid., 109–10.

26. Sam Gilliam and Annie Gawlak, "Solids and Veils," *Art Journal* 50:1 (Spring 1991): 10.

27. James Oles, *South of the Border: Mexico in the American Imagination, 1917–1947* (Washington, D.C.: Smithsonian Institution Press, 1993), 235.

28. Stuart P. Feld, letter to Henry Gardiner, May 31, 1972. The San Diego Museum of Art Archives.

29. Janet L. Comey, "Florida: The Late Work," in *Martin Johnson Heade*, exh. cat. (Boston: Museum of Fine Arts, Boston, 1999), 124.

30. Sarah Cash, *Ominous Hush: The Thunderstorm Paintings of Martin Johnson Heade*, exh. cat. (Fort Worth, TX: Amon Carter Museum, 1994).

31. Stephanie Hanor, "The Material of Immateriality," in *Phenomenal: California Light, Space, Surface*, ed. Robin Clark, exh. cat. (La Jolla, CA: Museum of Contemporary Art; Berkeley: University of California Press, 2011), 147.

32. The exhibition was featured in a number of prominent publications, such as *Art in America*, *Artforum International*, the *Los Angeles Times*, and the *New York Times*.

33. Stephanie Hanor et al., *Jasper Johns: Light Bulb*, exh. cat. (La Jolla, CA: Museum of Contemporary Art, San Diego, 2008).

34. James Rondeau, "Gray," in *Jasper Johns: Gray*, ed. James Rondeau and Douglas Druick, exh. cat. (Chicago: The Art Institute of Chicago in association with Yale University Press, 2007), 28.

35. Nan Rosenthal, "A Conversation with Jasper Johns," in *Jasper Johns: Gray*, ed. James Rondeau and Douglas Druick, exh. cat. (Chicago: The Art Institute of Chicago in association with Yale University Press, 2007), 156–61.

36. Ibid., 159.

37. Patricia Hills, *Eastman Johnson*, exh. cat. (New York: C. N. Potter, in association with the Whitney Museum of American Art, 1972), 72.

38. In *Sentences on Conceptual Art*, Sol LeWitt wrote, "Conceptual Artists are mystics rather than rationalists. They leap to conclusions that logic cannot reach." LeWitt's *Sentences on Conceptual Art* appeared in *Art-Language* 1, no. 1 (May 1969): 11–13. This text and others by the artist appeared in "Appendix: The Writings of Sol LeWitt," in *Sol LeWitt: A Retrospective*, exh. cat., ed. Gary Garrels (San Francisco: San Francisco Museum of Modern Art, 2000), 368–377.

39. *Roy Lichtenstein: A Retrospective*, exh. cat. (Chicago: The Art Institute of Chicago, 2012).

40. David Carrier, "Robert Mangold's 'Gray Window Wall'," in *The Burlington Magazine* 138: 1125 (December 1996): 828.

41. Ibid., 826.

42. Ben Neill, "Interview with Christian Marclay," *Bomb*, 84 (Summer 2003): 46.

43. Ibid., 49.

44. Daniel Zalewski, "The Hours: How Christian Marclay Created the Ultimate Digital Mosaic," *The New Yorker*, March 12, 2012: 51.

45. *The Selected Writings of John Marin*, ed. Dorothy Norman, (New York: Pellegrini and Cudahay, 1949), 149.

46. Lynne Cooke, ". . . in the classic tradition . . ." *Agnes Martin*, exh. cat. (New York: Dia Art Foundation, 2011), 12.

47. Richard Tobin, "Agnes Martin: Before the Grid," in *Agnes Martin: Before The Grid*, exh. cat. (Taos, New Mexico: the Museum, 2012), 17.

48. Ibid., 24.

49. Suzanne Hudson, "Agnes Martin, On a Clear Day," in *Agnes Martin*, exh. cat. (New York: Dia Art Foundation, 2011), 120.

50. "How does one go all the way? One keeps going. A conversation with John McCracken about proximity, captivity, and horizons," in *John McCracken*, ed. Andrea Bellini (Rivoli-Turin: Castello di Rivoli and Milan: Skira, 2011), 55.

51. Letter from Georgia O'Keeffe to Dorothy Brett, September 1932. Jack Cowart and Juan Hamilton, *Georgia O'Keeffe, Art and Letters* (Washington, D.C.: National Gallery of Art; Boston: New York Graphic Society Books, 1987), 210.

52. Peggy Samuels, Harold Samuels, Joan Samuels, and Daniel Fabian, *Techniques of the Artists of the American West* (Secaucus, NJ: The Wellfleet Press, 1990), 167.

53. Ibid.

54. Claes Oldenburg, "Multiples and Production Notes," in *Claes Oldenburg: Multiples in Retrospect, 1964–1990* (New York: Rizzoli, 1991), 45.

55. *The Mouse Museum, The Ray Gun Wing: Two Collections, Two Buildings*, exh. cat. (Chicago: Museum of Contemporary Art, 1977).

56. Oldenburg, 40.

57. Roberta Smith, "James Elliott, 76, a Curator Who Dabbled in Filmmaking," *New York Times*, September 25, 2000.

58. Victor Zamudio-Taylor, *Ultra Baroque: Aspects of Post Latin American Art*, exh. cat. (San Diego, CA: Museum of Contemporary Art San Diego), 144.

59. For more information on the meaning behind this cap, see the interview with Ortiz-Torres in this book.

60. Helen Pashgian, interview by Robin Clark, ACE Gallery, Beverly Hills, recorded on April 23, 2011, posted to the MCASD website in September 2011.

61. Ibid.

62. In addition to his sons, Charles Willson Peale's younger brother, James Peale, was also an artist, as was his nephew and namesake, Charles Peale Polk.

63. Alexander Nemerov, *The Body of Raphaelle Peale: Still Life and Selfhood, 1812–1824* (Berkeley: University of California Press, 2001), 101.

64. Ibid.

65. Mark Mitchell made this observation during a visit on June 30, 2011 to The San Diego Museum of Art.

66. Jan Rindfleisch, *Staying Visible, the Importance of Archives: Art and "Saved Stuff" of Eleven 20th-Century California Artists*, exh. cat. (Cupertino, CA: De Anza College, 1981), 8.

67. Ibid., 9.

68. Agnes Pelton, "Introduction to Paintings," archival material at The San Diego Museum of Art.

69. *Ceci n'est pas le surréalism: California, Idioms of Surrealism*, exh. cat., ed. Marie De Alcuaz (Los Angeles: Fisher Gallery, University of Southern California, and Art in California Books, 1983).

70. Michael Zakian, *Agnes Pelton: Poet of Nature*, exh. cat. (Palm Springs, CA: Palm Springs Desert Museum in association with the University of Washington Press, 1995).

71. Karen Moss et al., *Illumination: The Paintings of Georgia O'Keeffe, Agnes Pelton, Agnes Martin and Florence Pierce*, exh. cat. (London: Merrell Publishers in association with the Orange County Museum of Art, 2009).

72. http://www.pbs.org/americaquilts/century/stories/faith_ringgold.html (accessed May 25, 2012).

73. Neal Benezra, "Ed Ruscha: Painting and Artistic License," in *Ed Ruscha* by Neal Benezra and Kerry Brougher with a contribution by Phyllis Rosenzweig, exh. cat. (Washington, D.C.: Hirshhorn Museum and Sculpture Garden, Smithsonian Institution, 2000), 150.

74. Gail Levin, *Synchromism and American Color Abstraction, 1910–1925*, exh. cat. (New York: George Braziller in association with the Whitney Museum of American Art, 1978), 18.

75. Marilyn S. Kushner, *Morgan Russell*, exh. cat. (New York: Hudson Hills Press in association with Montclair Art Museum, 1990), 72.

76. Levin, *Synchromism and American Color Abstraction, 1910–1925*, 18.

77. Kushner, *Morgan Russell.*

78. Richard Serra, *Drawing: A Retrospective,* exh. cat. (Houston: Menil Collection, 2011).

79. Nancy Princenthal, "Gary Simmons: Disappearing Acts," *ART/TEXT* 57 (1997): 53.

80. Robert Storr, "Room for Maneuver," in *Tony Smith: Louisenberg* (New York: Mitchell-Inness & Nash, 2003), 5.

81. McNulty's stories date to the 1940s but became available to wider audiences with the publication of *This Place on Third Avenue: The New York Stories of John McNulty* (Washington, D.C.: Counterpoint, 2001).

82. Hollis Frampton took an iconic photograph of the artist, with paint on his trousers, standing outside the Cedar Tavern, *#42 (163 Cedar Street Tavern)*, from the portfolio *The Secret World of Frank Stella* (1958–62; Gallery of American Art).

83. Frances Colpitt, "The Shape of Painting in the 1960s," *Art Journal* 50: 1 (Spring 1991): 52.

84. Kenneth Dinin, "John Storrs: Organic Functionalism in a Modern Idiom," *The Journal of Decorative and Propaganda Arts* 6 (Autumn 1987): 61–63.

85. Lynne Warren, "Donald Sultan, Contemporary Art, and Popular Culture," in *Donald Sultan*, exh. cat. (Chicago: Museum of Contemporary Art Chicago; New York: H. N. Abrams, 1987), 36.

86. One of these works, Robert Irwin's *1°2°3°4°* (1997), is also included in *Behold, America!* The museum continues its engagement with monumental site-specific works by leading artists with its April 2012 acquisition of Spencer Finch's *Rome (Pantheon, Noon, June 14, 2011).*

87. Christian Viveros-Faune, "Sarah Sze's Return of the Real," *Village Voice*, September 29, 2010.

88. Melissa Chiu, Sarah Sze, and Vishaka Desai, *Sarah Sze: Infinite Line*, exh. cat. (New York: Asia Society Museum, 2011).

89. For more information on this artist, see Linda Norden et al., *Sarah Sze* (New York: H. N. Abrams, 2007), and Jeffrey Kastner, "Sarah Sze: Tipping the Scales," *Art/Text* 65 (May–July 1999).

90. Sean Gregory, "The Buck Stops Here: Dollar Stores Won Walmart Customers during the Recession—and Plan to Keep Them," *Time*, December 20, 2010, 54–56.

91. For more information, see http://www.coloraid.com/.

92. Brooke Hodge, "Seeing Things, Studio Visit: Pae White," T Magazine, *New York Times*, September 16, 2010, http://tmagazine.blogs.nytimes.com/

93. Andrea Zittel, "Biography," in *Andrea Zittel Diary #01* (Milan: Tema Celeste Editions, 2002), 137.

94. Zittel, *Andrea Zittel Diary #01*, 76.

95. Shakur has been referenced by other artists, including David Hammons (b. 1943), in his *Out of Sequence* (2000). Both *Spock, Tuvac, Tupac* and Hammons's *Out of Sequence* were included in *One Planet under a Groove: Hip Hop and Contemporary Art*, exh. cat. (New York: The Bronx Museum of the Arts, 2001).

96. Alexander Archipenko, "Archipenko's Writings," *Archives of American Art Journal* 7, no. 2 (April 1967): 7.

97. Ibid.

98. E. Maurice Bloch, *The Paintings of George Caleb Bingham: A Catalogue Raisonné* (Columbia: University of Missouri Press, 1986), 237.

99. Gutzon Borglum, handwritten notes, cited in Robin Borglum Carter, *Gutzon Borglum: His Life and Work* (Austin, TX. Eakin Press, 1998).

100. *Awakening* was included in the exhibition *Rodin and America: Influence and Adaptation, 1876–1936* at the Iris & B. Gerald Cantor Center for Visual Arts at Stanford University, California. See Bernard Barryte and Roberta K. Tarbell, eds., *Rodin and America: Influence and Adaptation, 1876–1936*, exh. cat. (Stanford, CA: Iris & B. Gerald Cantor Center for Visual Arts, Stanford University; Milan, Italy: Silvana Editoriale, 2011).

101. D. Scott Atkinson and Claudia Leos, "Art of North America," in *The San Diego Museum of Art: Selected Works* (San Diego, CA: The San Diego Museum of Art, 2003), 177.

102. Julia M. H. Carson, *Mary Cassatt: A Biography* (New York: D. McKay Co., 1966), 2.

103. Richard H. Love, *Mary Cassatt: The Independent* (Chicago: Milton H. Kreines, 1980), 124.

104. Eleanor H. Gustafson, "Museum Accessions," *Antiques* CXII (Aug. 1977): 220.

105. Paul Staiti, "Character and Class: The Portraits of John Singleton Copley," in *Reading American Art*, ed. Marianne Doezema and Elizabeth Milroy (New Haven, CT: Yale University Press, 1998), 26–27.

106. Carrie Rebora Barratt, *John Singleton Copley and Margaret Kemble Gage: Turkish Fashion in 18th-Century America*, exh. cat. (San Diego, CA: Putnam Foundation, 1998), 27.

107. Ibid., 34.

108. Hugo Crosthwaite, interview by the author, December 5, 2011.

109. Ibid.

110. Rochelle Steiner, "Interview with John Currin," in *John Currin*, exh. cat. (New York: Harry N. Abrams, 2003), 77.

111. Ibid., 78.

112. Claire Perry, *Young America: Childhood in 19th-Century Art and Culture* (New Haven, CT: Yale University Press, 2006), 69.

113. Michael Clapper, "Thomas Eakins and Chess Players," *American Art*, 21:3 (Fall 2010): 84.

114. H. Barbara Weinberg, "Thomas Eakins and The Metropolitan Museum of Art," *The Metropolitan Museum of Art Bulletin* 52:3 (Winter 1994–95): 38.

115. Susan Eakins, letter to Alfred Mitchell, 20 July 1937. The San Diego Museum of Art Archives.

116. Nicolai Fechin's *Portrait of Miss Sapojnikoff* came into the collection of The San Diego Museum of Art in 1964.

117. Raúl Guerrero, interview by author, March 15, 2012.

118. Ibid.

119. Ibid.

120. Jane Watson, "News and Comments," *Magazine of Art* 34, no. 7 (August–September 1941): 395.

121. "Pittsburgh Artist Winner in San Diego Competition," *San Diego Union*, June 24, 1941.

122. Sarah J. Rogers, "Ann Hamilton: Details," in *The Body and the Object: Ann Hamilton, 1984–1996*, exh. cat. (Columbus, Ohio: Wexner Center for the Arts, The Ohio State University, 1996), 15.

123. Ibid., 30.

124. Stephanie Hanor, "David Hammons," in *Lateral Thinking: Art of the 1990s*, exh. cat. (San Diego, CA: Museum of Contemporary Art San Diego, 2002), 61.

125. Ronald J. Onorato, "Collecting in Context," in *San Diego Museum of Contemporary Art: Selections from the Permanent Collection*, exh. cat. (San Diego, CA: San Diego Museum of Contemporary Art, 1990), 37.

126. John Loughery, *John Sloan: Painter and Rebel* (New York: Henry Holt and Company, 1995), 24.

127. Ibid., 23–24.

128. Robert Henri with Margery Ryerson, *The Art Spirit*, 5th ed, Philadelphia: J. B. Lippincott, 1930),79–80.

129. Clement Greenberg, "Hofmann," in *Hans Hofmann*, ed. Cynthia Goodman, exh. cat. (New York: Prestel-Verlag in association with the Whitney Museum of Art, 1990), 124. Reprinted with permission from Clement Greenberg, *Hans Hofmann* (Paris: Editions Georges Fall, 1961).

130. Hans Hofmann, "Statement, 1931" in Goodman, *Hans Hofmann*, 163–64.

131. Sarah Burns, "In Whose Shadow? Eastman Johnson and Winslow Homer in the Postwar Decades," in *Eastman Johnson: Painting America*, by Teresa A. Carbone and Patricia Hills, exh. cat. (New York: Brooklyn Museum of Art, in association with Rizzoli International Publications, 1999), 193.

132. My thanks to Anna Sophie Wilson for her help with this information.

133. Patricia Hills, *Eastman Johnson*, exh. cat. (New York: C. N. Potter in association with the Whitney Museum of American Art, 1972), 76.

134. Patricia Hills, *Genre Painting of Eastman Johnson: The Sources and Development of His Style and Themes* (New York: Garland Publishing, 1977), 81.

135. Anne C. Rose, "Eastman Johnson and the Culture of American Individualism," in Carbone and Hills, *Eastman Johnson: Painting America*, 228.

136. Walt Whitman, "A Song for Occupations," in Walt Whitman's *Leaves of Grass* (New York: Doubleday, Doran and Co., Inc., 1940), Section 3, 162.

137. Susan Morgan, *Joan Jonas: I Want to Live in the Country (And Other Romances)* (London: Afterall Books, 2006), 18.

138. "Universe" and another short story, "Common Sense," make up Heinlein's novel *Orphans of the Sky*.

139. For more information on the influential Julius Rosenwald Fund and its role in supporting African Americans involved in the arts, see Daniel Schulman, ed., *A Force for Change: African American Art and the Julius Rosenwald Fund*, exh. cat. (Chicago: Spertus Museum in association with Northwestern University Press, 2009).

140. Paul Chaat Smith, "Luna Remembers," in *James Luna: emendatio*, exh. cat. (Washington, D.C.: National Museum of the American Indian, 2005), 46.

141. Laura Roulet, "Ana Mendieta: A Life in Context," *Ana Mendieta, Earth Body: Sculpture and Performance*, exh. cat. (Washington, D.C.: Hirshhorn Museum and Sculpture Garden, Smithsonian Institution, 2004), 233.

142. Jane Blocker, *Where Is Ana Mendieta? Identity, Performativity, and Exile* (Durham, N.C.: Duke University Press, 1999), 109.

143. Julia P. Herzberg, "Ana Mendieta's Iowa Years, 1970–1980," in *Ana Mendieta, Earth Body*, 169.

144. Heather Diack, "Nobody Can Commit Photography Alone: Early Photoconceptualism and the Limits of Information," *Afterimage* 38, no. 4. (2011): 14–19.

145. This work is referenced in this volume in Patricia Kelly's "Mapping as Practice, or Finding the Subject in American Art, circa 1970."

146. In 1939, the Works Progress Administration was renamed the Works Projects Administration.

147. My thanks to Martin E. Petersen and James Grebl for their research on Mildred Myers Oldden.

148. "Conversation between Germano Celant and Dennis Oppenheim," in *Dennis Oppenheim* (Milan: Edizioni Charta, 1997), 36.

149. Warren Beach, letter to Mildred Steinbach. September 1, 1959. The San Diego Museum of Art Archives.

150. Edward Dwight, letter to Warren Beach, June 15, 1959. The San Diego Museum of Art Archives.

151. The birth and death dates of the subjects and their relatives were given to The San Diego Museum of Art by ancestors. The documents that offer this information are available in the archives of The San Diego Museum of Art.

152. Marion H. Reynolds, *The History and Some of the Descendants of Robert and Mary Reynolds (1630?–1931)* (Brooklyn, NY: The Reynolds Family Association, 1931), 167.

153. Ben Shahn and Forrest Selvig, "Interview: Ben Shahn Talks with Forrest Selvig," *Archives of American Art Journal* 17:3 (1977): 18.

154. Ibid., 21.

155. Janet Ruggles, conservator at the Balboa Art Conservation Center, has worked on a number of Shinn works and commented that this was an unusual practice for the artist.

156. "Conversation with the Artist: Isaac Julien and Thelma Golden," in *Lorna Simpson*, exh. cat. (New York: Harry N. Abrams, in association with the American Federation of Arts, 2006), 141.

157. Toby Kemps, "Lateral Thinking in the 1990s," in *Lateral Thinking: Art of the 1990s*, exh. cat. (San Diego, CA: Museum of Contemporary Art San Diego, 2002), 19.

158. Maura Reilly, "Notes on Kiki Smith's *Fall/Winter*," *Art Journal* 58:4 (1999): 7.

159. Martin E. Petersen, "The Warren Portraits by Thomas Sully," *Fine Arts Gallery San Diego Annual Report 1973–4*, 10.

160. Ibid., 8.

161. Emma W. Hart, letter to Martin E. Petersen, March 29, 1976. The San Diego Museum of Art Archives.

162. Spencer Michels, interview with Bill Viola, "Art in Motion," *PBS Newshour*, August 20, 1999, http://www.pbs.org/newshour/bb/entertainment/july-dec99/viola_8-20.html.

163. Deirdre Boyle, "Bill Viola's Phenomenology of the Soul," in *Bill Viola: Survey of a Decade*, exh. cat. (Houston: Contemporary Arts Museum, Houston, 1988), 9.

164. A. M. Weaver, "Carrie Mae Weems," *Artvoices Magazine* (April–May 2012): 53.

165. Derrick R. Cartwright, "Allegory and Allegiance in Benjamin West's Spenserian Subjects," in *Benjamin West: Allegory and Allegiance*, exh. cat. (San Diego, CA: Timken Museum of Art, 2004), 11.

166. Ibid., 1.

167. Ibid., 21.

168. "Interview: Mark Taylor in Correspondence with Vito Acconci," in *Vito Acconci* (London: Phaidon Press, 2002), 10.

169. Eleanor Antin, "Remembering 100 Boots." *100 Boots* (Philadelphia: Running Press, 1999), unpaginated.

170. Barbara Haskell, *Milton Avery*, exh. cat. (New York: Whitney Museum of American Art in association with Harper & Row, 1982), 117.

171. Mark Rothko, "Commemorative Essay, January 7, 1965," in *Milton Avery*, exh. cat. (Washington, D.C.: The National Collection of Fine Arts, Smithsonian Institution, 1969), unpaginated.

172. For more information, see Emily Grey, "A Painter's Paradise: Monhegan's Nineteenth-Century Artists," in *A Painter's Paradise: Monhegan's Nineteenth-Century Artists*, exh. cat. (Monhegan Island, ME: Monhegan Museum, 2009); Edward L. Deci, *The Monhegan Island Art Colony: 1858–2003*, exh. cat. (Clinton, N.Y.: Emerson Gallery, Hamilton College, 2003).

173. Don Bacigalupi and Rachel Evans, "Pursuing an Ideal: A History of the Museum's Collection," in *San Diego Museum of Art: Selected Works*, ed. Polly Crone (San Diego, CA: The San Diego Museum of Art, 2003), 12.

174. The San Diego Museum of Art owns three paintings and prints by Bellows, including some of his most recognizable works, such as the lithograph *A Stag at Sharkey's* (1917).

175. Kate Nearpass Ogden, "Sublime Vistas and Scenic Backdrops: Nineteenth-Century Painters and Photographers at Yosemite," *California History* 69:2 (Summer 1990): 134.

176. Richard A. Fine, "Albert Bierstadt, Fitz Hugh Ludlow and the American Western Landscape," *American Studies* 15:2 (Fall 1974): 93.

177. Ogden, "Sublime Vistas and Scenic Backdrops," 138.

178. Walt Whitman, "Song of Myself," in *Leaves of Grass* (1855; Doubleday, Doran, & Company, 1940), 57.

179. "Metamorphoses, Horse, Branch, and Bronze: A Conversation between Deborah Butterfield and Lawrence Weschler," in *Deborah Butterfield*, exh. cat. (Los Angeles: L.A. Louver, 2009), 157.

180. Butterfield's artistic approach and the inspiration for these works are examined more specifically in the interview in this book.

181. Lisa N. Peters, *Visions of Home: American Impressionist Images of Suburban Leisure and Country Comfort*, exh. cat. (Carlisle, PA: Trout Gallery, Dickinson College, in association with the University Press of New England, 1997), 28.

182. *The Running Fence Project* (New York: H. N. Abrams, 1977); Albert Maysles and David Maysles, *Running Fence* (New York: Maysles Films, 1978), VHS; *Christo and Jeanne-Claude: The Running Fence Revisited* (Washington, D.C.: Smithsonian American Art Museum, 2010).

183. Miki García, "Jamex and Einar de la Torre," in *TRANSactions: Contemporary Latin American and Latino Art*, exh. cat. (San Diego, CA: Museum of Contemporary Art, 2006), 57.

184. Simon Schama, *Landscape and Memory* (New York: A. A. Knopf, 1995), 14.

185. Patricia Hills, *Genre Painting of Eastman Johnson: The Sources and Development of his Style and Themes*, exh. cat. (New York: C. N. Potter, in association with the Whitney Museum of American Art, 197), 7.

186. Ralph Waldo Emerson, *The Poet* [1840] as cited in *Ralph Waldo Emerson: Essays and Lectures* (New York: The Library of America, 1983), 465.

187. Miwon Kwon, "Interview," in *Mark Dion*, by Lisa Graziose Corrin, Miwon Kwon, and Norman Bryson (London: Phaidon, 1997), 33.

188. Letter from Edith Hamlin to Martin E. Petersen, February 9, 1979; letter from Edith Hamlin to Martin E. Petersen, February 13, 1979. The San Diego Museum of Art Archives.

189. Peggy Samuels and Harold Samuels, *Techniques of the Artists of the American West* (Secaucus, NJ: The Wellfleet Press, 1990), 82.

190. Roger B. Stein, *The Seascape and the American Imagination*, exh. cat. (New York: Whitney Museum of American Art, 1975), 40.

191. Frank H. Goodyear, *Thomas Doughty, 1793–1856: An American Pioneer in Landscape Painting*, exh. cat. (Philadelphia: Pennsylvania Academy of the Fine Arts, 1973), 27.

192. Linda S. Ferber, "Asher B. Durand, American Landscape Painter," in *Kindred Spirits: Asher B. Durand and the American Landscape*, ed. Linda S. Ferber, exh. cat. (New York: Brooklyn Museum of Art, 2007), 154.

193. Walt Whitman, "Song of the Open Road," part 1, 3.

194. Walt Whitman, "Song of the Open Road," part 9, 9.

195. Hugh Davies and Lynda Forsha, interview of Ann Hamilton, in *Ann Hamilton*, exh. cat. (San Diego, CA: Museum of Contemporary Art San Diego, 1990), 68–69.

196. Gail R. Scott, *Marsden Hartley* (New York: Abbeville Press, 1988), 154.

197. The 1989 retrospective at the Guggenheim in New York consisted of some 534-feet of LED signs in the circular interior of the museum.

198. The work is sixty-one feet long and includes texts, in both Spanish and English, from different series by the artist.

199. Ronald J. Onorato, "Douglas Huebler: A Responsibility of Forms," in *Douglas Huebler*, exh. cat. (La Jolla, CA: La Jolla Museum of Contemporary Art, 1988), 38.

200. The screenplay has appeared in a variety of forms, including a series of comic strips published in *L.A. Weekly* from June 29 to August 30, 1984.

201. Painters such as John Frederick Kensett (1816–1872), who was associated with the Hudson River School, aimed for a more naturalistic representation of the landscape, and Asher B. Durand (1796–1886) sketched outdoors and then finished the final compositions in his studio. Although they typically altered aspects of their work in order to produce more engaging final paintings, they strove for realism in the foliage and mountains they portrayed.

202. Mark D. Mitchell, *George Inness in Italy*, exh. cat. (Philadelphia: Philadelphia Museum of Art, 2011), 38–39.

203. Ibid., 29.

204. George Inness, letter to "My dear wife," August 2, 1883, in *Life, Art, and Letters* (New York: Kennedy Galleries and Da Capo Press, 1969), 162.

205. George Inness, letter to "My dear Lizzie," August 4, 1883, in *Life, Art, and Letters* (New York: Kennedy Galleries and Da Capo Press, 1969), 163.

206. Armin Kietzmann, "Naturalism Predominates," *San Diego Union*, June 6, 1954.

207. Patricia Hills, *Eastman Johnson*, 8–9.

208. Sally Mills, "'Right Feeling and Sound Technique': French Art and the Development of Eastman Johnson's Outdoor Genre Paintings," in *The Cranberry Harvest, Island of Nantucket*, exh. cat. (San Diego, CA: Timken Art Gallery, 1990), 66.

209. Marc Simpson, "Taken with a Cranberry Fit: Eastman Johnson on Nantucket," in *The Cranberry Harvest, Island of Nantucket*, 36.

210. Ibid., 31.

211. The San Diego Museum of Art Archives, object file.

212. Peggy Samuels, *Techniques of the Artists of the American West*, 124–25.

213. Harold McCracken, *The Frank Tenney Johnson Book: A Master Painter of the Old West* (Garden City, NY: Doubleday, 1974), 91–92.

214. Margaretta Lovell is currently working on a book tentatively titled *Painting the Inhabited Landscape: Fitz H. Lane and Antebellum Globalism*.

215. Matt Stevens, interview with Margaretta Lovell, *Huntington Frontiers* (Spring–Summer 2010): 7.

216. Henry Ossawa Tanner (1859–1937) was elected to the National Academy of Design in 1927.

217. Richard Andrews, "Outside In: Maya Lin's Systematic Landscapes," in *Maya Lin: Systematic Landscapes*, exh. cat. (Seattle: Henry Art Gallery, 2006), 73.

218. Alfred Mitchell, *Mountain Landscape*, 1913. The San Diego Museum of Art owns eight paintings by the artist.

219. Martin E. Petersen, "Alfred R. Mitchell (1888–1972)," in *The Southland: Plein Air Painters of California* (Irvine, CA: Westphal Publishing, 1982), 198–207, 199.

220. An abbreviated list of books on the subject includes William H. Gerdts and Will South, *California Impressionism* (New York: Abbeville Press, 1998); Susan Landauer, *California Impressionists*, exh. cat. (Irvine, CA: Irvine Museum, 1996); and Patricia Trenton et al., *California Light, 1900–1930*, exh. cat. (Laguna Beach, CA: Laguna Art Museum, 1990).

221. Martin E. Petersen, "Fine Arts Gallery Acquires 3rd Thomas Moran Painting," *San Diego Union*, July 21, 1968.

222. Fritiof Fryxell, *Thomas Moran: Explorer in Search of Beauty* (East Hampton, NY: East Hampton Free Library, 1958), 56–57.

223. Ibid., 57.

224. Sharyn R. Udall, *Contested Terrain: Myth and Meanings in Southwest Art* (Albuquerque: University of New Mexico Press, 1996), 137.

225. Ibid.

226. Letter from Georgia O'Keeffe to Arthur Dove, September 1942. *Georgia O'Keeffe, Art and Letters,* by Jack Cowart and Juan Hamilton (Washington, D.C.: National Gallery of Art; Boston: New York Graphic Society Books, 1987), 233.

227. Valerie Loupe Olsen, "Rubén Ortiz-Torres—The Texas Leaguer," in *Rubén Ortiz-Torres: The Texas Leaguer*, exh. cat. (Houston, TX: Glassell School of Art, The Museum of Fine Arts, Houston , 2004), 11.

228. Tyler Stallings, "Cross-cultural Customizer," in *Desmothernismo: Rubén Ortiz-Torres*, exh. cat. (Huntington Beach, CA: Smart Art Press, 1998), 28–29.

229. Julie Schimmel and Robert R. White, *Bert Geer Phillips and the Taos Art Colony* (Albuquerque: University of New Mexico Press, 1994), 41.

230. Ibid., 142.

231. Ibid, 128.

232. Iana Quesnell, "Artist's Statement," www.ucsdopenstudios.com/2007. Accessed May 25, 2012.

233. Alfredo Ramos Martínez to Albert Bender, 17 July 1933, Albert Bender Papers, Mills College, Oakland, California.

234. Hamlin Garland, "Theodore Robinson," in *Brush and Pencil* 4:6 (September 1899): 285.

235. Ilene Susan Fort, "The Cosmopolitan Guy Rose," in *California Light, 1900–1930*, by Patricia Trenton and William H. Gerdts, exh. cat. (Laguna Beach, CA: Laguna Beach Art Museum, 1990), 99.

236. John Sloan, *Gist of Art* (New York: American Artists Group, Inc., 1939), 239.

237. Bruce St. John, ed., *John Sloan's New York Scene* (New York: Harper & Row, 1965), 314.

238. Helen Farr Sloan, "Introduction," in ibid., iv.

239. St. John, *John Sloan's New York Scene*, 428. The poem Sloan mentions, *Brooklyn Ferry*, is known as "Crossing Brooklyn Ferry."

240. Walt Whitman, "Song of Myself," 88.

241. Smithson is best known for his work *Spiral Jetty* (1970), realized in Rozel Point on the Great Salt Lake in Utah.

242. The lake might be as old as 1–3 million years, making it one of the oldest lakes in North America.

243. Claudine Chalmers, "Splendide Californie!: Selections by French Artists in California History, 1786–1900," *California History* 79:4 (Winter 2000–2001): 162.

244. Lisa N. Peters, *John Henry Twachtman: An American Impressionist*, exh. cat. (Atlanta, GA: High Museum of Art, 1999), 38.

245. Letter from Lisa N. Peters to Martin E. Petersen, 20 January 1995. The San Diego Museum of Art Archives.

246. The 2010 U.S. Census reported the population for the community as 3,622 people.

All entries were written by Amy Galpin.

SELECTED READINGS

Abrams, Janet and Peter Hull, eds. *Else/Where: Mapping New Cartographies of Networks and Territories.* Minneapolis: University of Minnesota Press, 2003.

Acconci, Vito. "Interview: Mark C. Taylor in correspondence with Vito Acconci." In *Vito Acconci*, 8–15. London: Phaidon Press, 2002.

Adler, Kathleen, Erica E. Hirschler, and H. Barbara Weinberg. *Americans in Paris, 1860–1900*, exh. cat. New York: The Metropolitan Museum of Art, 2006.

Alberro, Alexander. *Conceptual Art and the Politics of Publicity.* Cambridge, MA: The MIT Press, 2003.

Albright-Knox Art Gallery. *Contemporary Art, 1942–72: Collection of the Albright-Knox Art Gallery.* New York: Praeger Publishers in association with the Albright-Knox Art Gallery, 1973.

Allen, Gwen. "An Artists' Magazine: *Avalanche*, 1970–1976." In *Artists' Magazines: An Alternative Space for Art*, 91–120. Cambridge, MA: The MIT Press, 2011.

Althusser, Louis. "Contradiction and Overdetermination." In *The New Left Reader*, edited by Carl Oglesby, 57–83. New York: Grove Press, 1969.

——. *Lenin and Philosophy and Other Essays.* Translated by Ben Brewster. London: New Left Books, 1971.

Andrews, Richard. "Outside In: Maya Lin's Systematic Landscapes." In *Maya Lin: Systematic Landscapes*, exh. cat., 61–75. Seattle: Henry Art Gallery, 2006.

Antliff, Allan. *Anarchist Modernism: Art, Politics, and the First American Avant-Garde.* Chicago: University of Chicago Press, 2001.

Archipenko, Alexander. "Archipenko's Writings." *Archives of American Art Journal* 7, no. 2 (April 1967): 7.

Ashton, Dore. "Response to Crisis in American Art." *Art in America* 57 (January 1969): 24–35.

Atkinson, D. Scott. *William Merritt Chase: Summers at Shinnecock, 1891–1902.* Washington, D.C.: National Gallery of Art, 1987.

Auden, W. H. "Musée des Beaux Arts." In *The English Auden: Poems, Essays and Dramatic Writings, 1927–1939*, edited by Edward Mendelson, 237. London: Faber and Faber, 1977.

Bacigalupi, Don and Rachel Evans. "Pursuing an Ideal: A History of the Museum's Collection." In *San Diego Museum of Art: Selected Works*, edited by Polly Crone, 8–25. San Diego, CA: The San Diego Museum of Art, 2003.

Balken, Debra Bricker. *Dove/O'Keeffe: Circles of Influence*, exh. cat. Williamstown, MA: Sterling and Francine Clark Institute, distributed by Yale University Press, 2009.

Barron, Stephanie, Sheri Bernstein, and Ilene Susan Fort, eds. *Reading California: Art, Image, Identity, 1900–2000.* Los Angeles: Los Angeles County Museum of Art; Berkeley: University of California Press, 2001.

Barryte, Bernard, and Roberta Tarbell. *Rodin and America: Influence and Adaptation 1876–1936*, exh. cat. Stanford, CA: Iris & B. Gerald Cantor Center for Visual Arts, Stanford University in association with Silvana Editoriale, Milan, Italy, 2011.

Barthes, Roland. "Death of the Author." *Aspen*, no. 5–6 (Fall–Winter 1967).

Baume, Nicholas. ed. *Sol LeWitt: Incomplete Open Cubes.* Cambridge, MA: The MIT Press, 2001.

Beal, Graham. "'But Is It Art?': The Mapplethorpe/ Serrano Controversy." *Apollo* 345 (November 1990): 317–21.

Benezra, Neal David. "Ed Ruscha: Painting and Artistic License." In *Ed Ruscha*, exh. cat., edited by Neal David Benezra and Kerry Brougher, 145–155. Washington, D.C.: Hirshhorn Museum and Sculpture Garden and the Museum of Modern Art, Oxford, 2000.

Benjamin, Walter. "Eduard Fuchs, Collector and Historian." In *One Way Street and Other Writing*, translated by Edmund Jephcott and Kingsley Shorter, 349–86. London: Verso, 1985.

Best, Susan. "The Serial Spaces of Ana Mendieta." *Art History* 30 (February 2007): 57–82.

Bhabha, Homi. "Beyond Photography." In *A Living Man Dead and Other Chapters XVIII (2008–11)*, exh. cat. by Taryn Simon, 7–21. London: Mack, 2011.

Bloch, E. Maurice. *The Paintings of George Caleb Bingham: A Catalogue Raisonné.* Columbia, MO: University of Missouri Press, 1986.

Blocker, Jane. W*here Is Ana Mendieta?: Identity, Performativity, and Exile.* Durham, NC: Duke University Press, 1999.

Bochner, Mel. "The Serial Attitude." *Artforum* 6, no. 4 (December 1967): 28–33.

Boettger, Suzaan. *Earthworks: Art and the Landscape of the Sixties.* Berkeley: University of California Press, 2002.

Bodenhamer, David J., John Corrigan, and Trevor M. Harris, eds. *The Spatial Humanities: GIS and the Future of Humanities Scholarship.* Bloomington: Indiana University Press, 2010.

Boime, Albert. *The Magisterial Gaze: Manifest Destiny and American Landscape Painting, c. 1830–1865*. Washington, DC: Smithsonian Institution Press, 1991.

Bokovoy, M. F. *The San Diego Fairs and Southwestern Memory, 1880–1940*. Albuquerque: University of New Mexico Press, 2005.

Boris, Eileen. *Art and Labor: Ruskin, Morris, and the Craftsman Ideal in America*. Philadelphia: Temple University Press, 1986.

Brinton, Christian. "The San Francisco and San Diego Expositions." *International Studio* 55 (June 1915): cv–cx.

Bronx Museum of the Arts. *One Planet under a Groove: Hip Hop and Contemporary Art*, exh. cat. New York: Bronx Museum of the Arts, 2001.

Buchloh, Benjamin. "Conceptual Art, 1962–1969: From the Aesthetics of Administration to the Critique of Institutions." *October* 55 (Winter 1990): 105–143.

Burnham, Jack. "Systems Esthetics." *Artforum* 7, no. 1 (September 1968): 30–35.

Burns, Sarah. "In Whose Shadow? Eastman Johnson and Winslow Homer in the Postwar Decades." In *Eastman Johnson: Painting America*, exh. cat., edited by Teresa A. Carbone and Patricia Hills, 185–213. New York: Brooklyn Museum of Art, in association with Rizzoli International Publications, 1999.

Butler, Judith. "Performative Acts and Gender Constitution: An Essay on Phenomenology and Feminist Theory." In *Performing Feminisms: Feminist Critical Theory and Theatre*, edited by Sue-Ellen Case, 270–282. Baltimore, MD: Johns Hopkins University Press, 1990.

Carrier, David. "Robert Mangold's 'Gray Window Wall.'" *The Burlington Magazine* 138, no. 1125 (December 1996): 826–8.

Carson, Julia M. H. *Mary Cassatt: A Biography*. New York, D. McKay Co., 1966.

Cartwright, Derrick R. *Benjamin West: Allegory and Allegiance*, exh. cat. San Diego: Timken Museum of Art, 2004.

Casey, Edward S. *Earth-Mapping: Artists Reshaping Landscape*. Minneapolis: University of Minnesota Press, 2005.

——. "How to Get from Space to Place in a Fairly Short Stretch of Time: Phenomenological Prolegomena." In *Senses of Place*, edited by Steven Feld and Keith Basso, 13–52. Santa Fe, NM: School of American Research Press, 1996.

——. *Representing Place: Landscape Painting and Maps*. Minneapolis: University of Minnesota Press, 2002.

Castañeda, Antonia. "Language and Other Lethal Weapons: Cultural Politics and the Rites of Children as Translators of Culture." *Chicano-Latino Law Review* (Spring 1998): 229–241.

Castañeda, Antonia I. "Women of Color and the Rewriting of Western History: The Politics, Discourse, and Decolonization of History." *Pacific Historical Review* 61 (November 1992): 501–533.

Cembalest, Robin. "Goodbye, Columbus?" *ARTnews* 90 (October 1991): 104–109.

Chalmers, Claudine. "Splendide Californie! Selections by French Artists in California History, 1786–1900." *California History*, Vol. 79, No. 4 (Winter, 2000/2001), 154–179.

Chauvenet, Beatrice. *Hewett and Friends: A Biography of Santa Fe's Vibrant Era*. Santa Fe: Museum of New Mexico Press, 1982.

Collins, Georgia and Renee Sandell. "The Politics of Multicultural Art Education." *Art Education* 45, no. 6 (November 1992): 8–13.

Colpitt, Frances. "The Shape of Painting in the 1960s." *Art Journal*, 50, no. 1 (Spring 1991): 52–56.

Comey, Janet L. "Florida: The Late Work." In *Martin Johnson Heade*, exh. cat., edited by Theodore E. Stebbins, Jr., 123–127. Boston: Museum of Fine Arts, Boston, 1999.

Cooke, Lynne and Karen Kelly, eds. *Agnes Martin*. New York: Dia Art Foundation; New Haven, CT: Yale University Press, 2011.

Cooper, James Fenimore. *The Last of the Mohicans*. New York: Signet, 1962.

Cosgrove, Dennis, ed. *Mappings*. London: Reaktion Books, 1999.

Cowart, Jack, and Juan Hamilton, eds. *Georgia O'Keeffe, Art and Letters*. Washington DC: National Gallery of Art, 1987.

Davies, Hugh and Lynda Forscha, eds. *Ann Hamilton*, exh. cat. San Diego: Museum of Contemporary Art, San Diego, 1990.

Davis, Elliot Bostwick. "The Art of the Americas Wing, Museum of Fine Arts, Boston." *American Art* 24, no. 2 (Summer 2010): 9.

de Certeau, Michel. *The Practice of Everyday Life*. Translated by Steven Rendall. Berkeley: University of California Press, 1984.

de Laurentis, Teresa. *Alice Doesn't: Feminism, Semiotics, Cinema*. Bloomington: Indiana University Press, 1984.

Deleuze, Gilles and Félix Guattari. *A Thousand Plateaus: Capitalism and Schizophrenia.* Minneapolis: University of Minnesota Press, 1987.

Diack, Heather. "Nobody Can Commit Photography Alone: Early Photoconceptualism and the Limits of Information." *Afterimage* 38, no. 4. (January/February 2011): 14–19.

Dinin, Kenneth. "John Storrs: Organic Functionalism in a Modern Idiom." *The Journal of Decorative and Propaganda Arts* 6 (Autumn 1987): 48–73.

Dippie, Brian W. "The Winning of the West Reconsidered." *Wilson Quarterly Review* 14 (Summer 1990): 70–85.

Dion, Mark. "Interview with Miwon Kwon." In *Mark Dion*, edited by Lisa Graziose Corrin, Miwon Kwon, and Norman Bryson, 7–33. Phaidon, 1997.

Doezma, Marianne. "Bellows on Monhegan." *Colby Quarterly* 39, no. 4 (2003): 393.

Drake, James. *James Drake.* Austin: University of Texas Press, 2008.

Duncan, Carol. "The Art Museum as Ritual." In *The Art of Art History: A Critical Anthology*, 2nd edition, edited by Donald Preziosi, 424–434. Oxford and New York: Oxford University Press, 1998.

Dunkelman, Mark H. *Gettysburg's Unknown Soldiers: The Life, Death, and Celebrity of Amos Humiston.* Westport, CT: Praeger, 1999.

Eggebeen, Janna. "'Between Two Worlds': Robert Smithson and Aerial Art." *Public Art Dialogue* 1, no. 1 (March 2011): 87–111.

Eldredge, Charles C. *Reflection on Nature: Small Paintings by Arthur Dove, 1942–1943*, exh. cat. New York: The American Federation of Arts, 1997.

Emerson, Ralph Waldo. "Art." In *Essays: First Series*. 1841. Reprinted in *Ralph Waldo Emerson: Essays and Lectures.* New York: Library of America, 1983.

——. *Nature.* 1836. Reprinted in *Ralph Waldo Emerson: Essays and Lectures.* New York: Library of America, 1983.

Fahlman, Betsy. *John Ferguson Weir: The Labor of Art.* Newark: University of Delaware Press, 1997.

Farrell, Betty and Maria Medvedeva. "Demographic Transformation and the Future of Museums." From *The Center for the Future of Museums.* Washington, DC: American Association of Museums Press, 2010. http://www.futureofmuseums.org/reading/ publications/ upload/2DemoFoM_AAM2010.pdf (accessed May 2012).

Ferber, Linda S. *Kindred Spirits: Asher B. Durand and the American Landscape*, exh. cat. New York: Brooklyn Museum of Art, 2007.

Fine, Richard A. "Albert Bierstadt, Fitz Hugh Ludlow and the American Western Landscape." *American Studies*, Vol. 15, No. 2 (Fall 1974): 91–99.

Firestone, Shulamith and Ann Koedt, eds. *Notes from the Second Year: Women's Liberation; Major Writings of the Radical Feminists.* New York: Radical Feminism, 1970.

Foucault, Michel. *The Archaeology of Knowledge.* New York: Pantheon, 1972.

Foucault, Michel. *Discipline and Punish: The Birth of the Prison.* New York: Vintage Books, 1979.

Foucault, Michel. *The Birth of the Clinic: An Archeology of Medical Perception.* New York: Pantheon, 1973.

Franklin, Wayne. *James Fenimore Cooper: The Early Years.* New Haven, CT: Yale University Press, 2007.

Garcia, Matt. *A World of Its Own: Race, Labor, and Citrus in the Making of Greater Los Angeles, 1900–1970.* Chapel Hill and London: University of North Carolina Press, 2001.

Garland, Hamlin. "Theodore Robinson." *Brush and Pencil* Vol. 4, no. 6 (September 1899), 285–286.

Gerdts, William H. *American Impressionism.* New York: Abbeville Press, 1984.

Gerdts, William H. and Will South, *California Impressionism.* New York: Abbeville Press Publishers, 1998.

Gilliam, Sam and Annie Gawlak. "Solids and Veils." *Art Journal*, Vol. 50, No. 1 (Spring, 1991): 10–11.

Goodyear, Frank H. *Thomas Doughty, 1793–1856: An American Pioneer in Landscape Painting*, exh. cat. Philadelphia: Pennsylvania Academy of the Fine Arts, 1973.

Govan, Michael and Tiffany Bell, eds. *Dan Flavin: The Complete Lights, 1961–1996.* New York: Dia Art Foundation in association with Yale University Press, 2004.

Gulliford, Andrew. "Visitors Respond: Selections from 'The West as America' Comment Books." *Montana: The Magazine of Western History* 42, no. 3 (Summer 1992): 77–80.

——. "The West as America: Reinterpreting Images of the Frontier, 1820–1920." *Journal of American History* 79, no. 1 (June 1992): 199–208.

Gutierrez, David. "Significant to Whom? Mexican Americans and the History of the American West." *Western History Quarterly* 24, no. 4 (November 1993): 519–539.

Hanor, Stephanie. "The Material of Immateriality." In *Phenomenal: California Light, Space, Surface*, exh. cat. edited by Robin Clark, 129–149. Berkeley: University of California Press and San Diego: Museum of Contemporary Art, 2011.

Heartney, Eleanor. "Multiculturalism and Its Discontents: The New Word Order." *New Art Examiner*, April 1991.

Heat-Moon, William Least. *PrairyErth (A Deep Map): An Epic History of the Tallgrass Prairie Country.* Boston: Mariner Books, 1999.

Hendricks, Gordon. *Albert Bierstadt: Painter of the American West.* New York: Harry N. Abrams, 1988.

Henri, Robert. *The Art Spirit.* Philadelphia: J. B. Lippincott, 1923.

——. "An Ideal Exhibition Scheme," *Arts and Decoration* 5 (Dec. 1914): 49–52, 76.

——. "My People." *The Craftsman* 27 (Feb. 1915): 459–469.

——. "Progress in Our National Art Must Spring from Individuality of Ideas and Freedom of Expression: A Suggestion for a New Art School." *The Craftsman* 15, no. 4 (Jan. 1909): 387–401.

Higgins, Hannah. "Map." In *The Grid Book.* Cambridge, MA: The MIT Press, 2009.

Hirschler, Erica E. "Thomas Moran." In *The Lure of Italy: American Artists and the Italian Experience, 1760–1914,* exh. cat. edited by Theodore E. Stebbins, Jr. Boston: Museum of Fine Arts, Boston, 1992.

Homer, W. I. *Robert Henri and His Circle.* Ithaca, NY: Cornell University Press, 1969.

Howe, Daniel Walker. *What Hath God Wrought: The Transformation of America, 1815–1848.* New York: Oxford University Press, 2007.

Hudson, Suzanne. "Tara Donovan: Institute of Contemporary Art, Boston." *Artforum International* 47, no. 5 (January 2009): 204.

Inglehart, Ronald, Neil Nevitte, and Miguel Basáñez. *The North American Trajectory: Cultural, Political, and Economic Ties among the United States, Canada, and Mexico.* New York: Aldine de Gruyter, 1996.

Jack Rutberg Fine Arts. *Hans Burkhardt: Painting of the 1960s.* Los Angeles, CA: Jack Rutberg Fine Arts, 2008.

Jacob, Mary Jane. *Ana Mendieta: The "Silueta" Series, 1973–1980.* New York: Galerie Lelong, 1991.

Jameson, Fredric. *Postmodernism, or, The Cultural Logic of Late Capitalism.* Durham, NC: Duke University Press, 1991.

Johnson, Susan Lee. "'A Memory Sweet to Soldiers': The Significance of Gender in the History of the 'American West.'" *Western History Quarterly* 24, no. 4 (November 1993): 495–517.

Johnson, Paul E. and Sean Wilentz. *The Kingdom of Matthias.* New York: Oxford University Press, 1994.

Johnson, Paul E. *Shopkeeper's Millennium: Society and Revivals in Rochester, New York, 1815–1837.* New York: Hill and Wang, 1978.

Jones, Amelia. *Body Art: Performing the Subject.* Minneapolis: University of Minnesota Press, 1998.

Judd, Donald. "Specific Objects." *Arts Yearbook* 8 (1965): 74–82.

Karlstrom, P. J., ed. *On the Edge of America: California Modernist Art, 1900–1950.* Berkeley: University of California Press, 1996.

Karrow, Jr., Robert W. Introduction to *Maps: Finding Our Place in the World*, edited by James Ackerman and Robert W. Karrow, Jr., 1–18. Chicago: University of Chicago Press, 2007.

Kemps, Toby. "Lateral Thinking in the 1990s." In *Lateral Thinking: Art of the 1990s*, exh. cat., edited by Toby Kemps, 13–25. San Diego: Museum of Contemporary Art San Diego, 2002.

Kushner, Marilyn S. *Morgan Russell.* New York: Hudson Hills Press in association with Montclair Art Museum, 1990.

Kwon, Miwon. "One Place after Another: Notes on Site Specificity." *October* 80 (Spring 1997): 85–110.

Landauer, Susan, Donald D. Keyes, and Jean Stern. *California Impressionists.* Irvine, CA: The Irvine Museum/ Athens, GA: Georgia Museum of Art, 1996.

Lawrence, D. H. *Studies in Classic American Literature.* New York: Viking Press, 1973.

Lee, A. W. *Picturing Chinatown: Art and Orientalism in San Francisco.* Berkeley: University of California Press, 2001.

Lee, Erika. *At America's Gates: Chinese Immigration during the Exclusion Era, 1882–1943.* Chapel Hill: University of North Carolina Press, 2003.

Leeds, Valerie A. *My People: The Portraits of Robert Henri*, exh. cat. Orlando, FL: Orlando Museum of Art, 1994.

——. *Robert Henri in Santa Fe: His Work and His Influence*, exh. cat. Santa Fe, NM: Gerald Peters Gallery, 1998.

Leeds, Valerie A. "The Portraits of Robert Henri: Context and Influences." *American Art Review* 7, no. 2 (April–May 1995): 92–97, 157, 160.

Lefebvre, Henri. *Critique of Everyday Life*, translated by John Moore, 1947. Reprint, London: Verso, 1991.

Levander, Caroline F. and Robert S. Levine. "Introduction: Essays beyond the Nation." In *Hemispheric American Studies*, edited by Caroline F. Levander and Robert S. Levine. New Brunswick, NJ: Rutgers University Press, 2008.

Levin, Gail. *Synchromism and American Color Abstraction, 1910–1925*, exh. cat. New York: George Braziller in association with The Whitney Museum of American Art, 1978.

Lewis, Michael J. "Art for Sale." *Commentary* 191, no. 3 (March 2006): 32–38.

LeWitt, Sol. "Paragraphs on Conceptual Art." *Artforum* 5, no. 10 (June 1967): 79–83.

———. "Sentences on Conceptual Art," *Art-Language* 1, no. 1 (May 1969): 11–13.

Lima, Manuel. *Visual Complexity: Mapping Patterns of Information*. Princeton, NJ: Princeton Architectural Press, 2011.

Lippard, Lucy. "The Pains and Pleasures of Rebirth: Women's Body Art." *Art in America* 64, no. 3 (May–June 1976): 73–81.

Love, Richard H. *Mary Cassatt: The Independent*. Chicago: Milton H. Kreines, 1980.

Marcuse, Herbert. *One-Dimensional Man: Studies in the Ideology of Advanced Industrial Society*. Boston: Beacon Press, 1964.

Marcuse, *Essay on Liberation*. Boston: Beacon Press, 1969.

Marin, John. *The Selected Writings of John Marin*, edited by Dorothy Norman. New York: Pellegrini and Cudahay, 1949.

McCracken, Harold. *The Frank Tenney Johnson Book: A Master Painter of the Old West*. Garden City, NY: Doubleday, 1974.

Mendieta, Ana. "A Selection of Statements and Notes," *Sulfur* 22 (Spring 1988).

Meyer, James. "The Functional Site; or, The Transformation of Site Specificity." In *Space, Site, Intervention: Situating Installation Art*, edited by Erika Suderburg, 23–37. Minneapolis: University of Minnesota Press, 2000.

Miller, Angela L. *The Empire of the Eye: Landscape Representation and American Cultural Politics, 1825–1875*. Ithaca, NY: Cornell University Press, 1993.

Mills, C. Wright. *The Power Elite*. 1956. Reprint, Oxford: Oxford University Press, 1970.

———. *Power, Politics & People: The Collected Essays of C. Wright Mills*. 1963. Reprint, Oxford: Oxford University Press, 1967.

Mills, Sally. "Right Feeling and Sound Technique": French Art and the Development of Eastman Johnson's Outdoor Genre Paintings." *The Cranberry Harvest, Island of Nantucket*, exh. cat. San Diego, CA: Timken Art Gallery, 1990. 53–75.

Mitchell, Mark D. *George Inness in Italy*, exh. cat. Philadelphia: Philadelphia Museum of Art, 2011.

Mitchell, W. J. T. "Imperial Landscape." In *Landscape and Power*, edited by W. J. T. Mitchell, 5–34. Chicago: University of Chicago Press, 1994.

Morgan, Susan. *Joan Jonas: I Want to Live in the Country (And Other Romances)*. London: Afterall Books, 2006.

Morse, Samuel F. B. *Lectures on the Affinity of Painting with the Other Fine Arts*, edited by Nicolai Cikovsky, Jr. Columbia: University of Missouri Press, 1983.

Neill, Ben. "Interview with Christian Marclay." *BOMB*, No. 84 (Summer, 2003), 44–51.

Nemerov, Alexander. *The Body of Raphaelle Peale: Still Life and Selfhood, 1812–1824*. Berkeley: University of California Press, 2001.

———. *To Make a World: George Ault and 1940s America*, exh. cat. Washington, D.C: Smithsonian American Art Museum in association with Yale University Press, 2011.

Neuhaus, Eugen. *The Art of the Exposition*. San Francisco: Paul Elder and Company, 1915.

———. *The San Diego Garden Fair*. San Francisco: Paul Elder and Company, 1916.

Novak, Barbara. *Nature and Culture: American Landscape and Painting, 1825–1875*. Oxford: Oxford University Press, 2007.

Obama, Barack. *Dreams from My Father: A Story of Race and Inheritance*. New York: Three Rivers Press, 2004.

Ogden, Kate Nearpass. "Sublime Vistas and Scenic Backdrops: Nineteenth-Century Painters and Photographers at Yosemite." *California History* Vol. 69, No. 2 (Summer 1990): 134–153.

Oldenburg, Claes. *The Mouse Museum, The Ray Gun Wing: Two Collections, Two Buildings*, exh. cat. Chicago: Museum of Contemporary Art, 1977.

———. "Multiples and Production Notes." In *Claes Oldenburg: Multiples in Retrospect, 1964–1990*, 19–143. New York: Rizzoli, 1991.

Olsen, Valerie Loupe. *Rubén Ortiz-Torres: The Texas Leaguer*, exh. cat. Houston: The Glassell School of Art, The Museum of Fine Arts, Houston, 2004.

Onorato, Ronald J. "Collecting in Context." In *San Diego Museum of Contemporary Art: Selections from the Permanent Collection*, exh. cat., 10–40. San Diego: San Diego Museum of Contemporary Art, 1990.

———. "Douglas Huebler: A Responsibility of Forms." In *Douglas Huebler*, exh. cat., 30–41. La Jolla, CA: La Jolla Museum of Contemporary Art, 1988.

Oppenheim, Dennis. "Conversation between Germano Celant and Dennis Oppenheim." In *Dennis Oppenheim*, 17–53. Milan: Edizioni Charta, 1997.

Perlman, Bennard B. *Robert Henri: His Life and Art.* Minneola, NY: Dover Publications, 1991.

———. *Robert Henri, Painter*, exh. cat. Wilmington, NC: The Delaware Art Museum, 1984.

Perdue, Theda. *Sifters: Native American Women's Lives.* New York: Oxford University Press, 2001.

Peters, Lisa N. *John Henry Twachtman: An American Impressionist*, exh. cat. Atlanta: The High Museum of Art, 1999.

———. *Visions of Home: American Impressionist Images of Suburban Leisure and Country Comfort*, exh. cat. Carlisle, PA: Trout Gallery, Dickinson College in association with the University Press of New England, 1997.

Petersen, Martin E. "Alice Ellen Klauber & Friends." *Museum Artists Foundation* (September 2007), *www.aliceklauber.museumartistsfoundation.org* (accessed May 29, 2012).

———. "Henri's California Visit." *Fine Art Source Material Newsletter* 1, no. 2 (Feb. 1971).

Pile, Steve and Nigel Thrift. Introduction to *Mapping the Subject: Geographies of Cultural Transformation.* London: Routledge, 1995.

Plein Air Painters of California: The Southland. Irvine, CA: Westphal Publishing, 1982.

Pohl, Frances K. *Framing America: A Social History of American Art.* New York: Thames and Hudson, 2008 [2002].

Pointon, Marcia, ed. *Art Apart: Art Institutions and Ideology across England and North America.* Manchester: Manchester University Press, 1994.

Prown, Jules David. *American Painting from the Beginning to the Armory Show.* Geneva: Skira, 1969.

Prown, Jules David. "Benjamin West and the Use of Antiquity." *American Art* 10, no. 2 (Summer 1996): 28–49.

Reilly, Maura. "Notes on Kiki Smith's *Fall/Winter*." *Art Journal* 58, no. 4 (Winter 1999): 6–7.

Ringe, Donald A. "Chiaroscuro as an Artistic Device in Cooper's Fiction." *PMLA* 78, no. 4, pt. 1 (September 1963): 349–57.

Robbins, William G. "Laying Siege to Western History: The Emergence of New Paradigms." *Reviews in American History* 19, no. 3 (September 1991): 313–331.

Rogers, Sarah J. "Ann Hamilton: details." In *The body and the object: Ann Hamilton, 1984–1996*, exh. cat.,7–52. Columbus, Ohio: Wexner Center for the Arts, the Ohio State University, 1996.

Rondeau, James and Sheena Wagstaff, eds. *Roy Lichtenstein: A Retrospective*, exh. cat. Chicago: The Art Institute of Chicago, 2012.

Rosand, David. *The Invention of American Painting.* New York: Columbia University Press, 2004.

Rose, Anne C. "Eastman Johnson and the Culture of American Individualism." In *Eastman Johnson: Painting America*, exh. cat., edited by Teresa A. Carbone and Patricia Hills, 215–35. New York: Brooklyn Museum of Art, in association with Rizzoli International Publications, 1999.

Rose, Barbara. "Problems of Criticism 4: The Politics of Art, Part 1." *Artforum* 6, no. 6 (February 1968): 31–2.

———. *Readings in American Art, 1900–1975.* New York: Praeger, 1975.

Rosler, Martha. "Well, *Is* the Personal Political?" In *Feminism–Art–Theory: An Anthology, 1968–2000*, edited by Hilary Robinson, 95. Oxford: Blackwell, 2001.

Roth, Moira. "An Interview with Robert Smithson (1973)." In *Robert Smithson*, exh. cat., organized by Eugenie Tsai with Cornelia Butler, 81–94. Berkeley: University of California Press, 2004.

Rothko, Mark. "Commemorative Essay, January 7, 1965." In *Milton Avery*, exh. cat. Washington, D.C.: The National Collection of Fine Arts, Smithsonian Institution, 1969.

Sabbatino, Mary. "Ana Mendieta: Identity and the *Silueta* Series." In *Ana Mendieta*, edited by Gloria Moure. Barcelona: Ediciones Polígrafa, 1996.

Saito, L. T. *The Politics of Exclusion: The Failure of Race Neutral Policies in Urban America.* Palo Alto, CA: Stanford University Press, 2009.

Samis, Peter S. "Points of Departure: Curators and Educators Collaborate to Prototype a 'Museum of the Future.'" *Proceedings of International Cultural Heritage and Informatics Meeting*, 2001, http://www.archimuse.com/publishing/ichim01_vol1/ samis.pdf

Samuels, Peggy, Harold Samuels, Joan Samuels, and Daniel Fabian. *Techniques of the Artists of the American West.* Secaucus, NJ: The Wellfleet Press, 1990.

Sandmeyer, Elmer Clarence. *The Anti-Chinese Movement in California.* Champaign, IL: University of Illinois Press, 1991.

Schama, Simon. *Landscape and Memory.* New York: A. A. Knopf, 1995.

Schimmel, Julie, and Robert R. White. *Bert Geer Phillips and the Taos Art Colony.* Albuquerque: University of New Mexico Press, 1994.

Schwartz, Therese. "The Politicization of the Avant-Garde," Part 1. *Art in America* 59, no. 6 (November–December 1971): 97–105.

———. "The Politicization of the Avant-Garde," Part 2. *Art in America* 60, no. 2 (March–April 1972): 70–9.

———. "The Politicization of the Avant-Garde," Part 3. *Art in America* 61, no. 2 (March–April 1973): 69–71.

———. "The Politicization of the Avant-Garde," Part 3. *Art in America* 62, no. 1 (January–February 1974): 80–84.

Shahn, Ben and Forrest Selvig. "Interview: Ben Shahn Talks with Forrest Selvig." *Archives of American Art Journal*, Vol. 17, No. 3 (1977):14–21.

Simpson, Lorna, Isaac Julien and Thelma Golden. "Conversation with the Artist, Isaac Julien and Thelma Golden." In *Lorna Simpson*, exh. cat., edited by Okwui Enwezor, 134–141. New York: Abrams, in association with the American Federation of Arts, 2006.

Simpson, Marc. "Taken with a Cranberry Fit: Eastman Johnson on Nantucket." In *Eastman Johnson: The Cranberry Harvest, Island of Nantucket*, exh. cat., 31–51. San Diego, CA: Timken Art Gallery, 1990.

Sloan, John and Robert Henri. *Revolutionaries of Realism: The Letters of John Sloan and Robert Henri*, edited by Bennard B. Perlman. Princeton, NJ: Princeton University Press, 1997.

Smith, Paul Chaat. "Luna Remembers." In *James Luna: Emendatio*, edited by Truman T. Lowe and Paul Chaat Smith, 25–47. Washington, D.C.: National Museum of the American Indian, 2005.

Smith, Richard Cándida. *The Modern Moves West: California Artists and Democratic Culture.* Philadelphia: University of Pennsylvania Press, 2009.

Smithson, Robert. "The Monuments of Passaic: Has Passaic Replaced Rome as the Eternal City?" *Artforum* 6, no. 4 (December 1967): 48–51.

Smithson, Robert. *Robert Smithson: The Collected Writings*, edited by Jack Flam. Berkeley: University of California Press, 1996.

Solon, Deborah Epstein. *An American Impressionist: The Art and Life of Alson Skinner Clark*, exh. cat. Pasadena, CA: Pasadena Museum of California Art/Manchester, VT: Hudson Hills Press, 2005.

St. John, Bruce. *John Sloan's New York Scene.* New York: Harper & Row, 1965.

Staiti, Paul. *Samuel F. B. Morse.* Cambridge: Cambridge University Press, 1989.

Stallings, Tyler. "Cross-cultural Customizer." In *Desmothernismo: Rubén Ortiz-Torres*, exh. cat., 8–29. Huntington Beach, CA: Smart Art Press, 1998.

Stansell, Christine and Sean Wilentz. "Cole's America: An Introduction." In *Thomas Cole: Landscape into History*, edited by William H. Truettner and Alan Wallach, 3–21. New Haven, CT: Yale University Press, 1994.

Stebbins, Jr., Theodore E. *The Lure of Italy: American Artists and the Italian Experience, 1760–1914*, exh. cat. Boston: Museum of Fine Arts, Boston, 1992.

Stein, Roger B. *The Seascape and the American Imagination*, exh. cat. New York: Whitney Museum of American Art, 1975.

———. "Transformations: Copley in Italy." In *The Italian Presence in American Art, 1760–1860*, edited by Irma B. Jaffe, 53–55. New York: Fordham University Press, 1989.

Steiner, Rochelle. "Interview with John Currin." In *John Currin*, exh. cat., edited by Staci Boris and Rochelle Steiner, 77–86. Chicago: Museum of Contemporary Art, Chicago in Association with Harry N. Abrams, New York, 2003.

Steele, Claude M. *Whistling Vivaldi: How Stereotypes Affect Us and What We Can Do.* New York: W. W. Norton, 2010.

Stern, Jean. "Robert Henri and the 1915 San Diego Exposition." *American Art Review* 2 (Sept.–Oct. 1975): 108–117.

Storr, Robert. "Room for Maneuver." In *Tony Smith: Louisenberg*, exh. cat., 5–11. New York: Mitchell-Inness & Nash, 2003.

Tally, Jr., Robert T. "Jameson's Project of Cognitive Mapping: A Critical Engagement." In *Social Cartography: Mapping Ways of Seeing Educational and Social Change*, edited by Rolland G. Paulston, 399–416. New York: Garland, 1996.

Tamarkin, Elisa. *Anglophilia: Deference, Devotion, and Antebellum America.* Chicago: University of Chicago Press, 2008.

Tatham, David. "Samuel F. B. Morse's 'Gallery of the Louvre': The Figures in the Foreground." *American Art Journal* 13, no 4 (Autumn 1981): 38–48.

Taylor, Alan. *William Cooper's Town: Power and Persuasion on the Frontier of the Early American Republic.* New York: Vintage, 1995.

Taylor, Alex J. "Unstable Motives: Propaganda, Politics, and the Late Work of Alexander Calder." *American Art*, Vol. 26, No. 1 (March 2012): 24–47.

Thoreau, Henry David. *Walden.* 1854. Reprint, New York: Modern Library, 1950.

Tottis, James W. *Life's Pleasures: The Ashcan Artists' Brush with Leisure*, exh. cat. London: Merrell, 2007.

Trask, John Ellingwood Donnell Trask and John Nilson Laurvik, eds. *Catalogue Deluxe of the Fine Arts Department of the Panama Pacific International Exposition.* 2 vols. San Francisco: Paul Elder and Company, 1915.

Trenton, Patricia and William H. Gerdts, eds. *California Light, 1900–1930*, exh. cat. Laguna Beach: Laguna Beach Art Museum, 1990.

Truettner, William H., ed. *The West as America: Reinterpreting Images of the Frontier, 1820–1920*, exh. cat. Washington, DC: Smithsonian Institution Press, 1991.

Tuan, Yi-Fu. *Place, Art, and Self.* Chicago: Center for American Places in association with Columbia College, Chicago, 2004.

Viso, Olga M., ed. *Ana Mendieta: Earth Body; Sculpture and Performance, 1972–1985.* Washington, D.C.: Hirshhorn Museum and Sculpture Garden; Ostfildern-Ruit: Hatje Cantz Publishers, 2004.

Walker, Andrew. "Coming of Age: American Art Installations in the Twenty-First Century." *American Art* 24, no. 2 (Summer 2010): 2–8.

Wallach, Allan. "The Battle over 'The West as America.'" In *Exhibiting Contradiction: Essays on the Art Museum in the United States*, edited by Alan Wallach, 105–117. Amherst: University of Massachusetts Press, 1998.

Wallis, Brian, Marianne Weems, and Philip Yenawine, eds. *Art Matters: How the Culture Wars Changed America.* New York: New York University Press, 1999.

Wardle, Marian, ed. *American Women Modernists: The Legacy of Robert Henri*, exh. cat. Provo, UT: Brigham Young University Museum of Art, 2005.

Watts, Michael J. "Space for Everything (a Commentary)." *Cultural Anthropology* 7, no. 1 (February 1992): 115–129.

Weininger, Susan. "Modernism and Chicago Art: 1910–1940." In *The Old Guard and the Avant Garde: Modernism in Chicago, 1910–1940*, edited by Sue Ann Prince, 59–75. Chicago: University of Chicago Press, 1990.

Weinberg, Barbara H. and Carrie Rebora Barratt, eds. *American Stories: Paintings of Everyday Life, 1765–1915.* New York: The Metropolitan Museum of Art; New Haven, CT: Yale University Press, 2009.

Whitman, Walt. *Leaves of Grass.* 1855. Reprint, New York: Doubleday, Doran, & Company, 1940.

——. *Memoranda during the War*, edited by Peter Coviello. New York: Oxford University Press, 2004.

Wilentz, Sean. *Andrew Jackson.* New York: Times Books, 2005.

Wilentz, Sean. *The Rise of American Democracy: Jefferson to Lincoln.* New York: Norton, 2005.

Wolf, Bryan J. "How the West Was Hung, Or, When I Hear the Word 'Culture' I Take Out My Checkbook." *American Quarterly* 44, no. 3 (September 1992): 418–38.

Wolf, Bryan Jay. "All the World's a Code: Art and Ideology in Nineteenth-Century American Painting." *Art Journal* 44 (Winter 1984): 328–33.

Wollen, Peter. "Mappings: Situationists and/or Conceptualists." In *Rewriting Conceptual Art*, edited by Michael Newman and Jon Bird, 27–46. London: Reaktion Books, 1999.

Woods, Thomas. "Museums and the Public: Doing History Together." *Journal of American History* 82, no. 3 (December 1995): 1111–5.

Yorba, Jonathan. *Arte Latino: Treasures from the Smithsonian American Art Museum.* New York: Watson-Guptil Publications in association with the Smithsonian American Art Museum, 2001.

Yount, Sylvia. "'Provincial' No More: The Virginia Museum of Fine Arts." *American Art* 24, no. 2 (Summer 2010): 24–26.

Deborah Butterfield is a major American sculptor whose subject since the 1970s has been the horse. Butterfield earned a MFA degree from the University of California, Davis and is the recipient of numerous awards for her sculpture. In addition to group exhibitions, she has been granted solo exhibitions at museums including the Seattle Art Museum, The San Diego Museum of Art, the Denver Art Museum, and the Yellowstone Art Museum in Billings, Montana. Her work is located in a number of prominent collections such as the Art Institute of Chicago, the Hirshhorn Museum and Sculpture Garden, the Metropolitan Museum of Art, and the Whitney Museum of American Art. Born in San Diego, she splits her time between Montana, Hawaii, and Walla Walla, Washington.

Derrick R. Cartwright is an art historian who lives in Seattle. He has written and lectured extensively on American art and architecture. Recent publications include essays on Franco-American cultural exchange, the eighteenth-century American painter Benjamin West, and participation in twenty-first-century art museums. His essay in this volume on Robert Henri in La Jolla is part of a book-length project that explores decisive change in artistic careers. Cartwright was director of The San Diego Museum of Art from 2004 to 2009.

Amy Galpin is Assistant Curator, Art of the Americas at The San Diego Museum of Art. She received her PhD from the University of Illinois-Chicago in 2012. Her projects for The San Diego Museum of Art include the exhibitions, *Brutal Beauty: Hugo Crosthwaite*; *Portrait of an Artist as a Young Man: Rubén Ortiz-Torres*; and *Global Journey/Local Response: Jean Charlot*. In 2010, she curated the exhibition, *Translating Revolution: U.S. Artists Interpret Mexican Muralism* at the National Museum of Mexican Art in Chicago. Her research focuses primarily on the intersection of Mexican and American cultures in modern and contemporary art.

James Grebl became manager of the Library and Archives of The San Diego Museum of Art in 2000 and also teaches and lectures extensively on a variety of topics including classical and neoclassical art, nineteenth-century art, landscape painting, and the history of The San Diego Museum of Art. He received his MA and PhD degrees in classical art history from the University of California, Los Angeles and subsequently taught at San Diego State University for more than a decade.

Michael Hatt was head of research at the Yale Center for British Art before joining the University of Warwick in September 2007 as a professor in the History of Art Department. He has worked on a range of topics in nineteenth-century British and American art and visual culture and has interests in gender and sexuality and questions of visual racism.

Patricia Kelly is an associate professor of Critical + Cultural Studies at Emily Carr University of Art + Design. She has published on a diverse range of topics, including the work of Jo Baer and Barnett Newman, art in politics in Chicago in the 1960s, and American print culture of the early nineteenth century. Kelly's current book project, *On-Site: Art, Politics, and Viewers (New York, circa 1970)*, explores the aesthetic, cultural, and social possibilities initiated through new models of critical engagement and display.

Patrick McCaughey has been director of the National Gallery of Victoria (1981–87) in Melbourne; the Wadsworth Atheneum (1988–95) in Hartford, Connecticut; and the Yale Center for British Art (1996–2001) in New Haven, Connecticut. He was brought up in Australia and studied fine arts and English at the University of Melbourne, where he received an honorary LL.D. degree. McCaughey is the author of *Fred Williams 1927–1982* (2008); *Voyage and Landfall: The Art of Jan Senbergs* (2006); *Bert & Ned: The Correspondence of Albert Tucker and Sidney Nolan* (2006); and a memoir, *The Bright Shapes and the True Names* (2003).

Alexander Nemerov, the Carl and Marilynn Thoma Provostial Professor in the Arts and Humanities at Stanford University, teaches and writes about American visual culture of the eighteenth to the mid-twentieth century, focusing on painting, sculpture, photography, and film. His most recent book is *To Make a World: George Ault and 1940s America* (2011), which accompanied the exhibition he curated for the Smithsonian American Art Museum. He is also the author of *Acting in the Night: "Macbeth" and the Places of the Civil War* (2010), about a single night's performance of *Macbeth* attended by Abraham Lincoln in Washington in 1863. Nemerov has written a book on film, *Icons of Grief: Val Lewton's Home Front Pictures* (2005), and two books on painting, *The Body of Raphaelle Peale: Still Life and Selfhood, 1812–1824* (2001) and *Frederic Remington and Turn-of-the-Century America* (1995).

Rubén Ortiz-Torres was born in Mexico and has been living and working in Los Angeles since 1990. He is widely regarded as one of today's leading Mexican artists, innovating a specifically Mexican form of postmodernism. His wide-ranging body of work includes photography, altered readymades, film and video, painting, sculpture, customized cars and machines, photo collages, and performances; he has also curated exhibitions. Since 1982, Ortiz-Torres's work has been featured in twenty-five solo exhibitions and more than one hundred group shows in Australia, Canada, Europe, New Zealand, and the United States, while his films and video works have been screened more than fifty times. He has received awards and grants from the Andrea Frank Foundation, the Foundation for Contemporary Performance Arts (now the Foundation for Contemporary Arts), the U.S. Mexico Fund for Culture, and the Fulbright Foundation, among others.

Robert L. Pincus was the art critic for the *San Diego Union* and the *San Diego Union-Tribune* for twenty-five years, beginning in 1985, and the books editor and books columnist from 2008 to 2010. From 1981 to 1985, he was an art critic for the *Los Angeles Times*. Pincus received a BA degree with honors in comparative cultures from the University of California, Irvine, and holds an MA degree in American studies and a combined PhD degree in English and art history from the University of Southern California. He is the author of *On a Scale That Competes with the World,* a groundbreaking book on the artists Edward Kienholz and Nancy Reddin Kienholz and has contributed essays to several other books, including, most recently, *Sophie Calle: The Reader,* which accompanied the 2009 exhibition at the Whitechapel Gallery in London. Pincus has also written for numerous exhibition catalogues, contributed regularly to magazines, including *Artforum* and *Art News,* and has been a corresponding editor from San Diego for *Art in America* for more than two decades. He currently serves as the senior grants and art writer at the Museum of Contemporary Art San Diego.

Frances K. Pohl is the Dr. Mary Ann Vanderzyl Reynolds '56 Professor of Humanities and Professor of Art History at Pomona College, California. She is the author of *Ben Shahn: New Deal Artist in a Cold War Climate, 1947–1954* (1989); *Ben Shahn* (1993); *In the Eye of the Storm: An Art of Conscience, 1930–1970* (1995), and *Framing America: A Social History of American Art* (2002, 2008, 2012), a major textbook on American art. Pohl has also published articles and essays on the Los Angeles muralist Judith Baca and the Italian conceptual and concrete poet Mirella Bentivoglio.

Lorna Simpson received a BFA degree in photography from the School of Visual Arts in New York in 1983 and an MFA degree in visual arts from the University of California, San Diego, in 1985. Her work can be found in the collections of the Art Institute of Chicago, the Baltimore Museum of Art, the Detroit Institute of the Arts, the Whitney Museum of American Art, and the Metropolitan Museum of Art, among others. She has had solo exhibitions at leading institutions such as the Museum of Contemporary Art, Los Angeles, and the Brooklyn Museum.

Brian Ulrich's decade-long *Copia* project was published as the monograph *Is This Place Great or What* in 2011. He was awarded a Guggenheim Fellowship from the John Simon Guggenheim Memorial Foundation in 2009. His photographs are held in the collections of the Art Institute of Chicago; the Cleveland Museum of Art; the Museum of Fine Arts, Houston; the Museum of Contemporary Art San Diego; and the Museum of Contemporary Photography. He has had solo exhibitions at the Cleveland Museum of Art; Museum of Contemporary Art Chicago; the Nerman Museum of Contemporary Art; and the Museum of Contemporary Art San Diego.

CREDITS

Copyright information and photography credits of works included in this catalogue are below. Images without specific credit are courtesy the lending institution. Every effort has been made to credit the photographers and sources of all illustrations in this volume; if there are any errors or omissions, please contact The San Diego Museum of Art so that corrections can be made in a subsequent edition.

Cover, back cover, and pages 173, 337: © John Currin 1999.

Pages 3, 340: © Ann Hamilton 1986.

Pages 195, 372: © Ann Hamilton 1990.

Pages 7, 368: © Sergio de la Torre 2003.

Pages 16, 21, 359: © Fred Tomaselli 1996.

Pages 20, 360: © Bill Viola 1992.

Pages 32, 208, 387: © 2012 Estate of John Sloan/Artists Rights Society (ARS), New York.

Pages 38, 137, 317, 382–3: © 2012 Georgia O'Keeffe Museum/Artists Rights Society (ARS), New York.

Pages 41, 127, 147, 329: © 2012 Andy Warhol Foundation for the Visual Arts /Artists Rights Society (ARS), New York.

Pages 47, 310–11: Art © Jasper Johns/Licensed by VAGA, New York, NY.

Pages 53, 141, 312: © Ellsworth Kelly 1963.

Pages 55, 319: © Helen Pashgian.

Pages 57 (left), 355 (left): Courtesy Cindy Sherman and Metro Pictures.

Pages 57 (right), 355 (right): © Cindy Sherman 2000.

Pages 58, 368: © Mark Dion 1999–2000.

Page 65: Photo: Wadsworth Atheneum Museum of Art/Art Resource, NY.

Pages 72–73, 105, 220, 257: © The Metropolitan Museum of Art. Image source: Art Resource, NY.

Pages 76, 376: © 2010 Estate of Luis A. Jimenez, Jr./Artists Rights Society (ARS), New York.

Pages 77, 378: © Paul Kos 1989.

Pages 86, 88, 93, 328, 390: © Brian Ulrich (www.notifbutwhen.com).

Pages 98–99, 101, 103, 107: Photo: Terra Foundation for American Art/Art Resource, NY.

Pages 101, 104: © Réunion des Musées Nationaux/Art Resource, NY.

Page 105: © National Gallery of Canada.

Page 109: © 2012 Museum Associates/LACMA, licensed by Art Resource, NY.

Page 119: © 2012 Museum of Fine Arts, Boston.

Page 121: Photo: Newark Museum/Art Resource, NY.

Pages 165, 358: Permission of the Estate of Edward Steichen.

Pages 153, 169, 352: © The Estate of Alice Neel Courtesy David Zwirner, New York.

Pages 171, 341: © David Hammons 1989.

Pages 139, 323: © Ed Ruscha 1962.

Pages 143, 326: © 2012 Frank Stella/Artists Rights Society (ARS), New York.

Pages 145, 316: © The Estate of Agnes Martin/Artists Rights Society (ARS), New York

Pages 149, 313: © Estate of Roy Lichtenstein.

Pages 151, 322: © Courtesy Donald Young Gallery, Chicago.

Pages 175, 191, 363: © 2012 Milton Avery Trust/Artists Rights Society (ARS), New York.

Pages 193, 310, 375: © 2012 Robert Irwin/Artists Rights Society (ARS), New York.

Pages 198, 357: Courtesy Lorna Simpson and Salon 94, New York.

Pages 214, 347: © James Luna 1991.

Pages 251, 365: Art © Deborah Butterfield/Licensed by VAGA, New York, NY.

Pages 254, 257, 264–5, 349: © The Estate of Ana Mendieta Collection, Courtesy Galerie Lelong, New York.

Pages 256, 267, 313: © 2012 The LeWitt Estate/Artists Rights Society (ARS), New York.

Pages 257–60, 388: Art © Estate of Robert Smithson/Licensed by VAGA, New York, NY.

Pages 268, 373: © 2012 Estate of Douglas Huebler/Artists Rights Society (ARS), New York. Courtesy Paula Cooper Gallery, New York.

Pages 269, 373: © 2012 Jenny Holzer/Artists Rights Society (ARS), New York.

Pages 280, 386: © The Alfredo Ramos Martinez Research Project, Reproduced by Permission.

Pages 274, 284, 336: © 2012 Hugo Crosthwaite/Artists Rights Society (ARS), New York.

Page 300: © 2012 The Josef and Anni Albers Foundation/Artists Rights Society (ARS), New York.

Page 301: © Jo Baer 1966.

Page 302: Art © T. H. Benton and R. P. Benton Testamentary Trusts/UMB Bank Trustee/Licensed by VAGA, New York, NY.

Page 303: © Hans G. & Thordis W. Burkhardt Foundation.

Page 303: © 2012 Calder Foundation, New York/Artists Rights Society (ARS), New York.

Page 304: Art © Estate of Stuart Davis/Licensed by VAGA, New York, NY.

Page 305: © Obiarts, Inc.

Page 305: © 2004 Tara Donovan.

Page 306: © 2012 Estate of Dan Flavin/Artists Rights Society (ARS), New York.

Page 307: © 2012 Helen Frankenthaler/Artists Rights Society (ARS), New York.

Page 308: © Musa Mayer 1977.

Page 312: Art © Judd Foundation. Licensed by VAGA, New York, NY.

Page 314: © 2012 Robert Mangold/Artists Rights Society (ARS), New York.

Page 314: © Christian Marclay, courtesy Paula Cooper Gallery, New York.

This publication accompanies the exhibition *Behold, America! Art of the United States from Three San Diego Museums* on view at the Museum of Contemporary Art San Diego, The San Diego Museum of Art, and the Timken Museum of Art from November 10, 2012– February 10, 2013.

Lead support for the show is provided by a generous grant from the Qualcomm Foundation.

QUALCOMM FOUNDATION

Further major funding has been received from The Henry Luce Foundation and Jake and Todd Figi. Additional support for the show is provided by San Diego Gas & Electric®, US Bank, Mandell Weiss Charitable Trust, RBC Wealth Management, ResMed Foundation, the Wells Fargo Foundation, and the Members of the Museum of Contemporary Art San Diego, The San Diego Museum of Art, and the Timken Museum of Art.

Available through D.A.P./Distributed Art Publishers 155 Sixth Avenue, 2nd floor, New York, New York 10013 Tel: (212) 627-1999 Fax: (212) 627-9484 www.artbook.com

Produced by Marquand Books, Inc., Seattle www.marquand.com

Library of Congress Cataloging-in-Publication Data
 Behold, America! : Art of the United States from
 Three San Diego Museums/edited by Amy Galpin;
 with essays and contributions by Deborah Butterfield
 [and twelve others].
 pages cm
 Issued in connection with three distinct, related
 shows, November 10, 2012 through February 10, 2013,
 at the Timken Museum of Art, San Diego Museum of
 Art, and Museum of Contemporary Art San Diego.
 Includes bibliographical references and index.
 ISBN 978-0-937108-49-9 (alk. paper)
 1. Art, American—Exhibitions. I. Galpin, Amy, curator,
 editor of compilation. II. Timken Museum of Art,
 host institution. III. San Diego Museum of Art, host
 institution. IV. Museum of Contemporary Art, San
 Diego, host institution.
 N6505.B44 2012
 709.73′074794985—dc232012034588

Details:
Page 1 Benjamin West, *Fidelia and Speranza*, (cat. 117)
Page 3 Ann Hamilton, *Untitled* from the *body/object* series, (cat. 81)
Page 4 Albert Bierstadt, *Cho-looke, the Yosemite Fall* (cat. 124)
Page 7 Sergio de la Torre, *Thinking About Expansion* (cat. 132)
Page 15 Agnes Pelton, *The Primal Wing* (cat. 43)
Page 16 Fred Tomaselli, *Head with Flowers* (cat. 114)
Page 31 George Ault, *Untitled* (cat. 2)
Page 32 John Sloan, *Italian Procession, New York* (detail; cat. 168)
Page 42 Thomas Eakins, *Elizabeth with a Dog* (cat. 75)
Page 60 John F. Peto, *In the Library* (cat. 44)
Page 96 Asher B. Durand, *Landscape—Composition: In The Catskills* (cat. 137)
Page 116 Thomas Moran, *Opus 24: Rome, from the Campagna, Sunset* (cat. 155)
Page 127 Andy Warhol, *Flowers* (detail; cat. 60)
Page 153 Alice Neel, *Portrait of Mildred Myers Oldden* (cat. 98)
Page 175 Milton Avery, *Pool in the Mountains* (detail; cat. 120)
Page 202 Morgan Russell, *Synchromy with Nude in Yellow* (cat. 49)
Page 224 Robert Henri, *Mukie* (fig. 71)
Page 254 Ana Mendieta, *Untitled (from the Silueta Series)* (detail; cat. 96)
Page 274 Hugo Crosthwaite, *Bartolomé* (detail; cat. 73)
Page 299 Theodore Robinson, *The Edge of the Forest* (cat. 166)

Designed by Zach Hooker
Typeset in Chronicle by Maggie Lee
Proofread by Carrie Wicks
Color management by iocolor, Seattle
Printed and bound in China by C&C Offset Printing Co., Ltd.